THE
ESSENTIAL
GOMBRICH

THE
ESSENTIAL
GOMBRICH

SELECTED WRITINGS
ON ART AND CULTURE

EDITED BY
RICHARD WOODFIELD

Φ

Phaidon Press Limited
Regent's Wharf
All Saints Street
London N1 9PA

First published 1996
© 1996 Phaidon Press
Limited

ISBN
0 7148 3009 7 hb
0 7148 3487 4 pb

A CIP catalogue record
for this book is available
from the British Library

Printed in Hong Kong

Contents

Foreword

by E.H. Gombrich

When I was invited by my publishers to add a foreword to this selection from my published writings, I was glad of the opportunity to thank the editor, Mr Richard Woodfield, who had earned my gratitude earlier for a selection of my book reviews published under the title *Reflections on the History of Art*. This time I think his brief was more difficult, indeed I may be forgiven if I consider it impossible of fulfilment. I suppose no author likes to be told, at least by implication, that the majority of his writings, on which he spent a good deal of thought and labour, are inessential, particularly if this also applies to many chapters in his books. As it is, I have had to console myself remembering the splendid formulation in George Orwell's *Animal Farm*: 'All animals are equal but some animals are more equal than others.' Be this as it may, it seems to me that Mr Woodfield has done his difficult job much better than I thought possible. He has added to the selection a great deal of information that should help the reader to 'place me', as the saying goes. Here, however, it may be found useful if I briefly add not what I *have* done (which is not for me to say in any case), but what I have never done.

As explained more fully elsewhere in this volume, I see the field of art history much like Caesar's Gaul, divided into three parts inhabited by three different, though not necessarily hostile tribes: the connoisseurs, the critics and the academic art historians. I should like to insist on this distinction so as to counter the persisting legend that art history as such was brought to this country by immigrants from the continent of Europe. This may apply, to some extent, to us academic art historians since art history was not a university subject in the United Kingdom before we arrived, but this cannot

be true of the connoisseurs (despite their foreign designation), for after all, the great collections of this country could never have been built up without their knowledge and skill in weeding out copies and forgeries and spotting important masterpieces abroad and at home. As to the critics, the mere mention of names such as John Ruskin or Roger Fry should suffice to establish their English credentials. Not that the names of academic art historians, names such as Heinrich Wölfflin, Aby Warburg or Erwin Panofsky, have not been familiar to art lovers in this country, and I should be proud to be associated with them. All the more, I have generally followed their example, studiously to avoid trespassing on the territory of our respective neighbours. While I may have my private opinions on attributions, I have never aired them in public, and I have also felt reluctant to broadcast my views about contemporary artists or movements. For if the truth is to be told, for us academic art historians the emphasis lies on our task as historians, and I for one feel that the millennia of the past offer sufficient scope for our activities. I would never claim that these activities are as essential to the welfare of mankind as are those of our colleagues in the Medical Faculty, but if we cannot do much good, at least we do little harm, as long, at least, as we refrain from polluting the intellectual atmosphere by pretending to know more than we do.

Introduction

by Richard Woodfield

It is a fair guess that the name of Gombrich is more familiar to a large variety of people than that of any other living art historian. His book, *The Story of Art*, has gone through sixteen editions during the forty-five years of its existence to date, and has been translated into some twenty-three languages, including Turkish, Finnish, Japanese, Chinese and Korean. A great many people will also know him as the author of *Art and Illusion*, a theoretical book, published in seventeen languages so far. He is one of very few art historians to be interested in the scientific study of visual perception, and he has also had a lifelong fascination with the decorative arts, culminating in a major work, *The Sense of Order*. As a scholar he is an authority on the Renaissance, who has made a particular contribution to the study of Renaissance iconography. As a thinker with a rational, sceptical cast of mind he has been constantly preoccupied with questions of theory and method, and as a cultural historian and commentator he has been deeply concerned with the traditions and values of our civilization, and with keeping our knowledge of them alive. For Gombrich, an awareness of the past is a necessary part of being civilized.

Drawing on the whole range of Gombrich's published work, *The Essential Gombrich* brings together in one volume a selection of his best and most characteristic writing. Its aim is to make his ideas readily accessible to a wider public, and to underline the importance of his contribution to cultural debate.

Ernst Hans Josef Gombrich was born in Vienna in 1909, the son of a respected lawyer and a pianist of international reputation as a teacher. He studied the History of Art and Classical Archaeology at the University of Vienna. The university had two institutes of art history and he chose to work

in the second, led by Julius von Schlosser, who saw himself as inheriting the ideals of the Vienna School of Art Historians. Its earlier members had taken an interest in explaining the problem of art-historical development, why the art of the past should have taken the forms that it did. They turned to psychology in their search for answers, and Gombrich's venerated teacher, Emanuel Loewy, had tried to explain the development of naturalism in Greek art by appealing to the growth of visual knowledge and gradual rejection of 'memory images'. Other members of the school, notably Max Dvořák, also proposed large-scale explanations of artistic development by appealing to the history of culture, making complex associations between style, literature, philosophy and social history. In this respect Schlosser was the sceptic: he insisted that his students work with original material, in the museums or archives, and that they develop a clear sense of the problems involved. Gombrich's doctoral dissertation on the architecture of Giulio Romano shared his teacher's concerns.

After leaving university, Gombrich had little chance of full-time academic employment because of the growth of anti-semitism. Besides starting to learn Chinese he became involved in a number of projects: one was working with Ernst Kris, a museum curator and practising psychoanalyst, on the history of caricature; another, lesser, commitment was to write a short children's history of the world. It was through Kris that Gombrich became employed at the Warburg Institute in London, as a Research Fellow working on Aby Warburg's papers; meanwhile, the success of his book on world history had already prompted his publisher to urge him to write a similar book on art history, a suggestion that Gombrich initially rejected as impractical.

Gombrich moved to London in January 1936. The Warburg Institute had moved to London from Hamburg slightly earlier, providing a haven for German scholars interested in research into the *Nachleben* (afterlife) of classical antiquity. Its central focus was cultural history, as opposed to the Courtauld Institute's assignment to offer instruction in art history. Besides his research at the Warburg, Gombrich gave some classes at the Courtauld and was invited, with his colleague Otto Kurz, to prepare a student introduction to iconology, on the meaning of images. The war broke out and, again through Kris's intervention, Gombrich became employed by the BBC as a Radio Monitor: this left him with a life-long interest in the real problems of perception. During the war he continued to maintain his interest in academic research and was invited by Dr Horovitz, the founder of Phaidon Press, after all to write that book on art history, albeit for a different audience. Horovitz, incidentally, was also Viennese, Phaidon having been founded in Vienna and subsequently moved to London.

When the war was concluded, Gombrich returned to work at the Warburg Institute. He re-immersed himself in the study of the Italian Renaissance and published two outstanding articles, one on Botticelli's mythological paintings and the other on Renaissance theories of artistic symbolism.[1] But he also had to honour his promise to write a book for Dr Horovitz: this emerged as *The Story of Art* (1950). On completing the initial draft he contemplated writing another book, on 'The Realm and Range of the Image', which ultimately turned into *Art and Illusion* (1960). Thus started, effectively, three separate careers: the publicly acclaimed author of *The Story of Art*, the recondite scholar of the Italian Renaissance, and the famous commentator on the psychology of pictorial representation.

The success of *The Story of Art* led to Gombrich's appointment as the Slade Professor of the History of Art at Oxford University. This led, in turn, to a succession of invitations across the world to talk to the general, and non-specialist, public about the history of art. Conceived partly as a commentary on issues raised in *The Story of Art*, *Art and Illusion* applied new discoveries in the psychology of perception, linguistics and information theory to the study of naturalistic imagery. Its themes were pursued in papers and lectures presented mainly to scholarly audiences. And in specialist art-historical circles, he published articles and gave lectures on the art and culture of the Italian Renaissance. Three different audiences for one speaker, and although those audiences were separate the issues were not.

With his reputation as a scholar, teacher and guest lecturer fully established, in 1959 he was appointed as Director of the Warburg Institute and Professor of the History of the Classical Tradition in the University of London, positions he retained until his retirement in 1976. *Art and Illusion* rapidly became a scholarly and scientific classic, cited across an enormous spectrum of research. It was followed by a volume of studies on the theory of art, *Meditations on a Hobby Horse* (1963). This caused a certain amount of controversy amongst art critics and, together with *Art and Illusion*, led to his recognition as one of the century's leading theorists of art. *Norm and Form* (1966), a collection of essays focusing on patronage and questions of taste, was the first of four outstanding books on Italian Renaissance art and culture. The three others were *Symbolic Images* (1972), which satisfied the earlier request for an introduction to iconology, *The Heritage of Apelles* (1976), which pulled together Renaissance interests in art and science and considered the role of criticism in the growth of art, and *New Light on Old Masters* (1986), which again dwells on the theme of innovation. In 1970, he published *Aby Warburg: an Intellectual Biography*, before retiring from the Warburg Institute in 1976. In 1979, he published *The Sense of Order: a Study in the Psychology of Decorative Art*, which complemented his

earlier work on naturalistic imagery. In the meanwhile, he had been continuing to develop ideas from *Art and Illusion*, and some of his articles and papers were collected together and published as *The Image and the Eye* in 1982. Papers on broader issues connected with the relations between art and culture appeared in *Ideals and Idols* in 1979, and a volume of *Tributes*, dealing with those same issues but focused on the work of particular thinkers, ranging from Hegel and Freud to Kris and Boas, emerged in 1984. A collection of key reviews, *Reflections on the History of Art*, was published in 1987. Contemporary issues, such as the debate over relativism, and practices such as the titling of abstract works of art, were discussed in *Topics of our Time* (1991). We are now waiting for *The Preference for the Primitive*, which will consider a theme which Gombrich has been thinking and writing about since he left university. There is still a wealth of unpublished and uncollected material.

Gombrich's work is woven together by an intricate series of linking problems. In an illuminating remark in his autobiographical sketch he says, 'I wanted to write a commentary on what actually happened in the development of art. I sometimes see it as representation in the centre with symbolism on the one hand and decoration on the other. One can reflect about all these things and say something in more general terms.'[2] The notion of an extended 'commentary' does indeed provide a unifying thread. Behind *The Story of Art* is a theory about the development of the visual arts in the Western European tradition. Greek artists left a legacy of visual discoveries never quite forgotten in the Middle Ages, and fully resurrected by the artists of the Italian Renaissance. It reached its culmination in the recent developments of photography, film, television and, most recently, virtual reality. These discoveries did not, of themselves, create artistic masterpieces, which stand to those discoveries as literature stands to language. As Gombrich quoted Goethe: 'A genuine work of art, no less than a work of nature, will always remain infinite to our reason: it can be contemplated and felt, it affects us, but it cannot be fully comprehended, even less than it is possible to express its essence and its merits in words.'[3]

While *The Story of Art* vividly conveys a sense of what artists hoped to achieve through their works, it draws the line at explaining those achievements. No one can *explain* Michelangelo, least of all by reducing his work to formal diagrams or by discussing Italian politics or economics. It is, however, an illuminating comment to suggest that the greatness of Van Dyck's portraits, for example, 'helped to crystallize the ideals of blue-blooded nobility and gentlemanly ease which enrich our vision of man no less than do Rubens's robust and sturdy figures of over-brimming life'.[4]

The problem addressed by *Art and Illusion* is what makes the achievements of

naturalistic art possible. Image-makers across the world have been concerned to make phantom beings, substitute gods, demons and people. But the ambition to create figures of 'over-brimming life' has been primarily a preoccupation of Western art, that constitutes a 'living chain of tradition that still links the art of our own days with that of the Pyramid age'.[5]

The concern with 'over-brimming life' offers a clue to Gombrich's interest for scientists. It is every computer scientist's dream to create one which will simulate human behaviour: HAL, Stanley Kubrick's computer from 2001, springs to mind. At the end of his review of *Art and Illusion*, the famous American psychologist J. J. Gibson wrote:

> The discoveries of painters have been far more elaborate than the discoveries of psychologists, if less rational, and Gombrich shows that they are at least potentially investigable. The student of perception is tempted to limit his research to what he can experimentally control by the methods he has been taught. This book will widen his horizon and stimulate his ambition.[6]

Gibson was right in saying that the Western tradition of image making embodies an enormous stock of implicit knowledge which remains to be rediscovered. The artist's ability to simulate the appearance of visual reality offers important insights into the human perceptual process. We need to understand how the mind works before we can make any progress at all in its simulation.

In a sense *The Story of Art* and *Art and Illusion*, Gombrich's two most famous books, can be said to have set the agenda for all the rest of his work. The sense of 'a living chain of tradition' and the ceaseless effort to understand the workings of the human mind are constant features of Gombrich's many-faceted investigations of art and culture. In presenting some of these many facets, this volume is divided into eleven parts, which taken together explore a sequence of linked themes. For those who wish to dip into the volume rather than read it through, the division will provide points of orientation.

Gombrich's autobiography (Part I) offers more than anecdotal interest: it shows how his concerns emerged from a particular culture of values and problems. It takes him out the history of art history and places him in various fields of activity and human relationships: university, the BBC and the Warburg Institute. Cecil Gould once contrasted Kenneth Clark, 'a Scotsman brought up in England', with Gombrich, a product of 'the heady intellectual atmosphere of Vienna of the 1920s'.[7] But Gombrich would not be the person we know without his experience at the BBC, and one of the reasons for Clark's advancement of Gombrich's career was his own involvement in German

traditions of art-historical scholarship.[8] Nevertheless, *The Story of Art* was the product of a particular European tradition, one which Lord Clark shared and discussed in his television series *Civilisation*. The short piece from the *Independent* that complements the autobiographical sketch makes the interesting suggestion that *The Story of Art*'s roots in this tradition may help to explain its phenomenal success.

Gombrich's concern with the mechanics of the visual image (Part II), from comic book and advertisement to medieval illustration and Renaissance masterpiece, uniquely identifies him as an art historian. In an early review, reprinted in *Reflections on the History of Art* (1987),[9] he remarked that: 'The distinction between poetry and language has always been accepted as natural; the distinction between art and imagery is only gradually becoming familiar.' Perhaps, even now, it is not as familiar as it should be. The introduction to *The Story of Art* is as much about imagery as it is about art, as the homely example of the aesthetics involved in the choice of a tie demonstrates.

The section on 'Art and Psychology' (Part III) draws on material from *Art and Illusion* and *The Image and the Eye* (1982), supplemented by an extract from an important essay on 'Illusion in Art' and completed by an interview with Bridget Riley. Gombrich uses a wide range of psychological material and cannot be neatly pigeon-holed into one dominant theory. He employs what Popper has called the 'searchlight theory' of perception. Expectation is a key element in our experience both of life and of pictures, and prior 'knowledge' may be corrected by subsequent experience; this is his theory of 'making and matching'. The psychology of perception can consequently be linked to the 'linguistics' of the image: the similarities between the ways in which words and images parcel out experience. The artifice involved in seemingly natural representations of action and expression belies the idea that the image offers a 'slice of life'. Even abstract art offers scope for real insights into the working of perceptual processes, as the interview with Bridget Riley demonstrates.

The next section, 'Tradition and Innovation' (Part IV) shows that as the poet works with an inherited language, shaping it into new forms, so the traditions of the craft of visual imagery offer similar resources. Innovation, often thought to be the work of an inwardly looking creative imagination, turns out to have much more to do with the exploitation of resources already available in the public domain. In this context Gombrich has a new use for Freud and new things to say on the subject of the relation between tradition and innovation. Two essays from *Tributes* (1984) examine the ideas and an essay on Leonardo from *Norm and Form* (1966) shows the theory in practice.

'Psychology and the Decorative Arts' (Part V), comprising two consecutive chapters from *The Sense of Order* (1979), shows how certain ornamental forms

have been so persistent throughout history that they seem to have taken on a life of their own. If art and culture were simply a reflection of the Spirit of the Age, is hard to understand how this could happen. Explanation is called for and understanding the driving forces of ornamental patterns should help us to appreciate their appeal.

'Primitivism and the Primitive' (Part VI) has a double face. An intrinsic part of modernism was both a rejection of sophisticated ornamentation, in the International Style, and a drive towards the primitive, in such styles as Fauvism, Expressionism and Neo-Expressionism. The paradox is that a taste for the primitive is, itself, a product of hypersophistication. Pictorial satire, on the other hand, walks on a tightrope between visual sophistication and forms of psychological regression. The two articles published here are new to Phaidon's 'Gombrich Collection'. The first anticipates *The Preference for the Primitive*; the second returns to Gombrich's early work with Kris on caricature and cartoons, and is a major statement of his latest thoughts on the subject.

The question of primitivism raises the issue of the reasons for artistic change, which in turn raises the central problem of explanation in art history, dealt with in the section 'On the Nature of Art History' (Part VII). The question of change first emerged in connection with the transition from classical to medieval art, through the styles of late antiquity. It had originally been explained as a loss of skill; Gombrich's predecessor Riegl described it as the result of a change in 'artistic will', which he linked to the Spirit of the Age. But Gombrich turned to social psychology and the pressures generated by culture as a social institution. In the course of speculation he developed the idea of the 'ecology of the image': the way in which the functions of imagery and art within a culture affect their nature. Far from being hostile to the social explanation of artistic change, Gombrich has developed working ideas which have yet to be explored by sociologists, concerning particularly symptoms, syndromes and movements. The theory can be found in the essays of Part VII, drawn from *Topics of our Time* (1991), *Meditations on a Hobby Horse* (1963) and *Ideals and Idols* (1979). The practice is to be found in Part VIII, 'Alternatives to the "Spirit of the Age"', drawn from *New Light on Old Masters* (1986) and *The Heritage of Apelles* (1976). The distinctive quality of Giulio Romano's architecture is best sought in tastes shaped out of literary theory. The transformations of Brunelleschi's architecture can be understood as emerging out of a particular Florentine humanist culture. The 'Spirit of the Age', which is inherently vacuous in its explanatory power, can be replaced by studying the formation of movements, which consist of real people engaging in real activities.

Aby Warburg, the founder of the Warburg Institute, was interested in real

history: '... he collected everything that could contribute to the reconstruction and explanation of the milieu'.[10] His primary concern with images was for their use in understanding history, that is for their symptomatic value. Gombrich has naturally involved himself in Warburg's subjects (Part IX), but his results have been rather different, basically because of his deep interest in how images actually work and have worked. This involves pursuing the question of how works of art could and would have been understood at the time of their creation and the conventions that their artists would have followed. His major work in this area has been *Symbolic Images* (1972), though his warnings of the dangers of over-interpretation have been supported, for this volume, by one essay from *Reflections on the History of Art* (1987). 'On the Meanings of Works of Art' offers insights into the nature of symbolism and the ways in which historians can decipher Renaissance paintings. The 'case studies' show the way in which a scheme of Renaissance paintings could be explained in terms of a pictorial tradition and how a painting by Poussin poetically evokes a text. The essay on Dutch genre painting warns of the pitfalls of over-interpretation.

Warburg was interested in popular culture and Freud in the mechanics of daily thought. Gombrich worked with Kris on caricatures and cartoons and consequently became interested in vernacular imagery. 'High art and popular culture' (Part X) explores the intermediate zones. One of Goya's most famous compositions was shown to depend on a popular propaganda print and Steinberg is more the inheritor of Picasso's involvement with space than Pollock, and just as witty as Klee.

'Gombrich from within Tradition' (Part XI) concludes by returning full circle to his roots in Viennese culture and to the values that have informed his life-work. First and foremost, perhaps, to his love of classical music documented in his essay on Schubert (new to the Phaidon collected Gombrich), but also to his faith in 'Nature and Art as Needs of the Mind', a lecture drawn from *Tributes*. Finally, here printed for the first time in the author's own translation, his response on receiving the Goethe Prize of the City of Frankfurt-am-Main in 1994, a signal honour that prompted him to celebrate Goethe as the great mediator whose *œuvre* has given him access to the ideals and values of earlier conceptions of art that had been largely eclipsed for us moderns by the Romantic revolution.

While this selection introduces many aspects of Gombrich's work it has to be said that many also had to be left out. This *Essential Gombrich* is really a sampler. What it will make plain, however, is his commitment to high standards of argument in which both logic and evidence play an equally important role. The range and depth of his interests make him, without

doubt, one of the most fascinating thinkers of the twentieth century.

Most valuable of all, however, is his commitment to truth and to moral and intellectual integrity. The events of the twentieth century have shown that ideas can become deeds: shallow thought is irresponsible and fraudulent thought unacceptable. The false ideologies of Marxism and Nazism have resulted in some of the greatest crimes against humanity. Gombrich's deep hostility to the doctrines of relativism and the 'Spirit of the Age' is a response to advocates of totalitarian ideas, or, in the jargon, 'totality'.

I hope that this book will make Gombrich's work more accessible to the general reader. My notes at the end of each selection are intended to point to connections, within Gombrich's own work and outwards towards studies more familiar to specialists.

I would like to thank Sir Ernst for allowing me a free hand in making the selection for this volume and for his kindness in responding to so many of my questions across the years. I owe a particular debt on this occasion to Mr Richard Firmin, my surgeon, Dr Keith Morris, my cardiologist, and the staffs of the Queen's Medical Centre in Nottingham and the Nuffield Hospital in Leicester for my life. I would like to dedicate this book to the medical profession: *Ars longa, vita brevis*.

Professor Sir Ernst Gombrich, O.M., C.B.E., F.B.A., was made Director of the Warburg Institute and Professor of the History of the Classical Tradition in the University of London in 1959. He retired in 1976, when he was made Professor Emeritus. He was awarded the C.B.E. in 1966, knighted in 1972 and awarded the Order of Merit in 1988. He holds numerous honorary doctorates and has been awarded many prestigious prizes, including the Erasmus Prize, 1975; Austrian Cross of Honour 1st class, 1975; Österreichisches Ehrenzeichen, 1983; Balzan Prize, 1985; Preis der Stadt Wien, 1986; Ludwig Wittgenstein Preis, 1988; Brittanica Award, 1989; Goethe Medaille, 1989; Pergameno d'onore, Faenza, 1991; the Gold Medal of the City of Vienna, 1994, and the Goethe Prize in 1994.

Principal Works of E. H. Gombrich

The Story of Art (London: Phaidon, 1950; 16th edition, 1995)

Art and Illusion: a Study in the Psychology of Pictorial Representation
(London: Phaidon, 1960; 5th edition, 1977, latest reprint 1995)

Meditations on a Hobby Horse and Other Essays on the Theory of Art
(London: Phaidon, 1963; 4th edition, 1985, reprinted 1994)

Norm and Form: Studies in the Art of the Renaissance I
(London: Phaidon, 1966; 4th edition 1985, reprinted 1993)

Aby Warburg: an Intellectual Biography
(London: Warburg Institute, 1970; 2nd edition, Oxford: Phaidon, 1986)

Symbolic Images: Studies in the Art of the Renaissance II
(London: Phaidon, 1972; 3rd edition, 1985, reprinted 1993)

The Heritage of Apelles: Studies in the Art of the Renaissance III
(Oxford, Phaidon: 1976; reprinted 1993)

Ideals and Idols: Essays on Values in History and in Art
(Oxford: Phaidon, 1979; reprinted 1994)

The Sense of Order: a Study in the Psychology of Decorative Art
(Oxford: Phaidon, 1979; 2nd edition, 1984, reprinted 1994)

The Image and the Eye: Further Studies in the Psychology of Pictorial Representation
(Oxford: Phaidon, 1982; reprinted 1994)

Tributes: Interpreters of our Cultural Tradition (Oxford: Phaidon, 1984)

New Light on Old Masters: Studies in the Art of the Renaissance IV
(Oxford: Phaidon, 1986; reprinted 1993)

Reflections on the History of Art: Views and Reviews (Oxford: Phaidon, 1987)

Topics of our Time: Twentieth Century Issues in Art and in Culture
(London: Phaidon, 1991; reprinted 1994)

The four volumes of *Studies in the Art of the Renaissance* were reissued as a boxed
set under the general title *Gombrich on the Renaissance* (London: Phaidon, 1993)

Part I Autobiographical

An Autobiographical Sketch

Transcribed from the
tape-recording of an
informal talk given at
Rutgers University, New
Jersey, in March 1987;
published in *Topics of our
Time* (1991), pp. 11-24

Thank you for your kind invitation to talk about that particular subject I have never discussed in public in my life, that is, myself. I must warn you not to be disappointed when I talk about my life because there are no sensations, no scandals, no intrigues. The only strange and astonishing fact about my long life is that in a period which was so full of dangers, of horrors which were grim indeed, I managed by and large to lead what is known as the life of a cloistered scholar. I could not have written so much if I had been on the run, as many others had to be in those dreadful years we are talking about.

I was born in 1909. There are people who are always against teaching dates, but dates are the most important pegs on which to hang the knowledge of history. If you hear 1909 as the year of my birth, you will immediately realize that I was five when the First World War broke out and that, therefore, that period of Vienna (where I was born), which is now so much discussed, the Vienna of the *fin de siècle*, of the turn of the century, was for me a matter of history. I don't remember any of it. The Vienna in which I grew up, post-war Vienna, was a strife-torn, sad city with a great deal of economic misery. So, for me this idea of the Golden Age of Vienna, which I saw represented in an exhibition at the Centre Pompidou in Paris in 1986, and which also went to New York, is only hearsay. Even as hearsay, it is slightly stereotyped and simplified, as history tends to become when it is turned into myth. Vienna, like every other large city, consisted of many people, many different circles. It was not a monolithic society in which everybody talked about modern music or psychoanalysis. It was intellectually very lively but very different from the clichés, which you should take with a grain of salt.

On the other hand, the fact that I was born in 1909 does not tell you that I was born into a home where I could hear a lot about that famous period of Viennese life. My mother, who was a pianist, was born in 1873. That is to say, as a young musician she was able to hear Brahms himself. In the Vienna Conservatoire, she was a pupil of Anton Bruckner, who taught her harmony. She knew Gustav Mahler extremely well and also remembered Hugo Wolf. My father was one year younger, born in 1874. He was a classmate of Hugo von Hofmannsthal in the Akademische Gymnasium and knew him very well. But my family memory goes even further back, because my mother was a late child. My grandfather was 60 when she was born. He was, in fact, the same generation as Richard Wagner. It is strange to contemplate that history is so short. All these things are not as distant as people tend to think. They only appear to be so long ago because so many things happened in between.

I never knew my grandfather, who was born in 1813, but, again, I have some idea of the changes that occurred in his life and that of my parents. My mother remembered vividly the first exhibition of the uses of electricity, where for the first time she saw a lamp which plugged into the wall and lit up. What we today take for granted was a miracle at the time. And though, as I say, I was very young during the First World War, I still saw the Emperor Franz Josef riding in his carriage on his way to the castle of Schönbrunn. I also remember very well his funeral cortège, which we watched from a window on the Ringstrasse. So, by now, you will see that I'm really a historical monument.

I went to school, like many middle-class children, at the Humanistisches Gymnasium, where I learned Latin and Greek. Times were grim, as I have said, but there was a great deal of intellectual life, and a lot of music, as one expects of Vienna, even though the economic situation was not easy. My father was a lawyer, and much respected, but he was not one of those who are very successful in making money.

I think that my development was at least as much influenced by the music in the home of my parents as by any other influence. We were on very intimate terms with a great musician whose name you may no longer know, Adolf Busch, the leader of the Busch Quartet, a musician dedicated to the classical tradition of Bach, Beethoven, Mozart and Schubert, and very critical of the modern movement.[1] If people have accused me of being rather distant from the modern movement, it may be that this early imprinting played a part in my life. My mother knew Schoenberg quite well when she went to the Conservatoire, but she didn't like playing with him because, she said, he wasn't very good at keeping time. And my sister, who is still alive and is a violinist, knew Anton von Webern and Alban Berg extremely well – Berg even entrusted her with the first performance of one of his works. Even so, at this distance of

time, she is a little sceptical about the dodecaphonic music which Schoenberg tried to launch.

This is the background of a person who became an art historian rather than a musician. I did learn to play the cello very badly and never practised enough, but the visual arts played less part in my parental home. Of course, my father used to take us children to the Kunsthistorisches Museum, which was very close to where we lived. On a rainy Sunday we used to go there, though when I was a small child I always wished he would take us to the natural history museum with the stuffed animals. But later I, too, enjoyed the paintings in the Kunsthistorisches Museum, and my parents' library was certainly one of the formative influences of my life. Not that they had a particularly large library, but they had volumes of the *Klassiker der Kunst*. And the series edited by Knackfuss — monographs on the leading masters of the Italian Renaissance and of the Dutch seventeenth century — were a matter of course in our house.[2] We looked at these and talked about them. So that while I was at school at the Gymnasium, I acquired an increasing interest first in pre-history — stone axes and things which interest small boys — and later also in ancient Egypt and classical art. As happens in middle-class families, I would get books on subjects that interested me for my birthday or for Christmas. When I was about fifteen or sixteen, I read books on Greek art and on medieval art. As soon as Max Dvořák's book came out, with the title — not by him — *Kunstgeschichte als Geistesgeschichte* (*Art History as the History of the Spirit*), I was given it as a present and devoured it.[3] I found it one of the most impressive books I had ever read. On Greek art I read a book by Hans Schrader on Phidias.[4]

It was a convention in Austrian schools that for the final exam there should be what one might call an extended essay, written over the last few months of the academic year. In the year 1927–8, when I was eighteen, I selected as a subject the changes in art appreciation from Winckelmann to the present age. I have sometimes thought that this is all I have ever done — pursued my interest in this particular subject — and I have often asked myself why I selected this subject.

I selected it partly because I had read a book by Wilhelm Waetzoldt, *Deutsche Kunsthistoriker*, on the development of art history — which I found very interesting.[5] But I also selected it because I was puzzled. I was puzzled — remember, these are the late 1920s — because in the generation of my parents and of our friends, the approach to art was very traditional indeed. It was a tradition going back to Goethe and the eighteenth century, in which the subject-matter of art was very relevant and the classics were of great importance. People who had travelled to Italy came back talking about works of art they had seen and admired there. But I was already touched at that time

by the new wave, which reached me through books. I am speaking of Expressionism, of the discovery of late medieval art, of late Gothic, of Grünewald, of the woodcuts of the late fifteenth century and such things. I was, therefore, confronted with a new approach to art which did not chime in with what I knew from the older generation. I think this was the reason why I selected this topic of how the appreciation of art had changed from the time of Winckelmann to the Romantics, and from the Romantics to the Positivists, and from the Positivists to the later periods in which, of course, Max Dvořák figured largely, together with other writers of my own time.

With this idea in mind, that art was a marvellous key to the past – an idea which I had learned from Dvořák – I decided I wanted to read the history of art at Vienna University. There were two chairs of art history in Vienna because there had been a quarrel between Dvořák and a fellow professor. One holder of a chair was Josef Strzygowski. He was an interesting figure, a kind of rabble-rouser in his lectures, a man emphasizing the importance of global art, of the art of the steppes of the migrant populations.[6] It was, in a way, an early Expressionist version of anti-art, because he hated what he called *Machtkunst*, 'the art of the powers', and he wanted a complete re-evaluation of art. Not stone architecture, but timber architecture was what mattered, and such crafts as tent-making. I went to his lectures, but I found him very egotistic, very conceited, and I was rather repelled by his approach.

The holder of the rival chair, Julius von Schlosser, was a quiet scholar. He was the author of that famous standard work, *Die Kunstliteratur*, which is still the most admirable survey of writings about art from antiquity to the eighteenth century.[7] He was steeped in these texts, but he was not a good lecturer. His lectures were more or less monologues. He reflected on problems in front of his audience, in so far as the audience managed to keep awake. But he was, at the same time, a towering scholar. He was at the Vienna Museum before he took the chair at the university after Dvořák's death. Everybody knew that his erudition was formidable, and therefore one respected him despite his aloofness and oddity. Thinking back to how he taught, I'm still filled with admiration at the way he conceived his task of introducing his students to the history of art.

Apart from his lectures which, as I have said, were not very successful, Schlosser gave three types of seminars. One that was natural for him was on Vasari's *Lives of the Painters*. His students took one of the lives and analysed it according to the sources and all related aspects. It was taken for granted that everybody knew Italian. It was inconceivable that you should go to Schlosser and not be able to read Vasari. But there were two other more interesting seminars. Every fortnight he had a meeting in the museum in the department

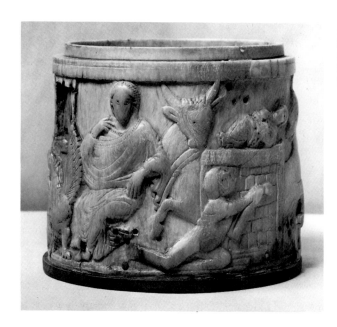

of which he had been the keeper, the Department of Applied Arts. He selected for his students objects which he had found puzzling while he was still in charge – an ivory here, a little bronze there – and he asked the student, 'What can you make of it? What do you think it is?' One had ample time to prepare these reports, because they were given out at the beginning of the year and they usually dragged on much longer than he intended. One had time therefore to find one's way into the problem that had interested him. For example, I had to talk about an ivory book-cover of the Carolingian period, representing St Gregory writing, and try to fit it into the period.

The following year, Schlosser gave me another ivory, a pyxis (Fig. 1). It was a little puzzling both in iconography and in other respects. It was considered Late Antique but I came up with the suggestion that it wasn't Late Antique, that it was a Carolingian copy of a Late Antique ivory. Schlosser said, 'Don't you want to publish this in our yearbook?' In those days, there was no real distinction between undergraduate and graduate. One was treated as an adult. As soon as you entered the seminar you were a colleague, as it were, and you were taken seriously. I think that was a great education. I did, in fact, publish something about this ivory in 1933.[8] It was my first publication. At that time I had started being a medievalist, as they would call it nowadays. I tried my best to survey the whole field. I was struck by its arbitrariness and by the many blank patches on the map of seventh-, eighth- and ninth-century art history. I became a little sceptical about the possibility of finding exactly when and where this particular ivory carving was made. And this was

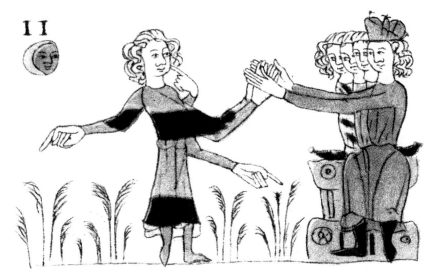

2
A vassal swearing the oath of allegiance to his lord, from *Der Sachsenspiegel*, a 14th-century manuscript. Heidelberg University Library

one of the reasons why I gradually turned away from medieval studies.

The other type of seminar which Schlosser gave was on problems. Although he was very aloof and one never thought that he had read a contemporary book, all the time he had his finger on the pulse. He asked me one day – he asked the students and I volunteered – to talk about *Stilfragen*, the first great book by Alois Riegl (1858–1905), on the history of ornamental decoration.[9] Schlosser had known Riegl very well. He used to talk about him with admiration, but also with slight distance. He always mentioned that Riegl had been very hard of hearing and was a rather lonely, self-centred scholar. I was asked to tell Schlosser and his seminar what I thought about the book after the lapse of many years – and this I did. Much later, I returned to the subject several times. I have been accused of not being particularly respectful about Riegl, but in fact I admire him very much and my acquaintance with his work goes back to those early student days.

Another problem which Schlosser set, one which I also discussed in one of his seminars, was the *Sachsenspiegel*, a legal manuscript of the fourteenth century which dealt with various legal rituals and the gestures appropriate to them: when you swear the oath to your feudal lord and similar formalities. These were the hand gestures represented in this manuscript. A historian called Karl von Amira had written about the *Sachsenspiegel*, and Schlosser was interested in fitting this into a general subject.[10] Thus I became interested in the gestures and rituals of medieval legal practice (Fig. 2). And this is another subject which has continued to fascinate me: communication through gesture.[11]

The subjects that were set, therefore, were certainly adult subjects. Standards were high. The number of students in Schlosser's seminar was not

large; we were a very close-knit community. One talked about one's subjects all day, with one's colleagues. They gave one tips. One gave them tips. And we also learned a great deal about each other's subjects. It was in this form that we studied art history. Lectures were not as important. Seminars much more so. And, of course, Schlosser wasn't the only one who gave seminars. We had some seminars in the museum. We also had seminars under Karl Maria Swoboda, under Hans R. Hahnloser and under Hans Tietze. At that time Tietze was writing about the Cathedral of St Stephen, so we had a seminar in front of the Cathedral on the various aspects of its history. The formation of a student was much less rigorous then. We were not expected to cover a particular ground. I am not sure that during all the years of my studies I heard the name of Rembrandt mentioned very often. But we were introduced into dealing with problems and methods and such matters.

In the Continental universities it was a matter of course that you didn't attend lectures only in your own subjects, but went to any lecture that interested you. If you wanted to hear about late Latin, you went to a lecture on late Latin. And if you wanted to hear about history, you went to the history lecture, or whatever it was. You went and sampled lectures and subjects, and I did so quite frequently, as did all my colleagues. It was, therefore, much less of a prescribed syllabus, except that you were expected at the end to select a subject for a thesis to submit to your teacher – in my case Schlosser. Because there was no division between undergraduate and graduate, the course ended when you had written your PhD thesis. Usually you were expected to do this at the end of the fifth year of study. It was considered very important, yet it didn't take more than a little over a year to write.

Vienna is geographically close enough to Italy and I went there fairly often to look at museums and works of art. On one of these trips I saw the Palazzo del Tè in Mantua and found it a very puzzling building indeed, with its strange architecture and its even stranger fresco cycle by Giulio Romano (Figs. 3 and 4). Now this was a time when Mannerism was all the intellectual fashion. People talked a good deal about the significance of Mannerism, and particularly about the problem of whether there was Mannerism in architecture as there was in painting. Here was a building, the Palazzo del Tè, which was built by the same man who did the paintings, Giulio Romano, and I thought that was a very good object for discussing the question of whether Mannerism existed in architecture. I suggested to Schlosser that I would like to write my dissertation on Giulio Romano as an architect. He thought it was a very good idea, and so off I went and did it.

I went to Mantua and worked in the archives a little. I tried to find new documents, but mainly I tried to interpret the strange shift in architecture

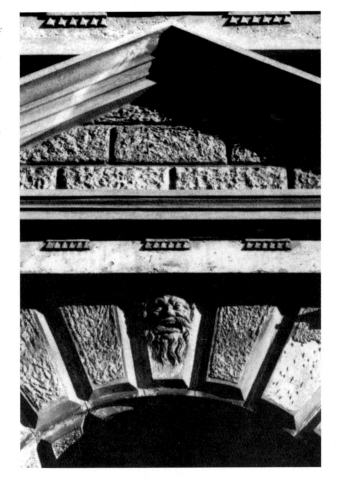

which had happened in the next generation after Raphael. After all, Giulio Romano was Raphael's favourite pupil. I discussed these matters in my dissertation. But throughout this time, I was becoming a little sceptical about the current interpretation of Mannerism as an expression of a great spiritual crisis of the Renaissance. If you sit down in an archive and read one letter after another by the family of the Gonzaga, the children and the hangers-on and so on, you become gradually much more aware that these were human beings and not 'ages' or 'periods' or anything of that kind. I wondered about these people undergoing such a tremendous spiritual crisis. Federigo Gonzaga, the patron of Giulio Romano, was in fact a very sensuous prince, particularly interested in his horses, his mistress, and his falcons. He was certainly not a great spiritual leader. Yet, Mannerism was the style in which he had built his castle outside the town, the Palazzo del Tè (see below, pp. 401–10). Therefore, I started asking myself whether this idea about art being the expression of the

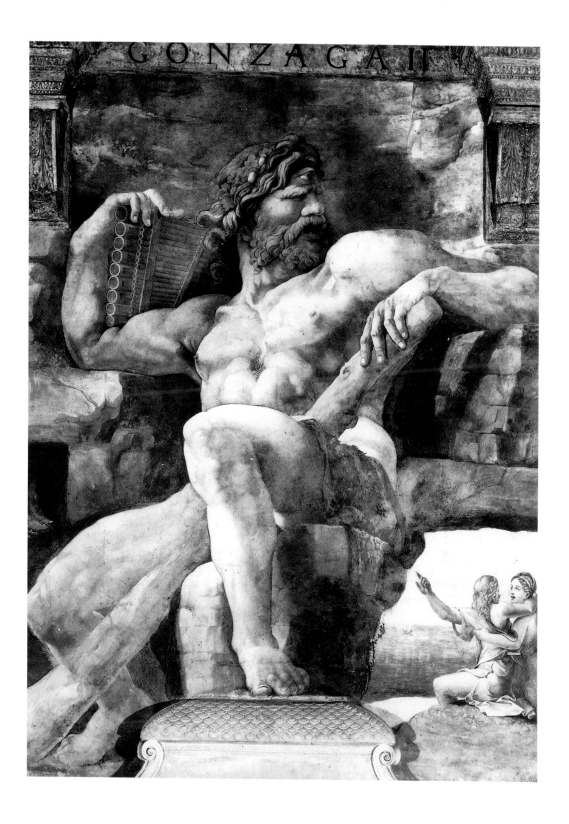

age wasn't a cliché that was in need of revision, and whether there were other forces operating within society. In this case it seemed pretty clear to me that what was expected of court artists such as Giulio Romano was something bizarre, something to surprise, something to entertain, and all this I found confirmed, in a way, while investigating this artist.

My development, therefore, intellectually moved away from the approach I had learned from Max Dvořák. This move was certainly encouraged by Schlosser, although he would never have said a word against a former colleague. Yet his scepticism and aloofness were very much felt in the way he spoke about these matters. He was really steeped in the past and disliked any stereotypes of this kind, without specifically condemning them.

I handed in my dissertation in 1933,[12] and thus completed my course in art history. At that time, the situation in Vienna was economically very serious. I had absolutely no chance of a job. My father had warned me of that long before, but he never protested against my studying art history. So, indeed, having graduated, I had no job. But I had friends and I went on working. One of the friends who had a great influence on me later on was Ernst Kris, who was keeper of what had been Schlosser's department before: the department of Applied Art in the Kunsthistorisches Museum.

Kris had meanwhile also become very interested in psychoanalysis. He belonged to the circle of Sigmund Freud. Having written some very important pieces of, as it were, orthodox art history on goldsmith work and engraved gems,[13] he hoped to see how much of this new approach could be applied to art history. Freud had written a book on wit, on the joke, and Kris had the idea that it would be very interesting to write on caricature as an application of wit to the visual arts. He invited me to be his assistant, to write on caricature with him. We jointly wrote a lengthy manuscript, which was never published, but we wrote small essays which were published.[14] I learned an enormous amount after my graduation, working practically every day with Kris on this project. He was a man of unbelievable industry. He was at that time both keeper of the department and a practising analyst, and in the evening I would come round after supper and he would explain to me things about psychology. I count him among my teachers, despite the fact that the project was aborted because of political events. I still have the vast unpublished manuscript at home.

The project was aborted because this was the time when National Socialism advanced in Germany and threatened the independence and the well-being of Austria. Kris was one of the few who were aware of what was happening in Europe: he always read the *Völkischer Beobachter*, the Nazi daily, and he knew what these people were about, what was awaiting us, and what was coming if

the international front, which very feebly tried to maintain the independence of Austria, broke down. He urged me to look for a job not within Austria, where I wouldn't have found one in any case, but outside. He recommended me to Fritz Saxl, the director of the Warburg Institute. At that time, the Warburg Institute had emigrated from Hamburg in Nazi Germany to London. Saxl engaged me to come to England in 1936 because he had committed himself to publishing the literary remains of the founder of the Institute, Aby Warburg. Obviously the notes and drafts of Warburg could be handled only by somebody whose mother tongue was German. He needed an amanuensis, as it were, to help sort these notes and write about them, because his assistant, Gertrud Bing, was too busy with other things and could not really find the time. I accepted his offer.

In the first week of 1936, I moved from Austria to England — before the *Anschluss*. I was immensely lucky that I did not have to witness the *Anschluss*. I escaped before it actually happened, because Kris had so strongly urged me to do so and because he found a job for me. Not that it was a very lucrative job. I received a grant and on that grant my wife and I decided to marry. It was a very, very small sum we had when we settled in London and I became part of the staff of the Warburg Institute.

Aby Warburg, who founded the Institute as his private library in Hamburg, was in fact an art historian very interested in cultural history, and in the tradition of Jakob Burckhardt.[15] He called his institute, or library, the Kulturwissenschaftliche Bibliothek Warburg, the library for cultural history. What concerned him was what he described as 'cultural psychology'. The most important thing to remember about the Warburg Institute is not what it is but what it is not. It is not an art-historical institute and it never was. Art history as an academic subject was quite new in England at that time. The Warburg Institute in England was privately supported. A number of refugee scholars worked there in many different fields connected with what interested Warburg: the 'after-life', as he called it, of classical antiquity.

So I found myself in an entirely new milieu[16] among rather eminent scholars, including my former friend and fellow student Otto Kurz, who had also come to the Warburg Institute through Kris. These were the 'overshadowed' years, before the outbreak of the war, when everybody felt that things couldn't last very long because Hitler was rising in power and was claiming one country after another. One felt that one day it was going to end in war. When war finally came, the Institute was evacuated. Because of the danger of bombing, the library was removed to a country estate. But I did not stay among the staff of the Institute. I spent the six years of the war listening to broadcasts, mainly German broadcasts. From 1939 till 1945, I was what was called a radio

monitor.[17] Not an easy job — hard work, long hours, much pressure. But I was, in one respect, very lucky. Imagine being forced for at least eight hours a day to translate from German into English. I learned the language reasonably well, of course. And I also learned other things. I became interested in perception, in the problem of hearing, and in other matters which were concerns at that time. So I wouldn't claim that these six years when we were not in London — London was under bombardment — were wasted years for me. They were wasted only in the sense that it was not until after the war that I could go back to scholarship. My first paper was very much in the tradition of the interest of the Warburg Institute at that time: Neo-Platonic symbolism. I wrote about Botticelli's mythologies and on emblematics.[18] I also resumed my work on the papers of Warburg and taught at the Institute, but not the history of art.

The institute of the history of art in London was, and is, the Courtauld Institute of Art. The Warburg Institute had meanwhile been taken over by the University of London, though it was a rather odd body and nobody knew quite what we were doing and why we were doing it. There was a rumour circulating that we were an institute for iconography, an idea that is quite wrong and quite misleading, but still widely believed. One of our interests was indeed in iconography, but it was not by any means the only interest that we had. I taught not art historians, but historians who were studying Renaissance civilization. I became a university teacher, taught classes on the patronage of the Medici, the survival of Neo-Platonism, Vasari, astrology — all these cultural subjects which are not directly connected with the history of art as the history of styles. Thus, what is usually called mainstream art history — connoisseurship, attributions — is very much on the fringe of my formation. I was never much concerned with it, not entirely through a lack of interest, but because my work took me into very different directions.

Perhaps I should mention that while still in Vienna and being rather underemployed in 1934–5, I had the opportunity given to me by a publisher to write a world history for children. This book, which I wrote very quickly in a few weeks' time, was a commission which simply required the help of an encyclopaedia, more or less. For example, I looked up when Charlemagne was born and I wrote it into the book, and then I quoted or paraphrased a contemporary source describing his personality and his habits. I tried to find at least one such source for every chapter to lend authentic local colour to the narrative. This book was an unexpected success. It was translated into a number of languages and it was even revived in Germany after fifty years.[18a]

Before the *Anschluss* put an end to everything, the Viennese publishers next asked me whether I would like to write a history of art for children — to which I replied, history of art isn't for children and I can't write it for children. So

they offered a little more money. Their first offers were very meagre, but I was in need of money and I tried to think of what I could do. This, of course, is really the origin of *The Story of Art*, which I started writing at the suggestion of an English publisher – who in the end did not take it. It was then written for the Phaidon Press.[19] As soon as my slavery at the monitoring service had ended, I decided I must quickly write this book because I wanted to go back to research. I engaged a typist to whom I dictated three times a week. In this way the book was soon finished. The publisher printed it and, once again, I had a piece of luck. It was a great success. Many editions were published. It has been translated by now, I think, into at least eighteen languages.

So at this point I had two lives, as it were. To the outside world, I was the author of *The Story of Art*. Within the Warburg Institute nobody was interested in that book, and I don't think anyone ever read it. In fact, Saxl, the director of the Institute, said that he did not want me to write such a popular book, but to return to research and do proper work. I nevertheless had promised to write the book – so I did. But I did it on the quiet, as it were, and yet for many outsiders this is what I am known for. I was able to write it, I think, because I used my own memory as a kind of filter. I wrote it almost without consulting reference books, I just put down what I remembered of the history of art after the distance of time and I told it as a story. This is how the book developed in its narrative form, and why it is called *The Story of Art*.

I used illustrations which I had at home. Thanks to my wife, we had the *Propyläen Kunstgeschichte* in our library. I picked out illustrations which seemed suitable to me, and in this way I improvised the various chapters. If the book has a certain freshness, it's because I never thought of it as a textbook or anything of that kind. I just had to write it, and so I wrote it. It interested me, of course, to see the conspectus of the whole development from a certain vantage point, but it wasn't intended as a teaching aid of any kind.

Even so, *The Story of Art* plays a certain part in my biography. I was back in London after the war when the book came out. A very favourable review appeared in the *Times Literary Supplement* which, I now know, was written by Tom Boase, the director of the Courtauld Institute. When it came to the election of a Slade Professor of Fine Arts for Oxford, which was a guest professorship for a period of three years, he proposed me and I became Slade Professor in Oxford. Not that this meant leaving the Warburg Institute; it was only a matter of twelve lectures or so in the academic year. However, the prestige of the position which Ruskin had once held was sufficient to give me a different kind of standing. For three years I was Slade Professor in Oxford and lectured on many topics. Later I was made Slade Professor in Cambridge and was also invited to Harvard. And so it went on and on. Thus, by this

concatenation of circumstances, I became sufficiently known so that from the point of view of my career I did not have to worry what my job would be.

The position at the Warburg was not so simple because, as I told you, it is not an art-historical institute and I was not an art historian there, but a reader in Renaissance studies. Through the mediation of Kenneth Clark, who had liked some of my writings, I was invited to give the Mellon Lectures in Washington, for which I chose the subject of art and illusion because of my interest in perception and in psychology.[20] This is the first book in which I staked my claim to be interested not only in the history of art as it is taught, but in something different.[21] That difference is an interest in *explanations*. Explanations are scientific matters: how do you *explain* an event? I thought that certain aspects of the development of representation in the history of art, which I had discussed in *The Story of Art* in the traditional terms of 'seeing and knowing', deserved to be investigated in terms of contemporary psychology. I spent a good deal of time in psychology libraries. I studied the subject for the sake of explanation – that is, explanation of the phenomenon of style – because the phenomenon of style as it had been seen traditionally did not satisfy me. Style became one of my worries, one of my problems, because the idea that style is simply the expression of an age seemed to me not only to say very little, but to be rather vacuous in every respect. I wanted to know what is actually going on when somebody draws a tree in a particular way, in a particular tradition and in a particular style. By looking into books on psychology, I learned the importance of formulae.

When another opportunity arose after the publication of *Art and Illusion*, and I was invited to give the Wrightsman Lectures in New York, I chose the other side, as it were. I thought, 'Well, I have tried to explain something about representation, now I should like to explain something about form or decoration.' So I gave a series of lectures which turned into the book *The Sense of Order*.[22] In other words, my ambition – and it was rather a lofty ambition – was to be a kind of commentator on the history of art. I wanted to write a commentary on what actually happened in the development of art. I sometimes see it as representation in the centre with symbolism on the one hand and decoration on the other. One can reflect about all these things and say something in more general terms. It was my ambition to do precisely this.

This, of course, meant that I never became a proper art historian. I never became a connoisseur. I wouldn't say, when people asked me, that I had no opinions about whether this painting is or is not by Raphael, but it isn't my main interest to practise connoisseurship. My main interest has always been in more general types of explanation, which meant a certain kinship with science. Science tries to explain. In history we record, but in science we try to explain

single events by referring them to a general regularity. Here, I think I should mention another friend who had a great influence on me, the philosopher of science, Sir Karl Popper, who was always interested in the problem of research and of scientific explanation. I learned very much from him about these matters, both in perceptual psychology and in the more general problems of science.

So you see that I moved in a certain sense outside the charmed circle of art history. By the 'charmed circle' I mean the people who say, 'You know this picture will come up at Christie's in three weeks' time. Do you really think it is by Luca Giordano? And if it is, how much do you think it will fetch?' I have never been able to join in these conversations, and I'm still unable to do so. On the other hand, I don't want to give you the idea that I look down on people who are able to do so. Some of my best friends are connoisseurs. If they are real connoisseurs, then I respect them very much.

But this is a different matter, a different approach altogether from the one which tries to explain. I should add briefly that in dealing with explanations, I became very interested in the changing functions of the visual image. Also, one can ask, how do traditions change? What is their influence? You all know the slogan that 'form follows function' in architecture. An element of that is true for the image-maker. The poster has a different type of formal treatment from an altar painting. Here, the history of image-making, as I like to call it, sometimes impinges on social developments, on the role of an image in a particular society. All this must interest anybody who looks at the whole development and asks the uncomfortable question, 'But why? Why? What actually went on at that time?' I don't claim that one can ever give a full answer to this question of why, but one can always speculate – and this is not always fruitless.

My current work deals with another approach to a question which was important in *Art and Illusion*. My discussion of the development of representation has led to the interpretation that I am an advocate of naturalism and that I see the history of art as an unbroken progress towards naturalistic, photographic images, which is, of course, nonsense. I am now interested in the reaction against certain movements in representation due to the tides of taste. One of my projects, upon which I have been working too long, is on what I call the preference for the primitive among lovers of art: that is, the rejection of things which are considered decadent, corrupt, too sweet, too insinuating, the reaction against the ideal of beauty. All these reactions have interested me for a long time. There are parallels in classical antiquity, but the movement really started in the eighteenth century. This book, which I am still hoping to write, is called 'The Preference for the Primitive', in which

psychological explanations inevitably figure, as do other things as well. So here, again, it is a rather large-scale topic I am trying to tackle. I have discussed it in lectures several times, which has its advantages and its disadvantages. Once a subject has gelled in one form, it's not so easy to boil it up again and to dissolve it to make it into a different kind of chapter. But I'm doing my best.[23]

Editor's Postscript

Gombrich has recently published more autobiographical material in A Lifelong Interest: Conversations on Art and Science with Didier Eribon *(London, 1993), which is also available in an American edition as* Looking for Answers. Conversations on Art and Science *(New York, 1993).*

A good historical introduction to Vienna, informed by personal memories, is Ilsa Barea's Vienna: Legend and Reality *(London, 1993). A more personal picture is offered by George Clare's autobiography,* Last Waltz in Vienna *(London, 1982). A gloriously illustrated book, to which Gombrich contributed himself, is* Vienne 1880-1938: L'Apocalypse joyeuse, *sous la direction de Jean Clair (Paris, 1986). A handy volume for the general intellectual background to Viennese culture is William M. Johnston,* The Austrian Mind: An Intellectual and Social History 1848–1938 *(Berkeley and Los Angeles, 1972).*

Of the books mentioned in the autobiography, readers might like to know of some translations. Max Dvořák's Kunstgeschichte als Geistesgeschichte *is now available, in parts, as* The History of Art as the History of Ideas, *trans. John Hardy (London, 1984) and* Idealism and Naturalism in Gothic Art, *trans. Randolph J. Klawiter (Notre Dame, 1967). The French edition of Schlosser's* Die Kunstliteratur *is Julius von Schlosser,* La Littérature Artistique *préface d'André Chastel (Paris, 1984). Alois Riegl's Stilfragen has been translated by Evelyn Kain as: Alois Riegl,* Problems of Style: Foundations for a History of Ornament *(Princeton, 1992). Alois Riegl's* Die spätrömische Kunstindustrie *has also been translated: Alois Riegl,* Late Roman Art Industry, *translated from the original Viennese edition with foreword and annotations by Rolf Winckes (Rome, 1985).*

Old Masters and Other Household Gods

Published in the
Independent, 6 January 1990,
on the 40th anniversary of
the first publication of *The
Story of Art*

When I was invited to offer my 'second thoughts' about the *Story of Art* I replied that they would have to be called my fifteenth thoughts, since that book had just been published in its fifteenth edition. If, however, second thoughts are meant to imply distance, I can truly say after 40 years that I have as much distance from the book as any author is ever likely to gain from his brainchild. Maybe I can now place it more easily into its context than I could have done earlier: though the book was written in England and in English, the context is still that of the Vienna of my youth.

Like any fine old city Vienna, with its Gothic Cathedral and its sumptuous Baroque churches and palaces, would be likely to stimulate an interest in the history of art in any alert child, but as far as I remember my own interest was also sparked off by the monumental edifices of the nineteenth century that line the broad avenue of the *Ringstrasse* which encircles the old city. The House of Parliament is in the Greek style, the mighty Town Hall in a version of Gothic, the museums and the University were built in a Renaissance idiom and the Postal Savings Bank pioneered a modern style. I cannot have been more than 12 years of age, possibly less, when this variety prompted me to plan my first art-historical book, a primer of styles based on Vienna's buildings.

But if architectural history thus became a natural interest, so did the history of painting. I cannot tell now which came first, my parent's library which contained many books about old masters, or the *Kunsthistorisches Museum* with its glorious collections brought together by the Habsburgs. Good taste had not yet outlawed the display of photographic reproductions on the walls of our apartment, and it was taken for granted that one knew and respected the

works of the masters who belonged to the 'canon of excellence' in art, much as Bach, Mozart or Beethoven did in music; Raphael and Michelangelo, Dürer and Rembrandt, but also Fra Angelico and Memling were household gods, the divinities of that middle-class religion that was known as *Bildung*. The term literally means 'formation' but can perhaps best be translated as 'mental furniture'. This being so, it was natural that adolescents were given books on art history for Christmas or for birthdays, and in the absence of television and videos they were even read. I especially remember an unpretentious survey by Julius Leisching called *Die Wege der Kunst* (*The Paths of Art*, Leipzig, 1911) which I read with gratitude and profit for the first orientation it offered. *The Story of Art* may be somewhat more sophisticated, but I might never have had the courage to undertake it without the memory of this slim volume which I still own.

That added sophistication can be traced back to the revolution in taste that we all witnessed in the immediate post-war period. The narrow confines of the canon were challenged by the wave of Expressionism with its exaltation of medieval and tribal art – previously neglected – and these shifts in preference interested me sufficiently to volunteer writing an extended essay on the vicissitudes of art appreciation since the eighteenth century (a topic that still concerns me). Having decided to read the History of Art and Classical Archaeology at the University of Vienna I became subject to further influences: the so-called 'Vienna School' of art history prided itself in having overcome the obsolete notions of 'decline' or 'decadence'. Late Roman art was in no way inferior to the art of classical Greece and the styles of Mannerism and Baroque merited the same attention as those of the High Renaissance. The new key to the history of art was the notion of continuity, the endurance of traditions behind the changing façades of period styles.

This, I believe, is also the underlying theme of *The Story of Art*, which tries indeed to do justice to every age on its own terms. As a trained art historian, I had to make choices in my specialized research, but the awareness of continuity remained background knowledge to be drawn upon on journeys and in museums.

One more biographical fact must perhaps be mentioned: as an unemployed graduate I was given the task of contributing a volume on world history to a series of children's books, and since I had to meet an almost impossible deadline I had no choice except to use such background knowledge of history as remained from my schooldays. To my surprise the book was widely read and has been reprinted in Germany after 50 years, but being written from the vantage point of the capital of Austria it could not be easily adapted for English children. Evidently the same does not apply to *The Story of Art*; not only, perhaps, because it was written in England, but because the history of art

is of more universal relevance than the wars and politics of central Europe which had to come into the earlier book.

I must not detain the reader with the concentration of circumstances that made me embark on a second such effort. After an abortive attempt the book was commissioned by the late Dr Horovitz of the Phaidon Press after his young daughter had approved of a sample chapter. This happened during the war when I was a member of the BBC Monitoring Service, and being so far away from active research may have helped me again to see the whole mountain range of the history of art as a continuous outline. It was this vision I attempted to convey when, after the war, I dictated the text, merely looking up examples of illustrations in the books my wife and I happened to own. Though completed in 1949, this text still reflects the outlook I had acquired on the Continent.

It is true that in subsequent years I added a good many pages to keep the story 'up to-date', and I am not sorry I did so. But maybe the value of the book lies elsewhere. It crystallizes the attitude of a vanished epoch for which art was not a subject of specialized knowledge, let alone of sensational auction prices, but still part of the mental furniture of civilized men and women.

Journalists sometimes describe an old country house which has preserved its contents untouched for several generations as a 'time capsule'. If *The Story of Art* is such a time capsule, its unexpected popularity seems to prove that even today readers want to keep contact with the past – their own, and that of art.

Editor's Postscript

For Gombrich's World History for Children, *see above, p. 32. The revised edition was published by Dumont (Cologne) under the title* Eine kurze Weltgeschichte für junge Leser. Bildung *is discussed further in 'Nature and Art as Needs of the Mind' and 'Goethe: The Mediator of Classical Values', below, pp. 565–90.*

For a fascinating insight into how art could form part of the mental furniture of a growing child, see Elias Canetti's autobiography, the volumes The Tongue Set Free *(London, 1989), and* The Torch in my Ear *(London, 1990), especially 'Samson's Blinding', pp. 112–18.*

Part II The Visual Image

The Visual Image: its Place in Communication

Originally published in
Scientific American, Special
Issue on Communication,
vol. 272 (1972), pp. 82-96;
reprinted in *The Image and
the Eye* (1982), pp. 137-61

Ours is a visual age. We are bombarded with pictures from morning till night. Opening our newspaper at breakfast, we see photographs of men and women in the news, and raising our eyes from the paper, we encounter the picture on the cereal package. The mail arrives and one envelope after the other discloses glossy folders with pictures of alluring landscapes and sunbathing girls to entice us to take a holiday cruise, or of elegant menswear to tempt us to have a suit made to measure. Leaving our house, we pass billboards along the road that try to catch our eye and play on our desire to smoke, drink or eat. At work it is more than likely that we have to deal with some kind of pictorial information: photographs, sketches, catalogues, blueprints, maps or at least graphs. Relaxing in the evening, we sit in front of the television set, the new window on the world, and watch moving images of pleasures and horrors flit by. Even the images created in times gone by or in distant lands are more easily accessible to us than they ever were to the public for which they were created. Picture books, picture postcards and colour slides accumulate in our homes as souvenirs of travel, as do the private mementos of our family snapshots.

No wonder it has been asserted that we are entering a historical epoch in which the image will take over from the written word. In view of this claim it is all the more important to clarify the potentialities of the image in communication, to ask what it can and what it cannot do better than spoken or written language. In comparison with the importance of the question the amount of attention devoted to it is disappointingly small.

Students of language have been at work for a long time analysing the various functions of the prime instrument of human communication. Without going

into details we can accept for our purpose the divisions of language proposed by Karl Bühler, who distinguished between the functions of expression, arousal and description. (We may also call them symptom, signal and symbol.) We describe a speech act as expressive if it informs us of the speaker's state of mind. Its very tone may be symptomatic of anger or amusement; alternatively it may be designed to arouse a state of mind in the person addressed, as a signal triggering anger or amusement. It is important to distinguish the expression of an emotion from its arousal, the symptom from the signal, particularly since common parlance fails to do this when speaking of the 'communication' of feeling. It is true that the two functions can be in unison and that the audible symptoms of a speaker's anger may arouse anger in me, but they may also cause me to be amused. On the other hand, someone may contrive in cold blood to move me to anger. These two functions of communication are shared by human beings with their fellow creatures lower down on the evolutionary scale. Animal communications may be symptomatic of emotive states or they may function as signals to release certain reactions. Human language can do more: it has developed the descriptive function (which is only rudimentary in animal signals). A speaker can inform his partner of a state of affairs past, present or future, observable or distant, actual or conditional. He can say it rains, it rained, it will rain, it may rain, or 'If it rains, I shall stay here'. Language performs this miraculous function largely through such little particles as 'if', 'when', 'not', 'therefore', 'all' and 'some', which have been called logical words because they account for the ability of language to formulate logical inferences (also known as syllogisms).

Looking at communication from the vantage point of language, we must ask first which of these functions the visual image can perform. We shall see that the visual image is supreme in its capacity for arousal, that its use for expressive purposes is problematic, and that unaided it altogether lacks the possibility of matching the statement function of language.

The assertion that statements cannot be translated into images often meets with incredulity, but the simplest demonstration of its truth is to challenge the doubters to illustrate the proposition they doubt. You cannot make a picture of the concept of statement any more than you can illustrate the impossibility of translation. It is not only the degree of abstraction of language that eludes the visual medium; the sentence from the primer 'The cat sits on the mat' is certainly not abstract, but although the primer may show a picture of a cat sitting on a mat, a moment's reflection will show that the picture is not the equivalent of the statement. We cannot express pictorially whether we mean 'the' cat (an individual) or 'a cat' (a member of a class);

moreover, although the sentence may be one possible description of the picture, there are an infinite number of other true descriptive statements you could make such as 'There is a cat seen from behind', or for that matter 'There is no elephant on the mat'. When the primer continues with 'The cat sat on the mat', 'The cat will sit on the mat', 'The cat sits rarely on the mat', 'If the cat sits on the mat ...' and so on *ad infinitum*, we see the word soaring away and leaving the picture behind.

Try to say the sentence to a child and then show him the picture and your respect for the image will soon be restored. The sentence will leave the child unmoved; the image may delight him almost as much as the real cat. Exchange the picture for a toy cat and the child may be ready to hug the toy and take it to bed. The toy cat arouses the same reactions as a real cat – possibly even stronger ones, since it is more docile and easier to cuddle.

This power of dummies or substitutes to trigger behaviour has been much explored by students of animal behaviour, and there is no doubt that organisms are 'programmed' to respond to certain visual signals in a way that facilitates survival. The crudest models of a predator or a mate need only exhibit certain distinctive features to elicit the appropriate pattern of action, and if these features are intensified, the dummy (like the toy) may be more effective than the natural stimulus. Caution is needed in comparing these automatisms to human reactions, but Konrad Z. Lorenz, the pioneer of ethology, has surmised that certain preferred forms of nursery art that are described as 'cute' or 'sweet' (including many of Walt Disney's creations) generate parental feelings by their structural similarity to babies (Fig. 5).

Be that as it may, the power of visual impressions to arouse our emotions has been observed since ancient times. 'The mind is more slowly stirred by the ear than by the eye,' said Horace in his *Art of Poetry* when he compared the impact of the stage with that of the verbal narrative. Preachers and teachers preceded modern advertisers in the knowledge of the ways in which the visual image can affect us, whether we want it to or not. The succulent fruit, the seductive nude, the repellent caricature, the hair-raising horror can all play on our emotions and engage our attention. Nor is this arousal function of sights confined to definite images. Configurations of lines and colours have the potential to influence our emotions. We need only keep our eyes open to see how these potentialities of the visual media are used all around us, from the red danger signal to the way the décor of a restaurant may be calculated to create a certain 'atmosphere'.' These very examples show that the power of arousal of visual impressions extends far beyond the scope of this article. What is usually described as communication is concerned with matter rather than with mood.

5
Baby and Adult Features:
Sequence after Lorenz.
From Tinbergen, *The Study of Instinct* (Oxford, 1943)

6
Cave Canem, mosaic of a
dog from Pompeii. Museo
Nazionale, Naples

A mosaic found at the entrance of a house in Pompeii shows a dog on a chain with the inscription *Cave Canem* (Beware of the Dog) (Fig. 6). It is not hard to see the link between such a picture and its arousal function. We are to react to the picture as we might to a real dog that barks at us. Thus the picture effectively reinforces the caption that warns the potential intruder of the risk he is running. Would the image alone perform this function of communication? It would, if we came to it with a knowledge of social customs and conventions. Why, if not as a communication to those who may be unable to read, should there be this picture at the entrance hall? But if we could forget what we know and imagine a member of an alien culture coming on such an image, we could think of many other possible interpretations of the mosaic. Could not the man have wanted to advertise a dog he wished to sell? Was he perhaps a veterinarian? Or could the mosaic have functioned as a sign for a public house called 'The Black Dog'? The purpose of this exercise is to remind ourselves how much we take for granted when we look at a picture for its message. It always depends on our prior knowledge of possibilities. After all, when we see the Pompeiian mosaic in the museum in Naples we do not conclude that there is a dog chained somewhere. It is different with the arousal function of the image. Even in the museum the image might give us a shadow of a fright, and I recently heard a child of five say when turning the pages of a book on natural history that she did not want to touch the pictures of nasty creatures.

Naturally we cannot adequately respond to the message of the mosaic unless we have read the image correctly. The medium of the mosaic is well suited to formulate the problem in terms of the theory of information. Its modern equivalent would be an advertising display composed of an array of

light bulbs in which each bulb can be turned either on or off to form an image. A mosaic might consist of standardized cubes (*tesserae*) that are either dark or light. The amount of visual information such a medium can transmit will depend on the size of the cubes in relation to the scale of the image. In our case the cubes are small enough for the artist to indicate the tufts of hair on the dog's legs and tail, and the individual links of the chain. The artist might confine himself to a code in which black signifies a solid form seen against a light ground. Such a silhouette could easily be endowed with sufficiently distinctive features to be recognized as a dog. But the Pompeiian master was trained in a tradition that had gone beyond the conceptual method of representation and he included in the image information about the effects of light on form. He conveys the white and the glint of the eye and the muzzle, shows us the teeth and outlines the ears; he also indicates the shadows of the forelegs on the patterned background.[2] The meaning so far is easy to decode, but the white patches on the body and, most of all, the outline of the hind leg set us a puzzle. It was the convention in his time to model the shape of an animal's body by indicating the sheen of the fur, and this must be the origin of these features. Whether their actual shape is due to clumsy execution or to inept restoration could only be decided by viewing the original.

The difficulty of interpreting the meaning of the dog mosaic is instructive because it too can be expressed in terms of communication theory. Like verbal messages, images are vulnerable to the random interference engineers call 'noise'. They need the device of redundancy to overcome this hazard. It is this built-in safeguard of the verbal code that enables us to read the inscription *Cave Canem* without hesitation even though the first *e* is incomplete. As far as image recognition is concerned it is the enclosing contour that carries most of the information. We could not guess the length of the tail if the black cubes were missing. The individual cubes of the patterned ground and inside the outline are relatively more redundant, but those indicating the sheen occupy a middle position; they stand for a feature that is elusive even in reality, although the configuration we now see could never occur.

However automatic our first response to an image may be, therefore, its actual reading can never be a passive affair. Without a prior knowledge of possibilities we could not even guess at the relative position of the dog's two hind legs. Although we have this knowledge, other possibilities are likely to escape us. Perhaps the picture was intended to represent a particular breed that Romans would recognize as being vicious. We cannot tell by the picture.

The chance of a correct reading of the image is governed by three variables: the code, the caption and the context. It might be thought that the caption alone would make the other two redundant, but our cultural conventions are

too flexible for that. In an art book the picture of a dog with the caption E. Landseer is understood to refer to the maker of the image, not to the species represented. In the context of a primer, on the other hand, the caption and the picture would be expected to support each other. Even if the pages were torn so that we could only read 'og', the fragment of the drawing above would suffice to indicate whether the missing letter was a *d* or an *h*. Jointly the media of word and image increase the probability of a correct reconstruction.

We shall see that this mutual support of language and image facilitates memorizing. The use of two independent channels, as it were, guarantees the ease of reconstruction. This is the basis of the ancient 'art of memory' (brilliantly explored in a book by Frances Yates[3]) that advises the practitioner to translate any verbal message into visual form, the more bizarre and unlikely the better. If you want to remember the name of the painter Hogarth, picture to yourself a *hog* practising his art by painting an *h*. You may dislike the association, but you may find it hard to get rid of.

There are cases where the context alone can make the visual message unambiguous even without the use of words. It is a possibility that has much attracted organizers of international events where the Babylonian confusion of tongues rules out the use of language. The set of images designed for the Olympic Games in Mexico in 1968 appears to be self-explanatory,[4] indeed it is, given the limited number of expected messages and the restriction of the choice that is exemplified best by the first two signs of the array (Fig. 7). We can observe how the purpose and context dictate a simplification of the code by concentrating on a few distinctive features. The principle is brilliantly exemplified by the pictorial signs for the various sports and games designed for the Winter Olympics at Grenoble the same year (Fig. 8).

We should never be tempted to forget, however, that even in such usages context must be supported by prior expectations based on tradition. Where these links break, communication also breaks down. Some years ago there was a story in the papers to the effect that riots had broken out in an underdeveloped country because of rumours that human flesh was being sold in a store. The rumour was traced to food cans with a grinning boy on the label. Here it was the switch of context that caused the confusion. As a rule the picture of fruit, vegetable or meat on a food container does indicate its contents; if we do not draw the conclusion that the same applies to a picture of a human being on the container, it is because we rule out the possibility from the start.

In the above examples the image was expected to work in conjunction with other factors to convey a clear-cut message that could be translated into words. The real value of the image, however, is its capacity to convey

7
Signs for the 1968 Olympic Games in Mexico City

8

Ice-skating symbol for the 1968 Winter Olympics in Grenoble

information that cannot be coded in any other way. In his important book *Prints and Visual Communication*[5] William M. Ivins, Jr., argued that the Greeks and the Romans failed to make progress in science because they lacked the idea of multiplying images by some form of printing. Some of his philosophical points can hardly be sustained (the ancient world knew of the multiplication of images through the seal, the coinage, and the cast), but it is certainly true that printed herbals, costume books, news-sheets and topographical views were a vital source of visual information about plants, fashions, topical events and foreign lands. But study of this material also brings home to us that printed information depends in part on words. The most life-like portrait of a king will mislead us if it is incorrectly labelled as being somebody else, and publishers of early broadsheets sometimes reused woodcuts showing a city devastated by a flood to illustrate an earthquake or another disaster (Figs. 9 and 10) on the principle that if you have seen one catastrophe, you have seen them all.[6] Even today it is only our confidence in certain informants or institutions that allays our doubts that a picture in a book, a newspaper or on the screen really shows what it purports to show. There was the notorious case of the German scientist Ernst Haeckel, who was accused of having tried to prove the parallelism of human and animal development by labelling a photograph of a pig's foetus as that of a human embryo. It is in fact fatally easy to mix up pictures and captions, as almost any publisher knows to his cost.

The information extracted from an image can be quite independent of the intention of its maker. A holiday snapshot of a group on a beach may be scrutinized by an intelligence officer preparing a landing, and the Pompeiian mosaic might provide new information to a historian of dog breeding.

It may be convenient here to range the information value of such images according to the amount of information about the prototype that they can encode. Where the information is virtually complete we speak of a facsimile or replica. These may be produced for deception rather than information, fraudulently in the case of a forged banknote, benevolently in the case of a glass eye or an artificial tooth. But the facsimile of a banknote in a history book is intended for instruction, and so is the cast or copy of an organ in medical teaching.

A facsimile duplication would not be classed as an image if it shared with its prototype all characteristics including the material of which it is made. A flower sample used in a botany class is not an image, but an artificial flower used for demonstration purposes must be described as an image. Even here the borderline is somewhat fluid. A stuffed animal in a showcase is not an image, but the taxidermist is likely to have made his personal contribution

through selecting and modifying the carcass. However faithful an image that serves to convey visual information may be, the process of selection will always reveal the maker's interpretation of what he considers relevant. Even the wax effigy of a celebrity must show the sitter in one particular attitude and role; the photographer of people or events will carefully sift his material to find the 'tell-tale' picture.

Interpretation on the part of the image maker must always be matched by the interpretation of the viewer. No image tells its own story. I remember an exhibition in a museum in Lincoln, Nebraska, showing skeletons and reconstructions of the ancestor of the horse. By present equine standards these creatures were diminutive, but they resembled our horse in everything but the scale. It was this encounter that brought home to me how inevitably we interpret even a didactic model and how hard it is to discard certain assumptions. Being used to looking at works of sculpture, including small bronze statuettes of horses, I had slipped into the mental habit of discounting scale when interpreting the code. In other words, I 'saw' the scale model of a normal horse. It was the verbal description and information that corrected my reading of the code.

Here as always we need a jolt to remind us of what I have called the 'beholder's share', the contribution we make to any representation from the stock of images stored in our mind. Once more it is only when this process cannot take place because we lack memories that we become aware of their role. Looking at a picture of a house, we do not normally fret about the many

things the picture does not show us unless we are looking for a particular aspect that was hidden from the camera. We have seen many similar houses and can supplement the information from our memory, or we think we can. It is only when we are confronted with a totally unfamiliar kind of structure that we are aware of the puzzle element in any representation. The new opera house in Sydney, Australia, is a structure of a novel kind, and a person who sees only a photograph of it will feel compelled to ask a number of questions the photograph cannot answer (Fig. 11). What is the inclination of the roof? Which parts go inward, which outward? What, indeed, is the scale of the entire structure?

The hidden assumptions with which we generally approach a photograph are most easily demonstrated by the limited information value of shadows on flat images. They only yield the correct impression if we assume that the light is falling from above and generally from the left; reverse the picture and what was concave looks convex and vice versa (Fig. 12). That we read the code of the black-and-white photograph without assuming that it is a rendering of a colourless world may be a triviality, but behind this triviality lurk other problems. What colours or tones could be represented by certain greys in the photograph? What difference will it make to, say, the American flag whether it is photographed with an orthochromatic or a panchromatic film?

Interpreting photographs is an important skill that must be learned by all

who have to deal with this medium of communication: the intelligence officer, the surveyor or archaeologist who studies aerial photographs, the sports photographer who wishes to record and to judge athletic events and the physician who reads X-ray films. Each of these must know the capacities and the limitations of his instruments. Thus the rapid movement of a slit shutter down the photographic plate may be too slow to show the correct sequence of events it is meant to capture, or the grain of a film may be too coarse to register the desired detail in a photograph. It was shown by the late Gottfried Spiegler that the demand for an easily legible X-ray image may conflict with its informative function.[7] Strong contrast and definite outlines may obscure valuable clues (Fig. 13). Needless to say, there is the further possibility of retouching a photographic record in the interest of either truth or falsehood. All these intervening variables make their appearance again on the way from the negative to the print, from the print to the photo-engraving and then to the printed illustration. The most familiar of these is the density of the halftone screen. As in the case of the mosaic, the information transmitted by the normal illustration process is granular, smooth transitions are transformed into discrete steps and these steps can either be so few that they are obtrusively visible or so small that they can hardly be detected by the unaided eye.

Paradoxically it is the limited power of vision that has made television possible: the changing intensities of one luminous dot sweeping across the screen build up the image in our eye. Long before this technique was conceived the French artist Claude Mellan displayed his virtuosity by engraving the face of Christ with one spiralling line swelling and contracting to indicate shape and shading (Fig. 14).

The very eccentricity of this caprice shows how readily we learn to fall in

13
X-rays with high contrast
(left) and soft contrast
(right). From G. Spiegler,
*Physikalische Grundlagen der
Röntgendiagnostik* (Stuttgart,
1957)

with the code and to accept its conventions. We do not think for a moment that the artist imagined Christ's face to have been lined with a spiral. Contrary to the famous slogan, we easily distinguish the medium from the message.

From the point of view of information this ease of distinction can be more vital than fidelity of reproduction. Many students of art regret the increased use of colour reproductions for that reason. A black-and-white photograph is seen to be an incomplete coding. A colour photograph always leaves us with some uncertainty about its information value. We cannot separate the code from the content.

The easier it is to separate the code from the content, the more we can rely on the image to communicate a particular kind of information. A selective code that is understood to be a code enables the maker of the image to filter out certain kinds of information and to encode only those features that are of interest to the recipient. Hence a selective representation that indicates its own principles of selection will be more informative than the replica. Anatomical drawings are a case in point. A realistic picture of a dissection not only would arouse aversion but also might easily fail to show the aspects that are to be demonstrated. Even today surgeons sometimes employ 'medical artists' to record selective information that colour photographs might fail to communicate. Leonardo da Vinci's anatomical studies are early examples of deliberate suppression of certain features for the sake of conceptual clarity. Many of them are not so much portrayals as functional models, illustrations of the artist's views about the structure of the body. Leonardo's drawings of water and whirlpools are likewise intended as visualizations of the forces at work.[8]

Such a rendering may be described as a transition from a representation to diagrammatic mapping, and the value of the latter process for the

14
Claude Mellan: detail
from *The Napkin of St
Veronica*, 1735. Etching

communication of information needs no emphasis. What is characteristic of
the map is the addition of a key to the standardized code. We are told which
particular heights are represented by the contour lines and what particular
shade of green stands for fields or forests. Whereas these are examples of
visible features, standardized for the sake of clarity, there is no difficulty in
entering on the map other kinds of feature, such as political frontiers,
population density or any other desired information. The only element of
genuine representation (also called iconicity) in such a case is the actual shape
of the geographical features, although even these are normalized according to
given rules of transformation to allow a part of the globe to be shown on a flat
map.

It is only a small step from the abstraction of the map to a chart or diagram
showing relations that are originally not visual but temporal or logical. One of
the oldest of these relational maps is the family tree. The kinship table was
often shown in medieval treatises of canon law because the legitimacy of
marriages and the laws of inheritance were in part based on the degree of

15
Johannes Andrei, *Tree of Affinities*, 1473. Woodcut

kinship (Fig. 15). Genealogists also seized on this convenient means of visual demonstration. Indeed, the family tree demonstrates the advantages of the visual diagram to perfection. A relationship that would take so long to explain in words we might lose the thread ('She is the wife of a second cousin of my stepmother') could be seen on a family tree at a glance. Whatever the type of connection, whether it is a chain of command, the organization of a corporation, a classification system for a library or a network of logical dependencies, the diagram will always spread out before our eyes what a verbal description could only present in a string of statements.

Moreover, diagrams can easily be combined with other pictorial devices in charts to show pictures of things in logical rather than spatial relationships. Attempts have also been made to standardize the codes of such charts for the purpose of visual education (particularly by Otto and Marie Neurath of Vienna, who sought to vivify statistics by such a visual code).[9]

Whether the developed practice of such visual aids is as yet matched by an adequate theory is another matter. According to press releases, the National

Aeronautics and Space Administration has equipped a deep-space probe with a pictorial message 'on the off chance that somewhere on the way it is intercepted by intelligent scientifically educated beings' (Fig. 16). It is unlikely that their effort was meant to be taken quite seriously, but what if we try? These beings would first of all have to be equipped with 'receivers' among their sense organs that respond to the same band of electromagnetic waves as our eyes do. Even in that unlikely case they could not possibly get the message. We have seen that reading an image, like the reception of any other message, is dependent on prior knowledge of possibilities; we can only recognize what we know. Even the sight of the awkward naked figures in the illustration cannot be separated in our mind from our knowledge. We know that feet are for standing and eyes are for looking and we project this knowledge onto these configurations, which would look 'like nothing on earth' without this prior information. It is this information alone that enables us to separate the code from the message; we see which of the lines are intended as contours and which are intended as conventional modelling. Our 'scientifically educated' fellow creatures in space might be forgiven if they saw the figures as wire constructs with loose bits and pieces hovering weightlessly in between. Even if they deciphered this aspect of the code, what would they make of the woman's right arm that tapers off like a flamingo's neck and beak? The creatures are 'drawn to scale against the outline of the spacecraft', but if the recipients are supposed to understand foreshortening, they might also expect

17
Osiris in Egyptian
hieroglyphics. British
Museum, London

to see perspective and conceive the craft as being farther back, which would make the scale of the manikins minute. As for the fact that 'the man has his right hand raised in greeting' (the female of the species presumably being less outgoing), not even an earthly Chinese or Indian would be able to interpret correctly this gesture from his own repertory.

The representation of humans is accompanied by a chart: a pattern of lines beside the figures standing for the fourteen pulsars of the Milky Way, the whole being designed to locate the sun of our universe. A second drawing (how are they to know it is not part of the same chart?) 'shows the earth and the other planets in relation to the sun and the path of Pioneer from earth and swinging past Jupiter'. The trajectory, it will be noticed, is endowed with a directional arrowhead; it seems to have escaped the designers that this is a conventional symbol unknown to a race that never had the equivalent of bows and arrows.

The arrow is one of a large group of graphic symbols that occupy the zone between the visual image and the written sign. Any comic strip offers examples of these conventions, the history of which is still largely unexplored. They range from the pseudo-naturalistic streaking lines indicating speed to the conventional dotted track indicating the direction of the gaze, and from the hallucinatory medley of stars before the eyes after a blow to the head to the 'balloon' that contains a picture of what the person has in mind, or perhaps just a question mark to suggest puzzlement. This transition from image to symbol reminds us of the fact that writing itself evolved from the pictograph, although it became writing only when it was used to transform the fleeting spoken word into a permanent record.

It is well known that a number of ancient scripts drew for this purpose on both the resources of illustration and the principle of the rebus: the use of homophones for the rendering of abstract words. Both in ancient Egypt and in China these methods were ingeniously combined to signify sounds and facilitate reading by classifying them according to conceptual categories. Thus the name of the god Osiris was written in hieroglyphics as a rebus with a picture of a throne ('usr') and a picture of an eye ('iri') to which was adjoined a picture of the divine sceptre to indicate the name of a god (Fig. 17). But in all ancient civilizations writing represents only one of several forms of conventional symbolism, the meaning of which has to be learned if the sign is to be understood.

Not that this learning need be an intellectual exercise. We can easily be conditioned to respond to signs as we respond to sights. The symbols of religion such as the cross or the lotus, the signs of good luck or danger such as the horseshoe or the skull and crossbones, the national flags or heraldic signs

such as the stars and stripes and the eagle, the party badges such as the red flag or the swastika for arousing loyalty or hostility – all these and many more show that the conventional sign can absorb the arousal potential of the visual image.

It may be an open question how far the arousal potential of symbols taps the unconscious significance of certain configurations that Freud explored and Jung was to link with the esoteric traditions of symbolism in mysticism and alchemy. What is open to the observation of the historian is the way the visual symbol has so often appealed to seekers after revelation. To such seekers the symbol is felt both to convey and conceal more than the medium of rational discourse. One of the reasons for this persistent feeling was no doubt the diagrammatic aspect of the symbol, its ability to convey relations more quickly and more effectively than a string of words. The ancient symbol of yin and yang illustrates this potential and also suggests how such a symbol can become the focus of meditation (Fig. 18). Moreover, if familiarity breeds contempt, unfamiliarity breeds awe. A strange symbol suggests a hidden mystery, and if it is known to be ancient, it is felt to embody some esoteric lore too sacred to be revealed to the multitudes. The awe surrounding the ancient Egyptian hieroglyphs in later centuries exemplifies this reaction.[10] Most of the meanings of the hieroglyphs had been forgotten, but the method of writing the name of the god Osiris was now believed to have symbolic rather than phonetic significance and the eye and sceptre were interpreted to mean that the god was a manifestation of the sun.

The reader need not look further than a US dollar bill to see how this association was tapped by the founding fathers in the design of the Great Seal (Fig. 19). Following the advice of the English antiquarian Sir John Prestwich, the design expresses in words and image the hopes and aspirations of the New World for the dawn of a new era. *Novus ordo seclorum* alludes to Virgil's prophecy of a return of the Golden Age, and so does the other Latin tag, *Annuit coeptis*, 'He [God] favoured the beginning.' But it is the image of the unfinished pyramid rising toward heaven and the ancient symbol of the eye suggesting the eye of Providence that give the entire design the character of an ancient oracle close to fulfilment.

Interesting as the historian must find the continuity of a symbol, such as the eye on the Great Seal, reaching back over more than 4,000 years, the case is somewhat exceptional. More frequently the past influences symbolism through the stories and lore in the language. Cupid's darts, Herculean labours, the sword of Damocles and Achilles' heel come to us from classical antiquity, the olive branch and the widow's mite from the Bible, sour grapes and the lion's share from Aesop's fables, a paper tiger and losing face from the Far

18
Yin and Yang symbol

19
Great Seal of the United States of America

20
'Vicky', *Achilles' Heel*, 1942

21
Raymond Savignac, *Astral: peinture, émail*. Offset poster.

East. Such allusions or clichés enable us to 'cut a long story short' because we do not have to spell out the meaning. Almost any story or event that becomes the common property of a community enriches language with new possibilities of condensing a situation into a word, whether it is the political term 'Quisling' or the scientific term 'fallout'. Moreover, language carries old and new figures of speech that are rightly described as images: 'The sands are running out', 'The pump must be primed', 'Wages should be pegged', 'The dollar should be allowed to float'. The literal illustration of these metaphors offers untold possibilities for that special branch of symbolic imagery, the art of the cartoonist.[11] He too can condense a comment into a few pregnant images by the use of the language's stock figures and symbols. Vicky's cartoon showing Italy as Hitler's 'Achilles' heel' is a case in point (Fig. 20).

Like the successful pun that finds an unexpected but compelling meaning in the sound of a word, Vicky's cartoon reminds us that Italy has a 'heel', and what else could it be but an Achilles' heel? But even if we can count on some familiarity with the shape of Italy and the story of Achilles, the aptness of the cartoon might need a good deal of spelling out forty years after its initial appearance. If there is one type of image that remains mute without the aid of context, caption and code, it is the political cartoon. Its point must inevitably be lost on those who do not know the situation on which it comments.

A glance at the imagery that surrounds us does not bear out the claim that our civilization lacks inventiveness in this field. Whether we approve or disapprove of the role advertising has come to play in our society, we can enjoy the ingenuity and wit used by commercial artists in the use of old symbols and the invention of fresh ones. The trademark adopted for North Sea Gas in Britain cleverly combines the trident, that old symbol of Neptune, with the

22, 23
Trident trademark,
adopted in Britain for
North Sea Gas. Realistic
version (*left*) and abstact
version

picture of a gas burner (Fig. 22). It is interesting to watch how this idea was first coded as a realistic representation and then reduced to essentials, the increase in distinctiveness making it both more memorable and easier to reproduce (Fig. 23).

Freud's analysis of the kinship between verbal wit and dreamworld could easily be applied, as Ernst Kris has shown, to the condensation of visual symbols in advertising and cartoons.[12] Where the aim is first and foremost to arrest the attention, condensation and selective emphasis are used both for their power of arousal and for their surprise effects. The incomplete image and the unexpected one (Fig. 23) set the mind a puzzle that makes us linger, and enjoy and remember the solution, where the prose of purely informational images would remain unnoticed or unremembered.

It might be tempting to equate the poetry of images with the artistic use of visual media, but it is well to remember that what we call art was not invariably produced for purely aesthetic effects. Even in the sphere of art the dimensions of communication are observable, although in more complex interaction. Here too it is the arousal function of the image that determines the use of the medium. The cult image in its shrine mobilizes the emotions that belong to the prototype, the divine being. In vain did the Hebrew prophets remind the faithful that the heathen idols were only sticks and stones. The power of such images is stronger than any rational consideration. There are few who can escape the spell of a great cult image in its setting.

The strength of the visual image posed a dilemma for the Christian church.

The church feared idolatry but hesitated to renounce the image as a means of communication. The decisive papal pronouncement on this vital issue was that of Pope Gregory the Great, who wrote that 'pictures are for the illiterate what letters are for those who can read.' Not that religious images could function without the aid of context, caption and code, but given such aid the value of the medium was easily apparent. Take the main porch of the cathedral of Genoa (Fig. 24), with its traditional rendering of Christ enthroned between the four symbols of the Evangelists (derived from the prophet Ezekiel's vision of the throne of the Lord as it is described in the Bible). The relief underneath will tell the faithful from afar to which saint the church is dedicated. It represents the martyrdom of St Lawrence. For all its impressive lucidity the image could not be read by anyone unfamiliar with the code, that is, with the style of medieval sculpture. That style disregards the relative size of figures for the sake of emphasizing importance through scale, and it represents every object from the most telling angle. Hence the naked man is not a giant hovering sideways in front of a grid. We must understand that he is stretched out on an instrument of torture while the ruler commands an executioner to fan the flames with bellows. Without the aid of the spoken word the illiterate, of course, could not know that the sufferer is not a malefactor but a saint who is marked by the symbol of the halo, or that the gestures made by the onlookers indicate compassion.

But if the image alone could not tell the worshipper a story he had never heard of, it was admirably suited to remind him of the stories he had been told

25
Stained-glass lancet
windows, early 13th
century. Chartres
Cathedral

in sermons or lessons. Once he had become familiar with the legend of St Lawrence even the picture of a man with a gridiron would remind him of the saint. It only needed a change in the means and aims of art to enable a great master to make us feel the heroism and the suffering of the martyr in images of great emotional appeal. In this way pictures could indeed keep the memory of sacred and legendary stories alive among the laity, whether or not they were able to read. Pictures still serve the purpose. There must be many whose acquaintance with these legends started from images.

We have touched briefly on the mnemonic power of the image, which is certainly relevant to many forms of religious and secular art. The windows of Chartres show the power of symbolism to transform a metaphor into a memorable image with their vivid portrayal of the doctrine that the apostles stand on the shoulders of the Old Testament prophets (Fig. 25). The whole vast genre of allegorical images testifies to this possibility of turning an abstract thought into a picture.[13] Michelangelo's famous statue of *Night* (Fig. 26), with her symbolic attributes of the star, the owl and the sleep-inducing poppies, is not only a pictograph of a concept but also a poetic evocation of nocturnal feelings.

The capacity of the image to purvey a maximum of visual information could be exploited only in periods where the styles of art were sufficiently

26
Michelangelo, *Night*, detail
from the Tomb of
Giuliano de' Medici,
1524–31. Medici Chapel,
San Lorenzo, Florence

flexible and rich for such a task. Some great artists met the demands of naturalistic portraiture and faithful views with consummate mastery, but the aesthetic needs for selective emphasis could also clash with these more prosaic tasks. The idealized portrait or the revealing caricature was felt to be closer to art than the wax facsimile could ever be, and the romantic landscape that evoked a mood was similarly exalted over the topographic painting.

The contrast between the prose and the poetry of image making often led to conflicts between artists and patrons. The conflict increased in acerbity when the autonomy of art became an issue. It was the Romantic conception of genius in particular that stressed the function of art as self-expression (even though the catchword is of later date). It is precisely this issue that remains to be discussed here, since it will be remembered that the expressive symptom of emotions was distinguished in the theory of communication from the dimension of arousal or description. Popular critics who speak of art as communication often imply that the same emotions that give rise to the work of art are transmitted to the beholder, who feels them in his turn.[14] This naïve idea has been criticized by several philosophers and artists, but to my knowledge the most succinct criticism was a drawing that appeared some years ago in *The New Yorker* (Fig. 27). Its target is the very setting in which the term self-expression has had the greatest vogue. A little dancer fondly believes

27
Sceptical view of non-verbal communication by CEM. From *The New Yorker*

she is communicating her idea of a flower, but observe what arises instead in the minds of the various onlookers. A series of experiments made by Reinhard Krauss in Germany some decades ago confirms the sceptical view portrayed in the cartoon.[15] Subjects were asked to convey through drawn abstract configurations some emotion or idea for others to guess at. Not surprisingly it was found that such guessing was quite random. When people were given a list of various possible meanings, their guesses became better, and they improved progressively with a reduction in the number of alternatives with which they were confronted. It is easy to guess whether a given line is intended to convey grief or joy, or stone or water.

Many readers will know the painting by Van Gogh of his humble bedroom painted in Arles in 1889 (Fig. 28). It happens to be one of the very few works of art where we know the expressive significance the work held for the artist. In Van Gogh's wonderful correspondence there are three letters dealing with this work that firmly establish the meaning it held for him. Writing to Gauguin in October 1888 he says:

> Still for the decoration [of my house] I have done … my bedroom with its furniture of whitewood which you know. Well, it amused me enormously to do that interior with nothing in it, with a simplicity à la Seurat: with flat paint but coarsely put on, the neat pigment, the walls a pale violet … '

28
Vincent van Gogh,
Bedroom at Arles, 1889. Art
Institute of Chicago

29
Vincent van Gogh, *The
Night Café*, 1888. Yale
University Art Gallery,
New Haven, Conn.,
bequest of Stephen
Carlton Clark, 1903

I wanted to express an absolute calm with these very different tones, you see, where there is no white except in the mirror with its black frame ...

A letter to his brother Theo confirms his intention and explains it further:

My eyes are still strained, but at last I have a new idea in my head ... This time it is quite simply my bedroom, colour alone must carry it off, by imparting through simplification a grander style to things, it should be suggestive of rest and sleep in general. In other words, the sight of the picture should rest the head, or rather the imagination ... The walls are pale violet, the floor tiles red ... the doors are green, that is all. There is nothing in the room with the shutters closed.

The squareness of the furniture should also express the undisturbed rest ... The shadows and modelling are suppressed, it is coloured with flat tints like the Japanese prints. This will contrast, for instance, with the *diligence* of Tarascon and the Night Café.

Here we have an important clue. Van Gogh had written of *The Night Café* (Fig. 29) that he wanted to show that it was a place where one could go mad. To him, in other words, his little room was a haven after the strain of work, and it was this contrast that made him stress its tranquillity. The manner of simplification he adopted from Seurat and from the Japanese print stood for him in clear opposition to the expressive graphological brushwork that had become so characteristic of his style. This is what he stresses in still another letter to his brother. 'No stippling, no hatching, nothing, flat areas, but in harmony.' It is this modification of the code that Van Gogh experiences as being expressive of calm and restfulness. Does the painting of the bedroom communicate this feeling? None of the naïve subjects I have asked hit on this meaning; although they knew the caption (Van Gogh's bedroom), they lacked the context and the code. Not that this failure of getting the message speaks against the artist or his work. It only speaks against the equation of art with communication.

Editor's Postscript

Scientific American is an unlikely place to find a contribution from an art historian, so it seems doubly appropriate that we should start a collection of readings which typifies Gombrich's work with this one.

Some of the issues which are raised by this essay are treated in much greater detail in Art and Illusion, The Image and the Eye *and* Meditations on a Hobby Horse.

Jonathan Miller conducted a BBC television interview with Gombrich, 'Psychological Aspects of the Visual Arts', which he published in States of Mind: Conversations with Psychological Investigators *(London, 1983). Altogether it is a fascinating collection of material.*

The J. Paul Getty Trust in collaboration with the Metropolitan Museum of Art has produced a video, Gombrich Themes, Part 1: Illumination in Art and Nature, *and Part 2:* Reflections in Art and Nature. *It is part of the Program for Art on Film. There is also a National Gallery video* Gombrich on Shadows *(London, 1995).*

Readers interested in the subject of perception are recommended to keep a watchful eye on Scientific American *publications.*

On Art and Artists

Introduction to
The Story of Art (1950, 16th
edition, 1995), pp. 15–37

There really is no such thing as Art. There are only artists. Once these were men who took coloured earth and roughed out the forms of a bison on the wall of a cave; today some buy their paints, and design posters for hoardings; they did and do many other things. There is no harm in calling all these activities art as long as we keep in mind that such a word may mean very different things in different times and places, and as long as we realize that Art with a capital A has no existence. For Art with a capital A has come to be something of a bogey and a fetish. You may crush an artist by telling him that what he has just done may be quite good in its own way, only it is not 'Art'. And you may confound anyone enjoying a picture by declaring that what he liked in it was not the Art but something different.

Actually I do not think that there are any wrong reasons for liking a statue or a picture. Someone may like a landscape painting because it reminds him of home, or a portrait because it reminds him of a friend. There is nothing wrong with that. All of us, when we see a painting, are bound to be reminded of a hundred-and-one things which influence our likes and dislikes. As long as these memories help us to enjoy what we see, we need not worry. It is only when some irrelevant memory makes us prejudiced, when we instinctively turn away from a magnificent picture of an alpine scene because we dislike climbing, that we should search our mind for the reason for the aversion which spoils a pleasure we might otherwise have had. There *are* wrong reasons for disliking a work of art.

Most people like to see in pictures what they would also like to see in reality. This is quite a natural preference. We all like beauty in nature, and are grateful to the artists who have preserved it in their works. Nor would

30
Peter Paul Rubens, *Portrait of his Son Nicholas*, c. 1620. Albertina, Vienna

31
Albrecht Dürer, *The Artist's Mother*, 1514. Kupferstichkabinet, Berlin

these artists themselves have rebuffed us for our taste. When the great Flemish painter Rubens made a drawing of his little boy (Fig. 30) he was surely proud of his good looks. He wanted us, too, to admire the child. But this bias for the pretty and engaging subject is apt to become a stumbling-block if it leads us to reject works which represent a less appealing subject. The great German painter Albrecht Dürer certainly drew his mother (Fig. 31) with as much devotion and love as Rubens felt for his chubby child. His truthful study of careworn old age may give us a shock which makes us turn away from it – and yet, if we fight against our first repugnance we may be richly rewarded, for Dürer's drawing in its tremendous sincerity is a great work. In fact, we shall soon discover that the beauty of a picture does not really lie in the beauty of its subject-matter. I do not know whether the little ragamuffins whom the Spanish painter Murillo liked to paint (Fig. 32) were strictly beautiful or not, but, as he painted them, they certainly have great charm. On the other hand, most people would call the child in Pieter de Hooch's wonderful Dutch interior (Fig. 33) plain, but it is an attractive picture all the same.

The trouble about beauty is that tastes and standards of what is beautiful vary so much. Figures 34 and 35 were both painted in the fifteenth century, and both represent angels playing the flute. Many will prefer the Italian work by Melozzo da Forlì (Fig. 34) with its appealing grace and charm, to that of his northern contemporary Hans Memling (fig. 35). I myself like both. It may take a little longer to discover the intrinsic beauty of Memling's angel, but once we are no longer disturbed by his faint awkwardness we may find him infinitely lovable.

What is true of beauty is also true of expression. In fact, it is often the expression of a figure in the painting which makes us like or loathe the work. Some people like an expression which they can easily understand, and which therefore moves them profoundly. When the seventeenth-century Italian painter Guido Reni painted the head of Christ on the cross (Fig. 36) he intended, no doubt, that the beholder should find in this face all the agony and all the glory of the Passion. Many people throughout subsequent centuries have drawn strength and comfort from such a representation of the Saviour. The feeling it expresses is so strong and so clear that copies of this work can be found in simple wayside shrines and remote farmhouses where people know nothing about 'Art'. But even if this intense expression of feeling appeals to us we should not, for that reason, turn away from works whose expression is perhaps less easy to understand. The Italian painter of the Middle Ages who painted the crucifix (Fig. 37) surely felt as sincerely about the Passion as did Reni, but we must first learn to know his methods of drawing to understand his feelings. When we have come to understand these different languages, we may even prefer works of art whose expression is less obvious than Reni's. Just as some prefer people who use few words and gestures and leave something to be guessed, so some people are fond of paintings or sculptures which leave them something to guess and ponder about. In the more 'primitive' periods, when artists were not as skilled in representing human faces and human gestures as they are now, it is often all the more moving to see how they tried nevertheless to bring out the feeling they wanted to convey.

But here newcomers to art are often brought up against another difficulty. They want to admire the artist's skill in representing the things they see. What they like best are paintings which 'look real'. I do not deny for a moment that this is an important consideration. The patience and skill which go into the faithful rendering of the visible world are indeed to be admired. Great artists of the past have devoted much labour to works in which every tiny detail is carefully recorded. Dürer's watercolour study of a hare (Fig. 38) is one of the most famous examples of this loving patience. But who would say that Rembrandt's drawing of an elephant (Fig. 39) is necessarily less good because it shows fewer details? Indeed Rembrandt was such a wizard that he gave us the feel of the elephant's wrinkly skin with a few lines of his chalk.

But it is not sketchiness that mainly offends people who like their pictures to look 'real'. They are even more repelled by works which they consider to be incorrectly drawn, particularly when they belong to a more modern period when the artist 'ought to have known better'. As a matter of fact, there is no mystery about these distortions of nature about which we still hear complaints in discussions on modern art. Everyone who has ever seen a Disney film or a comic strip knows all about it. He knows that it is sometimes right to draw things otherwise than they look, to change and distort them in one way or another. Mickey Mouse does not look very much like a real mouse, yet people do not write indignant letters to the papers about the length of his tail. Those who enter Disney's enchanted world are not worried about Art with a capital A. They do not watch his films armed with the same prejudices they like to take with them when going to an exhibition of modern painting. But if a modern artist draws something in his own way, he is apt to be thought a bungler who can do no better. Now, whatever we may think of modern artists, we may safely credit them with enough knowledge to draw 'correctly'. If they do not do so their reasons may be very similar to those of Walt Disney. Figure 40 shows a plate from an illustrated *Natural History* by the famous pioneer of the modern movement, Picasso. Surely no one could find fault with his charming representation of a mother hen and her fluffy chicks. But in drawing a cockerel (Fig. 41) Picasso was not content with giving a mere rendering of the bird's appearance. He wanted to bring out its aggressiveness, its cheek and its stupidity. In other words he resorted to caricature. But what a convincing caricature it is!

There are two things, therefore, which we should always ask ourselves if we find fault with the accuracy of a picture. One is whether the artist may not have had his reasons for changing the appearance of what he saw. We shall hear more about such reasons as the story of art unfolds. The other is that we should never condemn a work for being incorrectly drawn unless we have

made quite sure that we are right and the painter is wrong. We are all inclined to be quick with the verdict that 'things do not look like that'. We have a curious habit of thinking that nature must always look like the pictures we are accustomed to. It is easy to illustrate this by an astonishing discovery which was made not very long ago. Generations have watched horses gallop, have attended horse-races and hunts, have enjoyed paintings and sporting prints showing horses charging into battle or running after hounds. Not one of these people seems to have noticed what it 'really looks like' when a horse runs. Pictures and sporting prints usually showed them with outstretched legs in full flight through the air – as the great nineteenth-century French painter Théodore Géricault painted them in a famous representation of the races at Epsom (Fig. 42). About fifty years later, when the photographic camera had been sufficiently perfected for snapshots of horses in rapid motion to be taken, these snapshots proved that both the painters and their public had been wrong all the while. No galloping horse ever moved in the way which seems so 'natural' to us. As the legs come off the ground they are moved in turn for the next kick-off (fig. 43). If we reflect for a moment we shall realize that it could hardly get along otherwise. And yet, when painters began to apply this new

36
Guido Reni, *Christ
Crowned with Thorns*,
c. 1639-40.
Louvre, Paris

37
Tuscan Master, *Head of
Christ*, *c.*1175-1225.
Detail of a crucifix. Uffizi,
Florence

discovery, and painted horses moving as they actually do, everyone
complained that their pictures looked wrong.

This, no doubt, is an extreme example, but similar errors are by no means
as rare as one might think. We are all inclined to accept conventional forms or
colours as the only correct ones. Children sometimes think that stars must be
star-shaped, though naturally they are not. The people who insist that in a
picture the sky must be blue, and the grass green, are not very different from
these children. They get indignant if they see other colours in a picture, but if
we try to forget all we have heard about green grass and blue skies, and look at
the world as if we had just arrived from another planet on a voyage of
discovery and were seeing it for the first time, we may find that things are apt
to have the most surprising colours. Now painters sometimes feel as if they
were on such a voyage of discovery. They want to see the world afresh, and to
discard all the accepted notions and prejudices about flesh being pink and
apples yellow or red. It is not easy to get rid of these preconceived ideas, but
the artists who succeed best in doing so often produce the most exciting
works. It is they who teach us to see in nature new beauties of whose existence

we have never dreamt. If we follow them and learn from them, even a glance out of our own window may become a thrilling adventure.

There is no greater obstacle to the enjoyment of great works of art than our unwillingness to discard habits and prejudices. A painting which represents a familiar subject in an unexpected way is often condemned for no better reason than that it does not seem right. The more often we have seen a story represented in art, the more firmly do we become convinced that it must always be represented on similar lines. About biblical subjects, in particular, feelings are apt to run high. Though we all know that the Scriptures tell us nothing about the appearance of Jesus, and that God Himself cannot be visualized in human form, and though we know that it was the artists of the past who first created the images we have become used to, some are still inclined to think that to depart from these traditional forms amounts to blasphemy.

As a matter of fact, it was usually those artists who read the Scriptures with the greatest devotion and attention who tried to build up in their minds an entirely fresh picture of the incidents of the sacred story. They tried to forget all the paintings they had seen, and to imagine what it must have been like when the Christ Child lay in the manger and the shepherds came to adore Him, or when a fisherman began to preach the gospel. It has happened time and again that such efforts of a great artist to read the old text with entirely fresh eyes have shocked and outraged thoughtless people. A typical 'scandal' of this kind flared up round Caravaggio, a very bold and revolutionary Italian painter, who worked round about 1600. He was given the task of painting a picture of St Matthew for the altar of a church in Rome. The saint was to be represented writing the gospel, and, to show that the gospels were the word of God, an angel was to be represented inspiring his writings. Caravaggio, who

38
Albrecht Dürer, *Hare*,
1502.
Albertina, Vienna

39
Rembrandt van Rijn,
Elephant, 1637.
Albertina, Vienna

was a highly imaginative and uncompromising young artist, thought hard about what it must have been like when an elderly, poor, working man, a simple publican, suddenly had to sit down to write a book. And so he painted a picture of St Matthew (Fig. 44) with a bald head and bare, dusty feet, awkwardly gripping the huge volume, anxiously wrinkling his brow under the unaccustomed strain of writing. By his side he painted a youthful angel, who seems just to have arrived from on high, and who gently guides the labourer's hand as a teacher may do to a child. When Caravaggio delivered this picture to the church where it was to be placed on the altar, people were scandalized at what they took to be a lack of respect for the saint. The painting was not accepted, and Caravaggio had to try again. This time he took no chances. He kept strictly to the conventional ideas of what an angel and a saint should look like (Fig. 45). The outcome is still quite a good picture, for Caravaggio tried hard to make it look lively and interesting, but we feel that it is less honest and sincere than the first had been.

This story illustrates the harm that may be done by those who dislike and criticize works of art for wrong reasons. What is more important, it brings home to us that what we call 'works of art' are not the results of some mysterious activity, but objects made by human beings for human beings. A picture looks so remote when it hangs glazed and framed on the wall. And in our museums it is – very properly – forbidden to touch the objects on view.

42
Théodore Géricault,
Horse-racing at Epsom, 1821.
Louvre, Paris

But originally they were made to be touched and handled, they were bargained about, quarrelled about, worried about. Let us also remember that every one of their features is the result of a decision by the artist: that he may have pondered over them and changed them many times, that he may have wondered whether to leave that tree in the background or to paint it over again, that he may have been pleased by a lucky stroke of his brush which gave a sudden unexpected brilliance to a sunlit cloud, and that he put in these figures reluctantly at the insistence of a buyer. For most of the paintings and statues which are now lined up along the walls of our museums and galleries were not meant to be displayed as Art. They were made for a definite occasion and a definite purpose which were in the artist's mind when he set to work.

Those ideas, on the other hand, that we outsiders usually worry about, ideas about beauty and expression, are rarely mentioned by artists. It was not always like that, but it was so for many centuries in the past, and it is so again now. The reason is partly that artists are often shy people who would think it embarrassing to use big words like 'Beauty'. They would feel rather priggish if they were to speak about 'expressing their emotions' and to use similar catchwords. Such things they take for granted and find it useless to discuss. That is one reason, and, it seems, a good one. But there is another. In the actual everyday worries of the artist these ideas play a much smaller part than outsiders would, I think, suspect. What an artist worries about as he plans his

43
Eadweard Muybridge,
Galloping horse in motion,
1872.
Photograph sequence.
Kingston-upon-Thames
Museum

pictures, makes his sketches, or wonders whether he has completed his canvas, is something much more difficult to put into words. Perhaps he would say he worries about whether he has got it 'right'. Now it is only when we understand what he means by that modest little word 'right' that we begin to understand what artists are really after.

I think we can only hope to understand this if we draw on our own experience. Of course we are no artists, we may never have tried to paint a picture and may have no intention of ever doing so. But this need not mean that we are never confronted with problems similar to those which make up the artist's life. In fact, I am anxious to prove that there is hardly any person who has not got at least an inkling of this type of problem, be it in ever so modest a way. Anybody who has ever tried to arrange a bunch of flowers, to shuffle and shift the colours, to add a little here and take away there, has experienced this strange sensation of balancing forms and colours without being able to tell exactly what kind of harmony it is he is trying to achieve. We just feel a patch of red here may make all the difference, or this blue is all right by itself but it does not 'go' with the others, and suddenly a little stem of green leaves may seem to make it come 'right'. 'Don't touch it any more,' we exclaim, 'now it is perfect.' Not everybody, I admit, is quite so careful over the arrangement of flowers, but nearly everybody has something he wants to get 'right'. It may just be a matter of finding the right belt to match a certain dress, or nothing more impressive than the worry over the right proportion of, say, pudding and cream on one's plate. In every such case, however trivial, we may feel that a shade too much or too little upsets the balance and that there is only one relationship which is as it should be.

People who worry like this over flowers, dresses or food, we may call fussy,

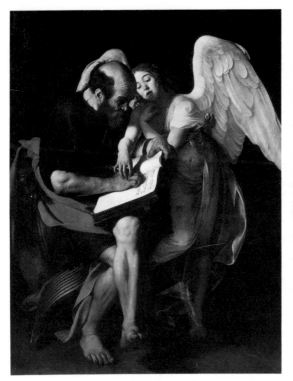

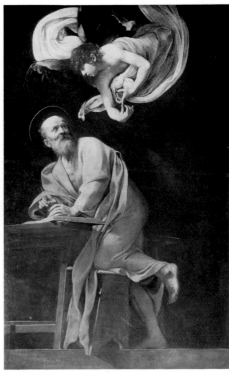

because we may feel these things do not warrant so much attention. But what may sometimes be a bad habit in daily life and is often, therefore, suppressed or concealed, comes into its own in the realm of art. When it is a matter of matching forms or arranging colours an artist must always be 'fussy' or rather fastidious to the extreme. He may see differences in shades and texture which we should hardly notice. Moreover, his task is infinitely more complex than any of those we may experience in ordinary life. He has not only to balance two or three colours, shapes or tastes, but to juggle with any number. He has, on his canvas, perhaps hundreds of shades and forms which he must balance till they look 'right'. A patch of green may suddenly look too yellow because it was brought into too close proximity with a strong blue – he may feel that all is spoiled, that there is a jarring note in the picture and that he must begin it all over again. He may suffer agonies over this problem. He may ponder about it in sleepless nights; he may stand in front of his picture all day trying to add a touch of colour here or there and rubbing it out again, though you and I might not have noticed the difference either way. But once he has succeeded we all feel that he has achieved something to which nothing could be added, something which is right – an example of perfection in our very imperfect world.

44
Caravaggio,
Saint Matthew, 1602.
Altar painting. Destroyed;
formerly Kaiser-Friedrich
Museum, Berlin

45
Caravaggio,
Saint Matthew, 1602
Altar-painting. S. Luigi
dei Francesi, Rome

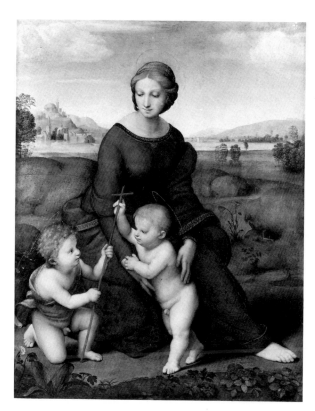

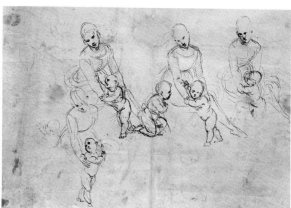

Take one of Raphael's famous Madonnas: the 'Virgin in the Meadow', for instance (Fig. 46). It is beautiful, no doubt, and engaging; the figures are admirably drawn, and the expression of the Holy Virgin as she looks down on the two children is quite unforgettable. But if we look at Raphael's sketches for the picture (Fig. 47) we begin to realize that these were not the things he took most trouble about. These he took for granted. What he tried again and again

to get was the right balance between the figures, the right relationship which would make the most harmonious whole. In the rapid sketch in the left-hand corner, he thought of letting the Christ Child walk away looking back and up at His mother. And he tried different positions of the mother's head to answer the movement of the Child. Then he decided to turn the Child round and to let Him look up at her. He tried another way, this time introducing the little St John – but, instead of letting the Christ Child look at him, made him turn out of the picture. Then he made another attempt, and apparently became impatient, trying the head of the Child in many different positions. There were several leaves of this kind in this sketch-book, in which he searched again and again to find how best to balance these three figures. But if we now look back at the final picture we see that he did get it right in the end. Everything in the picture seems in its proper place, and the pose and harmony Raphael has achieved by his hard work seem so natural and effortless that we hardly notice them. Yet it is just this harmony which makes the beauty of the Madonna more beautiful and the sweetness of the children more sweet.

It is fascinating to watch an artist thus striving to achieve the right balance, but if we were to ask him why he did this or changed that, he might not be able to tell us. He does not follow any fixed rules. He just feels his way. It is true that some artists or critics in certain periods have tried to formulate laws of their art; but it always turned out that poor artists did not achieve anything when trying to apply these laws, while great masters could break them and yet achieve a new kind of harmony no one had thought of before. When the great English painter Sir Joshua Reynolds explained to his students in the Royal Academy that blue should not be put into the foreground of paintings but should be reserved for the distant backgrounds, for the fading hills on the horizon, his rival Gainsborough – so the story goes – wanted to prove that such academic rules are usually nonsense. He painted the famous 'Blue boy', whose blue costume, in the central foreground of the picture, stands out triumphantly against the warm brown of the background.

The truth is that it is impossible to lay down rules of this kind because one can never know in advance what effect the artist may wish to achieve. He may even want a shrill, jarring note if he happens to feel that that would be right. As there are no rules to tell us when a picture or statue is right it is usually impossible to explain in words exactly why we feel that it is a great work of art. But that does not mean that one work is just as good as any other, or that one cannot discuss matters of taste. If they do nothing else, such discussions make us look at pictures, and the more we look at them the more we notice points which have escaped us before. We begin to develop a feeling for the kind of harmony each generation of artists has tried to achieve. The

greater our feeling for these harmonies the more we shall enjoy them, and that, after all, is what matters. The old proverb that you cannot argue about matters of taste may well be true, but that should not conceal the fact that taste can be developed. This is again a matter of common experience which everybody can test in a modest field. To people who are not used to drinking tea one blend may taste exactly like another. But if they have the leisure, will and opportunity to search out such refinements as there may be, they may develop into true 'connoisseurs' who can distinguish exactly what type and mixture they prefer, and their greater knowledge is bound to add to their enjoyment of the choicest blends.

Admittedly, taste in art is something infinitely more complex than taste in food and drink. It is not only a matter of discovering various subtle flavours; it is something more serious and more important. After all, the great masters have given their all in these works, they have suffered for them, sweated blood over them, and the least they have a right to ask of us is that we try to understand what they wanted to do.

One never finishes learning about art. There are always new things to discover. Great works of art seem to look different every time one stands before them. They seem to be as inexhaustible and unpredictable as real human beings. It is an exciting world of its own with its own strange laws and its own adventures. Nobody should think he knows all about it, for nobody does. Nothing, perhaps, is more important than just this: that to enjoy these works we must have a fresh mind, one which is ready to catch every hint and to respond to every hidden harmony: a mind, most of all, not cluttered up with long high-sounding words and ready-made phrases. It is infinitely better not to know anything about art than to have the kind of half-knowledge which makes for snobbishness. The danger is very real. There are people, for instance, who have picked up the simple points I have tried to make in this chapter, and who understand that there are great works of art which have none of the obvious qualities of beauty of expression or correct draughtsmanship, but who become so proud of their knowledge that they pretend to like only those works which are neither beautiful nor correctly drawn. They are always haunted by the fear that they might be considered uneducated if they confessed to liking a work which seems too obviously pleasant or moving. They end by being snobs who lose their true enjoyment of art and who call everything 'very interesting' which they really find somewhat repulsive. I should hate to be responsible for any similar misunderstanding. I would rather not be believed at all than be believed in such an uncritical way.

In the chapters which follow I shall discuss the history of art, that is the history of buildings, of picture-making and of statue-making. I think that

knowing something of this history helps us to understand why artists worked in a particular way, or why they aimed at certain effects. Most of all it is a good way of sharpening our eyes for the particular characteristics of works of art, and of thereby increasing our sensitivity to the finer shades of difference. Perhaps it is the only way of learning to enjoy them in their own right. But no way is without its dangers. One sometimes sees people walking through a gallery, catalogue in hand. Every time they stop in front of a picture they eagerly search for its number. We can watch them thumbing through their books, and as soon as they have found the title or the name they walk on. They might just as well have stayed at home, for they have hardly looked at the painting. They have only checked the catalogue. It is a kind of mental short circuit which has nothing to do with enjoying a picture.

People who have acquired some knowledge of art history are sometimes in danger of falling into a similar trap. When they see a work of art they do not stay to look at it, but rather search their memory for the appropriate label. They may have heard that Rembrandt was famous for his *chiaroscuro* – which is the Italian technical term for light and shade – so they nod wisely when they see a Rembrandt, mumble 'wonderful *chiaroscuro*', and wander on to the next picture. I want to be quite frank about this danger of half-knowledge and snobbery, for we are all apt to succumb to such temptations, and a book like this could increase them. I should like to help to open eyes, not to loosen tongues. To talk cleverly about art is not very difficult, because the words critics use have been employed in so many different contexts that they have lost all precision. But to look at a picture with fresh eyes and to venture on a voyage of discovery into it is a far more difficult but also a much more rewarding task. There is no telling what one might bring home from such a journey.

Editor's Postscript
The call for clarity in the final paragraph echoes Franz Wickhoff's famous manifesto for the Vienna School of Art History (1904):

> What it aims at ... is to place Art History into the ranks of the other historical sciences by treating its subject scientifically. For this has by no means been achieved as yet. It can everywhere be observed that despite a number of achievements the History of Art is not taken fully seriously by learned societies and collapses in the neighbouring fields of history and philosophy. One must admit that this does not happen without reason for their are few disciplines in which it is still possible for empty verbiage and shallow reasoning to be tolerated and for publications to be launched which must be regarded as sheer mockery of all principles of scientific method.[1]

Wickhoff and his disciples used their journal to attack shallow and specious reasoning, and the belles-lettristic approach to writing about art which was common at the time.

Wilfrid Blunt, reviewing The Story of Art for the Burlington Magazine on its first publication,[2] described the difficulties encountered in introducing art history to the school curriculum. The problems now are different. Owing to the explosion of interest in art, galleries have appeared in great numbers and blockbuster exhibitions are proving enormously popular with the general public. Many, if not the majority, of our art historians were first introduced to art history by reading Gombrich's book. Having become successful in one way, it has become a target for political correctness.

The first accusation is one of élitism. A great deal of confusion is caused by the word 'Art', which is now a general label for paintings, sculptures, pictures and objects produced by anyone or thing (including computers), while in the past it signified any skill (such as the art of conversation). A way through this is to bear in mind Gombrich's formulation in a later chapter, 'Experimental Art':

> It is the secret of the artist that he does his work so superlatively well that we all but forget to ask what his work was supposed to be, for sheer admiration of the way that he did it. We are all familiar with this shift of emphasis in more trivial instances. If we say of a schoolboy that he is an artist in boasting or that he has turned shirking into a fine art, we mean precisely this — that he displays such ingenuity and imagination in the pursuit of his unworthy ends that we are forced to admire his skill however much we may disapprove of his motives.[3]

In this sense the history of art is just as élitist as the history of sport. The second accusation is that it is anti-feminine. But the fact that The Story of Art is dominated by male artists reflects the historical situation that for most of the period covered, painting and sculpture were trades like carpentry and stone-cutting, organized in workshops according to the rules of diverse guilds. These were predominantly male occupations. Only when the system gave way to the conception of painting as a liberal art did women have a slight chance to display their talents, a development that came to fruition in the course of the eighteenth and nineteenth centuries. Historians have to take things as they were and are, not as we wish them to have been.

For a discussion of the idea of that there can be such a thing as a short-list of major works of art see 'Canons and Values in the Visual Arts: a Correspondence with Quentin Bell' in Ideals and Idols.

For an account of the historical emergence of the present day concept of Art see P. O. Kristeller, 'The Modern System of the Arts' in P. Kivy (ed.), Essays on the History of Aesthetics (Rochester, 1992), and also M. H. Abrams, 'Art-as-Such: The Sociology of Modern Aesthetics' and 'From Addison to Kant: Modern Aesthetics and Exemplary Art', Doing Things with Texts: Essays in Criticism and Critical Theory, ed. Michael Fischer (New York, 1991), pp. 135–58 and 159–87.

1. Franz Wickhoff, 'An die Leser!', Kunstgeschichtliche Anzeigen, no. 1 (1904); translation by E.H. Gombrich.
2. 'Art History and the Public Schools', The Burlington Magazine, 92 (1950), pp. 117-18.
3. The Story of Art, pp. 594-5.

Part III Art and Psychology

Psychology and the Riddle of Style

Extract from the Introduction to *Art and Illusion* (1960; 5th edition, 1977), pp. 2–8

Art being a thing of the mind, it follows that any scientific study of art will be psychology.
It may be other things as well, but psychology it will always be.

Max J. Friedländer, *Von Kunst und Kennerschaft*

48
Drawing by Alain, 1955.
From *The New Yorker*

I

The illustration in front of the reader (Fig. 48) should explain much more quickly than I could in words what is here meant by the 'riddle of style'. Alain's cartoon neatly sums up a problem which has haunted the minds of art historians for many generations. Why is it that different ages and different nations have represented the visible world in such different ways? Will the paintings we accept as true to life look as unconvincing to future generations as Egyptian paintings look to us? Is everything concerned with art entirely subjective, or are there objective standards in such matters? If there are, if the methods taught in the life class today result in more faithful imitations of nature than the conventions adopted by the Egyptians, why did the Egyptians fail to adopt them? Is it possible, as our cartoonist hints, that they perceived nature in a different way? Would not such a variability of artistic vision also help us to explain the bewildering images created by contemporary artists?

These are questions which concern the history of art. But their answers cannot be found by historical methods alone. The art historian has done his work when he has described the changes that have taken place. He is concerned with the differences in style between one school of art and another, and he has refined his methods of description in order to group, organize, and identify the works of art which have survived from the past. Glancing through the variety of illustrations we find in this book, we all react, to a major or minor extent, as he does in his studies: we take in the subject of a picture together with its style; we see a Chinese landscape here and a Dutch landscape

there, a Greek head and a seventeenth-century portrait. We have come to take such classifications so much for granted that we have almost stopped asking why it is so easy to tell whether a tree was painted by a Chinese or by a Dutch master. If art were only, or mainly, an expression of personal vision, there could be no history of art. We could have no reason to assume, as we do, that there must be a family likeness between pictures of trees produced in proximity. We could not count on the fact that the boys in Alain's life class would produce a typical Egyptian figure. Even less could we hope to detect whether an Egyptian figure was indeed made three thousand years ago or forged yesterday. The art historian's trade rests on the conviction once formulated by Wölfflin, that 'not everything is possible in every period'.[2] To explain this curious fact is not the art historian's duty, but whose business is it?

49
Rabbit or duck?

II

There was a time when the methods of representation were the proper concern of the art critic. Accustomed as he was to judging contemporary works first of all by standards of representational accuracy, he had no doubt that this skill had progressed from rude beginnings to the perfection of illusion. Egyptian art adopted childish methods because Egyptian artists knew no better. Their conventions could perhaps be excused, but they could not be condoned. It is one of the permanent gains we owe to the great artistic revolution which has swept across Europe in the first half of the twentieth century that we are rid of this type of aesthetics. The first prejudice teachers of art appreciation usually try to combat is the belief that artistic excellence is identical with photographic accuracy. The picture postcard or pin-up girl has become the conventional foil against which the student learns to see the creative achievement of the great masters. Aesthetics, in other words, has surrendered its claim to be concerned with the problem of convincing representation, the problem of illusion in art. In certain respects this is indeed a liberation and nobody would wish to revert to the old confusion. But since neither the art historian nor the critic still wishes to occupy himself with this perennial problem, it has become orphaned and neglected. The impression has grown up that illusion, being artistically irrelevant, must also be psychologically very simple.[3]

We do not have to turn to art to show that this view is erroneous. Any psychology textbook will provide us with baffling examples that show the complexity of the issues involved. Take the simple trick drawing which has reached the philosophical seminar from the pages of the humorous weekly *Die Fliegenden Blätter* (Fig. 49). We can see the picture as either a rabbit or a duck. It

is easy to discover both readings. It is less easy to describe what happens when we switch from one interpretation to the other. Clearly we do not have the illusion that we are confronted with a 'real' duck or rabbit. The shape on the paper resembles neither animal very closely. And yet there is no doubt that the shape transforms itself in some subtle way when the duck's beak becomes the rabbit's ears and brings an otherwise neglected spot into prominence as the rabbit's mouth.[4] I say 'neglected', but does it enter our experience at all when we switch back to reading 'duck'? To answer this question, we are compelled to look for what is 'really there', to see the shape apart from its interpretation, and this, we soon discover, is not really possible. True, we can switch from one reading to another with increasing rapidity; we will also 'remember' the rabbit while we see the duck, but the more closely we watch ourselves, the more certainly will we discover that we cannot experience alternative readings at the same time. Illusion, we will find, is hard to describe or analyse, for though we may be intellectually aware of the fact that any given experience *must* be an illusion, we cannot, strictly speaking, watch ourselves having an illusion.

If the reader finds this assertion a little puzzling, there is always an instrument of illusion close at hand to verify it: the bathroom mirror. I specify the bathroom because the experiment I urge the reader to make succeeds best if the mirror is a little clouded by steam. It is a fascinating exercise in illusionist representation to trace one's own head on the surface of the mirror and to clear the area enclosed by the outline. For only when we have actually done this do we realize how small the image is which gives us the illusion of seeing ourselves 'face to face'. To be exact, it must be precisely half the size of our head. I do not want to trouble the reader with geometrical proof of this fact, though basically it is simple: since the mirror will always appear to be halfway between me and my reflection, the size on its surface will be one half of the apparent size.[5] But however cogently this fact can be demonstrated with the help of similar triangles, the assertion is usually met with frank incredulity. And despite all geometry, I, too, would stubbornly contend that I really see my head (natural size) when I shave and that the size on the mirror surface is the phantom. I cannot have my cake and eat it. I cannot make use of an illusion and watch it.

Works of art are not mirrors, but they share with mirrors that elusive magic of transformation which is so hard to put into words. A master of introspection, Kenneth Clark, has recently described to us most vividly how even he was defeated when he attempted to 'stalk' an illusion. Looking at a great Velázquez, he wanted to observe what went on when the brushstrokes and dabs of pigment on the canvas transformed themselves into a vision of transfigured reality as he stepped back. But try as he might, stepping backward

and forward, he could never hold both visions at the same time, and therefore the answer to his problem of how it was done always seemed to elude him.[6] In Kenneth Clark's example, the issues of aesthetics and of psychology are subtly intertwined; in the examples of the psychology textbooks, they are obviously not. In this book I have often found it convenient to isolate the discussion of visual effects from the discussion of works of art. I realize this may sometimes lead to an impression of irreverence; I hope the opposite is the truth.

Representation need not be art, but it is none the less mysterious for that. I well remember that the power and magic of image making was first revealed to me, not by Velázquez, but by a simple drawing game I found in my primer. A little rhyme explained how you could first draw a circle to represent a loaf of bread (for loaves were round in my native Vienna); a curve added on top would turn the loaf into a shopping bag, two little squiggles on its handle would make it shrink into a purse; and now by adding a tail, here was a cat (Fig. 50). What intrigued me, as I learned the trick, was the power of metamorphosis: the tail destroyed the purse and created the cat; you cannot see the one without obliterating the other. Far as we are from completely understanding this process, how can we hope to approach Velázquez?

I had hardly anticipated, when I embarked on my explorations, into what distant fields the subject of illusion would take me. I can only appeal to readers who wish to join in this Hunting of the Snark to train themselves a little in the game of self-observation, not so much in museums as in their daily commerce with pictures and images of all kinds while sitting on the bus or standing in the waiting room. What they will see there will obviously not count as art. It will be less pretentious but also less embarrassing than poor works of art that ape the tricks of Velázquez.

When we deal with masters of the past who were both great artists and great 'illusionists', the study of art and the study of illusion cannot always be kept apart. I am all the more anxious to emphasize as explicitly as I possibly

can that this book is not intended as a plea, disguised or otherwise, for the exercise of illusionist tricks in painting today. I should like to prevent this particular breakdown of communication between myself and my readers and critics because I am, in fact, rather critical of certain theories of non-figurative art and have alluded to some of these issues where they seemed relevant.[7] But to chase this hare would be to miss the point of the book. That the discoveries and effects of representation which were the pride of earlier artists have become trivial today I would not deny for a moment. Yet I believe that we are in real danger of losing contact with the great masters of the past if we accept the fashionable doctrine that such matters never had anything to do with art. The very reason why the representation of nature can now be looked upon as something commonplace should be of the greatest interest to the historian. Never before has there been an age like ours when the visual image was so cheap in every sense of the word. We are surrounded and assailed by posters and advertisements, by comics and magazine illustrations. We see aspects of reality represented on the television screen and in the cinema, on postage stamps and on food packages. Painting is taught at school and practised at home as therapy and as a pastime, and many a modest amateur has mastered tricks that would have looked like sheer magic to Giotto. Perhaps even the crude coloured renderings we find on a box of breakfast cereal would have made Giotto's contemporaries gasp. I do not know if there are people who conclude from this that the box is superior to a Giotto. I am not one of them. But I think that the victory and vulgarization of representational skills create a problem for both the historian and the critic.

The Greeks said that to marvel is the beginning of knowledge and where we cease to marvel we may be in danger of ceasing to know. The main aim I have set myself in these chapters is to restore our sense of wonder at man's capacity to conjure up by forms, lines, shades, or colours those mysterious phantoms of visual reality we call 'pictures'. 'Should we not say', said Plato in the *Sophist*, 'that we make a house by the art of building, and by the art of painting we make another house, a sort of man-made dream produced for those who are awake?'[8] I know of no better description to teach us the art of wonder again – and it detracts nothing from Plato's definition that many of these man-made dreams, produced for those who are awake, are banished by us from the realm of art, perhaps rightly, because they are almost too effective as dream substitutes, whether we call them pin-ups or comics. Even pin-ups and comics, rightly viewed, may provide food for thought. Just as the study of poetry remains incomplete without an awareness of the language of prose, so, I believe, the study of art will be increasingly supplemented by inquiry into the linguistics of the visual image. Already we see the outlines of iconology, which

investigates the function of images in allegory and symbolism and their reference to what might be called the 'invisible world of ideas'.[9] The way the language of art refers to the visible world is both so obvious and so mysterious that it is still largely unknown except to the artists themselves who can use it as we use all languages – without needing to know its grammar and semantics.

A great deal of practical knowledge is stored in the many books written by artists and art teachers for the use of students and amateurs.[10] Not being an artist myself, I have refrained from enlarging on such technical matters beyond the needs of my argument. But I should be happy if each chapter of this book could be seen as a provisional pier for the much-needed bridge between the field of art history and the domain of the practising artist. We want to meet in Alain's life class and discuss the problems of the boys in a language that makes sense to both of us and, if luck will have it, even to the scientific student of perception.

Editor's Postscript

This extract opens the Introduction to Art and Illusion, *which poses the problem of 'Psychology and the Riddle of Style', famously captured by the Alain cartoon at the very beginning. The rest of the chapter clarifies the historical background to* Art and Illusion; *for further material consult E. H. Gombrich, 'Art History and Psychology in Vienna Fifty Years Ago',* Art Journal *(summer 1984), pp. 162-4.*

For further background to Gombrich's work see Gert Schiff (ed.), German Essays on Art History *(New York, 1988) and Richard Woodfield (ed.),* Gombrich on Art and Psychology *(Manchester, 1996). Difficult books for advanced readers are Michael Podro,* The Critical Historians of Art *(New Haven, 1982); Harry Francis Mallgrave and Eleftherios Ikonomou (eds.),* Empathy, Form and Space: Problems in German Aesthetics 1873–1893 *(Santa Monica, 1994) and* Histoire et théories de l'art: de Winckelmann à Panofsky, Revue Germanique Internationale, 2 *(1994), which is a collection of essays by a number of distinguished German art historians. Margaret Olin has produced a useful book,* Forms of Representation in Alois Riegl's Theory of Art *(Pennsylvania, 1992).*

Julius von Schlosser's vivid account of the history of the Vienna School still remains untranslated: 'Die Wiener Schule der Kunstgeschichte. Rüblick auf ein Säkulum deutscher Gelehrtenarbeit', Mitteilungen des Österreichischen Instituts für Geschichtsforschung *(Ergänzungsband) XIII, heft 2 (1934). There is also an interesting collection of essays in English, German and Italian in the Acts of the XXV International Congress on Art History, volume 1:* Wien und die Entwicklung der Kunsthistorischen Methode, *ed. Stefan Krenn and Martina Pippal (Vienna, 1984).*

Truth and the Stereotype

Chapter 2 of *Art and Illusion* (1960, 5th edition, 1977), pp. 55–78

The schematism by which our understanding deals with the phenomenal world . . .
is a skill so deeply hidden in the human soul that we shall hardly guess the secret trick
that Nature here employs.

Immanuel Kant, *Critique of Pure Reason*

I

In his charming autobiography, the German illustrator Ludwig Richter relates how he and his friends, all young art students in Rome in the 1820s, visited the famous beauty spot of Tivoli and sat down to draw. They looked with surprise, but hardly with approval, at a group of French artists who approached the place with enormous baggage, carrying large quantities of paint which they applied to the canvas with big, coarse brushes. The Germans, perhaps roused by this self-confident artiness, were determined on the opposite approach. They selected the hardest, best-pointed pencils, which could render the motif firmly and minutely to its finest detail, and each bent down over his small piece of paper, trying to transcribe what he saw with the utmost fidelity. 'We fell in love with every blade of grass, every tiny twig, and refused to let anything escape us. Every one tried to render the motif as objectively as possible.'

Nevertheless, when they then compared the fruits of their efforts in the evening, their transcripts differed to a surprising extent. The mood, the colour, even the outline of the motif had undergone a subtle transformation in each of them. Richter goes on to describe how these different versions reflected the different dispositions of the four friends, for instance, how the melancholy painter had straightened the exuberant contours and emphasized the blue tinges. We might say he gives an illustration of the famous definition by Emile Zola, who called a work of art 'a corner of nature seen through a temperament'.

It is precisely because we are interested in this definition that we must probe

51
Soldiers leaving Hastings,
from the Bayeux Tapestry,
c.1080. Musée de la
Tapisserie, Bayeux

it a little further. The 'temperament' or 'personality' of the artist, his selective preferences, may be one of the reasons for the transformation which the motif undergoes under the artist's hands, but there must be others — everything, in fact, which we bundle together into the word 'style', the style of the period and the style of the artist. When this transformation is very noticeable we say the motif has been greatly 'stylized', and the corollary to this observation is that those who happen to be interested in the motif, for one reason or another, must learn to discount the style. This is part of that natural adjustment, the change in what I called 'mental set', which we all perform quite automatically when looking at old illustrations. We can 'read' the Bayeux tapestry (Fig. 51) without reflecting on its countless 'deviations from reality'. We are not tempted for a moment to think the trees at Hastings looked like palmettes and the ground at that time consisted of scrolls. It is an extreme example, but it brings out the all-important fact that the word 'stylized' somehow tends to beg the question. It implies there was a special activity by which the artist transformed the trees, much as the Victorian designer was taught to study the forms of flowers before he turned them into patterns. It was a practice which chimed in well with ideas of Victorian architecture, when railways and factories were built first and then adorned with the marks of a style. It was not the practice of earlier times.

The very point of Richter's story, after all, is that style rules even where the artist wishes to reproduce nature faithfully, and trying to analyse these limits to objectivity may help us get nearer to the riddle of style. One of these limits we know from the last chapter; it is indicated in Richter's story by the contrast between coarse brush and fine pencil. The artist, clearly, can render only what his tool and his medium are capable of rendering. His technique restricts his freedom of choice. The features and relationships the pencil picks out will differ from those the brush can indicate. Sitting in front of his motif, pencil in hand, the artist will, therefore, look out for those aspects which can be

52
Paul Cézanne, *Mont Sainte-Victoire*, c.1905. Philadelphia Museum of Art

53
Mont Sainte-Victoire seen from Les Lauves. Photograph by John Rewald

rendered in lines – as we say in a pardonable abbreviation, he will tend to see his motif in terms of lines, while, brush in hand, he sees it in terms of masses.

The question of why style should impose similar limitations is less easily answered, least of all when we do not know whether the artist's intentions were the same as those of Richter and his friends.

Historians of art have explored the regions where Cézanne and Van Gogh set up their easels and have photographed their motifs[3] (Figs. 52 and 53). Such comparisons will always retain their fascination since they almost allow us to look over the artist's shoulder – and who does not wish he had this privilege? But however instructive such confrontations may be when handled with care, we must clearly beware of the fallacy of 'stylization'. Should we believe the photograph represents the 'objective truth' while the painting records the artist's subjective vision – the way he transformed 'what he saw'? Can we here compare 'the image on the retina' with the 'image in the mind'? Such speculations easily lead into a morass of unprovables. Take the image on the artist's retina.[4] It sounds scientific enough, but actually there never was *one* such image which we could single out for comparison with either photograph or painting. What there was was an endless succession of innumerable images as the painter scanned the landscape in front of him, and these images sent a complex pattern of impulses through the optic nerves to his brain.

Even the artist knew nothing of these events, and we know even less. How far the picture that formed in his mind corresponded to or deviated from the photograph it is even less profitable to ask. What we do know is that these artists went out into nature to look for material for a picture and their artistic wisdom led them to organize the elements of the landscape into works of art of marvellous complexity that bear as much relationship to a surveyor's record as a poem bears to a police report.

Does this mean, then, that we are altogether on a useless quest? That artistic truth differs so much from prosaic truth that the question of objectivity must never be asked? I do not think so. We must only be a little more circumspect in our formulation of the question.

II

The National Gallery in Washington possesses a landscape painting by a nineteenth-century artist which almost seems made to clarify this issue. It is an attractive picture by George Inness of *The Lackawanna Valley* (Fig. 54),[5] which we know from the master's son was commissioned in 1855 as an advertisement for a railroad. At the time there was only one track running into the roundhouse, 'but the president insisted on having four or five painted in, easing his conscience by explaining that the road would eventually have them'. Inness protested, and we can see that when he finally gave in for the sake of his family, he shamefacedly hid the patch with the non-existent tracks behind puffs of smoke. To him this patch was a lie, and no aesthetic explanation about mental images or higher truth could have disputed this away.

But, strictly speaking, the lie was not in the painting. It was in the advertisement, if it claimed by caption or implication that the painting gave accurate information about the facilities of the railway's roundhouses. In a different context the same picture might have illustrated a true statement – for instance, if the president had taken it to a shareholders' meeting to demonstrate improvements he was anxious to make. Indeed in that case, Inness' rendering of the nonexistent tracks might conceivably have given the engineer some hints about where to lay them. It would have served as a sketch or blueprint.

Logicians tell us – and they are not people to be easily gainsaid – that the terms 'true' and 'false' can only be applied to statements, propositions.[6] And whatever may be the usage of critical parlance, a picture is never a statement in that sense of the term. It can no more be true or false than a statement can be blue or green. Much confusion has been caused in aesthetics by disregarding this simple fact. It is an understandable confusion because in our culture pictures are usually labelled, and labels, or captions, can be understood as abbreviated statements. When it is said 'the camera cannot lie', this confusion is apparent. Propaganda in wartime often made use of photographs falsely labelled to accuse or exculpate one of the warring parties. Even in scientific illustrations it is the caption which determines the truth of the picture.[7] In a *cause célèbre* of the last century, the embryo of a pig, labelled as a human embryo to prove a theory of evolution, brought about the downfall of a great reputation.[8] Without much reflection, we can all expand into statements the

54
George Inness, *The Lackawanna Valley*, 1855. National Gallery of Art, Washington DC

laconic captions we find in museums and books. When we read the name 'Ludwig Richter' under a landscape painting, we know we are thus informed that he painted it and can begin arguing whether this information is true or false. When we read 'Tivoli', we infer the picture is to be taken as a view of that spot, and we can again agree or disagree with the label. How and when we agree, in such a case, will largely depend on what we want to know about the object represented. The Bayeux tapestry, for instance, tells us there was a battle at Hastings. It does not tell us what Hastings 'looked like'.[9]

Now the historian knows that the information pictures were expected to provide differed widely in different periods. Not only were images scarce in the past, but so were the public's opportunities to check their captions. How many people ever saw their ruler in the flesh at sufficiently close quarters to recognize his likeness?[10] How many travelled widely enough to tell one city from another? It is hardly surprising, therefore, that pictures of people and places changed their captions with sovereign disregard for truth. The print sold on the market as a portrait of a king would be altered to represent his successor or enemy.

There is a famous example of this indifference to truthful captions in one of the most ambitious publishing projects of the early printing press, Hartmann Schedel's so-called 'Nuremberg Chronicle' with woodcuts by Dürer's teacher Wolgemut.[11] What an opportunity such a volume should give the historian to see what the world was like at the time of Columbus! But as we turn the pages of this big folio, we find the same woodcut of a medieval city recurring with different captions as Damascus, Ferrara, Milan, and Mantua (Fig. 55). Unless we are prepared to believe these cities were as indistinguishable from one another as their suburbs may be today, we must conclude that neither the publisher nor the public minded whether the captions told the truth. All they were expected to do

was to bring home to the reader that these names stood for cities.

These varying standards of illustration and documentation are of interest to the historian of representation precisely because he can soberly test the information supplied by picture and caption without becoming entangled too soon in problems of aesthetics. Where it is a question of information imparted by the image, the comparison with the correctly labelled photograph should be of obvious value. Three topographical prints representing various approaches to the perfect picture postcard should suffice to exemplify the results of such an analysis.

The first (Fig. 56) shows a view of Rome from a German sixteenth-century news-sheet reporting a catastrophic flood when the Tiber burst its banks. Where in Rome could the artist have seen such a timber structure, a castle with black-and-white walls, and a steep roof such as might be found in Nuremberg? Is this also a view of a German town with a misleading caption? Strangely enough, it is not. The artist, whoever he was, must have made some effort to portray the scene, for this curious building turns out to be the Castel Sant' Angelo in Rome, which guards the bridge across the Tiber. A comparison with a photograph (Fig. 57) shows that it does embody quite a number of features which belong or belonged to the castle: the angel on the roof that gives it its name, the main round bulk, founded on Hadrian's mausoleum, and the outworks with the bastions that we know were there (Fig. 58).

I am fond of this coarse woodcut because its very crudeness allows us to study the mechanism of portrayal as in a slow-motion picture. There is no question here of the artist's having deviated from the motif in order to express his mood or his aesthetic preferences. It is doubtful, in fact, whether the

55
Michel Wolgemut,
woodcuts from the
Nuremberg Chronicle, 1493

Ein erschröcklich vnd grausamlich gewässer / so sich in der Statt
Rom durch die Tyber / begeben am 14. tag des Herplimonats 1557. Jar.

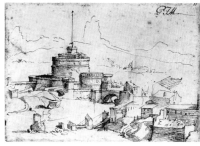

56
Castel Sant' Angelo,
Rome, 1557. Anonymous
woodcut

57
Castel Sant' Angelo,
Rome. Modern
photograph

58
Castel Sant' Angelo,
Rome, c.1540. Anonymous
pen and ink drawing.
Private collection

designer of the woodcut ever saw Rome. He probably adapted a view of the city in order to illustrate the sensational news. He knew the Castel Sant' Angelo to be a castle, and so he selected from the drawer of his mental stereotypes the appropriate cliché for a castle – a German *Burg* with its timber structure and high-pitched roof. But he did not simply repeat his stereotype – he adapted it to its particular function by embodying certain distinctive features which he knew belonged to that particular building in Rome. He supplies some information over and above the fact that there is a castle by a bridge.

Once we pay attention to this principle of the adapted stereotype, we also find it where we would be less likely to expect it: that is, within the idiom of illustrations, which look much more flexible and therefore plausible.

The example from the seventeenth century, from the views of Paris by that well-known and skilful topographical artist Matthäus Merian, represents Notre-Dame and gives, at first, quite a convincing rendering of that famous church (Fig. 59). Comparison with the real building (Fig. 60), however, demonstrates that Merian has proceeded in exactly the same way as the anonymous German woodcutter. As a child of the seventeenth century, his notion of a church is that of a lofty symmetrical building with large, rounded windows, and that is how he designs Notre-Dame. He places the transept in the centre with four large, rounded windows on either side, while the actual view shows seven narrow, pointed Gothic windows to the west and six in the choir. Once more portrayal means for Merian the adaptation or adjustment of his formula or scheme for churches to a particular building through the

addition of a number of distinctive features – enough to make it recognizable and even acceptable to those who are not in search of architectural information. If this happened to be the only document extant to tell us about the Cathedral of Paris, we would be very much misled.

One last example in this series: a nineteenth-century lithograph (Fig. 61) of Chartres Cathedral, done in the heyday of English topographical art. Here, surely, we might expect a faithful visual record. By comparison with the previous instances, the artist really gives a good deal of accurate information about that famous building. But he, too, it turns out, cannot escape the limitations which his time and interests impose on him. He is a romantic to whom the French cathedrals are the greatest flowers of the Gothic centuries, the true age of faith. And so he conceives of Chartres as a Gothic structure with pointed arches and fails to record the Romanesque rounded windows of the west façade, which have no place in his universe of form (Fig. 62).

I do not want to be misunderstood here. I do not want to prove by these examples that all representation must be inaccurate or that all visual documents before the advent of photography must be misleading. Clearly, if we had pointed out to the artist his mistake, he could have further modified his scheme and rounded the windows. My point is rather that such matching will always be a step-by-step process – how long it takes and how hard it is will depend on the choice of the initial schema to be adapted to the task of serving as a portrait. I believe that in this respect these humble documents do indeed tell us a lot about the procedure of any artist who wants to make a truthful record of an individual form. He begins not with his visual impression but with his idea or concept: the German artist with his concept of a castle that he applies as well as he can to that individual castle, Merian with his idea of a church, and the lithographer with his stereotype of a cathedral. The individual visual information, those distinctive features I have mentioned, are entered, as it were, upon a pre-existing blank or formulary. And, as often

59
Matthäus Merian, *Notre-Dame, Paris*, c.1635. Detail of an engraving from *Vues de Paris*

60
Notre-Dame, Paris. Modern photograph

happens with blanks, if they have no provisions for certain kinds of information we consider essential, it is just too bad for the information.

The comparison, by the way, between the formularies of administration and the artist's stereotypes is not my invention. In medieval parlance there was one word for both, a *simile*,[12] or pattern, that is applied to individual incidents in law no less than in pictorial art.

And just as the lawyer or the statistician could plead that he could never get hold of the individual case without some sort of framework provided by his forms or blanks, so the artist could argue that it makes no sense to look at a motif unless one has learned how to classify and catch it within the network of a schematic form. This, at least, is the conclusion to which psychologists have come who knew nothing of our historical series but who set out to investigate the procedure anyone adopts when copying what is called a 'nonsense figure', an inkblot, let us say, or an irregular patch. By and large, it appears, the procedure is always the same. The draughtsman tries first to classify the blot and fit it into some sort of familiar schema — he will say, for instance, that it is triangular or that it looks like a fish. Having selected such a scheme to fit the form approximately, he will proceed to adjust it, noticing for

instance that the triangle is rounded at the top, or that the fish ends in a pigtail. Copying, we learn from these experiments, proceeds through the rhythms of schema and correction.[13] The schema is not the product of a process of 'abstraction', of a tendency to 'simplify'; it represents the first approximate, loose category which is gradually tightened to fit the form it is to reproduce.

III

One more important point emerges from these psychological discussions of copying: it is dangerous to confuse the way a figure is drawn with the way it is seen. 'Reproducing the simplest figures', writes Professor Zangwill, 'constitutes a process itself by no means psychologically simple. This process typically displays an essentially constructive or reconstructive character, and with the subjects employed, reproduction was mediated pre-eminently through the agency of verbal and geometrical formulae …'[14]

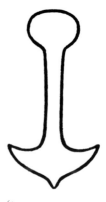

63
Test-figure, 'pickaxe', from F. C. Bartlett, *Remembering* (Cambridge, 1932)

If a figure is flashed on a screen for a short moment, we cannot retain it without some appropriate classification. The label given it will influence the choice of a schema. If we happen to hit on a good description we will succeed best in the task of reconstruction.[15] In a famous investigation by F. C. Bartlett, students had to draw such a 'nonsense figure' (Fig. 63) from memory. Some called it a pickaxe and consequently drew it with pointed prongs. Others accepted it as an anchor and subsequently exaggerated the size of the ring. There was only one person who reproduced the shape correctly. He was a student who had labelled the shape for himself 'a pre-historic battle axe'.[16] Maybe he was trained in classifying such objects and was therefore able to portray the figure that happened to correspond to a schema with which he was familiar.

Where such a pre-existing category is lacking, distortion sets in. Its effects become particularly amusing when the psychologist imitates the parlour game of 'drawing consequences'.[17] Thus F. C. Bartlett had an Egyptian hieroglyph copied and recopied till it gradually assumed the familiar shape and formula of a pussycat (Fig. 64).

To the art historian these experiments are of interest because they help to clarify certain fundamentals. The student of medieval art, for instance, is constantly brought up against the problem of tradition through copy. Thus the copies of classical coins by Celtic[18] and Teutonic tribes have become fashionable of late as witnesses to the barbaric 'will-to-form' (Fig. 65). These tribes, it is implied, rejected classical beauty in favour of the abstract ornament. Maybe they really disapproved of naturalistic shapes, but if they did we would need other evidence. The fact that in being copied and recopied

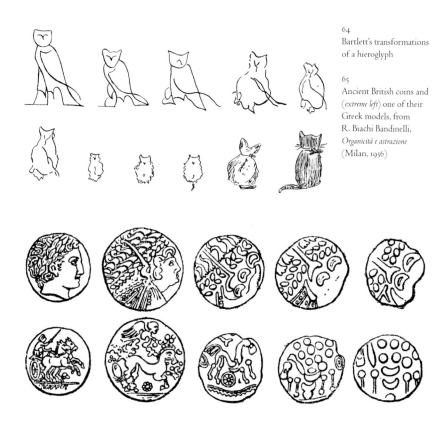

64
Bartlett's transformations
of a hieroglyph

65
Ancient British coins and
(*extreme left*) one of their
Greek models, from
R. Biachi Bandinelli,
Organicità e astrazione
(Milan, 1956)

the image became assimilated into the schemata of their own craftsmen demonstrates the same tendency which made the German woodcut transform the Castel Sant' Angelo into a timbered *Burg*. The 'will-to-form' is rather a 'will-to-make-conform', the assimilation of any new shape to the schemata and patterns an artist has learned to handle.

The Northumbrian scribes were marvellously skilled in the weaving of patterns and the shaping of letters. Confronted with the task of copying the image of man, the symbol of St Matthew, from a very different tradition, they were quite satisfied to build it up from those units they could handle so well. The solution in the famous Echternach Gospels (Fig. 66) is so ingenious as to arouse our admiration. It is creative, not because it differs from the presumed prototype – Bartlett's pussycat also differs from the owl – but because it copes with the challenge of the unfamiliar in a surprising and successful way. The artist handles the letter forms as he handles his medium, with complete assurance in creating from it the symbolic image of a man.

But did the designer of the Bayeux tapestry (Fig. 51) act very differently? He was obviously trained in the intricate interlace work of eleventh-century ornament and adjusted these forms as far as he thought necessary to signify

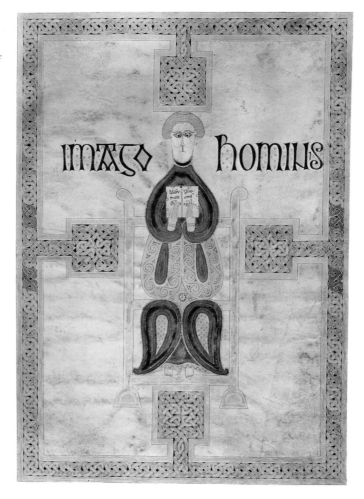

66
The Symbol of St
Matthew, c.690.
Illuminated page from the
Echternach Gospels.
Bibliothèque Nationale,
Paris

trees. Within his universe of form this procedure was both ingenious and consistent.

Could he have done otherwise? Could he have inserted naturalistic renderings of beeches or firs if only he had wanted to? The student of art is generally discouraged from asking this question. He is supposed to look for explanations of style in the artist's will rather than in his skill. Moreover, the historian has little use for questions of might-have-been. But is not this reluctance to ask about the degree of freedom that exists for artists to change and modify their idiom one of the reasons why we have made so little progress in the explanation of style?

In the study of art no less than in the study of man, the mysteries of success are frequently best revealed through an investigation of failures. Only a pathology of representation will give us some insight into the mechanisms

67
Plants brought by
Thutmose III from Syria,
c.1450 BC. Limestone relief
from the Temple of
Thutmose III, Karnak

which enabled the masters to handle this instrument with such assurance.

Not only must we surprise the artist when he is confronted with an unfamiliar task that he cannot easily adjust to his means; we must also know that his aim was in fact portrayal. Given these conditions, we may do without the actual comparison between photograph and representation that was our starting point. For, after all, nature is sufficiently uniform to allow us to judge the information value of a picture even when we have never seen the specimen portrayed. The beginnings of illustrated reportage, therefore, provide another test case where we need have no doubt about the will and can, consequently, concentrate on the skill.

IV

Perhaps the earliest instance of this kind dates back more than three thousand years, to the beginnings of the New Kingdom in Egypt, when the Pharaoh Thutmose included in his picture chronicle of the Syrian campaign a record of plants he had brought back to Egypt (Fig. 67).[19] The inscription, though somewhat mutilated, tells us that Pharaoh pronounced these pictures to be 'the truth'. Yet botanists have found it hard to agree on what plants may have been meant by these renderings. The schematic shapes are not sufficiently differentiated to allow secure identification.

An even more famous example comes from the period when medieval art was at its height, from the volume of plans and drawings by the Gothic masterbuilder, Villard de Honnecourt, which tells us so much about the practice and outlook of the men who created the French cathedrals. Among the many architectural, religious, and symbolic drawings of striking skill and beauty to be found in this volume, there is a curiously stiff picture of a lion,

68
Villard de Honnecourt,
Lion and Porcupine, c.1235.
Pen and ink drawing.
Bibliothèque Nationale,
Paris

69
Locust, 1556. Anonymous
woodcut

seen *en face* (Fig. 68). To us, it looks like an ornamental or heraldic image, but Villard's caption tells us that he regarded it in a different light: '*Et saves bien*', he says, '*qu'il fu contrefais al vif*.' 'Know well that it is drawn from life.'[20] These words obviously had a very different meaning for Villard than they have for us. He can have meant only that he had drawn his schema in the presence of a real lion. How much of his visual observation he allowed to enter into the formula is a different matter.

Once more the broadsheets of popular art show us to what extent this attitude survived the Renaissance. The letterpress of a German woodcut from the sixteenth century informs us that we here see 'the exact counterfeit' of a kind of locust that invaded Europe in menacing swarms (Fig. 69). But the zoologist would be rash to infer from this inscription that there existed an entirely different species of creatures that has never been recorded since. The artist had again used a familiar schema, compounded of animals he had learned to portray, and the traditional formula for locusts that he knew from an Apocalypse where the locust plague was illustrated. Perhaps the fact that the German word for a locust is *Heupferd* (hay horse) tempted him to adopt a schema of a horse for the rendering of the insect's prance.

The creation of such a name and the creation of the image have, in fact, much in common. Both proceed by classifying the unfamiliar with the familiar, or more exactly, to remain in the zoological sphere, by creating a subspecies. Since the locust is a kind of horse it must therefore share some of its distinctive features.

The caption of a Roman print of 1601 (Fig. 70) is as explicit as that of the German woodcut. It claims the engraving represents a giant whale that has been washed ashore near Ancona the same year and 'was drawn accurately from nature' ('*Ritratto qui dal naturale appunto*'). The claim would be more trustworthy if there did not exist an earlier print recording a similar 'scoop'

70
Whale Washed Ashore at
Ancona, 1601. Anonymous
Italian engraving

71
Whale Washed Ashore in
Holland, 1598. Engraving
after Goltzius

from the Dutch coast in 1598 (Fig. 71). But surely the Dutch artists of the late sixteenth century, those masters of realism, would be able to portray a whale? Not quite, it seems, for the creature looks suspiciously as if it had ears, and whales with ears, I am assured on higher authority, do not exist. The draughtsman probably mistook one of the whale's flippers for an ear and therefore placed it far too close to the eye. He, too, was misled by a familiar schema, the schema of the typical head.[21] To draw an unfamiliar sight presents greater difficulties than is usually realized. And this, I suppose, was also the reason why the Italian preferred to copy the whale from another print. We need not doubt the part of the caption that tells the news from Ancona, but to portray it again 'from the life' was not worth the trouble.

In this respect, the fate of exotic creatures in the illustrated books of the last few centuries before the advent of photography is as instructive as it is amusing. When Dürer published his famous woodcut of a rhinoceros (Fig. 72),[22] he had to rely on secondhand evidence which he filled in from his own imagination, coloured, no doubt, by what he had learned of the most famous of exotic beasts, the dragon with its armoured body. Yet it has been shown that this half-invented creature served as a model for all renderings of the rhinoceros, even in natural-history books, up to the eighteenth century. When, in 1790, James Bruce published a drawing of the beast (Fig. 73) in his *Travels to Discover the Source of the Nile*, he proudly showed that he was aware of this fact:

The animal represented in this drawing is a native of Tcherkin, near Ras el Feel … and this is the first drawing of the rhinoceros with a double horn that has ever yet been presented to the public. The first figure of the Asiatic rhinoceros, the species having but one horn, was painted by Albert Durer, from the life … It was wonderfully ill-executed in all its parts, and was the origin of all the monstrous forms under which that animal has been painted, ever since … Several modern

philosophers have made amends for this in our days; Mr Parsons, Mr Edwards, and the Count de Buffon, have given good figures of it from life; they have indeed some faults, owing chiefly to preconceived prejudices and inattention … This … is the first that has been published with two horns, it is designed from the life, and is an African.[23]

72
Albrecht Dürer, *Rhinoceros*, 1515. Woodcut

73
African rhinoceros, 1789. Engraving from James Bruce, *Travels to Discover the Source of the Nile* (Edinburgh, 1790)

If proof were needed that the difference between the medieval draughtsman and his eighteenth-century descendant is only one of degree, it could be found here. For the illustration, presented with such flourishes of trumpets, is surely not free from 'preconceived prejudices' and the all-pervading memory of Dürer's woodcut. We do not know exactly what species of rhinoceros the artist saw at Ras el Feel, and the comparison of his picture with a photograph taken in Africa (Fig. 74) may not, therefore, be quite fair. But I am told that none of the species known to zoologists corresponds to the engraving claimed to be drawn *al vif*!

The story repeats itself whenever a rare specimen is introduced into Europe. Even the elephants that populate the paintings of the sixteenth and seventeenth centuries have been shown to stem from a very few archetypes and to embody all their curious features, despite the fact that information about elephants was not particularly hard to come by.[24]

These examples demonstrate, in somewhat grotesque magnification, a tendency which the student of art has learned to reckon with. The familiar will always remain the likely starting point for the rendering of the unfamiliar; an existing representation will always exert its spell over the artist even while he strives to record the truth. Thus it was remarked by ancient critics that several famous artists of antiquity had made a strange mistake in the portrayal of horses: they had represented them with eyelashes on the lower lid, a feature which belongs to the human eye but not to that of the horse.[25] A German ophthalmologist who studied the eyes of Dürer's portraits, which to the

layman appear to be such triumphs of painstaking accuracy, reports somewhat similar mistakes. Apparently not even Dürer knew what eyes 'really look like'.[26]

This should not give us cause for surprise, for the greatest of all the visual explorers, Leonardo himself, has been shown to have made mistakes in his anatomical drawings.[27] Apparently he drew features of the human heart which Galen made him expect but which he cannot have seen.

The study of pathology is meant to increase our understanding of health: the sway of schemata did not prevent the emergence of an art of scientific illustration that sometimes succeeds in packing more correct visual information into the image than even a photograph contains. But the diagrammatic maps of muscles in our illustrated anatomies (Fig. 75) are not 'transcripts' of things seen but the work of trained observers who build up the picture of a specimen that has been revealed to them in years of patient study.[28]

Now in this sphere of scientific illustration it obviously makes sense to say that Thutmose's artists or Villard himself could not have done what the modern illustrator can do. They lacked the relevant schemata, their starting point was too far removed from their motif, and their style was too rigid to allow a sufficiently supple adjustment. For so much certainly emerges from a study of portrayal in art: you cannot create a faithful image out of nothing. You must have learned the trick if only from other pictures you have seen.

V

In our culture, where pictures exist in such profusion, it is difficult to demonstrate this basic fact. There are freshmen in art schools who have facility in the objective rendering of motifs that would appear to belie this assumption. But those who have given art classes in other cultural settings tell a different story. James Cheng, who taught painting to a group of Chinese trained in different conventions, once told me of a sketching expedition he

76
Chiang Yee, *Cows in Derwentwater*. 1936. Brush and ink on paper. From Chiang Yee, *The Silent Traveller* (London, 1937)

77
Derwentwater, looking toward Borrowdale, 1826. Anonymous lithograph from *Ten Lithographic Drawings of Scenery* (London, 1926)

made with his students to a famous beauty spot, one of Peking's old city gates. The task baffled them. In the end, one of the students asked to be given at least a picture postcard of the building so that they would have something to copy. It is stories such as these, stories of breakdowns, that explain why art has a history and artists need a style adapted to a task.

I cannot illustrate this revealing incident. But luck allows us to study the next stage, as it were – the adjustment of the traditional vocabulary of Chinese art to the unfamiliar task of topographical portrayal in the Western sense. For some decades Chiang Yee, a Chinese writer and painter of great gifts and charm, has delighted us with contemplative records of the Silent Traveller, books in which he tells of his encounters with scenes and people of the English and Irish countryside and elsewhere. I take an illustration (Fig. 76) from the volume on the English Lakeland.

It is a view of Derwentwater. Here we have crossed the line that separates documentation from art. Mr Chiang Yee certainly enjoys the adaptation of the Chinese idiom to a new purpose; he wants us to see the English scenery for once 'through Chinese eyes'.[29] But it is precisely for this reason that it is so instructive to compare his view with a typical 'picturesque' rendering from the Romantic period (Fig. 77). We see how the relatively rigid vocabulary of the Chinese tradition acts as a selective screen which admits only the features for which schemata exist. The artist will be attracted by motifs which can be rendered in his idiom. As he scans the landscape, the sights which can be matched successfully with the schemata he has learned to handle will leap forward as centres of attention. The style, like the medium, creates a mental set which makes the artist look for certain aspects in the scene around him that he can render. Painting is an activity, and the artist will therefore tend to see what he paints rather than to paint what he sees.

It is this interaction between style and preference which Nietzsche summed up in his mordant comment on the claims of realism:

'All Nature faithfully' — But by what feint
Can Nature be subdued to art's constraint?
Her smallest fragment is still infinite!
And so he paints but what he likes in it.
What does he like? He likes, what he can paint![30]

There is more in this observation than just a cool reminder of the limitations of artistic means. We catch a glimpse of the reasons why these limitations will never obtrude themselves within the domain of art itself. Art presupposes mastery, and the greater the artist the more surely will he instinctively avoid a task where his mastery would fail to serve him. The layman may wonder whether Giotto could have painted a view of Fiesole in sunshine, but the historian will suspect that, lacking the means, he would not have wanted to, or rather than he could not have wanted to. We like to assume, somehow, that where there is a will there is also a way, but in matters of art the maxim should read that only where there is a way is there also a will. The individual can enrich the ways and means that his culture offers him; he can hardly wish for something that he has never known is possible.

The fact that artists tend to look for motifs for which their style and training equip them explains why the problem of representational skill looks different to the historian of art and to the historian of visual information. The one is concerned with success, the other must also observe the failures. But these failures suggest that we sometimes assume a little rashly that the ability

of art to portray the visible world developed, as it were, along a uniform front. We know of specialists in art – of Claude Lorrain, the master of landscape whose figure paintings were poor, of Frans Hals who concentrated almost exclusively on portraits. May not skill as much as will have dictated this type of preference? Is not all naturalism in the art of the past selective?

A somewhat philistine experiment would suggest that it is. Take the next magazine containing snapshots of crowds and street scenes and walk with it through any art gallery to see how many gestures and types that occur in life can be matched from old paintings. Even Dutch genre paintings that appear to mirror life in all its bustle and variety will turn out to be created from a limited number of types and gestures,[31] much as the apparent realism of the picaresque novel or of Restoration comedy still applies and modifies stock figures which can be traced back for centuries. There is no neutral naturalism. The artist, no less than the writer, needs a vocabulary before he can embark on a 'copy' of reality.[32]

VI

Everything points to the conclusion that the phrase 'the language of art' is more than a loose metaphor, that even to describe the visible world in images we need a developed system of schemata. This conclusion rather clashes with the traditional distinction, often discussed in the eighteenth century, between spoken words which are conventional signs and painting which uses 'natural' signs to 'intimate' reality.[33] It is a plausible distinction, but it has led to certain difficulties. If we assume, with this tradition, that natural signs can simply be copied from nature, the history of art represents a complete puzzle. It has become increasingly clear since the late nineteenth century that primitive art and child art use a language of symbols rather than 'natural signs'. To account for this fact it was postulated that there must be a special kind of art grounded not on seeing but rather on knowledge, an art which operates with 'conceptual images'. The child – it is argued – does not look at trees; he is satisfied with the 'conceptual' schema of a tree that fails to correspond to any reality since it does not embody the characteristics of, say, birch or beech, let alone those of individual trees. This reliance on construction rather than on imitation was attributed to the peculiar mentality of children and primitives who live in a world of their own.

But we have come to realize that this distinction is unreal. Gustaf Britsch and Rudolf Arnheim have stressed that there is no opposition between the crude map of the world made by a child and the richer map presented in naturalistic images. All art originates in the human mind, in our reactions to the world rather than in the visible world itself, and it is precisely because all

art is 'conceptual' that all representations are recognizable by their style.[14]

Without some starting point, some initial schema, we could never get hold of the flux of experience. Without categories, we could not sort our impressions. Paradoxically, it has turned out that it matters relatively little what these first categories are. We can always adjust them according to need. Indeed, if the schema remains loose and flexible, such initial vagueness may prove not a hindrance but a help.[15] An entirely fluid system would no longer serve its purpose; it could not register facts because it would lack pigeonholes. But how we arrange the first filing system is not very relevant.

The progress of learning, of adjustment through trial and error, can be compared to the game of 'Twenty Questions', where we identify an object through inclusion or exclusion along any network of classes.[16] The traditional initial schema of 'animal, vegetable or mineral' is certainly neither scientific nor very suitable, but it usually serves us well enough to narrow down our concepts by submitting them to the corrective test of 'yes' or 'no'. The example of this parlour game has become popular of late as an illustration of that process of articulation through which we learn to adjust ourselves to the infinite complexity of this world. It indicates, however crudely, the way in which not only organisms, but even machines may be said to 'learn' by trial and error. Engineers at their thrilling work on what they call 'servo mechanisms', that is, self-adjusting machines, have recognized the importance of some kinds of 'initiative' on the part of the machine. The first move such a machine may make will be, and indeed must be, a random movement, a shot in the dark. Provided a report of success or failure, hit or miss, can be fed back into the machine, it will increasingly avoid the wrong moves and repeat the correct ones. One of the pioneers in this field has recently described this machine rhythm of schema and correction in a striking verbal formula: he calls all learning 'an arboriform stratification of guesses about the world'.[17] Arboriform, we may take it, here describes the progressive creation of classes and subclasses such as might be described in a diagrammatic account of 'Twenty Questions'.[18]

We seem to have drifted far from the discussion of portrayal. But it is certainly possible to look at a portrait as a schema of a head modified by the distinctive features about which we wish to convey information. The American police sometimes employ draughtsmen to aid witnesses in the identification of criminals. They may draw any vague face, a random schema, and let witnesses guide their modifications of selected features simply by saying 'yes' or 'no' to various suggested standard alterations until the face is sufficiently individualized for a search in the files to be profitable.[19] This account of portrait drawing by remote control may well be over-tidy, but as a

parable it may serve its purpose. It reminds us that the starting point of a visual record is not knowledge but a guess conditioned by habit and tradition.

Need we infer from this fact that there is no such thing as an objective likeness? That it makes no sense to ask, for instance, whether Chiang Yee's view of Derwentwater is more or less correct than the nineteenth-century lithograph in which the formulas of classical landscapes were applied to the same task? It is a tempting conclusion and one which recommends itself to the teacher of art appreciation because it brings home to the layman how much of what we call 'seeing' is conditioned by habits and expectations. It is all the more important to clarify how far this relativism will take us. I believe it rests on the confusion between pictures, words, and statements which we saw arising the moment truth was ascribed to paintings rather than to captions.

If all art is conceptual, the issue is rather simple. For concepts, like pictures, cannot be true or false. They can only be more or less useful for the formation of descriptions. The words of a language, like pictorial formulas, pick out from the flux of events a few signposts which allow us to give direction to our fellow-speakers in that game of 'Twenty Questions' in which we are engaged.[40] Where the needs of users are similar, the signposts will tend to correspond. We can mostly find equivalent terms in English, French, German, and Latin, and hence the idea has taken root that concepts exist independently of language as the constituents of 'reality'. But the English language erects a signpost on the roadfork between 'clock' and 'watch' where the German has only 'Uhr'. The sentence from the German primer, 'Meine Tante hat eine Uhr', leaves us in doubt whether the aunt has a clock or a watch. Either of the two translations may be wrong as a description of a fact. In Swedish, by the way, there is an additional roadfork to distinguish between aunts who are 'father's sisters', and those who are 'mother's sisters', and those who are just ordinary aunts. If we were to play our game in Swedish we would need additional questions to get at the truth about the timepiece.

This simple example brings out the fact, recently emphasized by Benjamin Lee Whorf, that language does not give names to pre-existing things or concepts so much as it articulates the world of our experience. The images of art, we suspect, do the same. But this difference in styles or languages need not stand in the way of correct answers and descriptions. The world may be approached from a different angle and the information given may yet be the same.[41]

From the point of view of information there is surely no difficulty in discussing portrayal. To say of a drawing that it is a correct view of Tivoli does not mean, of course, that Tivoli is bounded by wiry lines. It means that those who understand the notation will derive *no false information* from the

drawing – whether it gives the contour in a few lines or picks out 'every blade of grass' as Richter's friends wanted to do. The complete portrayal might be the one which gives as much correct information about the spot as we would obtain if we looked at it from the very spot where the artist stood.

Styles, like languages, differ in the sequence of articulation and in the number of questions they allow the artist to ask; and so complex is the information that reaches us from the visible world that no picture will ever embody it all. That is not due to the subjectivity of vision but to its richness. Where the artist has to copy a human product he can, of course, produce a facsimile which is indistinguishable from the original. The forger of banknotes succeeds only too well in effacing his personality and the limitations of a period style.

But what matters to us is that the correct portrait, like the useful map, is an end product on a long road through schema and correction. It is not a faithful record of a visual experience but the faithful construction of a relational model.

Neither the subjectivity of vision nor the sway of conventions need lead us to deny that such a model can be constructed to any required degree of accuracy. What is decisive here is clearly the word 'required'. The form of a representation cannot be divorced from its purpose and the requirements of the society in which the given visual language gains currency.

Editor's Postscript

Section VI, which starts with the sentence 'Everything points to the conclusion that the phrase "the language of art" is more than a loose metaphor' has generated an enormous amount of controversy. Some theorists, following Nelson Goodman, have taken this to mean that naturalistic imagery is just like language and thus a picture of a dog stands to a dog just as the word 'dog' does, an interpretation which he has explicitly rejected in a letter to Gombrich, published in The Image and the Eye, *p. 284n. Other theorists have tended to overemphasize naturalistic imagery's conventions, as opposed to its real advances in visual discovery.*

For Gombrich's response to Goodman see two of his essays: 'The "What" and the "How": Perspective Representation and the Phenomenal World', in Richard Rudner and Israel Scheffler (eds.), Logic and Art: Essays in Honor of Nelson Goodman *(New York, 1972) and 'Image and Code: Scope and Limits of Conventionalism in Pictorial Representation', in* The Image and the Eye. *Other relevant essays, such as 'Mirror and Map: Theories of Pictorial Representation', have been republished in* The Image and the Eye *as well. See also 'Recognizing the World: Pissarro at the RA',* The Royal Academy Magazine, *13 (summer 1993), p. 33 and 'Voir la Nature, Voir les Peintures',* Les Cahiers du Musée National d'art moderne, *24 (summer 1988), pp. 21-43.*

Gombrich's position has been completely consistent, though he has continued to refine it, since

writing a review of Charles Morris's Signs, Language and Behavior *(1949) reprinted in* Reflections on the History of Art.

Psychological theory has moved on in its investigations of the relationship between perception and the stereotype. Interesting reading is offered by Ulric Neisser, Cognition and Reality, *(New York, 1976) and Ilona Roth and John P. Frisby,* Perception and Representation: a cognitive approach *(Milton Keynes, 1986), which discusses the important work done by Eleanor Rosch. A very stimulating perspective from linguistics has been offered by Jean Aitchison,* Words in the Mind: An Introduction to the Mental Lexicon *(Oxford, 1987).*

The classic sociological study is Peter Berger and Thomas Luckmann, The Social Construction of Reality *(Harmondsworth, 1967). Thomas S. Kuhn,* The Structure of Scientific Revolutions *(2nd edn., London, 1969), discusses developments in science; note particularly 'Postscript - 1969'. Both books should be read very carefully because, despite popular belief, neither support purely conventionalist approaches to the relationship between language, thought and experience. They should both be read in the same direction as* Art and Illusion.

The net effect of recent research is to confirm Gombrich's view that despite a painting or drawing being a representation through a medium, the doctrine of complete conventionalism has no justification. Work on colour perception, for example, indicates that although our abilities to talk about colour discrimination are obviously affected by our language, colour discrimination itself is universal. Similarly, translation would not be possible unless there were an independent world to talk about.

The philosophical issues have been reviewed by Hilary Putnam, Renewing Philosophy *(Cambridge, Mass., 1992).*

Action and Expression in Western Art

A paper presented to a study group on non-verbal communication set up by the Royal Society under the chairmanship of W. H. Thorpe in 1970, and published in R. A. Hinde (ed.), *Non-Verbal Communication* (Cambridge, 1972); reprinted in *The Image and the Eye* (1982), pp. 78–104

1 *The Problem*

'It only lacks the voice.' This traditional formula in praise of works of art would suggest that painting and sculpture might present ready-made material for the student of 'non-verbal communication'. But, alas, painting not only lacks speech, it also lacks most of the resources on which human beings and animals rely in their contacts and interactions. The most essential of these, of course, is movement. Art can represent neither the nod nor the headshake. The sudden blush or the frequency of eye contact are equally outside its range. Indeed one may well wonder how art could ever have acquired the reputation of rendering human emotions.

The answer I shall propose in this paper will inevitably correspond to the one I have suggested elsewhere.[1] I have argued that the creation of images which satisfy certain specific demands of verisimilitude is achieved in a secular process of trial and error. 'Making' – I suggested – 'comes before matching.' Art does not start out by observing reality and trying to match it, it starts out by constructing 'minimum models' which are gradually modified in the light of the beholder's reaction till they 'match' the impression that is desired. In this process the resources which art lacks have to be compensated for by other means till the image satisfies the requirements made on it. Seen in this light we need not doubt that works of art have in fact satisfied succeeding generations who approached them with different demands, but with a desire for the convincing rendering of human expression. Indeed the literature on art testifies to the triumph of painting and sculpture over the limitations of their media. Works of art have traditionally been praised precisely for 'only lacking

the voice', in other words, for embodying everything of real life except speech.

To dismiss this reaction simply as a conventional exaggeration would exclude the student of non-verbal communication from the realm of art. It seems more fruitful and also more cautious to accept this reaction as a testimony to the combined power of convention and conditioning in creating a semblance of reality, a model to which men have responded as if it were identical with a life situation.

If art is thus seen as an experiment in 'doing without', an exercise in reduction (conventionally referred to as 'abstraction'), it is clear that the history of styles cannot be seen simply as a slow approximation to one particular solution. Different styles concentrate on different compensatory moves, largely determined by the function the image is expected to perform in a given civilization.

The most obvious way of compensating for the absence of speech is of course by the addition of writing, and this method was used with varying intensity in ancient Egypt, in archaic Greece, in medieval art where scrolls come out of the mouth of figures to show what they are saying, and once more in the modern comic with its 'balloons'. We may leave these on one side as evading the problem of 'non-verbal' communication.

2 Legible Interaction

There are at least two requirements for a 'still' to be legible in terms of expressive movements. The movements must result in configurations that can be easily understood and must stand in contexts which are sufficiently unambiguous to be interpreted.[2]

An example (Fig. 78) which dates from the third millennium BC may illustrate these postulates all the better because the interaction depicted is not cultural but 'natural' and concerns 'non-verbal communication' among animals. The Egyptian relief from the fourth dynasty shows a man carrying a calf on his shoulders which turns its head at a group of cows, one of which lifts her head towards it and appears to low. The movements represented are not only easily legible as significant deviations from the normal or expected postures of the animals, they also leave us in no doubt as to their expressive significance. We know that the man is taking the calf from the cow and thus we almost hear it low. If we asked somewhat pedantically how we can be sure, we would have to say that the man could not very well walk backwards in order to take the calf to the cow – quite apart from the fact that we would not know why he should do so, while we know very well why he takes the calf away.

Many of the resources of art for the depiction of expressive interaction are shown in this little group. It reminds us from the start that the transition from

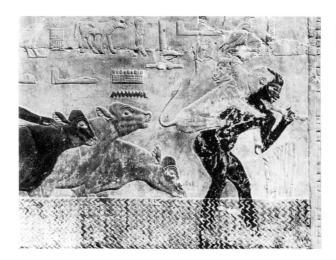

78
Return of the herds.
Detail of relief from the
Tomb of Ti. Egyptian,
4th dynasty

physical interaction to anticipatory movements is a gradual one, there is no intention on the part of the cow and the calf to express their reaction to the separation, only movements attempting to overcome it. It is up to us whether we interpret these movements as purposive or expressive.

3 Action and Expression on the Stage and in Art

This insight is an old one. It was developed with much subtlety by the eighteenth-century actor J. J. Engel, to whose *Ideen zu einer Mimik* (1785–6) Karl Bühler[3] has paid a justified tribute. Speaking of positive or negative reactions to an 'external object', Engel observes that they are both marked by an 'oblique position of the body'.[4]

> When desire approaches the object either to possess it or to attack it, the head and the chest, that is the upper part of the body, is shifted forward, not only because this will enable the legs to catch up more quickly, but also because these parts are most easily set in motion and man thus strives first to satisfy his urge through them. Where disgust or fear makes him shrink back from the object the upper part of the body bends backwards before the legs have started moving … A second observation which will always be confirmed where a vivid desire is at work is the following: it always tends towards the object or away from the object in a straight line …

Engel describes the human parallel to our animal example – the interaction between the child standing on tiptoes stretching its arms towards the mother and the mother bending down and extending her hands encouragingly towards her darling. He then proceeds to analyse reactions to more distant

objects, the posture of the listener who tries to overhear a conversation, the gaping onlooker. In all these movements of orientation the most active part of the body is turned towards the object of attention.

Engel's analysis of the conflicting pulls of contrary drives strikingly foreshadows the descriptions of modern ethologists.[5]

When Hamlet follows the ghost of his father his longing for the desired discovery of a dreadful family secret has the overwhelming preponderance; but this longing is weakened by his fear of the unknown being from a strange world, and increasingly weakened the nearer the prince comes to the ghost and the further he moves away from his companions. Hence his movement should only be lively when he breaks away from his companions with a threat. When he begins to walk, it should be without hurry or heat though still with firmness and determination, gradually his step should become more cautious, more soft and should bestride less space, the whole movement should be more inhibited and the body increasingly pulled back into a vertical position.

Nor is Engel unaware of the problem of the role of convention in expressive movements which must indeed obtrude itself on his kind of analysis. Having asserted that a lowering of posture is used by all nations as an expression of reverence, he discusses with honesty and circumspection anthropological evidence from Tahiti which appears to contradict this claim.[6]

As an actor, Engel also has many things to say about human reactions to internal states, to imagined situations and objects, the clenched fist of the revengeful rival who anticipates his coming fight, the movement of horror or of love in the actor's monologue. But he is also very much aware of the role which speech plays in explaining and communicating these reactions and sceptical even about the chances of pure mime. About painting, he explicitly forbears to speak.[7]

I have shown elsewhere[8] that Engel had an important predecessor in Lord Shaftesbury, who had attempted to bridge the gap between the movements of life and the 'stills' of painting by suggesting how the past and the future could somehow be made visible in the rendering of a transitory moment. In his *Characteristicks* (1714) he discussed the ways a painter could represent the story of the choice of Hercules (see Fig. 79), in which the hero is confronted by Pleasure and Virtue and decides for the latter.

Whatever we may think of his *a priori* analysis, it reminds us of the relevance of our two initial postulates, the need for legibility and for clear contextual clues. In art the two are obviously interdependent. The clearer the situational clues (as in our animal example), the less may there be need for perfect legibility, and vice versa.

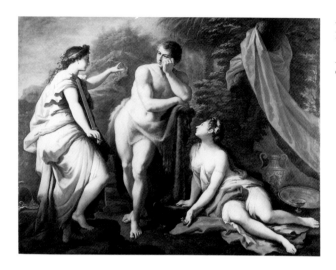

79
Paolo de Matteis, *The Choice of Hercules*, 1711. Ashmolean Museum, Oxford

4 Symbolic and Expressive Gestures

It is well known that 'primitive' or 'conceptual' styles of representation show much concern for clarity and legibility. But it will be found that some of the devices adopted towards this very end may interfere with the lucid rendering of expressive movement. The conventions of ancient Egyptian art strenuously excluded the rendering of foreshortening.[9] Every human figure had to be shown in a clear silhouette which looks somewhat distorted to us, precisely because every part of the body is so turned as to present its most lucid, 'conceptual' shape. It is partly for anatomical reasons that these needs interfered less with the rendering of animals and their movements and thus allowed the artist of our example to depict his little tragedy so movingly. Where human figures are shown interacting in violent motion, as in representations of teamwork, or of fighting, the needs of legibility sometimes lead to a wrenching and twisting of the body which somewhat hampers the convincing rendering of expressive gestures.

In the representation of social interaction recourse had therefore to be taken to social symbolism. Notoriously the important personage in Egyptian art is represented larger than are those on the lower rungs of the hierarchy. He is frequently marked with a sceptre or other insignia while those he commands or supervises are represented in submissive postures. Moreover it is well known that all civilizations have developed standardized symbolic gestures which approximate the vocabulary of a gesture language.[10] I have suggested in another essay[11] that these ritualized gestures of prayer, of greeting, of mourning at funeral rites, of teaching or triumph are among the first to be represented in art. They are much more easily fitted into the conventions of a

conceptual style, such as the Egyptian, than are the spontaneous movements of human interaction. These 'performative' gestures are self-explanatory actions which set up a clear context and are not concerned with the passage of time.[12] The King stands before his God, the Noble receives tributes, the dead are bewailed: all these are types of juxtaposition which lend themselves to unambiguous representation even within a style which excludes the realist approach to the human body in action.

It is well known that it is to Greek art that we must look for the conquest of appearances. I have suggested in *Art and Illusion* that the striving for this mastery was determined by the function of art within Greek civilization, where it required the illustration or even the dramatic evocation of mythological stories as told by the epic poets.[13] Be that as it may, Greek art certainly developed devices which compensate for the absence of movement not by symbolic expression but by the creation of images of maximal instability. Bodies are made to take up positions which we know from experience to be incapable of being maintained, muscles are tautened like a drawn bow, garments begin to flutter in the wind to indicate speed and transitoriness. By itself such a style need not be relevant to our topic, for theoretically the interaction of figures could remain on a purely physical level, fighting groups grappling and parrying blows, or athletes wrestling. But even in such situations it is no more possible than it was in our initial animal example to separate action from communication. We see the victim of aggression trying to ward off the coming thrust with a gesture of self-protection that also suggests pleading, we see the victor in an attitude of domination that suggests triumph or pride (Fig. 80). A study of these and similar motifs in ancient art reveals the need for a compromise between the conflicting demands of maximal legibility and maximal movement.[14] The attitude of both aggressor and victim must be transitory, but lucid, and those solutions which best do justice to these demands will tend to be adopted as a formula on which only slight variations need be played. Thus the moment in which 'non-verbal communication' between human beings was first specifically observed and rendered in art can never be determined with any degree of precision.[15] What matters is the degree of empathy expected and aroused.

If it really became the task of Greek art to turn the beholder into an eye-witness of events he knew from Homer and other poets, it is clearly not fruitful to look beyond this demand for a hard and fast distinction between physical and psychological interaction.

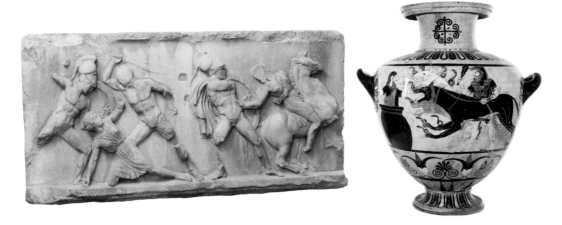

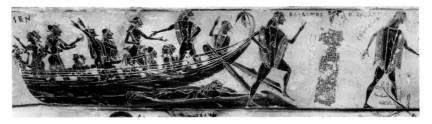

80
Greek fighting group
from the Halicarnassus
Mausoleum, *c*.350 BC.
British Museum, London

81
Eurystheus in his vat.
Detail from a hydria, *c*.530
BC. Louvre, Paris

82
Theseus's sailors landing
on Delos. Detail from the
François Vase, *c*.570 BC.
Museo Archeologico,
Florence

5 *Narrative and Interpretation*

We do not know how the Egyptians viewed the separation of the calf from its mother, but it is obvious that I have sentimentalized the scene in calling it a little tragedy. No empathy is likely to have been expected on the part of the beholder; even in human scenes there is little evidence of such a demand. It is this appeal to our responses which distinguishes Greek narrative art of the sixth and fifth centuries BC from most earlier styles. The fright of Eurystheus who (on a hydria in Paris) has crept into a vat and lifts his hands in horror as Hercules brings Cerberus (Fig. 81); the joy of Theseus's sailors (on the François Vase in Florence) gesticulating and throwing up their arms in pleasure as they land in Delos (Fig. 82); the sorrow of Ajax (on a cup in Vienna) who hides his head in grief when he loses his case for the arms of Achilles; the rapt attention of the Thracians (on a wine bowl in Berlin) who hear Orpheus sing (Fig. 83); the satyr (on a jug in Oxford) who dances with joy as he finds a nymph asleep – all these are examples taken from Greek vases[16] leading up to the period in the early fourth century when Xenophon in the *Memorabilia* represented Socrates discussing the subject of expression with the painter Parrhasios and the sculptor Cleiton. In both these little dialogues the artists must have their attention drawn to the possibility of representing not only the actions of the body but through the body the 'workings of the soul'.

83
Orpheus and Thracians.
Detail from a krater, c.450
BC. Staatliche Museen,
Berlin

'How could one imitate that which has neither shape nor colour … and is not even visible?' asks the puzzled Parrhasios, and is told of the effect of emotions on people's looks: 'Nobility and dignity, self-abasement and servility, prudence and understanding, insolence and vulgarity, are reflected in the face and in the attitudes of the body whether still or in motion.'[17]

The injunction has been repeated in countless variations throughout the literature of art which is based on the classical tradition. Not only are particular works of painting or sculpture praised for their mastery in conveying the character and emotions of the figures portrayed, many treatises on art since the Renaissance (e.g. by Alberti, Leonardo, Lomazzo, Le Brun) contain sections in which the outward symptoms of the emotions or 'passions' are described and analysed. Interesting as these discussions are for the history of our studies,[18] it must be admitted that most of them bypass the crucial difference between art and life which was our starting-point. Expressive movements are movements and once we lack the explanatory sequence to tell us how this configuration started and where it leads to, ambiguity will increase to an unexpected extent, unless, of course, the absence of movement is compensated for by situational cues. Eurystheus in his vat may be extending his hands because he cannot wait to stroke Cerberus, the sailor who throws up his arms for joy on landing in Delos may have been hit by an arrow, Ajax may be hiding his head to conceal not his sorrow but his laughter in having brought off a splendid trick, the Thracians may be bored by Orpheus's songs and even the satyr may jump and clap his hands in order to wake the sleeping nymph. There is a humorous book called *Captions Outrageous* (by Bob Reisner and Hal Kapplow) attempting such reinterpretations of famous masterpieces with more or less wit. Psychologists, moreover, know from the varying readings of the Thematic Apperception Test[19] how great is the spread of possible interpretations of any picture unless a firm lead is given by the context or caption. Experiments have shown that if

84
Aertgen van Leyden, *The Israelites in the Desert*, c.1550. Staatliche Museen, Berlin

we isolate an individual figure from the snapshot of an emotional scene it will only exceptionally allow us to guess the elements of the situation.[20] Even facial expression when isolated from casual snapshots turns out to be highly ambiguous. The contorted face of a wrestler may look in isolation as if he were laughing, while a man opening his mouth to eat may appear to be yawning.[21]

Thus art stands in need of very clear and unambiguous cues to the situation in which the movement occurs. In particular we have to know whether a movement should be interpreted as predominantly utilitarian or expressive. Fig. 84 is easily misinterpreted as a gesture of submission, that is an expressive movement of extreme obeisance. We have to know the context, the story of the Gathering of Manna, to understand why the man is cowering, on the ground and stretching out his hands – he is trying to grab as much as possible of the miraculous food that has fallen from heaven. A representation of interacting people is not necessarily self-explanatory. It must be interpreted and this interpretation implies setting the movements into an imaginary context.

85
Orpheus and Eurydice.
Roman copy of a Greek
5th-century relief. Museo
Nazionale, Naples

In most periods of art such a context is given by situational cues which are familiar to members of the culture. The painter and the sculptor make use of a good deal of symbolic lore to mark a personage as king or beggar, angel or demon, they introduce further emblems or 'attributes' to label individuals so that no difficulty arises in recognizing Christ or the Buddha, the Nativity or the Rape of Proserpina.

Take the relief of Orpheus and Eurydice (Fig. 85) after a Greek composition of the fifth century BC. First we must recognize the protagonists by what are called their 'attributes', the singer's lyre, or the traveller's hat of Hermes, the guide of the dead. Only then can we identify the episode here represented, the fatal moment when Orpheus has disobeyed the condition imposed on him and has looked back at Eurydice, who is therefore taken back to Hades by the god. Thus we may 'compare and contrast' it without irreverence with our Egyptian example (Fig. 78). The Greek work does not deviate much from that 'conceptual' clarity that presents the posture of every figure at its most legible, it is in fact in subtle departure from this normal position that the relationship of the three actors is most delicately conveyed. These small deviations are in

the direction postulated by Engel's analysis. Hermes is seen to bend back slightly as he gently takes Eurydice by the wrist to return her to the realm of Hades. The two lovers face each other, her hand rests on the shoulders of the guide who had failed her, her head is slightly lowered as they gaze at each other in a mute farewell. There is no overt expression in their blank features, but nothing contradicts the mood we readily project into this composition, once we have grasped its import.

Such a subtle evocation must rely on the kind of beholder who would also know how to appreciate the reworking of a familiar myth at the hands of a Sophocles or Euripides. The relief, in other words, is not really created to tell the story of Orpheus and Eurydice but to enable those who know the story from childhood to relive it in human terms. This reliance on suggestion is characteristic of the great period of Greek art in which every resource of expressive movement was used to convey the interaction of individuals. These resources were lost or discarded as soon as art was predominantly used to drive home a message and proclaim a sacred truth.

6 *The Pictographic Style*

During declining antiquity, with the rise of Imperial cults and, above all, with the development of Christian art, we can observe the re-emergence of frankly conceptual methods and a new standardization of symbolic or conceptual gestures.[22] These gestures of prayer, instruction, teaching or mourning help rapidly to set up the context and to make the scene legible. The Emperor sacrificing, the general addressing the army, the teacher instructing his pupils, the defeated submitting to the victor, all these are types of juxtaposition which lend themselves to as unambiguous a representation for those who know the conventions of gesture language, as do scenes of combat for those who do not. Such impressive legibility is demanded where the rendering of a holy writ almost forbids that free dramatic evocation that Greek art had evolved. Moreover, it needs much mastery on the part of the artist and the beholder to isolate and interpret expressive movements in the context of vivid interaction. Thus late antique and early Christian art generally played safe in the illustration of narrative texts. An almost pictographic idiom was distilled from the freer tradition of classical art. The need for unambiguous messages stilled the vivid and subtle interplay of action and reaction that marked the masterpieces of the earlier style.[23] Instead we are frequently shown the protagonist, Christ, a saint, or a prophet or even a pagan hero, standing erect, with a gesture of 'speaking' or command, the centre of the scene to which all other figures must be related.

To the student of non-verbal communication this extreme 'pictographic'

convention is of interest precisely because the need to turn art into a 'script for the illiterate'[24] brings out both the potentialities and the limitations of the medium and can serve as a point of reference in the consideration of other styles.

86
The Raising of Lazarus,
c.520 AD. Mosaic.
S. Apollinare Nuovo,
Ravenna

87
Moses Striking the Rock.
Catacomb painting, 4th
century AD. Coemeterium
Maius, Via Nomentana,
Rome

The pictographic style takes no chance with naturalism. There is no pretence, implied or overt, of presenting a snapshot of a given scene such as might have been seen and photographed by an imaginary witness. In fact the style makes it easy to show up the fallacies in this conception of art[25] which have haunted criticism since Lessing's *Laocoon*. Neither the prayer nor the speech, the wailing or the submission is imagined to be recorded at a particular moment of time. The assembled pictographs relate to a story in the past which is now accomplished and complete. Christ stands with extended hand in front of an edifice that contains a mummy, to symbolize the Raising of Lazarus (Fig. 86). Moses is seen with outstretched hand holding a rod, while water gushes from the rock as in many catacomb paintings (Fig. 87). It would be foolish to ask whether the act of striking is over or whether the artist has anticipated the effect by showing the jet of water. The juxtaposition simply conveys the story of the water miracle much as a brief narrative would. One might in fact translate the pictograph into a sentence in which the protagonist is the subject, the action the verb and the tomb or rock the object. The pictograph – to use a distinction I have found useful – represents the 'what' but not the 'how', the verb but not the adverb or any adjectival clause.

7 The Chorus Effect
There are several ways in which art can introduce these enrichments to convey not only the fact of the event but also some of its significance, and these invariably draw on the resources of 'non-verbal communication', that is on expressive as distinct from symbolic movement. Perhaps the most general

88
Giotto, *The Raising of
Lazarus*, c.1306. Fresco.
Arena Chapel, Padua

method in art has been to clarify the meaning of the action by showing the
reaction of onlookers. When Christ brings Lazarus to life, his two sisters
prostrate themselves before Him in awe and gratitude while the crowd shows
by their gestures and movements that they are witnessing a miracle. (Not to
mention the bystanders holding their noses to remind us that the corpse was
already far gone! Fig. 88.) When Moses strikes water from the rock, the Elders
who had come to witness the scene throw up their arms in wonder and the
thirsting Israelites extend their eager hands to drink (Fig. 89). There are many
themes of Western art which can best be described in terms of this formula
of action and reaction, the reacting crowds providing the 'chorus' explaining
the meaning of the action, and, in doing so, setting the key for the beholder's
response. The student of expression can here verify some of the analysis by
Shaftesbury and Engel mentioned above. The orientation of the figures
towards or away from the central event can express admiration, aggression,
flight or awe. But art, like the stage, has also explored less obvious reactions in
the depiction of great events – the 'autistic' gestures of the contemplative, the
fearful movement of the hand to the head, the abstracted look of those
immobilized by surprise and, to mention a frequent but very subtle formula,
the way a bystander may turn away from the main event to look into his
neighbour's eye as if to make sure that others, too, have seen the same and are
equally moved (Fig. 90).[26]

8 *Expression and Emphasis*
Needless to say, it is somewhat too schematic to call purposeful movements

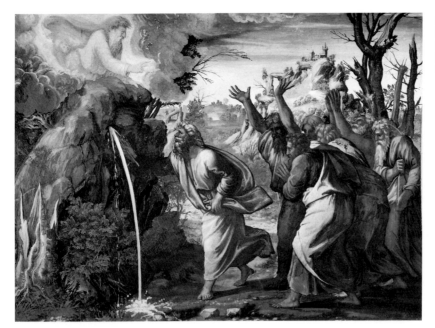

'action', and movements which are an expression of an inner state 'reaction'. Both action and reaction can be more or less communicative of psychological states, provided we have sufficient context to interpret them. This is a point where the 'language' of gestures can be compared with the language of words – every symbolic movement also has a 'tone' which conveys character and emotion; it can be tense or relaxed, urgent or calm. There are countless traditional subjects in Western art which allow us to study these possibilities of what Dante calls 'visible speech'. Describing a relief representing the Annunciation he says: 'The angel that came to earth with a decree of peace ... appeared before us so truthfully carved in a gentle gesture that it did not appear to be a silent image. One would have sworn that he said "*Ave*" ... and on to her attitude there was impressed that speech "*Ecce ancilla Dei*" exactly as a figure is sealed onto wax ...' (*Purgatorio*, x, 34–45).

In what I have called the 'pictographic' mode this exchange would be expressed simply by the Angel extending his hand in a speaking gesture while the Virgin's reaction and response were confined to a lifting of her palms in a movement of surprise (Fig. 91). But on reading the gospels the artist would find more about the supreme moment of the Incarnation, he would read that on seeing the angel 'she was troubled at his saying and cast in her mind what manner of salutation this should be' before the final submission, 'Behold the handmaid of the Lord; be it unto me according to thy word.'[27]

Any artist who wanted to depart from the pictographic method of narrative

to emulate the representation Dante had seen in his vision had therefore to
feel his way like an actor trying to express a complex emotion – the way fear
and wonder turn into unquestioning acceptance.

We happen to know through the writings of Leonardo da Vinci that the
right extent of departing from pictographic clarity towards the Greek style of
dramatic evocation was a subject of debate among artists of the Renaissance.
Chiding those of his fellow artists whom he regarded as mere 'face painters' –
specialists in portraiture – Leonardo comes to speak of his favourite topic, the
need for universality in an artist and especially the importance of observing
the expression of mental states. Those Florentine artists of the Quattrocento
who had gone furthest in exploring the representation of movement
encountered a certain amount of opposition in the name of 'decorum'.
Alberti in the 1430s speaks in general terms of the need for restraint, since
figures throwing their limbs about look like 'duellers'.[28] Filarete,[29]
paraphrasing this remark some twenty years later, identifies the target of these
strictures – he says that Donatello's disputing Apostles are gesticulating like
jugglers. Now Leonardo, who must have heard similar remarks passed about
his own paintings, goes over to the counter-attack. Specialists in portraiture,
he remarks, lack judgement in these matters because their own works are
without movement and they themselves are lazy and sluggish. Thus when they
see works showing more movement and greater alertness than their own, they
attack them for looking as if 'possessed' or like Morris dancers.[30] Admittedly,
Leonardo concedes, there can also be excesses in the other direction.[31]

One must observe decorum, that is the movements must be in accord with the movements of the mind … thus if one has to represent a figure which should display a timid reverence it should not be represented with such audacity and presumption that the effect looks like despair … I have seen these days an angel who looked as if in the annunciation he wanted to chase Our Lady out of her chamber with gestures which looked as offensive as one would make towards the vilest enemy, and Our Lady looked as if she wanted to throw herself out of the window in despair.

A painting in Glasgow (Fig. 92) from the workshop of Botticelli almost answers to Leonardo's satirical description.

But Leonardo, being Leonardo, did not remain content with these polemical remarks. He went on reflecting on the problem posed by such disparate judgements about works of art and came to the conclusion that the reactions of his fellow artists were invariably connected with their own style and temperament. 'He who moves his own figures too much will think that he who moves them as they should, makes them look sleepy, and he who moves them but little will call the correct and proper movement "possessed".'[12]

It is interesting to watch Leonardo himself groping for the 'correct and proper' rendering of 'timid reverence' in an early study for an *Adoration of the Magi* (Fig. 93). Once more it may be instructive to recall the 'pictographic' mode of illustrating the Biblical episode on early Christian sarcophagi, where the Virgin and Child are approached by three identical figures in the recognizable garb of the Magi in the symbolic act of paying homage (Fig. 94), their hands carrying the presents often covered by a cloth. For Leonardo, of course, the symbolic act must also be expressive of what goes on in the minds of the Kings who have come from afar to greet the newborn Saviour. He varies the gesture of presentation and submission from the upright and rather unmoved youngster in the left-hand corner who does not even look at the child, to the old King who humbles himself as he moves forward on his knees to extend his gift. But the right degree of emphasis is obviously only one of the needs the artist seeks to satisfy. He also takes great care that the posture and movement remain completely legible, turning the actors in such a way as to present the clearest silhouette. None of these attitudes is really a movement caught on the wing; each could be taken up and held in a *tableau vivant* and it is this among other things which Leonardo clearly wanted if the figures were not to incur the justified strictures of excessive movement.

Comparing his solution with that of his contemporaries one might imagine that the criticism that Leonardo's figures looked too lethargic might have come from Botticelli, whose later style is indeed almost 'possessed' (Fig. 95).

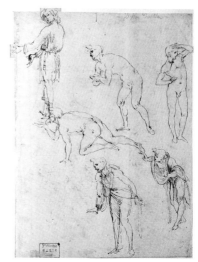

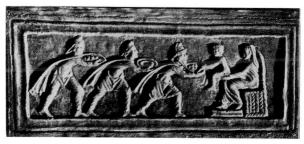

92
School of Botticelli, *The Annunciation*, c.1490. Art Gallery and Museum, Glasgow

93
Leonardo da Vinci, study for *The Adoration of the Magi*, c.1481. Drawing. Musée du Louvre, Paris

94
The Adoration of the Magi. Detail from a sarcophagus, 4th century AD. S. Giovanni Battista, Ravenna

The opposite objection, that Leonardo's own figures are 'gesticulating like mad', might have come from his other Florentine rival Ghirlandaio, whose *Adoration* provides a foil of stolid immobility to Leonardo's dramatic gestures (Fig. 96).

Leonardo's interesting observations can be generalized to apply not only to the varying standards of artists, but also to those of other critics. We all know that the Northerner will tend to find the expressive movements of the Latin nations over-emphatic and theatrical. In writing about Leonardo's *Last Supper*, Goethe[33] had to remind his German readers of this characteristic of Italian culture, and I have found that contemporary English students can be incredulous if they are told that Leonardo may really have intended the intensity of gesticulation he used in the *Last Supper* (Fig. 97) to convey the disciples' reaction to Christ's words that one of them would betray Him.[34] We certainly judge the emotional import of an expressive movement by comparing it with some mean, just as we do the loudness of speech or other dimensions of emphasis.

Thus the style of movement represented in art will depend on a great many

variables including the current level of emphasis, or the demand for restraint, which varies not only from period to period and nation to nation but also from class to class. Few aspects of 'manners' and behaviour were more eagerly discussed in treatises on acting and on art than this question of 'decorum'.

Nobility, on the whole, implied restraint or at least a stylized type of emphasis, while the vulgar could disport themselves more freely and more spontaneously, as in pictures of carnivals, of taverns, of the barber pulling a tooth. Naturally the resources of expressiveness continued to be adapted to different ends in conformity with these different ideals. It has been claimed[15] that the Church of the Counter-Reformation favoured the representation of martyrdoms to rouse the beholder. It is certain that the seventeenth century in Italy developed new formulae for extreme and ecstatic states.

By that time, of course, art may be said to have largely returned to a function akin to its role in classical Greece. It was not mainly there to tell the sacred story to the illiterate but rather to evoke it in a convincing and imaginative way to those who knew it. It is characteristic of art that ultimately the display of resources may become part of a novel purpose. This is certainly true of the rendering of expressive movement. The artist's mastery in conveying human emotions was so much admired that the illustration of a sacred or secular story becomes rather the occasion for the exercise of such mastery. Just as the libretto of the average opera was chosen to allow the composer to express or depict the widest range of human passions in his music, so the subjects selected by post-Renaissance artists were frequently intended to permit a maximum of dramatic effects.

Naturally in art no less than in drama these effects in their turn were subject to the rules of 'decorum', particularly in seventeenth-century France. When Poussin illustrated the story of Moses striking the rock (Fig. 98) – as he did three times in his life – he took great care that the thirsting Israelites in the

95
Botticelli, *The Adoration of the Magi*, c.1500. Uffizi, Florence

96
Ghirlandaio, *The Adoration of the Magi*, 1488. Ospedale degli Innocenti, Florence

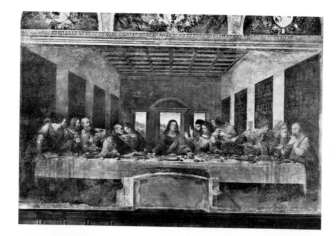

97
Leonardo da Vinci, *The Last Supper*, c.1497. S. Maria delle Grazie, Milan

98
Nicolas Poussin, *Moses Striking the Rock*, c.1637. Duke of Sutherland Collection (on loan to the National Gallery of Scotland, Edinburgh)

desert were made to express their response to the miracle with nobility and restraint. His rendering of the Gathering of Manna was the subject of a famous academy discourse by the painter Le Brun, who stressed the conformity of the various types to classical precedents.[36] The very approximation of pictorial representations to the stage, however, also produced a reaction. Epithets such as 'stagey' or 'theatrical' are not necessarily words of praise when applied to works of art, and the gradual eclipse suffered by academic art with its 'grand manner' is closely linked with the reaction against classical rhetoric in favour of a less formal and less public display of emphatic emotion.

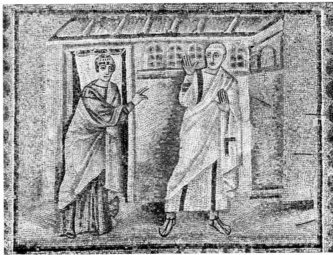

9 Inwardness and Ambiguity

The tradition of Northern art, less immediately affected by classical influences, had earlier on developed pictorial devices which appealed to this taste for a more inward, more lyrical and less dramatic expression in art. Instead of concentrating on expansive movement, the artist relied on the characterization of physiognomies and facial expression. A type of composition appeared towards the end of the fifteenth century in which the *dramatis personae* are shown in close-ups and all the psychological interaction must be read in the features.[17] Thus the artist may concentrate on representing the expression of devotion in the heads of the three Magi who offer their gifts to the Christ child (Fig. 99) or on contrasting the fierce aggression of Christ's tormentors with the Saviour's patience.

Northern art, like the drama of Shakespeare, was altogether less hemmed in by classical rhetoric and decorum, and this may explain the fact that in painting too the greatest portrayer of human reactions is to be found in the Protestant North, in Rembrandt, who had studied and absorbed both traditions. Once more it is instructive to compare his way of narration with the 'pictographic' method of early Christian art. One of the mosaics of S. Apollinare Nuovo (Fig. 100) illustrates the Denial of Peter (Luke 22: 54–62).

> Then took they him, and led him and brought him into the high priest's house. And Peter followed afar off. And when they had kindled a fire, in the midst of the hall, and were set down together, Peter sat down among them. But a certain maid beheld him as he sat by the fire and earnestly looked upon him, and said, This man was also with him. And he denied him, saying, Woman, I know him

99
The Hortulus Master, *The Adoration of the Magi*, c.1490. Bayerische Staatsbibliothek, Munich

100
St Peter's Denial, c.520. Mosaic. S. Apollinare Nuovo, Ravenna

101
Rembrandt, *St Peter's Denial*, c.1656. Rijksmuseum, Amsterdam

not. And after a little while another saw him, and said, Thou art also of them. And Peter said, Man, I am not. And about the space of one hour after another confidently affirmed, saying, Of a truth this fellow also was with him: for he is a Galilaean. And Peter said, Man, I know not what thou sayest. And immediately, while he yet spake, the cock crew. And the Lord turned, and looked upon Peter. And Peter remembered the word of the Lord, how he had said unto him, Before the cock crow, thou shalt deny me thrice. And Peter went out, and wept bitterly.

The Ravenna mosaic represents the essential elements in the story. The maid raises her hand in a speaking gesture towards St Peter, who shrinks back and vividly signals his denial. Rembrandt (Fig. 101) evokes the entire scene by the camp fire, but at first glance it would seem that he is less intent on translating speech into movement. The maid holds a candle close to Peter's face to scrutinize his features but he merely lifts one hand in a movement which is much less unambiguous than that of the early Christian mosaicists. Indeed, taken in isolation the figure may simply be shown to speak or even to make an inviting gesture asking one of the other figures to come forward. But the figure is not in isolation and thus Rembrandt compels us to picture the whole tragic scene in our mind, the anxious old man sadly facing the inquisitive woman and the two tough soldiers whose presence amply accounts for his denial. But what makes the picture particularly unforgettable is the barely visible figure of Christ in the dark background, who has been facing His accusers and is turning round, as the Bible says, to look at His erring disciple. It is the absence

of any 'theatrical', that is of any unambiguous, gesture which prevents us from reading off the story as if it were written on scrolls and involves us all the more deeply in the event. The very element of ambiguity and of mystery makes us read the drama in terms of inner emotions and once we are attuned to this reading we increasingly project more intensity into these calm gestures and expressions than we are likely to read into the extrovert gesticulations of the Latin style. The painting by Rembrandt demands quiet scrutiny and prolonged meditation. Moreover, it demands much more active participation on the part of the beholder, who must know the Biblical story and have pondered its universal significance if he is to understand the poignancy of Peter's expression and of Christ's unseen gaze.

Speaking somewhat schematically, it may be argued that from the Renaissance to the eighteenth century the function of art was conceived in the same way as it had been in ancient Greece – the artist should show his mettle by interpreting known texts. It was the 'how' and not the 'what' that the connoisseur admired and pondered. He appreciated the way the painter rendered a particular episode from the Bible or from the Classics and desired to share and understand the reaction of participants through an act of imaginative empathy. It is here, of course, that Rembrandt is supreme precisely because he has discovered and developed the perfect mean between the unrealistic pictographic gesture and the indeterminate representation of an enigmatic movement.

The importance for art of mobilizing the beholder's projective activities in order to compensate for the limitations of the medium can be demonstrated in a variety of fields. The indeterminate outlines of Impressionist pictures which suggest light and movement are a case in point. Such experiments should be of interest to the psychologist of perception for what they tell us about our reactions to real-life situations. This may also apply to the study of non-verbal communication. There is no reason to think that in such real situations the most unambiguous gesture or expression is also the most telling or moving. We learn to appreciate ambiguity, ambivalence and conflict in the reactions of our fellow human beings. It is this richness and depth of our response that a great artist such as Rembrandt knows how to evoke. Provided therefore we do not make the mistake of looking in the greatest works of dramatic narration for a realistic record of movements such as actually occur in non-verbal communication we can study these illustrations with much more profit than the limitations of the medium would allow one to expect.

This is true despite the fact that an inventory of expressive movements used in old master paintings would be likely to reveal a surprisingly limited range. The reasons for this restriction should have become clear from the preceding

examples. Perhaps the most decisive of them is the need for conceptual clarity in the posture presented to the beholder, which rules out a large range of movements in which limbs would be too much foreshortened or hidden for the movement to explain itself. Needless to say, neither this nor any other rule is absolute, and subsidiary figures can often be shown in postures of greater complexity or obscurity. However, the astonishment with which the first snapshots were greeted shows that the average observer rarely notices, let alone remembers, the more transient movements, which were therefore excluded from the traditional vocabulary of art. We must stress once more that in this as in other respects the realistic rendering of life situations did not arise from simple imitation but from the adjustment of a conceptual or pictographic tradition.

10 *Alternative Functions*

I have emphasized the interdependence of art and function because its recognition helps us to escape from a dilemma which still haunts the history and criticism of art. Originally this history was told in terms of progress, interrupted by periods of decline. It is this conception of history that we find in the authors of classical antiquity and in those from the Renaissance to the nineteenth century, who describe the gradual acquisition of mastery in the rendering of the human anatomy, of space, of light, texture and expression. To the twentieth century, which has witnessed the deliberate abandonment of these skills on the part of its artists, this interpretation of history has come to look naïve. No style of art is said to be better or worse than any other. We may accept this verdict within limits provided it does not tempt us into an untenable relativism concerning the achievement of certain aims — and the rendering of non-verbal communication is a case in point.

We have a right to speak of evolution and of progress in the mastery of certain problems and in the discovery of perfect solutions. Kenneth Clark, in a perceptive essay,[18] has singled out such a problem, the meeting and embrace as it occurs in the story of the Visitation, and has shown its progressive perfection towards what may be called a 'classic' form. We can acknowledge such perfection without forgetting the possibility of alternative solutions once a shift in the problem occurs.

Unfortunately the history of art has tended for too long to fight shy of this type of investigation. We have no systematic study of eye contacts in art[19] and even the exact development of facial expression is all but unknown. Clearly it would not be possible for this essay to reduce these large blank patches on the map of our knowledge. All that can still be done, in conclusion, is to point to their existence and to the location of some of them.

I have mentioned one at least by implication: there must be a great difference between a painting that illustrates a known story and another that wishes to *tell* a story. No history exists of this second category, the so-called anecdotal painting which flourished most in the nineteenth-century salon pictures. Indeed twentieth-century critics have covered the whole genre with such a blanket of disapproval that we are only now beginning to notice this phase in the history of art.[40]

It is likely, however, that the student of non-verbal communication would find a good deal of interest in these systematic attempts to condense a typical dramatic scene into a picture without any more contextual aids than, at the most, a caption. Clearly many of these painters must have profited from a study of the realistic stage rather than from an observation of life, but the fact remains that they made use of a very much enriched vocabulary. The painting by Haynes King, *Jealousy and Flirtation* (1874, Fig. 102), hardly stands in need of a caption. The flirting girl with her inviting look, her hands resting on her head, is immediately intelligible as is the awkward but pleased reaction of the young man. The expression of jealousy may be a little too obvious and genteel, though the 'autistic' gesture of the girl's left hand is expressive enough.

Or take *The First Cloud* (1887) by Orchardson (Fig. 103). It would be interesting to test the interpretations of this scene by subjects who do not know the caption. One could certainly think of alternative interpretations, for after all we only see the woman from the back and have to project into her movements whatever we read in the man's expression. According to Raymond Lister, 'she is walking off in a huff ... the man's eyes following her with a somewhat puzzled though obstinate expression ...'[41] At any rate his expressive posture is a novelty to art.

It would be interesting to trace the development of these novel means and in particular to examine the role which book illustration on the one hand and photography on the other played in this development. One thing seems to me

sure. Given the story-telling function of anecdotal art we should be enabled also to trace another series of progressive skills in this as in any other type of representation. In fact, if we go back to the roots of this art in the genre paintings of the Netherlands and if we stop to examine the methods used by the first deliberate story-teller, William Hogarth, we will in all likelihood find that there is a gradual process of enrichment and refinement regardless of whether we like or dislike the ultimate result.

One could think of other topics and social functions which have driven the artist towards the exploration of non-verbal communication. Advertising, for instance, frequently demands the signalling of rapturous satisfaction on the part of the child who eats his breakfast cereals, the housewife who uses a washing powder or the young man smoking a cigarette. It has equally specialized in the exploration of erotic enticement, the 'come hither look' of the pretty girl or the inviting smile of the secretary who ostensibly recommends a typewriter. Clearly the commercial artist and the commercial photographer are likely to know a great deal about the degree of realism and stylization that produces the optimum results for this purpose and also about the changing reactions of the public to certain means and methods. Finally we may point once more to the unexplored realm of the 'comics' with their own conventions of facial expressions and gestures which have penetrated into 'pop' art. Art is long and life is short.

Author's Postscript

In conclusion a further elucidation of the use of the term 'expression' in relation to art may be useful. The traditional usage here adopted, which applies this term to the expression of the emotions of the figures in a dramatic illustration (*Laocoön*, the *Pietà*), has indeed been partly superseded by the approach of twentieth-century aesthetics, which so frequently regards the work of art as an expression of the artist's inner states.[42] To these may be added the most ancient usage which relates art predominantly to the emotions it is capable of arousing.[43] The interplay of these usages can best be exemplified in the history of musical theory. The Greeks (including Plato) concentrated on the *effects* of music on the emotions, which ranged from magical efficacy to the creation of moods. The dramatic theory of music favoured by the revivers of opera in the Renaissance and the Baroque stressed the power of music to *depict* or paint the emotions of the noble hero or the desolate lover. It was only in the Romantic period that music was interpreted as an expression of the composer's moods and sentiments. It will be observed that this change of attitude may leave the correlation between certain types of music and certain types of emotion unaffected: the proverbial trumpet call may be seen as

arousing, depicting or manifesting war-like feelings. Interest in these aspects changes with the changing social functions of music. It is the same with the visual arts. The magical function of arousal may reach far back to apotropaic images and survives in religious, erotic and commercial art. Interest in art as an expression of the artist's personality and emotion presupposes an autonomy of art only found in certain societies such as Renaissance Italy. Indeed Leonardo's observations on the link between an artist's character and his dramatic powers quoted above (pp. 127–8) point the way to this evaluation.

Editor's Postscript

Gombrich's interest in gesture and expression dates back to his early years and his work with Kris on the expressions on the faces of the statues of the founders at Naumberg Cathedral; this is discussed in 'The Study of Art and the Study of Man', reprinted in Tributes. *He moved this exploration further in his essay 'Botticelli's Mythologies', in which there is a remarkable footnote (23) on the interpretation of Venus in* Primavera; *it may be found on pp. 204-5 of* Symbolic Images.

Other important essays on the same theme are: Chapter X 'The Experiment of Caricature', in Art and Illusion; *'Moment and Movement in Art', 'Ritualized Gesture and Expression in Art' and 'The Mask and the Face: The Perception of Physiognomic Likeness in Life and Art' in* The Image and the Eye; *'The Evidence of Images II: The Priority of Context over Expression' in Charles S. Singleton (ed.),* Interpretation, Theory and Practice *(Baltimore, 1969); 'Four Theories of Artistic Expression', reprinted in Richard Woodfield (ed.),* Gombrich on Art and Psychology *(Manchester, 1996). Also worth looking at are two reviews: 'Expressions of Despair' in* Reflections on the History of Art, *and the review of Heinz Demisch's* Erhobene Hände *in the* Burlington Magazine, 131, no. 1041 (December 1989), p. 859.

On a related theme is 'Pictorial Instructions' in Images and Understanding, *ed. Horace Barlow, Colin Blakemore & Miranda Weston-Smith (Cambridge, 1990).*

Jennifer Montagu's doctoral dissertation, mentioned in the footnotes, has now been published in a revised form: Jennifer Montagu, The Expression of the Passions *(New Haven, 1994).*

Illusion and Art

Extracts from the chapter
'Illusion and Art', in R. L.
Gregory and E. H.
Gombrich (eds.), *Illusion
in Nature and Art* (London,
1973), pp. 199–207, 225–43

Simulation and stimulation

It may be useful to follow Plato and to start a discussion of illusion by considering the lowest layers, what he would have called the vegetative soul.[1] Clearly any organism must be 'programmed' to react to internal and external stimuli in a specific way which allows it to adapt to diverse conditions. Science has been hard at work decoding these 'messages' which cause the organism to 'take action' and even to achieve certain effects by the simulation of false reports. Thus the 'pill' may be said to act by sending out a false chemical message to the effect that pregnancy has occurred after which ovulation is inhibited. While these and many similar effects are not directly 'monitored' by the conscious mind, other forms of simulation notoriously carry over into mental states. Not that these stages should be confused with a veridical perception of the trigger action. Black coffee after a heavy meal – to mention no more noxious drugs – gives us the illusion of easing the digestion by numbing the vegetative nerves which are labouring with this task and preventing them from sending groans to our brain. We feel relieved, but are not.

Plato would certainly not have objected to discussing drugs in conjunction with the illusion of art. It was a commonplace of ancient criticism that what mattered in art were the 'effects', and these were as close to the action of drugs as they were to that of magic.[2] Orators and poets, musicians and even painters were celebrated as 'spell binders' who were able to arouse or to calm the emotions. Here, too, the 'animal experiment' was never far from the critic's mind. Orpheus who could charm the wild beasts was the model artist.

What must interest us in this time-honoured approach is precisely the insight that stimulation can, but need not, rely on the imitation of the trigger. There are plants and animals which are found to have an 'internal clock' regulating growth and behaviour to the length of daylight throughout the seasons.[3] These can certainly be 'deceived' by simulating the identical stimulus with artificial light, that is to say *mimesis*, but there are other biological reactions which yield to a much wider spectrum of stimulations. We know that nature herself – that is evolutionary pressure – has evoked such dummy keys by which one species ensures its survival at the expense of another, and it is much to be welcomed that this important aspect of illusion is discussed in this book by Professor Hinton.[4] What these astounding phenomena teach the student of art is precisely that there is a limit to perceptual relativism. What looks like a leaf to modern European must also have looked like a leaf to predators in fairly distant geological epochs.[5] Likeness is not only in the beholder's eye. But sometimes it can be. Following the lead of Konrad Lorenz, ethologists have systematically varied their dummies to find out what minimum features are needed to stimulate or 'release' a particular reaction. It appears that there are two variables here to be considered – the internal state of the organism, its disposition to respond in a particular way, and the character of the trigger. The strange experiment of 'imprinting' shows how far objective likeness can be dispensed with in certain situations. The duckling that is 'set' to follow its mother will also follow any other moving object, such as a brown cardboard box, and once it has been made to react in this way it will apparently remain under the illusion for the rest of its existence that the cardboard box is its mother. There are situations, it seems, where such triumphs as that of Apelles[6] can easily be achieved.

Readers of *Art and Illusion*[7] will not be surprised to find me appealing to these observations for I have emphasized their importance in summing up some of its results:

> The history of art ... may be described as the forging of master keys for opening the mysterious locks of our senses to which only nature herself originally held the key. They are complex locks which respond only when various screws are first set in readiness and when a number of bolts are shifted at the same time. Like the burglar who tries to break a safe, the artist has no direct access to the inner mechanism. He can only feel his way with sensitive fingers, probing and adjusting his hook or wire when something gives way. Of course, once the door springs open, once the key is shaped, it is easy to repeat the performance. The next person needs no special insight – no more, that is, than is needed to copy his predecessor's master key.

104
Leonardo da Vinci,
drawing of a cat, 1513–14.
Royal Collection,
Windsor Castle

There are inventions in the history of art that have something of the character of such an open-sesame. Foreshortening may be one of them in the way it produces the impression of depth (Fig. 104): others are the tonal system of modelling, highlights for texture (Fig. 105), or the clues to expression discovered by humorous art (Fig. 106). The question is not whether nature 'really looks' like these pictorial devices but whether pictures with such features suggest a reading in terms of natural objects. Admittedly the degree to which they do depends to some extent on what we called 'mental set'. We respond differently when we are 'keyed up' by expectation, by need, and by cultural habituation. All these factors may affect the preliminary setting of the lock but not its opening, which still depends on turning the right key.

Response to Meaning: the Magic of Eyes
It will be noticed that this argument makes no sharp distinction between emotional arousal and perceptual reactions. The 'clues to expression' discovered by humorous art are treated on a par with the suggestion of texture by means of highlights. I believe that this approach can be justified, but it may

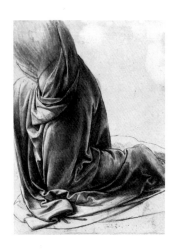

105
Leonardo da Vinci, study
of drapery, c.1483–5. Royal
Collection, Windsor
Castle

106
Leonardo da Vinci,
grotesque heads,
c.1487–90. Royal
Collection, Windsor
Castle

still be in need of explanation and elaboration. I should like therefore to take an example in which the two types of reaction are particularly closely allied, the perception and representation of eyes.

It is clear from the outset that real eyes cannot be simulated in images. Seeing eyes are in constant motion, pupils expand and contract, their colour tends to change with the light, their moisture varies, not to speak of the lids and surrounds that will incessantly transform the 'look' of the eye.

Without this influence the 'art' of make-up would never have developed.[8] The setting transforms the appearance of the eye, though exactly how it will transform it is impossible to predict in advance. It is experience, tradition and trial and error which show the make-up expert how to create 'the gentle look' (Fig. 107). We know it when we see it, because the springs of our response have been touched in the right way, but it is the meaning we perceive, not the means.

So dominant is this immediate reaction, that it comes as a mortifying discovery how hard it is to answer specific questions about the shape and appearance of the human eye. Of course this difficulty will not be experienced by ophthalmologists or by artists who were trained in the traditional way (Fig. 109), but most of us will hesitate when we are asked to draw a horizontal section through the head (Fig. 108), across the root of the nose, and indicating the exact shape of the eye sockets. It then turns out that we have a schematic image in our mind of their position when seen from *en face* and another, less accurate one, of the profile, but it is difficult for most people to visualize exactly the transition from one view to another, though they see it continually. I confess that I have to touch the two corners of my eyes to become fully aware of their relation in space.

This tendency of ours to look for meaning rather than to take in the real

107
The 'gentle look' and how to achieve it

108
The spatial relationship between the eyes and the surface of the face as shown in cross-section

appearance of the world has been a constant theme of art educators who want to change our attitude. I would not deny for a moment that it can be an exciting and liberating experience to discover the true look of things by learning to draw or by studying art, but what I am disposed to question is the assumption that scanning for meaning is just a form of mental laziness. We could not function without this vital principle which Bartlett called 'the effort after meaning'.

I believe this principle to be part of our biological inheritance. Whether or not our response to eyes is inborn – as I would suspect – or learned through something like early 'imprinting', there is an obvious survival value in recognizing the eyes, and even the direction of the gaze, of our fellow creatures. It is useful to know when and how we are being looked at if we want to respond adequately to the threat or invitation of another creature. Professor Hinton's chapter shows that this advantage has also led other organisms to react to the standard configuration of two eyes which may act as a warning signal of the presence of a lurking predator (Fig. 110).[9] This, at least, would explain the frequency with which certain moths have become marked with 'eyes' on the wings, a marking that appears to deter birds from approaching them. When the markings are artificially obliterated the moths are more frequently eaten by predators.[10]

Not even those of us who are not behaviourists would ever want to say that

the markings of the wings have produced an illusion in the birds, if by illusion we mean a state of consciousness, a false belief. Very likely the bird is stimulated to react without the possibility of conscious reflection. But the point is just that reaction precedes reflection, both phylogenetically and psychologically. What distinguishes us from the animal is not the absence of automatic responses, but the capacity to probe and experiment with them.

I have appealed to this method in *The Story of Art*,[11] where I asked the reader to scrawl an eyeless face on a piece of paper and to watch the experience of relief when two dots at last enable it to look at us. When I wrote the book I did not yet know the full weight of anthropological evidence which shows the strength and immediacy of this type of reaction. In Ceylon the act of endowing a Buddha statue with eyes is surrounded by strict taboos, because in painting in the eyes the craftsman brings the image to life. The effect is regarded with such awe that not even the craftsman himself is allowed to look while this miraculous transformation takes place. He paints the eyes over his shoulder while looking into a mirror, and nobody else is allowed to watch the ceremony. On his return from the sacred act the craftsman must be purged, and if he omits these precautions he will be exposed to supernatural sanctions. Richard F. Gombrich, to whom I owe this account,[12] stresses the paradox inherent in the situation. Any Buddhist knows that the Buddha has entered the Nirvana and has been thus liberated from the wheel of existence. Rationally, therefore, the Buddha image can be no more than a mere reminder of the great teacher. But man is not merely rational, and so he will react affectively to the image as if it could look through its eyes. The ritual testifies to the strength of an illusion that is explicitly ruled out by the cognitive doctrine which it serves.[13]

Yet, the illusion is not one of visual reality, it is one of meaning: the eyes

109
Drawing from an artist's manual by Louis Corinth, showing the eyes lying on a curve

110
The eye spot on the wing of an Emperor Moth even has a highlight in the 'pupil'

111
Agnolo Gaddi, *Madonna of Humility*, detail of the left eye. Courtauld Institute Galleries, London

112
Nicolas Poussin, *Eliezer and Rebecca*, c.1660, detail of eye. Fitzwilliam Museum, Cambridge

113
Rembrandt, *Self-Portrait*, 1669, detail of the right eye. National Gallery, London

114
Auguste Renoir, *La Loge*, 1874, detail of right eye. Courtauld Institute Galleries, London

appear to give the image sight. But is not this exactly the same reaction we have when looking at our fellow humans? We see them looking. Though we may know rationally that there is no difference in outward appearance between a seeing eye and a blind one and that even a glass eye can reasonably simulate this appearance, I contend it would be false to experience to say that any eye looks like a vitreous sphere. The task of the artist therefore is not necessarily to fashion a facsimile eye. It is to find a way of stimulating the response to a living gaze.

Different styles have adopted very different means of coping with this problem, which may be compounded by the very taboos I have mentioned. It would not be without interest to investigate in the light of this problem the variety of ways the human eye has been rendered in the history of art.

There is ample evidence in the history of sculpture for the difficulties craftsmen experienced in correctly shaping a face in the round. The eye sockets are frequently set into a flattened face, though squeezed profiles also occur. As far as the shape of the eye is concerned, there is a whole spectrum of possibilities, from the schematic dot to the artificial eye of a wax dummy. What may strike the historian of art as odd is how far some of the conventions adopted in certain periods or by various artists were at variance with real appearance. The Giottesque tradition favoured slanted eyes which almost look mongoloid (Figs. 111, 112); Poussin so emphasized the rim round the eyes that his figures often acquire the stony stare of the classical statues he so admired. It is impossible for us to tell how such deviations affected the artist's contemporaries who were not used to alternative solutions. Using the formulation I have quoted above, it might be said that we have acquired a different 'mental set' through 'cultural habituation' and no longer respond spontaneously to these renderings. It is because we do not so respond that

we see these eyes less as eyes than as slightly odd shapes on the canvas.

But here, as always, there is no need to draw a relativistic conclusion from this variety. There is little doubt in this case that the discovery that a glint can be given to the eye and make it shine enhanced the appeal of the image. Not that a great painter, a Rembrandt, a Renoir (Figs. 113, 114), needed to make an exact copy of the eye to achieve this effect. On the contrary, the true masters of illusionism knew of ever fresh ways to trigger our responses, precisely in the way I tried to describe in the simile of the lock and key. The most astounding of these devices is the one employed by the eighteenth-century sculptor Houdon. Marble, of course, is even less capable of imitating the appearance of a real eye than are pigments, and so he had recourse to the daring trick of making a protruding piece of stone stand for the light in the eye (Fig. 115). Much as I have always admired Houdon's splendidly life-like heads, I did not see this device till it was pointed out to me. The more a master succeeds in convincing us that the image looks at us, the less likely we are to realize what is actually there. He has transformed the image into a living presence.

'We might say that the eyes look like real eyes, though real eyes do not look at all like his representation. I am aware of the fact that logically this proposition is absurd. If *a* equals *b*, *b* must also equal *a*. But I have argued elsewhere that this symmetrical relationship does not describe what we experience as likeness in art. I have trailed my coat and proposed the formulation that the world does not look like a picture, but a picture can look like the world.[14] The catch, of course, is the word 'look'. I have argued that we are less aware of the look of things than of our response. If it is really part of our biological heritage that certain perceptual configurations can 'trigger' specific reactions, it is clear that these reactions are adjusted to our survival in the real world, not to our contemplation of pictures. If I am right that in this

respect, too, we are closer to the animal than our pride would want us to be, this might suggest that like the animals we do not know and do not have to be aware of what the world looks like. The person who has to be – so it would seem at first – is the artist who wants to contrive a configuration to which we react as if it were an aspect of the world. I have argued in *Art and Illusion* that even this conclusion need not hold: that even the artist has to grope his way by trial and error till he discovers the configuration that produces the desired response.

This response need not be visual – but clearly it can be. We may easily believe that we see more of the eye on the canvas than is present in the artist's brushstrokes. In other words the response to meaning guides our projection, and we think we see shapes and colours which are not actually there. . . .

Illusionistic painting

Maybe we are now at last equipped to return to the starting point of this debate, the degree of illusion evoked by a seascape on the museum wall. Those philosophers who claim that there is no difference in principle between the shapes we see on an illusionistic canvas and other conventional forms of notation may be granted the fact that any symbolic system could appeal to our imagination and transport us into an illusionary world.

It is quite true that if I am shown a map of my native city and asked to trace my daily way to school the shape and names of the streets may affect me emotionally (Fig. 116). I may even find that my imagination is stirred and that sights I had almost forgotten arise before the eyes of my mind. But of my mind only. My daydreaming would not interfere with my perception of the map or cause me to imagine shapes which on examination would prove to be illusory.

There are styles in art which are essentially map-like. They offer us an enumeration of what – for want of a better word – I still would like to call 'conceptual images', pictographs which tell a story or give an inventory of stage props. Many a medieval picture of the sea would fall into this category (Fig. 117). To read it may not differ much from reading a poem about the sea. But the historian of art also knows that at a given moment such diagrammatic pictures were rejected as inadequate, precisely because they fell so far short of the claims that had been made for the power of painting to create an illusion.[15] Slowly but surely those devices were developed which I have described as keys to the lock of our perception. Not that this fresh dimension would stunt the appeal to the imagination. A Dutch seascape may also cause me to dream and to imagine in a fleeting reverie that I hear the rush of the wind or sense the breeze (Fig. 118). Why else should Fuseli have quipped that the sight of

Constable's landscapes made him open his umbrella? Needless to say, however, he was not acting under the influence of an illusion. The visual illusion can only be said to take over where the beholder's reaction fuses with the picture and so transforms it that it becomes increasingly hard to specify exactly what is really there on the canvas.

Once more it seems to me a mistake to start this examination by asking whether I see painted distance as distant. It is more prudent to begin with the question as to whether certain tones or lines are actually given or merely imagined. For here, as always, perception will tend to 'run ahead of the evidence'. The problem, then, is in what direction it will run. It is here that the perception of meaning plays such a vital part. Take what we call the illusion of movement in a painting. Nobody thinks that the sailing boat is actually racing out of the frame, but there are experiments to suggest that if we understand its direction and speed we will anticipate its shift to some extent.[16] The configuration will be tense with a directional thrust which can be measured in the tachystoscope.

Gestalt psychologists have investigated the phenomenon of 'closure', the tendency to ignore the gap in the circle exposed to the view for a moment. Here, too, similar experiments might be devised for representational pictures. My hypothesis would be that the 'filling in' would again be determined by the

interpretation of what is represented. Everyday experience, even in looking at a blurred photograph, supports this assumption. In my submission we can even go further here. For I would contend that the filling in, the phantom percept, if we so want to call it, will not follow the lines on the surface as it does in the phenomenon of closure, but will obey the laws of three-dimensional representation. If I look at a painting of the calm sea convincingly showing the ripples of the waves, the reflections of boats and the sheen of light, I will fill in the surface of the water that is not actually represented in paint and will fill it in as a horizontal expanse, not as a vertical patch of pigment on the panel. The question of 'depth' or 'space', in other words, is bound up with that imaged orientation. To say that I have no illusion of depth is really to say that I only know intellectually that the ripples are not meant to be on top of each other but signify an extension into the distance.

Now this contention has in fact been experimentally tested and refuted. It has been refuted precisely because the 'tendency to run ahead of the evidence' can be shown to have the same kind of effect on the appearance of objects represented in pictures as it has on those in three-dimensional space. Our 'expectation' that a small object in the distance would prove to be larger than it appears to be at the moment, once we approach it, notoriously makes us see distant objects as larger than their retinal size would allow us to infer. This is

118
Willem van de Velde the
Younger, *The Shore at
Scheveningen*, c.1670.
National Gallery,
London

the so-called 'constancy' phenomenon. The term has been criticized because, as Dr Thouless has stressed,[17] phenomenal size appears to be a compromise between retinal size and inferred size. Personally I am not very happy with the concept of phenomenal size altogether, because in real life situations it proves to be a very elusive entity.[18] It is different with paintings.[19] We can measure the represented size and the apparent size by a variety of methods[20] and see that patches of paint which are objectively equal in extension 'appear' to be very different in size if they stand for a distant sail or for a pebble on the beach in the foreground. More evidence for the illusion of depth comes from the shift in apparent orientation following a change of viewing point (Figs. 119, 120, 121).[21] The 'constancies' mask the perspectival distortions of the picture plane and make us read them as movement in space.

If illusion was not a dirty word in visual research, we would by now know as much of these effects as Hi-Fi engineers presumably know about auditory perception. What, for instance, is the exact effect of stereoscopic devices on these illusory transformations? What is the relative importance of facsimile fidelity and of context? There is obviously a spectrum in the 'imitation of reality'. At one extreme we would find the panoramas beloved of the nineteenth century, in which real bushes and pebbles were placed in front of the curving canvas to give the visitor as complete an illusion as possible of being transported to an imaginary scene, be it a battle (as in the panorama of the Berg Isel still shown in Innsbruck) or a seascape (as in the Mesdag Museum in The Hague). Here the visitor can look around on all sides without encountering blatant contradictions, but it is well known that the

119, 120, 121
Meindert Hobbema, *The Avenue at Middelharnis*, 1689. National Gallery, London. Seen from any angle the road in the picture appears to lead towards us. The illusion is due to the transformation of the picture plane

very fidelity of detail may enhance the clash with the absence of movement and life. At the other end of the spectrum we would have to place those media which exclude surface fidelity, be they monochrome sculptures or line drawings (Fig. 122). What happens here to the observed effects on the constancies of size and orientations?

To some extent these phenomena are independent of the medium: they occur in line drawings as well as in naturalistic paintings. The question would be to what extent. Gibson, of course, is quite right in stressing the relative

122
Willem van de Velde the
Younger, *Two Men of War at
Anchor with Three Small Boats*,
c.1686. Fogg Art Museum,
Cambridge MA

character of naturalism when it comes to representing an open-air scene.[22] Pigments can never fully simulate those textural gradients which he has shown to be of such importance to our perception of depth, nor can painting offer us the resources of binocular vision. The field is wide open for experiments to probe and explain the degree to which these apparent handicaps can be overcome in mobilizing our response and projection (Fig. 123). One of these experiments is easy to perform. We need only look at our seascape through a tube, thus cutting out the frame and any surrounding features. The result can be dramatic, so much so that I know of a medical student who, having discovered this effect for himself, wanted tubes to be on sale or loan at picture galleries to facilitate the enjoyment of paintings. Artists and critics are unlikely to adopt this device, but psychologists should not ignore its heuristic value. Obviously the tube masks the contradictory percepts of the frame and the wall and obviates in this respect the need for the all-round panorama. Even more important, it cuts out binocular disparity which normally enables us to perceive the orientation and location of the canvas, and this alone eliminates more contradictory percepts. It becomes genuinely difficult in this situation to estimate our distance from the painting. True, it may not always be easy to estimate our distance from a blank wall either, when we look at it through a tube, but the point is precisely that where our perception is unsettled, as it is in this case, illusion more easily takes over. We fill the void of our uncertainty with the information we are fed by the pictures, and since it coheres in our field of vision we begin to enter into the game.

Here, moreover, is the moment to recall the fact mentioned at the outset, that the production of a perfect facsimile of a flat object is not, by itself, beyond the resources of art. There are passages in many naturalistic paintings

which come close to such a facsimile, be it of a curtain, a book cover or a leaf. Isolating such passages will naturally enhance their *trompe l'œil* effect, but it will also make us more ready to give credit to the surround – the same effect that is served by the real foreground features of the panorama. The smaller the visual field the more likely will this effect obtain, though here again we would need controlled experiments to examine the variables that come into play.

One thing might be predicted. In low-fidelity media the tube experiment would reveal more complex relationships. Looking at a painting as meticulously detailed as a Van Eyck even the smallest area of a painted damask (Fig. 124), or even of a lawn, would mobilize our projection. Looking at a line drawing we would obviously have to see enough to be able to make sense of the configuration before the effects of illusion could take over. It is precisely in this way that we could therefore study the devices evolved by art to suggest convincing readings without any recourse to facsimile. We would find that it is in the exploitation of our response to gradients that the graphic arts have found such a compelling trick. The invention of hatching enables the draughtsman or engraver to indicate form and depth by variations of density (Fig. 125). If we narrow our tube, the moment will surely come when we see the medium rather than the message (Fig. 126). There will be senseless lines rather than a representation. What happens when we then return to the unimpeded view? To what extent can we retain our awareness of the means and see the representation at the same time? Perhaps the word 'seeing' is too

imprecise here to settle this much-discussed question.[23] What can be investigated is the tendency so to ignore contradictory clues that the percept in front of us is transformed. I contend (to repeat) that there is a different between the appearance of a piece of paper showing the map of a city (Fig. 116) and one showing a view of a city (Fig. 195). In the first case there is 'ground', in the other 'background'. The degree of this transformation must depend on many variables – cultural conditioning, emotional involvement and therefore the nature of the subject-matter. Some of these variables I discussed in the section dealing with the rendering of eyes. It is probably less easy to see an eye in a mere scrawl or pattern of dots on the surface of the paper than it is to see a fold in a sleeve in this way (Fig. 127). But as soon as the representation clicks and we obey its instruction the object that we recognize will also be felt to be potentially mobile. It will tend to be surrounded by a fluctuating halo of imaginary space. Unless my introspection deceives me, the extent of this halo on a plain background will roughly coincide with the area of focused vision. We can fix it more firmly by drawing a frame round the object. Provided we

124
Jan van Eyck, *Madonna and Child with St Donatian, St. George and Canon van der Paele*, 1436, detail of robe. Musée des Beaux-Arts, Bruges

125
Fingal's Cave. Engraving

126
Cross-hatching. Details of
the cliff face in Fig. 125

take in the framing line and the image at one glance the drawing surface is likely to recede from our awareness.

It is for this reason that I am not quite happy with the suggestion made by Gregory[24] that representations should be classified as 'impossible objects' – objects, that is which give us contradictory impressions at the same time. Once more it may be worth reverting to our tube. Viewing a drawing of an 'impossible object', such as the notorious tuning-fork, through a narrow opening, we see indeed a coherent configuration which suggests a hypothesis of what might come into view when we move the tube elsewhere.[25] These assumptions will be belied by another view, which will suggest a different reading, inconsistent with the first. But here there is no uncertainty, no way of ironing out these disturbing contradictions except by adopting the correct hypothesis that what we see is not a turning-fork of impossible shape but a very possible drawing on paper.

The situation may be a little more complex in the case of a real object, such as the barber-pole illusion. Looking at the turning pole through our tube, we have no means of knowing that there is not a real ribbon rising and rising. Seeing the whole we must revise our interpretation, but since the correct hypothesis is a little harder to grasp, the illusion of the rising ribbon may persist against our better knowledge.

One may grant that there is something of this experience in the viewing of certain representations when our attention becomes divided. The Victorian literature on decoration is full of warnings against the use of illusionistic three-dimensional pictures on fabrics or china, lest the conflict of looking at the jug and at the landscape may be felt to be disturbing (Fig. 128). But I do not believe that such a conflict is frequently experienced. Few of us find it troublesome to look at a cereal package with lettering and pictures. There is

nothing paradoxical about them, and neither is there, I would suggest, in a painting on the wall.

It is here that we may concede a point to the 'conventionalists' who compare the inspection of paintings with the reading of any other notation. What the two activities have in common is surely the effort after meaning to which I have devoted so much space in this essay. This effort involves the 'mental set' of readiness for anticipation; it implies fitting the percept at least provisionally into an imaginary sequence to which we become keyed to attend.[26]

All looking — not only looking at pictures — involves a sequential process that has something in common with reading. True, we can sweep our focus more readily round the room than we can pick up the letters, words and meanings of this page, but both activities are essentially constructive processes that happen over time.[27]

Photographs of eye movements in inspecting paintings confirm that trying to understand a representation involves a test of consistency. As such, it is a sequential process with a logic of its own. The focus of attention shifts from points of high information content to those areas where the postulated interpretation is likely to be confirmed or refuted. The road towards illusionism is the road towards visual consistency, the non-refutation of any assumption the representation evokes. The road away from illusion in twentieth-century art led through the cunning inconsistencies and ambiguities of Cubism which deny us the resolution of a coherent reading — except that of the canvas.[28]

A number of experiments might be devised to test the sequential nature of these activities and its influence on our perceptions. They might make use of ambiguous figures, new and old, but put them into a slightly novel context. Take the example of eyes for a last time. There are humorous drawings which show an eye that is common to two faces (Fig. 129). We can make the one a happy and the other a melancholy face. Clearly, in focusing on the alternate faces the double eye changes its character and mood, reinforced by the fact that once it is a left eye with eyebrows raised to the centre, and then a right eye with the eyebrows drooping in the other direction. It is the direction through which we come at these drawings that may determine our reading.

It might be worth while to investigate some of the familiar ambiguous figures and other illusions known to psychologists to see how a given reading can be suggested or enforced. Rubin's vase easily becomes a vase when we add flowers and just as easily two faces when we give them ears outside the frame (Fig. 130). Mask either, and the other reading is ensured. Put the 'American Indian or Eskimo' figure into appropriate contexts, and you may also eliminate the other reading (Fig. 131).

127
Has the medium — dots of varying size — to be suppressed if we are to see the message? Hold the book at a distance and the image becomes an eye. What happens when you return to the close-up?

128
Vase decorated with a landscape figure. Is there a conflict between landscape and vase?

129
Happy and melancholy
faces

130
Rubin's vase

It is from here that I should like to return to our central problem, the double perception of paintings, the one demanding concentration within the frame, the other a different sequence that takes in the wall and the surround. The effect of these sequences could also be tested by making use of those constancy illusions that occur within paintings. Take the shapes of objectively equal size which appear to grow as they are placed farther back in a perspective schema. How far would the phenomenon persist if we repeated the shapes outside the frame and turned it into a motif of the wall-paper? In that case, I suggest, the effect would be influenced by the sequence of fixation points (Fig. 132). The illusion should diminish if we read the shapes across the picture and concentrate on the repeat pattern.

Those who ask about our 'beliefs' in front of paintings are certainly asking the wrong question. Illusions are not false beliefs, though false beliefs may be caused by illusions. What may make a painting like a distant view through a window is not the fact that the two can be as indistinguishable as is a facsimile from the original: it is the similarity between the mental activities both can arouse, the search for meaning, the testing for consistency, expressed in the movements of the eye and, more important, in the movements of the mind.

This result does not seem to square too badly with the main findings of Deregowski's chapter about the reactions of naïve subjects to representations,[29] though the interpretation of these findings may well be in need of further refinement. For anyone who has never seen a snapshot, an illustration or a painting it cannot be obvious how to deal with this unfamiliar object. But if the picture coheres in the manner described above so as to confirm and refute predictions, it should not be hard to transfer the skill of perceiving a scene to the reading of the representation.

This hypothesis seems to me strengthened by the effect of moving pictures. Where there is a sequence imposed upon us within the frame which carries the confirmation and refutations we employ in real-life situations, it becomes indeed almost impossible to read the picture and attend to the alternative system in which the screen is an object like any other in the room. The cinema, of course, enhances the illusion by darkening the room, and television viewers may do the same, but even without this additional aid to illusion it seems to me very hard to remain aware of the projecting surface. Even if the show will not involve us emotionally, it is next to impossible to 'concentrate' on the screen to the extent that we merely see expanding and contracting shapes rather than people and objects approaching and receding. I, for one, have never succeeded in so suppressing my responses and anticipations. Not, to repeat, that this compels me to say that the cinema or television so overwhelms my critical faculty that I become deluded: but my experience is

131
The Winson figure.
American Indian or
Eskimo?

132
When we isolate the
perspectival picture (by
covering up the rest of the
illustration) the three
figures within the frame
appear to take up a
different amount of room
on the page. What
happens when we see
them in conjunction with
the identical silhouettes
arranged in a pattern?

shot through with illusions which remain uncorrected. One of them — as Gregory has reminded me — is actually the same as the despised ventriloquist illusion. I hear the voice of people coming out of their moving mouths and shift direction as they change their place on the screen, but this is merely due to the unrefuted expectation that speech and lip movements are connected.

It would be interesting to investigate further the hypothesis here presented, that the illusion of representations rests on the degree to which they arouse our mental and physical activity, much of which lies outside the reach of introspection. Perhaps we could take our doubting Thomases to one of the simulators used for training drivers and pilots, where the screen shows a moving picture of the road or landscape through which they are supposed to be moving while they have to make such predictions and take such actions as the situation would demand, steering clear of sudden obstacles or correcting the tilt of the plane by pressing levers and reading instruments. Not that even this creation of a highly consistent interlocking system would necessarily blot out their knowledge of where they are and what they are doing, but they would have less and less time to spare for the confirmation of their disbelief.

I should like to make it clear that I do not propose to subject my philosophical critics to this ordeal in order to demonstrate to them that all art aspires to the condition of simulators. It does not. My point is rather that they might be hard put to if they wanted to describe their reactions in what is called 'ordinary language'. Language, I believe, developed as a social tool to communicate ordinary experiences, hypotheses about the world out there and our normal reaction to typical events. It fails notoriously when we want to convey the elusive states of subjective reactions and automatic responses. Art,

I have tried to show, plays on these responses, which lie largely outside our awareness. Plato, indeed, wanted to see it banished from the state precisely because it strengthened those responses of the 'lower reaches of the soul' which he wanted to submit to the dominance of reason. To him illusion was tantamount to delusion. He saw art in terms of a drug that enslaved the mind by numbing our critical sense. No wonder the tradition of classical aesthetics has tried to rescue art from this charge by insisting on the 'aesthetic distance' that keeps the mind in control. There is much value in this tradition, but I believe that no verbal formula can do justice to the complex interplay between reflex and reflection, involvement and detachment that we so inadequately sum up in the term 'illusion'.

Editor's Postscript

This extract develops the arguments of 'Conditions of Illusion' in Art and Illusion, *which also generated a great deal of controversy. It is a text which has tended to be neglected in the debates over pictorial illusion.*

Many philosophers and literary theorists have made the mistake of thinking that Art and Illusion *offers the theory that art's business is deception. But art includes many other things besides naturalistic paintings and deception is not the same as illusion. We might remember Constable's remarks on the diorama: 'It is in part a transparency; the spectator is in a dark chamber, and it is very pleasing, and has great illusion. It is without [i.e., outside] the pale of art, because its object is deception. The art pleases by reminding, not by deceiving.' Despite views to the contrary, this was a typical attitude amongst naturalistic artists; on this subject see, for example, Svetlana Alpers, 'Ekphrasis and Aesthetic Attitudes in Vasari's Lives',* Journal of the Warburg and Courtauld Institutes, *23 (1960). It is, though, a remarkable fact that naturalistic artists can simulate the appearance of the visible world.*

This discussion of projection, which is at the heart of illusion, usefully complements Gombrich's views on the role of categorization in 'Truth and the Stereotype'. Any adequate theory of perception will have to take both phenomena into account; this makes many psychologists extremely uncomfortable. On this subject note, for example, Gombrich's debate with J. J. Gibson, the famous theorist of ecological perception: J. J. Gibson, 'The Information Available in Pictures', Leonardo, *4 (1971), pp. 27-35; Gombrich's response, ibid., pp. 195-7; Gibson's rejoinder, ibid., pp. 197-9; Gombrich's reply, ibid., p. 308. Gombrich then (1974) made a contribution to Gibson's festschrift, '"The Sky is the Limit": The Vault of Heaven and Pictorial Vision', reprinted in* The Image and the Eye. *Gibson took up the argument again in 'The Ecological Approach to the Visual Perception of Pictures',* Leonardo, *11 (1978), p. 227; Gombrich's comment,* Leonardo, *12 (1979), pp. 174-5. See also his review of Edward S. Reed,* James. J. Gibson and the Psychology of Perception *in* The New York Review of Books, *21, 22 (19 January 1989), pp. 13-15. There are additional comments in* A Lifelong Interest, *for which consult its index. Further relevant material is available in* The Image

and the Eye. *It is a matter for some concern that psychologists have rarely taken cognisance of this debate.*

While writers on aesthetics have doubted the facts of illusion, modern technology serving the entertainment industry has made spectacular advances in its production, culminating for the time being in what has been called virtual reality. These discoveries have also served the practical purposes of training car drivers and pilots in their contact with the real world. Before the movies, the toy and entertainment industry also created undoubted experiences of illusion, notably in the diorama and stereoscope.

The subject of phantom visions needs further exploration by psychologists.

1. *Quoted by Gombrich in* Art and Illusion, p. 33

The Use of Colour and its Effect: the How and the Why

This text is an edited version of a conversation between Gombrich and Bridget Riley, the second of five interviews with the painter produced by Judith Bumpus and broadcast on BBC Radio 3 in connection with Bridget Riley's exhibition *According to Sensation, Paintings 1982–1992*, held at the Hayward Gallery, London, autumn 1992; published in the *Burlington Magazine*, 126 (1994), pp. 427–9

EG: Bridget Riley, I would like to start by asking you your views on Constable's pronouncement that painting is a science and should be pursued as an enquiry into the laws of nature. Constable continues that pictures may be regarded as experiments in that science. What is your attitude to this idea?

BR: I have always loved Constable, but I can't quite agree that painting is a science, or at least not what I understand by science. Nor do I think that his paintings are experiments. He was working at the end of a great tradition when painting had become stale, tasteful and 'historical'. Artists were imitating, quite blindly, 'the look of art', making paintings which looked like earlier great works but which didn't spring from original feeling or insight. In that sort of context studying atmospheric phenomena, *knowing* exactly what gave rise to the formation of a particular cloud, for instance, set him free to respond in a fresh way to nature instead of simply exploiting what turned up in the way of paint blotches.

EG: But surely it is observation he also had in mind? At that time observation was considered to be the key to a natural science, but I believe you have also said that in your own work it is not a theory of optics that interests you, but the appearance of things, and therefore the behaviour of light as you can observe it, rather than the optical reasons for the behaviour of light.

BR: That is true, my work has grown out of my own experiences of looking, and also out of the work that I have seen in the museums and in galleries, so I have seen other artists seeing, and that has been an enormous help to me

and a kind of pattern maker, in that it has shown me how a formal structure of looking is shaped and can shape in turn the way that one proceeds with one's own work.

EG: So you prefer to look at pictures rather than to read books on optics?

BR: Yes, I do.

EG: I'm glad to hear that. And for that reason I suppose in your own work, you have always concentrated on particular problems which interested you, visual problems, rather than scientific problems, which you try to work out in exemplifications, as it were, by relatively controlled and clear juxtapositions of shapes at first, and colours later in your work, which have sometimes a very surprising effect, that you could not have predicted from the pure physics of the behaviour of light. Would you agree there?

BR: I haven't studied the pure physics of the behaviour of light, but in the early 1960s I realized that the most exciting way of setting about work was to establish limits, in terms of each particular piece, which would sometimes push me and the work as we evolved together into such tight corners that they yielded surprising riches. It was like a forcing house: through limiting oneself, even severely, one discovers things that one would never have dreamt of.

EG: I'm sure that it's so. But that of course has a parallel in science, and in a way also in our world of art, that the artist cannot roam all over the place, he must 'concentrate'. That is perhaps the simplest word. In your catalogue you quote a beautiful passage from Stravinsky about it. Would you like to read it to us?

BR: It's from one of the six lectures on the making of music that Stravinsky gave at Harvard in the winter of 1939–40. They were published in a book called *The Poetics of Music*, which, along with Paul Klee's *Thinking Eye*, became one of my 'bibles' in the 1960s, and this particular paragraph struck a very powerful chord: 'My freedom thus consists in my moving about within the narrow frame that I have assigned myself for each one of my undertakings. I shall go even further: my freedom will be so much the greater and more meaningful the more narrowly I limit my field of action and the more I surround myself with obstacles. Whatever diminishes constraint diminishes strength. The more constraints one imposes, the more one frees oneself of the chains that shackle the spirit.' I think that's a very beautiful piece, and it became a guiding principle.

EG: I found it immensely illuminating, that in connection with this problem of self-limitation, you write or say 'if the modern artist is no longer subject to external restrictions, then this simply means that he has this freedom to set himself limitations, to invent, so to speak, his own sonnet form'.' I think

that is a very beautiful and illuminating comparison, and it made me think of what Goethe said about the sonnet, which, as you indicate in your quotation, is of course also restricted to fourteen lines and a fixed rhyme scheme. I cannot translate Goethe's sonnet about a sonnet in rhyme, but I've tried to make it at least scan. These are the concluding lines:

> This is the way with all types of creation:
> It is in vain that an unbridled spirit
> Will try to reach the summit of perfection.
> Self-discipline alone can lead to greatness.
> Accepting limits will reveal the master,
> And nothing but the law can give us freedom.

I believe that you must have experienced this freedom within the law in your creations which parallel the trying to write a sonnet.

BR: Yes, I have. Those marvellous moments of freedom are the rewards, they are amongst the pleasures for which one works.

EG: Do you think that you can predict these moments, or do they come unbidden, as a grace, as it were?

BR: They come unbidden. I find that if they become...

EG: Predictable?

BR: Yes, predictable, then they lose their bite, they lose their vitality.

EG: Lose their bite for *you*?

BR: Exactly. Then I can't go on in that particular vein because the contact with what I am doing, the feeling of life, comes in part out of being surprised.

EG: I see. It is the medium which gives you surprise?

BR: Indeed it's the medium that surprises. One of the most wonderful things about painting is that its resources are inexhaustible.

EG: It is the dialogue with the medium, if you like, I think you also said that somewhere. I'm sure that it's very, very important.

BR: Yes, until you get this dialogue going, you're getting nowhere.

EG: You cannot simply lie in your bed and imagine what you will want to paint?

BR: That's impossible!

EG: It will turn out differently?

BR: You cannot plan like that.

EG: No.

BR: But that, of course, is one of the most exasperating things about making a painting, because although one longs to use one's intellect as such, one

finds that one cannot do so in the way one normally does. What is in that way viable turns out to be beside the point. It seems to be less a question of successive thinking than an instantaneous response.

EG: You must remain open to what the medium wants?

BR: Yes, and one will need all one's experience and flexibility to field it.

EG: I'm sure it's a little similar to the chess-player who knows all the openings by heart, but gradually it becomes unpredictable what is going to happen, otherwise it wouldn't be a game at all?

BR: That's a good comparison.

EG: The reason, I suppose, is that particularly as soon as you work with colours, the mutual effect of colours are indeed almost unpredictable because there are so many variables involved. We all know that if you put two colours side by side, the contrast may enhance them, or there may be what has been called the spreading effect, they may spread into each other visually, and therefore change in the other direction. I'm sure that in your work you must experience this all the time, and be both delighted and sometimes perhaps disappointed by this mutual effect of colour.

BR: Yes, that is true, very much so, but it is also true of black and white. In my earlier work during the 1960s I found that they, along with greys, behave in a way somehow similar to colours, that is to say activities such as contrast, irradiation and interaction were taking place there too. I think that painters have known this for a very long time – there are a myriad sensations and one has to pick one's way through. There is a story of Delacroix running into Charles Blanc one night and explaining to him the secret of colour painting. He points at the muddy pavement saying 'if someone asked Veronese to paint a fair haired woman with those colours, he would do just that and *what a beautiful blond he would make on his canvas!'*[3]

EG: Wonderful, this is absolutely true, and in a way we may also describe it as scientifically correct. Even so, I am convinced that John Ruskin was also right, when he said that there are no rules by which you can predict these effects. If I may quote him at some length:

> While form is absolute … colour is wholly relative. Every hue throughout your work is altered by every touch that you add in other places … In all the best arrangements of colour, the delight occasioned by their mode of succession is entirely inexplicable. Nor can it be reasoned about. We like it, just as we like an air in music, but cannot reason any refractory person into liking it if they do not. And yet there's distinctly a right and a wrong in it, and a good taste and a bad taste respecting it, as also in music.[4]

BR: He's absolutely right. It's interesting that he makes this comparison with music. The common ground between music and painting seems to lie in the organisation of their abstract qualities. In music it's very clear, such things as the accumulation of sound, the dispersal of sound, the ebb and flow, the rise and fall, the contrasts and harmonies are arranged according to certain principles. In picture-making the masses, the open and closed spaces, the lines, tones and colours can be organized in a parallel way. It's as though these relationships are built up in all their complexity in order to provide a vehicle for those things which cannot be objectively identified but which can nevertheless be expressed in this way. Music articulates this indefinable content and it seems to me that this also applies to abstract painting, or at least the strongest of it.

EG: You have talked about a cycle of repose, disturbance, and repose, and surely this is, at least in Western music, in our diatonic system, the basis of all music, the possibility of a resolution of a discordant sound in the cadence and so on. And I'm sure that here too, we have of course a scientific background in acoustics, as colour has a scientific background in optics, but acoustics alone have been shown not to work if you really want to analyse music, because in acoustic, what is called even temperament has no place. That is to say the scales of our piano are not tuned exactly according to the laws of acoustics.

BR: That's splendid – that's exactly the point. Simple regular symmetrical thinking does not take sufficient account of the imaginative relations and balances. Without that input, which 'beds in' sensation, one can't listen, interpret or look with any real precision and certainty.

EG: Apparently our mind has many more dimensions or variables, or whatever you call it, than you would have been able to predict from the study of the physical correlates which form our sensations. It seems that in the last thirty years or so we have really moved away, or scientists have moved away very much, from the theories of vision which were accepted as gospel truth, and which we even have learnt at school, which place all the sensations in the retina and think that by explaining what happens in the retina we can explain how we see. This is obviously no longer a fact, that is to say, it never was a fact. The discoverer of the Polaroid Camera, Edwin Land, showed in a number of experiments that the most surprising colour phenomena can be produced by using only two colours, something very similar to what Delacroix mentioned in the anecdote you told. And more recently neurologists, particularly Margaret Livingstone in Harvard, have probed the brain with electrodes and made unpleasant experiments made on monkeys and have really found that there are centres in the brain which respond only

to colour, others only to shape, others only to movement and these various systems interact in the most surprising and bewildering way, so that what another student of vision, J. J. Gibson at Cornell, called 'the awe-inspiring complexity of vision' has by now become a scientific fact.[5]

BR: I think your account of those experiments just makes the precedence of Delacroix's observation so much more poignant. This probably dates back to his visit to North Africa. He noticed several interesting things happening in the appearance of objects. What his discoveries amount to is that taking a white cloth in sunlight, for instance, he saw there a violet shadow and a fugitive green – but it also seemed to him that he saw more colours than just those two: was there not an orange there as well? Because, he argued, in the elusive green he found the yellow and in the violet the red. Delacroix was convinced that there were always three colours preceptually present in what we see, and he found more evidence in various other observations he made and concluded that the continual presence of three colours could be regarded as a 'law' in the perception of colour.[6]

EG: Have you had similar experiences to the one of Delacroix in looking at a white piece of linen or any other such objects in the sunlight?

BR: I have never re-run that purely as an experiment, but the second colour painting I made in 1967 *Chant 2* is all about this. I did not know anything of Delacroix's discoveries at the time, but as I worked on my studies I could see that something was beginning to happen, and I built the painting to articulate this visual energy as I called it then. I saw this as an instance of the innate character of colour when set free from any sort of task describing or depicting things. In nature this sort of thing happens more or less clearly quite often. In the Mediterranean landscape there is a quite common example that anyone can observe. If in the field of vision there should be a fair amount of ochre ground or rocks of an orange or an orange red, and maybe some strong green vegetation or turquoise green in the shallows of the sea, one will then see violets particularly along any edges where the oranges and greens are seen one against the other. In Cornwall a few years ago I remember a spectacular instance; looking at the sea coming in over little rocks – which was basically a few greens and a great many blue violets produced by various reflections – there was also – and this is important – quite a lot of dull orange brown in the seaweed floating in the water. As a result the whole surface of the water was flecked with tiny fugitive crimson points. It seems that as sight is always in action – is working all the time – whatever one looks at one cannot help but look through one's own sight.

EG: Of course.

BR: I have found that as a painter you develop a kind of screen or veil

between you and external reality which is made up of your own practice or habits of seeing. Monet's '*enveloppe*' and Cézanne's '*harmonie générale*' are actually such fabrics or veils by means of which their perception is so heightened that they can penetrate further and with greater precision than they could without it.

EG: And in addition of course, as you said, it is the scale of the patches or strokes of colour, which change the behaviour of colour in our perception, and therefore when you step too far away and they become too small for the interaction to have the same effect you aimed at, you may really see grey. Was that what happened?

BR: Artists have usually held this very subtle question of distance and the perception of their work in their minds when they are making something. For instance, in Tiepolo's ceiling paintings in Würzburg, the blues over yellows, the reds over greens, the brush marks which cancel out, or even destroy, the purity of those colours, makes instead a beautiful, luminous, fresh grey which is what one sees from the floor, which I'm sure was his intention. An artist does know – should know – the effect of distance, it's part of his work to understand those things.

EG: How far do you take this into account? Have you any particular ideal distance at which you would like to see your colour compositions viewed?

BR: No, each painting is specific and its viewing distance is equally specific. But I have noticed in my own work and in other painters' that if an artist is working by response then the distance from which the work has been seen in the making, in the studio or wherever, is usually the one which perceptive spectators will instinctively take up on their own accord later on.

EG: Thank you, Bridget Riley, for having told us such illuminating facts about your work and your experience.

Editor's Postscript

It is often thought that Gombrich is hostile to modern art, but he is merely hostile to certain ideologies of modern art which tend to worship novelty and expect us to 'go with the times' regardless of where the times may lead us. He is all the more happy to have enjoyed the confidence of several contemporary masters whose work he profoundly admires. He has also acknowledged that contemporary art has affected his perception of art's history. Picasso's versatility led him to have second thoughts about the idea of the stylistic uniformity of the age, when he was a student (see my postscript on p. 410). So it is as true for Gombrich as for any other historian of art or culture that contemporary achievements can affect the way in which they perceive those of the past. This conversation with Bridget Riley demonstrates that there are still ways in which contemporary art can participate in the Western tradition of genuine experiment and analytical observation.

See also his interview with the Turner Prize winner Antony Gormley in J. Hutchinson, E.H. Gombrich and L. Njatin, Antony Gormley *(London: Phaidon, 1995), pp. 8-29.*

Part IV Tradition and Innovation

The Necessity of Tradition: an Interpretation of the Poetics of I. A. Richards

The Darwin Lecture given at Cambridge University in November 1979; published in *Tributes* (1984), pp. 184–209

1 Aesthetics and the History of the Arts

Any art historian who likes to exchange ideas with colleagues in other departments of the Faculty of Arts will notice how many of the problems that he encounters in his field are also familiar to those who teach the history of music, or literature, or perhaps the dance. These historians all explore the history of traditions and conventions, because these alone permit them to assign a date or place to a painting, a building, a poem or a piece of music. Yet, when we enquire after a department in which these general questions are made the object of study, we may draw a blank. It is true that some philosophers may give courses on aesthetics, but they are more likely to discuss there the notions of beauty or of expressiveness than the more down-to-earth mechanisms of tradition.

Small wonder that many of the historians I have mentioned have little time or patience with the generalizations which they find in books on aesthetics. Frankly, I am also somewhat uneasy when I am confronted with disquisitions about 'the artist' or 'the work of art' without being told whether I am expected to think of the Temple of Abu Simbel or of a screenprint by Andy Warhol. Yet we historians of the arts would be lacking in gratitude if we ever forgot that our disciplines are in fact the offspring of aesthetics – whether the topic was known by that name or not. It is not long since the history of all the arts was conceived as the story of their beginnings, their rise, their efflorescence and their ultimate decline. The paradigm of that conspectus of aesthetics and the history of an art is of course Aristotle's *Poetics*, especially the

pages devoted to the evolution of Greek tragedy from rude beginnings to the classic perfection of Sophocles, an evolution in the course of which it revealed its intrinsic essence. Subsequent critics who accepted this reading were bound to regard any play which deviated from this model as decadent.

It was no doubt history which helped to soften the normative dogmatism of aesthetics and induced it to admit a plurality of values, which could encompass Shakespeare and even Kālidāsa without loss of status. But there came a moment, I believe, in which aesthetics took the initiative to expel the historians of the arts from its sacred precincts, at least those historians who concerned themselves with conventions.

I have a vivid personal memory of the intellectual crisis into which a great art historian was plunged by this move. I am referring to my teacher Julius von Schlosser,[1] whom even our fast-living times remember as the author of the standard work on the literature on art from antiquity to the end of the eighteenth century. Before he had become a university teacher relatively late in life, Schlosser had worked among the treasures of the vast Habsburg collections of sculpture and applied art at the Vienna Museum, and many of his monumental papers on problems of late medieval art laid the foundation of much subsequent work. This erudite and sensitive practitioner, who was half Italian by birth, contracted a close friendship with the greatest aesthetician of his generation, Benedetto Croce, some of whose writings he translated into German. I cannot of course do justice to the philosophy of art which Croce championed with much verve and learning at the turn of the century in his *Estetica come scienza dell'espressione e linguistica generale*, a philosophy which found such a persuasive exponent in this country in R. G. Collingwood. I can only touch on the relation of this system of aesthetics to the history of the arts.

This relation could only be antagonistic, for though a brilliant historian himself, Croce had no use for the traditional Aristotelian view that the arts could be seen to have developed. He had to reject this whole approach and all its consequences, for he had come to the conclusion that art was pure expression. 'Since every work of art expresses a state of the soul', he wrote, 'and the state of the soul is individual and always new',[2] any attempt to classify these incommensurable expressions was doomed from the start. The division of the arts is without foundation. Any picture is as distinct from any other picture as it is from a poem. All that matters is what they can tell the spirit. There may be a craft of painting, as there is one of shoe-making, but its history belongs to what Croce called the practical, and not to the aesthetic sphere.

It was this radical doctrine which had such an unsettling effect on Schlosser

133
I. A. Richards giving a
lecture, 1979. Photograph
taken during his last visit
to China.
Ivor Armstrong Richards,
the leading English critic
of his generation, was
born in Cheshire on 26
February 1893 and
educated at Clifton and
Magdalene College,
Cambridge. Together with
C. K. Ogden he advocated
a scientific approach to
the study of English
literature, based on the
results of linguistic and
psychological theories.
After his Cambridge years
he went to Peking
(1929–30), returning there
for the last time shortly
before his death. In 1939
he transferred to Harvard
University, from which he
retired in 1963, ultimately
to settle in his old college
in Cambridge. Having
published many successful
books on criticism he
unexpectedly turned in
his fifty-seventh year to
the writing of verse. The
insight he gained in this
last phase (to which this
essay is devoted) is best
summed up in the reply
he gave when
complimented on one of
his poems: 'It is all in the
language.' He was a
dedicated teacher, who
pinned great hopes on the
reform of the means of
communication, and, like
his wife Dorothea, a
fearless mountaineer. He
died in Cambridge on 7
September 1979.

as I knew him. He still felt entitled in his lectures to communicate his response to the great art of Piero della Francesca, but what should his attitude be to a master such as Uccello, who was celebrated for his obsession with perspective, if that was irrelevant to the history of true art?

I realize that the writings of Croce, Collingwood and even Clive Bell, who took a similar anti-historical line, are no longer much read, but I for one have continued to feel the dilemma posed by their challenge. On the one hand, I welcomed the individualistic implications of an approach which made short shrift of all versions of historical collectivism. I have always been on guard against the temptation to hypostasize the spirit of the age into a super-artist who expresses himself in the styles of painting, poetry or music. And yet I could not accept the dismissal of these styles and conventions as aesthetically irrelevant. Any system of aesthetics that has nothing to say about the place of conventions in the process of creation seems to me of little use to the historian of the arts.

2 I. A. Richards

This being my conviction, I was very moved when I received from my revered and lamented friend Ivor A. Richards a copy of his Presidential Address to the English Association for 1978, entitled 'Prose versus Verse'; for he there reverses the verdict of Croce and, as he says, puts the responsibility for composing the poetry on the language, not on the intellect, feeling or wisdom of the poet. A language, he continues, has much stronger and broader shoulders than any poet.

It is not for me to comment on the trajectory of Richards's thought, but I think that the address testifies to a trait which made itself increasingly felt in his life after he had written *The Meaning of Meaning* (1923), an awareness of the mystery of language.

It was this awareness, I believe, which made him turn in his fifty-seventh year from the criticism and analysis of literature to the writing of poetry. He relates in his Address how he was writing a play which required 'some sort of song' and enjoyed 'the new exercise and its reward so much that the game became a habit, an addiction, call it what you please'. Let me quote from the cycle of sonnets which he called '*Ars Poetica*' — admitting characteristically that he was a bit taken aback at its audacity in assuming so ambitious a title — with which he concluded his moving lecture:

> Our mother tongue, so far ahead of me,
> Displays her goods, hints at each bond and link,
> Provides the means, leaves it to us to think,
> Proffers the possibles, balanced mutually,
> To be used or not, as our designs elect,
>
> To be tried out, taken up or in or on,
> Scrapped or transformed past recognition,
> Though she sustains, she's too wise to direct.
> Ineffably regenerative, how does she know
> So much more than we can? How hold such store
> For our recovery, for what must come before
> Our instauration, that future we will owe
> To what? To whom? To countless of our kind,
> Who, tending meanings, grew Man's unknown Mind.

It will be my task in this part of the lecture to spell out somewhat more fully the theory which Richards espoused, the theory that, as he put it, replaces Apollo as the source of the poet's inspiration by Language as his teacher and guide. I do not think he would have considered it offensive to hear it described in the terms of modern engineering as a theory of feedback. The language reacts back on the speaker. It is this important observation which puts any simplistic theory of self-expression in poetry out of court, precisely because it neglects the creative share language always has in any act of expression.

3 *The Grid of Language*
I have no credentials, academic or otherwise, for discussing the mysteries of language except the credentials those of us have who had to switch languages relatively late in life. It was in this slow process that I learned to appreciate the meaning of I. A. Richards's image that language 'displays her goods, hints at each bond and link'. I found to my surprise that in describing the same

painting in German and in English I had to take the goods which were on offer and thus had to single out different aspects of the same painting. Both descriptions, I hope, were correct, but they differed from each other in the elements they singled out from the infinite multitude of impressions. The grid or network of language we impose on the landscape of our experience will inevitably result in different maps. I need not go further than the topic of this lecture to illustrate this decisive point. My first subtitle, 'Aesthetics and the History of the Arts', could not be formulated in Latin, for Latin like Greek, notoriously lacks a term for art or the arts – or more exactly: the ancient term comprises a much wider category, as it still does in English idioms like the art of war and the art of love. Moving closer to our own day I find that a small coin of popular aesthetics, the term 'self-expression', cannot be exchanged on the Common Market, for there is no term in either German, French or Italian which corresponds exactly.[4] It is in the task of translating, not only poetry but even expository prose, that we learn that such a lack of exact correspondence is the rule rather than the exception. I believe it was also in this context of translation that the complexities of the issues first obtruded themselves on the thoughts of I. A. Richards; I am thinking of his book *Mencius on the Mind* (1931), which wrestles with the problem of rendering the system of a Chinese thinker into English. It is in such situations that we are forced to abandon the naïve idea of language as a set of labels or names affixed to existing notions – for language has created the notions which lose their existence when deprived of their names. We need not go quite as far in this approach to the creativity of language as the American linguist Benjamin Lee Whorf, who insisted that different languages fashion radically different mental universes which are mutually exclusive. We all live in the same world, but the accents we set, particularly the social values we experience, surely reflect language as much as language reflects them.

4 *'Second Nature'*
Considered in the light of anthropology rather than that of pure linguistics – if the two can ever be separated – the term 'self-expression' loses its validity not so much because of the theory of expression it implies – I shall come back to that – but because of its simplistic assumption that the self is an independent entity which does the expressing. What we know about human nature makes us question this idea, for we have all experienced how much man resembles that admirable creature, the chameleon. But he goes one better, he can change not only the colour of his skin, but even the cast of his personality. A telling idiom says that a given environment, social and psychological, can 'bring out' the best or the worst in us. The role which life assigns to us colours

our personality to such an extent that we all recognize the typical don, the typical civil servant or hotel porter when he is presented to us on the stage or in a film. The language we adopt will mould our personality more subtly, but perhaps even more decisively. This language can become, as another splendid idiom has it, 'second nature'. When William of Wykeham said 'Manners maketh man' he certainly included language – public-school language.

Language may be described as a set of conventions and rules, but strangely enough you do not have to be aware of them to master the language. It certainly is not passed on in the culture as a skill which has to be learned by rote. The drill of imitation plays only a minor part in the language acquisition of the child. We have been frequently reminded of late, and rightly so, that the power of language does not reside in its vocabulary, but in its infinite flexibility. To learn a language is to learn to make statements which we have never heard before; language makes us creative without our being at all conscious of the miracle. Of course we do not acquire this instrument all at once, we learn, as we always learn, by feedback, by trial and error. We make mistakes and are corrected. But that is not the whole story. Somehow we must be capable after such a correction to generalize on the new rule we have learnt. If we could not transfer it to a whole family of utterances we could never make progress.

5 Perceptual Generalizations

We may envy children their pliability in casting their thoughts into these moulds, but for the student of language as a medium of literature and poetry, there are adult performances which are even more instructive. I mean the skill some people have for mimicry, parody or even forgery. On its lowest level it may be the skill of impersonating a teacher, which may blossom into a fine ear for mannerisms of speech and style and result in a *tour de force* of a page written convincingly in the style of a famous master. The reason why I am interested in this lowly art is precisely because I think it is not a matter of conscious effort. The parodist does not first sit down and tabulate the characteristics of the style he wishes to mimic. This would not get him very far. He rather acquires it by the direct method. He reads a lot and finds that gradually the mannerisms, rhythms and cadences of his prospective victim will come to him unsought. I do not know if any psychologist has devoted research to this capacity, which I would describe as that of perceptual generalization, the capacity not only to classify families of form but also spontaneously to produce fresh instances. It is this feat which the parodist performs when he learns to generate the style of an author, to the mortification of those who have valued the original effort as unique and inimitable. Again this process is

not likely to succeed without trial and error; once in a while he will be tempted to use a word or phrase which on reflection he finds to be 'out of character'. How and why, it is hard to say, but it seems that people are still better at that kind of game than computers are — how long, I would not venture to predict.

I believe that if we knew more about these processes of generalizations which underlie the learning of language and the imitation of style, we would also come closer to understanding what interests the historian of the arts: the changes in style which all the arts have in common. Among the variety of forces which act upon language some may be called practical or functional, others aesthetic and social. The word 'feedback' belongs to the first category. It was coined when the engineers felt the need for a general term describing such effects as that of the governor of the steam engine or the thermostat. Strangely enough, ordinary language knew only of vicious circles, not of virtuous ones, but once a new term was launched, one wondered how one ever got along without it.

But the drifts of language also obey less tangible pressures of social preference and of fashion, a fact which we may deplore but can rarely avert. New ideals are imposed on speakers and writers which are frequently rules of avoidance rather than of use. Your style should not be stilted, precious or ponderous, and conversely it should not resemble colloquial style too much. The cumulative effect of these changes in use and in usage is a transformation of language and, given the creativity of the medium, also a transformation of what can and will be communicated.

6 *The Darwinist Approach to Art History*
It may not be inappropriate for the Darwin lecturer to bring out this notion of creation without a creator which is implicit in Richards's 'Ars Poetica', all the less since Richards himself invoked the biological metaphor in earlier parts of the poem.

> Conceive your embryo at its earliest age,
> The germ just entered the awaiting egg.
> What were you then? And how has what ensued
> Guided you since in all that you have done? . . .
> What guides this life to what it comes to be?
> What led it through so blind a whirl of being?
> What served throughout as substitute for seeing,
> Settled each loop and twist decisively? . . .

The answer given by Darwinism to these questions may be summed up, I take it, in the sobering terms 'random mutation and survival of the fittest'. It is this dual mechanism which has driven evolution forward, a creation without a creator, even, if one may so put it, a blind creation.

Transferred from the vast panorama of geological epochs to the narrow stage of human history, the mechanism goes under the name of trial and error. It was in particular Sir Karl Popper, the first Darwin lecturer, who convinced me that this formula throws light not only on the growth of science, but also on the evolution of art.

I profited from his insight when writing my book *Art and Illusion* because it opened my eyes to the important fact that even the so-called imitation of nature cannot be achieved without the feedback principle. Even here there is an element if not of blind creation at least of groping. If I may quote my summing up from the last chapter of the book at some length:

> The history of art ... may be described as the forging of master keys for opening the mysterious locks of our senses to which only nature herself originally held the key. They are complex locks which respond only when various screws are first set in readiness and when a number of bolts are shifted at the same time. Like the burglar who tries to break a safe, the artist has no direct access to the inner mechanism. He can only feel his way with sensitive fingers, probing and adjusting his hook or wire when something gives way. Of course, once the door springs open, once the key is shaped, it is easy to repeat the performance. The next person needs no special insight – no more, that is, than is needed to copy his predecessor's master key.
>
> There are inventions in the history of art that have something of the character of such an open-sesame. Foreshortening may be one of them in the way it produces the impression of depth; others are the tonal system of modelling, highlights for texture, or the clue to expression discovered by humorous art ... The question is not whether nature 'really looks' like the pictorial devices but whether pictures with such features suggest a reading in terms of natural objects ...

Leaving aside the art of burglary the paragraph states that the tricks of illusionistic representation could never have been developed simply by looking out of a window or going for a walk. They could only be found in the process of painting. For it was not at all easy for the Greek pioneers of the fifth century to predict that in representing a hoop as an oval (Fig. 134) rather than as a circle (Fig. 135) it would seem to extend in depth. It is tempting to say that hoops seen at an angle look like ovals, but this is a somewhat dubious assertion. Psychologists as sophisticated as J. J.

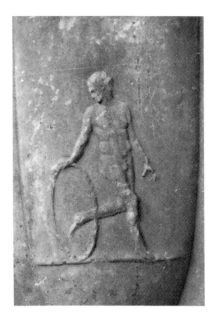

134
Boy with a hoop. Detail
of a Greek marble relief,
5th century BC. National
Archaeological Museum,
Athens

135
The Berlin Painter,
Ganymede with a Hoop.
Greek krater, early 5th
century BC. Louvre, Paris

Gibson would insist that they look circular because they are circular.

The same applies *mutatis mutandis* to the other means of naturalistic painting to which I referred. You might argue about whether a head painted in various tones of red and blue looks like a head, but it can certainly suggest one. The same applies to the suggestive power of tonal gradation from warm to cool tints which landscape painters exploited for the rendering of distance.

I am confirmed in my conviction about the limits of introspection in these matters by the debate which was caused by my book on *Art and Illusion*. It seems difficult to arrive at an agreement among philosophers, psychologists and artists on what is actually their experience in looking at a representation. There are some who speak as if they simply saw a surface covered with pigments, while for me this is the hardest to see. I have frequently[5] reverted to the example of the rendering of eyes, particularly the magic of the white dot which simulates a highlight and imparts an added degree of intensity to the gaze of the Hellenistic portrait from Egypt (Fig. 136) I find hard to discount. I believe that our response to these experiences is too deeply rooted in our biological heritage to yield to conscious analysis. I have been much impressed in this context by the observation that long before art discovered the trick of eliciting this response nature had stumbled on it by random mutation and natural selection.[6] There is an incredible caterpillar (Fig. 137) which carries on its body two simulated pairs of eyes; together these suggest a threatening head, which the creature displays to deter predators, meanwhile curling up and hiding its real tiny head.

136
Hellenistic portrait from
Egypt, *c.*150 BC. Staatliche
Museen, Berlin

137
Larva of a Noctuid Moth

Evidently such forms would hardly have evolved if they did not provide the advantage to the species of triggering a response of fear in its natural enemies, presumably birds or reptiles. From ethologists we are learning more about the power of such trigger mechanisms, which release certain pre-programmed responses. Now I do not want to advocate the wholesale transfer of these modes of thought into aesthetics. We are not simple trigger mechanisms which react to given configurations in a predictable way. Not even animals are. Their reactions, as we know, are also governed by their past history. That intriguing phenomenon of 'imprinting' reminds us of the importance of what in humans we might call the most impressionable age. I would not be surprised if aesthetic effects we have experienced early in life determined our reactions in later years and if this might also help to explain the power of local traditions in the arts. To be sure, traditions can lose their hold and give way to new reactions, but I do believe that an awareness of our biological heritage should make the student of aesthetics pause before he undertakes to account for our responses to art.[7] Understandable as it is for us to ask of a work of art which moves us, 'why is this so beautiful? so exhilarating? or so heartbreaking?', I am not sure there will ever be an answer except the old one: that the artist has found the way to our heart. For if I am sceptical about the power of introspection in matters of representation, I am doubly so when it comes to our response to what is more specifically called expression.

Darwin himself, of course, devoted a book to the study of expression, his great work *The Expression of the Emotions in Man and in Animals*, which is mainly devoted to a minute examination of the facial symptoms of feelings, which are traced back to similar reactions in primates and other animals. But Darwin

138
The mourning of the
dead. Detail from a Greek
vase in the 'Geometric'
style, 8th century BC.
National Archaeological
Museum, Athens

would not have been Darwin if he had remained unaware of what I have called the feedback principle, though he turns to it only in his concluding remarks. 'The free expression by outward signs of an emotion', he writes, 'intensifies it', adding a footnote on the effect of an actor's movements on the actor (which had actually been noticed by Lessing) and on the observation that 'passions can be produced by putting hypnotized people in appropriate attitudes'. 'He who gives way to violent gestures', Darwin says, 'will increase his rage; he who does not control the signs of fear will experience fear in a greater degree.' These are adumbrations of what became known as the James–Lange theory of expression, the intimate link between bodily and psychological states. It is an area which was of particular interest to Aby Warburg, the founder of the Warburg Institute, who was deeply influenced by Darwin's book on Expression.

7 Grief in Greek Art

I can think of no better illustration of this unity of experience and expression which concerned Warburg than the articulation of the feelings of grief and mourning which we owe to Greek art.

Geometric vases of the mid-eighth century show us the ritual lament during the funeral ceremonies in appropriately schematic shapes (Fig. 138). We can infer nothing about the sentiments of those mourners, who clasp their hands to their heads, but then we might not have done so either if we had attended the funeral, for wailing is a ritual that has to be performed for its magic effect rather than for its expressive function.[8] Looking at a detail from a red-figured vase of c. 470 BC (Fig. 139) we feel in the presence of death; there is still the ritual gesture of tearing the hair, but the contrast between the impassive beauty of the dead woman on the bier and the grief-stricken man could not be more poignant. Around the middle of the fifth century, Attic painters began to articulate these feelings of mourning in representations of funeral rites on white-grounded *lekythoi*, small oil flasks for libations. They convey grief, not lament, a respect for the dead even shared by the genii or spirits of sleep and

death as on this famous *lekythos* in the British Museum (Fig. 140). Attic sculptors of tombstones took part in this movement of crystallizing the valedictory mood. Instead of the loud lament you have the simple handshake of farewell, maybe of father and son, or of man and wife (Fig. 141). In some of the most moving of these monuments as in the example now in Berlin (Fig. 142) nearly all outward gestures are stilled, the family are together in silent mourning at the inevitable.

This is the time when Xenophon makes the Socrates of the *Memorabilia* ask the sculptor to render not only the movements of the body but also the workings of the soul, *tēs psychēs erga*.[9] It is hard to imagine that these articulations of human feelings did not affect those who visited these tombs. The convention, for it was a convention, must have helped them to bear their loss without denying their grief. Towards the end of that century Aristotle was to make his somewhat cryptic remarks about the effects of tragedy, the much debated notion of *katharsis*, the purgation of the emotions. It suits my argument that this term refers not to the feelings of the playwright, but to the experience of his audience. And as with the dramatist the feelings of the sculptor who was commissioned to carve these stelae do not come in. There is no reason to think that he felt sadder than did the wailing women of yore. And yet there is a difference. Whether or not he was affected by the death of that particular person, he must surely have known about the workings of the soul, he must have known about sadness. In arranging his figures and their poses he must have watched their effect on his own mood. Elsewhere[10] I have

141
Attic tombstone,
c.440 BC. Staatliche
Antikensammlungen,
Munich

142
Attic tombstone,
5th century BC. Staatliche
Museen, Berlin

143
Sidonian sarcophagus,
mid-4th century BC.
Archaeological Museum,
Istanbul

contrasted this idea of feedback with that of self-expression, which I have called a centrifugal theory since it regards the artist as a sender who transmits his own feelings to the beholder. Instead I have proposed a centripetal theory, which lays stress on the effects which the work has on the artist's own response to the conventions with which he operates. There are many ways of rendering the emotions of grief, but they may not all strike a chord in the maker. Take another Greek work of the period, but from Asia Minor, the weeping women sarcophagus from Sidon (Fig. 143), which links once more with the theme of the ritual lament, but in a new style. It is a fine work in which the show of grief is fully humanized, but not all these figures are equally convincing, at least to me. Some are moving, others rather empty. The sculptor had failed to apply the test of my centripetal theory, not because he failed to grieve, but because he was less concerned with that authenticity which only his own reaction could confirm. Feeling alone will not produce a work of art, nor will a mastery of means, both have to be present in abundance.

8 Michelangelo's Moses

Nobody can talk about self-expression without thinking of that archetypal genius, Michelangelo, who imposed his personality on his creations. His *Moses* (Fig. 144) may well be the most famous instance of this unity between the maker and the work, the powerful prophetic figure with his formidable turn

144
Michelangelo, *Moses*, c.1515.
S. Pietro in Vincoli, Rome

145
Donatello, *St John*, 1413–15.
Museo dell'Opera del
Duomo, Florence

of the body and his fierce and dominating mien. But even this individual vision of prophetic might is not without precedent. Donatello's statue of St John (Fig. 145) must have impressed itself on Michelangelo in his Florentine days. Some artists and critics flinch when they hear art historians talking about influence, as if we accused a genius of having pinched his ideas from someone else. But we have all pinched our ideas, because, as Richards reminded us, we owe our language 'to countless of our kind, who, tending meanings, grew Man's unknown Mind'. What inspired Michelangelo was the tradition he found most beautifully embodied in Donatello's majestic seated evangelist; it was a tradition which had blossomed forth in many great works throughout the centuries. Witness a prophet by that great artist born in the twelfth century, Nicolaus of Verdun (Fig. 146), perhaps the equal of Donatello and Michelangelo. It is next to impossible that the later artist can have known it. What he had inherited was the language, the conventions of Western sculpture in rendering figures of authority and power.

The needs for this mastery were manifold throughout the history of Christian art; let me only remind you of the convention of placing such prophets and apostles in serried ranks in the voussoir of cathedral porches like the one from Rheims (Fig. 147), which dates from around 1230. To be an artist in this tradition you had to be able to produce any number of variations on this theme. Today one has to go to architectural or decorative monuments to

146
Nicolaus of Verdun,
Jeremiah, detail from the
'Dreikönigsschrein', early
13th century. Cathedral
Treasury, Cologne

147
Voussoir from the
Callixtus portal, Rheims
Cathedral, c.1230

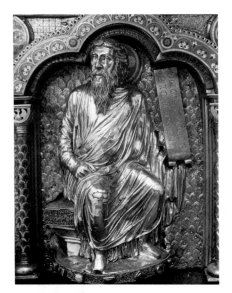

experience the range of inventiveness which allowed the artist to discover ever fresh potentialities of such a motif. Our museums have yielded to the pressure of hurried and bored visitors who shy away from such plenitude. To appreciate a work they want to see it in artificial isolation.

I suspect that this tendency also obscures for them what is such a vital characteristic of the arts in the past – the possibility of teamwork. I am not sure that in our individualistic age and with our individualistic aesthetics we can ever quite reconstruct the processes of collective creativity. It was one of the inestimable values of the rule of conventions that it made collaboration possible.

Take that beautiful monument of Florentine craftsmanship, Ghiberti's first door of the Baptistery (Fig. 148), showing eight panels of such seated figures, the four doctors of the Church and the four Evangelists. We know the names of a round dozen of assistants who worked in the workshop during the two decades or more the work was in progress, among them Paolo Uccello and Michelozzo, but we have little idea how the work was distributed. I think the temptation must be resisted to assign the portions we like best to the master and the parts which appeal to us less to a more menial hand. What I said about picking up and mimicking a manner and style of speech to the point of possible forgery must surely also have applied to the gifted members of a workshop. Working for so long and in such close association, they could probably do you a Ghiberti, that is to say, a figure of which Ghiberti would have approved. If he had not, he would have sent them away. He could always intervene at any stage as the leader of any team does, either by precept or

148
Lorenzo Ghiberti, the
first bronze doors of the
Florence Baptistery
(bottom four panels),
completed 1424

149
Andrea da Sangallo after
Michelangelo, study for
the lower part of the tomb
of Pope Julius II, 1513.
Casa Buonarroti, Florence

demonstration. Like the producer of a play or of a film, he would remain in charge and take the credit. This is a point, I think, where art history can profit from the emphasis on feedback I am here advocating. It illuminates the possibility of creation by remote control.

Not all artists were equally suited for this method of teamwork. Michelangelo was not. His conception of creativity evidently excluded the kind of workshop which alone made the execution of major enterprises in sculpture possible. There is a famous drawing or copy of a drawing showing his original conception of the tomb of Julius II (Fig. 149), on which the Moses was to figure. It remained a torso. Only in the medium of painting could even the superman Michelangelo realize the potential of his immense creativity.

I have talked of Michelangelo because he became the archetype in Western thought of the Neoplatonic conception of genius, the visionary who rivals the demiurge in creating a world out of nothing by gazing at the realm of ideas. I do not deny for a moment that the very sublimity of this thought has added a new dimension to our ideas about art, but I also believe that for aesthetics this model was not wholly beneficial, and that it is time to redress the balance.

9 Changing Aims

An apocryphal anecdote about Turner may serve as a convenient parable for the conception of creativity I have been advocating in this lecture. The painter is supposed to have 'got three children to dabble watercolours together till he suddenly stopped them at the propitious moment'. Judging by the size of the Turner bequest — almost 20,000 items in the British Museum alone — the children must have kept him pretty busy — that is, if they were children and not rather demons or angels.

Whatever may have been the intention of those who originally circulated this story, I certainly do not think that the element of feedback diminishes the dignity of genius. It may stand for what Karl Popper in his opening address of

the Salzburg Festival of 1979 called 'Creative Self-Criticism in Science and in Art'.[11] Admittedly, there are vital differences in the two areas of human creativity. The aims of science are more easily formulated than those of art. Paul Ehrlich called the drug against syphilis he had developed Salvarsan 606 because he and his collaborators had tried out 605 compounds of arsenic before they found one they considered non-toxic for humans. This is an example of applied science where the criteria may be easiest to specify, but though there are no such clear-cut criteria of success or failure in art, the same forces operate which I have mentioned in relation to language. Use and purpose have had a vital influence on the development of artistic conventions and media, they have led to unintended discoveries which were embodied in creative conventions. Moreover in art various periods accepted what I called Principles of Exclusion which are enshrined in the so-called 'Rules of Art'. In poetry there may be the elementary demand of grammar or versification, in the painting of certain periods the laws of perspective or of anatomy, which might figure in criticism or self-criticism. But the point is precisely that criticism here can operate on any level of the creative process. If the children had been dabbling paint for Kandinsky, he would have stopped them at a different point. He would not have wanted a landscape to emerge, but rather a combination of colours to which he could attribute special spiritual significance. It is this change in the rules of elimination which largely constitutes the history of style. I remember an American artist telling me that he had started painting a picture of a girl taking off her shift when he saw a painting of the same motif in an art journal. To safeguard his originality he turned his painting upside-down and transformed it into an abstract. Needless to say a Russian icon painter would not have cancelled his painting on finding that it resembled another icon. He would have been more likely to have had second thoughts if he had found that what he had painted was without precedent and therefore without authority. There are less easily formulated grounds for criticism which still may be applied in this sifting process, the shibboleths of schools or of movements which help to guide the artist who is his own critic. But on a deeper level it must surely be the effect which the creation has on the maker himself which must be decisive for the real artist: the process I have called authentication. Trying out possibilities within his range and medium he will find that his self – and here I would like to speak of his 'self' – resonates to a particular configuration. It is this experience, I think, to which Picasso referred when he said proudly and justly, 'I do not seek, I find'.

For there is one aim which has united the arts in many historical periods and which alone entitles them to the claim of creativity—the aim of novelty. A

simple repetition of what has been done before falls outside this concept of art. I believe this creativity is inseparable from what I described as articulation. Just as language teaches the poet to articulate his experience, so the visual arts serve as instruments for the discovery of new aspects of the outer and inner world. Whether you think of Michelangelo or of Rembrandt, of Rubens or of Van Gogh, we know what we mean when we say that the visual and psychological experiences they embodied in their work only entered our heritage through their mediation.

10 *Innovation and Refinement*

There is one distinction here which I still like to introduce: creative articulation can take two almost opposite directions. The artist can strain the medium in an effort to extend its range and thus to discover novel possibilities at the extremes as it were. But he can also make discoveries by refining his medium, by introducing a more subtle calibration which permits him to bring out new shades and nuances never recorded or expressed before. Not that these two ways of enriching the language of art need be mutually exclusive. The greatest masters were frequently creative in both directions. But it is in the nature of things that their more dramatic innovations are more easily described and appreciated than their miracles of refining.[12] I had a wonderful opportunity to reflect on the magic of artistic refinement when I was fortunate enough to visit the Chardin Exhibition in Paris in 1979. But the subtleties of tone and of texture which turn these paintings of simple kitchen utensils into the visual equivalent of great poetry do not survive the process of mechanical reproduction, let alone the change of scale and tonal range of the screen. I believe it is inevitable that these and similar limitations of our methods of communication have introduced a bias into the discussion of artistic achievements which is far from healthy.

There may be artistic traditions which depend even more on the need to appreciate such fine calibration than does our Western art. Compared to the masters of the Far East, our Western painters may sometimes look coarse. I lack the knowledge to substantiate this hunch, nor does it much matter in my present context, for I hope I can make the same point in turning in conclusion to the history of yet another art, that of music.

11 *Music*

I know there are musicians who dislike any talk of the expressive character of music, but I think that their approach flies in the face of experience. At any rate, for the purpose of my exposition, I side with Plato, who stressed the ethical or psychological effects which music has on the hearer. Remember that

he condemned the effeminating effects of the Lydian Mode and only wished to admit the invigorating Dorian Mode into his Ideal State. One is tempted to call this ancient approach to the arts, for which I have also quoted Aristotle, a magico-medical one, there are tranquillizing spells as in the lullaby and rousing ones as in the Bacchic dance. I should like to emphasize again that those affected in these and countless other ways need not know and possibly can never know how and why the spell works. They need not know about the secrets of music any more than the tea-drinker need know about the chemically active agents in 'the cup that cheers'.

There is a history of the spread of tea drinking from China to Europe, but, I suppose, the effects of tea have remained very much the same. The effects of music have proved less stable. A pure trigger-theory of music will work as little as a trigger-theory of any other art, but though effects may change with training and habituation, no other art, not even poetry, may be more indebted to conventions which crystallized in a long tradition. What seems to me so characteristic of the great masters of the medium is the extent of their voyages of discovery throughout the length, breadth and depth of the tonal system they inherited. The mere sight of the collected works of Bach, Haydn, Mozart or Schubert is awe-inspiring even if you do not remember how short a lifetime was allotted to some of them. How did Schubert manage to write more than six hundred songs, in addition to all the piano works, chamber music, symphonies, abortive operas, Masses and choral compositions, in a period of some fifteen years? Surely only by letting music serve him, as he served music.

It seems to me that music must always have filled the minds of these masters, tunes and harmonies were always running in their heads, they were incessantly composing and what they left us are only the snatches they managed to write down when some commission or occasion prompted them to do so. I know that not only the very great exhibited this prodigious productivity. If you consult your *Grove* you will frequently find that the composer of whom you have heard for the first time wrote scores of Masses and dozens of operas. Many of these minor masters were also on intimate terms with their medium and thanks to the radio we can now sometimes enjoy their work. We will be struck at first by the kinship of their inventions with those of the masters, but after a time we will also frequently find that they fail to hold us because for all their euphony they offer far fewer surprises, far fewer riches than the canonic composers. Maybe they let the medium take over and failed to watch their own response. It is this evident danger which has given the term 'convention' a bad name. I have sufficiently explained why we cannot do without the creative potential of artistic conventions.

Of course, music like the other arts has come to rely among other effects on

the effect of novelty, but here as elsewhere, there is always a danger that the craving for this stimulation swallows up all other charms music holds in store. In contemplating the situation in music as an outsider, it seems to me that the two contrasting possibilities of articulation which I discussed in relation to art, have come to dominate two entirely different branches of our musical life. Composers are understandably anxious to make an impact by extending the range of the medium by new inventions, but meanwhile the cultivation of subtle calibration has found its own place in the musical life of our century. I am referring to the art of performance. In this respect, I believe we must be living in a Golden Age. There must be more great pianists today than we could count on our fingers, masters of the keyboard who are outstanding not only as technical virtuosos but also as profound musicians who can give us the feeling that it is not they who play the music, but the music which plays them. Music lovers, and there are plenty of them, are avid for this experience, they flock to hear performances of the same compositions because they have become sensitive to the small and important range of legitimate variants in timing, touch and phrasing which reveal new facets of the great masterpieces. Music critics sometimes chide the public for their conservativism in the matter of programmes, but for me this developed sensitivity is a reassuring token of the continued vitality of the arts which no student of aesthetics should ignore. For if he accepts the insight of Ivor A. Richards that it is always the idiom which inspires the artist he will also be led to reflect anew on the relation between the forming and the performing arts.

Editor's Postscript

So much emphasis has been placed on self-expression and creativity in art education today that a corrective is needed. The Story of Art *described the evolution of a tradition which offered artists the resources for its development, and it has to be said that a close reading of modern art and many of its artists' statements would reveal that artistic traditions have often been raided to generate new imagery. The traditional model of artistic influence, which may be true of rote learning, should be replaced, in cases of genuine creativity, by one of artists' active development of past artistic achievements. The idea that the art's history is a dead weight on creativity was not even true of modernism.*

This is Gombrich's only essay in aesthetics and it discusses the generative potential of artistic traditions. See also 'The Tradition of General Knowledge' in Ideals and Idols *and 'The Force of Habit' and 'Verbal Wit as a Paradigm of Art' reprinted in this volume (pp. 189–210, 223–56). For examples of historical analysis based on this approach see, for example, 'The style all'antica: Imitation and Assimilation' and 'Reynolds's Theory and Practice of Imitation' in* Norm and Form; *'Botticelli's Mythologies' reprinted in* Symbolic Images, *and 'Raphael's Stanza della Segnatura' reprinted in this volume (pp. 485–514).*

Verbal Wit as a Paradigm of Art: the Aesthetic Theories of Sigmund Freud

Lecture given at Vienna University in May 1981 on the 125th anniversary of the birth of Sigmund Freud; published in *Tributes* (1984), pp. 92–115

A recent display in the exhibition rooms of the British Library assembled in a special showcase the first editions of three books which constitute landmarks in the intellectual history of Europe: Galileo Galilei's *Dialogue Concerning the Two Principal World Systems* of 1632, the book which ultimately secured the victory of the Copernican system against all opponents; Charles Darwin's *The Origin of Species* of 1859, a work which encountered similar resistance in its attempt to define the place of man in the evolution of organic life; and finally *The Interpretation of Dreams* by Sigmund Freud published in the year 1900, the book which ushered in a new epoch in the exploration of the human psyche. This work also met with much hostility and misunderstanding, not only because in it the power of instinct was assigned a greater role than was generally welcomed, but most of all because for the first time the mental life of normal adults was considered in conjunction with the symptoms of neurotics, indeed of psychotics. After all, the dream is here interpreted as a result of mental conflicts which so frequently deny to civilized man the fulfilment of instinctual urges. During that third part of our lifespan in which waking consciousness is out of action, the same forces fight for dominance which can serve also in the explanation of madness and neurosis.

I am not a psychiatrist, but a historian of art, and it would be impertinent of me to attempt in my turn to interpret *The Interpretation of Dreams*. But the art historian can no more ignore its implications than the ethologist can neglect the impact of Darwin's *œuvre*. Least of all can he do so if his interests include the theory of art.

I can only attempt to indicate the stage of development in which the work

150
Sigmund Freud in his
study in Vienna with his
art collection and his
chow, c.1936
Sigmund Freud –
Founder of
Psychoanalysis, as he is
described on the
commemorative plaque of
his London house – was
born on 6 May 1856 in
Freiberg in Moravia,
which was then part of
the Austro-Hungarian
Empire. In 1860 his father,
a wool-merchant, moved
with his family to Vienna
where Freud attended
school, including a
classical grammar school,
before entering Vienna
University as a medical
student in 1873. He
graduated in 1881. At the
time his interest (and
publications) centred on
neurology and in 1885 he
spent four months in
Paris with J. M. Charcot,
a leading authority on the
subject. In 1886 he
established his private
practice in Vienna and in
1895 published, jointly
with Josef Breuer, *Studies in
Hysteria*, which laid the
foundation of his theory
about the causes of
neuroses. *The Interpretation
of Dreams* appeared in
1900. The Nazi
occupation of Austria in
1938 compelled him as a
Jew to leave Vienna and
seek refuge in England.
He died in London on 23
September 1939.

of Sigmund Freud entered the theory of art, and even for this purpose I must digress a little. To put it briefly, up to the eighteenth century the theory of art in the Western world was dominated by ancient philosophy. It was most of all Plato's metaphysics which, in a number of variations and even distortions, attributed to the artist the capacity of perceiving the divine ideals of beauty beyond the world of the senses and of embodying them in his creations. The rejection of this mystical view of art in the course of the eighteenth century, most of all in England, was bound to make theorists turn to psychology, a new branch of knowledge which had become prominent in the philosophy of John Locke. Foremost among them was Edmund Burke, whose *Philosophical Enquiry into the Origin of our Ideas of the Sublime and Beautiful*, first published in 1756, created a profound impression also in Germany. It was the first time that an author undertook to establish aesthetics on biological foundations, and he thus struck a note which still reverberates in Freud's writings. According to Burke, the human mind is dominated by two basic emotions, the desire for self-preservation and that for the propagation of the species. The latter manifests itself, of course, as the sexual instinct, and Burke explains the sensation of the beautiful as deriving from the attractions of a fine physique. The instinct for self-preservation rests on the striving for safety and on the avoidance of any threat. This avoidance is served by fear, which constitutes as it were a biological warning system. Fear in moderate doses explains the sensation of the sublime which the poets celebrate in storms and tempests.

What separates Burke's approach from the psychoanalytic theory of art,

despite a certain rudimentary kinship, is above all the fact that Burke concerns himself not with the artist but with the beholder. As a student of emotional effects he is indebted to the tradition of ancient rhetoric, to which he also owes the concept of the sublime. It centres on the power of the poet, the musician and the painter to arouse or to calm the passions. What psychological dispositions enable the creator to play on the keyboard of the soul is much less at issue. M. H. Abrams in his classic study *The Mirror and the Lamp*[1] has described the decisive reorientation that led from the aesthetics of effects to the aesthetics of self-expression at the time of Romanticism and its aftermath in our age. In Germany it was the movement of 'Storm and Stress' which marked the break, as when a young lover in Goethe's *Götz von Berlichingen* says, 'Thus I feel this moment what makes the poet: a heart wholly overflowing with emotion', or when Goethe later makes Tasso speak the beautiful words, 'Where man falls silent in torment, a god gave me the power to say what I suffer.'

In the late eighteenth and nineteenth centuries, therefore, the theory of art shifts from objective to subjective criteria. In poetry, music and the visual arts, interest centres on the experience of the creator; indeed, in the absence of genuine experience the work of art is considered wholly bogus, a kind of forgery or confidence trick which pretends that the artist had felt something whereas in reality he was only out for effects. Around 1900, the year of Freud's *Interpretation of Dreams*, three names commanded immense respect among critics of art: Nietzsche, who approximated artistic creation to intoxication, Tolstoy, who in his book *What is Art?* equated art with the communication of feeling, and Benedetto Croce, who dismissed all art as mere rhetoric if it failed as genuine lyrical expression.

Small wonder that Freud's book made its greatest impression on artists and critics, who had always inclined to regard the work of art as subjective expression and to consider its affinity with the dream. The kinship of the genius and the madman had in any case been a favourite topic of the *fin de siècle*. Freud also paid tribute to the aesthetics of expression when he tried to interpret a work of art like a dream or a day-dream, above all in his famous study of Leonardo da Vinci.

Freud's characterization of this study in a letter to the painter Hermann Struck[2] deserves to be quoted in full since he always weighed his words very carefully. '*Es ist übrigens auch halb Romandichtung. Ich möchte nicht, dass Sie die Sicherheit unserer sonstigen Ermittlungen nach diesem Muster beurteilen.*' ('It is, incidentally, also half novelistic fiction. I would not want you to judge the certainty of our other investigations by this example.') A good deal of ink could have been saved if that remark had been known before the publication of Freud's

correspondence in 1960. When Freud referred to 'novelistic fiction' (*Romandichtung*) he was obviously thinking of the famous historical novel on Leonardo da Vinci, the second volume of an ambitious trilogy by the Russian author D. S. Merezhkovsky, published in German in 1903, which is mentioned in Freud's study. It must indeed have been an episode in that novel which sparked off Freud's interest in Leonardo's childhood. In chapter nine Leonardo visits his childhood home as a man of fifty, prior to joining Cesare Borgia's army, and reminisces about his past.

> Leonardo remembered his mother as in a dream – especially her smile, tender, imperceptibly flitting, full of mystery, seeming somewhat sly and odd on her simple, sad face of an almost austere beauty ... The little house where Caterina [his mother] dwelt with her husband was situated not far from the villa of Ser Antonio [his grandfather].

Describing the young Leonardo's secret day-time visits to his mother we are told that 'he would throw himself upon her, and she would cover with her kisses his face, his eyes, his lips, his hair'. But, we read, the boy liked the meetings at night still more. Knowing the times when his stepfather was out young Leonardo would with

> exceeding caution arise from the wide family couch, where he slept beside his grandmother Lucia: half-dressed he would noiselessly open the shutter crawl out of the window ... and run to Caterina. Sweet to him were the chill of the dewy grass ... the fear lest his grandmother, awakening, miss him; and the mystery of the seemingly criminal embraces, when, having gotten into Caterina's bed, in the darkness, under the blanket, he would cling to her with all his body.

The way is not far from this imaginary oedipal scene to Freud's reading of Leonardo's *Virgin and St Anne* (Fig. 151) as representing his 'two mothers'.

I wish to stress from the outset that Freud's wide culture and his insights saved him here and elsewhere from the mistake of confusing the biography of an artist with the theory of the arts. What he says about this point in his autobiographical account could not possibly be more explicit.

> It must be confessed to the layman, who may possibly expect too much of analysis in this respect, that it does not throw any light on two problems which probably interest him most. Analysis has nothing to contribute to the explanation of an artist's gifts, nor is it competent to lay bare his method, his artistic technique.[5]

With these words Freud decisively indicated the frontiers between his insights and the concerns of the art historian. For if he did not want to enter into a discussion of artistic gifts, he thereby eliminated the problems of value. If, for instance, Leonardo means so much more to us than his pupil Luini, this is ultimately due to their different talents. To renounce discussion of the artist's method or technique affects still wider and more decisive problems. The methods which both the most gifted and the less talented must learn from their masters are, after all, inseparable from that manifestation of art which concerns the art historian most, I am speaking of style. Without the technique of vaulting there would be no Gothic architecture, without the technique of oil painting no Rembrandt, without the art of the fugue no Bach, and without the development of the drama no *Oedipus the King* by Sophocles.

Freud was fully aware of the significance of this renunciation. In his essay on 'Dostoyevsky and Father-Killing' of 1927 he declares right at the outset that *The Brothers Karamazov* is the greatest novel ever written, and the episode of the Grand Inquisitor one of the high points of world literature.

'Unfortunately', he continues, 'analysis must surrender arms when confronted with the problem of the creative writer.'

But though Freud was not afraid here to draw the line, we must not infer that he wished subjectivism in art to be given free rein. On the contrary, throughout his life he energetically opposed the conclusions which some of his contemporaries wanted to draw from psychoanalysis in relation to art. He explicitly condemned both currents of radical subjectivism in the art of the twentieth century, Expressionism and Surrealism, and I must not pass over these remarks, despite the fact that I have commented on them before.[4]

His criticism of Expressionism was stimulated by a little book from the pen of Oskar Pfister, the Zurich parson with whom Freud engaged in a lively exchange of ideas and who, in 1920, sent him his publication on *Der psychologische und biologische Hintergrund des Expressionismus* (The Psychological and Biological Background of Expressionism). In the introduction Pfister protests against 'the shrieks of horrified maiden aunts' and scolds the philistines who, as he says, 'believe they have done enough when they bandy about words like "disgusting", "barbaric", "daubs", "perverse" and "pathological" to characterize the new movement'. 'To get our bearing in the chaos of these serious problems', he continues, 'we must peer into the secret womb of the unconscious' and use the methods of Sigmund Freud which 'penetrate below the outer crust of the conscious mind'. Pfister wants to define Expressionism

154
Ferdinand Georg
Waldmüller, *Springtime in
the Vienna Woods*, 1861.
Österreichische Galerie,
Vienna

as 'any subjective representation which totally or almost totally distorts nature'. But he also includes abstract art, referring explicitly to the Cubists and the Dadaists, wishing, however, to refrain from any aesthetic judgement. For a short time the author had taken an artist of this school into analysis and during the sessions the patient made drawings and offered his free associations for interpretation (Fig. 152). With good reason, therefore, Pfister dealt with these images as he would have dealt with a dream told by his patient. He distinguishes between their manifest and their latent content, and attempts to probe the private meanings which appear behind the enigmatic shapes. He is profoundly disquieted by what he found there. He writes:

> After analysis has made us see what a welter of hatred, revenge, helplessness, inner conflicts and confusion sometimes lies in these images, one becomes doubly disinclined to attribute any human value to this autism. What concern to us are those brawls, disappointments, miserable childhood incidents which the Expressionist secretly embodies in his work?

One can certainly understand Pfister's outburst, and yet I think that it is also unjust. We must not be surprised if the analysis of an artist produces associations of this kind since that was part of its purpose. It seems to me entirely possible that Anton Pilgram, the great master of the pulpit of St

Stephen's Cathedral in Vienna (Fig. 153), or Ferdinand Waldmüller, the lovable painter of *Springtime in the Vienna Woods* (Fig. 154), might have produced similar associations on the analyst's couch which also would somehow have been connected with their works. But this speaks neither for nor against these creations. What distinguishes the works of the Expressionists from those of Pilgram's or Waldmüller's time is not so much their origin as their style, the idea the artist wished to realize. The artists whom Pfister had in analysis could not be blamed for the prominence their subjective experience assumed in their creations; the responsibility lies with that theory of arts which, as I hinted, increasingly put the accent on self-expression and demanded nothing but honesty of these intimate exposures.

For the same reason I cannot agree with Pfister who, like so many others, wishes to explain the Expressionist cries of anguish by referring to the distress of the age. No doubt the age was indeed distressing, but then which age is not? Anton Pilgram certainly had reasons to be terrified by the danger threatening Vienna from the Turks, and even beneath the apparent idyll of Waldmüller's art there grumbled the volcano of social and national tensions.

What was at issue in the movement of Expressionism was nothing less than a new conception of art, a new idea of the task and indeed of the duty of the artist, and without taking note of this conception it will never be possible to do justice to these creations. What we call 'art' is among other things a social phenomenon and the artist also identifies with the role which society assigns to him. Thus the psychology of artistic creation is intimately connected with the theory of art which happens to be dominant in a period. In case this formulation sounds puzzling I should like to relate an experience I had in Vienna some fifty years ago: I was approached by a young man of my age in the lecture room of the University who told me that he was an artist and urged me passionately to look at his works. He took me to his rooms and pointed to a covered work. On lifting the dust sheet with great solemnity I saw an almost shapeless lump of clay in which one might possibly, and with much goodwill, find the marks of a human face. On my embarrassed silence he assured me with fanatical intensity: 'It is a work of art, I know it is a work of art because it originated like a work of art.' What he wanted to say was that he had experienced the urge to create and that the product had arisen from the depth of his soul. To cut short any further discussion, he opened a drawer in his desk and took out a sheet of paper covered with neat handwriting. It was a letter addressed to him which was signed 'Michelangelo' and said roughly: 'At last you have achieved what I always tried to do.' I was glad to get safely out of the door, but I have never forgotten the experience because from the point of view of an extreme subjectivism, it would indeed have been impossible to

refute the argument of that poor madman. Yet even he sensed somewhere that his subjective convictions alone were not enough, for else he would not have produced the fantasy of a testimonial by Michelangelo, whose name stands for such a totally different conception of art. What matters to us in Michelangelo's oeuvre is less how it originated than what he accomplished.

Sigmund Freud, who during his stay in Rome stood every day in front of Michelangelo's statue of *Moses* to probe its meaning, never doubted the importance of the artist's mastery even though he felt unable to discuss it. But like his contemporaries he took it for granted that this mastery had to be placed in the service of a personal artistic concern. His reading of Leonardo's *Virgin and St Anne*, for instance, rests on the implicit assumption that the urge to create it arose from within the artist and not from without, as was the rule in the Renaissance. For Freud technical skill consisted in the ability to realize fantasies. But just as in a beautiful letter about ethics[5] he quoted the saying of Friedrich Theodor Vischer: 'Morality must always be taken for granted', so he probably would have said: 'The aesthetic must always be taken for granted'.

Precisely because he found his expectations here disappointed he rejected with the utmost vigour the whole movement of art which Pfister called Expressionism. His letter to Pfister of 21 June 1920 may well alienate readers today, but it cannot be ignored.

> Dear Doctor,
> I took up your pamphlet about Expressionism with no less eager curiosity than aversion and I read it in one go. In the end I liked it very much, not so much for the purely analytic parts, which can never get over the difficulties of interpretation for non-analysts, but for what you connect with it and make of it. Often I said to myself: 'What a good and charitable person free from all injustice Pfister is, how little you can compare yourself to him and how nice it is that you must come to agree with everything at which he arrives in his own way.' For I must tell you that in private life I have no patience at all with lunatics. I only see the harm they can do and as far as these 'artists' are concerned, I am in fact one of those philistines and stick-in-the-muds whom you pillory in your introduction. But after all, you yourself then say clearly and exhaustively why these people have no claim to the title of artist.
> Let me therefore thank you cordially for this new enrichment of my psychoanalytic storehouse.

More formidable even was the thunderbolt hurled by the irate writer at a poor painter who had made a portrait of Karl Abraham in 1922:

Dear Friend,

I received the drawing which allegedly represents your head. It is ghastly. I know what an excellent person you are, I am all the more deeply shocked that such a slight flaw in your character as is your tolerance or sympathy for modern 'art' should have been punished so cruelly. I hear from Lampl that the artist maintained that he saw you in this way. People such as he should be the last to be allowed access to analytic circles, for they are all-too-unwelcome illustrations of Adler's theory that it is precisely people with severe inborn defects of vision who become painters and draughtsmen. Let me forget this portrait in wishing you the very best for 1923.[6]

Who would have expected to encounter here of all places an anticipation of the hatred against an allegedly degenerate art? Maybe Freud wrote with so little restraint because he himself sensed somehow that the younger generation found in psychoanalysis a bridge to that movement of art which he so passionately disliked.

Thus it is wholly understandable that it has meanwhile become usual to explain and if possible to excuse Freud's rejection of modern art by pointing to the prejudices of his generation and of his milieu. But it is always somewhat risky to dispose of the views of a great man which we find uncomfortable. Moreover, I think that in the case of Freud this escape route is barred. If there was ever anyone who proved that the prejudices of his generation had no such power over his thought it was Sigmund Freud. We may be quite sure that he had theoretical reasons for his attitude.

Fortunately opportunity arose for him to explain these reasons in a letter. By a happy coincidence he was prompted to clarify his position towards the most extreme form of artistic subjectivism, the movement of Surrealism, which relied programmatically on the kinship between the dream and the work of art and hence on the automatism of creation: Stefan Zweig had asked Freud to receive Salvador Dali (Fig. 159) in London and Freud, then eighty-two, agreed and wrote on 20 July 1938:

Dear Doctor,

I can really thank you for the introduction which yesterday's visitor brought me. For up to then I was inclined to consider the Surrealists, who appear to have chosen me as their patron saint, pure lunatics or let us say 95 per cent, as with 'pure' alcohol. The young Spaniard with his patently sincere and fanatic eyes and his undeniable technical mastery has suggested to me a different appreciation. It would indeed be very interesting to explore the origins of a painting by him analytically. Yet, as a critic, one might still be entitled to say that the concept of

art resists an extension beyond the point where the quantitative proportion between unconscious material and preconscious elaboration is kept within a certain limit. In any case, however, these are serious psychological problems.

I owe it to the guidance of Ernst Kris[7] – who, before his exile, was a Keeper at the Kunsthistorisches Museum in Vienna and a joint editor of the psychoanalytic monthly *Imago* – that I may perhaps venture to interpret Freud's highly complex utterance and thus to elucidate what he here considered to be 'serious psychological problems'. He first remarks that it would be interesting to explore the origins of a painting by Dali analytically, interpret it through free association and memories like a dream, as Pfister had done in his time. But, Freud continues, as a critic one might say that even so it was not by any means a work of art but like a dream, because 'the concept of art resists an extension beyond the point where the quantitative proportion between unconscious material and preconscious elaboration is kept within a certain limit'. Too much unconscious material and too little preconscious elaboration does not result in what Freud would acknowledge as a work of art.

The terminology which Freud uses points to one of his works which is of decisive importance for the theory of the arts; I am thinking of his book *The Joke and its Relation to the Unconscious* of 1905. This estimation should not come as a surprise. For it was precisely in this context that Freud demonstrated what the comparison with the dream could achieve and where it lets us down. When we speak of good and bad dreams we surely mean something very different from calling a joke good or bad. The problem of value, which no theory of art can ignore, stands in this brief and highly personal book in the

centre of attention and I believe that some light is thrown in it even on the problems of technique and of style.

Freud's starting-point is the observation of the frequency with which we can find in dreams witty comparisons, puns and allusions, which must serve the purpose which he attributes to all dreamwork: the purpose of both liberating and disguising wishful fantasies.

What Freud in *The Interpretation of Dreams* describes as the mechanism of the primary process, that is condensation, displacement and the transformation into an image, can also be found in the joke. It was particularly the pun in which the double meaning of a word makes us laugh that interested Freud.

Puns, of course, resist translation, but even before illustrating the kind of verbal joke which Freud enjoyed it may be worth pointing out that contrary to the popular stereotype of his bias his book on the Joke by no means concentrates on sexual innuendoes. On the contrary, he singles out for quotation the witticisms of 'one of the leading figures of Austria who after a brilliant career in science and in the civil service now occupies an exalted post in the State'. The joker had made fun of a historian who happened to have red hair, calling him something like 'that ginger bore who bores his way through the history of Napoleon's family'. Admittedly the pun is a little wittier in German;[8] but even if these witticisms were translatable they would hardly make us laugh today since we no longer know their butts. However, what Freud wished to bring out was that an educated man would hardly have allowed himself to express his distaste of tedious writings, let alone of red hair, except in a malicious quip. We feel free to laugh because the derogatory remark does not appear as naked aggression, but as a play with language which, as it were, seduces us to share in the speaker's sentiment.

It is precisely this possibility of sharing which represents the decisive difference between the joke and the dream. 'The dream', as Freud writes,

is a wholly asocial psychic product: it has nothing to say to anyone else. Having originated within a person as a compromise between contending psychic forces, it remains unintelligible even to that person and is wholly uninteresting to others. Not only can the dream dispense with intelligibility, it must even beware of being intelligible, for else it would be destroyed; it can only exist in disguise. Hence it can make full use of those mechanisms which dominate our unconscious thoughts, distorting them beyond any possibility of retrieval. The joke on the other hand is the most social of all psychic achievements aiming at pleasure ... thus it is bound by conditions of intelligibility.[9]

This intelligibility – if I may pursue this thought – rests of course on the

common store of culture, most of all on the common possession of language. Freud regarded the pleasure in wordplay as a continuation of the childish pleasure in experimenting with speech sounds, experiments which gradually lead to the mastery of language. The pleasure in free permutations and twistings of words manifests itself in verbal tomfoolery as well as in witticisms; it is part of that regression to earlier psychic states to which Freud's theory assigns such an essential role. What ultimately matters is that in Freud's theory play and regression are simply the means of which we make use when cracking a tendentious joke, regardless of whether we proceed consciously or the joke comes to us as a fully fledged idea. To quote Freud's own formulation again:

> The work on the joke manifests itself ... in the choice of such verbal material and such imaginary situations which make it possible for the old game with words and ideas to withstand the test of criticism, and for this purpose all peculiarities of the vocabulary and all constellations of associated connections must be most skilfully exploited.[10]

'The most skilful exploitation of all the peculiarities of the vocabulary', that is the demand we make on the joke. The wittiest writers, whether Karl Kraus, whose jokes about psychoanalysis Freud understandably failed to relish, or Lichtenberg, whom he highly esteemed, were all masters of language. To put it in a nutshell, a good joke is not an invention but a discovery. The identity or similarity of speech sounds on which the pun rests did not have to be invented: it had merely to be discovered, though one might quarrel over the word 'merely'. In a letter to Jung[11] Freud speaks in this connection of language meeting us half-way, just as he also acknowledges coincidences meeting us half-way. But both the coincidence and language only meet those half-way who are already on the road.

 I can illustrate the situation by means of a *mot* attributed to Erwin Panofsky, who warned his students to be aware of the 'boa constructor', a danger he knew he had courted himself. We might imagine the discovery of the verbal similarity between constrictor and constructor by picturing two libraries, one neatly arranged according to subject-matter where no doubt the giant snake would be found under Herpetology, while construction might be treated in the section on Engineering. There would be no way from the one to the other. But according to Freud's model of the psyche the library of our waking consciousness is supplemented by one deposited in a dark basement where books and loose pages are piled up in wild confusion. Here the word 'constructor' might accidentally adjoin 'constrictor', for instead of well-

trained librarians imps are having their fun down there, assembling texts or words according to their own whim, for instance according to sounds, images or emotional associations. The result will certainly lack rational meaning, and without further interpretation it might look like mere verbiage. But anyone who, like Panofsky, enjoys dressing a thought in a surprising garment has more chance of making a useful discovery down there than in the well-ordered library upstairs.

The successful joke, therefore, demands a brief descent into the cellars of the unconscious, but also an elaboration by the preconscious of the finds made down there. In contrast to mere punning the successful witticism must satisfy at least two standards, that of meaning and that of form, and in the choice of both there lies an element of style. In Anglo-Saxon circles the pun is much less highly esteemed than in Freud's Austria or Panofsky's Germany. Punning is considered the lowest form of humour because traditionally it is confined to a juggling with sounds rather than with meanings.

But naturally the verbal pun is far from being the only form in which the surprising arrangements of the unconscious come into their own. We need only think of that humble device, the rhyme. Anyone who has ever tried to compose a few lines of doggerel knows that he must surrender to the life of language to find the desired meeting of sounds which may at least mildly please or evoke a smile. The experienced word-smith knows the territory and will avoid the tritest of rhymes because he is sure of making more inspired discoveries. The real poet, of course, is endowed with genuine mastery, and you will not suspect me of confusing rhyming with poetry.

It will be seen how effortlessly Freud's approach in his book on the Joke permits a transition to those areas which he considered outside the competence of psychoanalysis, that is the areas of artistic gifts and of artistic techniques. And yet we may also divine the reasons which deterred Freud from proceeding further along that road: any attempt to translate a verbal joke is doomed to failure. To use traditional terminology, the joke simply does not permit us to separate form from content. However, this was precisely what Freud aimed at in his clinical work. He regarded himself as a translator who was able to interpret for his patients the latent contents of their dreams and their symptoms. To 'interpret them' could only mean to put them into words. But what the theory of art, to which Freud approximated the theory of the joke, teaches us is precisely that this kind of interpretation will never be possible; one can never put into words what a work of art 'says'.

Freud realized that this impossibility troubled him. Thus he prefaced his interpretation of Michelangelo's *Moses* with a telling remark which should by no means be taken to be a mere *captatio benevolentiae*:

> I must begin with the declaration that I am not an expert on art but a layman. I have often noticed that the content of a work of art attracts me more than do its formal and technical qualities, which the artist values most of all. I lack the proper understanding of many media and several effects of art.[12]

I believe Freud to have been too modest in this declaration. He exaggerated his difficulties because he identified understanding with the capacity to comprehend the means and effects of art in terms of a content which could be translated into words, as he was trying to do with the posture and gesture of the statue of *Moses*. It was probably on this occasion, when he first attempted to reconstruct the various stages of the hypothetical movement of the Prophet in a series of drawings, that he arrived at the conviction to which he gave expression much later in a letter to Lou Andreas-Salomé: 'But despite the compliments they pay me I am not an artist, I could never have rendered the effects of light and colour and could only have drawn hard contours.'[13]

We must not doubt his words, and yet — would he not have despaired of achieving the effects of light and of colour if he had not understood their subtleties?

How indeed could Freud have so enjoyed collecting art and visiting art centres if he had lacked a natural response to the works of the masters or to the splendours of the Acropolis? But what in this letter he described as 'hard contours' may perhaps be compared with his insistence on literal understanding, which also explains how he could tell Romain Rolland that music was a closed book to him.[14] Music eludes verbal interpretation but not understanding, and it almost looks as if Freud had debarred himself from this natural access in a posture of defiance.

In a cheerful letter which he wrote to his family from Rome in 1907 he describes a performance of Bizet's *Carmen* and mentions quite naturally that he had stayed until the Third Act despite the endless intervals, because he so loved the music of the fortune-telling episode. Nor does he refrain from criticizing the performance: 'The wonderful tunes came well into their own, but everything was somewhat coarsened and too noisy.'[15] No one who quite lacks an ear for music could have made these remarks.

It would scarcely be just, however, to blame Freud's one-sided approach to art simply on his personal bias. The responsibility lies again with the theory of art which was dominant at that time, the theory which identified art with expression or even with communication. The most profound criticism of the theory is contained in an epigram by Friedrich Schiller headed 'Language': 'Why is the life of the spirit for ever concealed from the spirit? When you hear

156
Andrea del Verrocchio,
head of a Virtue from the
Forteguerri Monument,
completed in 1489. Pistoia
Cathedral

the soul *speak*, know that here speaks not the *soul*.'[16] Immediate contact between soul and soul, in other words, is an unrealizable dream. If that were not the case, we may add to Schiller's words, we would not stand in need of psychoanalysis.

I do not want to be misunderstood. In questioning the proposition that artistic creation can be identified with communication, I do not want to deny that the artist is concerned with the effect of his work on others. But this effect results from the manipulation of his medium, the lines, colours or tones through which he can move the human heart. Such an aesthetics of effects rests on the empirical observation that we all react to sense impressions, whether we experience them in nature or in front of works of art. It matters little whether we can regard such effects as constant or whether they are conditioned by culture. There certainly exist elementary reactions which are almost or wholly universal, for instance the impression made by light, by bright or shining surfaces, by the disgusting and by the erotically arousing. What concerns me is only that all arts make systematic use of such effects and that the artist therefore builds on observations he has made on himself and on others. That is why I like to insist on the formulation that the artist must be

157
The Karlskirche, Vienna,
built by Fischer von
Erlach, c.1725. Engraving
by H. Sperling after S.
Kleiner

158
Trajan's Forum, Rome,
with the 16th-century
church of S. Maria di
Loreto on the right,
Trajan's Column
(dedicated in AD 114) in
the centre, and the church
of SS. Nome di Maria
(completed in 1738) on
the right

a discoverer. Just as the verbal joke is discovered in the language, so the masters
of other artistic media find their effects prefigured in the language of style
which – to return to Freud's words – 'meets us half-way'. Even if Freud was
right in accepting Merezhkovsky's intuition that Leonardo had developed his
ideal of womanhood out of memories of his childhood[17] – something that can
neither be proven nor refuted – the artist must in any case have discovered it
among the female types of his master Verrocchio (Fig. 156), which he varied

159
The Great Mosque at
Bursa. Illustration from
Fischer von Erlach,
*Entwurf einer historischen
Architektur* (Vienna, 1721)

and refined. Without the mason's lodge and pattern books Anton Pilgram could not have designed his beautiful pulpit in St Stephen's Cathedral, and without the achievements of Romantic landscape painting Ferdinand Waldmüller would not have been able to conjure up for us his *Springtime in the Vienna Woods*. Even Cubism has been observed to rest on certain faceting effects in the late paintings of Cézanne where, of course, they served a different artistic purpose.

As for architecture: however original Fischer von Erlach's Karlskirche in Vienna (Fig. 157) may be, he too discovered rather than invented its forms and even their combinations; far from creating them out of nothing he merely modified and reinterpreted what he found in tradition. Even so the church is not a mere pastiche, but a masterpiece because the architect knew how to render the individual set pieces pliable as it were and to fuse them together: the memory of the domed churches, temple fronts and triumphal columns of Rome (Fig. 158) is combined with an allusion to the scheme of the mosque with flanking minarets (Fig. 159), to mention only some of the elements.

Music I need hardly talk about, since the whole structure of the tonal system of Western music can be described as a series of discoveries which

enabled the composers to create their towering works. Naturally this could never have happened if there had not been musicians who responded to tones and harmonies which meant something to them; in fact they meant everything to them, but not as translatable symbols, at the most as metaphors which only have meaning within the context of the language itself. I know of a musician who had the feeling as she was lying in bed half awake, during an illness, that if she could only find the position in F sharp minor she would be able to sleep. To the analyst such emotional relationships must be familiar, but what matters to me is the fact that even feelings of this kind presuppose an existing tonal language which meets the fevering patient half-way. An out-and-out atonal composer or possibly a conservative Indian could never have sensed this equivalence. Naturally, also, nobody would expect such a private meaning to be communicated in performance. What asks for interpretation is the increasing refinement, I would almost say physiognomization, of the language of tones through which the sound poem can ultimately make us respond, whatever private associations it may evoke in us.

What the study of effects suggests is that we are in need of a special branch of psychology which might be called 'metaphorics'. It can be exemplified from a section in Goethe's *Theory of Colour* to which he gave the fitting heading: 'The sensually-moral effect of colours' (*die sinnlich-sittliche Wirkung der Farben*). A few extracts must suffice:

> The pleasantly cheerful feeling which reddish-yellow gives us is changed into the sensation of intolerable violence when it is heightened into intense yellowish-red. The active aspect manifests itself here in its extreme energy, and so we need not be surprised that energetic, healthy, rude people evince a particular pleasure in this colour. This preference has been universally noticed amongst savages. And when children who are left to themselves begin to paint they will not spare vermilion and red lead.

To illustrate these 'moral' effects Goethe mentions a highly intelligent and observant Frenchman of whom it was told that 'he had noticed that the tone of his conversation with Madame had changed after she had changed the upholstery of the furniture from blue into crimson'. We do not hear in what direction the tone of the conversation had altered, but Goethe tells us later that the French obviously hate crimson (*cramoisi*) since the expressions '*sot et cramoisi*' or '*méchant et cramoisi*' signify the extreme of tastelessness and evil. Poor Madame probably had to suffer for her lapse in taste.

Possibly Goethe's anecdote sounds a little like Andersen's famous tale of the 'Real Princess'. To find out whether she was indeed genuine the Prince's

mother placed a tiny pea on the bedstead and piled upon it twenty mattresses and twenty feather beds for her to sleep on. When she complained next morning that she hardly slept a wink because something in the bed had badly disturbed her she had passed the test triumphantly. What makes a real artist is precisely such a heightened sensitivity, responding to the slightest differences in shade imperceptible to a less delicate sensorium.

Goethe, of course, was a poet, not a painter, or at the most a failed painter, if we remember his own confession in the 'Venetian Epigrams':

> Much have I tried in my life, to sketch and make copper engravings,
> Painting pictures in oil, modelling figures in clay;
> Lacking persistence, however, I learned and produced next to nothing,
> Only through one of my gifts came I to mastery close:
> That of writing in German, and thus, I unfortunate poet
> In the meanest of means squandered my life and my art.

We must not hold this spell of ill-humour against the great man. I only quote these lines to bring out the contrast between his sensitive response to all the shades of colour and his self-confessed inability to master colour as he mastered language. So much has come together to transform artistic sensibility into artistic creativity. In this context, of course, the historical situation must not be left out of account. The son of a Frankfurt middle-class family who had taken drawing lessons in Leipzig with Oeser, Goethe was much too old for a change of careers at the time of his Italian journey when he first fully discovered the greatness of the masters. But who would apportion the respective shares to luck and to merit in the life of such a man?

Would Freud have felt equally honoured, on receiving the Goethe Prize, if Goethe had ended up a painter rather than a poet? He himself, after all, was a master of language, a wizard with words, who in his turn embarked on voyages of discovery in Goethe's work and who on any occasion could produce an uncannily fitting quotation from Goethe's *Faust*. It cannot be denied that his attitude to painters was much more reserved. He had much less understanding of their world. After having spent an evening with painters he wrote a letter in English to Ernest Jones which speaks of his impatient reaction: 'Meaning is but little to these men all they care for is line, shape, agreement of contours. They are given up to *"Lustprinzip"* [pleasure principle].'[18] He must have forgotten at that moment that these men could never have become artists if line, forms and contours had meant nothing to them. And while he approached poets and writers with real humility he seems to have derived his image of the artist from the novels of the turn of the century which wallowed

in the depiction of the *vie de Bohème*; witness a letter he wrote in November 1914 to Hermann Struck, who had painted his portrait and to whom he sent his article on the *Moses* of Michelangelo: 'I must hurry to say that I am well aware of the basic weakness of my work. It lies in my effort to see the artist rationally like a scientist or engineer while he is after all a very special kind of being, aloof, self-centred, unprincipled, occasionally rather unintelligible.'[19]

We will not enquire whether Struck liked to hear that he belonged to such an 'unprincipled' ilk. But in Freud's repeated insistence that artists remained rather unintelligible to him, we also sense his desire to distance himself as a scientist from their alleged irrationality.

It is only in a work of Freud's old age, *Civilization and its Discontents*, that a different attitude towards the artist comes to the fore. He there discusses the burden civilization imposes on us by barring the satisfaction of our drives; he mentions the Eastern and Western ideals of their control and continues:

> Another technique of defence against suffering makes use of that shifting of libido which our psychic apparatus permits and through which its function gains so much in flexibility. It must solve the problem of how to shift the aims of the drives in such a way that they cannot be affected by the denials imposed on us by the environment. Here the sublimation of drives will help. The optimum is achieved when one knows how sufficiently to increase the pleasure gained from the exercise of mental and intellectual faculties. In that case fate will have lost much of its power over us. Satisfactions of this kind, such as the pleasure of the artist in creating, in embodying the visions of his imagination, that of the scientist in the solution of problems and the discovery of truth, have a special quality which we certainly will be able one day to characterize metapsychologically.[20]

Here the achievement of the artist is accorded the same rank as that of the scientist searching for truth, and Freud expresses his confidence that it would be possible one day to discover the psychic sources of this mental attitude. But even here his confidence concerns a future psychology of the artist rather than a psychology of the arts. He never denied the limits of his methods, and even less did he hide them behind a fog of impressive words as has so often happened and still is happening in the theory of art.

The more one concerns oneself with Sigmund Freud's life-work, the more impressed must one be by his personality, his human dignity. We have seen him strictly observe the moral imperative of the scientist never to say more than he thought he could answer for. Even the most daring flights of his intellect do not tell us more of his greatness than does this noble reserve. He certainly was no friend

of flag-waving and so it seems to me that on this day we cannot honour him better than by refusing to make these matters look simpler than they happen to be.

Editor's Postscript

Gombrich's interest in Freud dates back to his association with Ernst Kris, which is discussed in 'The Study of Art and the Study of Man' (reprinted in Tributes*). They collaborated on a project on caricature, which was intended to match Freud's work on the verbal joke.[1] The resulting book was never published though they did publish an article, 'The Principles of Caricature', in the* British Journal of Medical Psychology, *17 (1938), pp. 319-42, which was reprinted in Ernst Kris,* Psychoanalytic Explorations in Art *(New York, 1952), and a King Penguin,* Caricature *(London, 1940). Gombrich has recently published a major revision of the project's underlying theory, 'Magic, Myth and Metaphor: Reflections on Pictorial Satire', reprinted in this volume (pp. 331–53), and he has continued to work on the mechanics of caricature and the cartoon throughout his career. 'Psychoanalysis and the History of Art' is another essay in the Freudian idiom and has been republished in* Meditations on a Hobby Horse. *The theme of regression occurs throughout Gombrich's work.*

When theorists have used Freud to elucidate works of art, they have typically focused on his work on the dream. Dreams are, however, private and works of art are, like jokes, public. The model of dreaming fits well with an emphasis on the interiority of artistic life but does little to account for its social function.

A criticism of a Jungian approach to the history of art can be found in 'Kenneth Clark's "Piero della Francesca"', reprinted in Reflections. *Following the article republished here, the obvious criticism of Jung is that there is no need to invent the existence of a Collective Unconscious when one has the Third World of culture. On the Popperian notion of the Third World see Karl. R. Popper,* Objective Knowledge: An Evolutionary Approach *(Oxford, 1972), index 'world 3'. But see also Gombrich's remarks on Jung on pp. 246–7 of* The Sense of Order.

A complementary essay, 'Freud's Aesthetics', has been reprinted in Reflections. *See also my postscript on pp. 352–3 below.*

1. Sigmund Freud, Der Witz und seine Beziehung zum Unbewussten *(1905) translated by James Strachey, revised by Angela Richard as* Jokes and their Relation to the Unconscious *(Harmondsworth, 1976).*

Leonardo's Method for Working out Compositions

This paper was a
contribution to the
Congress on Leonardo da
Vinci at Tours in 1952;
published in *Norm and
Form* (1966; 4th edition,
1985), pp. 58–63

Anyone who looks through Berenson's Corpus of Florentine drawings[1] must
be struck by the novelty of Leonardo's drawing style. He works like a sculptor
modelling in clay who never accepts any form as final but goes on creating,
even at the risk of obscuring his original intentions. There are drawings such
as one for the *St Anne* (Fig. 160) where we no longer find our way through the
welter of *pentimenti,* and may doubt if Leonardo could. In fact we know that
Leonardo had to clarify his idea by using a stylus and tracing the line he finally
chose through the paper to its reverse (Fig. 161).

There is no parallel for such a procedure in the work of earlier artists.
Leonardo knew that the method was his own and in the passage I want to
discuss he explains both its novelty and its *raison d'être:*

> You who compose subject pictures, do not articulate the individual parts of
> those pictures with determinate outlines, or else there will happen to you what
> usually happens to many and different painters who want every, even the slightest
> trace of charcoal to remain valid; this sort of person may well earn a fortune but
> no praise with his art, for it frequently happens that the creature represented fails
> to move its limbs in accordance with the movements of the mind; and once such
> a painter has given a beautiful and graceful finish to the articulated limbs he will
> think it damaging to shift these limbs higher or lower or forward or backward.
> And these people do not deserve the slightest praise in their art.[2]

The polemical note suggests that Leonardo must have argued about his
method with fellow artists who took a different view. Their standard, we can

gather, was that of the sure, unfailing line which needed no correction and no second thoughts. It is the idea of the perfect draughtsman crystallized in Vasari's anecdote of the King of Naples asking for a token of Giotto's skill: the master drew a perfect circle, the proverbial '*O di Giotto*', to prove his skill of hand.[3] It is this quality of the perfectly controlled line that we admire in such medieval drawings as have come down to us, for instance in Villard d'Honnecourt's *Swan* (Fig. 162).[4] Nor did this standard of artistic perfection change in the early Quattrocento. Cennini[5] implies that the young apprentice must copy the works of his chosen masters till he can write them down with the same perfect assurance; better still, we have the evidence of the drawings themselves which, despite all the variations of style and technique, show the same concern for 'tidiness' Leonardo attacks. Even Pisanello, who laid up such a store of studies from nature in his sketchbooks, practised this restrained and careful line; in an unfinished drawing such as his *Hawk* (Fig. 163) the heraldic formula of the pattern book can still be felt. But is it possible that artists before Leonardo never had second thoughts? Did they really believe that *ogni segno di carbone sia valido*? As long as the function of drawing in the medieval workshop was not clearly analysed these questions could scarcely be answered with assurance, but since the careful researches of Oertel[6] and of Degenhart[7] we have begun to see that drawing did in fact serve a different purpose in a world where the artist was so much guided by traditions and patterns. Where invention is not expected and demanded of the artist,

162
Villard d'Honnecourt,
Swan, mid-13th century.
Bibliothèque Nationale,
Paris

163
Antonio Pisanello, *Hawk*.
Louvre, Paris

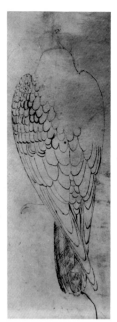

emphasis must be on his facility in mastering the 'simile', the formula, and fumbling will therefore be frowned on.[8] This is not to say that artists of that period never introduced a correction into an existing drawing. *Negativa non sunt probanda*, as the lawyers say. But it remains remarkable how rare even small *pentimenti* are in drawings. As a rule, if one of these artists did have doubts about which pattern to adopt for a composition he preferred to begin afresh, to draw two or more alternatives side by side.[9] A late Trecento drawing in the Louvre is a good example of an artist trying to select the right composition for an Annunciation without resorting to a pentimento (Fig. 164).

Before this background of an established workshop practice and of rigid standards of propriety we must look at an early drawing by Leonardo (Fig. 165) in order to gauge the revolutionary character of his wayward approach to his calling.

The continuation of the *Precetti* of which I quoted the first passage shows the terms in which Leonardo saw and meant to justify this departure:

Now have you never thought about how poets compose their verse? They do not trouble to trace beautiful letters nor do they mind crossing out several lines so as to make them better. So, painter, rough out the arrangement of the limbs of your figures and first attend to the movements appropriate to the mental state of the creatures that make up your picture rather than to the beauty and perfection of their parts.[10]

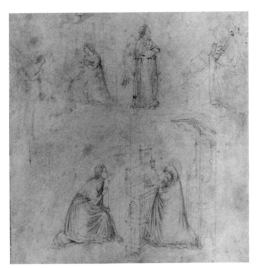

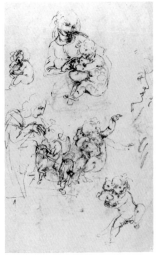

164
North Italian artist,
studies for an
Annunciation, *c*.1400.
Louvre, Paris, Cabinet des
Dessins

165
Leonardo da Vinci, *Studies
of the Virgin and Child, c.*1478.
British Museum, London

The appeal to the practice of the poet could not be more significant. We are familiar with Leonardo's insistence on the dignity of painting, on its status as one of the Liberal Arts and its equality with poetry, if not its superiority over it. But here we meet with a tangible and far-reaching result of this insistence. Painting, like poetry, is an activity of the mind, and to lay stress on tidiness of execution in a drawing is just as philistine and unworthy as to judge a poet's draft by the beauty of his handwriting. One feels the pride in Leonardo's argument, but one can also sense the dangers which threatened his art from that direction. Who has not met the intellectual or poet who has tried to justify his illegible handwriting by saying or implying that it does not matter *how* he writes but *what* he writes? The insistence on invention, on the mental quality of art can certainly become destructive of standards of craftsmanship. In Leonardo, as we all know, it was destructive of that patience that alone could have kept him at his easel. But it is not on this negative aspect of Leonardo's new doctrine of the sketch that I wish to dwell. For good or ill, Leonardo here argues from an entirely new conception of art, and he knows it. What concerns the artist first and foremost is the capacity to invent, not to execute; and to become a vehicle and aid to invention the drawing has to assume an entirely different character – reminiscent not of the craftsman's pattern but of the poet's inspired and untidy draft. Only then is the artist free to follow his imagination where it leads him and to 'attend to the movements appropriate to the mental states of the figures which make up his story'. He needs the most pliable of mediums which allows him to write down quickly whatever he sees in his mind – as a variant of our passage in Leonardo's notes says:

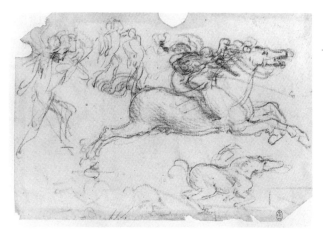

166
Leonardo da Vinci, *Study for the Battle of Anghiari*, *c*.1503. Royal Library, Windsor Castle

Sketch subject pictures quickly and do not give the limbs too much finish: indicate their position, which you can then work out at your leisure."

We can follow the development of this technique in Leonardo's drawings. The early sketches are still in Verrocchio's tradition, but also show a change of emphasis. One can see that what matters for Leonardo is the *moto mentale*, and that he occasionally even resorts to a plain scrawl (Fig. 160) because his attention is not on the *bellezza e bontà delle . . . membra*.

In the studies for the *Battle of Anghiari* (Fig. 166) we find the new method fully developed. In this technique the inner vision, the inspiration, is 'thrown' on to the paper as if the artist were anxious to strike the iron while it is hot. It is from such works that the new conception of the sketch takes its starting point, a conception which culminates in the eighteenth century when Lemierre wrote in his poem *La Peinture* (1770):

> *Le moment du génie est celui de l'esquisse*
> *C'est là qu'on voit la verve et la chaleur du plan . . .*"

But Leonardo's *Precetti* do not end with the comparison between the artist and the poet. The final passage, and the most interesting one, suggests that to him the sketch was not only the record of an inspiration but could also become the source of further inspiration.

> For you must understand that if only you have hit off such an untidy composition in accordance with the subject, it will give all the more satisfaction when it is later clothed in the perfection appropriate to all its parts. I have even seen shapes in clouds and on patchy walls which have roused me to beautiful

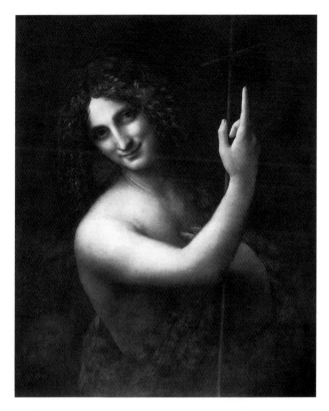

inventions of various things, and even though such shapes totally lack finish in any single part they were yet not devoid of perfection in their gestures or other movements.[13]

Here, then, Leonardo links his technical advice on the best method of sketching with that psychological observation and advice which is also formulated in one of the most famous passages of the *Trattato*, that in which he recommends 'a new invention for meditation ... to rouse the mind to various inventions',[14] looking at crumbling walls, glowing embers, speckled stones, clouds or mould, because in these irregular shapes one can find strange inventions, just as we are apt to project words into the sound of church bells. The passage has always fascinated psychologists concerned with artistic creation.[15] It suggests that Leonardo could deliberately induce in himself a state of dreamlike loosening of controls in which the imagination began to play with blots and irregular shapes, and that these shapes in turn helped Leonardo to enter into the kind of trance in which his inner visions could be projected on to external objects. In the vast universe of Leonardo's mind this invention is contiguous with his discovery of the 'indeterminate' and its power

168
Leonardo da Vinci, *Virgin and Child with a Cat*, c.1478. British Museum, London

169
Leonardo da Vinci, *Girl with a Unicorn*, c.1478. Ashmolean Museum, Oxford

over the mind, which made him the 'inventor' of the *sfumato* and the half-guessed form (Fig. 167).[16] And we now come to understand that the indeterminate has to rule the sketch for the same reason, *per destare l'ingegnio*, to stimulate the mind to further inventions. The reversal of workshop standards is complete. The sketch is no longer the preparation for a particular work, but is part of a process which is constantly going on in the artist's mind; instead of fixing the flow of imagination it keeps it in flux.

There is evidence that Leonardo did in fact use his sketches as he says one should use crumbling walls, to help his 'invention' regardless of the subject. It has often been observed, and recently been emphasized by more detailed observation,[17] that the sketches for the *St Anne* (Fig. 160) develop motifs of his *Virgin and Child with a Cat* (Fig. 168) and other early drawings. What is remarkable in these instances is the way in which certain motifs which have a clear symbolic significance in the finished version grow out of entirely different forms – the Lamb of the *St Anne* composition which, we know, signifies the Passion of Christ[18] was formerly a cat and even a Unicorn (Fig. 169). In searching for a new solution Leonardo projected the new meaning into the forms he saw in his old discarded sketches. Another such instance suggests itself: we know from Vasari that Leonardo made the famous *Neptune* sketch for Segni while in Florence engaged on the *Battle of Anghiari*. Does it not look as if the welter of forms in this *componimento inculto* (Fig. 170) with the figure rising with upraised arm over the group of horses had evoked in Leonardo's searching mind the image of Neptune driving his sea horses (Fig.

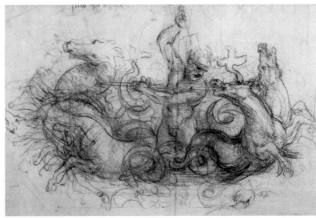

171)? As it was, the group did not satisfy him; not only do we find countless *pentimenti* in the fantastic shape of the sea horses – in his constant internal monologue he even calls the written word to his aid and writes on top of the group: *abasso i cavalli*. One may imagine that it was with this problem in his mind that he attended the meetings of the committee for the placing of Michelangelo's *David*, for as he looked at this towering figure and drew it on a sheet (Fig. 172) he again began to project the form for which he was searching into the drawing he had made, and tentatively added some sea horses to the version of the *David*.[19]

There is perhaps nothing more astounding in Leonardo's *œuvre* than this divorce between motif and meaning. We are all familiar with the persistence in his creation of certain images which are given different names according to the context they are made to serve. Only a conception of art so utterly personal and almost solipsistic as Leonardo's could have brought about this most significant break with the past. For ultimately it is the act of creation itself that matters to him: 'If the painter wants to see beautiful women to fall in love with, he has it in his power to bring them forth ... '[20] The more the sketch can stimulate the imagination the better can it fulfil its purpose. True, to Leonardo this is only one side of the question. The more personal his art becomes, the more we feel that he is a prey to the obsession of certain stereotyped visions, the more he also insists on the objectivity of his art and on the need of rational variation grounded on observation.[21] There is no contradiction here. Leonardo knew that the fantasies he discovered in the indeterminate could only be made to spring to life by lucid knowledge.

> For confused things rouse the mind to new inventions; but see to it that you first know all the parts of the things you want to represent, be it those of animals, of landscapes, of rocks, plants or others.[22]

170
Leonardo da Vinci, *Study for the Battle of Anghiari*, *c*.1503. Accademia, Venice

171
Leonardo da Vinci, *Neptune*, *c*.1504. Royal Library, Windsor Castle

172
Leonardo da Vinci, *Study of Michelangelo's David*, c.1504. Royal Library, Windsor Castle

173
Leonardo da Vinci, *The Deluge*, c.1514. Royal Library, Windsor Castle

Our distinction between 'art' and 'science' would have been unintelligible to Leonardo. It could not even be made in a language in which medicine or hawking was an 'art' and painting could be termed a 'science'. But it stands to reason that within the conventions of painting as conceived by the Renaissance any increase in that imaginative freedom we call 'art' demanded an equal intensification of those studies we call 'scientific'. Once the sway of the pattern book is broken and the painter is enjoined to visualize an infinite variety of groupings and movements, only the most intimate knowledge of the structure of organic form can enable him to clothe his *primo pensiero* with flesh and bones.

> The master who would let it be known that he could keep in his mind all the forms and effects of Nature would certainly seem to me graced with much ignorance, insofar as those effects are infinite and the capacity of our memory is not such that it would suffice.[24]

And so the advice to the artist to adopt a new method of sketching leads of necessity to a more exacting standard of procedure:

> You will first attempt in a drawing to give to the eye an indication of the intention and the invention which you first made in your imagination, then proceed to take away and add till you are satisfied, and then let draped or nude models be posed in the manner in which you have arranged the work; and see to it that they accord in measurement and scale to perspective so that there should be nothing in the work that is not in accord with reason and natural effects.[24]

174
Raphael, *Virgin and Child*,
c.1502–3. Ashmolean
Museum, Oxford

175
Raphael, *Studies of the Virgin
and Child*. About 1505.
British Museum, London

But even this exacting work from the posed model was futile unless the painter
had full knowledge of what Leonardo calls *l'intrinsica forma*.[25] To give substance
to a figure that had emerged from the artist's *immaginativa* and been adjusted
levando e ponendo, nothing less would suffice than a knowledge of those laws of
growth and proportion by which Nature herself would create it. But what if
disappointment awaited even the artist who applied infinite knowledge and
infinite patience to the achievement of that complete illusion of tangible
reality which – whether we like it or not – seemed to Leonardo indispensable
if art was to keep the promise of rivalling the Creator ? All the science of
painting cannot make a picture 'look real' because, with two-eyed vision we
will always perceive the difference between a flat surface and a thing in the
round.[26]

There was a flaw in the dream of the painter who could 'make' any creature
he desired to see. But if the hubris of his ambition had led to a tragic failure,
his belief in the power of art was unshaken. Perhaps it was outside the power
of painting to build up a perfect little universe: it could still demonstrate its
might in images of chaos and destruction (Fig. 173). The famous passage in
the *Trattato* strangely called *piacere del pittore*[27] exemplifies *la deità, ch' a la scientia del
pittore* by a verbal orgy of destructive fury in which the elements seem to return
to their primeval mixture. There are many aspects to these fantasies of his old
age but one of them belongs to our context. For may it not be that Leonardo's
mind loved increasingly to dwell on these scenes of utter confusion because
here he had found a realm of art where the *componimento inculto* acquired an
unexampled force? In these deluge drawings Leonardo's earlier procedure
seems somehow reversed. They are based on his scientific views of the laws
and motions of the elements, but the spiralling chaos creates that 'confusion'
on paper through which the 'imagination is stirred to new inventions'. The

chaos of superimposed lines conjures up ever new visions of that cataclysm in which all human striving would come to rest.

These truly titanic tensions are of course personal to Leonardo's genius. But the concept of art which gained shape in his mind lived on and learned to resign itself to its own sphere. We can almost watch this process in the life of the artist destined to give it its canonic form, Raphael. Raphael's early Umbrian period shows him devoted to the traditional standards of tidy draughtsmanship. An early Madonna study (Fig. 174) simply treasures up, for future reference, one of the approved patterns of the sacred theme. In a later drawing (Fig. 175) we can see what happened to him under the impact of Leonardo's genius. He has learned to use the *componimento inculto* as if he had listened to Nietzsche's advice: 'You must be a chaos, to give birth to a dancing star'.

Editor's Postscript

Freud published an essay on Leonardo,[1] which has subsequently given rise to a great deal of comment. This essay shows that the peculiarity of Leonardo's St Anne has rather a great deal to do with his innovatory drawing techniques. See also Gombrich's comments on the painting on pp. 476–8 of this volume and A Lifelong Interest, p. 159.

Gombrich's interest in Leonardo started when, as a schoolboy, he was asked to write about his favourite hero. Ever since then he has been a constant source of fascination. The following articles have been published in Phaidon's Gombrich Collection: In The Heritage of Apelles: *'Leonardo's grotesque heads. Prolegomena to their study'; 'The Form of Movement in Water and Air'. In* New Light on Old Masters: *'Leonardo on the Science of Painting: Towards a Commentary on the "Trattato della Pittura"'; 'Leonardo and the Magicians: Polemics and Rivalry'. In* Reflections on the History of Art, *reviews of: Carlo Pedretti,* Leonardo da Vinci on Painting: a Lost Book (Libro A) *and Sigmund Freud,* Leonardo da Vinci and a Memory of his Childhood *as 'Seeking a key to Leonardo'; V.P. Zubov,* Leonardo da Vinci, *as 'Leonardo da Vinci in the History of Science'; Martin Kemp,* Leonardo da Vinci, *as 'The marvel of Leonardo'.*

See also 'Kenneth Keele's Contribution to the Study of Leonardo da Vinci', Journal of the Royal Society of Medicine, 82 (1989), pp. 563-6; *'Leonardo's* Last Supper', Papers *given on the occasion of the dedication of the* Last Supper (after Leonardo), Magdalen College Occasional Papers, 1 (October 1993), pp. 7-19, and the review of Richard Turner, Inventing Leonardo, in The New York Review of Books (June 1994), pp. 39–40.

A fascinating article on the later history of drawing is 'Watching Artists at Work: Commitment and Improvisation in the History of Drawing', in Topics of our Time.

1. Eine Kindheitserinnerung des Leonardo da Vinci, *translated by James Strachey, 'Leonardo da Vinci and a Memory of his Childhood', in Sigmund Freud,* Art and Literature *(Harmondsworth, 1985).*

Part V Psychology and the Decorative Arts

The Force of Habit

Chapter 7 of *The Sense of Order* (1979), pp. 171–94

Progress, degradation, survival, revival, modification, are all modes of the connection that binds together the complex network of civilization ... Looking round the rooms we live in, we may try here how far he who only knows his own time can be capable of rightly comprehending even that. Here is the 'honeysuckle' of Assyria, there the fleur-de-lis of Anjou, a cornice with a Greek border runs round the ceiling, the style of Louis XIV and its parent the Renaissance share the looking-glass between them. Transformed, shifted, or mutilated, such elements of art still carry their history plainly stamped upon them; and if the history yet farther behind is less easy to read, we are not to say that because we cannot clearly discern it there is therefore no history there.

Edward Burnett Tylor, *Primitive Culture*[1]

1 Perception and Habit

The force of habit may be said to spring from the sense of order. It results from our resistance to change and our search for continuity. Where everything is in flux and nothing could ever be predicted, habit establishes a frame of reference against which we can plot the variety of experience. If the preceding chapters explored the relevance of our need for spatial order in our environment, we must now turn to the manifestations of the temporal sense of order, the way the force of habit, the urge for repetition, has dominated decoration throughout history.

176
Rorschach ink blot, originally devised as a psychological diagnosis test

In the study of perception the force of habit makes itself felt in the greater ease with which we take in the familiar. We have seen that this ease can even result in our failure to notice the expected because habit has a way of sinking below the threshold of awareness. As soon as a familiar sequence of impressions is triggered we take the rest as read and only probe the environment perfunctorily for confirmation of our hypothesis. I have alluded to this role of perceptual habits in the preceding chapter when I referred to the notion of 'chunks', those units of skill which have become automatic and are thus available to us for the construction of further hierarchies of skills. It may be argued that what we call projection in the theory of vision or hearing is an aspect of that tendency, a manifestation of the force of habit. The ink blot vaguely resembling a familiar sight such as an insect (Fig. 176) will be seen in this habitual way. There are perceptual habits even more deeply ingrained than the sight of butterflies, notably the sight of the human face. Whether

a b c d

e f g h

this habit has an inborn component or not, it is notorious that we are particularly prone to project faces into any configuration remotely permitting this transformation. The tendency may help to account for certain decorative motifs which must have sprung up independently in many parts of the globe. The bulging form of a vessel shaped to hold a liquid has often been endowed with eyes and other facial features to resemble a head, a bird or the semblance of a whole portly figure (Fig. 177). We shall find, in chapter 10, that these and similar habits of 'animation' are frequently reinforced by the belief in the efficacy of eyes,² limbs or claws as protection against evil. What concerns us here is the power of inertia which contributed to the survival of such devices as the transformation of supports into clawed legs long after the magic connotation has been forgotten (Fig. 178). If it is true, as one sometimes reads, that in respectable Victorian homes the legs of the piano were draped (Fig. 179), this need not be interpreted as a symptom of excessive prudery. After all, once we adopt the perceptual habit of looking at these props as legs they are not exactly beautiful legs. In other words, once a perceptual interpretation is set up for whatever reasons, it is likely to persist. From the operation of the force of habit in space we must pass to the consideration of its working in time.

2 Mimicry and Metaphor

In *Art and Illusion*¹ I have tried to make a case for the view that art and artifice grow out of the same psychological roots. It is artifice first of all which is called upon in human culture to resist change and to perpetuate the present.

177
Animated vessels. Heads;
(a) Mexican, c.1300–1500;
(b) Picasso. Animals: (c)
Chinese, c. 1st millennium
BC; (d) Greek, 5th century
BC; (e) Mosan, early 13th
century. Human bodies;
(f) urn from prehistoric
Troy; (g) Peruvian, 1st
millennium AD; (h) Toby
Jug, English, 18th century

a b c

178
Animal feet: (a) Egyptian
sledge, 2nd millennium
BC; (b) Roman table, 1st
century AD; (c) 18th-
century table

179
Draped piano leg

180
Grinling Gibbons, detail
of reredos, Trinity
College, Oxford, c.1700

Where things decay the craftsman can create the substitute that remains –
whether we think of the cowrie shells serving as eyes in the Jericho heads of
some six thousand BC, or of nothing more solemn than the cosmetics industry.
Artificial beards worn by the Egyptian Pharaohs, the wigs which have played
such a part in human attire over the centuries, artificial eye-lashes or artificial
teeth, all testify to the urge which makes man try to defeat nature and to go
one better wherever possible.

In Chapter 6 we have seen the floral motif taking over from the shortlived
flower. Not that this translation from life into stone or paint must have been
literal. It rarely was. But who can doubt that the decorator's repertory would
be the poorer without his power to remind us of blossoms, leaves, gardens,
wreaths, and festoons (Fig. 180)?

And as with flowers so with furnishings. Real curtains fall to pieces, painted
curtains are cheaper and more durable. In one of the earliest monuments of a
settled civilization, the Neolithic site of Çatal Hüyük in Anatolia excavated by
Dr Mellaart,[4] we find walls covered with patterned paintings which the
excavator considers to be imitations of woven rugs. It may be impossible to
confirm this hypothesis, but when we come to the mural of the tomb of
Hesire from the Old Kingdom in Egypt (Fig. 181) one cannot doubt that what
is here reproduced is the pattern and appearance of a woven hanging. This
convention of imitating a wall-hanging in paint is particularly widespread and
tenacious. We find it in many medieval churches (Fig. 182) and even in the
Sistine chapel, below the Quattrocento fresco cycle.

Modern designers have a term for this kind of imitation. They call it
mimicry. The lino which imitates bathroom tiles or parquet flooring, the
wallpaper which imitates damask or wood, the marbling of stuccoed walls,
the false timber frontage – what Osbert Lancaster called 'stockbroker's
Tudor' – there is no end to these devices all around us. Of course they are

181
Painted curtain. Egyptian,
*c.*2700 BC

182
Painted curtain. Yugoslav
mural, 1252 AD

not exactly popular with modern designers.

We have observed the roots of this revulsion at the time of the Industrial Revolution when the power of the machine to simulate expensive handiwork and even costly materials threatened the established hierarchies of the earlier craft traditions. Mimicry was identified with the vulgar desire to keep up with the Joneses on the cheap, and was thus condemned in the name of honesty. But to some extent this criticism misses the point of an age-old tradition, for is there really much 'make-believe' involved? We all know that the painted curtain is not real and the lino parquet not made of wood; maybe therefore this habit of providing substitutes, cheaper and more adaptable than the original material, is not rooted in our wickedness. Instead we may see it as a feat of the imagination, the discovery of fiction, the liberation from literalness in a playful shifting of functions.

To the Puritan revolution of the twentieth century, make-believe as such is a symptom of escapism, the refusal to adapt to change. I would agree with this diagnosis but I would plead for another psychological assessment of this force of habit. Mimicry can ease us into adaptation, the adaptation to new materials, new conditions, new tools, by providing that element of continuity for which there is so strong a need. It is well known that the first railway carriages imitated coaches (Fig. 183)[5] and the first gas lamps candelabras (Fig. 184). Even in our fast-moving times, which discourage conservatism, examples

183
Early railway carriage
imitating a coach

184
Early gas lamp imitating a
candelabra

185
'Coal-effect' electric fire

of this craving for continuity are too numerous to specify. One can still see advertisements for electric heaters which imitate coal fires (Fig. 185) and even re-create the beloved cosy glow by means of a red lamp and an engine-driven device to produce the flicker.

Rather than mocking the man who had organized his life round the fireplace, where he liked to sit and relax, and who refuses to change his habits for the sake of technical change, we should consider the strength that comes from this capacity of adjusting the new to the old. To gain an estimate of the force and source of this strength we may do well to look from decoration to the greatest example of continuity in human culture, I mean the development of language. Many of the words we use can be traced by etymology to roots which can be found in Sanskrit texts dating from the second millennium BC But impressive as are these testimonies to the tenacity of traditions in language, etymology also demonstrates to us the capacity of the human mind to keep language a pliable tool. The meaning of the original root has sometimes changed beyond recognition, and yet it is often possible to make this change intelligible. As new concepts come in, old words have to perform new functions. Thus nearly all our abstract terms can be traced back to a more concrete usage.[6] The terms for spirit started their career in nearly all languages as words designating the breath, and the term 'abstract' itself of course means pulled away — away from the concrete or literal meaning. In studying these extensions and transfers of meaning, etymology comes to concern itself with what the Greeks called metaphor,[7] which really means transfer or carry-over. It is this capacity of the human mind for assimilating the new to the old which is also at work in the humble device of decorative mimicry. It is a form of metaphor.

Take the new element in our lives which is air travel. If anyone said of an aeroplane that 'the silver bird winged its way over a carpet of clouds', we would classify this as a metaphor and a poor cliché to boot. But let us go to the airport and look at the aircraft from its nose to its tail units with its fins

and its rudders, its wings and its engines, of so and so much horsepower, and fuelled with a product of petrol which is, of course, 'rock oil'. Our boarding passes will take us on board, but not on any boards. We glance at that mysteriously named cockpit and pass down the aisle guided by the air hostess, who is no hostess and who tells us to fasten our seatbelts, which are no belts. Such derivations make the dictionary one of the most fascinating books on our shelves. Who could have guessed that the jumbo jet owes its name to an elephant in the London zoo famous for its size and that he in turn was probably called after mumbo-jumbo, the alleged name of a West African divinity or bogey first recorded in 1738?

How merciful it is that language has retained this capacity of being stretched and changed to take in the new while linking it with the old. Naturally it would have been possible to invent new names for every fresh feature, just as the word gas was invented by Van Helmont (d. 1644) to denote a novelty, though even he modelled it on the Greek word for chaos. There are fields nowadays in which new words proliferate and one sometimes suspects them to be used as status symbols, the esoteric language of a new tribe. Metaphor and extended meaning illustrate adaptation, the way of assimilation to which our mental apparatus is attuned. Our very process of growth, of learning from childhood onwards, extends, ramifies and assimilates new emotional and intellectual experiences by way of stretching the old system of classification. We learn about the emotional side of this continuity through psychoanalysis. Freud's concept of the symbol refers to the primal categories which are still close to our biological dispositions, the sexual symbol, the father-figure.[8] All these can be interpreted as expressions of the force of habit, of continuities which can be extended and refined but will somehow remain alive in our minds.

3 The Language of Architecture

If these considerations have taken us a little far away from the topic of decoration there exists luckily a visual tradition of acknowledged importance which permits us to illustrate the workings of the force of habit from a variety of aspects – the history of Western architecture from ancient Greece to the present century. In the introductory pamphlet to a series of Radio talks on 'The Classical Language of Architecture' Sir John Summerson has called this tradition 'the most comprehensive and stable manner of design the world has ever seen'.[9] The origins of the language, the etymology of many of its motifs, can certainly be traced back to the elements of primitive timber architecture, the post and the lintel. It was Vitruvius himself who explained the salient features of the Doric order (Fig. 186) as imitations of forms originally used in

187
Doric and Corinthian
orders, from John Shute,
*The First and Chief Grounds
of Architecture* (London,
1563)

wood. If he was right, which it is hard to doubt, the origins of the classical tradition in architecture lie in 'mimicry' – only this time it is the more expensive but more durable material of marble which is used to simulate the traditional timber structure. What was it that made the ancient architects stick to such features as triglyphs and metopes which make obvious sense as part of a wooden rafter, but only cause additional work to the masons of a temple built of stone? Can it have been anything but the tenacity of perceptual habits which had come to expect certain structural elements? The triglyph, for instance, offered and still offers what I have called an explanatory accent. It showed where the transversal supports of the roof ended and how they were laid. True, other accents are not so easily explained in terms of mimicry. The entasis, the gentle swelling of the column, for instance, which contributes so much to the organic impression conveyed by Greek architecture, has less mechanical origins. We must accept the contribution here of what Wölfflin in his architectural studies describes as empathy, the habit of projecting life into inert shapes.[10] The column seems to carry the load like a living shaft and indeed like a human being. The endowment of the various forms of columns, the 'orders', with human characteristics is an essential feature of the classical tradition and also goes back to Vitruvius, though the metaphor was not illustrated before the sixteenth century (Fig. 187).

In the history of language there are two main factors making for change. One is the natural drift of language, the changes in usage and pronunciation by which Latin turned into 'vulgar' Latin and into the various regional dialects

188, 189
Romanesque and Gothic
chapels in the Castle of
Cheb (Eger), Bohemia,
1183 and 1295. From W.
Lübke, *Geschichte der
Arkitechtur* (Cologne, 1858)

which became the Romance languages. In the eyes of the schoolmasters most
of these changes were corruptions and so they saw it as their task to reform
the language of the tribe. The efforts of the Renaissance humanists to restore
Latin to its pristine purity are an example of the second kind of change, the
deliberate reform from above. Both these factors have their exact analogue in
the history of Europe's architectural language. Seen from the vantage point of
the Renaissance theorists of architecture, the millennium extending from the
decline of the Roman empire to Brunelleschi's reforms was an age of
corruption in which the good laws of classical grammar were perverted by the
barbarians.[11] It is well known that the terms Gothic and Romanesque were
originally connected with this interpretation. When it gave way to an
appreciation of these styles on their own merits, emphasis centred on the
distinctive features allowing for easy classification, the round arch, the pointed
arch, methods of vaulting and forms of tracery. It may be argued, however,
that these necessary classifications somewhat obscured that unity of tradition
which is more relevant to my present context. Corrupt or no, distinctive or
not, the Romanesque column (Fig. 188) is a development of the ancient
column and even the slender columnettes and soaring piers of Gothic
interiors betray this origin at first sight (Fig. 189). The history of architecture
describes in detail what technical and social conditions accounted for these
mutations; it also reminds us of their aesthetic potential. To make the support
heavier or lighter than usual, to make it alternate with piers or introduce more
complex rhythms, to imprison the supports in masonry or let them form a
fictitious network, all these modifications are bound to affect the impression
created by a building (Figs. 190 and 191).[12] It is here that the tenacity of

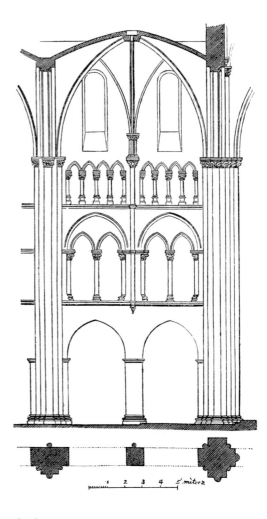

traditions yields an unexpected advantage. It is only where expectations are formed that they can also be reassuringly confirmed, playfully disappointed or grandly surpassed. There is no period in European architecture in which these possibilities were not instinctively felt or exploited by builders of genius. And yet these masterpieces in the vernacular may somewhat differ in kind from the self-conscious products of the reform movement which we associate with the Renaissance theorists Alberti, Serlio, Vignola and Palladio, who reduced the Vitruvian rules to what Sir John Summerson called 'the architectural equivalent of the Latin tongue'. To continue the quotation from his masterly account: 'It has a strict grammatical discipline, just as Latin has, but also like Latin is capable of magnificent rhetoric, calm pastoral beauty, lyrical charm or sustained epic grandeur.'

Such diversity in unity may only become possible where the designer works

within strict alternatives which the public learns to appreciate. He knows which of the five orders will suit which type of building and which position within the building. It is against this background also that wilful deviations can make their effect. 'The giant orders' which Michelangelo introduced in his design of the Capitol (Fig. 192) presented such a bold departure because normally each storey of a building was assigned its own order. Well might Vasari say that Michelangelo's departures from the proportions, order and rule of common usage derived from Vitruvius and antiquity 'have placed artists under an infinite obligation because he broke the fetters and chains which kept them always on the common highway'.[13] And yet nobody reading these words would guess that the classical tradition in architecture continued quite unbroken throughout the subsequent styles of the Baroque, Neo-classicism, the Greek Revival, right into the twentieth century. As in the past, the licence, even the extravagance, of certain solutions presupposed the coherent framework of an accepted language. The pliability of this language, its adaptability, poses a problem of aesthetics and of social psychology which might puzzle us more if we had not come to take it for granted. Not only the builders adopted the idiom as a matter of course, it spread from architecture to carpentry and cabinet-making, indeed to all forms of decoration which used the elements originally developed for the timber structures of early Greek temples (Fig. 193). The spread of these motifs can be traced in the manuals and pattern books of the various decorative crafts (Fig. 194);[14] to master the rudiments of the orders and the shapes of mouldings was a necessity. It is in these less conspicuous forms that the force of habit makes itself felt. Look around in any house built before the functional revolution of the twentieth century and you will see shapes of door frames, of table ledges or of ceiling cornices, reflecting designs invented more than two thousand five hundred years ago.

No doubt there are many reasons for this conservatism of the crafts. We

know that even in our fast-moving times the introduction of new models of machinery requires a period of 'tooling up', and the masons' and the carpenters' tools were necessarily adjusted to certain forms and unsuitable for others. It may soon become as difficult to get a door frame with mouldings made as it would have been some decades ago to persuade the builder to leave the frame uncut. But here as often the conservatism of the craft may be due to a large variety of factors. An interesting suggestion in this respect has recently been made by Konrad Lorenz, who compared the tenacity of conventions in the traditional crafts with the process that students of animal behaviour call 'ritualization'. In both cases, so he argues, the rigid stereotype facilitates communication and preservation. The movements and actions the craftsmen perform must not only be performed correctly, they must also be correctly handed down to the next generation.

'It is hardly an exaggeration to say that every pattern handed down by tradition becomes, with time, endowed with those frills and embellishments which, by making it more impressive, facilitate handing-down. The apprentice of the ancient smith had to learn that a newly forged sword must be tempered while still red-hot, in cold water, but if he is taught to do it three times, twice in running water and once in the morning dew, according to the precept of Kipling's Weyland, smith of the gods, the procedure is so much more impressive … and what is more, that kind of embellishment *may* contain, irrespective of their non-rational origin, some very real improvements, which are consequently taken up and reinforced by natural selection.'[15] Certainly the craftsman will not be inclined to 'reason why' his tools

195
The Michaelerplatz,
Vienna, with Adolf Loos's
Goldman and Salatsch
building (1909) on the left
and St Michael's Church
(18th century) on the right

and patterns are adjusted to mouldings, and mouldings he will make.

Not that this tradition remains confined to members of the crafts. The ritual – if we so want to call it – carries over to the public in the form of perceptual habits. On the whole we only become conscious of these habits when we are asked to break them. Every traveller knows how often he is made aware of a habitual assumption only when it fails to work. If you want to switch on the light in England you press the switch down, in America you push it up. The resistance to change in technology and in art, so much deplored by critics and reformers, must be symptomatic of a deeply felt need. I know no better example of this link between conservatism and perceptual habit than the hostile reaction with which the public of Vienna greeted the first functional façade by Adolf Loos (Fig. 195). It was dubbed 'the house without eyebrows', because the windows lacked the customary cornice or gables, with which normal windows of whatever style were marked in Vienna.

4 The Etymology of Motifs

The radicalism of Adolf Loos was a symptom of the malaise which decoration had caused for so long among the theorists of the nineteenth and early twentieth centuries. We have seen that this malaise, rooted in the decline of the craft tradition, also led to those reflections on the nature and origin of decoration which formed the subject of our second chapter. It is against this background that the most important work on the history of a decorative

motif must be seen, Alois Riegl's *Stilfragen* of 1893. Born in 1858, Alois Riegl was trained in the strict and proud tradition of the Vienna Institut für österreichische Geschichtsforschung before, at the age of 28, he joined the staff of the Österreichisches Museum für Kunst und Industrie, closely modelled on the Victoria and Albert Museum in London. These centres had been founded in the hope of fostering a new awareness of the laws of design among manufacturers and among the public.

As a Keeper in the textile department of the Museum, Riegl was in charge of one of the richest collections of oriental rugs anywhere in the world. It was to these treasures, therefore, that he devoted his first book of 1891, *Altorientalische Teppiche*, and his Preface shows that he was well aware of the topical relevance of his subject. Oriental carpets had become fashionable; and not only among the rich, but in much wider circles it had become 'a point of honour' to own at least one such piece. There was no doubt in Riegl's mind as to the source of this trend. It was the corruption of the industrial arts of Europe which had sparked off the reform movement calling for a return to simplicity. Citing Gottfried Semper and Owen Jones, who had specifically commended the unerring taste in design to be found in oriental rugs, Riegl reminded his readers that the sands were running out. Even in the East the conditions of home crafts under which these rugs were produced were about to disappear, and collectors would do well to hurry before commercialism had done its worst.

But Riegl was not only aware of the aesthetic problems of his time. He was also eminently responsive to the intellectual climate of these decades, which were still dominated by the impact of Evolutionism. His historical training had acquainted him with the persistence of Roman Law in formularies, charters and other documents of the Middle Ages, and he had earned his spurs with a paper on medieval calendar illustrations, which likewise proved the unbroken power of the classical tradition. These were the years when Aby Warburg, born eight years after Riegl, took up the problem of the tenacity of the classical tradition, to which he devoted his life and his library, precisely because the universal demand for a New Style challenged the historian to ponder the relation between continuity and change.[16] What Springer had called *Das Nachleben der Antike* – the 'afterlife' of the ancient world – was a potent factor wherever the historian looked.

It turned out that it was also a factor in the history of oriental rugs. Dissatisfied with the vague talk which linked these products with the legendary splendours of the ancient East, Riegl began to analyse the principal motifs occurring in the designs of these regions. The result was startling. The vocabulary of these visual poems derived frequently from Greek roots.

196
Border of a Persian rug,
16th century. From A.
Riegl, *Stilfragen* (Vienna,
1893)

197
Two borders from Split,
3rd century AD. From
Riegl, *Stilfragen*

Take the motif so often found on the borders of oriental rugs, which looks like a series of pomegranates linked by leaves (Fig. 196). Riegl was able to show that it could be traced back over more than a thousand years to the leaf-palmette of a type used, for instance, in the late antique temple of Split from the time of Diocletian (Fig. 197). The similarity of the arrangement of alternating directions in the flowers and undulating leaves confirms a common ancestry. By the time Diocletian's craftsmen used it in the fourth century AD, however, the arrangement was in fact at least a thousand years old. A vase from Melos dating from the seventh century BC (Fig. 198) shows that the principle of alternating flowers with their scrolly links had been established in Greek art during the period of its dawn. Like the etymologist who traces the roots of a particular word through the history of various languages, Riegl was able to identify basic motifs behind changing appearances. His method triumphed in the demonstration that the typical arabesque, such as we find in the stucco motifs of Islamic Egypt, can be revealed as a transformation of a Greek palmette if only we alter the relation between figure and ground (Fig. 199). Thus the whole vast growth of decorative ornament we associate with this form of the arabesque was in fact a development or transformation of the Greek style of ornament, just as French or Spanish is a development of the Latin language.

At the very time when Riegl was busy tracing the continuous development of the Greek palmette over 2,500 years to his own time, another scholar was digging on the other side of the tunnel, as it were, to lengthen the story in the

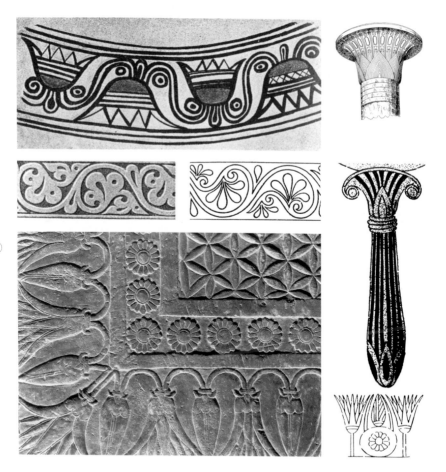

other direction. He was the American, W. H. Goodyear, the Keeper of the
Egyptian Collection of the Brooklyn Museum, whose book *The Grammar of
Lotus* also appeared in 1891.[17] Goodyear's background and motivation differed
from Riegl's. His interest had been fired by the search for ancient symbols in
the traditions of the East, a search to which I shall have to refer again. The
purpose of *The Grammar of Lotus* is not only to show that the beautiful plant of
the Nile was a symbol of the Sun, but that this sacred character of the flower
explains its universal application in Egyptian art, on columns and on borders
(Figs. 200, 201). Moreover Goodyear tried to show that this solar symbolism
spread from Egypt to other Eastern civilizations, all of which adopted the
lotus (Fig. 202), and that it finally infiltrated ancient Greece, where the
decorative forms of the palmette (Fig. 203) and of other elements turn out to
be nothing but transformations of this solar flower.

Goodyear's theory of the ubiquity of solar motifs has not recommended
itself to scholars, but his proof of the link between Greek and Egyptian

203
From the lotus to the
Greek palmette. From W.
H. Goodyear, *The Grammar
of Lotus*, 1891

204
Egyptian ceiling pattern
from Thebes, 19th
dynasty, 1348–1315 BC.
From N. M. Davies,
Ancient Egyptian Paintings
(Chicago, 1936)

ornament could not be gainsaid. This means that another 2,500 years could easily be added to Riegl's story, for the use of the lotus certainly goes back to early Egyptian dynasties in the fourth millennium BC. The discovery that so many of the decorative elements still in circulation in his time had such a venerable continuous history inspired Riegl to write his *Stilfragen*. He must have worked at surprising speed, for the book came out in 1893, only two years after Goodyear's publication.

I have called *Stilfragen* perhaps the one great book ever written about the history of ornament. It owes its greatness to the inspiring vision which rose up before Riegl's eyes when he realized that the study of ornament was a strictly historical discipline. The opening paragraphs of his Introduction indicate that he expected opposition to this point of view. The accepted orthodoxy among his colleagues regarded ornament as a by-product of technical procedures, and such by-products could arise spontaneously at any time and in any region. We remember that it was Gottfried Semper whose name had become associated with the so-called 'materialistic' explanation of decorative forms, though Riegl is careful to dissociate Semper himself from the thoughtless application of his original insights. 'Certainly Semper would have been the last to want to replace a freely creative will to art by an essentially mechanistic and materialistic imitative urge.' This is the polemical context in which Riegl first introduced his famous term *Kunstwollen* (will-to-art or will-to-form) and I have stressed in Chapter 3 that he was right in reminding his contemporaries of the limited explanatory power of any purely technical explanation.[18] What Riegl may have underrated is the degree to which the sense of order also dominates technical artefacts, and further the force of habit which, as we have seen, makes for the survival of orders once created. Not that he denied the possibility of such survivals, of which the influence of timber construction on the Doric order is a classic example, he only turned against the lazy assumption that all geometrical motifs must arise

spontaneously again and again from the techniques of basketry or weaving. It was this kind of assumption which blinded students or art to those continuities which he had observed, and he made it his programme to 'tie together the thread which had been cut into a thousand pieces'. It was the thread that linked the earliest Egyptian Lotus ornament with the latest arabesque.

There were two places only where loose ends needed knotting. One was the transformation of the lotus ornament into the scroll, the other the origin of the dominant classical motif, the acanthus. It was his concentration on the scroll which had prevented Riegl in his first book from anticipating Goodyear's insights into the Egyptian origin of European plant ornament. For the Egyptians did not know the undulating scroll and neither did the art of Mesopotamia. The ancient Oriental styles with their tendency to lucid isolation and geometric rigidity could not, so it seems, accommodate the freely waving line as a link. Their decorative repertory included spirals (Fig. 204), but these were strictly confined to repeat patterns and never extended along borders. In searching for the origins of this linking device which proved of such immense consequence for the history of decoration, Riegl was of necessity restricted by the archaeological material known in his time. The art of Crete, for instance, with its wealth of decorative forms, had not been discovered yet, but Riegl knew of Schliemann's finds of Mycenaean pottery and it was there that he found the motif he was looking for, the wavy or undulating scroll either as a geometrical design or as a plant motif (Fig. 205). Whatever the ethnic origins of the Mycenaeans may have been, the fertile invention of this design was made in the orbit of ancient Greece. As Riegl put it, 'a whole world separates the limited (borniert) artistic spirit of Egypt from that which manifests itself in the Greek vegetative scroll'.

As a child of his time, Riegl never doubted the influence of racial factors on stylistic development. Those of us who are disinclined to accept such explanations have to look for alternatives, provided explanations are ever possible. No doubt the absence of a motif which seems so natural and so useful as the wavy line from a style extending over several thousand years and over a large geographical area, presents a problem. It is not lessened by the fact that undulating lines of one kind or another can also be observed in the decorative repertory of other prehistoric styles which need not necessarily have had any connections with Mycenaean Greece.[19] Maybe one element of the explanation would have to be sociological, that is, it might be found in the working procedures of the Egyptian decorative crafts. The strictly designed repeat pattern permits division of labour and the collaboration of large teams such as were undoubtedly needed for the colossal enterprises of the Oriental

205
Mycenaean motif. From A. Riegl, *Stilfragen*

empires. There is a Greek anecdote illustrating the point. Two sculptors working in different places were each producing one half of a colossal figure; using 'the Egyptian system of proportion' they achieved such accuracy that the two halves were found to fit without the slightest flaw.[20] Such precision requires rigidity; the elements of Egyptian (and Mesopotamian) decoration usually fit together like the blocks or tiles composing the building. Riegl was right when he felt that the undulating line was contrary to the spirit of these styles. It is essentially a motif suggesting a free-hand design which allows a certain amount of elasticity and irregularity (Fig. 206). In fact, it is this elasticity which proved so invaluable to the decorator once the motif had been integrated into the repertory, because – as Riegl knew – the wavy line is infinitely adaptable to any area it is expected to fill, allowing for contractions or extensions, stretching along borders or masking a gap. There is no doubt that this adaptability and flexibility secured the success of the motif once it had been introduced. But maybe in considering its relatively late adoption in a developed form, we should not disregard the hidden complexity which we found when analysing its perceptual effect. Perceptually the wavy line (Fig. 207) is far from simple because of the fluctuating interactions between figure and ground which arise as we look from bulge to bulge or from hollow to hollow. Moreover, any diagonal configuration is perceptually less easy to grasp

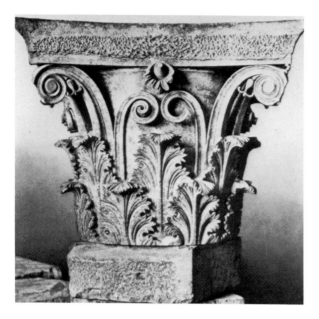

208
Corinthian capital,
c.300 BC. Archaeological
Museum, Epidaurus

209
Acanthus. From *Curtis's
Botanical Magazine* (1816)

than the horizontal or vertical connection. Small children have considerable difficulty in copying a square with a diagonal because, if we may simplify a complex argument, it disturbs their rigid habit of expectations.[21] It would be an abuse of such psychological results to suggest that the ancient Egyptians had not yet attained the degree of intellectual maturity necessary for the adoption of the wavy scroll, but they may have resisted it as a somewhat irrational element which contravened their own rigorous sense of order.

We have seen the way Greek art combined the motif of the lotus blossom with the wavy scroll, and we followed with Riegl the transformation of this design into the palmette as used in oriental rugs. But if Riegl wanted to be faithful to his programme of demonstrating continuity, one other important novelty had to be accounted for, a novelty more famous even in the history of Greek ornament than the wavy scroll — I refer again to that hallmark of ancient decorative art, the acanthus.[22]

The ancients had certainly believed the acanthus to be a straight imitation of a real plant. Vitruvius had told the touching story of the origin of the Corinthian capital (Plate 208) — that it had been modelled by the sculptor Kallimachos on the chance find of a basket with toys which a faithful nurse had deposited on the tomb of a girl and which had become enclosed by acanthus leaves. Riegl could surely not be expected to believe this *ad hoc* invention, but he was altogether sceptical about the derivation of the plant motif from the particular weed which grows in such profusion all over Greece and Italy (Plate 209). Was the leaf all that similar to the leaf of *Acanthus spinosus*

which he found illustrated in Owen Jones? It was not. There really was no need to give up the hypothesis of continuity, for if you looked at certain early forms you could see that the so-called acanthus was really no more and no less than the old palmette turned into a leaf (Fig. 210). Nowhere does Riegl's forensic skill shine out more clearly than in this plea for continuity. He marshals most convincing comparisons between an indubitable row of palmettes (Fig. 211) and an early acanthus frieze from the Erechtheion (Fig. 212) to make his interesting case.

No doubt there was a good deal of special pleading in Riegl's presentation. He had to circumvent a number of inconvenient facts such as the naturalistic rendering of acanthus leaves on vase paintings representing funeral stelae (Fig. 213). Moreover, it is clear that the leaf he illustrated was far from being the closest example he could have chosen. The early examples do not represent the leaves of the plant. They resemble the supports of the chalice (Fig. 214). The Greek designers also place them in the corresponding positions to the stem (Figs. 215 and 216). It has been argued correctly that in these early versions it certainly is not the palmette which turns into a leaf. The palmette seems to be conceived as a blossom and the acanthus as the chalice (Figs. 217 and 218). Indeed, in all the early versions of the acanthus scroll the function of the leaf is to mask the divisions of the stem.

Maybe we can here recall another perceptual element which may have played its part in the adoption of this motif; I mean the tendency of searching for continuities. There is something slightly unsatisfactory in a wavy line from which other lines fork off. The change of direction in the undulation can be taken in our stride, but the additional complication demands some kind of visual explanation. The joints conflict with continuity not only because a new direction is introduced, but also because the continuous width of the line is

210
Corinthian capital. From A. Riegl, *Stilfragen* (1893)

211
Row of palmettes. From A. Riegl, *Stilfragen* (1893)

212
Lotus-palmette frieze from the Erechtheion, c.415 BC. From A. Riegl, *Stilfragen* (1893)

213
Design from an Attic
lekythos. From A. Riegl,
Stilfragen (1893)

214
Acanthus. From R.
Hauglid, *Akantus* (Oslo,
1950)

215
Detail of a frieze from the
Erechtheion, *c.*415 BC.
From A. Riegl, *Stilfragen*
(1893) Cf. Fig. 216

216
Ornamental frieze from
the Erechtheion, Athens,
*c.*415 BC. British Museum,
London

217
Detail of a gold quiver,
5th century BC. From A.
Riegl, *Stilfragen* (1893) Cf.
Fig. 218

218
Gold quiver. Greek
workmanship, late 5th-
early 4th century BC.
Archaeological Museum,
Rostov-on-Don

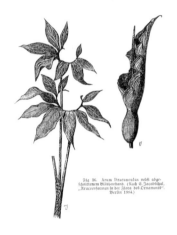

compromised at the joint. Should both be imagined to taper where they are joined, and if not, which of the two is continuous? In metalwork the joints have to be hammered or tied, introducing another discontinuity (Fig. 219). It can be masked if the scroll becomes an acanthus scroll (Fig. 220). It has been suggested that the Greeks observed this advantage in a different plant, *Arum dracunculus*,[21] which has stems growing out of blossom in a similar way (Fig. 221). If that is true, it would strengthen rather than weaken Riegl's case because what he was after was the priority of formal requirements over purely imitative interest in a particular plant.

It would be a pity if the immense value of Riegl's observations were obscured by certain weaknesses in his method, weaknesses closely linked to his evolutionist background. Like Darwin he looked for 'missing links', links between the palmette and the acanthus. But the designs he identified as such links do not necessarily prove his case. Granted that there are motifs which can be interpreted as something between a palmette and an acanthus leaf, are we entitled to place them chronologically between the former and the latter? Is it necessarily the case that anything that looks like a transitional form must be evidence for a gradual evolution? We might put the question in the most abstract form. If we have a motif 'a' and another 'b' and we find a mixed form

'ab' does this necessarily show that 'a' developed into 'b' via 'ab'? Could not 'ab' be a subsequent hybrid or an assimilation of one form to the other?

The history of ornament knows many such cases, and some of them come very close to Riegl's example. There are oriental rugs of the kind Riegl studied, in which the shapes of the scroll are assimilated to pheasants or parrots (Fig. 222). We could obviously not apply Riegl's criterion here and say that all parrots in Persian decoration are nothing but transformed scrolls.

It is important to stress, however, that these and other criticisms that could be made of Riegl's specific hypothesis concerning the origins of the acanthus motif in Greek art do not invalidate his basic postulate of continuity. For whether or not the palmette can be watched as turning itself into an acanthus, it is still likely that the plant motif was received into the repertory of Greek ornament because it could so easily be assimilated to the traditional palmette. We see once more that force of visual habits at work which ensures the role of the 'schema' in the procedures of art. The schematic motifs which Greek designers had derived from the ancient Orient were returned to life in the great awakening that can be observed in all aspects of Greek civilization. The 'animation' of the scroll into a living plant with a resemblance to a familiar weed is part of that evolution which became a revolution.

It remains fascinating to follow Riegl as he takes us, in the last four sections of the book, through a further thousand years of stylistic change, to analyse with him the transformations of the Corinthian capital from the fourth century BC to the late antique versions of the motif in the Byzantine Church of St John (Fig. 223) and in the Hagia Sophia (Fig. 224). He pays tribute to Owen Jones, who had recognized that this development led directly to the arabesque, but he criticizes the emphasis Jones places on the novelty of the design in which the distinction between stem and leaf is lost, observing that this same tendency makes itself felt much earlier in Greek ornament.

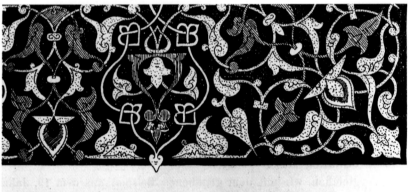

223
Capital from the Church
of St John,
Constantinople, 6th
century AD. From A.
Riegl, *Stilfragen*

224
Capital from the Hagia
Sophia, Constantinople,
6th century AD. From A.
Riegl, *Stilfragen*

225
Analysis of the arabesque.
From A. Riegl, *Stilfragen*

226
Acanthus scroll on a stone
relief from the Church of
SS. Sergius and Bacchus,
Constantinople, 527–36
AD. From A. Speltz, *The
Styles of Ornament* (1910)

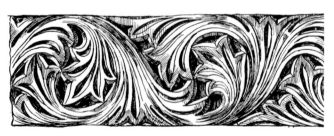

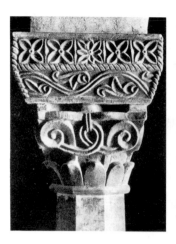 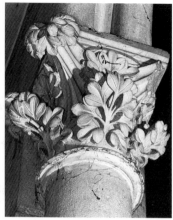 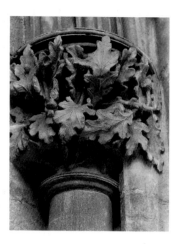

227
Romanesque capital from
the crypt of St Servatius,
Quedlinburg, consecrated
1129

228
Capital from the
triforium, Rheims
Cathedral, c.1250–60

229
Capital from the Chapter
House, Southwell
Minster, c.1330

Resuming his arguments from the book on oriental rugs, Riegl completes the demonstration of the continuous development from Byzantine to Sassanian and Syrian variants of plant ornament, culminating in the developed forms of Moorish art, which still betray to the practised eye their origin from the Greek palmette and the acanthus (Fig. 225).[24]

Riegl was perfectly aware of the fact – as he says in the Introduction to *Stilfragen* – that the history of the classical plant ornament could be continued throughout the Middle Ages and to the Renaissance, but strange as it may sound, nobody has yet written a worthy continuation of the book. Needless to say, it could only be written with Riegl's single-minded concentration on individual problems, for nobody could ever map out the ramifications and transformations of the acanthus scroll in all their surprising varieties. Once our eyes have been sharpened to these continuities of the motif we shall encounter it again and again. It luxuriates in Byzantine stonework (Fig. 226) and on Romanesque capitals (Fig. 227), it turns into Gothic foliage,[25] where it is metamorphosed into native plants. Indeed, one of the many urgent tasks for a new Riegl would be to investigate the apparent naturalism of Gothic leaf work in the light of his treatment of the acanthus. Were the craftsmen who fashioned the marvellous decorations of Rheims (Fig. 228) and Amiens, so admired by Ruskin, or the famous 'Leaves of Southwell' (Fig. 229), so lovingly described in a charming book by Nikolaus Pevsner,[26] really and exclusively relying on a study of living plants, or can we sometimes, at least, still feel the schema of the traditional acanthus leaf behind the renderings of the native flora? Did the continuous tradition facilitate the reabsorption of classical forms in the Renaissance? What was borrowing and what independent growth in the heavier forms of the scroll favoured in the Baroque such as we encountered on the frame of Raphael's *Madonna della Sedia* (Fig. 230)? And to

230
Raphael, *Madonna della
Sedia*, c.1516, in a frame of
c.1700. Palazzo Pitti,
Florence

231
Designs by F. Cuvilliès,
engraved by Lespilliez,
c.1740. Victoria and
Albert Museum, London

232
J. E. Nilson, 'Neues
Caffehaus', 1756. From
P. Jessen *Meister des
Ornamentstichs* (Berlin,
1923)

233
Chinese tomb relief slab,
later Han dynasty, c.150
AD. Royal Ontario
Museum, Toronto

what extent can Riegl's method be used for the explanation and analysis of the Rocaille?²⁷ Are these playful shells (Figs. 231 and 232) just another metamorphosis of the acanthus, or are those versions of the motif which suggest this affinity also hybrids which sprang from the unlikely crossing of two different motifs?

But tempting as it would be to linger over these questions, other problems posed by Riegl's researches might prove even more rewarding to any intrepid explorer who took up the etymology of motifs. I am referring to the astounding spread of the scroll across Asia into the Far East. It appears in China during the Han dynasty in the first centuries of our era, approximated to the Chinese idiom but still recognizable as the Greek scroll (Fig. 233), and is finally adapted there to the great tradition of floral decoration without fully losing its Greek accents (Fig. 234). In India, where it seems to have been associated at first with Buddhist imagery as on the halo of the Buddha from the fifth century (Fig. 235), it finally achieves in Hindu sculpture a lush richness not rivalled anywhere (Fig. 236). It also penetrates into the folk art of

234
Chinese vase, Sung
dynasty, 12-13th century.
Royal Ontario Museum,
Toronto

235
Detail of an Indian
Buddha, Gupta period,
5th century AD. Indian
Museum, Calcutta

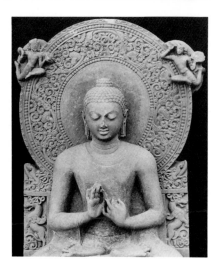

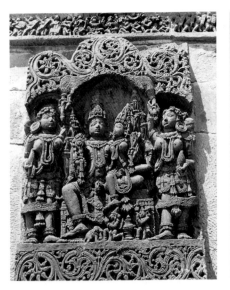

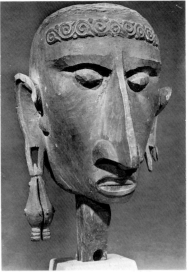

the South East, as witnessed by its appearance on what looks like a primitive tribal mask from a Moluccan ritual pole (Fig. 237). Clearly the etymology of motifs would still offer interesting problems for research and indeed for the demonstration of the interdependence of all civilizations of the Old World. Not that the flow was all one way. There are some motifs which developed in China and percolated to the West; one of them is the so-called cloud band (Fig. 238), which was assimilated into the vocabulary of Oriental rugs and sometimes crossed with the western scroll (Fig. 239).[28] More enigmatic in its derivation and spread is the so-called Paisley pattern (Fig. 240),[29] for which many explanations have been suggested, none of which is wholly satisfactory.

5 Invention or Discovery?

But what would constitute a satisfactory explanation? We know that the force of habit is selective and survivals are often capricious. We also know from the example of language that it is frequently useless to ask why certain roots or forms lived on over thousands of years while others were eliminated without a trace. Any historian must surely approach such problems of explanation with diffidence and with scepticism but, speaking in the most general terms, it may still be accepted that the principle of the survival of the fittest is a useful guideline. Maybe motifs survive because they are easy to remember and easy to apply in diverse contexts. It was suggested in a previous chapter for instance that the Paisley pattern combines the advantage of distinctness with the possibility of introducing a directional element, a slight loosening of symmetrical rigidity which could easily be regulated or counteracted at will.

236
Relief from the
Hoysaleswara Temple,
Halebid, Mysore, India,
1141–82

237
Carved head from
Tanimbar, Moluccan
Islands. Rijksmuseum
voor Volkenkunde,
Leiden

238
Cloud band

239
The cloud band motif in
an Oriental rug. Victoria
and Albert Museum,
London

Could not similar advantages be found in all motifs which remained
successful over the centuries?

The manifold versions of the palmette in the textile motifs which reached
Europe from the East (Fig. 241), variously described as pineapple or artichoke
designs and also assimilated to the pomegranate or the carnation, must owe
their survival to this adaptability. While the basic arrangement was given, it
still allowed the designer subtly to adjust the relation between figure and
ground and to lighten or increase the relative weights of the motif and the
framing device.

One of Saul Steinberg's delightful covers for *The New Yorker* (Fig. 242)

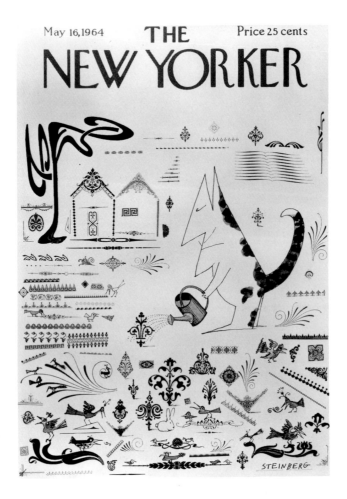

suggests the fantasy of a garden in which the traditional floral motifs of the decorator's repertory have reverted to the soil, as it were, and are tended by a grave feline gardener. Which of them is destined to grow and prosper, and which will fall victim to the voracious ornamental birds which haunt the plot? Does it make sense even to ask this kind of question in the harsher world of historical realities?

We certainly must not claim that we could ever have predicted the course of events and foreseen the road, which led from the lotus to the acanthus and beyond to the rocaille. But if the perpetual study of decoration is to benefit the historian it must at least be able to identify certain advantages which Riegl's animated undulating scroll enjoyed and which may therefore account for its survival and proliferation. Partial explanations of its perceptual appeal have indeed been offered in the past. Hogarth's discussions of the 'line of beauty' are entirely based on his idea of visual satisfaction, and so is Owen

Jones's analysis of the arabesque in terms of eye-movements. I believe that both these authors were right in their contention that there are formal motifs which are not only inventions but also discoveries. By this I mean that they are found to fit certain psychological dispositions which had not been satisfied before. Medicine speaks of drugs which are 'habit-forming', and the history of such habit-forming drugs or spices is writ large over the face of the globe. No doubt it would be foolhardy to apply this idea uncritically to the history of art, but it is worth asking whether we may not speak of decorative motifs which, once invented, turn out to be habit-forming. Maybe the acanthus has a claim to our attention similar to that of the vine or the tobacco plant. If that is true it may still be impossible to specify exactly wherein lies the psychological attraction of the motif. But some tentative answers suggest themselves. First it has all the decorative advantages we found in the wavy line without the possible disadvantage of that abstract motif. The advantage, we remember, lies in its flexibility, which makes it applicable to any empty area, the disadvantage derives from the inbuilt ambiguity between figure and ground, which may introduce an undesirable element of visual complexity. The transformation of the line into a plant scroll firmly establishes the relation between figure and ground, introduces explanatory accents which allow subsidiary scrolls to grow out of the stem without visual discomfort and gives the decorator the option of introducing as many additional directional accents as he wants, varying the symmetry and balance according to the demands of his task (Fig. 243).

Thus the acanthus scroll offers scope for all the basic activities of the decorative designer which I described in Chapter 3 as 'framing, filling and linking' – the latter taking the forms of branching or radiation – and combines them in so flexible and sensitive a way that it offers the perfect instrument for the organization of areas. Moreover, the animation of the line which turns it into a live organic motif offers many pleasant associations with flowers and greenery so closely linked since time immemorial with the habit of decoration. Last but not least, the restriction to particular motifs offers the same aesthetic opportunities we observed in the cases of the architectural order. The trained public will come to sense the exact degree to which the plant is stylized or animated, lush or lean, and will respond to these variations with increasing sensitivity, if not necessarily as violently as Ruskin did when he distinguished between temperance and luxury in a scroll (Fig. 244).

I realize that any such analysis must, by its very nature, have all the faults of an *ad hoc* hypothesis which cannot be tested. All we can ask is whether it may be an improvement on Riegl's explanatory hypothesis. Riegl, it will be remembered, had used the discovery of continuity to counter the 'materialist'

theory of decoration which appealed to the authority of Gottfried Semper for the role played by technique in the spontaneous generation of decorative motifs. It was this materialism, this disregard of the aesthetic and psychological urges underlying artistic creativity, which Riegl wanted to put out of court by his demonstration of a millennial development. As he studied the vicissitudes of the lotus turning itself successively into the palmette, the acanthus and the arabesque, he began to think of it as if it were endowed with a life and will of its own. Thus we read that Hellenistic art brought the Greek scroll to the end towards which it had been consistently driving for centuries, or that it was its essential aim to unfold freely over large areas. In other words, he was more Lamarckian than a Darwinist, or more precisely an Aristotelian who thought in terms of a 'final cause'. That 'will-to-art', which Riegl had conceived as an alternative to the mechanistic explanations of individual motifs, developed into a vitalistic principle underlying the whole history of art.

It is this shift of emphasis which also helps to explain Riegl's unwillingness to follow up *Stilfragen* with further studies in the history of motifs. Having proved his point he must have found it more important to consolidate his concept of the *Kunstwollen* by a different approach. It had to be shown that this inherent force pervaded all artistic manifestations of a particular period or style. Once it could be demonstrated that architecture and sculpture, design and ornament obeyed one unifying principle, the ghost of 'materialism' was surely laid for good and all.

The Swiss scholar Ferdinand de Saussure,[10] who so greatly influenced

243
Relief on the Ara Pacis Augustae, Rome, 13-9 BC

244
John Ruskin, 'Temperance and Intemperance in Curvature'. From *The Stones of Venice* (London, 1853)

modern linguistics, introduced the distinction between the 'diachronic' and the 'synchronic' study of language. The first deals with historical changes (e.g. the changing forms and meanings of the term 'pattern'); the second with language as it can be observed at any particular point in time (e.g. the current usage of the term). Applying this distinction, it is clear that *Stilfragen* is a diachronic study of ornamental motifs. To supplement it by a 'synchronic' account Riegl had to turn to the analysis of a particular stylistic period. An opportunity for this shift offered itself very soon when he was commissioned to publish the 'Works of late antique decorative art found in the area of the Austro-Hungarian Monarchy'. His work, entitled *Die spätrömische Kunstindustrie* (1901), presents a further stage in his interpretation of the place of the decorative arts within stylistic history.

Editor's Postscript

Gombrich used an analogy between verbal language and naturalistic imagery in Art and Illusion. *He did so again in* The Sense of Order, *but this time between language and ornament. Underlying both analyses is the use of information theory. The title of the Northcliffe Lectures, from which this book ultimately grew, was* Rhyme and Reason in Pattern Making. *It is the completion of a rhyme that invites analogy with the development of an ornamental motif.*

The problem that Gombrich addresses in this chapter is one of ornamental sophistication, having shown in 'Art and Self-Transcendence' (Ideals and Idols) *that even the simplest decorative pattern, such as a row of dots around a pot, requires planning. Sophisticated ornament grows out of a tradition of handling visual complexity, not unlike problem solving in mathematics. Indeed, the analogies with mathematics are worth exploring: fractals seem quite boring in comparison with the work of the decorators of the Alhambra or Book of Kells. Pattern has a generative capacity, like language, mathematics and music. Language's generative power lies in, amongst other things, metaphor, so it is no surprise that this chapter starts off with that subject. For* Art and Illusion, *the artist's first metaphor was the hobby horse.*

Art and Illusion *looked at the psychology of image production from the artist's point of view: the existence of style could be explained by the fact that the image was a complex artefact which the artist needed to learn to produce. A cluster of paintings could be assigned to a particular place and time because they embodied a local practice, like a language. The larger development of a style could be explained by the persistence of a tradition. In ritualized societies (note Gombrich's remarks on Konrad Lorenz's ideas) styles would remain static. Where a premium was placed on innovation, style could become a motivator for change and generate its own feedback. In naturalistic imagery, each new achievement would result in a re-evaluation of what had been done before: this ties together the ancient and Renaissance accounts of development of technique, such as Pliny's* Historia Naturalis *(books 33-6)[1] and Vasari's* Vite *(particularly the Prefaces).[2]*

The central difference between fractal-generating computers and human beings is that computers do not have imaginations. Vasari said that Michelangelo broke the chains of common usage, and perhaps he did more than that, as may be witnessed in the work of his followers: there is nothing like deviant behaviour to create greater deviancy. Deviant behaviour need not be disordered, but organized at a different level.

On the imagination run riot see 'The Edge of Chaos' in The Sense of Order. See also the preceding section in this volume.

For a concise statement of the central argument of The Sense of Order see the Preface to the 2nd edition (Oxford, 1984). See also Joaquín Lorda's essay 'Orders with Sense: Sense of Order and Classical Architecture', in Richard Woodfield (ed.), Gombrich on Art and Psychology (Manchester, 1996).

1. See Jex-Blake and Sellers, The Elder Pliny's Chapters on the History of Art (reprinted Chicago, 1968).

2. Any number of editions of Vasari's Vite are available. On my bookshelf is the four volume translation by A. B. Hinds, Giorgio Vasari, The Lives of the Painters, Sculptors and Architects (London, 1963).

The Psychology of Styles

Chapter 8 of *The Sense of Order* (1979), pp. 195–216

How I am always overcome by fear whenever I hear a whole nation or age being characterized in a few words — for what an immense mass of varieties are comprised in such words as nation or the Middle Ages or the Ancient or Modern Times!

Johann Gottfried von Herder, *Ablandlungen und Briefe über schöne Literatur und Kunst, Viertes Fragment.*[1]

1 Riegl's Perceptual Theory of Style

If Riegl's *Stilfragen* is the greatest book among studies of decorative design (see above, pp. 235ff.), his *Spätrömische Kunstindustrie* may be described as the most challenging. One cannot ignore its thesis even if one cannot accept it uncritically. There is a great difference between the two books in the way the evidence is handled. The diachronic unity of stylistic developments which he demonstrated in *Stilfragen* brilliantly survived the test of observation. The 'synchronic' unity of style in any one period is much closer to a metaphysical postulate. It is doubtful whether it can be tested at all. But this ambitious attempt to demonstrate what may be undemonstrable also offers a clear-cut psychological theory of style. In a field as vast and as varied as is the study and interpretation of style, it is only too easy to lose one's way. Riegl's *Kunstindustrie*[2] can serve as a landmark even for those of us who may ultimately wish to go in another direction.

There are few episodes in the history of artistic theories which allow us to observe the interaction between contemporary issues and intellectual arguments with greater clarity than the genesis of Riegl's most famous work. Just as Goodyear's *Grammar of Lotus* was a catalyst which permitted the great synthesis of *Stilfragen*, so *Die spätrömische Kunstindustrie* constitutes Riegl's response to the book by the holder of the Chair of Art History in Vienna, Franz Wickhoff, on the *Vienna Genesis* (1895).[3] Originally conceived as the introduction to the publication of a famous early Christian manuscript, this interpretation of late antique art (published in English as *Roman Art*) set out to clear the stylistic development from Augustus to Constantine from the

stigma of decline. It does so quite explicitly by referring to the topical issues of Wickhoff's period, notably the battle around Impressionism. Where earlier critics had merely seen the corruption of Greek sculpture and painting in slovenly and sketchy procedures, Wickhoff stressed the positive gains achieved by this development in what he called 'illusionism'. What is important in our context is the attention he paid in this analysis to works of decorative art. Among his prime witnesses were the beautiful slabs of the tomb of the Haterii in the Lateran Museum, dating from the first century AD (Fig. 245). In his sensitive description Wickhoff stresses the refusal of the craftsmen to imitate the roses surrounding the pillar with all naturalistic detail. 'Only the impression was to be rendered, the impression made by a rosebush full of buds, flowers and leaves trembling in the air.' Referring to Riegl's *Stilfragen*, which had come out two years earlier, Wickhoff stresses the continuity of stylistic development in the rendering of plant motifs. He asks how the characteristic beauty of this decorative masterpiece could have been overlooked for so long, and blames the orthodoxies discussed in Chapter II.[4] While the academies of art taught the painters to imitate reality to the point of deception, the schools of design warned their students never to imitate the art of illusionistic periods, but rather to choose as their models the decoration of those ages of European art which had not yet 'outgrown the charmingly childish babble of stylized representation'. We also learn from Wickhoff that the inevitable reaction against this dogmatism was connected with an event 'unprecedented in the history of art' – the impact of Japanese art on the West. According to Wickhoff it was this discovery which helped to remove the taboo on naturalism. 'In the wake of this development, we can now appreciate the beauty of such works as the rose pillar which a previous generation would have rejected as contravening the rules of design.'

Wickhoff's interpretation and advocacy naturally added a new element to the study of ornament, on which Riegl was to seize. The account in *Stilfragen* of the development of plant motifs had been mainly descriptive. Changes in treatment and style were attributed to the changing *Kunstwollen* (will-to-form), but no further analysis was given to explain why the artistic notion had changed. Wickhoff provided part of the answer. The change ran parallel to the one observed in the history of European painting from the Renaissance onwards. Close attention to detail had given way to the summary treatment we associate with a rapid visual impression. Here another book which had aroused much discussion in these years came to Riegl's aid, the book by the sculptor Adolf von Hildebrand, *The Problem of Form in the Figurative Arts*,[5] which had been published in the same year as *Stilfragen*. Prompted by the same issues which had interested Wickhoff, but less sympathetic to Impressionism,

245
Rose pillar from the tomb of the Haterii, 1st century AD. Rome. Vatican Museums

246
Openwork, c.3rd century
AD. From A. Riegl, *Die
spätromische Kunstindustrie*
(Vienna, 1901)

247
Chipcarving, c.5th century
AD. From A. Riegl, op.
cit.

248
Garnet insets. The
Ixworth Cross, Anglo-
Saxon, c.600 AD.
Ashmolean Museum,
Oxford

Hildebrand set out to define the contrasting approaches to nature in terms of perception. Classical sculpture was essentially based on sensations of touch, Impressionist painting was purely visual – ignoring at its own peril the residues of tactile sensation which are invariably associated with visual perception. We are in the years when Berenson was to elevate these tactile sensations into an aesthetic principle, while Wölfflin used the polarities of Hildebrand for his even more influential analysis of stylistic developments since the Renaissance.

Riegl's *Spätrömische Kunstindustrie* of 1901 is the most consistent and uncompromising application of this perceptual theory of art. Its thesis can be briefly summed up: the history of art from ancient Egypt to late antiquity is the history of the shift of the *Kuntstwollen* from tactile (Riegl says haptic) to visual or 'optic' modes of perception. This shift can be observed not only in the figurative arts, it also manifests itself in architecture and in the decorative crafts. Every architectural motif, every brooch or fibula of a given period, must and can be shown to obey the same inherent laws of stylistic development that drove art relentlessly from touch to vision. It will be remembered that Riegl's assignment had in fact been the publication and description of archaeological finds in the soil of the Austro-Hungarian Monarchy. The thoroughness and consistency with which he carried out his programme must command admiration even where it does not command acceptance. Here, as in his earlier book on Oriental rugs, his first aim was to reduce as far as possible the share claimed for other cultures and other tribes. The finds from the period of migration had to be shown to form part of the artistic development of the Graeco-Roman world if they were to be explained as the products of a late phase of the *Kunstwollen*, the outcome of one specific phase of perceptual bias. Three techniques are here analysed in succession – openwork (Fig. 246), chipcarving (Fig. 247) and garnet insets (Fig. 248). They show, in Riegl's view, the progressive abandonment of the isolated motif lucidly standing out against a neutral ground such as we know it from classical Greek art. Instead we get a blurring of the distinction between figure and ground. I have mentioned in an earlier chapter that it was Riegl who anticipated psychologists of perception in his discussion of the change between figure and ground that marks certain styles of ornament (see above, p. 236). The feature first emerged in certain types of openwork where the figure and the void balance each other visually. In the technique known as chipcarving it is even harder to tell whether it is the ridge or the groove that should be seen as dominant. In the garnet inlay of the dark ages the golden setting sometimes provides a pattern and the dark red stones impress us as ground. The reversal is complete. For Riegl this development runs exactly parallel to the changes in

249
Detail from a panel of
Marcus Aurelius, Rome,
c.175 AD. Palazzo dei
Conservatori, Rome

sculpture observed during that period. Instead of the careful tactile modelling of every individual feature, late Roman sculpture developed that summary treatment which gave it such a bad name, the use of drills as distinct from chisels, leading to an exploitation of deep shadows and strong lights (Fig. 249). Instead of that loving articulation of the individual element which we admire in the best products of Greek art, we get massed effects, more impressive from the distance than from close quarters. According to Riegl it is not only useless but also shortsighted to decry this change as a decline, because without this inevitable development art could not have progressed to the rendering of space and atmosphere in that second cycle which started in the Renaissance and culminated in Riegl's time.

That there is a certain amount of special pleading in this remarkable demonstration almost goes without saying. A careful reader of the book will find, for instance, that Riegl sometimes rejected the evidence of coins found with the objects, because they suggested a date too early to suit his sequence. Moreover, some of the perceptual effects he so brilliantly analysed as manifestations of a given phase in the evolution of the *Kunstwollen* are far from unique to this stylistic group. After all, there is no ornament which plays more teasingly with the switch between figure and ground than the Greek key pattern (Fig. 206). A stroll through any collection of tribal art is also likely to produce intriguing parallels to Riegl's specimens (Figs. 250, 251, 252). Some tribal artefacts may be explained as the results of diffusion and imitation, but

250
Matwork by Brazilian
Indians. From G.
Weltfish, *The Origins of Art*
(Indianapolis, 1953)

251
Amazon Indian club.
From H. Stolpe, *Amazon
Indian Designs* (1927)

252
Ancient Mexican stamp.
From J. Enciso, *Design
Motifs of Ancient Mexico*
(1947)

with others there is no such possibility, and we would have to attribute to various remote regions the same perceptual development which we found in the Western world.

Riegl would have found difficulty in admitting such pluralism because, like his earlier *Stilfragen*, the *Spätrömische Kunstindustrie* has a polemical edge. The demonstration of the 'synchronic' unities of artistic developments and of their intrinsic necessity was aimed – consciously or unconsciously – at the critics of modern developments who were trying in vain to stop the stars in their courses. Its message, popularized in Worringer's *Abstraction and Empathy*, was taken up by the revolutionary movements in the art of the early twentieth century, which strove to fashion a new art for the new age. The longing for such an escape from the stale round of historical styles inspired the movement of *Art Nouveau*, for which the unity of high art and applied art was so vital a demand. No wonder that the study of styles was coloured by this quest for inner cohesion and unity. Its roots lie in the artistic situation of the nineteenth century.

2 *The Pervasiveness of Style*[6]

The idea of linking period styles with distinctive types of ornament was commonplace in nineteenth-century schools of design. Any number of books took the student through the repertories of forms associated with classical, Byzantine, Gothic or Renaissance ornament to enable him to design façades, interiors or furnishings in any of the period styles favoured by changing fashions and requirements (Fig. 253). Turning the pages of these books, we are immediately reminded of one of the principal sources of these unified repertories. Architectural styles are in the lead and tend to determine the forms of furniture and of implements in a very direct way. We have seen this principle of unity at work in the preceding chapter (see above, pp. 230–4). The classical orders and their subsidiary elements, such as mouldings, were applied by carpenters to wardrobes and chests, which were turned in this way into

metaphorical buildings. We can observe the same process in Gothic furnishings with their blind arcades suggesting windows and mullions. Nor is it difficult to see how these elements of design spread from here to other media and other purposes whenever function invited decorative enhancement. The Gothic chalice or ivory diptych will exhibit Gothic designs, much as the Renaissance title-page or picture frame will display elements of the Renaissance repertory. The nineteenth century was obsessed with style precisely because it felt itself to be without a style of its own. The misguided efforts of restorers to rid buildings of later accretions and to return them to a fictitious purity of style are symptomatic of this preoccupation. But the very difficulties in achieving this desired cohesion also drew attention to the fact that there is more to style than a mere repertory of forms. The Gothic churches of the Victorian age stubbornly refuse to look medieval. It may be no

accident therefore that we find one of the greatest students of design, Viollet-le-Duc, whose name has become unjustly associated merely with radical restoration of Gothic cathedrals, postulating this principle of a higher unity in the article on style he wrote for his *Dictionnaire raisonné de l'architecture française* (1854–69).[7] In this article he makes the very point which has so often been made against his restorations: 'We cannot adopt the style of the Greeks because we are not Athenians. We cannot recover the style of our medieval forebears because times have marched on. All we can do is to affect the manner of the Greeks or of the medieval masters, in other words, make pastiche. Instead we must do what they did or at least proceed as they proceeded, that is to say penetrate to the true and natural principles to which they penetrated, and if we do that our works will have style without our seeking for it.'

What Viollet-le-Duc, like Riegl, wanted to demonstrate was the logical cohesion of every great style. He saw such styles as vast deductive systems in which every form followed from the central principle adopted by the architects. In this sense style is 'a kind of unsought emanation of forms'. 'Whenever a population of artists and craftsmen are thoroughly imbued by the logical principles by which every form derives from the purpose of the object the style shows itself in all works issued from the hands of man, from the most ordinary pot to the exalted monument.'

But what is this logical calculus which could tell the Greek or the Gothic craftsman on the grounds of first principles what form he should give to an ordinary pot? Surely the Cartesian tradition here played a trick on Viollet-le-Duc in making him extend the principle of deduction much further than logic warrants. It is not hard to see that his assertion represents one of the many attempts to rationalize the intuitive feeling that the various manifestations of an age are not random, but exhibit a common character, a common spirit.

Having frequently criticized these rationalizations, particularly in their Hegelian versions, I feel reluctant to return to this elusive question once more, but no discussion of style can possible evade it. I vividly remember a conversation with Erwin Panofsky when I accompanied him on Cape Cod as he was walking his dog in the summer of 1951. He told me how puzzled he had been in his student days by the expression 'Gothic painting'. He could understand the application to buildings or decoration, but in what sense could a painting be Gothic? I summoned my courage and asked, 'Do you think that all this really exists?', to which he replied with an uncompromising 'yes'. Only later I realized that in his lectures on *Gothic and Scholasticism* he had just committed himself to another attempt to justify the Hegelian tradition of governing spirits. The intuitive feeling that there is an affinity between the structures of Gothic cathedrals and the philosophical system of the

254
Gregor Erhart, high altar
of the Klosterkirche,
Blaubeuren, Germany,
1493–4.

Scholastics need not concern us here, but the reasons which prompted Panofsky to set aside his initial doubts are surely relevant to the history of design. Reformulating Panofsky's question, we may ask whether there exists a link between a painting and its frame, or more specifically between all the elements of a Gothic altar (Fig. 254), the shrine with its sculptures, the wings with their reliefs and painted panels and the architectural detail of its fretwork setting.

To deny this coherence would be to fly in the face not only of Hegelianism[8] but of the most cherished conviction of aesthetics, which postulates the 'organic unity' of works of art. And yet it is hard to see how this conviction could be tested objectively. What could we say to a sceptic who objects that our feeling of unity is simply due to the force of habit? We have so often seen paintings of this style associated with Gothic shrines that the sight of one calls up the other — much as the sight of a friend's hat on a peg may call up his face, some imaginative people even seeing a kind of phantom head peeping

out under it. No doubt, the sceptic might continue, this experience may lead to the subjective conviction that the hat belongs of necessity to this man and to nobody else, and once this conviction is settled it can be rationalized in any number of ways. The sceptic certainly has a case there; and his case can even be strengthened – as I have argued elsewhere – where various features are seen as the 'expression' of one and the same spirit or mind. The sense of order turns out to be a somewhat disturbing element in the cool examination of what I might venture to call Panofsky's first problem. For nowhere is the integrative capacity of our mind more in evidence than in our physiognomic reactions. Every movement of our facial features, the smiling mouth, the wrinkled brow, is experienced as expressive, and any combination of movements sets the mind the task of deciphering their joint significance. So automatic is this achievement, that we find the reading almost inescapable even where we know it to be mistaken. We all extend this synoptic vision[9] of our fellow humans from their facial expressions to their gestures, their gait, their voice and their habits – including their choice of a hat, and it is in the nature of things that we can never be refuted. If an old friend turns up wearing a strange hat we may register a momentary surprise, after which we adjust our picture of his character to allow for this whimsical aberration. It is only as a last resort that we decide something to be so much 'out of character' that we must attribute it to some external cause.

The sceptic might grant that such intuitions are not wholly fanciful. We do form a 'global' impression of our fellow humans which allows us to sense their character and their likely actions and reactions. Without some such faculty we could hardly get on in life. How far these feelings are open to rational analysis is a different matter, but the claims of graphology, which imply that it is possible from the traces of handwriting to infer other character traits, cannot be entirely dismissed.

At this point, however, the sceptic may well remind us that the assessment of the expressive character of handwriting is only possible within a very firm pre-established context. What the graphologist may find symptomatic is the way a given writer modifies the traditional lettering he has learnt. He has not invented the script we are judging, and if he had, its diagnostic value might be less rather than more. It is precisely because we can trace the causative chain of tradition in the teaching and learning of writing that we may be able to plot and assess the slight individual deviations which we find symptomatic of a whole coherent system of character traits. To transfer this method by analogy to the study of styles may be illicit on at least two counts: first because such a transfer implies a belief in some kind of collective spirit or group mind which would permit us to speak of races, classes or ages in the terms we use for

Qvesta opra da ogni patte e un libro doro
Non fu piu preciofa gemma mai
Dil kalendario : che tratta cofe afai
Con gran facilita : ma gran lauoro
Qui numero aureo : e tutti i fegni fuoro
Defcripti dil gran polo da ogni lai :
Quando ti fole : e luna eclipfi fai :
Quante terre fe rece a fto thexoro.
In un inftanti tu fai qual hora fia :
Qual fara lanno : giorno : tempo : e mexe :
Che tutti ponti fon daftrologia .
Ioanne de monte regio quefto fexe :
Coglier tal frutto acio non graue fia
In breue tempo : e con pochi penexe .
Chi teme cotal fpexe
Scampa uirtu. I nomi di impreffori
Son qui da baffo di roffi colori .

Venetijs. 1476

Bernardus pictor de Augufta
Petrus lofiein de Langencen
Erhardus ratdolt de Augufta

255
Hans Schönsperger,
woodcut from the first
German law book
(Augsburg, 1496).
Reproduced in E. Lehner,
Alphabets and Ornaments
(1952)

256
Title page by Erhard
Ratdolt (Venice, 1476).
Reproduced in E. Lehner,
op. cit.

individuals, secondly because the styles and forms of visual arts may vary for a number of reasons entirely unconnected with their expressive force. We lack the clearcut context which may justify graphology.

Even so the history of art criticism shows that the temptation to treat stylistic changes as symptoms of changing spirits is almost inescapable. We remember how Ruskin turned 'graphologist' in inferring the moral decay of the age from the lush form of a scroll (Fig. 244). We may grant that the change in the form of the scroll is not an isolated phenomenon, but must it be symptomatic of everything else in art and society? If it is not, at what point would it be prudent to stop analogizing?

We need not go further than script to define this question. There is certainly a formal affinity between Gothic script and Gothic ornament (Fig. 255), just as we can appreciate why Renaissance humanists changed over to the clear forms of Carolingian minuscules, which they described as *all'antica* and which was adopted by their printers (Fig. 256; see also below, pp. 420–4). But is there also a special Gothic mentality behind Gothic lettering? Did not any scribe of the period have to learn and practise this kind of script, of which we can trace the evolution in a secular process ? Does it make sense, therefore, to diagnose the spikiness of Gothic shapes by the same standards we might adopt when seeing such spiky forms in a contemporary hand?

3 Heinrich Wölfflin

None of the great historians of art expended more energy on this type of question than Heinrich Wölfflin. A master in conveying the physiognomic qualities of forms and of styles, Wölfflin loved to exercise his skill. But unlike

266 | Part V: Psychology and the Decorative Arts

257, 258
Gothic and Renaissance
shoes (E. Viollet-le-Duc,
*Dictionnaire du Mobilier
Français*, 1858–75)

some of his less critical successors, he was well aware of the sceptic looking over his shoulder. Throughout his life he was a physiognomist with an uneasy conscience. This inner conflict is apparent even in his first book, *Renaissance and Baroque*, published in 1888, thirteen years before Riegl's *Kunstindustrie*. Its famous chapter on the causes of change in style opens with a confrontation between two theories then current; one, the psychological hypothesis of a German architect Adolf Göller, who regarded the sequence of forms from the Renaissance to Baroque as a result of blunted sensitivity, of the need for stronger stimulation resulting from visual boredom; the opposing theory prevalent in Wölfflin's day saw style as an 'expression of the age'. We are once more faced with the duality between a diachronic or sequential explanation and a synchronic or holistic one. Wölfflin was critical of the Hegelian type of holism, which lumps together feudalism, scholasticism, spiritualism etc. as 'expressions' of the Gothic age. He knew that little more was needed than a modicum of ingenuity to find affinities between these disparate manifestations. What we must ask, he argues, is what characteristics of an age are at all capable of being expressed in a visual form. It is here that he comes up with his physiognomic theory of architecture, which is a theory of empathy. According to this view, which enjoyed a great vogue at the end of the nineteenth century, we respond to shapes much as we respond to music by dancing inwardly. The lean vertical shaft may make us tense and stretch our muscles, the spreading horizontal shape will make us feel relaxed and calm. It is in this body reaction that Wölfflin seeks to locate the mediating factor between various aspects of the Gothic style.[10]

There is . . . a Gothic deportment, with its tense muscles and precise movements; everything is sharp and precisely pointed, there is no relaxation, no flabbiness, a will is expressed everywhere in the most explicit fashion. The Gothic nose is fine and thin. Every massive shape, everything broad and calm has disappeared. The body sublimates itself completely in energy. Figures are slim and extended, and appear as it were to be on tip-toe. The Renaissance, by contrast, evolves the expression of a present state of well-being in which the hard frozen forms become loosened and liberated and all is pervaded by vigour, both in its movement and its static calm.

The most immediate formal expression of a chosen form of deportment and movement is by means of costume. We have only to compare a Gothic shoe [Fig. 257] with a Renaissance one [Fig. 258] to see that each conveys a completely different way of stepping; the one is narrow and elongated and ends in a long point; the other is broad and comfortable and treads the ground with quiet assurance.

259
Italian chest, c.1540.
Formerly Kaiser Friedrich
Museum, Berlin

This masterly characterization has become a *locus classicus*, but in Wölfflin's pages it is followed by qualifications. He does not intend to deny the validity of technical explanations in the history of architecture, nor does he think that style is always a mirror of its time. Sometimes, for instance, architecture has ceased to be responsive to the moods of an age, whose formal sensibility then finds an 'outlet' in the decorative arts.

Wölfflin never resolved the contradiction between his physiognomic and his formalistic approach to style. His *Principles of Art History* still aims at establishing identifiable categories for the description of the same stylistic transformation he had discussed in *Renaissance and Baroque*.[11] But now he is less concerned with their expressive character than with basic organizational principles. Wölfflin likes to speak in this context of contrasting 'modes of seeing' which accompany (if they do not explain) the shift in artistic styles from hard-edged to soft-edged, from closed form to open form. His approach here has much in common with Riegl's but it is less unitary, less deterministic. Even so he felt moved in 1933 to publish an essay entitled *Revision* to clarify his position.[12] The diagnostic tools he had sharpened in his first book had meanwhile become vulgarized and sensationalized in the writings of Worringer and of Oswald Spengler, and talk of 'Gothic Man' and 'Renaissance Man' had become the small coin of the market place. Wölfflin evidently wished to call a halt. Surely, he says, we must not overdo this. There are phases in the history of painting which exhibit their own logic. The development of Italian painting from the Early to the High Renaissance seems to him a case in point. 'It would be absurd to postulate that every step in this evolution corresponds to a distinctive nuance of "classic man", resulting in its own kind of art.' He warns his readers not to expect too much

and not to demand an exact parallel between the 'history of seeing' and the general history of the human spirit. It looks as if his conscience was not only troubled by certain over-statements in the *Principles*, but quite especially by its sequel, the book *Die Kunst der Renaissance in Italien und das Deutsche Formgefühl* (rather misleadingly translated as 'The Sense of Form in Art'). For here Wölfflin had shown himself more responsive to the intellectual currents of the time and had exercised his interpretative skill in the elaboration of national physiognomies, contrasting the classic lucidity of Italian Renaissance creations (Fig. 259) with the intricate, dynamic and irregular shapes beloved of German art Fig. 260). What had driven him to this investigation was the difficulty of assuming that mentalities changed as rapidly as did styles. But these doubts led him to the even more dubious assumption of a racial theory.[13]

> We have become too much used to identifying the history of art with a sequence
> of closed stylistic systems, allowing the idea to slip in that every style originates
> something entirely new. A moment's reflection suffices, however, to realize that in
> the various styles prevalent in a country there remains still one element in
> common to them all which stems from the soil, from the race, so that the Italian

261
Lucas Cranach, *St Valentine and Donor*, c.1503. Akademie der Bildenden Künste, Vienna

262
Wolf Huber, pen drawing, c.1520. Göttingen University

263
Martin Schongauer, Gothic ornamental leaf, 2nd half of the 15th century. British Museum, London

Baroque, for instance, does not only differ from the Italian Renaissance but also resembles it, since behind both styles there remains Italian Man, as a racial type which only changes slowly.

Mercifully the sceptic and the humanist in Wölfflin kept him from further elaboration of this philosophy, and so we can examine his comparisons without *parti pris.* Maybe one should even be grateful for the fact that the sceptic did not prevent the exercise altogether. For though no reader will suspect me to be neutral in this matter, my scepticism, like Wölfflin's holism, is sometimes troubled by an uneasy conscience. No student of decorative art can deny that some of Wölfflin's confrontations are persuasive. His contrast between an Italian Renaissance chest and a Gothic wardrobe is certainly no less telling than is the comparison between Gothic and Renaissance lettering. The notion of an underlying sense of form which mediates between the various visual arts need not be a mere figment of the imagination simply because the explanations offered have proved so feeble. We all feel sure that a Rococo ornament would look out of place in an ancient Egyptian temple or a chinoiserie in a Renaissance church. It is a satisfying game to look for decorative motifs which seem to go together with other elements of a particular style. After all it was the Greeks themselves who stressed that the columns of their temples had something in common with human types; they were seen as visual metaphors (Fig. 187) and it is easy to understand the ground of this comparison. No doubt the same is true of Gothic forms and certain aspects of Gothic sculpture and painting. To the Romantics the

264
Giotto, decorative panel
from the Arena Chapel,
Padua, c.1306.

265
Vermeer, detail from *A
Young Woman standing at a
Virginal*, c.1670. National
Gallery, London

comparison of Gothic architecture with northern forests was a commonplace and it is easy to see the kinship between Cranach's crozier and Cranach's tree (Fig. 261).[14] Many trees on German drawings (Fig. 262) seem to obey the same sense of form as a Gothic ornament (Fig. 263). Remembering Panofsky's early qualms, we may say that there is indeed some real coherence between the frame of the Gothic shrine and its figurative elements, the rich whirling drapery of Gothic sculpture certainly goes well with the fretwork of the crowning decoration. There are periods where this formal coherence between the arts is obtrusive, none more so than the period of *Art Nouveau* with its preference for sinuous lines in painting and decoration. But how pervasive are even these principles? Not all buildings or furnishings produced in the years when *Art Nouveau* was *en vogue* followed these laws; on the contrary, even among the advanced designers of the period there were opponents such as Adolf Loos, who preached a functionalism *avant la lettre.* Indeed, if the examples of such affinity can be multiplied, so can the counter-examples. Would we expect the decorative forms Giotto used in his frescoes (Fig. 264), if we did not know them?[15] Would the original frames of Dutch paintings strike us as visually fitting (Fig. 265)? What decorative feature from Spanish seventeenth-century interiors could be set beside a Velázquez without a sense of strain?

Maybe a champion of Riegl's unitary theories would here object that our comparisons remained too close to the surface of the phenomena. If we dig deep enough we may still find the same *Kunstwollen* manifested in all of them. However they may differ in aesthetic qualities and status, they still show the same pointer readings when examined along the scale between the extremes of tactile and optic perception. But there are episodes in the history of art which make this postulate of perceptual unity extremely doubtful. One of them, as we remember, was actually mentioned by Riegl's predecessor Franz Wickhoff: Victorian theory insisted on the need for a clear separation between the forms

266
Tapestry of St Michael,
2nd half of the 12th
century. Halberstadt
Cathedral

of applied art and those of high art. The decorator should stylize, the painter should not. A flower on a wallpaper should be flat, a flower in a picture three-dimensional. And lest it is suggested that this late example is the product of an intellectual dogmatism alien to earlier periods, we may point at a similar cleavage in the early Middle Ages, though here the roles are reversed. Romanesque painting tends to be flat, emphasizing the plane and permitting the figures to stand out as lucidly legible shapes. In the decorative borders, however, the illusionistic devices of Hellenistic painting live on, as if the artists enjoyed showing their skill in these simple tricks (Fig. 266).[16] They would not have done so, if their public had not shared this pleasure, which was no longer offered by narrative painting. Whatever the reasons for this division of skills, perceptual unity is certainly sacrificed wherever one craft tradition sticks to old patterns while the other transforms the models in a particular direction.

4 Focillon and the 'Life of Forms'

But do we need this postulate of uniformity for each style and period? The need has certainly been denied not only by sceptics suspicious of all generalizations of this kind, but also by schools of art history anxious to arrive at some underlying law. I am particularly thinking of Henri Focillon,[17] whose brief book *Vie des Formes* made many converts to a stylistic pluralism, allowing every medium and art form its own pace of evolution.

'All interpretations of stylistic movements', he writes, 'must take account of

two essential facts: several styles can live at the same time, even in closely adjoining or the same area; and styles do not develop in the same way in different technical domains.' Though Focillon acknowledged the temptation which always exists to 'demonstrate an internal logic which governs the forms', he asked his readers and pupils never to forget the contingent, the experimental and the creative elements in the history of art. But what concerns us here is that he all but exempted the study of ornament from this caution.

> It lies in the essence of ornament that it can be reduced to the purest forms of intelligibility, and that geometrical reasoning can be applied without hindrance to an analysis of its constituent relationships ... In such a field it is not illicit to assimilate style to stylistics and to establish a logical process which is forcefully and demonstrably at work inside the style—it always being understood, however, that the temporal or regional sequences may differ in speed and purity.[18]

The phases which a style normally undergoes in its development Focillon called 'Experimental', 'Classic' and 'Baroque', and it is clear that he found identical tendencies in the architectural decorations of late Romanesque and late Gothic. The parallelism is well brought out in the way in which, in *The Art of the West*, he described the final stages of both styles. He writes of twelfth-century Romanesque:

> By spreading itself with a lavishness which disregarded architectural discipline, and by overrunning members for which it was ill adapted or whose function it obscured or enfeebled, the decoration escaped from the strict regime which had confined it to definite situations and definite frames ... A network of flickering shadows, a scattering of excessively numerous and varied accents, compromise the balance and unity of the monumental block ...' (Fig. 267).[19]

And this on the Flamboyant style, the 'Gothic Baroque':

> This new instinct which ... assailed the fundamental principles of the structure, also undermined the strength and stability of external masses ... This stippling of light and shadow, this undulating movement of the forms, these flames of stone are the most prominent features of the glistening cloak, an optical illusionism which conceals the annihilated masses (Fig. 268).

Focillon, of course, is aware of this affinity between the final stages of the two dominant medieval styles, and broaches the possibility of a deliberate revival, a cyclical theory in which like comes to borrow from like. What is even more

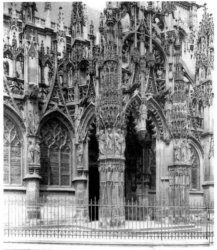

267
Capital from Saint-Julien,
Brioude, Haute-Loire,
12th century

268
Revetment from Notre-
Dame, Louviers, late 15th
century

interesting is the kinship between his description of styles he considered degenerate and those condemnations of similar developments we found in Vitruvius and in Vasari. Indeed Focillon's characterization of Milan Cathedral (Fig. 269) consciously or unconsciously echoes Vasari's condemnation of the 'Gothic' style. He calls it 'the masterpiece of all false masterpieces ... As an optical illusion, Milan Cathedral successfully produces an effect of grandeur and luxury. But the profusion of gables, pinnacles, finials, balustrades, statues and statuettes cannot conceal from the practised eye the poverty of the architecture and the extreme mediocrity of the technique.'

It is striking to what extent Focillon here continues the tradition of French medieval studies largely inaugurated by Prosper Mérimée, witness the opening of Mérimée's essay on medieval religious architecture in France published as early as 1838:

Studying the buildings erected between the Roman era and that of the Renaissance, one will find that the history of every architectural style is the same, as if their progress and decadence followed a general law. Simple at first, the buildings gradually become adorned; as soon as they have acquired all the elegance and all the richness which belong to the style, without it being altered, the age has arrived at the perfection of that style or, if one prefers the formulation, at its greatest development. Soon, however, the tendency to decorate, to enrich the original repertory exceeds the bounds we have set. Instead of being accessories ornamentation becomes the principal aim.[20]

269
Milan Cathedral, founded
1386

Given this ancestry, it is not unexpected that Focillon's analysis restates the
very views against which Riegl had reacted so strongly. That 'inner logic' of
which he speaks derives from the academic theory of art, based in its turn on
the criticism of rhetoric in antiquity. The conquest of means, the perfect fit
between ends and means, and the final display of virtuosity in which means
become an end in themselves – all these are features of the traditional
vocabulary of criticism which implied and justified that notion of progress
and decline which was so abhorrent to Riegl. Moreover, in scrutinizing
Focillon's accounts, we shall find the same emphasis on certain decorative
features, the reliance on shadows, the exuberance of texture, which Riegl had
placed into the centre of his analysis of late antique art while refusing at the
same time to brand it with the stigma of 'decadence'. He did so in the name
of scientific objectivity, which had no room for such notions as decline.

5 'Purity' and 'Decadence'

It is all the more surprising to find that Riegl's interpretation of late antique
decoration shows a remarkable affinity with that of John Ruskin, who would
have abhorred the intrusion of science into the study of art. The chapter on
'The Lamp of Power' in Ruskin's *Seven Lamps of Architecture* contains a passionate
appreciation of Byzantine ornament (which is meant to include what we call
Romanesque) for its masterly exploration of light effects. This, as Ruskin
stressed, was alien to ancient Greek art, for the Greek 'attention was
concentrated on the one aim of readableness and clearness of accent … what
power of light these primal arrangements left, was diminished in successive

270, 271
John Ruskin, illustrations
from *Seven Lamps of
Architecture* (London, 1849)

refinements and additions of ornament; and continued to diminish through Roman work'.[21] He attributes the reversal of this technique to the introduction of the dome:

> Hence arose, among the Byzantine architects, a system of ornament, entirely restrained within the superficies of curvilinear masses, on which the light fell with as unbroken gradation as on a dome or column, while the illumined surface was nevertheless cut into details of singular and most ingenious intricacy. Something is, of course, to be allowed for the less dexterity of the workmen; it being easier to cut down into a solid block, than to arrange the projecting proportions of leaf on the Greek capital: such leafy capitals are nevertheless executed by the Byzantines with skill enough to show that their preference of the massive form was by no means compulsory, nor can I think it unwise. On the contrary, while the arrangements of *line* are far more artful in the Greek capital, the Byzantine light and shade are as incontestably more grand and masculine ... (Figs. 270, 271).

As so often in his great and enigmatic book, Ruskin all but drowns this important observation in a hymnic praise of the power of nature and the beauty of light falling on clouds, mountains and trees, 'that diffusion of

light for which the Byzantine ornaments were designed'.

Those builders had truer sympathy with what God made majestic, than the self-contemplating and self-contented Greek. I know that they are barbaric in comparison; but there is a power in their barbarism … a power that neither comprehended nor ruled itself, but worked and wandered as it listed … and which could not rest in the expression or seizure of finite form. It could not bury itself in acanthus leaves.

In a footnote added later to this passage, Ruskin withdrew his slighting remark about the self-contented Greek. He had evidently been carried away by his own power of advocacy, but this recantation only enhances the kinship of his account with that of Riegl and even Wölfflin. Every style exists in its own right. The Greek style aims at legibility (Fig. 216) and a line executed with skill; late antique art worked in masses for powerful visual effects, sacrificing some dexterity for a grander impression of the whole.

Ruskin's account can dispense with the apparatus of perceptual psychology and the recourse to evolutionist determinism and yet successfully defend the later style against the charge of corruption. He can do so even without denying that some skill must have been lost in the transition from a linear to a summary treatment of forms. Whether he was right in his suggestion that this change was due to the introduction of the dome is a different matter. The idea that architecture must always be the leading art may have influenced his view; but taken in a more general way there may be some truth in this hypothesis. The tendency towards the grandiose and colossal which pervades the development of late antique architecture and culminates in the Hagia Sophia cannot be divorced from the changes in decoration. Nobody today

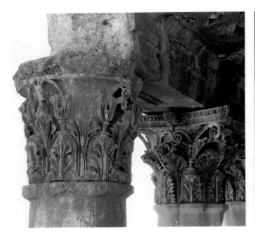

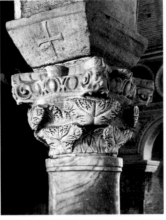

273
Capitals from the Temple
of Bacchus, Baalbek,
Lebanon, 138–61 AD

274
Capital from S.
Apollinare in Classe,
Ravenna, 534–9 AD

would want to leave out of account the difference in the organization and workforce needed to build the Erechtheion on the Acropolis (Fig. 272) as against the temples of Baalbek (Fig. 273). The small band of Greek fifth-century masons would necessarily work differently from the armies of workmen needed for the vast architectural enterprises of the orientalized emperors. The gradual adoption of the mechanical drill instead of the chisel on decorative detail must be as much connected with this development as with a perceptual bias for deep shadows (Fig. 274). But need one explanation exclude the other? Great art is great because it is resourceful. If the road is barred to one kind of perfection, the desire for excellence searches for a compensating move, turning a handicap into an unexpected advantage. To ignore or deny the existence of such handicaps may well block our understanding of stylistic change. It is for this reason that the replacement of the idea of skill by that of 'will' seems to me unhelpful. It can never do justice to that process of adaptation, that interplay between sacrifice and exploration which characterizes all successful developments in science, technology and art. To deny that representational skills declined in late antiquity seems to me as perverse as to withhold admiration from the marvels of Ravenna or the Lindisfarne Gospels.

Maybe it is precisely here that the study of decorative art can clarify some of the relevant issues. One of them engaged our attention in Chapter VI, where the Kaleidoscope introduced us to the effects of patterning and led to the conclusion that there are contrary pulls at work in our perception of things and of patterns.[22] Repetition, we found, devalues the individual motif, isolation enhances it. The designer will accordingly tend to stylize the repeated elements and animate the enhanced representation. The dispute between Ruskin and his more orthodox opponent helped to bring out this

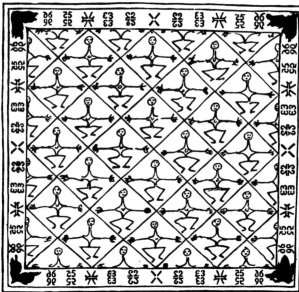

opposition,[23] which is equally relevant to our present concerns. That childish scrawl he had produced as a challenge (Fig. 275) turned out to serve quite well as a repeated motif, where its individuality was scarcely noticeable (Fig. 276). It would have been wasteful and pointless to produce a masterpiece of figure drawing to function in this capacity, just as it would be ludicrous to employ no more skill than Ruskin used for this figure in a narrative composition.

Not that this illustration should be taken *au pied de la lettre*. What deserves consideration is merely that compensatory character between decoration and representation which the extreme example brings out. The isolation and the refinement of the Greek acanthus scroll are two sides of the same coin, as are the multiplication and the simplification of floral motifs in late antique art (Figs. 223, 224, 225).[24] Or observe the delicacy of the Rose pillar (Fig. 245) which so enchanted Wickhoff. It could find no place in the rich design of late antique scrollwork, in which we cannot concentrate on the individual motif because of the pull of redundancies. We find a similar decline of naturalism in the development of late Gothic ornament which Focillon characterized as decadent. The reason for his charge here was not so much the summary execution, as the disregard of the architectural structure these motifs had originally been meant to enhance rather than obscure.

This phase also seems to be common to many styles.[25] Discussing the same subject of French Flamboyant decoration, the popular handbook on *The Styles of Ornament* by Alexander Speltz says (in the English edition): 'The desire for greater lightness becoming now apparent, and the purity of design being

neglected at the same time, it finally happened that the Ornament grew apace and masked the form, a fate which in the end overtook almost all styles of architecture.'[26] There may be an element of overstatement here, but in any case one would like to describe this typical development in more neutral terms.

That subservience to structure which is so often identified with 'purity' corresponds, in our terms, to the use of 'explanatory articulation'. Ornament serves to facilitate the grasp of the object it decorates. We have observed this function in the extended application of the Classical orders, as when pilasters and friezes turn an otherwise amorphous wall into the semblance of supports and lintels. The most important instance of such explanatory articulation in the whole history of architecture, however, may turn out to be the Gothic rib and the other members of the Gothic repertory. At any rate there is a school of thought which denies the functional explanation of these features.[27] Ribs do not necessarily add to the stability of a vault, nor, so it seems, do flying buttresses. It is likely that this denial of an old orthodoxy overstates its case, but in doing so it has brought into relief the articulating function of certain features formerly thought of as purely structural. What was it then that led to the loss of purity here and in the case of the orders? It is hard to know whether such a question permits an unambiguous answer, but here, as in the previous instance, we can at least remember the homely adage that you can't have it both ways. Articulation demands that 'magnet for the eye' that comes from discontinuity, it presupposes a paucity of accents enhanced by that 'field of force' we have observed in this context. The multiplication of accents and the complications of design which lead to enrichment and profusion cannot but detach the decoration from the structure and set up a rival attraction. This does not mean that, as with representation, a balance can never be struck between those conflicting demands – on the contrary, we speak of masterpieces precisely where we feel that this difficult feat has succeeded. But it is likely that the difficulty will increase with the complexity of elements to be handled and reconciled, and if this general statement is acceptable, it helps to justify not only the idea of decline, but also the conviction that styles come to an end when these developments have run their course and can go no further.

There is no intention of offering these remarks as an original contribution to the dynamics of stylistic change. They are no more than reformulations of ideas which are implicit in the whole conception of a 'logical development' with which most historians of design have operated. It should be the task of the future to turn this loose metaphor into a serviceable tool of historical analysis.

6 The Logic of Situations

The first step in such an analysis would consist of a clearing operation. We must acknowledge that it is individual people, craftsmen, designers, patrons, who are the subject of history, rather than the collectives of nations, ages, or styles, yet we must also recognize the limits of the individual and the strength of co-operative action in society and over time, for it is this aspect of human existence which entitles us to speak of evolution. The coral reef of culture was built by short-lived and weak human beings, but its growth is a fact, not a myth. Looking at any final achievement we can trace the contributions of individuals and understand both their greatness and their inevitable limits. The first child (if there ever was such a child) who cut a twig from a willow tree and made a whistle may have been a genius, but however great we may imagine him to have been, he could not have evolved the complex instrument of the organ and written Bach's organ fugues single-handed and within the span of a human life. We have a right to say that both the instrument and the music evolved step by step from small beginnings, maybe from the whistle via the pan-pipe. Whether we call this a logical development is another matter. It is logical only in the sense in which K. R. Popper speaks of the logic of situations,[28] the course of action a rational being would choose in pursuit of a particular aim. This approach offers a powerful tool for any historian of technology, for where the aim is given, the choice of means can be rational. The historian of the arts is in a less comfortable situation. The aims of art – if we can speak of such aims – may shift, and what we take to be the end-point of a logical evolution may only look this way by hindsight. The piping shepherd had no thought of church organs, and Bach's fugues would have left him cold.

It is important to face the fact that in this respect the history of figurative art differs radically from that of decorative design. In *Art and Illusion* I have tried to show 'why art has a history'. I gave psychological reasons for the fact that the rendering of nature cannot be achieved by any untutored individual, however gifted, without the support of a tradition. I found the reasons in the psychology of perception, which explains why we cannot simply 'transcribe' what we see and have to resort to methods of trial and error in the slow process of 'making and matching', 'schema and correction'. Given the aim of creating a convincing picture of reality, this is the way the arts will 'evolve'; the aim, in its turn, must depend on the function assigned to the visual arts in a particular culture such as that of ancient Greece. It should be clear even from this brief recapitulation why the logic of situations cannot yield a similar clear-cut hypothesis for the decorative arts. Both the aims and the means are more diffuse. Even so we need not give up altogether, for we have seen that

here, as in the case of pictorial styles, certain facts have been established against which we can test the tool of situational logic.

One of them was the subject of the preceding chapter (see above, pp. 223–55): the tenacity of decorative traditions exemplified in the millennial history of Western architecture and in the evolutions of the plant motifs traced in Riegl's *Stilfragen*. What these observations confirm is the psychological fact that designers will rather modify an existing motif than invent one from scratch. The difficulties in the way of a radical innovation are both psychological and social. The number of truly original minds is small and those which exist are apt to be told by the public to stick to established traditions Hence, as George Kubler, Focillon's disciple, says in his thoughtful book on *The Shape of Time*: 'The human situation admits invention only as a very difficult tour de force.'[29]

Nothing comes out of nothing. The great ornamental styles could no more have been the invention of one man, however inspired, than could the organ fugue. Anglo-Irish ornament, the arabesque or the rocaille come to mind as such typical 'end-products' of a long sequence of what Kubler calls 'linked solutions'. We have seen why it is much easier to modify, enrich or reduce a given complex configuration than to construct one in a void. Hence certain formal sequences resemble the game of cat's cradle, with every craftsman taking over the threads from the hands of his predecessor and giving them an extra twist. Though we cannot trace these evolutions in detail, we are satisfied that the development must have taken its starting point from a less complex form, such as the interlace of late antique mosaics, and reached the end points through the collective efforts of generations of craftsmen. It is sequences of this kind which are most readily described as 'logical', but they are logical only if we assume that maximal complexity was the aim from the very beginning. If we shrink from such teleological language, we have to account for the observed sequence in different terms. It would be in accord with a logic of situation to say that it is rational for human beings to want to advance in the pecking order. In most societies some kind of competition is not only permitted but encouraged. Thus patrons and craftsmen vie to 'outdo' each other for the sake of attention, prestige and fame. I have discussed elsewhere what profit the historian of fashions, trends and styles may derive from the analysis of such basic situations, what I have called 'The Logic of Vanity Fair'.[30] The point to remember here is merely that once competition has settled on one particular feature, be it expenditure, pomp or refinement, it lies within the logic of the situation that this line will be followed as long as the game is worth the candle. If intricacy becomes a 'critical issue', it is in intricacy that artists and patrons will want to 'overtop' each other. Given the right

277
Chi-Rho page from the
Book of Kells, early 9th
century. Trinity College,
Dublin

conditions and the right craftsmen, the competition may culminate in such extremes as the Book of Kells (Fig. 277). Is it only hindsight which makes us call it an extreme?

The idea that a style becomes 'exhausted' must always be somewhat suspect, for how should we know what fresh possibilities a genius might still have discovered in a given repertory of forms? It is well to remember that, while the style of interlace came to an end at the time of the Book of Kells, there is no such dramatic termination of the arabesque. To be sure it may be argued that something of the zest and vitality of earlier periods was later lost in mere routine; maybe the spirit of competition declined after driving the style to its perfection, but having reached this plateau of excellence, it may have settled into a splendid convention which is still practised in the East.

Everything speaks against the existence of all-pervasive laws which would permit us to explain any such development as an inevitable sequence of events. Even those sequences which appear to be following an internal logic can be

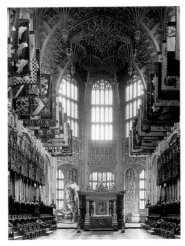
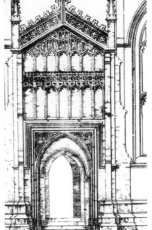

shown not to be fully determined. The course of Gothic decoration, the last phase of which was so brilliantly described by Focillon, is a case in point. In England, as is well known, the Decorated Style was succeeded by what is known as the Perpendicular Style. Focillon speaks of 'the revenge of the straight line, supplanting, with all its rigidity and purity, the capricious sinuosities of curve and counter curve'.[11] Thomas Rickman, who gave these styles their names in the early nineteenth century, has a more down to earth explanation. He writes that the Decorated Style 'was very difficult to execute, from its requiring flowing lines where straight ones were more easily combined, and at the close of the fourteenth century' (in fact before its middle) 'we find these flowing lines giving way to perpendicular and horizontal ones, the use of which continued to increase, till the arches were almost lost in a continued series of panels, which, at length, in one building – the chapel of Henry VII (Fig. 278) – covered completely both the outside and inside; and the eye, fatigued by the constant repetition of small parts, sought in vain for the bold grandeur of design which had been so nobly conspicuous in the preceding style' (Fig. 279).[12]

If we are to believe the writer and other critics, there was no escape from decadence, whichever way the Gothic designer turned. Is this mere bias or can we justify this universal feeling in terms of the logic of situations? Maybe we can, at least up to a point. We have seen that this criticism attaches to styles in which the play of forms acquires a certain autonomy, unconnected with its decorative purpose of serving as explanatory articulation. It is not hard to see how such emancipation can result from that very game of competition we have been considering. As soon as the need to trump the rival in one particular quality becomes paramount, all other purposes are forgotten or at least

278
Chapel of Henry VII,
Westminster Abbey,
London, 1503–19

279
Example of the
Perpendicular style. From
T. Rickman, *An Attempt to
Discriminate the Styles of
Architecture in England*
(London, 1836)

280
Mouldings, Divinity
Schools, Oxford, *c*.1440

neglected. Not that such emancipation need result in genuine decline. After all, we have the example of music to show how an art form transcended its social setting to create a world of its own.

Up to a point this happened even to the art of ornament, at least as soon as a medium was at hand to allow the craftsmen to exercise their ingenuity divorced from any immediate purpose. I am referring to the flood of engravings with ornamental inventions which were produced between the fifteenth and the late eighteenth centuries. Ostensibly they are meant to serve as models and patterns, but few of them could be applied consistently without modification and simplification. They are autonomous products of the artist's creative imagination.[33]

There is evidence to show that the spirit of 'outdoing' sometimes passed from the patrons to the artists. Employers had to restrain their designers for fear of bankruptcy. There is a telling example still visible in the Divinity Schools at Oxford, where we know that the master Thomas Elkyn was instructed in 1440 to dispense with the 'housings of images, casements and fillets, and other frivolous and irrelevant elaborations' initiated by his predecessor Robert Winchcombe. As a result we can still see the transition from complex mouldings and traceried panels to simpler forms (Fig. 280) – an episode for which there are any number of parallels in more recent university buildings.[34] We do not know whether Thomas Elkyn submitted meekly or under protest, but evidence from later periods confirms that it was sometimes the artists rather than the patrons who were committed to the game of 'one-upmanship'. Writing about the extension of his country seat, which he had entrusted to Lucas von Hildebrandt, Count Harrach bursts out in his correspondence: 'That accursed Jean Luca properly wallows in the grandiose ... whenever I suggest an omission or an economy Jean Luca raves like one possessed. It cannot be, it cannot be, my honour and reputation depends on it.'[35] Much of the work discussed in that correspondence is lost, but the Lower Belvedere, which Hildebrandt designed for Prince Eugene at about that period (Fig. 281) gives an idea of his ambition. There may be something in the frequent charge heard since the times of Ben Jonson that it was the architects who seduced their patrons to indulge in spending sprees they could not afford or justify.

Once more it may be in the 'logic of situations' that this urge to show off – whether on the part of the patron or of the artist – could lead to short-cut methods, cheaper materials, coarser craftsmanship, which invited the stricture of purists and accounts for the charge of decadence. Whether or not we share these misgivings, they are not entirely irrational. Nor is there any need to dismiss altogether the explanation of 'aesthetic fatigue' first proposed by

281
Lucas von Hildebrandt,
the Hall of Mirrors,
Lower Belvedere, Vienna,
c.1725

Adolf Göller; it is based on the undeniable psychological fact that the familiar tends to register less than the unfamiliar, and that the public therefore demands ever stronger stimuli.[16] The theory was rejected by Heinrich Wölfflin in his *Renaissance and Baroque* but is treated with somewhat greater respect by George Kubler. That it cannot express a universal law is obvious, for there have been great styles which changed very little. The ancient Egyptians do not seem to have tired of their decorative repertory for a very long time. It may be well to remember in this context that where ritual is concerned there is no demand for novelty. Ritualistic art rests on the strong desire for re-enactment and preservation rather than for fresh stimulation. The opposite attitude, the search for novel impressions, may only arise in more fluid situations where

competition establishes new hierarchies. Here lie the germs of that attitude which Harold Rosenberg has aptly called 'the tradition of the new'. Those caught in such a situation will look for 'originality', which means that they must implicitly compare what they see with what they have seen before. There certainly are different degrees of emphasis here, ranging from a mild interest in innovation to the impatient rejection of last year's model, and all of these attitudes may co-exist in one society. It would make sense, however, to suggest that where the demand for stimulation outruns the capital of inventiveness inflation sets in. There is such a thing as the debasement of coinage in art no less than in economics – and, as I had occasion to remark in discussing Ruskin's moral comments on Fig. 244, in neither case can the fault be laid at the door of the individual.[17]

Thus, while we must give up the search for the laws of history which could explain every stylistic change, we are still entitled to watch out for sequences and episodes which we can hope to explain in terms of the logic of situations. For though a non-deterministic account must restore to the individual artist his freedom of choice between various rational options, this choice need not therefore be random. The aims of competition on which attention has become focused at any particular moment may certainly influence his choice of a novel modification.

The movements of fashion show this selectivity in bizarre magnification. Whether the competition is in high hats, short skirts or small waists, those who join in the game must follow suit – at least for a while, till the folly reduces itself ad absurdum. There need be no such excess in design, but here, too, we can observe trends and directions in features which come to the fore while others are suppressed or neglected. How far can we identify these trends in terms of the perceptual factors analysed in Chapter V, factors such as 'repose' and 'restlessness', 'lucid' or 'blurred'?[18] The temptation is great to identify the first with Wölfflin's 'classic' or Riegl's 'tactile' as against their 'baroque' and 'optic'. But we must beware of overstatements. A configuration can be clear and asymmetrical, indistinct but flat. What remains true is that any one of these features can become dominant, a focus of interest and competition.

7 The Rococo: Mood and Movement

We certainly must not fall into the trap of reducing the artist's choice to a few alternatives. Style in art, like style in language, is rather a matter of weighted preferences. It is only where there is a choice that those who aim at a plain style will go for the short word, whereas personalities manifesting predilections favouring polysyllabic alternatives activate opposite selectivities. In practice

282
Pierre Le Pautre,
engraving of a
chimneypiece for Marly.
From the *Livre des cheminées
executées à Marly* (1699)

283
Chimneypiece from P.-J.
Mariette's edition of A. C.
d'Aviler, *Cours d'Architecture*
(Paris, 1760)

distinctions are less clear-cut than in this example. In judging a style we judge a tendency. This, I believe, is one of the factors which account for the different interpretations which have been the subject of this chapter. We may discern a tendency 'globally' without being able in any individual case to pin it down. There is no better example of this difficulty than the most detailed investigation ever made of the origin of a decorative style – Fiske Kimball's masterly book *The Creation of the Rococo*. Where a student of Wölfflin might have conjured up for us the image of 'Rococo man', the product of the dancing master and the tailor, advancing with mincing steps and an air of frivolity, the author shows us the result of his work in the archives of the French court, analysing the contributions of individual designers who continued, developed and modified the decorative schemes of their predecessors. We are enabled to trace precisely the tendency towards asymmetrical designs which marks the second generation of these masters, and learn that their source was not so much the chinoiseries which came later into fashion, as individual experiments of an earlier date. No wonder the author made short shrift of the generalizations of German art historians. His criticisms hit their mark, and yet, could it be that somewhere he failed to see the wood for the trees? Could it not be argued that the individual innovations introduced step by step have something in common, if only a revulsion from the heavy grandeur of the

earlier style? The delicate flatness of Mansart's ornaments engraved by Lepautre in 1699 (Fig. 282) may be seen to move in the same direction as the subsequent introduction of playful asymmetries by Mariette in 1735 (Fig. 283). To be sure, I am enough of a sceptic not to attribute this tendency to a new all-pervasive body-feeling, but are we not entitled to speak of such global impressions as lightness and grace? Fiske Kimball was not unaware of this general quality. He twice quoted the famous minute by Louis XIV in which the ageing monarch criticizes the choice of subjects for the palace of a young princess—*'Il me paroit qu'il y a quelque chose à changer, que les sujets sont trop sérieux et qu'il faut qu'il y ait de la jeunesse mêlée dans ce que l'on fera. Vous m'apporterez des dessins quand vous voudrez … Il faut de l'enfance répandue partout.'*[19] Referring, as it does, to the choice of subjects for paintings which were to have included such grave divinities as Minerva and Juno, the King, with his demand for 'childhood everywhere', may only have insisted on the principle of *decorum*, the fitting subject for the fitting place. Why does it produce such resonance in us as we notice the coincidence of its date, 1699, with the initiation of the new trend?

It is the theory of decorum itself which implies and demands a correlation of styles with emotive tones. For Vitruvius, as we recall (Fig. 209), Doric was robust and severe, Corinthian maidenly. I have generalized this theory in *Art and Illusion* to explain the links between formal and physiognomic qualities, drawing not on the theory of empathy, which was favoured by Wölfflin, but on the findings of Charles S. Osgood in his book *The Measurement of Meaning*, to which I referred in Chapter V.[40] They can reassure us at least that we are not talking plain nonsense when we attribute an overall physiognomic quality to a style. Fashion writers would not have needed this assurance. They know what they mean when they announce that the coming collection will have a feminine touch or an accent on severity. What is relevant to our quest in these loose global descriptions is that they characterize certain effects to be aimed at by whatever means. The unitary aim may influence the choice of colour schemes, of textures or of cuts – there is no demonstrable link between these various decisions except their desired end effect.

It is for this reason that I have declared myself a sceptic with an uneasy conscience. For if there are such global aims in styles which can be reached along different ways and in different media, the type of bias which Wölfflin described as *Formgefühl* may still be definable in psychological terms. There is even hope of making progress in the solution of what I have called Panofsky's first problem, the problem of why we can speak of Gothic painting. We all feel that a painting by Watteau aims at a similar range of feelings as does an ornamental design of his *ambiente*. Maybe there is also some affinity between a Gothic painting and its contemporary setting? To be sure, there are no laws

imposing the same aim on any artist working at a given time, just as there is
no compulsion for all to compete along the same lines. Any artist may strike
out in a different direction and may start another bandwagon rolling – or else
he may not. The sceptic remains right in insisting on the role played by
individual temperaments, talents and opportunities.

On one point in particular the sceptic must not be tempted into
concessions to the collectivists. There is no need whatever to assume that a
taste for robust effects in art must be the symptom of a robust mind, or that
conversely a bias for the light touch correlates with a lighthearted disposition.
There are any number of counter-examples which should dispose of these
facile conclusions. It was the austere, harsh and rationalist Prussian Frederick
the Great who surrounded himself at Potsdam with the most whimsical
Rococo decorations (Fig. 284). On the other hand it was the flighty Marie
Antoinette with her pastoral entertainments who inhabited the Petit Trianon
(Fig. 285), one of the first buildings in France which showed the influence of
neo-classicism.

I have argued elsewhere that this absence of correlations would have to be
expected if we replaced the Hegelian idea of a spirit of the age by the more
concrete notion of movements.[41] Movements may be started by individuals
who find followers among whom a strong sense of identity develops.
Sometimes they want to distinguish themselves from others in their dress,
deportment and preferences. Sometimes they may even adopt a style as their
badge.

I have suggested that for a time, at least, the Renaissance was such a

movement and that a building *all'antica* could proclaim the patron's adherence
to its ideals. It could, but it need not. Inertia or lack of funds may have kept
many a friend of the humanists in Gothic surroundings, conformism and
fashion may have made a prince adopt the new style even though his outlook
was thoroughly medieval. It would be the task of a future sociology of art to
establish when and under what circumstances a style, a family of forms, was
adopted as a badge. We must agree with Fiske Kimball that the Rococo was
not associated with a movement. On his own showing, however, the reaction
against the Rococo was. We have seen in the first chapter[42] that it drew some
of its arguments from the general ideals of the Enlightenment, the worship of
Nature, the cult of Reason and the authority of the ancients. The political and
cultural prestige of England, as Fiske Kimball has rightly stressed, also played
its part in discrediting a fashion which had never been fully accepted by the
British.

These and similar facts may suffice to explain why my troubled conscience
has not led me to abandon my sceptical convictions. Maybe it is only *post
factum,* by a process of hindsight, that styles can come to express the spirit of
an age—an age which has acquired the quality of a myth.[43] It was in this way
that the nineteenth century used the historical styles of Gothic and
Renaissance as symbols to proclaim political and ideological allegiances. A.

286
Contrasted royal chapels.
From A. W. N. Pugin,
*Contrasts, or a Parallel between
the Noble Edifices of the
Fourteenth and Fifteenth
Centuries and Similar
Buildings of the Present Day*
(London, 1836)

W. Pugin articulated this opposition in his *Contrasts or A Parallel between the Noble Edifices of the Fourteenth and Fifteenth Centuries and Similar Buildings of the Present Day* (1836) (Fig. 286). Henceforward the Gothic style was firmly identified with the Age of Faith and its ideals. Churches and colleges were conventionally built in that guise while the advocates of progress and secularism preferred the Renaissance style. The subject as such lies beyond the scope of this book, but we must turn to the general role of symbolic meaning in design.

Editor's Postscript

In this chapter from The Sense of Order *Gombrich examines style from the spectator's point of view. Riegl, once more, offers a starting point: if family resemblances may be seen across a range of artefacts what is the logic governing their connection? Play with figure and ground relationships, for example, doesn't characterize just the one moment of artistic development in late antiquity; it can be found scattered across a variety of styles. This would upset Riegl's theory of the indissoluble unity of stylistic development.*

If Gombrich's theory of physiognomic perception had explained historians' willingness to find SuperMinds behind the styles of the past, it could also be used to explain the perceived unity of styles. Our recognition of a friend depends upon the perceived unity of his appearance, and the acquisition of a beard or the loss of a favourite hat swiftly becomes incorporated in one's image of the person. For Gombrich's ideas on physiognomic perception see 'On Physiognomic Perception' and 'Art and Scholarship', reprinted in Meditations on a Hobby Horse.

In this chapter, Gombrich also introduces the theme of 'purity and decadence'. Associated articles and papers are: 'Visual Metaphors of Value in Art' and 'Psychoanalysis and the History

of Art', in Meditations on a Hobby Horse; his Listener articles on primitivism, reprinted in this volume (pp. 295–330), and 'The Logic of Vanity Fair', in Ideals and Idols. Also related are: 'Norm and Form: The Stylistic Categories of Art History and their Origins in Renaissance Ideals' and 'Mannerism: The Historiographic background', both in Norm and Form. Which leads into the topic of 'style', for which see: 'Style' in the International Encyclopedia of the Social Sciences (New York, 1968) and Styles of Art and Styles of Life (The Reynolds Lecture, London, 1991). For 'style' seen through the logic of the situation see, besides the articles mentioned in the footnotes to this extract, the essays generally in Norm and Form, Architecture and Rhetoric in Giulio Romano's Palazzo del Tè (below, pp. 401–10), From the Revival of Letters to the Reform of the Arts (below, pp. 411–35), 'In Search of Cultural History', 'The Leaven of Criticism in Renaissance Art: Texts and Episodes' in The Heritage of Apelles and 'Patrons and Painters in Baroque Italy', 'The Whirligig of Taste' and 'A Theory of Modern Art' in Reflections on the History of Art.

A classic essay on style is Meyer Schapiro's 'Style' in A. L. Kroeber (ed.), Anthropology Today (Chicago, 1953). And a fascinating book tracking the art historiography of the Gothic style is Paul Frankl, The Gothic: Literary Sources and Interpretations through Eight Centuries (Princeton, 1960), on which see Norm and Form, p. 88.

For Riegl, see now Margaret Olin, Forms of Representation in Alois Riegl's Theory of Art (Pennsylvania, 1992), and for Worringer see Neil H. Donahue (ed.), Invisible Cathedrals: The Expressionist Art History of Wilhelm Worringer (Pennsylvania, 1995).

Part VI Primitivism and the Primitive

The Primitive and its Value in Art

Four talks broadcast on
BBC Radio 3 in 1979, and
published in *The Listener*,
15 February, pp. 242–5;
22 February, pp. 279–81;
1 March, pp. 311–14;
8 March, pp. 347–50

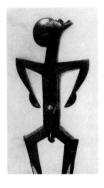

287
Jacob Epstein, *Cursed be the
Day Whereon I was Born*,
1913–14. Plaster and wood,
painted red. Location
unknown, probably
destroyed

1 *The Dread of Corruption*

The idea of the 'primitive' in art or in civilization has become increasingly problematic to this century since we have lost the faith in the superiority of our own culture. Art historians, in particular, have long withdrawn to a position of safety in these matters. They consider it more scientific to classify and label the heritage of the past without pronouncing judgement. But neither artists nor art collectors have shared this detached attitude. The more sophisticated they were, the more they preferred the values of primitive art.

This bias is usually connected with the birth of the modern movement in the turbulent years before the First World War, when Pablo Picasso suddenly threw overboard all the skill and refinement which had informed his masterpieces of the 'blue' period. It was in 1907 that he first took to carving crude images on the model of primitive idols and started on a voyage of exploration to the distant shores of tribal art. He was followed as early as 1912 or 1913 by Jacob Epstein, whose expressive carving, *Cursed be the Day Whereon I was Born* (Fig. 287), so closely resembles the conventions of the African sculpture he collected and admired, though, like Picasso, he continued throughout his life to display his virtuosity in portraits and images of a naturalistic idiom.

It is precisely the point that many of the possessors of supreme formal mastery have been most attracted by such voyages in space and time. Think of Henry Moore, whose keen awareness of tradition has prompted him to grope in his works for the aura of mystery that surrounds the strange and weathered idols of a lost world.

Meanwhile, the discovery of naïve painters such as the Douanier Rousseau led to a search for talents outside the formal disciplines of the art school; and, following that quest, the Hungarian photographer, Brassai, recorded the traces of the primitive in the rude graffiti on the walls of our big cities, while the painter Dubuffet adopted their idiom in his highly priced paintings. Needless to say, this only means that Dubuffet is a much more sophisticated purveyor of images than, say, the designers of alluring picture postcards or chocolate-boxes, with their smiling goldilocks or their mouthwatering cherries.

Indeed, this awareness of the essentially unprimitive nature of esoteric primitivism in art has worried some artists and critics of the last few decades who want art to escape from the esoteric world of the élite and find fresh contact with the images which the masses appear to prefer. I am thinking of the movement called 'pop art', which went in search of models in the urban folk art of the comic strip or the hamburger stand.

I hope that even these few examples have convinced you that we are in need of clarifying these issues. It so happens that I have also a personal reason for wanting to raise them again. I have tried in two books to describe the development of pictorial styles, first in *The Story of Art*, and then in a more theoretical framework in *Art and Illusion*. It was almost inevitable that the attention I paid in these books to representational skills such as the rendering of space, of light and shade, of the human body or the facial expression caused a certain uneasiness among my friends and critics.

What have these skills to do with art? Were those picture postcards and chocolate-boxes the crowning achievements towards which the centuries had been driving? Of course they were not. Technical skill in art, like any other skill, can be used or abused. But for this very reason, I would venture the paradox that for the historian, as distinct from the critic of art, the chocolate-box is one of the most significant products of our age, precisely because of its role as a catalyst. I believe that we cannot hope to understand the course taken by art in more recent times if we fail to appreciate the holy terror of what was called chocolate-boxy, kitsch or saccharine. The desire to get away from the cheap, the tainted, the corrupt has been one of the prime motive forces of artistic developments, and not only in this century. And it was this desire that led to the adoption of the term 'primitive' as a term, not of condescension, but of admiration.

We know the place and the year, almost the day, when the word 'primitive' was launched as a word of praise in the world of art.' It happened in Paris in 1797 in the atelier of Jacques-Louis David. David's pupil, Delécluze, who was present, vividly described many years later how his master at that time was full

of ideas for his new painting of *The Intervention of the Sabine Women* (Fig. 288). His earlier works, such as the *Brutus* of 1789, he confessed to his pupils, had still traces of Roman influence, but now he wanted to model himself exclusively on the purity of Greek art.

He must have raised the hopes of his followers too high, for when the pupils were at last allowed to see the painting their hearts sank. Maybe some of them had studied the latest archaeological publications of Greek vases to greater purpose than their busy master. They granted that his intentions were good, but, to quote Delécluze, 'You find in it no grandeur, no simplicity, in short, nothing "primitive"' – that was at the time the word to conjure with, *le grand mot*, which had been applied to Greek vase paintings.

David's heretic pupils held a meeting and, in three dismissive words, declared him to be 'Vanloo, Pompadour, Rococo'. It is the first time, too, that we hear the word 'rococo', a term of ridicule and abuse for the frivolous fashion fostered by the meretricious Pompadour under whose auspices, by the way, the painter Carle Vanloo had been head of the *Académie*.

Poor David! He had tried so hard to be severe and classical, but primitivism is a draught which asks for more. 'One is always somebody's reactionary', as Clemenceau once said in a different context. David found himself outclassed by a generation who wanted to go much further in the direction of severity, and who lumped him together with the very style which he had taught them to regard as corrupt.

Delécluze has left us a moving literary portrait of Maurice Quai, the young rebel who became the leader of the sect of *Les Primitifs* or *Les Penseurs*, but who was destined to die before he ever completed any of the great works of which he dreamt. Dressed as Agamemnon, with long flowing beard, Maurice Quai venerated Homer, the Bible and, above all, Ossian, for Ossian was the most *primitif* of them all. As for Euripides, he was just 'Vanloo, Pompadour, Rococo'! The only works of art Maurice Quai acknowledged were the earliest Greek vase paintings, statues and reliefs. Anything done after Phidias was to him mannered, false, theatrical, abominable and ignoble. The picture gallery of the Louvre should really be burned.

With his radicalism, Maurice combined an intense personal piety which may have endeared the word 'primitive' to him even more, since the return to primitive Christianity must have appealed to a young man who specially loved the story from the Gospels when Christ blessed the little children.

It is important to see his revolt in an even wider perspective, for it is clear that his passionate rejection of the arts after Phidias and his desire to burn down the Louvre stemmed from a conviction that the increase in technical skill had led art to perdition. Virtuosity had tempted art to adopt the seductive wiles of a Pompadour – in other words, to lose its innocence.

There will be few art lovers today who would feel quite unable to share some at least of this reaction. Walking through a collection of ancient statuary, we are all more likely to pass by the virtuoso pieces of Hellenistic sculpture and to stop in front of some archaic torso. The Greek critics who first chronicled the rise of sculpture would have found here only the first stirrings of mimesis, the imitation of nature in which they saw the aim of art. They saw the progress in the rendering of the human figure exemplified in the change from the rigid kouroi of the sixth century to the classical poise of Polyclitus, and on to the grace and ease of Praxiteles and the naturalism of Lysippus in the fourth century. Why do we experience a certain reluctance in accepting their interpretation?

Surely because we have come to love the earlier phases and would not want them to be different. They stand like landmarks in the panorama of history, and we would no more like to see them changed than we would want to alter the outlines of the Mont Cervin. It is a good reason and one with which I should not want to quarrel. It is only when we try to mobilize arguments in favour of our preferences that we become aware of the complexities of these issues which Maurice Quai so bravely ignored. I believe that all these arguments were rehearsed in classical antiquity, though not so much by the critics of sculpture and painting as by writers about that art which meant most to the ancients, the art or rhetoric, of oratory. It is here, first of all, that we find

the roots of Quai's identification of skill with corruption which I would like to call the moral argument.

From Plato onwards, critics have been increasingly concerned with the possibility that skills might be abused. Living in this self-questioning and technological age, we can understand this suspicion of progress only too well. Plato resisted or resented the power of all art to pander to the lower faculties of the soul. He looked back to the ritualistic immobility of Egyptian music, liturgy and art; but the main cause of his concern was the increasing skill of the sophists in swaying the emotions of the crowd. It was they who had corrupted the honesty of argument by introducing illicit effects that should flatter the ear with jingling euphonies, rather than persuade reason with sound evidence.

The arch-corrupter, to Plato, was Gorgias, and it was from him that the school of oratory derived that became known as the Asiatic school. Asianism, hence, became the stock example of moral corruption and of the prostitution of speech.

I cannot judge the validity of this accusation against the sophists; I am only concerned with it as one of the possible reactions to the progress of skill. If the skill of persuasion can be used for seduction, one can understand the nostalgia for a period where this skill was unknown and where artists were still innocent of such evil tricks.

In their classic book on *Primitivism and Related Ideas*,[2] Arthur Lovejoy and George Boas have profoundly and wittily distinguished what they call 'hard primitivism' from 'soft primitivism'; the dream of the Golden Age of Innocence standing for the soft, and the vision of hard and rugged heroes for the hard kind.

Both forms, of course, are reactions to what Freud calls the discontents of civilization. Whenever our guilt feelings accuse us of being spoilt and effeminate, we idealize a primitive state of hard virility. If our conscience keeps before our mind the sins of lust and venality of which our society is guilty, we take refuge in the image of an age of childlike and noble innocence. It may well be one of the secrets of the appeal of primitive styles that here the two interpretations are not experienced as mutually exclusive. Hard or soft, robust or delicate, the art that does not know any tricks is at any rate honest.

Now that question of honesty in art that looks so simple is really one of the most elusive of all. But luckily, I need not tackle it now if I merely want to come closer to a psychological understanding of this fear of corruption in 'art' – as distinct from 'oratory'. For if you scan the critical literature, you will find that honesty and innocence are frequently contrasted with one particular trick of seduction, the sensual appeal of erotic art. What else, after all, lies behind

Quai's charge of 'Pompadour', than this form of meretriciousness so characteristic of the age of Boucher and Fragonard? Now this kind of seduction certainly stands in need of technical mastery. It was the proud boast of the cult statue of Aphrodite, made by Praxiteles for the temple of Cnidos, that the image of the goddess aroused desire in all who beheld it. Here the power of art was still in the service of religion, but the possibilities opened up by this skill account for some of the most violent denunciations of the dangers of corruption. It is here, also, that the difference between use and abuse, chaste beauty and meretricious sweetness, is balanced on a knife-edge.

I do not want to give the impression that erotic seduction is the only form of corruption to which artistic skills were seen to be prone. I have put it first mainly because, even in this century of Freud, it is a strangely unacknowledged subject. Moreover, the development of means to create images of seductive beauty tends to fuse with the second argument in favour of primitivism, to which I must now turn.

If Plato can be called the originator of the moral condemnation of corruption, it is in his pupil Aristotle that we find the model of the organic metaphor, in which the development of any art is identified with the life cycle of an organism from youth to maturity and then declining to death.

Our model of human progress has tended to be furnished by science and technology. We need only remember science fiction to see that here progress is visualized as infinitely extendable. The ancient, and particularly the Aristotelian, model was that of organic growth. The oak progresses from the acorn to the mature tree by transforming its potentialities into actuality. Greek drama, according to Aristotle, developed in this way from the rude shows of Thespis to the masterpieces of Sophocles and Euripides. 'Little by little', he said, 'tragedy grew as people developed whatever of it came to light, and, going through many transformations, came to rest when it had attained its own nature.'

There is no doubt that Aristotle would have said the same of sculpture and painting. If their essential nature was the imitation of beautiful things, for instance, they had to progress till they had attained that skill. Any further change would then automatically be corruption, since it would lead away from that true nature.

It is well known that it was Vasari, two thousand years later, who applied the organic metaphor to the rebirth of the arts; he applied it to that repetition of the gamut of skills that occurred between the thirteenth and the sixteenth century. Vasari saw this in phases – from the rude Byzantine manner to the awakening of art in Cimabue and Giotto; hence to the conquest of reality by Masaccio in the Quattrocento, and, finally, of beauty by the third and

perfect manner of which Raphael offered a prime example.

It is this Aristotelian conception also that makes us speak of the 'evolution' or the development of an art, and within this context, the term 'primitive' will apply to the early phase of the process. But here it will not mean uncorrupted so much as undeveloped. Yet the difference is not as radical as it may sound; for within the life cycle, the first or primitive phase leads upwards towards the perfection of maturity, while maturity itself is bound to decline into old age and decay. Hence the primitive can be equated with youth or with spring, while the last phase will strike us as autumnal or decadent.

Like the Platonic theory of corruption, the Aristotelian image of the organic growth of an art is capable of a perfectly rational interpretation. Why should not some human activity attain an optimum through a long process of trial and error? I am not a chess player, for instance, but I could well imagine that those who are find the game perfect in its present set of rules; they would neither like to go back to earlier forms nor complicate the rules further. The theory of limited progress to beauty, in other words, need not be false just because the organic metaphor is only a metaphor. It may well be argued that the ideal of human beauty is much less subject to change than it is sometimes alleged. After all, it is grounded on our biological response to youth and health, and those critics of the academic persuasion who urged the artist to study the Apollo Belvedere or the Capitoline Venus to learn their secret need not have been all that misguided.

What is misguided, to my mind, is only the simplistic assumption that the life cycle of an art must directly reflect the life cycle of the human spirit. We must not yield to the temptation of imagining archaic Greece populated by solemn kouroi and delicate korai, the age of Pericles by living replicas of the youths and maidens of the Parthenon frieze growing progressively more relaxed and sensuous as time marched on.

I once described this temptation as that of the physiognomic fallacy, and if you keep your eyes open, you will find its influence in many writings on the arts of the past. How often, for instance, has the art of the Italian Quattrocento been celebrated as virginal and spring-like, as if the gawkish beauty of Botticelli's young girls could be identified with the mentality of the fifteenth-century Florentines, while sixteenth-century Venice is visualized as an age of ripe and seductive forms embodied in the reclining Venuses by Titian.

Nobody who has accustomed himself to dissecting his own and other people's reactions to art will underrate the compulsive force of this interpretation. All forms have a physiognomy, all styles elicit an emotional response. The impassive grandeur of Egyptian sculpture, the solemnity of

Byzantine icons, the hieratic stillness of Romanesque porches, the delicacy of Gothic fretwork, how else can we see them but in terms of our response to forms? There is no need to suppress this response any more than there is to avoid the so-called pathetic fallacy in our commerce with nature, reading joy into the song of birds and melancholy into the drooping branches of a weeping willow. But we do not psychologize birds and willows, and we should beware of equating families of forms with types of mentality.

Here also our reaction to the changing forms of language offers an instructive parallel. The modes of expression used in old texts and documents tend to strike us as more weighty, more sublime than the apparent ease of the current vernacular. Naturally this impression was not lost on those subtle analysers of our emotional reactions to forms and sounds, the ancient orators. Asianism, for instance, was alleged to attempt the sublime in oratory but to produce merely bombast, precisely because it relied on artifice.

The true sublime, in the immortal phrase of Longinus, is the ring of the noble soul, and this natural nobility was, he thought, the property of the early and uncorrupted ages.[3] Longinus gives as an example of that elusive but all-important power of utterance God's words of the first book of Genesis, 'Let there be light, and there was light.'

Quintilian's characterization of the early Roman poet, Ennius, sums up and anticipates a whole category of critical appraisals: 'Let us worship Ennius', said Quintilian, 'as we do sacred groves hallowed by age, where the grand old oak trees are not perhaps as beautiful as they are awe-inspiring.'[4]

I have contrasted this reaction to venerable age with the interpretation of early stages as young, but such contrasts are too logical to be true to our real experience. It is the privilege of early art that it is not only both heroic and idyllic, but also both old and venerable, young and endearing.

It was Cicero who first rebelled against the tacit assumptions underlying all the interpretations of the primitive I have discussed so far. He had every reason to be critical of them, since the preference for uncorrupted sublimity threatened his very position as Rome's foremost orator. Having spent his life in polishing and perfecting the beauty of pure Latinity, he found the very beauty of his famous cadences an obstacle to their appreciation. His memorable defence before the court of posterity shows the great lawyer at his most subtle. One of his arguments is that the classicism of his opponents who called themselves Atticists was really a primitivism in disguise. He recognizes the power of primitive modes as just one stop on the grand organ of speech, but he will not have it restricted to this narrow range. Most of all, he wished to dispose of the moral argument in favour of earlier styles. Far from accepting the physiognomic fallacy, he looks for an alternative to account for

the undeniable appeal of rugged simplicity. He finds it in the psychology of the educated public:

> It is difficult to say for what reason the very things that move our senses most to pleasure, and appeal to them most speedily at first, are the ones from which we are most quickly estranged by a kind of disgust and surfeit. How much more brilliant, as a rule, in beauty and variety of colouring are new pictures compared to old ones. But though they captivate us at first sight, the pleasure does not last, while the very roughness and primitiveness of old painting maintain their hold on us. In singing, how much softer and more delicate are glides and trills than firm and severe notes. But not only people of austere taste but often even the crowd protest if such effects are too much repeated. The same is true of the other senses. We enjoy ointments prepared with an extremely sweet and penetrating scent less long than those that are subdued, and even the sense of touch wants only a certain degree of softness and lightness. Taste is the most pleasure-loving of the senses and more easily attracted by sweetness than the others, yet how quickly it rejects and dislikes anything sweet ... Thus, in all things, disgust borders immediately upon pleasure.[5]

As you see, Cicero brushes aside the theories I have been considering so far to replace them by a theory of response. Some people get tired of beauty, and it is this moment of fatigue that makes them open to alternatives such as the rough sublimity of early art. The sin, as it were, is not in the harmonies themselves, it is the beholder's sophistication that makes him reject an overdose of skill.

There is no doubt that when Cicero speaks of the preference for archaic paintings – and he does so more than once – he speaks from experience. His hints are reinforced by Quintilian, who also mentions people who prefer the first beginnings of the art of painting to its later perfection, though Quintilian dismisses this as snobbery and affectation, a kind of one-upmanship of connoisseurs who want to impress others.[6] They do it *intelligendi ambitu*, to show off their understanding – another subjective interpretation and not always a wrong one. That Roman collectors did, in fact, enjoy the remote charm of archaic art is amply shown by the copies and adaptations of these motifs that have come down to us. They confirm what Cicero suggests, that where the gamut of skill goes in one direction, the movement of taste may tend the opposite way.

At the same time, his analysis of sophistication raises a warning against any unreflective acceptance of the earlier three interpretations, the moral, the organic and the physiognomic. Not that this disposes of the problem of

corruption or debases the primitive to appear the mere by-product of a jaded palate. On the contrary, in a curious and paradoxical sense, Cicero's argument clears the ages where this reaction occurs from the charge of decadence and moral decay.

Would they have longed with such passion for the paradise of a lost innocence and the vigour of a bygone simplicity if they had, indeed, been devoid of moral standards? A sensitive conscience is usually not the sign of moral depravation. And it is this uneasy conscience, this feeling of discontent, that fuses the various responses to the history of styles into one living metaphor in the fire of love and of hate. Indeed, if we turn again to the historical sources of our modern preferences for the primitive, we shall find them all stirred together in one heady brew.

2 The Turn of the Tide

In my first talk, I described how the term 'primitive' became a vogue word of praise towards the end of the eighteenth century. It was a word much bandied about among the radical students of the neo-classical painter, Jacques-Louis David, who were obsessed with the dangers of corruption in art. I also tried to show that the dread of these dangers could be traced back to the most influential thinkers of classical antiquity, to Plato and Aristotle. Plato had warned his disciples against the lure of an oratory that flattered the ear and numbed the reasoning faculties; Aristotle had taken it for granted that the human arts evolved from primitive stages towards perfection from which they could deviate only at the risk of declining. No wonder the official doctrines of the academies of art in the seventeenth and eighteenth centuries stressed the need for the pupil to keep to the straight and narrow path blazed by the embodiments of perfection, the ancients or Raphael, and not to indulge the vulgar mob who merely looked for sensuous pleasures.

But the sermons of high-minded critics such as Giovanni Bellori in the seventeenth century, who preached a return to the ideals of Raphael and condemned the naturalism of Caravaggio, can hardly be said to have changed the course of art or influenced public taste. It was only when the whole progress of civilization was put in question, and the age and the culture of the age accused of being corrupted and corrupting, that the public conscience was aroused. I am, of course, alluding to the effect created in the whole of Europe by the writings of Jean Jacques Rousseau. It has been stressed, and rightly so, that Rousseau's famous call for a return to nature should not be interpreted as out-and-out primitivism.[7] Voltaire's jest of inviting Rousseau to graze on his estate was a deliberate travesty. Like Aristotle, Rousseau did not deny the reality of human progress, but, unlike him, he focused attention on

the danger of decline from health to effeminacy, from virtue to debauchery.

The noble savage, that figment of eighteenth-century imagination, was noble because he had not been spoilt by the luxuries of civilized Europe. Without Rousseau, there would have been no young radicals like Maurice Quai to exalt the superiority of everything '*primitif*' over the arts of later periods. Nor would Quai have been likely to condemn all the arts after Phidias as 'Pompadour, Rococo, Vanloo', if it had not been for that other great prophet of the eighteenth century, Johann Joachim Winckelmann.

It is likely that Winckelmann had read Rousseau when he issued his first manifesto, in the mid-1750s, against the corruption of taste in his time, and urged a return to the pure fountainhead of Greek art. Shaftesbury, Winckelmann's other mentor, had warned his English readers against everything that is 'gaudy, luscious and of a false taste'.[8] But what made Winckelmann's appeal to the Greeks so much more compelling was his adoption of what, in my first talk, I called the physiognomic approach. The calm grandeur and noble simplicity which he found to be the hallmark of great Greek art of the best period was, to him, the direct revelation of the Greek soul in all its nobility and restraint.

In poetic prose unequalled in writings on art before his time, Winckelmann exalted the ideal beauty of Greek sculpture – sculpture which, at first, he knew only from plaster casts and, after his move to Rome, from Roman copies, such as Apollo Belvedere or the Niobe. For him, the appeal of these noble heads was a moral appeal; they were symbols of a loftier form of existence. Strictly speaking, perhaps, he valued them as much for what they were not, as for what they were. They were not touched by those corrupting influences which tempted the artist on the path of outward show and cheap effects. In modern times, Bernini had been the arch-corrupter; no doubt the Greeks, too, had had their Bernini who had brought the glories of ancient art to an end.

Winckelmann was too anxious to lavish praise on classical art to dwell at length on any monuments showing such symptoms of decline or debasement. But reading between the lines, one can well understand how his account of the history of Greek art, which was published in 1764, implicitly favoured the period of Phidias rather than the more sensuous, insinuating style of the subsequent centuries. In particular, it was he who drew attention to the beauty of Greek vase painting, which he took to be Etruscan and which he admired in particular for its clean and disciplined outlines.

Indeed, no trick of style fell more quickly under the suspicion of corrupt meretriciousness than the pride of the virtuoso painter in the bravura of his brushwork. What could be more dishonest than the smudging of outlines, leaving the beholder to guess where the figure ended and the background

began? You will remember that the severity of style which David's pupils missed in his painting of the Sabine women was that of Greek vases — vases they called 'primitive'. It was an ideal of purity which was to be popularized all over Europe by Flaxman, whose rejection of blurred lines was passionately shared by William Blake.

It is only an apparent paradox that Winckelmann's extreme brand of neoclassicism also helped to pave the way for a new appreciation of Gothic art, which had, heretofore, been considered barbaric. In a way, Winckelmann had been hoisted with his own petard. If it was true that Greek art reflected the unique grandeur of the Greek soul, it was, after all, futile to ask other nations to follow this ideal. It was the German critic and polymath, Johann Gottfried Von Herder, who drew attention to these consequences. What about the German soul? Did it have no authentic expression in the great poetry of the Middle Ages? Was it not less corrupt than the modish effeminacy that governed the elegant Parisians?

We still tend to regard Classicism and Romanticism as two contrasting movements, but in this obsession with the corruption of the age, they were really one. Goethe, in his Strasbourg period in 1772 where he had fallen under the spell of Herder and had discarded the rococo taste of his Frankfurt home and his years in Leipzig, denouncing the fashionable painters of his time, wrote:

> How I hate those painted dolls of our masters ... They have caught the eyes of the women-folk with their theatrical poses, their made-up tints and their gaudy dresses. Honest Albrecht Dürer, whom our moderns mock, the most wooden of your figures is dearer to me![9]

But Goethe went even farther in his rejection of Rococo culture and ideals. The occasion of his enthusiasm was the Gothic minster of Strasbourg, and he wanted to demolish all prejudices that stood in the way of its appreciation. If the soft doctrines of modern beauty-mongers had spoilt their enjoyment of the significantly rugged, they would have to learn that art is long creative before it is beautiful. It is nonsense, Goethe said, to speak of an instinct for 'beauty' in man; his instinct is for 'creation'.

> In this way, the savage moulds his coconuts, his feathers or his body with terrifying shapes and loud colours ... and let this art consist of the most arbitrary combinations, it will harmonize without any system of proportions, for one emotion welded all the elements into one significant whole. It is this significant art that is the only true one.

It is no accident, of course, that this astonishing challenge was thrown out in an essay which the young Goethe wrote under the inspiration of Herder. Herder's enthusiasm for folksongs and the relics of ancient poetry which owed so much to British examples, to Percy and Ossian no less than to the theories of Vico, swept aside the standards of classicism in poetry. Poetry, after all, was the primordial language of mankind, and all peoples revealed their soul in song. Seen against this background, the historian's problem is less how the taste for primitive art arose, than why its acceptance was delayed till the twentieth century.

I hope to show in my next talk that this delay applied only to representational art — not to design and pattern. In the rendering of the figure, fidelity to nature counted for too much to permit any aesthetic response to distorted images of the human form. And so we have the curious paradox that the word 'primitive', or, at any rate, 'les primitifs', came to be applied as praise, not to the very beginnings of Italian painting, but to fifteenth-century artists such as Fra Angelico, Francesco Francia, or Perugino. These masters were felt to have progressed far enough in skill to represent plausible human figures but had not yet been spoilt by meretricious virtuosity.

It is worth pointing out that this kind of primitivism does not rest on a rejection of the organic theory, the theory that art gradually ripens into perfection, but on its acceptance. After all, it is only in relation to Vasari's version of the organic growth of art that the painters of the fifteenth century can be called more primitive than those of the sixteenth. And so Vasari, the proud court painter of the grand dukes of Tuscany, became a kind of breviary for the new devotions. In 1797, the German Romantic, Wackenroder, published his notorious *Outpourings from the Heart of an Art-loving Monk*. In it, he revamped a few stories from Vasari in a gushing style. Raphael is still at the pinnacle where Vasari had put him, but the earlier generations, Francesco Francia, Perugino and, of course, Fra Angelico, get their share of admiration.[10]

It may surprise those who accuse Vasari of a shallow progressivism that he could thus provide the main source for the Romantic revivalists, but, on reflection, this is quite natural. The academic creed had ignored the primitives as mere stages of transition, to be discarded when beauty had been discovered. Vasari had not been so narrow. He recorded the lives and habits of these earlier masters, masters who, in his view, had led the arts to the heights, with a love and admiration that was much more laudatory and understanding than anything the Romantics could find elsewhere. Moreover, he told the history of art in human terms. He described the piety of Fra Angelico, the simple habits of Donatello, the escapades of Filippo Lippi, and the oddities of Piero

di Cosimo. He presented the picture of an environment where art was still practised as an honest craft. Most of his story lies technically still within the Middle Ages, the age of faith.

It was a happy circumstance that Vasari's high point, what he called the third or perfect style, almost coincided with the technical end of the Middle Ages, the discovery of America in 1492. Leonardo was then forty, Michelangelo seventeen and Raphael eight. Thus, the whole Modern Age could take on its new role of the corrupter of the arts for which it had been cast by romantics from Plato onwards. For this was a new version of Plato's tale of corruption. The corrupter was not skill, not even sin, but reason itself. This is the message of Chateaubriand's influential book, *Le Génie du Christianisme*, that came out in 1802. 'Painting, architecture, poetry and oratory', he claimed, 'have always degenerated in philosophical ages, for the reasoning spirit destroys the imagination and saps the foundations of the fine arts.'[11]

It was at that time, in the early 1800s, that the German Romantic poet and critic, Friedrich Schlegel, came to Paris to learn Sanskrit, and it was here that he wrote an essay that gave new substance and intellectual stamina to the vapid enthusiasm of Wackenroder. The essays on paintings which he published in his journal, *Europa*, are perhaps the first in which the doctrine of corruption is extended even to those academic masters like Guido Reni who had, so far, been considered the main bulwark against decline. Schlegel admits that the frigid grace of Guido Reni and the shiny rose-and-milk flesh tints of Domenichino do not appeal to him. It is the calm, sweet beauty of late Quattrocento masters such as Giovanni Bellini or Perugino which he exalts.[12] The stage is now set for the rejection of Vasari's canon, and the dethronement of Raphael, the demi-god of the academics, for it was Raphael who could be blamed for having departed, in his later style, from the chaste beauty of his teacher, Perugino, and having prepared the way — however unwittingly — for the frigid beauty of a Guido Reni.

This is the decisive turn of the tide, also, which was to lead within a generation to the programmatic name of the Pre-Raphaelite Brotherhood; they were inspired, in their turn, by the German Romantic painters who banded together in the early decades of the nineteenth century and adopted the name of the Nazarenes. We have seen that this reaction reaches much farther back. Only, where Winckelmann had preached the noble simplicity of the ancients, the new medievalizers were captivated by what they saw as the devout simplicity of the age of faith.

One of the earliest documents of this change of heart is a letter written by the German painter, Franz Pforr, in March 1810, in which he recounts his conversion to the older style of art — a conversion which he experienced in the

Vienna Gallery early in 1808.[13] The masters of the high Renaissance, Titian, Tintoretto, Veronese or Correggio, he discovered, often concealed their cold hearts behind bold brushstrokes and fine colours; worse still, they seemed to aim at the arousal of sensual emotions. In contrast, the early Italian and German masters, with their chaste simplicity, spoke loudly to these young art students. 'Brushstrokes, after all, are only necessary evils and should not divert the beholder's attention from the subject-matter.'

One would like to know by what underground channels these sentiments of Franz Pforr's came to correspond so closely to those expressed by William Blake in the descriptive catalogue of his exhibition in May 1809:

> Clearness and precision have been the chief objects in painting these pictures. The Venetian and Flemish practice is broken lines, broken masses, and broken colours. Mr Blake's practice is unbroken lines, unbroken masses, and unbroken colours. Their art is to lose form, his art is to find form and keep it.[14]

Blake's polemics are principally directed against Stothard, whom he accused of having plagiarized his project of the Canterbury Pilgrims, but, strangely enough, Stothard himself prefaced his own version of the theme by a letter from Hoppner, of 1807, commending its 'primitive simplicity' and total absence of all affectation.[15]

It is only four years later that we read the first comment on similar ideals among the German artists in Rome, who, wrote Count Üxküll,

> have renounced the advantages of oil painting and paint in the manner of watercolours. They have sharp, clear outlines and they deliberately reject aerial and linear perspective because the ancient masters did not have them either. Their colours are often loud and their figures frequently flat. Consistently, therefore, they consider that even Raphael's way of painting after he had abandoned the manner of his teacher, Perugino, was an aberration of that great man.[16]

It is interesting and, perhaps, a little disappointing to turn from these programmatic descriptions to the actual works of these painters (Fig. 289), which often strike one as a mere pastiche of motifs from German and Italian painting of around 1500. Moreover, we, in our time, have become used to very much greater doses of primitivism, and so these first efforts to rectify the fatal step that Raphael had taken will inevitably strike us as tame and timid. But we must not allow our impatience with the Nazarenes or even our eagerness to get to Gauguin, to miss their problem. Their concern was still with the morals

289
Johann Friedrich
Overbeck, *Self-portrait with
his Wife and Son*, 1820–2.
Museum für Kunst und
Kulturgeschichte der
Hansestadt Lübeck

290
Angel on a medieval
Venetian tomb. From
John Ruskin, *Seven Lectures
on the Elements of Sculpture
given before the University of
Oxford*, Michaelmas Term,
1870

of art, with the avoidance of certain sins, like that of smudging, for example.

In our histories of art, the Nazarenes figure as an abortive movement anticipating the Pre-Raphaelites, who petered out, in their turn. But this version of the history of nineteenth-century art overlooks the enormous production of neo-Gothic devotional art which transformed and possibly ruined a vast majority of church interiors in Europe. These stereotyped, well-groomed saints, with their smooth draperies and bland expressions, epitomize, to my mind, the fatal flaw of nineteenth-century primitivism, the concentration on negative virtues, for the concern of these generations was with art as the expression of a state of mind, rather than with the creation of forms. It was the state of mind of late Raphael and of his age, such as they saw it, which these men wished to reject, not the mastery of representation.

It is easy to dismiss their concern as sentimental and their reasoning as fallacious. It is much less easy to rid oneself of the interpretations which these writers and critics have so successfully imposed on the high Renaissance. Nor do we improve matters greatly if we do a Maurice Quai and successively call the Quattrocento, the Trecento and, possibly, even the Duecento, 'Vanloo, Pompadour, rococo'.

For this, in a way, is what happened in the second half of the nineteenth century, after the uneasy stability of the early Victorian age. Uneasy indeed, if you read the turbulent and contradictory pages of Ruskin. He learned to see virtue even where he found childishness. Comparing archaic Greek art with a medieval Venetian tomb (Fig. 290), he thundered at his Oxford audience, in 1870–1:

In both examples, childish though it may be, this heathen and Christian art is alike sincere, and alike vividly imaginative: the actual work is that of infancy: the thoughts in their visionary simplicity are also the thoughts of infancy, but in their solemn virtue they are the thoughts of men. We, on the contrary, are now, in all that we do, absolutely without sincerity: absolutely, therefore, without imagination, and without virtue. Our hands are dextrous with the vile and deadly dexterity of machines ...

The young gentlemen who listened to Ruskin's denunciations were of the same generation as Gauguin, who was born in 1848. They realized increasingly that the Middle Ages were not the only alternative to the tainted dexterity of industrialized Europe. In fact, when Jacob Epstein, one of the leaders of twentieth-century primitivism, shocked the public in 1908 with his sculpture for the Medical Research Council, in the Strand, one of Ruskin's successors to the Oxford chair, Sir Charles Holmes, came to his aid in the columns of *The Times* by appealing to this very continuity:

The Pre-Raphaelites, it will be remembered, turned back from the over-ripe tradition of painting to the example of an earlier age. Is not Mr Epstein doing exactly the same in turning back from our tired and sweetened adaptations of late Greek ideals to the stern vigour of the pre-Phidian epoch?[17]

But, by 1908, these words of Sir Charles Holmes, for all their good intention, had already a slightly old-fashioned ring. For, meanwhile, the defence of earlier styles had long adopted a new line of argument which had nothing to do with such subjective reactions; it based itself on the inability of naturalistic techniques to come to grips with the problems of form. It is to these arguments that I shall turn in my third talk.

3 *The Priority of Pattern*

Last time, I considered that turning of the tides of taste which led so many Victorian art lovers to reject the mature art of Raphael or of Titian in favour of such earlier painters as Fra Angelico, Botticelli and Perugino. These masters, they felt, were displaying the virtues of innocence and honesty, and therefore they described them as the Primitives. Basically, these critics were animated by that dread of corruption, that same fear of seductive skill which I traced back to the doctrines of Plato.

The superiority of the Primitives was seen to be a moral superiority rather than a superiority in the mastery of the medium. They were first valued for

what they were not, rather than for what they were. They were not meretricious, not sensuous, not out to impress by bravura and virtuosity. But, as these formerly neglected masters were increasingly brought to the attention of the public, it was only natural that critics also wished to account for their preference in more positive terms; they wanted to evaluate the artistic achievement of painters who may have been lacking in such naturalistic skills as the rendering of anatomy, of atmospheric effects or of texture, but whose masterpieces never make us miss such a command of natural appearances.

One of the first critics who consciously looked for such alternative criteria by which to judge the so-called Primitives was Goethe. You may remember that, in the 1770s, the young Goethe had fallen in love with the Gothic Minster of Strasbourg, and had been led to attack the cult of beauty of his contemporaries as effeminate. Rugged strength was what made art great. At that time, he was still in the thrall of the moral argument. But, later in life, Goethe went to Italy and there he experienced a conversion to the ideals of Classical art, the ideals of the Greeks and of the high Renaissance.

As he got older, his attitude hardened and he looked askance at the younger German artists who turned from the pagan ideal of physical beauty to the innocent piety of the earlier masters. Given the influence which Goethe, in his later Weimar years, exerted over the intellectual life of Germany, his lack of sympathy for the Romantics and Nazarenes deeply hurt the younger generation and they tried to convert the old man to their new enthusiasm. The leading collectors of German Gothic art, the brothers Boisserée, invited Goethe to visit their collection in Bonn and, sure enough, they found the old Olympian responsive to the charm of these pictures.

His published account of his journey to Bonn and the Rhineland in 1814 and 1815 deserves to be better known, for Goethe reflects on the characteristics of earlier styles and puts forward an idea of his own.[18] Briefly, he does not propose to subvert Vasari's scheme of the progress of skill in the rendering of nature which had led from the stiffness of Byzantine images to the supple grace of Raphael, but he makes the all-important point that, in art, any such gain must also imply a loss.

The style of the earlier Middle Ages, which Goethe, following Vasari, always referred to as Byzantine, may indeed have been rigid and stiff, but this very defect enabled these artists to fulfil the most exalted task of the figurative arts; the task of decorating a particular space such as an interior. This task, as he observes, demands a respect for symmetry and a lucid composition, and it was in this orderly distribution of elements that the Byzantine masters had excelled.

The very progress of naturalism which led to so many artistic conquests, on

the other hand, undermined this earlier achievement. In other words, it becomes more difficult, if not impossible, to preserve the balance of a perfect pattern when you concentrate on the imitation of three-dimensional space, on naturalistic light and lively movement. The marvellous innovations of a Jan van Eyck, for instance, in the minute rendering of visible nature, Goethe thought, had led him to lose that respect for order that marks the earlier Gothic panels, with their golden background and their lucidly silhouetted figures.

Here, then, a new argument, which was quite independent of ideological considerations, was introduced into the debate. The question whether or not the Middle Ages masters were more moral and less sensuous than the later masters could be safely left on one side. What commanded admiration was not really their state of mind, but their decorative skill, a skill which fell victim to a development which preferred the illusion of reality to balanced symmetries.

The argument was independent of ideology, but it could also be used by the religious medievalizers. In England, it was Augustus Pugin, son of a Catholic French émigré, who championed a return to Gothic architecture and decoration, and was therefore anxious to prove the superiority of Gothic over modern decorative design. He stressed that the patterns used by medieval craftsmen for the embellishment of walls or floors tended to be flat and stylized, much to the advantage of the general effect.[19] The intrusion of illusionism into decoration could only be disturbing: we do not want to tread on simulated flowers or see walls broken up by naturalistic vistas.

The effect of Pugin's remarks was, perhaps, out of all proportion to their original purpose, because he hit on a sensitive point, indeed, on a matter of public concern to the early Victorians. Proud as they were, and had every reason to be, of the spectacular progress in technology which completely transformed industry and life, they were increasingly aware of certain shortcomings which were inextricably linked with this irresistible advance: one of the victims of the industrial revolution was precisely a sense of design – the furnishings, lamps, inkstands and cutlery turned out in such profusion by the factories of Birmingham and elsewhere were, in the words of their critics, aesthetic abominations, veritable monstrosities. Moreover, poor design resulted in poor sales, particularly abroad, and thus it happened that the aesthetics of decoration which had, in the past, been safely left to the instinct of the craftsman, moved into the centre of public debate.

The high intellectual level on which these debates were conducted makes them of continued relevance to anyone interested in the theory of decorative art. But what matters to me now is the eagerness with which the reformers of

design – men like Henry Cole and Richard Redgrave – began to study, not only medieval, but also exotic styles of decoration.

The focus of these discussions was, of course, the Great Exhibition of 1851, organized with the express purpose of surveying the state of the arts and crafts in the whole world. Though it was so splendidly arrayed in its Crystal Palace setting, the exhibition occasioned much heart-searching. 'It was but natural,' wrote one of its organizers, the architect, Matthew Digby Wyatt, 'that we should be startled when we found that in consistency of design … those whom we had been too apt to regard as almost savages were infinitely our superiors.'[20]

Five years later, in 1856, the eminent decorator, Owen Jones, gathered the harvest of the exhibition in a sumptuous tome entitled *The Grammar of Ornament* and, as his very first example, he chose a tattooed severed head from New Zealand in the museum in Chester (Fig. 291). It was meant as a deliberate

shock to the Victorian public; to show, in his words, that 'in this very barbarous practice, the principles of the very highest ornamental art are manifest,' and Jones recommended 'the admirable lessons in composition' which artists could derive 'from the works of savage tribes'.

How could one account for these newly discovered values embodied in the arts of pre-industrial societies? The most systematic and considered reply to this vital question was given by the German architect, Gottfried Semper. Semper had fled from Germany to England after the failure of the revolution of 1848, and had been drawn into the ongoing discussion. No doubt Semper had read Goethe, and he applied Goethe's insights to the problems of textile design. He accepted the current dogma – that decorative patterns must be flat to fit easily into ordered arrangement – and concluded:

> It follows that textile art must never concern itself with a faithful imitation of nature and a naturalistic treatment of ornament. We stand in no need of perspective nor of light and shade, but very much of regular composition. Wherever there are figures in the design, they must be shown as much as possible in profile, since profile results much more in the impression of a flat plane than a frontal view. The law of regular symmetrical repetition is being observed by the uncivilized nations, possibly for the reason that they lack the means of deviating from it. Thus nature preserves them from sin. We, on the other hand, are the masters of enormous means, and it is this abundance of means which is our greatest danger. Only by reasoning are we able to get some kind of order into this matter, since we have lost our feeling for it. Even so, the Indians have a tremendous start over us ... and are still superior over all laws of style.[21]

Remember that, for the nineteenth-century art lovers and collectors, these were far from merely academic questions. There was a widespread fear abroad that the germ of disintegration that had affected the applied arts of the West was rapidly spreading all over the world. Contact with Europe was about to spoil the precious heritage that had been maintained over so many centuries in the village industries of what we today call the underdeveloped countries.

In a catalogue of industrial arts published in 1862[22], J. B. Waring lavished special praise on mattings from Central and South Africa for their artistic arrangement of patterns and colours, and warned the Turks, whose rugs he rightly admired, not to abandon their traditions of craftsmanship in exchange for Western methods. 'Whatever other improvement the Turk may obtain by European intercourse,' he wrote, 'let us assure him that these are not among the number.'

In 1879, William Morris admitted, regretfully, that the famous wares of

India, 'so praised by those who, thirty years ago, began to attempt the restoration of popular art … are no longer to be bought at a reasonable price.'[23] They had fallen victim to short-cut methods. One European export in particular used to be blamed for much of this deplorable decline – the replacement of natural dyes by aniline colours. Thanks to their spread, the subtle harmonies that had been developed over the centuries disintegrated everywhere, and loud and vulgar wares took their place. Through these and similar short-cuts, the traditions of the native styles collapsed within a generation, to be replaced, at best, by a self-conscious manner which has had to be kept alive artificially.

I need not point out that all this is still a subject or urgent topicality. The newly emancipated nations in Africa, Asia and South America want to cultivate their ancient artistic traditions, but are threatened by commercialism and by new tools as well as by new skills. The result, too often, is that type of pastiche that has come to be known as 'airport art'. The corruption may be irreparable.

Remember, however, that in my first talk I presented various interpretations of the value of the primitive in art. To those who share Plato's approach, airport art must be symptomatic of a loss of moral fibre, of a decline of the superior values expressed in the traditions of the tribe. Without wanting to rule out this diagnosis, I should like to remind you of the view that Aristotle might have taken. In his philosophy of art, as we may reconstruct it, the primitive is the undeveloped. While new inventions or innovations may lead to a perfect balance between means and ends, decline sets in when there is a loss of that balance, a cultivation of means in excess of the ends they were intended to serve.

The range and intensity of aniline colours, in other words, may well have upset a balance instinctively achieved in a slow development, but, much as we may regret this loss, we need not attach to it any moral or psychological significance. It is the style of the tribe which is corrupted, not its soul.

This Aristotelian interpretation offers more to the student of art than all the Platonic moralising or sentimental nostalgia of the Romantic view. It seems to me worth paying particular attention to this alternative approach which I might call, without irreverence, 'the argument from design', for it helps to establish a value of the primitive which is more defensible rationally and therefore more interesting than some of the reactions I described in my earlier talks.

Take an example frequently discussed in the nineteenth century: the history of Greek vase-painting. There is no more wonderful application of decorative discipline known to me than the famous wares which emerged from the Attic

workshops of the sixth and fifth centuries out of a long tradition of geometric styles. Most of the black-figures vases still exhibit this marvellous decorative balance and, even with the arrival of the more naturalistic red-figured style of the early fifth century, the design is not disrupted by the new freedom of dramatic narrative. Had Aristotle written the history of vase-painting rather than the history of tragedy, he would have been right, in my view, in demonstrating how the mutually limiting demands of the lucid pattern and the naturalistic rendering were here harmonized in a perfect whole.

But it has always been felt that this perfection was threatened by the further advance of naturalism. When Greek painting developed foreshortening and modelling in light and shade, these inventions introduced a disturbing element in the finely calculated balance between pattern and dramatic evocation. Those who accept Aristotelian terms will describe fourth-century vases as decadent. Of course, there is a subjective element in this judgement, and yet I think it could be argued that the new inventions objectively disrupted the art of vase-painting. The game was up, the trade declined. It had been spoilt by demands which, artistically, could not be assimilated.

Or take another example even more frequently discussed in the nineteenth century: I mean, the art of the stained-glass window. Ruskin laid it down as:

a practical matter of immediate importance that painted windows have nothing to do with chiaroscuro ... If you care to build palaces of jewels, painted glass is richer than all the treasures of Aladdin's lamp; but if you like pictures better than jewels, you must come into broad daylight to paint them. A picture in coloured glass is one of the most vulgar barbarisms ...[24]

I would claim that, despite its characteristic emotionalism, this passage from Ruskin differs from the one I quoted last time, in which he exalted the childlike grandeur of early art. It differs because of its implicit rationality: if you want this, you must do that.

And, of course, he is right that the full colour of stained glass is compromised by modelling in light and shade. It surely makes sense, from this point of view, to say that stained-glass painting was a medium more easily compatible with the style of the twelfth and thirteenth centuries than with that of the Renaissance. The great masters of Florentine realism, Ghiberti, Castagno and Uccello, all designed stained-glass windows, but they are practically illegible because of their complexity. Naturalism had killed one of the glories of medieval art.

And so, when William Morris and Edward Burne-Jones tried in their church windows to move away from the illusionistic devices of Victorian

painting, they were not only motivated by a nostalgia for the admired primitives. They felt, and rightly felt, that the medium demanded a greater restraint in the deployment of naturalistic effects. It was a significant move, for it was the purpose of the Arts and Crafts Movement to break down the artificial separation between design, on the one hand, and the fine arts, on the other. Whether in monumental sculpture or in the art of the mural, whether in tapestries or in the art of the book, the priority of the pattern over the demands of realism became an article of faith as the century drew to its close.

The most emphatic assertion of the freedom of decorative art from the fetters of naturalistic demands can be found in Walter Crane's books and articles championing the Arts and Crafts Movement. In two of his characteristic essays,[25] Crane reviews the sculpture and the painting of his time from what he calls a decorator's point of view. His imaginary decorator has decided to turn for a moment from his all-engrossing studies in stained glass, tapestry, and the like to an exhibition of painting. He is appalled by the chaos of the arrangement, but even more by the 'futility of an aimless and therefore inartistic imitation'. Sculpture, we learn, is a little better off, for 'while the witchery of imitative skill may lead painters astray, in sculpture we are forced back to what may be called the more purely artistic qualities of design, of style.'

Crane never ceases to drive home this distinction between what he calls imitative and constructive design: 'the one seeking rather to imitate planes and surfaces, accidental lighting, phases and effects, the other constructive, depending, for its beauty, on qualities of line and form and tint, unaffected by accidental conditions, seeking typical rather than individual forms and ornamental rather than realistic results.' What, in Crane's eyes, gives this pursuit its fascination is precisely that there are no scientific rules to determine its success: 'The way is perpetually open for new experiments, for new expositions, and new adaptations and applications.'

I am convinced that the modern movement owes this openness, this sense of adventure and experiment, to no small extent, to the renewed interest in decorative art which I have examined today. When the competition of the camera had become oppressive, when 'photographic' became tantamount to vulgar, a whole alternative tradition was ready to receive the artist who rejected the Western preoccupation with imitative skills.

No other tradition proved more attractive in this respect to European artists of the final decades of the nineteenth century than that of the Japanese print (Fig. 292). Maybe the style of these masterpieces of decorative tact was particularly accessible to Western artists because Japan had absorbed and assimilated some elements of the Western methods without thereby

292
Shiko, *Watching Dancers*,
*c.*1800. Print

surrendering its individuality. It is interesting to see how these prints first appeared in quotation marks, as it were, in the backgrounds of naturalistic paintings such as Manet's portrait of Zola. Japonism, the rage for Japanese art, among painters such as Whistler or the designers of Art Nouveau, became a bridge over which artists and art lovers could pass more effortlessly towards an appreciation of more alien styles. For Van Gogh, it was not so much the refinement of these compositions which counted as their bold forms and unbroken colours. A few years later, his erstwhile companion, Gauguin, left for the South Seas and introduced in the background of his paintings elements of a more or less fantastic South Sea art. In his prints and sculptures, he went even farther and tried to imitate altogether the style of native art, as he saw it.

I confess that I share, to some extent, the doubts about Gauguin's greatness to which his former teacher, Pissarro, often gave vent. But it is not difficult to see, in our present context, why Gauguin's decision to abandon naturalistic

conventions was felt as such a liberation, as what, in the jargon of our science journalists, would now probably be called a 'breakthrough'. He had dared to cut the Gordian knot and to resolve the irreconcilable conflict between design and representation that was such an increasingly disturbing element in the work of his less resolute contemporaries, such as the masters of Art Nouveau, like Gustav Klimt. Gauguin's example gave the signal to treat the human form – indeed, the human face – with as much freedom as any other part of nature, and, suddenly, the new values of tribal art were revealed to artists. Not only their decoration was superb, but their treatment of the human form displayed the same freedom from doubts, the same assurance, for which these nineteenth-century Paris artists longed. Picasso, in 1907, copied tribal idols as artists a generation earlier had studied Gothic stained glass, or Maurice Denis at Pont-Aven had studied the peasant art of Bretagne.

But then, after 1906, when the grand assault on the academic fortress began in earnest, the garrison had long lost its will to resist. I should like to quote to you a passage from the last of six lectures on painting which the traditionalist English painter, George Clausen, delivered at the Royal Academy in 1904. These lectures are, to me, as moving in their honesty as they are interesting as a historical document. Having passed in review all the achievements of Western art in colour, light and perspective, Clausen comes, in conclusion, to speak of the art of Japan:

> There is something disquieting in the fact that Japanese art is so beautiful and, at the same time, so altogether different from ours, so much so as to cause a momentary thought whether it is not finer. But whether or not, we must keep on our own road, for our traditions and practice do not lead us to render nature like the Japanese ... Our art appeals through representation or imitation, creating an illusion of nature in its three dimensions; while the Japanese representation of nature is not imitative, but selective ... And their art seems, in this respect, to have developed to its final perfection on the lines of the earliest forms of art, without changing its direction.
>
> If we go back to beginnings, to the Egyptian wall-paintings, to the Greek vase-paintings, or to the earliest Italians, or even if we look at the drawings of children, we find they are alike in this; that they draw the things they want to express and leave out the rest. The Japanese make their selection in the same way: their art has developed, but has not changed.[26]

I have quoted this passage with an ulterior motive. It is to answer a question that may have been forming in your minds for some time. What right have I to bracket an art as sophisticated and as subtle as the art of the Far East with

ideas of the primitive? The answer is, as you see in Clausen, that here, as always, a negative characteristic counts as much in the history of taste as any positive features.

It is the absence of the third dimension, the absence of the European skills of creating illusion through perspective and light and shade that made Clausen concentrate on the common denominator between child art and Japanese art. For the historian, this bracketing is as illuminating as it is perplexing to the critic. The discovery of child art falls indeed into the same period of crisis towards the end of the nineteenth century that made Gauguin embark for the South Sea Islands.

The significance of this development and the questions it poses will be one of the themes of my last talk.

4 The Tree of Knowledge

Since these talks have been announced I have several times been asked what I mean by the 'primitive'. Those who have followed me so far will not be surprised at my answer. I mean any kind of art which was called primitive at some time, particularly when the word was used as a term of praise. It is such praise, after all, which implies the presence of a value in the primitive with which I am here concerned. Remember that the first group of monuments singled out for this particular praise in the late eighteenth century were Greek vases – presumably works we would now call archaic rather than primitive. In the nineteenth century, 'the primitives' became the generic term for the early Italian and Netherlandish schools; painters such as Fra Angelico or Jan van Eyck, whose art certainly does not look primitive to us. Yet if you consult the *Shorter Oxford Dictionary*, revised in 1947, you will still read that 'a primitive is a painter of the period before the Renaissance, or a modern painter who imitates the style of these.'

The preference for that style obviously implies a dissatisfaction with the course art had taken since. It was thought necessary to go back in time beyond the moment when 'the rot had set in'. A. O. Lovejoy and George Boas, whose standard work on primitivism in antiquity I have mentioned before, propose to call this version 'chronological primitivism'; it is, in a way, a form of the longing for the good old days, for the lost paradise of innocence. Discontent with civilization as such they call 'cultural primitivism', the dream that we would all be better off without the blessings of science and technology. It is this conviction, applied to art, which has led to the meaning of the term today.

To quote the words of Henry Moore in 1941[27]: 'The term Primitive Art is generally used to include the products of a great variety of races and periods in history ... In its widest sense, it seems to cover most of those cultures

which are outside European and the great oriental civilizations.' He is right that we would expect a book entitled *Primitive Art* to range from African masks and Ashanti gold weights to Maori carvings, Haida totem poles and Peruvian textiles. I made the point last time that the qualities of these styles were first discerned by Victorian critics who deplored the decline of the arts and crafts in the industrialized countries. Here, the Great Exhibition was an eye-opener, showing the superior standards in design of cultures not yet touched by the blight of the machine. You will also remember that this European malaise culminated in the cultural primitivism of Gauguin, who, in 1895, called civilization a sickness and barbarism a rejuvenation.

A mere decade after Gauguin's final flight to the South Seas, artists of the Paris avant-garde took to picking up what they called Negro sculpture from curio shops. Much to the dismay of the conservative critics, they came to study these carvings rather as the Impressionists had copied Japanese prints and Renaissance artists ancient sarcophagi. As Herbert Read wrote in 1930: 'From a study of the Negro and the Bushman we are led to an understanding art in its most elementary form, and the elementary is always the most vital.'[28]

I have quoted the words of this influential critic because they reveal the link which existed for his generation between cultural primitivism and chronological primitivism. To assume that the Negro and the Bushman practised 'art in its most elementary form' implies, after all, that they are closer to the origins, and that it is this that makes their products more vital than the derivative traditions of the ageing West. Not that Herbert Read was alone in this conviction. The idea that civilization had slowly emerged out of savagery, and that in looking at the lives of so-called savage tribes we were really looking at our own distant past, had taken root as early as the eighteenth century. Darwin's and Herbert Spencer's theories of evolution appeared to provide scientific sanction for this rather simplistic view, which was generally accepted without much question. Without this view, of course, there would have been no justification whatever in applying the term 'primitive' to all the varieties of complex styles developed by non-Western cultures. Surely there was no reason to assume that these styles did not also have their own millennial history. No wonder anthropologists today have come to reject the term 'primitive' for the art of the tribes they study, and not only because the educated members of the tribe resent the appellation which, somewhat misguidedly, they regard as a slur.

But the dismantling of an old prejudice always leaves one with a problem. Granted that it is little short of absurd to assume that the art and culture of so many non-European peoples represent an earlier phase of human development than we do, how could intelligent critics ever believe this?

The brief answer is that they took a technological view of human evolution. The technological superiority of Western civilization stands in no need of demonstration. We can indeed speak of primitive technologies and of developed ones. It is well known that such complex cultures as the Maya and the Inca never developed the wheel, which is undoubtedly an important invention, though it is salutary to remember that the Western nations never knew the boomerang, which is also an ingenious device. To Australian Aborigines, our ignorance of that weapon may indicate a rather primitive mentality. Now, from a technological angle, the styles of non-Western traditions certainly have this in common; they all represent the visible world as did the West before certain inventions were made, by which I mean those skills in the imitation of nature which I have mentioned before: foreshortening, perspective and the rendering of light and of texture which can, in certain cases, result in an illusion of reality. In my book, *Art and Illusion*, I argued that, whether or not you like these inventions, it is a mistake to regard this result of a long development as obvious or easy. For reasons which are deeply rooted in the psychology of perception, nobody is capable of copying an aspect of nature which he sees in front of him unless he has *learnt* how to do it. He must, for instance, be taught to measure the apparent size of distant objects against the brush held in the outstretched hand, or to judge the modification of colours by the fall of light or the casting of shadows. All these procedures, it turns out, require the art student to fight down his natural tendencies towards looking at the world. The appearance of nature can only be 'trapped' by a roundabout strategy. But, paradoxically, knowing how complex that 'trap' is makes me question the description of non-naturalistic styles as 'primitive'. They are the rule rather than the exception, because the 'normal' method of making an image employs what is called a conceptual schema, one which embodies what is known rather than what is seen. To call this normal method 'primitive' is as misleading as to call 'walking' a primitive form of locomotion because we have developed the internal combustion engine.

The reaction of Europeans to non-European traditions has not been free of similar misunderstandings, for the absence from their styles of one particularly complex technique does not imply a lack of skill in any other respect. We know, in fact, that the products of many tribal traditions often show a control of tools and materials that comes from a long and disciplined practice. Compared to the precision of these native craftsmen it is often the Western handiwork which looks clumsy.

It is for this reason also that the comparison between tribal art and the art of children, which was so dear to evolutionists, now seems totally misguided.

The mere fact that child art also employs conceptual methods no longer justifies the idea that primitive art takes us back to the childhood of man; for, in every other respect, the two types of art are diametrically opposed. Most forms of native art are highly controlled. Child art is spontaneous, happy-go-lucky, even slapdash, especially since modern schools rightly encourage inventiveness and originality at the expense of manual skill. It has often been observed that this carefree stage comes to an end with puberty and the growing self-consciousness of the adult. No wonder, then, that, in child art, cultural primitivism has found another object of nostalgia. I mentioned in the first of these talks that Maurice Quai, that leader of the rebellious students in David's atelier who called themselves *Les Primitifs*, was a young man of great piety. He liked to dwell on the teaching of Jesus Christ that we shall not enter the kingdom of heaven unless we become as little children. But even these radicals did not apply Christ's saying literally; they did not make their art similar to that of children. It took more than a century for the seed of primitivism to flower into the conviction that not only the academic drill of perspective and shading, but virtually all the artistic skills were a hindrance rather than a help in striving for immediacy. Only in the twentieth century were the drawings and paintings of children taken sufficiently seriously to be shown in art exhibitions. During a visit to one such exhibition Picasso is reported to have expressed his admiration and, indeed, his envy in these words: 'When I was a child I could draw like Raphael. I have been trying ever since to draw like these children.' We need not take these *obiter dicta*, even of great artists, too seriously. Picasso could not draw like Raphael when he was a child; what he meant is merely that he had mastered the academic routines of drawing from the plaster cast which his father, an art teacher, had obviously trained him to copy. But, in adding that he had been trying to discard these skills and draw like these children, Picasso implied, quite correctly, that it is far from easy for anyone to unlearn what he has learned.

Whether or not Raphael knew that we cannot tell, but it so happens that we know that his contemporary, Michelangelo, did and that he succeeded in this difficult task of drawing like a child. This, at any rate, is what his biographer, Vasari, tells us: 'Once, in his youth, Michelangelo and some of his painter friends wagered a dinner to be stood to the winner in a competition for doing a figure completely devoid of draughtsmanship, one as clumsy as the mannikins scrawled by the ignorant who deface walls.' It was here, Vasari says, that Michelangelo's memory stood him in good stead. For he remembered having seen such a scrawl on a wall and he perfectly imitated it as if he had it in front of him, thus surpassing all the other painters; 'a difficult feat' – Vasari adds – 'for a man so steeped in design.'[29]

Whatever the exact truth of this story, I think it throws considerable light on a value of the primitive which may be called extraneous rather than intrinsic, for it is obvious that the interest of the drawing would have been lost on anyone who did not know that its author was the admired master of draughtsmanship. The joke rested on the distance between his real skill and the clumsiness of the showpiece. Indeed, nowhere is it easier to demonstrate this particular effect of the primitive than in the realm of humour. No wonder that the distinctive characteristics of the unskilled scrawl were first observed and exploited for fun. William Hogarth, ever ready to reflect on the means and methods of his art, also included in his satirical painting, *The Invasion*, a rude grafitto of the French king drawn on a wall by a child. When, in the late eighteenth century, the craze for caricatures spread to amateurs, it is often hard to tell to what extent the clumsiness of some of these products was intentional, for the crudity adds to the humorous effect.

My eyes were sharpened for the significance of this effect by my late friend, Ernst Kris; Kris was an eminent Viennese art historian who joined the circle of Sigmund Freud and explored the psychoanalytic theory of art. It was in the theory of verbal humour, of jokes and puns, that Freud had stressed the role of a deliberate relaxation of standards, the reversal to gratifications was enjoyed in our childhood. His example was the babblings of the infant who plays with the noises he can make. In a joke, so Freud thought, these playful variations and distortions are placed in the service of a repressed thought, and emerge in the guise of a witticism which society accepts because of the amusing wrapping.

Generalizing this model, Kris compared the stage of babbling in verbal humour with that of the scrawl in graphic wit. Both share the mechanism psychoanalysts call 'regression', the reversal to earlier phases of mental development; indeed, the surrender of the rationality and control that characterize the adult mind. There are few theories of art which do not take account of such a surrender, whether it is to dream-like states or to the ecstasies of inspiration. What is characteristic of many twentieth-century movements is the almost frantic search for such states through contact with the primitive. Whether you think of French Fauvism or German Expressionism, of Dada or Surrealism, or Abstract Expressionism – not to mention more recent movements and fads – they all have this in common: that they value regression. This valuation, as we have seen, reflects the distaste for the skills developed by the Western tradition. While I do not share this distaste I can appreciate the causes of this revulsion: the achievement of naturalistic representation as such has become trivialized. It has, anyhow, become somewhat redundant through the invention of photography. The

resulting attitudes confront art with urgent problems.

An experience which I had when writing *Art and Illusion* may illustrate what I mean. Interested as I was in the integrative skill which is required in composing a naturalistic landscape, I asked a child of 11 to copy a reproduction of one of the masterpieces of John Constable. It was the picture, *Wivenhoe Park*, which now hangs in the National Gallery in Washington. As I had expected, the child disregarded the interaction of elements, and so the copy, which I also included in my book, considerably reduced the complexity of the painting. The main elements of the scene are all recorded, the house in the distance behind the lake, the swans on the water and the cows in the fields, but all these items are arranged on a flat surface, lacking in depth and atmosphere, but compensating for this lack by a greater intensity of colours and a greater simplicity of the component shapes.

You will not be surprised to hear that when I showed the result to an art student of my acquaintance he expressed a strong preference for the child's drawing over Constable's masterpiece. You will admit that there is a problem here. Because, if there is anything I know about values in art, it is that Constable was the better artist. This experiment took place many years ago, and the child in question has meanwhile grown into a splendid young woman, yet she never wanted to add art to her many accomplishments, let alone to surpass Constable.

On the other hand, it is easy enough to read the mind of the art student. You may remember that, at the very beginning of these talks, I contrasted the cover of a chocolate-box with a child-like scrawl by the French painter, Dubuffet. I ventured to say that, without the chocolate-box, we would not have Dubuffet. The sweet picture of smiling goldilocks or the bowl of appetizing cherries mobilizes the dread of kitsch because it is found to be cloying. Cloying at least to those among us whose taste has undergone that process of sophistication of which, two thousand years ago, Cicero gave such a masterly description, which I have quoted in my first talk. To be found actually liking such a piece would be a social embarrassment, the admission of an undeveloped, that is, a primitive taste. A taste for the primitive scrawl of a Dubuffet, on the other hand, is safe from this suspicion.

Now this, to be frank, is the danger I see in the cult of the primitive. It is the cult of an extraneous negative virtue, the preference for the absence of certain qualities which we have been taught to reject. But negation can never be enough. Nor can regression be. If I may return to Freud's example, it is not the childish babble which makes the joke, but the skilful use of verbal confusion in the witty *bon mot*. True, sheer nonsense can also be delightful, as in the rhymes of Lewis Carroll or Edward Lear, but who can miss the mastery with

which this nonsense is presented?

I believe the great artists of the twentieth century who admired the primitive and appeared to reject the skills of tradition, knew equally well how to use regression in play or in earnest without surrendering to its pull. Take Picasso, whom I quoted for his alleged desire to draw like children. He never did. But in one instance, at least, where we find him deliberately regressing to the methods of child art, we can guess his purpose. I am thinking of one of his preparatory drawings for *Guernica*, the mural he did to commemorate the destruction of the small Basque town in the Spanish Civil War.

When Picasso received the commission to paint a work for the Spanish Government Pavilion at the Paris International Exhibition of 1937 he first thought of symbolizing the civil war through the fairly obvious analogy of a bullfight. As a passionate *aficionado*, he had often painted and drawn bullfights before, and the theme of the gored and dying horse came to him almost unbidden. Some of these earlier compositions reach an intensity and poignancy in the image of the rearing creature in its death agony that illustrates how much the motif must have meant to him. It is precisely this formula which he first tried out and yet discarded in favour of what looks like a childish scrawl. He drew a horse which really recalls a child's drawing, with four straight legs sticking out of an oval body and a crude head attached to a clumsy neck (Fig. 293). Other sketches show even wilder distortions.

I do not think I am over-interpreting if I say that Picasso tried to revert to elementals precisely because he found his skill obtrusive. He wanted to get away from what threatened to become a facile stereotype; he wanted to learn to draw like children. His fury and grief at the violation of his country may

have demanded from him something more genuine, more intense than a repetition of a symbol, however moving. But for Picasso this extreme regression was a passing phase, a fresh charging of the mind with artistic energies. It is not the least instructive aspect of his search for an expressive symbol that, in the end, Picasso reverted to his earlier invention, the rearing horse in the agony of death. He must have felt that he could not do better and that the painting as such had meanwhile become so charged with emotion that he could afford this self-quotation. Even with this amendment Picasso's *Guernica*, in its final form, remains one of the most impressive instances of the power of regression, casting aside the niceties of style in the heat of emotion. But just as the great actor can scream or roar without losing control of his faculties, so Picasso gave vent to his fury without becoming inarticulate.

This seems to me the decisive point in the use and abuse of regression as cultivated in our century. The disregard of the rules of grammar that occurred in poetry or of that of plot in the novel or drama, the casting aside of dexterity and even of the brush itself, must be compensated for by a heightened awareness of the means at the artist's disposal. If I were asked to name one artist who exemplifies in his work just the right balance between regression and control, the exact dosage of the primitive handled with mastery, it would be Paul Klee. Studying his *œuvre* and that of his peers in the employment of primitive modes, one arrives at a conclusion which is only an apparent paradox: the more the Western artist courts the primitive, the more must his art differ from his admired models. African or Polynesian art – the styles we used to call primitive – have many resources, but, for good or ill, they must lack the one so dear to the sophisticated. I mean, of course, primitivism. The tribal artist cannot regress to an earlier phase for the sake of effect. The technical developments of the Western tradition have thus given to art an unexpected dimension. Hence one of the values of the primitive in art, its otherness, turns out to be a by-product of the striving for progress which the ancients and Vasari celebrated in chronicling the evolution of Greek and Renaissance art. It is a progress achieved by the systematic correction and adjustment of the conceptual schema. Without this effort and the artistic perils it disclosed, we could not appreciate that distance between the elemental and the slick which plays such a decisive role in our taste today. We cannot opt out of this development which has carried us so far away from the genuine primitive. Nor can the self-conscious artist escape from the hall of mirrors which gives an added significance to whatever he does or leaves undone.

I was confirmed in my diagnosis of the situation in which the artist and the public find themselves in reading some of the utterances made by Roy

Lichtenstein, whose rejection of artistic sophistication drove him to seek inspiration in the popular art of the comic strip (Fig. 294). Asked by a reporter of *Art News*, 'Are you anti-experimental?' he replied, 'I think so, and anti-contemplative, anti-nuance, anti-getting-away-from-the-tyranny-of-the-rectangle, anti-movement and light, anti-mystery, anti-paint-quality, anti-Zen and anti-all of these brilliant ideas of preceding movements which everyone understands so thoroughly.' Apparently, Lichtenstein found himself trapped in a field of force in which he could see no move but that of turning to the imagery beloved of the unsophisticated masses. And yet he, too, realized in his heart of hearts that art cannot come of rejection alone. Three years later, he put this insight into the following words:

> I'm interested in portraying a sort of anti-sensibility that pervades the society, and a kind of gross over-simplification. I use that more as style than as actuality. I really don't think that art *can* be gross and over-simplified and remain art. I mean it must have subtleties and it must yield to aesthetic unity; otherwise it's not art. But using it as a style, I think that it's really a kind of conceptual rather than a visual style which maybe permeates most art being done today, whether it is geometric or whatever.[30]

We must hand it to Lichtenstein that he has seen the dilemma in which his negation of negations has landed him and so many of his fellow artists. He realized the resulting plight, and tried to extricate himself by claiming that his art is really very different from the style he imitates, and therefore very subtle. But, whether true or false, this claim only brings us back to that sophisticated élitism from which he, like so many other primitivists, wanted to escape. But, on his own showing, the dilemma in which he finds himself enmeshed is the result of intellectual rather than purely artistic ambitions. If I am right that this applies to much of the art of our time, then intellectual arguments may also offer a remedy. I have always seen myself as a historian rather than a critic, and I would never want to tell artists what to do as long as they, and their public, are happy. But I think that, in the present malaise, even the historian of art can make a contribution because it was he, as I tried to show in these talks, who first appeared in the guise of the serpent, tempting the artist to eat from the Tree of Knowledge.

Editor's Postscript

Gombrich showed his interest in primitivism in a very early article, republished as 'Achievement in Medieval Art' in Meditations on a Hobby Horse. *A seminal essay for later studies of primitivism was 'The Debate on Primitivism in Ancient Rhetoric',* Journal of the Warburg

and Courtauld Institutes, 29 (1966), pp. 24-37, which followed 'Vasari's Lives and Cicero's Brutus', Journal of the Warburg and Courtauld Institutes, 23 (1960), pp. 309-11. The psychological theory was developed in 'Visual Metaphors of Value in Art' and 'Psychoanalysis and the History of Art', also in Meditations on a Hobby Horse.

We are currently waiting for his forthcoming book The Preference for the Primitive. Its preliminary ideas were spelt out in Ideas of Progress and their Impact on Art, The Mary Duke Biddle Lectures given at the Cooper Union (New York, 1971), which were privately circulated, though there has been a German translation, Kunst und Fortschritt (Cologne, 1978), and in French, L'Écologie des Images (Paris, 1983), contains 'Les Idées de progrès et leur répercussion dans l'art'.

'The Values of the Byzantine Tradition: A Documentary History of Goethe's Response to the Boisserée Collection' in G. P. Weisberg and L. S. Dixon (eds.), The Documented Image (Syracuse, 1987), and 'From Archaeology to Art History: Some Stages in the Rediscovery of the Romanesque', in Icon to Cartoon: a Tribute to Sixten Ringböm (Åbo, 1995), may give a taste of what is about to come. In Italian there is Il gusto dei primitivi (Naples, 1985).

Useful background works remain George Levitine, The Dawn of Bohemianism: the Barbu Rebellion and Primitivism in Neoclassical France (Pennsylvania, 1978), and Robert Goldwater, Primitivism in Modern Art (enlarged edn., Cambridge, Mass., 1986).

For a commentary on the work so far see Graham Birtwistle, 'When Skills Become Obtrusive: on E. H. Gombrich's Contribution to the Study of Primitivism in Art' in Richard Woodfield (ed.), Gombrich on Art and Psychology (Manchester, 1996).

Magic, Myth and Metaphor: Reflections on Pictorial Satire

Paper delivered at the 23rd Congrès International d'Histoire de l'Art, Strasbourg, September 1989, and published in the proceedings, *L'Art et les révolutions, conférences plenières* (Strasbourg, 1990), pp. 23–66.

When our President, Professor Châtelet, did me the honour of inviting me to give this lecture, he was kind enough to remind me that I had written in the past on one of the main topics of this congress – my paper on the symbolism of the French Revolution[1] – but he also indicated that I was free to stray beyond the limits of this topic. I am grateful for this permission since the precise subject of 'Caricature in the French Revolution' has recently been fully explored in an exhibition at Los Angeles with a valuable catalogue in which several other aspects of the topic are also discussed.[2] As you will see, I have made grateful use of this material to do justice to the occasion, but by and large my talk will rather fit the rubric of section II, *Changements et continuité dans la création artistique des révolutions politiques* and conceivably touch on section V, *Révolution et évolution de l'histoire de l'art de Warburg à nos jours.*

I hope it should not be too difficult to explain what I mean by the three notions or concepts mentioned in my title, the notions of magic, myth and metaphor in the context of pictorial satire. I need only remind you of the most frequent motif in this type of political imagery, the figure of the Devil. If a computer were ever employed to record and analyse all satirical prints of the last five hundred years in a database, the Devil is likely to come out on top.

That the Devil is connected with magic requires no elaborate proof: what is called 'black magic' rested firmly on the belief that the powers of darkness could be enlisted to do the bidding of the witch or wizard who had entered into a pact with the Devil. It almost follows that this same Devil is also part of myth, if by this we mean the system of shared beliefs that hold a society together. Few of us may still entertain that belief, but the Devil still lives on in

DIGNA MERCES PAPAE SATANISSIMI ET
CARDINALIVM SVORVM.

Luthers vnd Lutzbers
eintrechtige vereinigung/ſo in rriij
vrgenſchafften ſinde allenthalben gleychförmig verfaget/

Wenn zeitlich geſtrafft ſolt werden/
Bapſt vnd Cardinel auff Erden/
Ir Leſterzung verdienet het/
Wie jr Eecht hie gemalet ſieht.
Mart. Luther D.

295
Lucas Cranach the Elder,
'The Pope cast into Hell'.
From *Passionale Christi et
Antichristi* (1521)

296
Workshop of Lucas
Cranach, 'The Pope and
Cardinals Hanged'. From
Abbildung des Papstums (1545)

297
Title page to Petrus
Sylvius, *Luther und Lucifer*
(1535)

298
King Henri III led to Hell.
Bibliothèque Nationale,
Paris, Cabinet des
Estampes

our speech, the metaphors we use in expressions of disapproval, calling a cruel
ruler a veritable fiend, or even in expressions of endearment, as when we
describe a lively child as a little devil.

My first point must be, however, that the very variety in what we may call
the ontological status of the Devil presents an enduring problem to the
student of pictorial satires. How can we really tell what any of them mean
when they represent the Devil? I think we know the answer in the case of the
first systematically organized campaign of pictorial satire, that of Martin
Luther, whose violent attacks on the Church of Rome were supported by a
famous series of woodcuts, in which the Devil or devils are frequently shown
in such images as hurling the Pope to Hell (Fig. 295) or seizing the the souls
of the Pope and cardinals, shown hanging on the gallows (Fig. 296)ˢ. Visitors
to the Wartburg are still shown the stain on the wall of Luther's cell which is
said to have been caused by the inkpot he hurled at the Devil, who came to
tempt him. Whether or not there is anything in that anecdote, we have
Luther's pamphlets and hymns to prove that for him the Devil was no less a

reality than was almighty God. The same is surely true of his opponents who retaliated by linking the name of Luther with 'Lucifer', and published a print showing the reformer hand in hand (or rather hand in claw) with the Devil (Fig. 297).

Nor can we forget that the Church of Rome claimed the power of anathema, the curse that is really a prayer to God to consign a person to Hell. Heretics condemned to the stake were frequently made to wear a mitre showing devils, as if to anticipate their eternal torment.[4] Presumably a crude woodcut such as that showing the king of France, Henri III, being taken to Hell (Fig. 298) was intended to be taken literally,[5] since the world was seen as the stage upon which the opposing forces of good and evil were intervening in the affairs of man.

The famous print of 1621 celebrating the 'double deliverance' of England from the Gunpowder Plot and the Spanish menace (Fig. 299) may stand for many.[6] Alas, these prints were not made to be shown in lectures limited to one hour and so I must restrict myself to pointing out the Devil who is sitting in his tent plotting with the King of Spain and the Pope while the Divine Eye, looking down on Guy Fawkes, is labelled *video rideo* ['I see, I laugh'].

In seventeenth-century prints the Devil or devils are regularly shown to govern the real or pretended machinations of the Jesuits in their devil's kitchen (Fig. 300). It is also the disgraced Jesuits who, in a French print of the eighteenth century, are seen to be hurled into Hell (Fig. 301).

Needless to say, the prints of the French Revolution do not let us down. Here is a print of 1790 showing the member of the Third Estate who plays the fiddle to drive the other two into Hell, '*Les aristocrates aux diables*' (Fig. 302). In another print of the same year two devils are shown defecating on two members of the National Assembly who championed the traditional position of the Church (Fig. 303). Luther's old theme of the Pope in Hell was taken up in another print (Fig. 304), while an elaborate composition by Villeneuve of

January 1793 illustrates the arrival of the beheaded King in Hell, surrounded by previous victims of Divine justice (Fig. 305). Surprisingly, even the neo-classicist master Jacques-Louis David accepted a commission for a propaganda print in which the British government is shown as the Devil (Fig. 306). More homely, if that is the right word, is the *Souper du Diable* of 1793 where the Devil prepares to roast and eat Marat (Fig. 307), while an anonymous print in the grand manner, *A la mémoire de Marat, l'ami de peuple*, associates his murderess, Charlotte Corday, with a winged devil (Fig. 308).

But how many of those who produced or saw these prints believed in the Devil? That slow process of emancipation that D. P. Walker has traced in his memorable book on *The Decline of Hell*[7] had certainly had its effect on many free spirits of the time who may still have used the figure as a convenient code, a pictograph that signified evil. That all-important moment of transition when myth fades into metaphor must of necessity elude the student of pictorial satire.

But is it not exactly the same with our speech? Can we ever draw a line between cursing and swearing? Would we gain much if a recording angel was

EXPLICATION

SOUPER DU DIABLE.

À la mémoire de MARAT, L'ami du Peuple, assassiné le 13 Juillet 1793.

305
Villeneuve, *Réception de Louis Capet aux Enfers*, 1793. Bibliothèque Nationale, Paris, Cabinet des Estampes

306
Jacques-Louis David, *Gouvernement anglois*, 1793–4. Bibliothèque Nationale, Cabinet des Estampes

307
Souper du Diable, c.1793. Bibliothèque Nationale, Paris, Cabinet des Estampes

308
À la mémoire de Marat, 1793. Bibliothèque Nationale, Paris, Cabinet des Estampes

equipped with a computer to list every moment when we say 'Go to Hell', or 'Damn it', or 'What the Hell are you doing here?' The more we are in the grip of emotions, the more easily do we feel tempted to regress to the remnants of irrational belief which form part of our cultural heritage. Few of us, if asked at pistol point, would avow that we really meant what we said when we thus invoke the Devil, but somewhere the figure of speech still retains its power over our half-conscious mind.

This willing suspension of disbelief is cleverly exploited in a modest little pocket cartoon of the last war that shows Goebbels watching Hitler going to bed and discovering that he really has the hooves of the Devil. 'Himmel,' he is made to exclaim, 'I thought Churchill meant it as a figure of speech' (Fig. 309). I wonder if we would be tickled if we did not sense for a split second that after all there may be some kind of reality behind the metaphor.

My late friend Ernst Kris, who introduced me to this whole area of studies more than half a century ago, would have argued that it is on this oscillation between reality and dream, between myth and metaphor, that pictorial satire relies for its psychological effect. His starting point had been Freud's theory

of the Joke or Wit which he condensed into the formula that this genre made use of 'regression in the service of ego', in other words, of a conscious exploitation of an unconscious mechanism.[8] And just as Freud had looked at verbal wit mainly as an outlet of human aggression, so Kris saw pictorial satire as an instrument of hostile impulses.

It was in this context that he was led to include magic, the first of my three notions, into the equation. He proposed to trace the whole genre of pictorial satire back to its distant roots in the murky practices of black magic. Images certainly play a part in these widespread rituals when a wax doll serves as a substitute for the intended victim and is pierced amidst some mumbo jumbo. Kris was impressed by the similarity between this hostile act and the custom of hanging or burning in effigy in which the image of the enemy is subjected to the death penalty. Thus he was specially interested in the late medieval institution of defamatory images such as this crude drawing of 1438 showing the Landgrave of Hesse and his coat of arms suspended upside down from a gibbet (Fig. 310). The mere threat of publicizing such an image could be used as a means of pressure to ensure the repayment of a loan or the righting of a wrong. Mark that this pictorial insult is not a caricature; there is no attempt to distort the nobleman's physiognomy. It was in fact in the contrast between the aggressive use of images and the artistic genre of 'caricatura', that emerged in Italy around 1600, that Kris looked for the key to the comparatively late arrival of portrait caricature. As long as the aggressive intention, he argued, was linked with a threat of magic, it would have been inconceivable to make play with the features of a dignitary as Bernini did in his caricature of the Pope (Fig. 311). While mankind remained in the thrall of magic fears it was literally no joke to transform a person's likeness. It was a neat hypothesis, and I certainly learned a lot in pursuing it jointly with a mentor of such profound insights.[9] However, it is one of the advantages of a long life, that one is granted time for second thoughts.

The book we finished in 1937 never came out, because of the political upheavals that preceded the last war, and when Kris and I met some ten years later, we had both gained some distance from our pet ideas. What began to disturb us was that our story was a trifle too tidy.[10] Like Freud himself, and also like Aby Warburg, Kris had been under the spell of an evolutionist interpretation of human history which was conceived as moving from primitive irrationality to the triumph of reason. Just as Warburg arranged the sections of his library to illustrate the progress from magic to science, so the history of pictorial satire in our book was to illustrate a corresponding secular development.

Recent experience has disabused all of us of such optimism. Not that we

309 Neb (Ronald Niebur), *Goebbels and Hitler*. Pocket cartoon from the *Daily Mail*, 26 August 1941

310
Defamatory image of the Landgrave of Hesse, 1438

311
Gianlorenzo Bernini, *Caricature of Scipione Borghese*

312
Andrea del Sarto, *Sketches of hanged Men*. Uffizi, Florence

need deny the reality of progress in the history of civilizations, but one can hold on to this belief and yet accept the basic fact that what is called human nature never changes.[11]

Luck will have it that I do not have to lose myself in abstract speculations to justify this conviction. It so happens that in the month of July 1989, while I was preparing this text, the London *Times* printed two items which illustrate my point to perfection. One was a court case in which it was reported that a woman had paid a practitioner of the occult the paltry sum of £25 to kill her estranged husband by means of the usual paraphernalia of a wax doll and earth from a cemetery;[12] a story as recent as you could wish. The other, eight days later, was a letter describing an incident in which the effigy of a British Minister of the Crown was burnt in protest against a planning regulation.[13] You see, *plus ça change* ... Even so, the values of our civilization asserted themselves in both cases. In the past the magician would certainly have been condemned to be burnt at the stake; in the case in question, the judge merely told him that he was a silly man. Equally telling is the fact that the Minister of the Crown received a public apology for the outrage, which in the eyes of his very opponents could only do harm to their case. What the fabric of civilization had achieved was to impose its conventional code of manners that aims at taming such manifestations of human savagery.

I do not think one could easily imagine a social code that condoned the intentions of black magic aiming at clandestine murder. It is entirely different with punishments in effigy. We have seen that such rituals were in fact part of the legal code in many medieval communities. Samuel Edgerton has devoted a monograph to part of this tradition in his book on *Painting and Punishment in Tuscany*,[14] in which he shows how frequently leading painters such as Andrea del Sarto were commissioned to represent on the façade of town halls criminals or public enemies as hanging ignominiously from the gallows (Fig. 312). I must agree with him that this has nothing to do with what he calls voodoo. The worthy city magistrates would have been horrified if they had been told that they practised *maleficium*. Their aim was not to enlist the services of the Demon to contravene the laws of man and of nature by inflicting physical damage on the enemy. They wanted rather to perpetuate or, if necessary, to replace the public disgrace of a shameful execution.

Many years ago I wrote a little essay with the title 'Meditations on a Hobby Horse', in which I argued that the toy served the child as a substitute for the real thing.[15] Those who cheer at mock executions are not children, but they share with children that capacity of entertaining fictions that is really part of unchanging human nature. When I wrote that essay I did not know, or did not remember, that the German philosopher Vaihinger had written a heavy tome

on what he called *Die Philosophie des Als-Ob*, the philosophy of 'as if',[16] pointing out how much of human culture comes under the heading of *Als-Ob*, of fiction; not only art, and play of course, and a good deal of science, but also the conventions and traditions of social life. Whether we begin a letter with 'Dear Sir' or end it with 'Yours sincerely', we do not expect to be asked how dear the addressee happens to be to us, or how sincerely we mean it. Culture as we know it could hardly exist without our joining in these perpetual games of make-believe which oil the wheels of social interaction. Thus in referring to the basic fictional character of these insulting images I do not want to minimize their social importance. Even though the purpose was not to injure the victim physically, it was still intended to injure his or her *persona*, its position in that network of cultural conventions of which I have spoken, that sum of all the shared values and beliefs that secure a person's standing; everything, in fact, that distinguishes him or her from an animal and is experienced as honour.

313
Workshop of Lucas Cranach, 'The Papal Arms defiled'. From *Abbildung des Pappstums* (1545)

The annals of human cruelty record only too many methods by which a person could be dishonoured, from the victor setting his foot on the neck of the vanquished, to the stock and the pillory and similar exposures to public derision and disgrace. I need not tell you that the code of honour maintained by society is no laughing matter; an insult would leave a stain that could only be washed off with blood, as the saying went. The metaphor of the stain is as telling as any. If honour was equated with purity, dishonour meant besmirching, defilement, that horror of our early childhood dating back to our toilet training.

We may here return to Luther, whose polemics and prints equally indulged in scatological imagery, as in the print of the peasants relieving themselves into the papal tiara (Fig. 313). I claimed that human nature remains the same, and sure enough you find a close parallel in that anti-clerical print of the French Revolution where the papal *breve* is used as toilet paper (Fig. 314). If proof were needed that revolutions can be pretty revolting, you would have it here. Revolting, yes – but effective? In asking this simple question we must surely distinguish between their effect on the followers and on the opposing camp. No doubt the demonstration that you can desecrate with impunity what the others hold sacred may have strengthened waverers. Like the prophets and missionaries of old, Luther and the anti-clerical revolutionaries were eager to demonstrate that the gods their opponents worshipped were unable to protect their honour. You could insult the Vicar of Christ in the crudest manner and the heavens did not fall. One is tempted to describe the desired effect if not as magic at least as anti-magic, undoing the opponents' pretensions to supernatural power. But was this demonstration likely to

314
Bref du Pape, 1791.
Bibliothèque Nationale,
Paris, Cabinet des
Estampes

BRÉF. DU. PAPE. EN. 1791.

convince anyone not yet converted to such daring views? Would it not rather arouse contempt and fury and rally them to defend the honour of their faith?

Once more I find confirmation of the views implied in this sceptical question in events with which recent press reports have made us only too familiar. I am thinking first of all of the case recently in front of the Supreme Court of the United States dealing precisely with the defilement of a national symbol, the case of the youngster who had spat on the American flag amidst derisory chants before burning it in public. The court allowed him to go free since the States, unlike other communities, has no laws forbidding such outrages. But the very decision of the court caused such a public reaction that it certainly had the opposite effect of that intended by the silly insult. Far from bringing the flag into disrepute, it led to a widespread demand for its sanctification. Indeed, I can document this reaction once more from the pages of *The Times*, an article of 31 July 1989 containing the dire prediction that 'future historians will date the decline and fall of the United States' from that decision.

Not surprisingly, perhaps, this opinion was voiced in connection with that other topical example of a real or alleged insult, Salman Rushdie's alleged blasphemy against the prophet of Islam. If any single act could have served to rally and unite the Muslim world, it was the publication of Rushdie's novel *The*

315
William Hogarth, *The Gate of Calais* (detail), 1748–9

316
James Gillray, *French Liberty, British Slavery*, 1792. British Museum, London

Satanic Verses, which few of the protesters are likely even to have read. No matter – they are forced by public pressure to act as if they have read it and have taken deep offence.

It is observations of this kind which have prompted second thoughts in me about the true function of pictorial satire. There is a heavy German volume on this subject with the title *Bild als Waffe* (*The Image as a Weapon*),[7] which also contains an old paper of mine called, in the same vein, 'The Cartoonist's Armoury'.[18] But are these images such formidable weapons? No doubt they were often so intended, but have they not frequently backfired? Is their true function not rather to preach to the converted?

I know we frequently use this phrase when we wish to dismiss an effort of this kind as pointless, but if preaching to the converted were quite without a function there would have to be no sermons, day in, day out, in all the churches and shrines of the world. The sermon, like other ritual acts, exists of course to renew and reinforce the ties of common faith and common values that hold the community together.

What is described nowadays as a sense of identity is always buttressed by an assumption of superiority over those who do not belong. It is this function satire has always served, whether we think of images, of songs, or merely of anecdotes and jokes at the expense of the neighbours. The guild of the cobblers used to mock that of the tailors, the city-dwellers the clod-hopping peasants, the sailors the landlubbers, and no doubt, if you listen to common-room conversation, you will hear art historians who feel superior to scientists or vice versa. Every nation invents derisory names for their neighbours, the British used to call the French 'frogs' and the Germans 'Krauts', because their diet was considered contemptible.

It is this rather fatuous sense of superiority to which pictorial satire has contributed by reinforcing the stereotype any group has of itself and of others. Think of Hogarth's *Gate of Calais*, which mocks the gluttonous French monk and the starveling frontier guard greedily eyeing the roast beef, that symbol of

317
Papstesel, 1523

British well-being (Fig. 315); or of Gillray's cartoon of 1792 tellingly contrasting 'French liberty and British slavery' (Fig. 316). No doubt the cohesion of the group tends to precede rather than to follow the sharing of ideologies.

Returning from this side to the role of myth in pictorial satire, we may see more easily how a mythical figure such as the Devil retains its position across the transformations we have observed. There are many ways in which the shared values and beliefs of a myth can turn into the fiction of 'as if' without losing their hold on the group. The patriotic conviction that God is on our side in any conflict is rarely challenged even by those who cannot share it, and here again irrational beliefs may be seen to shade into mere metaphor. Nearly all early cultures, for instance, shared the belief in portents and apparitions as signals and signs from superior powers. Comets or monstrous births have been universally interpreted as signs from above presaging cataclysmic events, and political imagery has never been slow in taking up these prognostics. Their role in the German Reformation has been described in a memorable paper by Aby Warburg.[19] Their meaning and message is summed up most succinctly in the caption of the notorious woodcut of the *Papstesel* or Popish ass, the alleged miscarriage of a donkey said to have been washed up by the Tiber at the end of the fifteenth century (Fig. 317):

> *Was Gott selbs von dem Bapstum helt*
> *Zeigt dis schrecklich Bild hie gestellt.*

'What God himself thinks of Popery is shown in the awesome image here represented.' We may compare it with Villeneuve's powerful image from the French Revolution, alluding to the Biblical portent of the 'Writing on the Wall' at Belshazzar's feast (Fig. 318). But here again the question arises how far the artist or his public believed in the literal truth of that story, or whether he merely tapped it, as it were, to enhance the prediction of doom.[20] Luck will have it that one of the many political satires against Louis XIV explicitly answers this question. I refer to a German print of 1706 celebrating Marlborough's victory over the *Roi Soleil* as *Die grosse Sonnenfinsternis*, the great eclipse in the sky on 12 May (Fig. 319). There actually had been an eclipse on the day when the battle of Ramillies was fought which attracted much comment, but the letterpress of our print is careful to explain to the reader that 'it is well known in our enlightened century that events in Heaven have no influence on what happens on earth'. The eclipse is to be interpreted as a metaphor for the defeat of the *Roi Soleil*. The author seems to have been eager to distance himself from the common run of vulgar prognostics and to appeal

318
Villeneuve, *Louis le traître, lis ta sentence*, 1793. Bibliothèque Nationale, Paris, Cabinet des Estampes

319
Die grosse Sonnenfinsternis, 1706. British Museum, London

to the sense of superiority of his more sophisticated public while deflating the talk about the Sun King as mere make-believe. Naturally, in taking this stance, the author of this satirical image must forgo the original advantage of the use of myth, which could explain to the reader the true significance of events in the news. Unlike Luther's Popish ass or the print celebrating the failure of the Gunpowder Plot, the metaphorical comment can now claim no more than being a witty marginal note to the news of the day. Its merits must lie in its aptness. Thus, by disclaiming all magic or mythical elements, our print reveals itself as an early example of what we now call a political cartoon. It is this genre of the cartoon, of course, that derives its effect from the use of the metaphor to comment on the topical reports of the day. It relies on a public that enjoys the wit of the comparison which may not explain but sum up a situation.

In the same years in which our mock prognostic appeared, a clever publisher of prints in Holland seized on this potentiality of pictorial comparison to make easy money. He evidently bought up a number of old copper plates with biblical illustrations and reissued them with new superimposed texts alluding to the events of the day.[21] Thus one of Lucas van Leyden's prints showing David returning with the head of Goliath is reinterpreted as the 'Goliath of War beheaded by Peace' (Fig. 320). I do not propose to pursue the further allusions in the text nor show you some of his more far-fetched comparisons which can never have been very funny or effective. Even so, I find the example as illuminating as the one previously discussed, because it exemplifies in the neatest possible form what the cartoonist is trying to do in his play with metaphors. He is applying a story or myth known to the public to an event that is news and thus links the familiar with the unfamiliar. He treats the

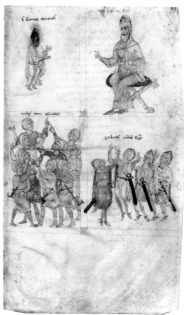

incidents of the day as if they were all part of the old story, as if there was
never really anything new under the sun. If one of the functions of myth may
be said to offer an explanation for the events in nature, the skilfully applied
metaphor will present at least a fictional explanation of world events. Hence
nothing is more characteristic of pictorial satire than its conservatism, the
tendency to draw on the same old stock of motifs and stereotypes. These
motifs can take the place of the communal myth serving to reassure in the
guise of an explanation.

I should like to document the tenacity of these traditions by going back as
far as possible in the history of the genre, in fact to the end of the twelfth
century, and to show to what extent the motifs and metaphors that served a
medieval author retained their usefulness for six hundred years or more. My
demonstration piece will be an illuminated manuscript from southern Italy
preserved in the library at Berne, which contains a poem by Pietro da Eboli
celebrating the triumph of one of the Hohenstauffen Emperors, Henry VI,
over Tancred in the struggle for power over the kingdom of Sicily in the years
between 1190 and 1194.[22] Not that the satirical pictures of Tancred which you
will see can have been meant as propaganda in the modern sense. The
manuscript was not intended for publicity but as a gift to the Emperor, who
might just have chuckled over the derision of his erstwhile opponent.

This opponent had actually been elected king by a vocal section of the
population as you see it represented on one of the first folios of the codex

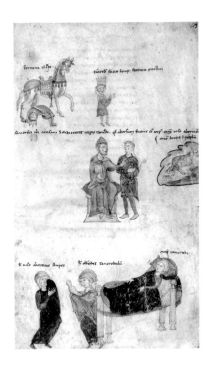

THE HORSE AMERICA, throwing his Master.

(Fig. 321). Tancred appears to have been small of stature and of questionable noble birth, and the author goes all out in his book to lampoon him for these disadvantages.

The most telling of the pages setting the scene anticipates the story to follow: the man falling from his horse is labelled 'fortuna Tancredi' (Fig. 322). Naturally this does not represent a real incident but refers to his sin of pride, one of the seven mortal sins in the moral system of the period, which is also represented by a rider falling from his mount on the jambs of Notre-Dame-de-Paris and Amiens dating from the same decades (Fig. 323). But while the images on the cathedral porch offer a generalized picture sermon, our manuscript singles out Tancred as an exemplar of pride, much as Dante, more than a century later, was to select his memorable portraits of individual sinners and saints from within the cosmic framework of the Divine Comedy. But the metaphor of the rider falling from his mount is too tempting a comparison ever to be abandoned. Here you see a print of 1779 showing George III being thrown by the horse America (Fig. 324); the satire dates from the period when portrait caricature had been absorbed by political prints. The drawing next to the horse is so faded that I prefer to show it in a reasonably accurate eighteenth-century copy (Fig. 325). It should certainly be of interest to the historian of portrait caricature because it will compel him to qualify the assertion of the late emergence of that genre.

Here Tancred is vilified as having the 'body of a boy and the face of an old man' – *Facie senex, statura puelli*. We may never know how close this description came to the real appearance of Tancred, but we can see that the author, skilled as he was, was defeated in portraying these contradictory features: he drew both a boy and the head of an old man. It took some time in the history of the genre for this formula to become commonplace. Let me take David Low's teasing caricature of Beaverbrook, whose body he deliberately reduced in scale to concentrate on the grinning head (Fig. 326).

Maybe it was because of his inability to do justice to his theme of Tancred's ugliness by purely pictorial means that the author indulged himself on the rest of the page (Fig. 322) in a lengthy account of the reasons for that physical deformity. A medical expert from Salerno had explained to the author that this deformity was the result of the child's mixed blood which produced such abominations in men and animals. He shows us below the scene of the birth where the midwife holds up the newborn, and another woman hides her face in horror.

You might think and even hope that this coarse kind of vilification did not survive into more enlightened ages – but this hope would be disappointed. There is a satirical print against the poet Alexander Pope, whose name is indicated by the punning symbol of the Papal tiara for 'Pope', and whose monkey's body brutally alludes to the poet's physical deformity (Fig. 330). The caption echoes the earlier slander in even more brutal terms:

Nature herself shrank back when thou wert born
And cry's the work's not mine –
The midwife stood aghast, and when she saw
Thy mountain back and thy distorted legs
The face half-minted with the stamp of man,
And half o'ercome with Beast stood doubting long …

The temptation of comparing a small man with a monkey was too obvious to

327
'Tancredus futura cogitans lacrimat[ur]', from Pietro da Eboli, *De Rebus Siculis*, Stadtbibliothek, Berne, MS. 120, fol 121

328
'Simia factus rex', from Pietro da Eboli, *De Rebus Siculis*, Stadtbibliothek, Berne, MS. 120, fol. 104

329
Congrès des rois coalisés, *c*.1793. Bibliothèque Nationale, Paris, Cabinet des Estampes

330
Satire against Alexander Pope, 1728. British Museum, London

have been resisted by our medieval illuminator, who describes and depicts Tancred on another page as a monkey turned king, *Simia factus rex* (Fig. 328). You will not be surprised that this kind of mockery survived into the French Revolution, though I find it neat that on this print it happens to be the King of Naples who is represented as a monkey (Fig. 329).

It used to be the fashion in art history to deny or at least to minimize the element of skill needed in shaping an image, everybody could do what he

331
Johann M. Voltz, *Blick in die Vergangenheit und Zukunft beim Anfang des Jahres 1814*

332
Honoré Daumier, *Le Passé, le présent, l'avenir*, from *La Caricature*, 9 January 1834

333
Honoré Daumier, *Louis-Philippe, 1830 and 1833*, from *La Caricature*, 15 August 1833

wanted to do. I have never believed this. In any case, our twelfth-century artist certainly made a valiant effort to render his victim with the appropriate facial expression. He represented Tancred sitting on his throne in the solitude of his chamber meditating on his helplessness in the face of the approaching armies, 'Thinking of the future, Tancred weeps' — *Futura cogitans, lacrimatur* (or rather, *lacrimat*) (Fig. 327). It is a motif which has equally appealed to later satirists. Here is a German cartoon against Napoleon showing him as a double-headed Janus, smiling at the past and trembling at the future (Fig. 331); and here is the master of the genre, Daumier, going one better, using the caricatured head of Louis-Philippe, the *poire* of Philippon's campaign, as a *signum triceps*, the triad of the past, present and future (Fig. 332). Nor can I resist showing that other print purporting to demonstrate how the King's face had changed from confident bonhomie to disgruntled pessimism (Fig. 333), reminding us what a real master of satire can do with an ancient motif.

Turning to the concluding pages of our medieval manuscript, we find the participants of the struggle inserted into the cosmic conflict between good and evil. The legitimate Emperor, Henri VI, is attended by the seven virtues; below you see the goddess Fortuna (Fig. 334). We read that she wanted to join the Emperor's attendants, but was repulsed, and rightly so — for Fortune is fickle, she continuously turns her wheel, and he who is exalted to glory, as the caption says, is diminished and carried downwards, as happened to Tancred whom we see prostrate below.

This particular visualization of the ups and downs of fate has appealed to the imagination of man ever since it was first conceived by Boethius. The Wheel of Fortune became part of the stock-in-trade of the political satirist. This print of 1621 (Fig. 335) applies the metaphor to the dramatic story of Frederick of the Palatinate, the so-called Winter King who lost his short-lived kingdom of Bohemia at the Battle of White Mountain. Few episodes of the past provoked a larger spate of satirical prints than this discomfiture of a pretender.[23] It is fairly obvious once more, therefore, that these prints were not intended as weapons. He had failed and serves him right. His case, like that of

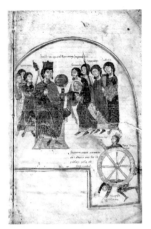

Tancred, would confirm the homely adage that pride comes before a fall. We know for whom Pietro da Eboli had produced his poem, and why. He did so to flatter the Emperor and benefit from his bounty. But what can have moved the publishers of these prints to go to such trouble? The answer may be simple – they also wanted to make money, and they knew that their public would enjoy the reassuring news that those who ride too high will come to grief. It may not be to the credit of mankind that satire so often hits at those who are down, but the German proverb says: *Wer den Schaden hat, hat auch den Spott*, roughly translated: Injury attracts Insult. It is often claimed that English has no word for the ugly emotion of *Schadenfreude*, but it has the verb 'gloating', and gloating is precisely what satirists have done since the days of Pietro da Eboli. How else can we describe the concluding page of the manuscript with the glorification of the Emperor, who sits on the throne of Solomon, the seat of Wisdom, flanked and guarded by his faithful Paladins (Fig. 336). Wisdom once more rejects Fortuna who is seen to weep while Tancred has fallen under her wheel. Wisdom reminds her of another Sicilian usurper, one Andronicus, who had recently come to grief, and she recalls the fate of Icarus and that of the giants who were hurled down by Jove. The crudely drawn falling limbs under the image of the sun are another reminder of the sticky end to which ambition must ultimately lead.

Once more the same association occurred spontaneously to subsequent generations of satirists for whom Icarus provided a convenient metaphor. Here is Gillray in 1807 representing the fall from office of Lord Temple, with George III as the sun (Fig. 337). But the jokes and allusions of this cruel print are much more complex in the way they condense any number of metaphors into one image. Temple had belonged to a cabinet which was said to have been broadly based and whose members were therefore lampooned by Gillray as

334
'Henri IV and Fortuna', from Pietro da Eboli, *De Rebus Siculis*, Stadtbibliothek, Berne, MS. 120, fol. 146

335
Frederick of the Palatinate under the Wheel of Fortune, 1621, Kunstammlungen der reste Coburg

336
'Henri IV triumphing
over his Enemies', from
Pietro da Eboli, *De Rebus
Siculis*, Stadtbibliothek,
MS. 120, fol. 147

337
James Gillray, *The Fall of
Icarus*, 20 April 1807.
British Museum, London

broad-bottoms. When leaving office he was rumoured to have taken with him a good deal of official stationery and sealing wax, and this provided the idea of his having needed wax to make wings as Daedalus and Icarus had done. The stake on which he is about to impale himself, by the way, is not merely a sadistic addition. It refers to a remark by Lord Temple who claimed that he had a stake in the country, which had provoked the retort that he had stolen the stake from the public hedge. Such jokes and tittle-tattle were frequently suggested as material to Gillray by far from disinterested amateurs, and what must look laboured to us was probably quite obvious to their fellow politicians. Cruel or not, they must have found the print extremely funny. The way all these motifs and several others are condensed into one image illustrates the sophistication that pictorial satire had reached as an art form. True, the insinuations woven into this lampoon cannot but have been wounding to the victim, all the more as there was no substance to the story of the purloined sealing wax. The print impugns Lord Temple's honour, but he had no redress, and I doubt that he looked for one. We do not read that he wanted to horse-whip Gillray, for all is fair in love and war, and in the game of politics you had to take the rough with the smooth. It is this new tolerance in relation to honour which the student of satire cannot leave out of his equation.[24]

There is a striking episode in Gillray's career which proves this radical change more vividly than any other. It turns out that at the time when George Canning was still an aspiring politician eager for publicity, he moved heaven

338
James Gillray, *The Promis'd Horrors of the French Invasion*, 20 October 1796. British Museum, London

and earth for his picture to be included in one of Gillray's cartoons, regardless of whether it made fun of him or not. The relevant documents, which are published in Draper Hill's book on Gillray, make hilarious reading.[25] It took a long time for Gillray to comply and in the end he finally paid Canning the desired compliment by hanging him in effigy from a lamp-post (Fig. 338). The reversal could not have been more drastic. The context of Gillray's print of October 1796 fits in well with the leading theme of this conference: it is called *The Promis'd Horrors of the French Invasion or Forcible reasons for negociating a Regicide Peace*. In the centre we see Pitt tied to a liberty tree and scourged by Fox. Decapitated heads abound, while the Whigs, gathered at their club at Brooks's, rejoice; and White's, the club of the Tories, is invaded by French soldiers.

You might think, and think rightly, that horrors, even imaginary horrors, are not a laughing matter. Indeed, the history of pictorial satire records many blood-curdling prints of atrocities committed by Turks or Spaniards in the terrible wars of the past. But for Gillray, pictorial satire had become a humorous genre; and so he gives his account of the horrors a humorous twist by lampooning the scaremongers. In doing so, of course, he makes light of the real terrors of the French Revolution, which a solid Englishman need not take seriously.

'Making light' seems to me altogether the formula for describing many of the political prints or cartoons which accompany the events of the eighteenth and nineteenth centuries. What better method of 'making light' than a lighthearted comparison, an illustrated metaphor? Take Gillray's print of 1798 entitled *Fighting for the Dunghill* (Fig. 339). He presents the war with all its dangers and agonies, *as if* it were nothing but a fight for a dunghill. In any case

339
James Gillray, *Fighting for the Dunghill*, 20 November 1798. British Museum, London

340
John Tenniel, *Dropping the Pilot*, March 1890

Fighting for the DUNGHILL : — or — *Jack Tar settling* BUONAPARTE .

there is nothing to worry about. Jack Tar may be a bit slow and uncouth, but he can take on anybody, and the comic emaciated Frenchman with his theatrical airs is surely no match for him. It is a reassuring picture, less an incitement against Napoleon than a boost to the morale at home.

The nearer we move to our time, the more this aspect of political satire appears to have come to the fore. On the whole it is more important for the political satirist to flatter his public than to incite to hatred. The recipe for success is rarely different from that of the popular press and the popular television programme. Build up their egos, confirm their prejudices, and above all, tell them not to worry.

Take that classic of a political cartoon, Tenniel's reaction to the news of Bismarck's dismissal – his famous drawing for *Punch*, captioned *Dropping the pilot* (Fig. 340). It must have been a shock for English readers to receive the news at their breakfast table that the most respected and feared statesman, the most powerful figure of the political chessboard, was to disappear overnight at the whim of the young Kaiser. Tenniel's comment on this turn of the wheel of Fortune is a reassuring one. By equating the event with the institution of dropping the pilot, his cartoon must have acted as a shock-absorber. It has often been observed that the metaphor was totally misleading. The pilot goes of his own accord, having performed his service of guiding the ship through the dangerous passage. Bismarck had not been a pilot, he had been the captain of the ship of state he himself had helped to launch, and he did not leave voluntarily. But it is precisely by masking this bitter truth that the cartoon must have achieved such popularity. All is well with the world and God in heaven, we need neither be sorry for the grand old man nor incensed about the Kaiser. Pass the butter please. This may be an extreme case, but all the more telling for that.

341
Nicholas Garland,
Cartoon for the
Independent, January 1989

Ladies and gentlemen, it does not often happen that an art historian is lucky enough to find that the results of his somewhat laborious thought-processes harmonize with the ideas a contemporary artist has formulated more succinctly about his craft. You can imagine, therefore, how delighted I was when I listened to a radio interview given by Nicholas Garland, a leading British newspaper cartoonist of our day, who worthily and wittily continues the tradition of David Low and Vicky.[26] Let me show you his cartoon for the *Independent*, dated 24 January 1989, in which he prophetically applied the metaphor of 'dragging someone kicking and screaming into the twentieth century' to the evolving situation in Poland (Fig. 341). With your permission, I should like to leave the last word to him.

Asked by the interviewer whether he wanted to influence what people think, Nicholas Garland replied emphatically, 'I never, never think of political cartoons influencing people . . . but they do something else, I think. The cartoons I particularly remember are cartoons that in some encapsulated way express something I already know, but in a form that is very readily available to me . . .' The cartoon, he says, 'simplifies what are often very complicated political issues right down to very child-like, simple pictures. It creates a little world in which all sorts of issues . . . that affect you in rather serious ways you can get another look at. Sometimes it has the effect of rather reducing one's anxiety about it . . .'

Editor's Postscript

Gombrich has mentioned his early published work with Ernst Kris in his own footnotes to this chapter. As he has often remarked, one of the problems of the early caricature problem was Kris's Freudian-Lamarckian assumption that human civilization was the achievement of biological evolution. This led to the idea that portrait caricature and the modern cartoon emerged from the

rejection of image magic and the taboos governing the use and abuse of personal imagery (see Art and Illusion, *Chapter X, pp. 289–91). The events of Nazism proved Freud wrong. Gombrich subsequently came to the view that the visual image can work at a number of levels and the way in which beliefs about them are activitated depends upon social circumstance: so we still see cases of image violation today. This essay sums up his present thoughts on the subject.*

In 1938, Gombrich and Kris published an article 'The Principles of Caricature' in the British Journal of Medical Psychology. *Gombrich also published a short essay on 'Art and Propaganda' in* The Listener *(7 December 1939), pp. 118-20; with Kris,* Caricature *(Harmondsworth, 1940) and 'The Artist and the Art of War', in* The Listener *(29 August 1940), pp. 311-12.*

He wrote 'Cartoons and Progress' in A. G. Weidenfeld (ed.), The Public's Progress *(London, 1947). A review of William Waldmann,* Honoré Daumier *for the* Burlington Magazine, *91 (1949), pp 231-2, was the first in a succession of reviews of books on cartoons and caricatures which he published there in 1948, 1954, 1957 and 1966. He developed his views on metaphor in 'Visual Metaphors of Value in Art' which was reprinted with 'The Cartoonist's Armoury' in* Meditations on a Hobby Horse. *More on the metaphor may be found in the extended version of 'Icones Symbolicae' in* Symbolic Images, *'Nature and Art as Needs of the Mind', reprinted in this volume (pp. 565–84), and 'Relativism in the Humanities: The Debate about Human Nature' in* Topics of our Time. *He also developed his ideas on caricatures and cartoons in 'The Dream of Reason', mentioned in the footnotes to this article, and the 1979 Freud Lectures at Yale University 'Impulse and Acceptance', from which the analysis of the Tancred images in this essay is drawn. He published a summary of his B. I. S. Leconfield Lecture, 'Italian Caricature and its English Transformation', in* Rivista: Journal of the British-Italian Society *(January/February 1988), pp. 1-4.*

Another related work is Ernst Kris and Otto Kurz, Legend, Myth, and Magic in the Image of the Artist *(New Haven, 1979), which has a preface by Gombrich.*

Part VII On the Nature of Art History

Approaches to the History of Art:
Three Points for Discussion

Introductory remarks
given at the Erasmus
Symposium in Holland in
1988; published in *Topics of
our Time* (1991), pp. 62–73

1 *The Problem of Explanation*

In science we seek to explain an individual event by referring it to a general law of nature. If I let go of this pencil and it falls, we explain this fact by Newton's law of gravity. Strictly speaking this is not quite so. For if this pencil were made of light material and filled with gas it might not fall but rise to the ceiling like a balloon, being lighter than the air it displaces, which may cause us to remember the law for floating bodies discovered by Archimedes, who was so excited about it that he ran naked through the streets of Syracuse shouting 'Eureka!' (I've got it!).

Unlike scientists, who have had many reasons since the time of Archimedes for shouting Eureka!, we humanists have been less fortunate, and that for the obvious reason that the events we try to explain tend to be immensely complex and can never be reduced to one easily formulated law, which we may describe as the cause of the event.

Even so, I agree with Sir Karl Popper that there is no difference in principle between explanations in history and in science; the difference is in the direction of our interest.[1] We humanists are less interested in such general questions as why bodies fall, sink or float, than in individual cases, particular events such as the outcome of a battle or the spread of a style.

The need for the explanation of singular events is not really peculiar to history. It also arises quite frequently in our daily lives and it is useful to remember these examples first. Think of one of the many accidents or disasters of which you read in the newspapers: an explosion, an air crash, Chernobyl, or the Zeebrugge ferry disaster. In each of these cases, committees of experts have been appointed to pinpoint the causes, not only for apportioning blame and legal costs, but also for the sake of preventing a repetition of the accident. These experts, it is useful to remember, work

within the framework of science. They know that a ferry cannot float on the surface when the open bow doors allow the water to stream in, and that a plane will crash when the engines stop. They do not mention these general laws in their final report because they are taken for granted. What they want to find out in every case is the combination of causes that ultimately led to the tragic outcome, and they know perfectly well that they would be faced by what is called an 'infinite regress' if they pursued every individual cause to its antecedents. They may find, for example, that the member of the ferry crew whose job it was to close the doors went to sleep instead, but they do not then go into the question of why he was sleepy or neglectful. These facts may perhaps interest his counsel for the defence in an ultimate trial, but they are not what the commission was asked to find out.

What it is always asked to do is to *eliminate wrong explanations*, let us say the charge of sabotage or maybe of black magic. If somebody tried to explain a disaster by pointing to the fact that it happened on a Friday the 13th, or because the planet Saturn was in the House of Aquarius, we would be entitled to reject the explanations as nonsense. I believe that for the historian this rejection of false or naïve explanations is as important as the search for better and more correct causal theories. We must clear the ground of rubbish before we can build.

If I am asked how I came to be interested in many so-called disciplines outside my own field, I need only quote the writings of the first art historian, Giorgio Vasari, to be precise the preface to the second part of his *Lives of the Painters* published in 1550:

> When I first undertook to describe these lives, it was not my intention merely to give notice of these artists and, so to say, present an inventory of their work; nor would I have considered it a worthy aim of my long and hard labours to trace their numbers, their place of origin or the place where they worked or where their works are at present to be found, because all that I could have done by means of a simple tabulation without anywhere giving my own opinion.[2]

Taking a leaf out of the ancient historians, Vasari, the contemporary of Machiavelli and of Guicciardini, then proceeds to explain what he considers the true tasks of a historian to be, and confesses that it is these he adopted as his model, endeavouring not only to express his judgement but also to explain 'the causes and the roots of style' (*le cause e le radici delle maniere*). With our expectation thus raised we may feel a sense of anticlimax when Vasari comes up with his explanation. He attributes what he calls the rebirth of the arts principally to the special air of Tuscany, while he also expresses his conviction

that the arts resemble the human body in having their birth, their growth, their maturity and their decline. Such analogical thinking, as you know, is still very widespread in historical writings, which abound in biological terms such as 'decadence'.

Anybody who takes these matters seriously must be struck by the inadequacy of the explanations which art historians have used in the context of their narratives. I need hardly mention what I have called the mythological tendencies of romantic historiography.[1] Mythology, of course, may be described as a primitive form of explanation. To use one of Popper's examples: the ancients might explain a storm or an earthquake by the theory that Neptune was angry, or a plague by the omission of a sacrifice demanded by the Gods. Romantic historiography, as I see it, is full of such mythological entities as the *Zeitgeist*, the *Volksgeist*, the process of production and the mechanism of biological evolution which are supposed to explain the historical destiny of cultures.

It is quite an interesting, if somewhat dispiriting, task to go through the writings of some of our best art historians to probe the explanations they incidentally or systematically offer their readers. Take Bernard Berenson, no doubt a great art historian, whose tabulations, as Vasari would have called his lists, certainly represent a landmark in our discipline. But when it comes to 'the cause and roots of style', to use Vasari's expression once more, Berenson has this to say in his brilliant essay on the Venetian painters, first published in the 1890s:[4]

> The growing delight in life with the consequent love of health, beauty and joy were felt more powerfully in Venice than anywhere else in Italy. The explanation of this may be found in the character of the Venetian government which was such that it gave little room for the satisfaction of the passion for personal glory, and kept its citizens so busy in duties of state that they had small leisure for learning. Some of the chief passions of the Renaissance thus finding no outlet in Venice, the other passions insisted all the more on being satisfied.

It was against this kind of easy chatter that what became the Vienna School of Art History reacted, insisting that their discipline should aspire to the status and precision of the sciences. One finds this overriding ambition particularly in the writings of the great Alois Riegl, who died in 1905 and left a body of work that is still regarded as presenting a challenge to his successors. It was Riegl who attempted to ground the history of art in the science of psychology as he knew it. According to the tradition of that time, which reaches back over many centuries, we must analyse perception into its main constituents, seeing

and touching. The eye, so it was believed, can be considered an optical instrument much like a photographic camera, allowing an image of the outside world to be formed on the retina. This image was necessarily flat and we derived our experience of space, of the third dimension, exclusively from touch. Using this simple framework, Riegl developed an all-embracing theory according to which the representation of nature in art underwent cycles of changes, moving from touch to vision or, as he put it, from the haptic to the optic. The ancient Egyptians built up their images from knowledge acquired by touch, the Impressionists from the image on the retina. This secular process Riegl proposed to explain by the theory that man's will-to-form (*Kunstwollen*) moved with a kind of clockwork regularity from the 'haptic' to the 'optic' pole.[5]

The skill, ingenuity and learning with which Riegl fitted his observations of figurative art, of ornament and of architecture into this scheme, which he even extended to embrace the development of philosophy, must certainly demand admiration, but having read Riegl with much care in my student days I felt the need to examine the evidence afresh.

Needless to say, this desire does not imply a lack of respect for the author of these theories – in a way we should always probe theories before adopting them in our work. In this particular case it is surely evident that the psychology of perception current today differs vastly from the simplistic ideas about vision and touch with which Riegl operated. To mention only one factor, we are very much more aware than he was of the role of movement in our perception of space. To put it a little more technically, it is the flow of information reaching us from the visual world which matters decisively in our perception. One of the problems faced by the painter who wants to represent an aspect of the visual world is of course that pictures do not move. He must stop the flow of information on which he is used to rely and this is no trivial feat. To cut a long story short, this fact accounts for the observation that the imitation of nature in art is a skill encoded in tradition that must be learned – a point to which I shall return. It was also the topic of my book *Art and Illusion*,[6] in which I attempted to account for the slow evolution of naturalistic styles from what one might call pictographic methods to more or less photographic ones.

But let me emphasize very strongly that the psychology of perception which interested me in that book can never offer more than a very partial explanation of an individual event in our field. It may contribute one of the strands in the complex tissue of interacting causes and events, but there will always be a myriad of others: the psychological disposition to enjoy splendour and sparkle and the counteracting effects of sophistication resisting these

primitive delights;[7] the social aspects of competition, the desire to outdo one's rival in any one particular effect, a desire which also presupposes that we must have information about what the rival has achieved. I have written of the auction effect, what I called the logic of Vanity Fair.[8]

Looking at the world of fashions and of styles the historian will notice that some particular feature will suddenly attract attention and become the object of rivalry. It may be the length or shortness of skirts, the size of orchestras in which the princelings of Germany competed, or the daring in breaking social taboos on the stage with more and more nudity, such as we have witnessed in our day. I have suggested that it is part of that logic that to attract attention you must be different from the others, and therefore you must think of something new as soon as the others have caught up with you. It is important to realize that these matters are not really the province of psychology. They are not rooted in what is called human nature, because after all there are many societies in which there are no similar competitions. What must be taken into account in such events is also what Popper has called the logic of situations. He refers to such simplified models as are now familiar from the science of economics which investigate the possible effects of a particular move.[9] To use his example: if somebody wants to buy a house in a particular area he wants to pay as little as possible, but the very fact that he has entered the market is likely to drive the price up. On a more drastic scale we have experienced the effect of the introduction of computers as at least one cause of the recent crash of the Stock Exchange. If you programme your computers to sell shares when their price drops below a certain point, more and more shares will be thrown on the market in a feedback effect which will increasingly lower the prices.

Even here you must be aware of hitting upon an explanation which really explains too much and would never allow the situation to be remedied. Quite generally, it stands to reason that the historian must apply what is called common sense. There are so many competing overriding theories offered to him – Marxism, racialism, psychoanalysis, structuralism and any other global theory claiming to explain the whole of human behaviour and of history. These claims often sound attractive: they operate with selected examples and promise the practitioner a safe method of dealing with his material, but a moment of reflection should convince him that their promise is bound to be spurious. It is bound to be spurious because the explanations we seek will always depend on our interest and on the question we wish to ask.

When I gave a seminar on these questions of method attended by a number of excellent young historians we developed a kind of shorthand language for this problem. We called it 'Cupology'. The word arose because one of us took a teacup which stood on the table and attempted to list the questions you

might ask about it. You might begin by wanting to know what it was made of: if it was made of china the train of thought would get you immediately to the fascinating history of its manufacture, if it was made of plastic even more so. If you asked why it had a handle you needed some elementary physics to explain the conduction of heat to your fingers. You needed medicine to explain the popularity of tea as a refreshment, and geography to describe how tea came to the West from China. You needed botany for your account of tea plantations, not to mention the tragic effect of the importation of Tamils into Ceylon by the British to work these plantations. Surely it would not be hard to introduce aesthetics or sociology. Properly handled, each of these questions might result in an interesting paper, or even in a book. The decision as to which question to ask will always remain with us. We will be guided partly by the tradition of research in these matters, partly also by the chance we perceive of finding out something new. What the historian needs in such matters is some tact and some flair, what is called 'an eye for a problem'.

We are often exhorted to engage in interdisciplinary research, but I am far from sure that this is a valid issue. What we call disciplines are, at best, matters of organizational convenience in academic life. It is surely convenient to have a department of Sanskrit in which you find the dictionaries and the texts relevant to this study, and also the specialists whom you can consult. But each of these specialists is likely to ask very different questions, questions of comparative philology, of the history of religion or of the development of Sanskrit logic. Each of them must be able to look out of the window, for if we draw the blinds and close the shutters we shall see precisely nothing.

2 *Technology and Tradition*
As I indicated above I believe that the history of art can be conceived in terms of a technological progress, a series of technical inventions which led to the increasing perfection of the imitation of nature, which of course is not the same as aesthetic perfection. Not only can the history of art be so conceived, it was written in this form by the first historians of art in antiquity and in the Renaissance. If you open the thirty-fifth and thirty-sixth books of Pliny's *Natural History*, [10] written at the beginning of our era, you will find that he regularly mentions the technical improvements introduced by individual artists. A certain Cimon of Cleone was said to have invented the painting of profiles and also of heads looking back, upwards or downwards. He distinguished between the joints of the limbs and made the veins visible. The famous Polygnotus started to paint people with their mouth open, showing the teeth, thus overcoming the rigidity of their features. Parrhasius was the first to bring symmetry into paintings, to impart expression to the head, and

to paint hair beautifully. And so it goes on. Pliny compiled these rather primitive characterizations from Greek sources which are lost to us. Primitive or not, there is little doubt that the history of art owes its existence to the realization that the methods of artists had changed and were changing at the time when these writers lived, and that works of art produced a few generations or centuries earlier looked to them crude and unskilled.

As we know, Vasari looked upon the development of painting and sculpture up to his own time in a similar way, though with greater understanding and sophistication. His work became the standard account of the development of Italian art from the thirteenth to the fifteenth century, but ever since the Romantic period his technological bias presented something of an embarrassment to historians of art. They rightly hesitated to speak of progress between such great masters as Giotto and Fra Angelico, Botticelli and Michelangelo. The devaluation of technological skill in twentieth-century art and art teaching further contributed to this embarrassment. The history of art should not be taught as a history of technological progress but as the history of various styles, each perfect in its own right as a valid expression of the age.

I take a different line. Not that I want to deny the glories of Archaic or Romanesque art, which are no longer in need of defenders. But I have become convinced in my work that the technological approach has been sadly neglected in the history of art and that it is time to restore it.

When I referred in the first part of this essay to 'Cupology', I stressed that you can go in any direction from any object and find interesting problems for your research. But precisely because this is so, I think we should not be tempted too easily to neglect the object itself. We must learn to focus on it rather than yield to what may be called the centrifugal tendencies of certain intellectual fashions. No doubt it is interesting when studying the arts of Florence to learn about the class structure of that city, about its commerce or its religious movements. But being art historians we should not go off on a tangent but rather learn as much as we can about the painter's craft. We should ask ourselves how these masters achieved certain effects and how these effects or tricks were introduced and modified – precisely the type of question Vasari asked.

I have found in my work that so little has been done in this respect that I have sometimes been tempted to say that we do not yet have a history of art worthy of its name. More or less the only aspect of this history that has been thoroughly discussed is what is called the rendering of space, including the history of perspective. There is little work of equal detail on the history of light in painting or on the rendering of texture." I was astonished to find for

instance how little art historians had attended to the ways of painting eyes or to the question of when and how the highlight in the eyes was first discovered and then rediscovered. Another time I was equally surprised to find, when studying Leonardo's *Trattato* and his precepts for painting trees and foliage in various types of illumination,[12] how little attention had been paid to the history of this development, though I was able to pay tribute to John Ruskin's *Modern Painters*, a work that certainly does not neglect the craft aspect of painting – but then it was written almost a century and a half ago.

I trust I need hardly explain how I see the connection between the study of technology, the tricks of the trade in the crafts, and the study of tradition. We all know that the craftsman learned while serving as apprentice to a master and that these systems and standards were carefully regulated by the guilds. But even before and after this system had crystallized, the need of any craft demanded the continuity of its exercise. Hence what is characteristic of almost any craft tradition is the formation of centres of excellence.

Go back in history as far as you like, to the days when Solomon built his temple in Jerusalem. We read that he sent for Hiram of Tyre, the son of a Phoenician and a man filled with wisdom and understanding and cunning, to carry out all work in brass.[13] Who can doubt that the account reflects the situation, so often repeated in history, that in the absence of a local tradition a master was called from a centre of acknowledged excellence? In later centuries the city of Damascus gave its name to high-quality blades, while in the Middle Ages the Moselle region produced that wonderful Mosan type of metalwork of which the church treasures of Europe contain such lovely examples. We all know of Persian carpets, Brussels lace, Delft tiles, Dresden china, Cremona violins, to list a few more examples almost at random, and in more recent time, Swiss watches, Japanese cameras and perhaps Scotch whisky.

I frankly do not know if any social historian has set himself the task of investigating this phenomenon as such; maybe he would find that there are too many variables involved to make a profitable field of study. Many craft traditions are no doubt dependent on the availability of materials, like china clay or lacquer, and with them on tools and equipment which are literally handed on from master to apprentice. But what matters most is obviously a kind of skill which cannot be learned overnight, what we call 'know-how', which is more than theoretical knowledge and rather a feel for the material and for the problems of the craft which must become second nature.

I know perfectly well that craftsmanship alone is not the same as artistic genius. Dou, the marvellous craftsman, never became a Rembrandt. But could Rembrandt himself have become Rembrandt if he had never mastered the

craft? Once more I think that much contemporary aesthetics tends to neglect what I have called the technological aspect of the great achievements in the history of art. As far as we can tell, these transcending achievements have always grown out of the soil prepared and fertilized by a great craft tradition. I believe that in this and other respects we tend to use the word creativity too lightly. Creativity does not come out of the void. It is the impulse to search out the possibilities and the varieties of solutions offered by the craft tradition which will produce novelty and originality, because what the craftsman learns is not only to copy but also to vary, to exploit his resources to the full and push his skill to the very limits of what a task will allow and suggest. This is what almost any master will do, but the outstanding individual will transcend this high level and produce a work that we then see as the culmination of the tradition: a Stradivarius violin in Cremona, a Taj Mahal in India, or the stained-glass window of the *Belle Vierge* at Chartres Cathedral. The question I should like to raise briefly is whether there can possibly be an explanation of these high points in the history of art.

We art historians are so used to acknowledging the importance of these centres of excellence that we do not hesitate to call a painting or an illuminated manuscript 'provincial' if we find that it does not come up to the standards of the tradition. But why should a work produced in a provincial workshop far from the hub of events fall short of excellence? Why should not a man of talent and originality have lived and worked anywhere and produced works to equal or surpass the most renowned creators of the age? It is a question which also engaged the mind of Vasari, and his answer has a strong sociological slant. He attributes the decline in standards to the lack of competition. Thus he tells us of the reason why the great Donatello decided to return to Florence after completing his wonderful works at Padua. He found, according to Vasari, that he encountered too much praise and applause. He preferred to go back to his native city where he was constantly criticized, because these strictures would make him work harder and thus achieve greater glory.[14]

I have quoted elsewhere Vasari's marvellous analysis of the Florentine situation in his *Life of Perugino*, which again centres on the bracing artistic climate of Florence, where you had to be very good indeed to survive at all.[15] We know that Vasari does not speak for himself only. When Dürer came from Nuremberg to Venice he noted with some surprise that a Venetian engraver he had admired in Germany, Jacopo Barbari, was not highly esteemed in his native town. 'People say', wrote Dürer, 'that if he were better he would stay here.' In other words he would brave the competition of his rivals.[16]

I would not have referred to these testimonies if I did not think that there

is something in this sociological explanation of artistic excellence. What it brings out implicitly, above all, is the importance of a critical audience, a public of discriminating connoisseurs whose high standards do not allow the artist to get away with anything but the best. Indeed, if we speak of traditions here, we must never forget the role of the consumer, patron or client who forms an important element in the equation.

In my essay on 'Art History and the Social Sciences'[17] I stressed that this rise of an informed public is by no means confined to the arts and that there is no kind of display or skill in any culture which lacks its connoisseurs or its fans. There will always be a circle of followers who can discuss and appreciate the so-called finer points and whose response will help to make or break reputations. There are traditions in appreciation as well as in creativity. It will be the point of the last section of this essay that we neglect this tradition at our peril.

3 'Value-Free' Humanities?

My answer to the question posed by the title will surprise no one. I have always been convinced that the humanities must depend on a system of values and that this is precisely what distinguishes them from the natural sciences. Even so, it may still be worthwhile rehearsing my reasons for this opinion, because there is a strong intellectual trend nowadays advocating the opposite point of view. What is sometimes called 'The New Art History', which is sometimes but not necessarily allied to a Marxist interpretation, aspires precisely to an elimination of bourgeois prejudices and academic conservatism. Why just study Raphael or Rembrandt? Should the historian not be as neutral as the scientist? The astronomer will not pick on stars for his spectral analysis because they sparkle so prettily, and the botanist will not stick to just roses or tulips.

Of course there is something to this argument. There is no reason why an art historian should not study the minor masters or the humble products of popular crafts. Just as the linguist will be concerned with any text in the language he studies, a magic spell, a prayer, a contract or an offer of sale, so the student of images should be ready to concern himself with any product of the kind. The reason why I am sceptical about this claim that has been made for a new art history is not that I find this approach wrong or distasteful, but rather because I cannot see what should be new in it. We have had this kind of discipline for several centuries; it is called archaeology, a type of study that has particularly flourished in England, where the Society of Antiquaries was founded back in the eighteenth century. If you turn the pages of their Journal and their Yearbook you will not see many paintings by Raphael among the

illustrations, but figurines, potsherds, carved beams or tombstones, in short any artefact that interests the archaeologist as evidence for his investigations – be it of early settlements, of trade routes, of patterns of cultivation or any other aspect of our history. Archaeology may indeed claim to be a science making increasing use of scientific tools and methods such as carbon dating, pollen analysis or thermoluminescence. Needless to say, these methods have also spilled over into art history because we cannot afford to neglect any kind of evidence or source of knowledge. But neither can we afford to lack a principle of selection, a point of view. Once more I may remind you here of what we called 'Cupology' (see p. 359). 'Cupology', if I understand it rightly, belongs to archaeology. Any cup or beaker may serve to get us talking and investigating one of the innumerable chains of cause and effect that ultimately resulted in the object in front of us. But as art historians we have a different ambition. We are concerned with the history of art and art is an embodiment of values. Admittedly I am begging the question here. As I have stressed elsewhere,[18] there are two meanings of the term 'art' in English, a neutral one which describes any image, as when we speak of child art or the art of the insane, and a valuative one, as when we say 'this may be the work of a madman but what he has produced is a work of art'. We cannot say this without an implicit standard of values and this standard we cannot find in the objects; we can only find it in our own mind. The history of art, like the history of literature or the history of cookery, is concerned with achievements. In the second part of this essay I outlined some of the conditions of such achievements – the competition of craftsmen and the encouragement of a discriminating public. This discrimination can admittedly also go wrong or be imperilled by intellectual fashions or snobbish concerns. It may have happened in Holland in the late seventeenth century, when Frenchified fashions all but destroyed the native tradition; it may have happened again in our own days, when the cult of progress threatened the continuities of art.[19] But whether you agree with this verdict or not, we could not even discuss it with-out our own standards of values.

I can well imagine that those who have read my essay on 'Art History and the Social Sciences' were disappointed about my discussion of values in the arts. Having insisted at such length that I believed in the reality of these values, that I was sure Michelangelo was indeed a greater artist than the English seventeenth-century painter John Streater, you found me confessing that these things cannot be proved by arguments. I mentioned the many teachers today who feel the need to convince their students of the reality of these achievements, but I expressed the view that these values are too deeply embedded in the totality of our civilization to be discussed in isolation.

'Civilization', I wrote, 'can be transmitted, it cannot be taught in courses leading to an examination.'[20] Maybe you found this a disappointing conclusion to an important debate.

I am all the more happy to find that I can reinforce this conclusion by quoting the authority of that great Dutch historian Johan Huizinga. I suppose I had read this important utterance long before I wrote my paper, but I had forgotten how much I owed to it. I am referring to his brief article on 'The Definition of the Notion of History'.[21] The article takes issue with a number of definitions Huizinga found in authoritative German handbooks for students of history which concentrate on history as a science. Without wishing in any way to deny the scientific aspirations of the modern historian, Huizinga found this approach much too narrow. After all, history existed as a pursuit long before academic history was established.

In reflecting about the history of historiography Huizinga rightly stressed what I have also stressed, that all historiography must be selective. Imagine the modern historian visiting an archive to pursue his research. He will find room after room and shelf after shelf filled with mountains of files. They are the written records of a tiny selection of events now lying in the past, maybe the records of land sales, police records, or registers of births and deaths. What we call historical research is of course really nothing but a search among these records, a search for an answer to the question which happens to interest us for the moment. As Huizinga said, 'The past as such without a further qualification means nothing but chaos.'

Every civilization has conceived of history as a search for its own origins. Earlier cultures received their history in the form of myths and in the shape of epics such as Homer's. I need hardly stress what role the cult of ancestors and the legal claims based on ancestry played in the formation of historiography. Thus Huizinga comes to the conclusion that history is best defined as 'the intellectual form in which a civilization renders account to itself of its past'.

Note that this definition does not exclude that value-free investigation of the history of settlements or of trade routes, which I relegated to archaeology. Our civilization is a rational one and it demands rational answers based on evidence which can be tested by the methods of science. But our civilization, like all civilizations, is also held together by values – social, moral or aesthetic. It is these values which I found embodied in what I call the canons of art, the standards of mastery without which there could be no history of art. I mentioned earlier that the first historians of art selected their material by the criteria of the technological progress in the representation of nature. They did so because these were the standards of their own civilizations. We all know that these standards have fluctuated and changed. Practically every new

movement in art has looked for its own ancestors and has influenced the writing of art history. German Expressionism all but discovered Grünewald; the Surrealists not only admired Bosch but even erected a special pedestal for Arcimboldo, who has not yet entered my canon. In any case it is a proof of the liveliness of our civilization that the canon is often revised and new values are emphasized. These values need not be mutually exclusive; you may be able to appreciate both Raphael and Rembrandt, both Dante and Tolstoy. What you are not able to do, in my view, if you want to go on practising the humanities, is to throw away all standards of value. Dehumanizing the humanities can only lead to their extinction.

Editor's Postscript

This is the most compact of Gombrich's statements on 'approaches to the history of art'. Such an expression is better than 'method' because he argues that there is no one method for addressing the many problems that art's history raises. A variety of questions, originating from different kinds of concerns, may be addressed at the same object. Hence 'cupology', which is not, of course, an 'ology' at all.

As it is clear from his introduction to Art and Illusion, *relativism is one of his major concerns and this passage from the introduction to* Topics of our Time *will explain why:*

I am not alone in my fear that this trend constitutes a very real threat to all aspects of scholarship because it denies the existence of any objective standards of truth. To be sure we must never claim the monopoly of truth, let alone look down on other cultures whose values and convictions differ from ours. But the recognition of such differences must not lead us to deny the unity of mankind. Nobody needs persuading today what havoc this denial caused when it appeared in the guise of racialism. The grotesque claims that German physics was bound to differ from the Jewish physics of Einstein illustrate the link of this heresy with the dangers I have in mind. There are, alas, analogous absurdities to be found in Marxist writings which make the standards of truth dependent on the class situation. Unhappily this insidious corrosion has by now seeped into other academic fashions, teaching students that any belief in objective results is naïve and obsolete (p. 8).

Topics also contains 'Relativism in the Humanities: The Debate about Human Nature', 'Relativism in the History of Ideas' and 'Relativism in the Appreciation of Art'.

Other useful reading is 'Focus on the Humanities' in Tributes, *'Art and Scholarship' in* Meditations on a Hobby Horse, *'A Plea for Pluralism' and the other essays generally in* Ideals and Idols, *and there are many scattered remarks and observations in* Reflections.

The whole of Gombrich's work concerns itself, in one way or another, with implicit reflection on art-historical method. As he remarked in his autobiographical sketch: 'my ambition - and it was rather a lofty ambition - was to be a kind of commentator on what actually happened in the development of art.'

If there is one concern which he feels is insufficiently addressed, it is the ways in which the works of art in the past achieved their effects as works of art. On this see 'Michael Podro in Conversation with Sir Ernst Gombrich', Apollo, *130 (1989), pp. 374-8. His recent work* Shadows: the Depiction of Cast Shadows in Western Art *(exhibition catalogue, National Gallery, London, 1995) extends his work on perspective (*Art and Illusion *and* The Image and the Eye*) and modelling (*The Heritage of Apelles*). See also the Getty Foundation video:* Gombrich Themes: Part 1: Illumination in Art and Nature; *Part 2:* Reflections in Art and Nature. *In his conversations with Didier Eribon,* A Lifelong Interest, *Gombrich also mentions his intention of joining forces with a practising painter, Stanley Meltzoff, to continue these technical investigations.*

A general background book which is still useful is W. Eugene Kleinbauer, Modern Perspectives in Western Art History: an Anthology of 20th-century Writings on the Visual Arts *(New York, 1971). It includes Gombrich's essay 'Light, Form and Texture in Fifteenth-century Painting', reprinted in* The Heritage of Apelles.

The Social History of Art

Written as a review of Arnold Hauser's *Social History of Art* (New York and London, 1951) in *The Art Bulletin* (March 1953); reprinted in *Meditations on a Hobby Horse* (1963; 4th edition, 1985), pp. 86–94

If by the 'social history' of art we mean an account of the changing material conditions under which art was commissioned and created in the past, such a history is one of the *desiderata* of our field. Documents there are, of course, in profusion, but it still is not easy to lay one's hand quickly on information regarding, say, the recorded rules and statutes of lodges and guilds, the development of such posts as that of the *peintre du roi*, the emergence of public exhibitions or the exact curricula and methods of art teaching. What precisely is our evidence for the role of those 'humanist advisers' of whom we have heard a good deal of late? When did a job at an art school become the normal stand-by of young painters? All these are questions which could and should be answered by a social history of art. Unfortunately, Mr Hauser's two volumes are not concerned with these minutiae of social existence. For he conceives his task to be quite different. What he is out to describe throughout the 956 pages of his text is not so much the history of art or artists, as the social history of the Western World as he sees it reflected in the varying trends and modes of artistic expression—visual, literary or cinematic. For his purpose facts are of interest only in so far as they have a bearing on his interpretation. Indeed, he is inclined to take their knowledge for granted and to address a reader familiar with the artists and monuments under discussion, assuming that he merely seeks guidance about their significance in the light of social theory.

The theory that Mr Hauser offers us as a key to the history of human thought and art is dialectical materialism. His basic approach is exemplified in such statements as that 'Nominalism, which claims for every particular a share in being, corresponds to an order in life in which even those on the lowest rung of the ladder have their chance of rising' (p. 238), or that 'the unification of space and the unified standards of proportion [in Renaissance art] ... are the creations of the same spirit which makes its way in the organization of labour ... the credit system and double entry book keeping' (p. 277). Mr Hauser is deeply convinced that in history 'all factors, material and intellectual, economic and ideological, are bound up together in a state of indissoluble interdependence' (p. 661), and so it is perhaps natural that to him the most serious crime for a historian is the arbitrary isolation of fields of inquiry. Wölfflin, for instance, comes in for strong criticism on the score of his 'unsociological method' (p. 430) and Riegl's *Kunstwollen* is rejected for its 'romantic' idealism (p. 660). He seems less conscious of the fact that this insistence on the 'indissoluble interdependence' of all history makes the selection of material no less arbitrary. Where all human activities are bound up with each other and with economic facts, the question of what witness to call for the writing of history must be left to the historian's momentary preference. This is indeed the impression one gains from Mr Hauser's book. Artistic styles are mainly questioned for the interpretation of periods where more articulate documents are rarer. Thus the first volume, which reaches from the 'magic naturalism' of the Early Stone Age to 'the baroque of the protestant bourgeoisie', concentrates on the analysis of sculpture and painting, though the Homeric epic and Greek tragedy, the Troubadours and Shakespeare are each in their turn related to the stylistic and social trends of their period. In the second volume which extends from the eighteenth century to the present day, literary forms of expression, notably the social novel and the film, come to the fore, though the related movements of Rococo, Classicism, Realism, Impressionism and Symbolism are also evaluated for what they may tell us of the underlying cross-currents of society.

As far as the visual arts are concerned, Mr Hauser's starting-point seems to be the superficially plausible assumption that rigid, hieratic, and conservative styles will be preferred by societies dominated by a landed aristocracy, while elements of naturalism, instability, and subjectivism are likely to reflect the mentality of urban middle-class elements. Thus the geometric character of Neolithic, Egyptian. Archaic Greek, and Romanesque Art may seem roughly to fit this first approximation, since the 'progressive' revolutions of Greek and Gothic naturalism are each connected with the rise of urban civilizations.

But Mr Hauser is too conscientious and too knowledgeable a historian to be satisfied with such a crude theory. He is, moreover, well aware of the many instances which seem to refute it, and so we watch him almost from page to page thinking out ever new and ingenious expedients in order to bring the hypothesis into harmony with the facts. If an Egyptian King such as Akhnaton initiated a shift towards Naturalism, the movement must be rooted in urban middle classes (p. 61); if the urban culture of Babylon, on the other hand, exhibits a rigid formalism, this must be due to the hold of the priests (p. 65). If the classical age of Greek art is also the age of democracy this can be explained by the fact 'that classical Athens was not so uncompromisingly democratic nor was its classical art so strictly "classical" as might have been supposed' (p. 95). In the course of these attempts to rescue his basic assumption, Mr Hauser makes many shrewd and illuminating remarks on the limitations of sociological explanations (p. 70), on the impossibility of accounting for artistic quality by a 'simple sociological recipe' (pp. 103 and 162), on the possibility of time lags between social and stylistic changes (pp. 132, 293, 643), on the different stages of development in different artistic media (p. 153), and even on the futility of too facile comparisons between social structures and stylistic features (*ibid.*). The more one reads these wholesome methodological reminders the more one wonders why the author does not simply give up his initial assumption instead of twisting and bending it to accommodate the facts. And then one realizes that this is the one thing he cannot do. For he has caught himself in the intellectual mousetrap of 'dialectical materialism', which not only tolerates but even postulates the presence of 'inner contradictions' in history.

A brief methodological digression may serve to elucidate the cause of Mr Hauser's theoretical paralysis. To us non-Hegelians, the term 'contradiction' describes the relation of two 'dictions' or statements such that they cannot both be true, for example 'Socrates drank hemlock' and 'Socrates did not drink hemlock'.¹ Now we all know that there are many apparently contradictory statements both of which seem true – e.g., 'Socrates was mortal' and 'Socrates was not mortal' – but we also know that this apparent contradiction is simply due to the term 'mortal' being used in a different sense in the two statements. Ordinarily if the context leaves doubt as to what we mean by 'not mortal' we choose another term, or at least qualify it in some way, so as to remove any contradiction. This, however, is not the way of the dialectician. Mr Hauser, for instance, can describe a style as 'classicist and anti-classicist at the same time' (p. 627), or he can pronounce the terms 'symbolism' and 'impressionism' to be 'partly antithetical, partly synonymous' (p. 896) without feeling the need to discard them. For Hegelians

believe they have discovered the secret that Socrates, being both mortal and not mortal, 'harbours contradictions' and that this, indeed, is true of all reality. Now within the fantasy-world of Hegel's metaphysical system there was at least a reason why the distinction between statements and objects became blurred. For Hegel, of course, believed that reality was 'identical' with the process of reasoning, and that history was nothing but the unfolding of the Absolute Idea in time. Within this system the contention that any separate phase or aspect of history must 'harbour contradictions' (in the mind of God, as it were) which are resolved in the cosmic syllogism is at least of a piece with the rest. Materialists who do not believe that reality is only the thinking process of the Absolute have no such excuse for retaining such 'dialectics'.

Clearly, material objects as well as human beings, societies, or periods may be subject to conflicting pulls, they may contain tensions and divisions, but they can no more 'harbour contradictions' than they can harbour syllogisms. The reason why Marxist critics so often forget this simple fact is that they are mostly concerned with the analysis of political systems. It may be true or not that 'capitalism' – if there is such a thing – contains 'inner contradictions' if we take capitalism to be a system of propositions, stating beliefs or intentions. But to equate the conflicts within capitalist society with its 'contradictions' is to pun without knowing it. It is where the politician turns historian that this confusion becomes disastrous. For it prevents him from ever testing or discarding any hypothesis. If he finds it confirmed by some evidence he is happy; if other evidence seems to conflict he is even happier, for he can then introduce the refinement of 'contradictions'. Much as it is to Mr Hauser's credit that he rejects the cruder version of historical materialism according to which 'the quality of the actual means of production is expressed in cultural superstructures' (p. 661), such a theory might at least be tested and found wanting. His more esoteric doctrine, according to which 'historical development represents a dialectical process in which every factor is in a state of motion and subject to constant change of meaning, in which there is nothing static, nothing eternally valid' (ibid.), denies the very possibility of such a test.

Of course it, too, rests on a Hegelian confusion. Granted that when we watch history we always watch changes, there is no reason why – given the evidence – we should not be able to describe such changes just as well as we describe changes of the weather. Mr Hauser's 'factors' may conceivably be 'in motion' (e.g. the trade winds) but they cannot change their 'meaning' because meaning is a term that does not apply to things or forces but to signs or symbols. And, contrary to the belief of the dialecticians, we can make

perfectly valid statements about these signs – else the hieroglyphs could never have been deciphered and the chronology of red-figured vases never established.[2] If Mr Hauser finds that he is concerned with entities in history which constantly elude his grasp, if he finds that the bourgeoisie and the aristocracy, rationalism and subjectivism constantly seem to change places in his field of vision, he should ask himself whether he is looking through a telescope or a kaleidoscope. If one approaches the past with such statements as 'The late Middle Ages not merely has a successful middle class – it is in fact a middle-class period' (p. 252), one cannot but run into various barons and dukes who will serve as 'contradictions'. And if the Duc de Berry sponsored such unhieratic works as the *Très Riches Heures*, Mr Hauser need not revise his notion of aristocratic styles, he merely finds his view confirmed, for 'even in court art … middle-class naturalism gains the upper hand' (p. 263).

But it is in Mr Hauser's discussion of the social significance of French classicism that the dialectic tangle becomes well-nigh impenetrable.

> The archaic severity, the impersonal stereotyped quality, the die-hard conventionalism of that art [of Le Brun] were certainly in accordance with the aristocratic outlook on life – since for a class which bases its privileges on antiquity, blood and general bearing, the past is more real than the present, … moderation and self-discipline more praiseworthy than temperament and feeling – but the rationalism of classicistic art was just as typical an expression of middle-class philosophy … the efficient, profit-making burgher had begun to conform to a rationalistic scheme of living earlier than the aristocrat … And the middle-class public found pleasure in the clarity, simplicity and terseness of classicistic art more quickly than the nobility (p. 451).

'Classicistic art certainly tends towards conservatism … but the aristocratic outlook often finds more direct expression in the sensualistic and exuberant baroque' (p. 623). 'There arises in French art and literature a curious proximity and interaction of classicistic and baroque tendencies, and a resulting style that is a contradiction in itself – baroque classicism' (p. 627). It is in this way that we are led to the contradiction referred to above – the style that is classicist and anti-classicist at the same time.

Perhaps the above quotations have somewhat illuminated the method by which Mr Hauser arrives at this logical absurdity. He has built into the groundwork of his system a psychology of expression that is simply too primitive to stand the test of historical observation. For though I have called superficially plausible the theory that rigid noblemen will like a rigid style and that agile merchants will be eager for novelty, the contrary assumption – that

blasé aristocrats love ever new sensual stimuli while strict businessmen, with their 'double entry book-keeping', want their art neat and solid – sounds equally convincing. And so Mr Hauser's sociological explanations really turn out to be vacuous as explanations.

To be sure, it would not be fair to blame Mr Hauser for adopting a type of reasoning which has deep roots in the tradition of art-historical writing. Specious arguments about expression are not, alas, Mr Hauser's monopoly. His analysis of Mannerism is a suitable case in point. It is closely modelled on Max Dvořák's interpretation, to which he pays tribute (p. 357), and, although it lacks the sweep and subtlety of Dvořák's lectures and articles, it may have its value as the most detailed discussion of Mannerism that has so far appeared in the English language. Mr Hauser is well aware of the roots of this interpretation in contemporary art movements; indeed he is at his best wherever he can point to the 'conditioning' of historians by their own period. But he has no qualms about following Dvořák and Pinder in projecting 'expressionist' and even 'surrealist' attitudes into Mannerism. The style (and he insists that it was a distinct style, whatever that may mean) becomes 'the artistic expression of the crisis which convulses the whole of Europe in the sixteenth century' (p. 361). He sees it connected with 'the religious revival of the period, the new mysticism, the yearning for the spiritual, the disparagement of the body ... The new formal ideals do not in any way imply a renunciation of the charms of physical beauty, but they portray the body ... bending and writhing under the pressure of the mind and hurled aloft by an excitement reminiscent of the ecstasies of Gothic art' (*ibid.*). One wonders what Benvenuto Cellini would have done to anyone who told him that he 'disparaged the body', or how Giambologna would have reacted on hearing his *Mercury* compared to the 'ecstasies of Gothic art'. And was there more 'yearning for the spiritual' at the court of Cosimo I than in the household of Cosimo *Pater Patriae?* Was there more of a 'crisis' in the Europe of 1552, when Bronzino painted his *Christ in Limbo,* than in 1494, when the French descended on Italy and the Florentines drove out the Medici and fell under the sway of Savonarola – while all the time Perugino went on painting his utterly serene compositions? In other words, can we really use such generalities as 'explanations' or are we just shifting the responsibility into another, less familiar field? To attribute to the '*Zeitgeist*' of an epoch the physiognomic characteristics we find in its dominant artistic types is the constant danger of *Geistesgeschichte.*

No one would deny that there is a genuine problem hidden here. There is such a thing as a mental climate, a pervading attitude in periods or societies, and art and artists are bound to be responsive to certain shifts in dominant

values. But who, in the middle of this twentieth century, would still seriously assert that such crude categories as 'sensuousness' or 'spirituality' correspond to identifiable psychological realities? To say with Mr Hauser that the Renaissance was 'world-affirming' and therefore given to placing figures in a 'coherent spacial context', in contrast to the 'otherworldly' Mannerists (p. 388), whose treatment of space betrays the 'weakened sense of reality of the age' (p. 389), may sound impressive, particularly when coupled with a reference to Spengler. But is all this true? Can we continue to teach our students a jargon which beclouds rather than clarifies the fascinating issue at stake?

Those of us who are neither collectivists believing in nations, races, classes or periods as unified psychological entities, nor dialectical materialists untroubled by the discovery of 'contradictions', prefer to ask in each individual case how far a stylistic change may be used as an index to changed psychological attitudes, and what exactly such correlation would have to imply. For we know that 'style' in art is really a rather problematic indication of social or intellectual change; we know this simply because what we bundle together under the name of art has a constantly changing function in the social organism of different periods and because here, as always, 'form follows function'. It is curious that all his insistence on 'dialectics' has not prevented Mr Hauser from comparing, say, Mannerist art with late Gothic art as if they were commensurable. Before we ask ourselves what they 'express', we must know into what institutional framework they are meant to fit, and this frame of reference clearly changes between Gothic and Mannerism. In this sense Borghini's account of the origin of Giambologna's *Rape of the Sabine Women* as a deliberate challenge to the connoisseurs who had doubted his power to create a monumental group, and the story of its subsequent naming and placing, tell us more of the background of Mannerism than all the religious tracts of the Counter-Reformation taken together.[1] It is not a story to be found in Mr Hauser's book. Paradoxical as it may sound, the most serious objection to his approach is that it bypasses the social history of art.

It is true that the author sometimes interrupts his description of styles and movements to devote brief sections to the social position of artists or the organization of their profession. Although there is little organic relation between these passages and the main argument of the book, the information he supplies should be of use to the student. Mr Hauser is a prodigious reader who has consulted most of the comparatively few studies which exist in this field. His chapter on the social position of the artist in the ancient world is mainly based on B. Schweitzer, *Der bildende Künstler und der Begriff des Künstlerischen in der Antike*, 1925. He might have made even more use, in later

chapters, of H. Huth, *Künstler und Werkstatt der Spätgotik*, 1924, and of H. Floercke, *Studien zur niederländischen Kunst- und Kulturgeschichte*, 1905, both of which works are mentioned in his notes. He missed Jean Locquin, *La Peinture d'histoire en France de 1747 à 1785* (1912), which could have told him so much about the social and political background of classicism, but he has made extensive excerpts from W. Wackernagel, *Der Lebensraum des Künstlers in der florentinischen Frührenaissance*, 1938, which gives substance to his chapter on the social position of Renaissance artists. But even where he can thus rely on excellent groundwork, his preoccupation with generalities makes him careless of the significant detail. To find him speak of the 'St Luke's Guild' in Florence (p. 311) shakes one's confidence in his reliability, for there was no such body. This is a confusion between the religious confraternity of St Luke and the guild of the *Medici e Speciali* to which the painters belonged.

And where can Mr Hauser have found evidence for his statement that Botticelli and Filippino Lippi were the 'close friends' of Lorenzo de' Medici or that Giuliano da Sangallo built for him the Sacristy of San Lorenzo (p. 304)? Sometimes it is only too clear how the information compiled in his reading is transformed in the retelling. His impression of Bertoldo di Giovanni's relation with Lorenzo is obviously derived from Bode's monograph: 'Bertoldo lived with him, sat daily at his table, accompanied him on his travels, was his confidant, his artistic adviser and the director of his academy. He had humour and a sense of tact and always retained respectful distance from his master despite the intimacy of their relationship.' But this is not a social history but historical fiction.

All we really know from documents about this relationship is (a) that Bertoldo wrote one bantering letter to Lorenzo dealing mainly with cookery; (b) that a room in the Medici palace was called '*del Bertoldo o del cameriere*'; (c) that Bertoldo died in Poggio a Cajano; and (d) that on one occasion '*Bertoldo schultore*' is listed among the retinue of thirty-one that Lorenzo took with him to the baths at Morba – far below the musicians, by the way, and right above the barber. Would not this list have told the reader more of the social history of art than the romance about the tactful confidant? One hopes Bertoldo was not taken along as a 'cameriere' for his skill in cookery, and that he was at least allotted one of the fourteen beds available for the thirty-one members of the retinue.

One more example must suffice to show how dangerous it can be for the historian to think himself 'in the know' about the past. Speaking of Donatello's position, Mr Hauser says: 'What he himself thinks about the relation between art and craft is best shown by the fact that he plans one of his last and most important works, the group of Judith and Holofernes, as a

decoration for the fountain in the courtyard of the Palazzo Riccardi' (p. 311). This Palazzo, of course, was the Medici Palace and, as it happens, the group was not planned as a 'decoration' (though it stood above a fountain) but was charged with an unusually explicit social and political message. Piero il Gottoso had placed under it the Latin inscription *Regna cadunt luxu, surgunt virtutibus urbes, caesa vides humili colla superba manu* (Kingdoms fall through luxury, cities rise through virtue. Behold the proud neck felled by the arm of the humble). Apparently the Medici wanted, by this *exemplum*, publicly to proclaim their continued belief in what Mr Hauser would call their 'middle-class virtues' – a proclamation much needed in view of the criticism their princely *magnificentia* had caused. When at last Piero di Lorenzo's 'reign' did fall *luxu*, the citizens of Florence must have bethought themselves of this prophetic image, for they placed it in front of the Palazzo Vecchio as a suitable reminder. Mr Hauser, of course, need not, and possibly could not, know all the evidence,[4] but he gives no sign of really seeking out the vivifying contact with texts and documents.

Whatever the historian's individual outlook may be, a subject such as the social history of art simply cannot be treated by relying on secondary authorities. Even Mr Hauser's belief in social determinism could have become fertile and valuable if it had inspired him, as it has inspired others, to prove its fruitfulness in research, to bring to the surface new facts about the past not previously caught in the nets of more conventional theories. Perhaps the trouble lies in the fact that Mr Hauser is avowedly not interested in the past for its own sake but that he sees it as 'the purpose of historical research' to understand the present (p. 714). His theoretical prejudices may have thwarted his sympathies. For to some extent they deny the very existence of what we call the 'humanities'. If all human beings, including ourselves, are completely conditioned by the economic and social circumstances of their existence then we really cannot 'understand' the past by ordinary sympathy. The 'man of the Baroque' was almost a different species from us, whose thinking reflects 'the crisis of Capitalism'. This is indeed the conclusion which Mr Hauser draws. He thinks that 'we are separated from all the older works by an unbridgeable gulf – to understand them, a special approach and a special effort are necessary and their interpretation is always involved in the danger of misunderstanding' (p. 714). This 'special approach', we may infer, demands of us that we look on the more distant past from the outside, as on an interplay of impersonal forces. Perhaps this aloof attitude accounts for the curious lack of concreteness in Mr Hauser's references to individual works of art. The illustrations seem only to exist as an afterthought of the publishers and their captions have a strangely perfunctory character. Has a 'social historian' really

nothing to say about Ambrogio Lorenzetti's *Good Government* other than that its master, 'the creator of the illusionistic town panorama, takes, with the greater freedom of his spatial arrangement, the first important step in the artistic development leading beyond Giotto's style' (caption to plate XXII)? Even in the comparatively few descriptions of earlier works of art, the qualities Mr Hauser emphasizes are more often than not those the works 'ought to have' rather than those we see. Thus we read that in the dedicatory mosaics of San Vitale 'everything complicated, everything dissolved in halftones is excluded ... everything is simple, clear and obvious ... contained within sharp, unblurred outlines ...' (p. 143). This, of course, is as it should be with aristocratic works, but surely such a description is quite misleading. His similar remarks about Le Brun's 'orthodox style' almost make one wonder whether he has ever looked at one of these paintings with care.

The same sense of remoteness is certainly responsible for the difficulty of Mr Hauser's style. The book is translated from the German and the author was not always well served by his translator, who puts 'the free arts' (*die freien Künste*) for the 'liberal arts' (p. 322) and is capable of writing: 'The perspective in painting of the Quattrocento is a scientific conception, whereas the Universum of Kepler and Galileo is a fundamentally aesthetic vision' (p. 332). But the basic character of the writing cannot be blamed on the translator. It is rooted in Mr Hauser's approach, which may be illustrated by the following specimen, neither worse nor better than many others: 'For even where Italian culture seems to succumb to the Hispanic influence it merely follows an evolutionary trend resulting from the presuppositions of the Cinquecento ...' The abstractions set on their course here are in the thought, not merely in the language. The remarkable thing is how this bloodless, cramped style changes when the author reaches the 'Generation of 1830', 'our first intellectual contemporaries' (p. 715). Here he permits himself to trust his own responses and sympathies; the pace quickens, we are given some telling quotations and are made to feel that we are concerned with people rather with 'factors'. These are the chapters where first literature and then the film predominates, but they include, for instance, a page on Impressionist technique alive with the thrill of intuitive understanding (p. 872). Such pages, no less than the various penetrating asides scattered throughout the two volumes, only increase one's regret that a misconceived ideal of scientific sophistication has all but cheated the author and the reader of the fruits of an immense labour.

Editor's Postscript
Sociologists often feel that Gombrich is hostile to the social explanation of art because of this essay; such a belief is misguided. If style is the set of visual characteristics of a work of art which enable

the historian and connoisseur to date it to a particular place and time, this cannot be explained simply by the state of the society at that time; the whole matter is much more complex than that. As Gombrich said in his review of Francis Haskell's History and its Images:

> Art does not reflect the Spirit of the Age, for the notion is too vague to be of any use. But why should not have artists shared the values and aspirations of their culture and society? Their sense of decorum, their heroic ideals or their love of refinement? Maybe the historian of art cannot tell the historian much he could not also have gained from other sources, but surely the historian can still assist the historian of art in interpreting the art of the past in the light of textual evidence. New York Review of Books (21 October 1993), p. 62.

'From the Revival of Letters to the Reform of the Arts' reprinted in this volume (pp. 411–35) offers a demonstration case.

One of the basic problems of Arnold Hauser's book The Social History of Art is that it commits the physiognomic fallacy. As Gombrich observed in 1937, to insist that the fallacy is one is to:

> forgo a source of strong and subjectively very genuine enjoyment. The social success of art history today, its receptivity to the art of all times and all peoples, rests all too often on just such a view of the past. It is not the individual work of art which is enjoyed, rather, the language in which it is formulated is treated as if it were itself a work of art. it would be superfluous to cite examples, one ought rather first to look for those who have resisted this temptation to do this – indeed it is more than a temptation, it is virtually a compulsion.[1]

The subject is also discussed in 'André Malraux and the Crisis of Expressionism' and 'Art and Scholarship', in Meditations on a Hobby Horse. The evidential nature of the visual arts was argued by J.H. Huizinga, 'The Aesthetic Element in Historical Thought' in Dutch Civilisation in the 17th Century and other essays (London, 1968). Huizinga stood at precisely the opposite pole to Curtius, who Gombrich discusses in his review, 'What Art Tells Us', of Francis Haskell's fascinating book History and its Images (New Haven, 1993), in The New York Review of Books, (21 October 1993), pp. 60-2.

For further theoretical treatment of the problems see 'Art History and the Social Sciences' and 'In Search of Cultural History' (part of which is reprinted in this volume) in Ideals and Idols.

For further historical reflections see: 'The Renaissance Conception of Artistic Progress and its Consequences' in Norm and Form; 'The impact of the Black Death' and 'Patrons and Painters in Baroque Italy' in Reflections on the History of Art; (with David Chambers), 'Annibale Litolfi, a Sixteenth-Century Nature Lover: Spoglie from the Gonzaga Archives', Renaissance Studies, 2 (1988), pp. 321-6; 'Supply and Demand in the Evolution of Styles: The Example of International Gothic', Three Cultures, ed. M. Bal et

al. *(The Hague, 1989)*; Styles of Art and Styles of Life *(The Reynolds Lecture, London, 1991)*.

An *important essay to read in conjunction with the Hauser Review is Popper's 'What is Dialectic?' in Karl R. Popper,* Conjectures and Refutations *(London, 1972)*.

1. *'Achievement in Medieval Art',* Meditations on a Hobby Horse, *p. 76.*

In Search of Cultural History

Extract from the Philip
Maurice Deneke Lecture
delivered at Lady
Margaret Hall, Oxford,
19 November 1967;
published in *Ideals and Idols*
(1979), pp. 42–59

4 *Hegelianism without Metaphysics*

Thus it is quite consistent that Burckhardt's successor in Basle, the great art historian Heinrich Wölfflin, writes in his first book, *Renaissance and Baroque* of 1888:

> To *explain* a style cannot mean anything but to fit its expressive character into the general history of the period, to prove that its forms do not say anything in their language that is not also said by the other organs of the age.[1]

Wölfflin was never quite at ease with this formula[2] but it still dominated his work and that of others. Not that Hegelian metaphysics were accepted in all their abstruse ramifications by any of these historians any more than they were by Burckhardt. The point is rather that all of them felt, consciously or unconsciously, that if they let go of the magnet that created the pattern, the atoms of past cultures would again fall back into random dustheaps.

In this respect the cultural historian was much worse off than any other historian. His colleagues working on political or economic history had at least a criterion of relevance in their restricted subject-matter. They could trace the history of the reform of Parliament, of Anglo-Irish relations, without explicit reference to an all-embracing philosophy of history.

But the history of culture as such, the history of all the aspects of life as it was lived in the past, could never be undertaken without some ordering principle, some centre from which the panorama can be surveyed, some hub on which the wheel of Hegel's diagram can be pivoted (Fig. 342). Thus the

subsequent history of historiography of culture can perhaps best be interpreted as a succession of attempts to salvage the Hegelian assumption without accepting Hegelian metaphysics. This was precisely what Marxism claimed it was doing. The Hegelian diagram was more or less maintained, but the centre was occupied not by the spirit but by the changing conditions of production. What we see in the periphery of the diagram represents the superstructure in which the material conditions manifest themselves. Thus the task of the cultural historian remains very much the same. He must be able to show in every detail of the period how it reflects its essential economic character.[3]

Lamprecht, whom I mentioned before as one of Warburg's masters, took the opposite line. He looked for the essence not in the material conditions but in the mentality of an age.[4] He tried, in other words, to translate Hegel's *Geist* into psychological terms. The psychology on which he relied, Herbarthian associationism, makes his attempt sound particularly old-fashioned today, but as an effort to rescue or rationalize the Hegelian intuition, his system is still of some interest. A similar turn to psychology was advocated by Wilhelm Dilthey, himself the biographer and a very sophisticated critic of Hegel, who yet, I believe, remained under his spell in the way he posed the problem of what he calls the 'structural unity of culture', especially in his later fragments. He there postulates as 'the most important methodological principle' that a culture should always be approached by the historian 'at its greatest height'.

> At this point a state of consciousness has developed in which the relationship of the elements of the culture has found a definite expression in its structure, values, meanings and the sense of life ... which is expressed in ... the configurations of poetry, religion and philosophy ... The very limitations inherent in any culture even at its height postulate a future.[5]

Dilthey is the father of the whole trend of German historiography significantly called *Geistesgeschichte*, the school which has made it its programme to see art, literature, social structure, and *Weltanschauung* (world-view) under the same aspect.[6]

In my own field, the history of art, it was Alois Riegl who, at the turn of the century, worked out his own translation of the Hegelian system into psychological terms.[7] Like Hegel he saw the evolution of the arts both as an autonomous dialectical process and as wheels revolving within the larger wheel of successive 'world-views'. In art the process went spiralling twice: from a tactile mode of apprehension of solid matter to an 'optic' mode, first in the case of isolated objects and then in that of their spatial setting. As in Hegel, also, this process with its inevitable stages puts the idea of 'decline' out

of court. By classical standards of tactile clarity the sculpture of the Arch of Constantine may represent a decline, but without this process of dissolution neither Raphael nor Rembrandt could have come into being.

Moreover, this relentless development runs parallel with changes in the 'world-views' of mankind. Like Hegel, Riegl thought that Egyptian art and Egyptian *Weltanschauung* were both on the opposite pole from 'spiritualism'. He postulates for Egypt a 'materialistic monism' which sees in the soul nothing but refined matter. Greek art and thought are both dualistic while late antiquity returns to monism, but at the opposite end of the scale, where (predictably) the body is conceived of as a cruder soul.

> Anyone who would see in the turn of late antiquity towards irrationalism and magic superstitions a decline, arrogates for himself the right to prescribe to the spirit of mankind the way it should have taken to effect the transition from ancient to modern conceptions.[8]

For Riegl was convinced that this late antique belief in spirits and in magic was a necessary stage without which the mind of man could never have understood electricity. And he proved to his own satisfaction (and to that of many others) that this momentous process was as clearly manifested in the ornamentation of late Roman *fibulae* as it was in the philosophy of Plotinus.

It was this claim to read the 'signs of the time' and to penetrate into the secrets of the historical process which certainly gave new impetus to art-historical studies. Max Dvořák, in his later years, represented this trend so perfectly that the editors of his collected papers rightly chose as title *Kunstgeschichte als Geistesgeschichte*[9] ('Art History as a History of the Spirit'), a formulation which provoked Max J. Friedländer to the quip, 'We apparently are merely studying the History of the Flesh' ('*Wir betreiben offenbar nur Körpergeschichte*'). The great Erwin Panofsky, like Dilthey, presents a more critical and sophisticated development of this programme, but those who have studied his works know that he too never renounced the desire to demonstrate the organic unity of all aspects of a period.[10] His *Gothic Architecture and Scholasticism*[11] shows him grappling with the attempt to 'rescue' the traditional connection between these two aspects of medieval culture by postulating a 'mental habit' acquired in the schools of the scholastics and carried over into architectural practice. In his *Renaissance and Renascences in Western Art*[12] he explicitly defended the notion of cultures having an essence.

But perhaps the most original rescue attempt of this kind was made by the greatest cultural historian after Burckhardt, his admirer, critic and successor, Johan Huizinga.[13]

Burckhardt had advised his friend to ask himself: 'How does the spirit of the fifteenth century express itself in painting?'[14] The average art historian who practised *Geistesgeschichte* would have started from the impression Van Eyck's paintings made on him and proceeded to select other testimonies of the time that appeared to tally with this impression. What is so fascinating in Huizinga is that he took the opposite line. He simply knew too many facts about the age of Van Eyck to find it easy to square his impression of his pictures with the voice of the documents. He felt he had rather to reinterpret the style of the painter to make it fit with what he knew of the culture. He did this in his captivating book, *The Waning of the Middle Ages*,[15] literally the autumn of the Middle Ages, which is Hegelian even in the assumption of its title, that here medieval culture had come to its autumnal close, complex, sophisticated and ripe for the sickle. Thus Van Eyck's realism could no longer be seen as a harbinger of a new age; his jewel-like richness and his accumulation of detail were rather an expression of the same late-Gothic spirit that was also manifested, much less appealingly, in the prolix writings of the period which nobody but specialists read any more.

The wheel had come full circle. The interpretation of artistic realism as an expression of a new spirit, which is to be found in Hegel and which had become the starting point for Burckhardt's reading of the Renaissance, was effectively questioned by Huizinga, who subsequently devoted one of his most searching essays to this traditional equation of Renaissance and Realism.[16] But as far as I can see, he challenged this particular interpretation rather than the methodological assumption according to which the art of an age must be shown to express the same spirit as its literature and life. Critical as he was of all attempts to establish laws of history, he still ended his wonderful paper on 'The Task of Cultural History'[17] with a demand for a 'morphology of culture' that implied, if I understand it correctly, a holistic approach in terms of changing cultural styles.

Now I would not deny for a moment that a great historian such as Huizinga can teach the student of artistic developments a lot about the conditions under which a particular style like that of Van Eyck took shape. For obviously there is something in the Hegelian intuition that nothing in life is ever isolated, that any event and any creation of a period is connected by a thousand threads with the culture in which it is embedded. Who would not therefore be curious to learn about the life of the patrons who commissioned Van Eyck's paintings, about the purpose these paintings served, about the symbolism of his religious paintings, or about the original context of his secular paintings which we only know through copies and reports? Clearly neither the *Adoration of the Lamb* nor even the lost *Hunt of the Otter* can be

understood in isolation without references to religious traditions in the first case and to courtly pastimes in the second.

But is the acknowledgement of this link tantamount to a concession that the Hegelian approach is right after all? I do not think so. It is one thing to see the interconnectedness of things, another to postulate that all aspects of a culture can be traced back to one key cause of which they are the manifestations.[18]

If Van Eyck's patrons had all been Buddhists he would neither have painted the *Adoration of the Lamb* nor, for that matter, the *Hunting of the Otter*, but though the fact that he did is therefore trivially connected with the civilization in which he worked, there is no need to place these works on the periphery of the Hegelian wheel and look for the governing cause that explains both otter hunting and piety in the particular form they took in the early decades of the fifteenth century, and which is also expressed in Van Eyck's new technique.

If there is one fact in the history of art I do not find very surprising it is the success and acclaim of this novel style. Surely this has less to do with the *Weltanschauung* of the period than with the beauty and sparkle of Van Eyck's paintings.

I believe it is one of the undesirable consequences of the Hegelian habit of exegetics that such a remark sounds naïve and even paradoxical. For the habit demands that everything must be treated not only as connected with everything else, but as a symptom of something else. Just as Hegel treated the invention of gunpowder as a necessary expression of the advancing spirit, so the sophisticated historian should treat the invention of oil painting (or what was described as such) as a portent of the times. Why should we not find a simpler explanation in the fact that those who had gunpowder could defeat those who fought with bows and arrows or that those who adopted the Van Eyck technique could render light and sparkle better than those who painted in tempera?[19] Of course no such answer is ever final. You are entitled to ask why people wanted to defeat their enemies, and though the question may once have sounded naïve we now know that strong influences can oppose the adoption of a better weapon. We also know that the achievement of life-like illusion cannot always be taken for granted as an aim of painting. It was an aim rejected by Judaism, by Islam, by the Byzantine Church and by our own civilization, in each case for different reasons. I believe indeed that methodologically it is always fruitful to ask for the reasons which made a culture or a society reject a tool or invention which seemed to offer tangible advantages in one particular direction. It is in trying to answer this question that we will discover the reality of that closely knit fabric which we call a culture.[20]

But I see no reason why the study of these connections should lead us back

to the Hegelian postulates of the *Zeitgeist* and *Volksgeist*. On the contrary, I have always believed that it is the exegetic habit of mind leading to these mental short-circuits which prevents the posing of the very problem Hegelianism set out to solve.[21]

5 *Symptoms and Syndromes*

One may be interested in the manifold interactions between the various spheres of a culture and yet reject what I have called the 'exegetic method', the method, that is, that bases its interpretations on the detection of that kind of 'likeness' that leads the interpreter of the scriptures to link the passage of the Jews through the Red Sea with the Baptism of Christ. Hegel, it will be remembered, saw in the Egyptian sphinx an essential likeness with the position of Egyptian culture in which the Spirit began to emerge from animal nature, and carried the same metaphor through in his discussion of Egyptian religion and Egyptian hieroglyphics. The assumption is always that some essential structural similarity must be detected which permits the interpreter to subsume the various aspects of a culture under one formula.[22] The art of Van Eyck in Huizinga's persuasive morphology is not only to be connected with the theology and the literature of the time but it must be shown to share some of their fundamental characteristics. To criticize this assumption is not to deny the great ingenuity and learning expended by some cultural historians on the search for suggestive and memorable metaphorical descriptions. Nor is it to deny that such structural likenesses between various aspects of a period may be found to be interesting, as A. O. Lovejoy tried to demonstrate for eighteenth-century Deism and Classicism.[23] But here as always *a priori* assumptions of such similarity can only spoil the interest of the search. Not only is there no iron law of such isomorphism, I even doubt whether we improve matters by replacing this kind of determinism with a probabilistic approach as has been proposed by W. T. Jones in his book on *The Romantic Movement*.[24] The subtitle of this interesting book demands attention by promising a 'new Method in Cultural Anthropology and History of Ideas'; it consists in drawing up such polarities as that between static and dynamic, or order and disorder, and examining certain periods for their bias towards one or the other end of these scales, a bias which would be expected to show up statistically at the periphery of the Hegelian wheel in art, science and political thought, though some of these spheres might be more recalcitrant to their expression than others. In the contrast between 'soft focus' and 'hard focus' the Romantic, he finds, will be likely to lean towards the first in metaphysics, in poetical imagery and in paintings, a bias that must be symptomatic of Romantic mentality.

Such expectations, no doubt, accord well with commonsense psychology; but in fact no statistics are needed to show in this case that what looks plausible in this new method of salvaging Hegel still comes into conflict with historical fact. It so happens that it was Romanticism which discovered the taste for the so-called 'primitives' in painting, which meant, at that time, the hard-edged, sharp-focused style of Van Eyck or of the early Italians. If the first Romantic painters of Germany had one pet aversion it was the soft-focused bravura of their Baroque predecessors. Whatever their bias in metaphysics may have been, they saw in the smudged outline a symptom of artistic dishonesty and moral corruption. Their bias in the syndrome – to retain this useful term – was based on very different alternatives, alternatives peculiar to the problems of painting. Paradoxically, perhaps, they identified the hard and naïve with the otherworldly and the chaste. It was soft-focused naturalism that was symptomatic of the fall from grace.

We have met this bias before in the discussions among cultural historians of the symptomatic value of painting styles. It might not have assumed such importance if it had not been such a live issue in the very time and ambience of Hegel and of the young Burckhardt. This was of course the time when the trauma of the French Revolution aroused a new longing among certain circles for the lost paradise of medieval culture. The German painters who became known as the Nazarenes regarded realism and sensuality as two inseparable sins and aimed at a linear style redolent of Fra Angelico and his Northern counterparts. They went to Rome, where most of them converted to Roman Catholicism, they wore their hair long and walked about in velvet caps considered somehow to be *alt-deutsch*. Now here the style of these artists and their *Weltanschauung* was clearly and closely related, their mode of painting, like their costume, was really a badge, a manifesto of their dissociation from the nineteenth century. If you met a member of this circle you could almost infer from his attire what he would say and how he would paint, except, of course, whether he would paint well or badly.

It is legitimate for the cultural historian to ask how such a syndrome arose which marks what we call a movement. It is possible to write the history of such a movement, to speculate about its beginnings and about the reasons for its success or failure. It is equally necessary then to ask how firmly the style and the allegiance it once expressed remained correlated; how long, for instance, the anti-realistic mode of painting remained a badge of Roman Catholicism. In England the link between Catholicism and a love of Gothic is strong in Pugin, but was severed by Ruskin, while the Pre-Raphaelite Brotherhood even aimed at a certain naïve and sharp-focused realism.

Even here, though, the style expressed some kind of allegiance to the Age of

Faith. Judging by a passage from Bernard Shaw's first novel, this syndrome had dissolved by 1879 when it was written. In *Immaturity* Shaw wittily described the interior decoration of a villa belonging to a patron of the arts, a salon with its walls of pale blue damask and its dados 'painted with processions of pale maidens, picking flowers to pieces, reading books, looking ecstatically up, looking contemplatively down, playing aborted guitars with an expressive curve of the neck and fingers ... all on a ground of dead gold' (pp. 102–3). 'People who disapproved of felt hats, tweed and velveteen clothes, long hair, music on Sundays, pictures of the nude figure, literary women and avowals of agnosticism either dissembled or stayed away.' The syndrome, if Shaw was right, had changed from medievalism to aestheticism and a generalized nonconformism. Burne-Jones was now the badge of allegiance of a progressive creed.

I hope this little example may make it easier to formulate my criticism of Huizinga's Hegelian position *vis-à-vis* van Eyck's realism. For we can now ask with somewhat greater precision whether the style of Van Eyck was felt in the Flanders of his time to belong to any such syndrome, whether, in other words, on entering a great man's hall and finding there a newly acquired painting by the master, you could expect certain other attitudes on the part of your host or his guests. I doubt it. Yet, if this sounds anachronistic, I would venture to suggest that if, only a little later, you had come into a room with a painting of Venus in a style *all'antica* this might have entitled you to expect the owner to want his son to learn good Latin and perhaps, generally, to meet a crowd hoping to discard and transcend the traditions of the past.[25]

6 Movements and Periods

The distinction at which I am aiming here is that between movements and periods. Hegel saw all periods as movements since they were embodiments of the moving spirit. This spirit, as Hegel taught, manifested itself in a collective, the supra-individual entities of nations or periods. Since the individual, in his view, could only be thought of as part of such a collective it was quite consistent for Hegelians to assume that 'man' underwent profound changes in the course of history. Nobody went further in this belief than Oswald Spengler, who assigned different psyches to his different culture cycles. It was an illusion due to sentimentalizing humanitarians to believe that these different species of man could ever understand each other.

The same extremism was of course reflected in the claims of the totalitarian philosophies which stemmed from Hegel to create a new 'man', be it of a Soviet or of a National Socialist variety. Even art historians of a less uncompromising bent took to speaking of 'Gothic man' or 'Baroque

psychology', assuming a radical change in the mental make-up to have happened when building firms discarded one pattern book in favour of another. In fact the study of styles so much fostered a belief in collective psychology that I remember a discussion shortly after the war with German students who appeared to believe that in the Gothic age Gothic cathedrals sprang up spontaneously all over Europe without any contact between the building sites.

It is this belief in the existence of an independent supra-individual collective spirit which seems to me to have blocked the emergence of a true cultural history. I am reminded of certain recent developments in natural history which may serve as illustrations. The behaviour of insect colonies appeared to be so much governed by the needs of the collective that the temptation was great to postulate a super-mind. How else, argued Marais in his book *The Soul of the White Ant*,[26] could the individuals of the hive immediately respond to the death of the queen? The message of this event must reach them through some kind of telepathic process. We now know that this is not so. The message is chemical; the queen's substance picked up from her body circulates in the hive through mutual licking rather than through a mysterious mental fluid.[27] Other discoveries about the communication of insects have increased our awareness of the relation between the individual and the hive. We have made progress.

I hope and believe cultural history will make progress if it also fixes its attention firmly on the individual human being. Movements, as distinct from periods, are started by people. Some of them are abortive, others catch on. Each movement in its turn has a core of dedicated souls, a crowd of hangers-on, not to forget a lunatic fringe. There is a whole spectrum of attitudes and degrees of conversion. Even within the individual there may be various levels of conviction, various conscious and unconscious fluctuations in loyalty. What seemed acceptable during the mass rally or revivalist meeting may look pretty crazy on the way home. But movements would not be movements if they did not have their badges, their outward signs, their style of behaviour, style of speech and of dress. Who can probe the motives which prompt individuals to adopt some of these, and who would venture in every case to pronounce on the completeness of the conversion this adoption may express? Knowing these limitations, the cultural historian will be a little wary of the claims of cultural psychology. He will not deny that the success of certain styles may be symptomatic of changing attitudes, but he will resist the temptation to use changing styles and changing fashions as indicators of profound psychological changes. The fact that we cannot assume such automatic connections makes it more interesting to find out if and when they may have existed.

The Renaissance, for instance, certainly had all the characteristics of a movement.[28] It gradually captured the most articulate sections of society and influenced their attitude in various but uneven ways. Late Gothic or Mannerism were not, as far as I can see, the badge of any movement, though of course there were movements in these periods which may or may not have been correlated with styles or fashions in other cultural areas. The great issues of the day, notably the religious movements, are not necessarily reflected in distinctive styles. Thus both Mannerism and the Baroque have been claimed to express the spirit of the Counter-Reformation but neither claim is easy to substantiate. Even the existence of a peculiar Jesuit style with propagandist intentions has been disproved by the detailed analysis of Francis Haskell.[29]

We need more analyses of this kind, based on patient documentary research, but I venture to suggest that the cultural historian will want to supplement the analysis of stylistic origins by an analysis of stylistic associations and responses. Whatever certain Baroque devices may have meant to their creators, they evoked Popish associations in the minds of Protestant travellers. When and where did these associations become conscious? How far could fashion and the desire for French elegance override these considerations in a Protestant community? I know that it is not always easy to answer these questions, but I feel strongly that it is this type of detailed questioning that should replace the generalizations of *Geistesgeschichte*.

7 Topics and Techniques
The historian does not have to be told that movements offer promising topics for investigation. The rise of Christianity, of Puritanism, of the Enlightenment or of Fascism has certainly not lacked chroniclers in the past and will not lack them in the future. The very fact that these movements detached themselves from the culture in which they originated offers a principle of selection. But it may be claimed that this advantage is bought at the expense of offering a panorama of the whole civilization such as Burckhardt or Huizinga tried to offer. The criticism of Hegelian determinism and collectivism therefore strikes indeed at one of the roots of cultural history. But there are other reasons for the malaise of the cultural historian.

The Victorian editor of Cicero's *Letters to Atticus* did not have to subscribe to Hegelian tenets to sketch in what was sometimes called the 'cultural background' in his introduction and notes. He had that unselfconscious sense of continuity with the past that allowed him to take for granted what was in need of explanation, and what was obvious to his readers. The modern student of Cicero's letters has lost this assurance. What is background and what foreground to him in such a cultural document?

But though there is a loss in this uncertainty of perspective, there is also a gain. He will be more aware than his predecessor was of the question he wants to ask. He may search the letters for linguistic, economic, political or psychological evidence, he may be interested in Cicero's attitude to his slaves or his references to his villas. Classical scholars were never debarred from asking this kind of question, but even classics are now threatened by that fragmentation that has long since overtaken the study of later ages.

That same fragmentation also threatens to eliminate another traditional form of cultural history – the old-fashioned biography of the 'Life and Letters' type, which used to present its hero in the living context of his time. I fear, if a survey were made, it would be found that books of this kind are more frequently written nowadays by amateurs than by professional historians. The average academic lacks the nerve to deal with a man of the past who was not also a specialist. Nor is his reluctance dishonourable; we know how little we know about human beings and how little of the evidence we have would satisfy a psychologist interested in the man's character and motives. The increasing awareness of our ignorance about human motives has led to a crisis of self-confidence.

Having criticized a Hegel, a Burckhardt, or a Lamprecht for their excess of self-confidence in trying to solve the riddles of past cultures, I am bound to admit in the end that without confidence our efforts must die of inanition. A scholar such as Warburg would not have founded his Library without a burning faith in the potentialities of *Kulturwissenschaft*. The evolutionist psychology that inspired his faith is no longer ours, but the questions it prompted him to ask still proved fruitful to cultural history. In proposing as the principal theme of his Institute '*das Nachleben der Antike*' – literally the after-life of ancient civilization – he at least made sure that the historian of art, of literature or of science discovered the need for additional techniques to hack a fresh path into the forest in pursuit of that protean problem. Warburg's library was formed precisely to facilitate the acquisition of such tools. It was to encourage trespassing, not amateurishness.

Warburg's problem arose in a situation when the relevance of the classical tradition for the cultural life of the day was increasingly questioned by nationalists and by modernists. He was not out to defend it so much as to explain and assess the reasons for its long 'after-life'. The continued value of that question for the present generation lies in the need to learn more about a once vital tradition which is in danger of being forgotten. But I would not claim that it provides the one privileged entry into the tangled web of Western civilization.

Both the dilemmas and the advantages of cultural history stem from the fact

that there can be no privileged entry. It seems to me quite natural that the present generation of students is particularly interested in the social foundations of culture; having myself been born in the reign of his Apostolic Majesty the Emperor Francis Joseph, who had come to the throne in 1848, I certainly can appreciate the rapidity of social change that prompts fresh questionings about the past. That all-pervasive idea of rank and hierarchy that coloured man's reaction to art, religion and even to nature, has become perplexing to the young. It will be the task of the cultural historian to trace and to explain it wherever it is needed for our understanding of the literature, the philosophy or the linguistic conventions of bygone cultures.

Perhaps this example also illustrates the difference between the social and the cultural historian. The first is interested in social change as such. He will use the tools of demography and statistics to map out the transformations in the organization of society. The latter will be grateful for all the information he can glean from such research, but the direction of his interest will still be in the way these changes interacted with other aspects of culture. He will be less interested, for example, in the economic and social causes of urban development than in the changing connotations of words such as 'urbane' or 'suburbia' or, conversely, in the significance of the 'rustic' order in architecture.

The study of such derivations, metaphors and symbols in language, literature and art provides no doubt convenient points of entry into the study of cultural interactions.[10] But I do not think more should be claimed for this approach than it is likely to yield. By itself it cannot offer an escape from the basic dilemma caused by the breakdown of the Hegelian tradition, which stems from the chastening insight that no culture can be mapped out in its entirety, while no element of this culture can be understood in isolation. It appears as if the cultural historian were thus still left without a viable programme, grubbing among the random curiosities of antiquarian lore.

I realize that this perplexity looks pretty formidable in the abstract, but I believe it is much less discouraging in practice. What Popper has stressed for the scientist also applies to the scholar.[11] No cultural historian ever starts from scratch. The traditions of his own culture, the bias of his teacher, the questions of the moment can all stimulate his curiosity and direct his questionings. He may want to continue some existing lines of research or to challenge their result; he may be captivated by Burckhardt's picture of the Renaissance, for instance, and fill in some of the gaps left in that immensely suggestive account, or he may have come to distrust its theoretical scaffolding and therefore feel prompted to ask how far and by whom certain Neoplatonic tenets were accepted as an alternative to the Christian dogma.

Whether we know it or not, we always approach the past with some

preconceived ideas, with a rudimentary theory we wish to test. In this as in many other respects the cultural historian does not differ all that much from his predecessor, the traveller to foreign lands. Not the professional traveller who is only interested in one particular errand, be it the exploration of a country's kinship system or its hydroelectric schemes, but the broadminded traveller who wants to understand the culture of the country in which he finds himself.

In trying to widen his understanding the traveller will always be well advised to treat inherited clichés about national characters or social types with a healthy suspicion, just as the cultural historian will distrust the second-hand stereotypes of the 'spirit of the age'. But neither need we ever forget that our reactions and observations will always be dependent on the initial assumptions with which we approach a foreign civilization. The questions we may wish to ask are therefore in no way random; they are related to a whole body of beliefs we wish to reinforce or to challenge. But for the cultural historian no less than for the traveller the formulation of the question will usually be precipitated by an individual encounter, a striking instance, be it a work of art or a puzzling custom, a strange craft, or a conversation in a minicab.

Take any letter that arouses our attention, say Burckhardt's letter to Fresenius on Hegel to which I have referred.[12] Clearly we may use it as a document for a study of Burckhardt and his circle of friends, and try to build up, through careful reading and an expansion of the references, a picture of that 'sub-culture' in which the young Burckhardt moved. But we can also change the focus and use the letter as a starting point for very different lines of research – for instance into the history of epistolary styles. A hundred years earlier a student would have been most unlikely to pour this kind of confession into a letter to a friend, and if we go back to the Renaissance such a self-revelation, for which there is no Ciceronian model, would have been unthinkable. We might of course shift the focus even further and ask about the history of forms of address; we may wonder whether Burckhardt wrote with a quill and when this habit came to an end. We may speculate about the influence of postal services on the form of communications and blame the telephone for the relative decline of letter-writing today. By and large, therefore, we may either be interested in individuals and the situation they found themselves in, or in traditions passed on by hosts of anonymous people. If labels are needed we may speak of contiguity and continuity studies, though neither of these can be kept wholly apart from the other. The research into continuities may lead us still to individuals who stand out of the anonymous crowd for the impact they made on traditions, and the

biographical approach will raise ever fresh questions about cultural conventions, their origins, and the time of their validity.

Either approach may thus lead us to consult works on economics or social science, on psychology or on the theory of communication; unless we do, we risk talking nonsense, but for the question in hand theories are critical tools rather than ends in themselves. It is true that the cultural historian may harbour ulterior ambitions; he sometimes dares to hope that there is a bonus in store for good work in this as in any other field. A worthwhile contribution to cultural history may transcend the particular, suggesting to other students of culture fresh ideas about the innumerable ways various aspects of a civilization can interact.

Of these interactions, the way forms, symbols and words become charged with what might be called cultural meanings seems to me to offer a particular challenge to the cultural historian. I have tried to hint at this problem at the outset of this lecture in drawing attention to certain overtones of the word 'culture' which can hardly be found in any dictionary. In our own cultural environment we catch these resonances without having to spell them out; the picture on the wall of the living-room, the accent, the handwriting, the manner of dress and the manner of greeting all reverberate for us with countless such cultural and social overtones, but if we are no Hegelians we also realize that these clusters of meaning cannot always be interpreted correctly in psychological terms. Much criticism of contemporary culture by the elderly misses the mark for this very reason. The widespread success of so-called psychedelic patterns is not really correlated to the strength of this silly and suicidal cult, but it still mildly partakes of the flavour of escapist conformism, which is not, I hope, a portent of things to come. It is only the Hegelian who believes that whatever is right and who therefore has no intellectual defences against the self-appointed spokesman of the *Zeitgeist*.

I have alluded to styles in painting, in dress and in pattern-making, but the best example of what I mean by resonance is surely the realm of music. The jazzy rhythm, the folksy tune, the march, the hymn, the minuet, they all evoke clusters of cultural resonances which we do not have to have explained.

Or do we? I think my own roots are still sufficiently deep in the past for me to understand Beethoven's Pastoral Symphony. I do not claim that I have ever seen merry-making peasants quite in the style Beethoven saw, or that I have joined in a thanksgiving hymn after a thunderstorm, but all these associations still come naturally to me as I can connect the 'awakening of cheerful emotions on arrival in the country' with my own memory of excursions from Vienna.

But today you leave the city by car along a motor-road which leads through

ribbon developments to petrol stations. There are no merry-making peasants either in life or even in fiction, and attendance at thanksgiving services is notoriously small. The mood of the 'pastoral' may soon have to be explained as elaborately as has the mood or 'flavour' of an Indian Raga.

Our own past is moving away from us at frightening speed, and if we want to keep open the lines of communication which permit us to understand the greatest creations of mankind we must study and teach the history of culture more deeply and more intensely than was necessary a generation ago, when many more of such resonances were still to be expected as a matter of course. If cultural history did not exist, it would have to be invented now.

8 Academic Attitudes

It seems to me that the academic world is very slow indeed in responding to this growing need. History in our universities still means largely political and perhaps economic history. It is true that a few other disciplines have also by now received a licence to make their own cuttings into the forest of the past in pursuit of the history of literature, of music, of art, or of science. But unless I am much mistaken students are frequently advised to keep to these straight and narrow paths to the Finals and onwards to research, looking neither right nor left and leaving vast areas of the forest unvisited and unexplored.

I would hate the idea of my criticism of *Geistesgeschichte* giving aid and comfort to such enemies of cultural history. It cannot be repeated sufficiently often that the so-called 'disciplines' on which our academic organization is founded are no more than techniques; they are means to an end but no more than that. Clearly the historian of music must learn to read scores, and the economic historian must be able to handle statistics. But it will be a sad day when we allow the techniques we have learned, or which we teach, to dictate the questions which can be asked in our universities.

If the cultural historian lacks a voice in academic councils, it is because he does not represent a technique, a discipline. Yet I do not think he should emulate his colleagues from the departments of sociology in staking a claim to a method and terminology of his own.[33] For whatever he may be able to learn from this and other approaches to the study of civilizations and societies, his concern, I believe, should still be with the individual and particular rather than with that study of structures and patterns which is rarely free of Hegelian holism.[34] For that same reason I would not want him to compete for the cacophonic label of an interdisciplinary discipline, for this claim implies the belief in the Hegelian wheel (Fig. 342) and in the need to survey the apparently God-given separate aspects of a culture from one privileged centre. It was the purpose of this paper to suggest that this

342
Diagram of the Hegelian
system showing the spirit
at the hub determining
all aspects of culture

Hegelian wheel is really a secularized diagram of the Divine plan; the search for a centre that determines the total pattern of a civilization is consequently no more, but also no less, than the quest for an initiation into God's ways with man. But I hope I have also made it clear why the disappointing truth that we cannot be omniscient must on no account lead us to the adoption of an attitude of blinkered ignorance. We simply cannot afford this degree of professionalization if the humanities are to survive at all.

I know that sermons against specialization are two a penny and that they are unlikely to make an impression on those who know how hard it is even to master a small field of research. But I should like to urge here the essential difference, in this respect, between the role of research in the sciences and in the humanities. The scientist, if I understand the situation, must always work on the frontiers of knowledge. He must therefore select a small sector in which hypotheses can be tested and revised by means of experiments which may be costly and time-consuming. He, too, no doubt, should be able to survey a larger field, and be well-read in the neighbouring disciplines, but what he is ultimately valued for is his discoveries rather than his knowledge. It is different, I contend, with the humanist. Humanistic education aims first and foremost at knowledge, that knowledge that used to be called 'culture'.[35] In the past this culture was largely transmitted and absorbed in the home or on travels. The universities did not concern themselves with such subjects as history or literature, art or music. Their aim was mainly vocational, and even

a training in the Classics, though valued by society, had its vocational reasons. Nobody thought that it was the purpose of a university education to tell students about Shakespeare or Dickens, Michelangelo or Bach. These were things the 'cultured' person knew. They were neither fit objects for examinations nor for research. I happen to have some sympathy for this old-fashioned approach, for I think that the humanist really differs from the scientist in his relative valuation of knowledge and research. It is more relevant to know Shakespeare or Michelangelo than to 'do research' about them. Research may yield nothing fresh, but knowledge yields pleasure and enrichment. It seems a thousand pities that our universities are so organized that this difference is not acknowledged. Much of the malaise of the humanities might disappear overnight if it became clear that they need not ape the sciences in order to remain respectable. There may be a science of culture, but this belongs to anthropology and sociology. The cultural historian wants to be a scholar, not a scientist. He wants to give his students and his readers access to the creations of other minds; research, here, is incidental. Not that it is never necessary. We may suspect current interpretations of Shakespeare or the way Bach is performed and want to get at the truth of the matter. But in all this research the cultural historian really aims at serving culture rather than at feeding the academic industry.

This industry, I fear, threatens to become an enemy of culture and of cultural history. Few people can read and write at the same time; and while we pursue our major and minor problems of research, the unread masterpieces of the past look at us reproachfully from the shelves.

But who, today, still feels this reproach? In our world it is the phrase 'a cloistered scholar' that reverberates with reproach. The cultural historian draws his salary from the taxpayer and should serve him as best he can.

I hope I have made it clear in what his service can consist. For good or ill the universities have taken over from the home much of the function of transmitting the values of our civilization. We cannot expect them to get more thanks for this from some of the students than the parental home sometimes got in the past. We surely want these values to be probed and scrutinized, but to do so effectively their critics must know them. Hence I do not see why we should feel apologetic towards those who urge us to concern ourselves with the present rather than with the past. The study of culture is largely the study of continuities, and it is this sense of continuity rather than of uncritical acceptance we hope to impart to our students. We want them to acquire a habit of mind that looks for these continuities not only within the confines of their special field, but in all the manifestations of culture that surround them.

Take the occasion of this paper. When I was honoured by the invitation to give the Philip Maurice Deneke Lecture, the question naturally struck me how

the Institution arose in which I was to play a part. I knew that this particular series owes its existence to the beneficence of the Misses Deneke who instituted it in 1931 in memory of their father. But in making this benefaction they followed a tradition which is by now firmly established in the whole Anglo-Saxon world, the tradition of named lectures as monuments to private persons.

It took a 'traveller from foreign lands' to notice this tradition, for I found that my English colleagues took it so much for granted that I had to explain and confirm that there are no such lectures on the continent of Europe.

In England, it turned out, these lectureships developed organically out of the educational foundations exemplified by the colleges of the ancient universities which, in their turn, arose quite naturally from the medieval bequests for chantries. France still witnessed a parallel growth in the Sorbonne of Paris, called after a private founder, but soon the privilege of naming such institutions was apparently confined to princes and rulers. My own school in Vienna was called the Theresianum, after the Empress, but not before the nineteenth century were Austrian schools called after commoners. What was it that secured this continuity and ramification in England? What induced Lady Margaret Beaufort to found a Lady Margaret Readership and what part was played in the encouragement and preservation of this swelling number of benefactions by the Laws of Trust, which are also apparently peculiar to this country?[16] Admittedly I found it safer to ask these questions at the end of this paper rather than at the beginning, for I do not know the answers. But I believe that these answers could be found and that they need be neither vague nor, as the jargon has it, 'value-free'. Paying tribute to a great tradition, they would also help to vindicate the name and function of cultural history.

Editor's Postscript

A great deal of ink has been spilt over Gombrich's hostility to Hegel and whether the historians mentioned in 'In Search of Cultural History' were properly speaking Hegelians; this is about as profitable as trying to identify true Marxists. Anyone who is inclined to view Marxism as one thing should read Maynard Solomon (ed.), Marxism and Art: Essays Classic and Contemporary *(Brighton, 1979); the experience is salutary.*

The point of Gombrich's critique is the untenability of the idea that all of the human and cultural manifestations of a society can be regarded as a unified manifestation of a mode of thought, or Spirit. Talk about the Spirit of the Age is selective and self-confirming; some alternative is needed. He developed a theoretical alternative to historicism in 'The Logic of Vanity Fair', in Ideals and Idols; *it was his response to Karl Popper's* The Poverty of Historicism *(London, 1957).*

This chapter offers a point of departure for a new kind of analysis of the social functions and determinants of art. It should be noted that Gombrich has always adopted the view that a cultural practice such as painting is important as an institution, and as such is subject to the vicissitudes of social life. It is in such a context that one should read the points raised about the development of modern art in the 1965 Postscript to The Story of Art, incorporated into chapter 28, 'A story without end', in the 1995 edition.

In addition to the material cited in my postscript on pp. 367–8 consult: 'The Renaissance – Period or Movement' in J. B. Trapp (ed.), Background to the English Renaissance (London, 1974) and George Boas's article, 'Historical Periods', Journal of Aesthetics and Art Criticism, 11 (1952-3), pp. 248-54. See also Gombrich's 'Prolusion' to Alison Brown (ed.), Language and Images of Renaissance Italy (Oxford, 1995).

Gombrich's book on The Preference for the Primitive is going to be a further application of the analysis of 'symptoms and syndromes' but until it appears consult his work on the Renaissance and the Reynolds Lecture.

See also the postscript on pp. 378–9.

Part VIII Alternatives to the 'Spirit of the Age'

Architecture and Rhetoric in Giulio Romano's Palazzo del Tè

A lecture given in Mantua in August 1982; published in *New Light on Old Masters* (1986), pp. 161–70

The Palazzo del Tè, which figures in the preceding survey of Giulio Romano's work in the service of the Gonzaga, is a characteristic product of its time. Its function seems to have been from the beginning to entertain and to impress. Hence Giulio pulled out all the stops to create those *bizarri* which his predecessor Leonbruno had promised in vain.[1] Flimsy as the structure really is, it is intended to give the impression of a heavily rusticated stone building (Figs. 3, 343, 344), a design which incorporated some of Giulio's most notorious surprise effects such as the triglyphs in the entablature of the courtyard (Fig. 345) which appear to wait for the mason's hand to be put into place. A similar striving for variety and effect also dominates the frescoed rooms of the palace, with the portraits of horses in the Sala dei Cavalli (Fig. 346), the sensual mythologies of the Sala di Psiche (Figs. 4, 347), the austere simulated marble reliefs of the Sala di Stucchi (Fig. 348) and the climax of it all – the Sala dei Giganti (Fig. 349), where the walls seem to be crashing down on the unsuspecting visitor.

No wonder that this *plaisance* aroused very different reactions in different visitors. The tourists of the nineteenth and early twentieth centuries who came to Italy in search of beauty largely passed it by. It was only after the First World War that interest began to focus on the post-classical style of the late Renaissance known by the dismissive term of 'Mannerism'.[2] It was felt that a kinship must exist between the psychological *malaise* that pervaded the modern movements and the shrill effects of Mannerist art. When, in the early thirties of this century, I made the palace the centrepiece of my doctoral

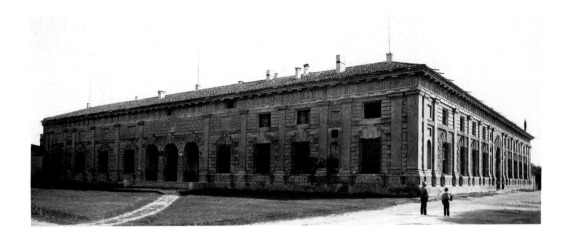

343
Palazzo del Tè, Mantua,
1527–34

dissertation on Giulio Romano's architecture[3] I certainly stood under the spell of this fashionable interpretation, though as I have explained elsewhere my work in the Gonzaga archives soon weaned me of the idea that this art was a manifestation of a profound spiritual crisis.[4] Still, what I saw and stressed was the contrasting effects Giulio liked to employ of unexpected dissonances and cool classical forms. I was particularly interested at the time in the psychological significance of both these modes of expression, equating the oppressive forms and cruel imagery with the tendencies of Mannerism, and the detached reserve with a neo-classical trend, symptomatic of the master's inner conflicts.

Returning to the palace after the war I wondered whether I had not taken it too seriously, and was glad that I had at least paid some attention to the social conditions in which it took shape.[5] Not that this aspect would necessarily disprove my psychological interpretation – after all when Diaghilev said to Cocteau, '*étonnez-moi*', the artist so addressed was bound to search his own mind and his own nightmares for surprise effects. But with the accumulation of new evidence in the form of drawings and documents showing that the building had been much altered in the course of the centuries, I preferred to leave it to the next generation to reinterpret this Renaissance 'folly'.

Yet, having read more recent publications[6] with interest and profit, it seemed to me a pity that the contemporary texts I had used in my thesis should be buried in the ruins of my early interpretation, and it is to these texts that I propose to return here, since I believe that they still demand to be considered. I refer most of all to the passage in the Fourth Book of Sebastiano Serlio's treatise on architecture in which he speaks of our palace.

It was the habit of the ancient Romans to mix the rustic style not only with the

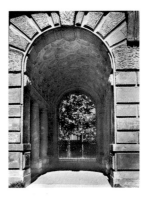

344
Entrance arch, Palazzo del
Tè, Mantua, 1532

345
Courtyard façade, Palazzo
del Tè, Mantua, c.1532

Doric but also with the Ionic and the Corinthian orders. Thus it will not be a mistake to make such a mixture with one of these styles representing in this way partly a work of nature and partly the work of the craftsman; because the columns bound by rustic stone, and also the architrave and the frieze interrupted by the columns, show the work of nature, but the capitals and part of the columns and also the cornice with the pediment represent the work of the human hand and this mixture is in my opinion very pleasing to the eye and shows great strength … and Giulio Romano has taken more delight in this mixture than anyone else, witness various places in Rome and also in Mantua, that most beautiful Palazzo del Tè, not far outside that city, truly a model of architecture and of painting for our age.[7]

It seems to me that the importance of that comment has not been diminished by the interesting discovery that the eighteenth-century restorers frequently exaggerated the roughness of the rustic. Given Serlio's interpretation of the rustic as the work of nature I ask myself whether he had not heard it from Giulio's own lips. Clearly he had seen the palace, is it not likely that he also talked about it with its architect?

In Serlio's opinion the mixture with the rustic 'is very pleasing to the eye and shows great strength'. Another text which I quoted in my thesis allows us to go further still: the passage in the Munich manuscript where Serlio describes the doorway of a Roman camp in Dacia: 'This is the main doorway of the encampment … It is composed of the Corinthian order mixed with the rustic to demonstrate metaphorically the tenderness and pleasantness of the Emperor Trajan in forgiving and his robustness and severity in punishing.' Elsewhere in the same manuscript he says that 'The encampment had two gateways of extreme difference in workmanship. The one in the rustic style was on the side where the barbarians were more ferocious … and the other of Corinthian workmanship was on the side towards Italy.'[8]

346
Sala dei Cavalli, 1527–8.
Palazzo del Tè, Mantua

347
Sala di Psiche, 1528.
Palazzo del Tè, Mantua

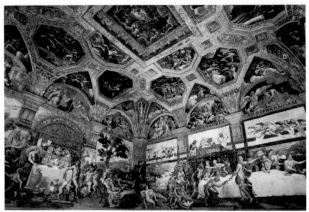

There are not many observations of this kind in the sixteenth-century treatises on architecture. Where do they come from? Here Serlio names his informant as Marco Grimani, the Patriarch of Aquileia. It is easy to see that the Patriarch owed this way of looking at architecture neither to Vitruvius nor to Alberti. He must have derived it from the theory of rhetoric.[9] It was in the ancient treatises on oratory that the Renaissance scholar learned how to throw a bridge between form and meaning, between sense impression and the expression of emotion. It was a fundamental axiom of ancient rhetoric that there should be a correspondence between the sound of a statement and its meaning.

The closest parallel to the interpretation which Serlio owed to Grimani can be found in the treatise by Dionysius of Halicarnassus, *De collocatione verborum*, where the ancient author speaks of the impression of strength that can be

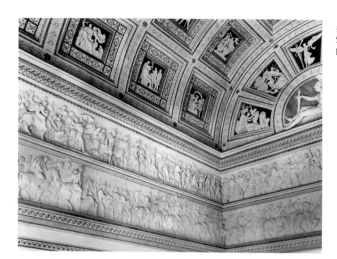

348
Sala di Stucchi, c.1530.
Palazzo del Tè, Mantua

achieved through the absence of polish by means of hard and even harsh sounds, and where he compares these effects with the roughness of primitive buildings. The austere style demands the arrangement of words in an abrupt way 'not unlike those ancient buildings made of uncut square blocks, not even arranged at right angles, which give the impression of an improvised piling-up of rough stones'.[10]

One cannot be sure that Grimani had these very words in mind, though they were printed by Aldus Manutius in Venice in 1508 in a collection of Greek rhetorical texts. In any case that aesthetic doctrine which Dionysius illustrated with the help of architecture occurs frequently in ancient treatises on oratory. Demetrius in his treatise *On Style*, which was also printed in the same edition, teaches that an excessively polished composition does not suit a strong language, but that dissonant sounds contribute to the vigour of a speech. Words which occur to the speaker at the moment, especially in a moment of rage, are more effective than an excessive care for form and harmony.[11]

The same idea is ventilated in a text which was much better known, *The Orator* by Cicero, but here there is a slight shift of emphasis. Where Cicero talks about his favourite subject, the distinction between the three styles of speech, he begins by explaining the character of the humble style. What characterizes that style is a certain artlessness; all the tricks of oratory such as rhythm and euphony must be discarded. While it was an accepted rule of style to avoid the *hiatus* and the *concursus*, that is the clash of vowels or other dissonances, Cicero admits that in this particular case such errors can contribute to a pleasing impression of negligence. It is true that he adds significantly that there exists such a thing as a calculated negligence (*sed quaedam negligentia est diligens*). Just as certain women are more beautiful without

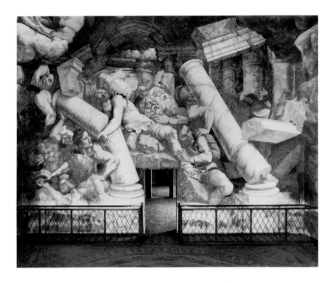

349
Giulio Romano, fresco in
the Sala dei Giganti,
1532–4. Palazzo del Tè,
Mantua

adornments, so a simple and indeed careless style gives pleasure *(subtilis etiam incompta oratio delectat)*.[12]

What Cicero stresses in the aesthetics of the natural and the artless is not so much its vigour as its pleasing character. It is well known that the praise of cultivated negligence was elaborated by Baldassare Castiglione in one of the most famous passages of *The Book of the Courtier,* his praise of *sprezzatura,* which means literally disdain.

Castiglione's starting-point is the conviction that what must be avoided at all costs is affectation. 'Hence it can be said that the true art consists in not looking like art.'[13] The consequences which Castiglione derived from this maxim are well known. Speaking of music he reminds his readers that pure harmony can also displease, while certain dissonances are delightful. As to painting 'it is said that it was proverbial among some of the best painters of antiquity that too much application can be harmful and that Apelles censured Protogenes because he did not know when to take his hand off the panel.' He adds from his own observation that 'frequently in painting a single effortless line, a single brushstroke drawn with facility in such a way that the hand has moved by itself according to the painter's intention without being guided by any study or skill, clearly reveals the excellence of the artist. Anybody can apply this observation according to his own judgement and the same is true of all other matters.'

Among the 'other matters' there was certainly architecture. I have said that Serlio may have had contact with Giulio. I can repeat with much more certainty that Giulio Romano must have frequently talked to Baldassare Castiglione. When Giulio introduced in his work the idea of the

'unfinished' he developed, I believe, another form of intentional negligence.

I agree with the opinion of those authors who maintain that in his playful use of the unfinished as a form of negligence Giulio made a virtue of necessity. The whole procedure of the construction of the palace forced him to improvise, and what better solution could he find than to combine the reality of improvisation with the appearance of a deliberate disdain of pedantic rules. There is no contradiction here between these ideas and those of Serlio, because what the 'disdain' really signifies is the virtue of naturalness rather than artifice.

But it seems to me important to emphasize that licence ceases to be licence if there are no rules to contravene. In architecture no less than in rhetoric there is an enormous difference between being ignorant of the rules and breaking them intentionally. In other words, the desired effect depends on the perceptions of a public that can appreciate the deviation from the rules.

I no longer believe that Mannerism can be called an anti-classical style, but one cannot doubt that it was a post-classical style which is, in a sense, parasitical on the classical. In my dissertation I also quoted Serlio's testimony on that point. In his *Libro extraordinario*, which contains rather bizarre designs for portals (Fig. 350), he defends himself against the insinuation that he did not know the classical rules and writes:

> I must tell you, honoured reader, why I have frequently been so licentious. I know that the majority of people are mostly desirous of new things and that many of them want in every little work they commission to place inscriptions, coats of arms, reliefs, ancient or modern portraits and similar things. It is for that reason that I have indulged in these licences, frequently breaking an architrave or a frieze, or the cornice, but always relying here on the authority of some Roman buildings ... I have rusticated columns and pilasters and sometimes interrupted the friezes ... but if you remove these features and replace the cornice where it is broken or complete the columns which are incomplete the design will remain intact and in its pristine shape.[14]

It can hardly be denied that the existence of these rules provoked ambivalent feelings among certain artists of the period. After all, there is evidence of this reaction in a famous passage of Vasari, himself an architect of the sixteenth century and born only twelve years after Giulio, for whom he had a profound admiration. I refer to the famous words of praise for Michelangelo's New Sacristy of San Lorenzo, Florence: 'For the interior he designed a decoration composed in a style of greater variety and greater novelty than any ancient or modern masters had been able to create up to that time.'[15]

After praising the novelty of the architectural elements Michelangelo had designed, Vasari continues:

> He made them rather different from those which people had made so far who followed the measurements, the orders and the rules generally in use according to Vitruvius and the antique ... This licence has much encouraged those who studied his work to imitate him, and new imaginative work resulted ... Hence, artists owe him an infinite and eternal obligation for having broken the fetters and the chains which had forced men constantly to follow the common road.

350
Sebastiano Serlio, gateway in a mixture of orders. From his *Libro extraordinario* (1551)

What interests me most in this passage is not so much the praise Vasari bestowed on the master he so much admired as his hostility to the 'fetters and chains' imposed by Vitruvius and the ancients. Could one imagine Giuliano da Sangallo or Bramante rebelling in this way?

It certainly was an anachronism to equate the so-called Mannerism with the artistic situation of the early twentieth century, but today, after that distance of time, it is not hard to see how this anachronism arose. What the two periods have in common is a certain loss of innocence in which even naturalness becomes an artifice.

When I wrote my dissertation I ventured to go further still: I suggested that the ambivalent feelings towards rules and conventions were not confined to the sphere of art. I referred to the impassioned words of Torquato Tasso in the *Aminta*, where he deplores the loss of pristine innocence and the tyranny of honour:

> O lovely Golden Age, not just because the rivers flowed with milk and the woods were rich in honey ... But only because that vain word without meaning, that idol of errors, idol of deceit, which by the vulgar insane was later called *honour*, that tyrannized over our nature, did not mix its sufferings among the sweet joys of the amorous youth; nor was its hard law known to those minds grown up in liberty; but their golden and happy law was the one Nature herself had inscribed: 'If it pleases it is permitted' ... It was you, Honour, who first threw a veil over the fount of delight ... Go from here and disturb the dream of the illustrious and powerful: Let us, the neglected and lowly crowd, live without you in the manner of the ancient people.[16]

Was this really what Tasso thought? Yes and No. We must not make the mistake of confusing art with life. The chorus which I quoted is part of a dramatic work and Tasso, being a great poet, here expresses sentiments with which we are all familiar. You might call it rhetoric, since every playwright

must be a master of rhetoric. I believe that what art historians sometimes overlook (and this applies also to my own dissertation) is precisely that dramatic and rhetorical dimension. When we speak of the meaning of a work of art we need not think that the work was intended to proclaim a truth.

In accordance with the trends of our time the most recent studies of the palace have been particularly concerned with its political meaning. Thus Professor Forster's interesting observations drawing attention to the similarity between the imperial palace represented in a mosaic at Ravenna and the Garden front of the Palazzo del Tè have prompted him to interpret the whole of the building as a propagandist celebration of the imperial power or at least the imperial aspirations of Federico Gonzaga.[17] Professor Verheyen has gone further still and has interpreted the greater part of the pictorial decorations of the interior as political propaganda.[18]

But what is propaganda? *Propaganda Fides* means the work of spreading the faith and of converting the pagans. Propaganda is tantamount to an effort to influence public opinion. The typical instruments of propaganda are sermons for the masses and the popular press. You do not make propaganda by means of a garden façade or frescoes in private cabinets. I believe that we use this term too freely if we want to say that the Gonzaga desired to persuade anyone of their political power by their palaces. No one who had inside knowledge of the game of politics would have allowed himself to be so easily influenced.

But rhetoric is not always intended to persuade. Rhetoric does not claim to speak 'the truth and nothing but the truth'. *Aliud est laudatio, aliud est historia* (praise is one thing, history another) said Bruni.[19] In the game of rhetoric one could compare the ruling prince to Jove and his mistress to Venus and could do so easily because reality did not enter. What we can learn from the parallel with rhetoric is to respect the autonomy of art. The Palazzo, its architecture and its frescoes take us into an unreal world, much as did the festivals and spectacles of the time. If we place too much weight on these rhetorical fictions we make them dissolve.

'The painter', said Plato, 'makes a dream for those who are awake',[20] not his personal dream and even less his private nightmare, as I once believed. What counts is the power of the imagination to leave empirical reality behind. I certainly would not deny that a link must exist between the creation and its creator, just as there must be some relation between the position of the patron and his taste in art. Giulio Romano was no Raphael and Duke Federico was no Agostino Chigi. But today it seems to me that what mattered is the existence of a world of art, a world of dreams, a universe created for our delight.

Editor's Postscript

Gombrich's interest in Giulio Romano started with his doctoral dissertation (see above, p. 28), parts of which have been published in English in 'Mantuan Caprice', FMR (English edition, March/April 1987), pp. 25-63. In addition to the present essay, "'That rare Italian Master...": Giulio Romano, Court Architect, Painter and Impresario' was published in New Light on Old Masters.

In his doctoral dissertation, Gombrich used Giulio Romano's architecture as a test case to determine whether Mannerism was a style. Max Dvořák had argued that Mannerism reflected the spiritual crisis which followed the Sack of Rome. It was in the Mantuan archives that:

> I learned what I should always have known, that the past was not peopled by abstractions but by men and women. I found it hard to credit them all with that spiritual predicament Dvořák and others had found expressed in the style of Mannerism, and I cast around for alternative explanations of the style, including the demands and expectations of Giulio's princely patron, the spoilt and pleasure-loving Feredrico Gonzaga, about whom we know a good deal from the documents. I have been wary of collectivism ever since. ('Focus on the Arts and Humanities', Tributes, p. 14.)

In A Lifelong Interest *he reflected:*

> In his architecture Giulio used all those capriccios and jeux d'esprit which characterized the Mannerist style. ... At the time I maintained that Giulio Romano had two completely opposed aesthetic languages: one classical and relatively severe, the other extravagantly Mannerist. Today I do not think things are as simple as that, but at the time it made quite an impression. Much later, I realized that I had undoubtedly been influenced by Picasso: Picasso had worked in a Neoclassical style – in his designs for the Ballets Russes, and so on – but elsewhere he had also carried distortion to an extreme. Thus an artist could have different modes of expression (p. 41).

In addition to the sources cited in the footnotes to this essay the reader might consult 'Psychoanalysis and the History of Art', in Meditations on a Hobby Horse, 'Mannerism: The Historiographic Background', in Norm and Form, and 'The Debate on Primitivism in Ancient Rhetoric', Journal of the Warburg and Courtauld Institutes, 29 (1966), pp. 24-37.

The standard biography of Giulio Romano is F. Hartt, Giulio Romano (New Haven, 1958).

From the Revival of Letters to the Reform of the Arts: Niccolò Niccoli and Filippo Brunelleschi

This was a contribution to the *Essays in the History of Art* presented to Rudolf Wittkower (London, 1967); reprinted in *The Heritage of Apelles* (1976), pp. 93–110

Cultural history is passing through a crisis, the crisis engendered by the slow demise of Hegelian 'historicism'. Its repercussions have been felt with particular force in Renaissance studies because it is here that the link between developments in art and in other fields has proved to modern research to be so much more complex and problematic than it appeared to the philosopher of progress. It was Hegel even more than Burckhardt who had first projected a unifying vision of the Renaissance as a forward surge of the spirit, a phase that expressed itself with equal authenticity in the revival of learning, the flourishing of the arts and the geographical discoveries, three facts representing for him the 'dawn that precedes the sunrise of the Reformation'.[1]

However little Hegel's optimistic metaphysics may have appealed to individual historians, the need for a unifying principle made it hard to forgo this conception of a new age without being left with unrelated fragments of an unintelligible past.

Rudolf Wittkower is one of the students of the period who has shown that this dilemma is unreal. Boldly challenging the traditional view that the Renaissance predilection for centralized church buildings is the expression of a new paganizing aestheticism, he has also refused to withdraw into a positivist collection of dates and groundplans.[2] He could thus show that in one particular area a bridge exists between ideas and forms without falling back on generalizations about the new age and the new man

It is the purpose of this chapter to follow up this success by facing Hegel's questions once more to look for an answer not in the metaphysics of history but in the social psychology of fashions and movements. Maybe the solution

it tries to offer is premature. It is certainly one-sided. But it will have served its end if it shows once more that if we follow Wittkower in concentrating our attention on living people in concrete situations, we are more likely even to find texts and cues that explain the interaction of changes in various fields than if we are satisfied with the pseudo-explanation of a 'spirit'.

The Renaissance is the work of the humanists. But to us this term no longer denotes the heralds of a new 'discovery of man' but rather the *umanisti*, scholars, that is, who are neither theologians nor physicians but rather concentrate on the 'humanities', principally the *trivium* of grammar, dialectic and rhetoric.[3] How was it, we must ask, that these preoccupations could lead to a revolution not only in classical studies but also in art and ultimately even in science? What started the landslide that transformed Europe?

Any movement that thus conquers society must have something to offer that establishes its superiority in the eyes of potential converts. Where what is offered is a useful invention the historian need hardly puzzle his head why it was accepted. We know only too well why gunpowder was quickly taken up in Europe, which it had reached from the East, and we are not surprised that spectacles were a success when they were first invented about 1300 in Pisa.[4] What 'movements' offer their new adherents, however, is generally something a little less tangible but psychologically more important. They offer them a feeling of superiority over others, a new kind of prestige, a new weapon in that most important fight for self-assertion which the English humorist Stephen Potter has so aptly described as the game of 'one-upmanship'. The early humanists evidently had both to offer, real inventions or at least discoveries which established their superiority in some respects over more old-fashioned scholars, but also a new emphasis on that superiority, a new glamour and self-confidence that carried everything before it, even though it was based at first on precariously narrow foundations. The humanists, as Ruskin once put it, 'discovered suddenly that the world for ten centuries had been living in an ungrammatical manner, and they made it forthwith the end of human existence to be grammatical ...'[5]

To be sure this interpretation has been increasingly challenged in recent years. Many students of the period have come to emphasize the importance of 'civic humanism' in the outlook of such great humanists as Coluccio Salutati and Leonardo Bruni Aretino, who certainly cared for many things besides grammar.[6] The question is only whether it was these virtues which secured humanism its ascendancy and ultimate triumph. The time may have come to focus attention once more on those representatives of the movement who are nowadays sometimes censured for their exclusive concentration on classical studies. Of these, by common consent, the most outstanding and the most

extreme example is Niccolò Niccoli, 1367–1437, a Florentine merchant of a well-to-do family.[7]

Every student of the period knows the charming portrait of the aged Niccoli, which Burckhardt quoted from Vespasiano da Bisticci's biography: 'always dressed in the most beautiful red cloth, which reached to the ground … he was the neatest of men … at table he ate from the finest of antique dishes … his drinking cup was of crystal … to see him at the table like this, looking like a figure from the ancient world, was a noble sight indeed.'[8]

Every line of Vespasiano's beautiful biography breathes his veneration for a man he is proud still to have known, and whom he describes as a central figure in that great circle of enthusiasts who experienced the exhilarating tide of new texts and new information. We can confirm from the correspondence of Poggio Braccriolini, Ambrogio Traversari, Bruni, Aurispa and others that in this respect Vespasiano had not exaggerated. Niccolò Niccoli was the man to whom discoveries were reported from abroad and who passed on information and codices. His library, which went to San Marco, testifies to his industry and his devotion to the cause of classical studies.

Many decades after his death, when Vespasiano looked back, Niccolò Niccoli's role as one of the originators of the humanist movement was no longer a point of contention. 'It may be said that he was the reviver of Greek and Latin letters in Florence … although Petrarch, Dante and Boccaccio had done something to rehabilitate them, they had not reached the height which they attained through Niccolò.'[9] In all its deceptive simplicity the sentence still sums up the theme of Niccoli's life, his ambivalence towards the three great luminaries of Florentine literature who had to be surpassed if the recovery of Greek and Latin standards was to be attempted in earnest. It was his respect for these standards, we learn from Vespasiano, that accounts for the fact that Niccolò himself never published anything. His taste was so fastidious that he never satisfied himself.

Even in this idealized portrait it is possible to discern the type of pioneer to which Niccolò Niccoli belongs. They may be called the catalysts, men who effect a change through their mere presence, through conversation and argument, but who would be unknown to posterity if others had not left records of their encounters. Socrates is the most exalted example (save for religious leaders). Like Socrates, Niccoli is known to us mainly in the dual reflection of hostile satire and pious evocation. He was singled out for scurrilous diatribes and as an interlocutor in many a humanist dialogue that tried to evoke the atmosphere of discussions in Florence during its most creative period.[10]

The most telling of these dialogues was composed at a time when Niccoli

was in his middle thirties; it is the first of Leonardo Bruni's famous *Dialogi ad Petrum Histrum*[11] which is often quoted for Niccoli's unbridled attack on Dante, Petrarch and Boccaccio in which it culminates.

> What are these Dantes, these Petrarchs, these Boccaccios you remind me of? Do you expect me to judge by the opinion of the vulgar and to approve and disapprove of the same as does the crowd? ... I have always suspected the crowd, and not without reason.

Quite apart from Dante's anachronisms and mistakes he was devoid of Latinity. Niccoli had recently read some of Dante's letters:

> By Jove, nobody is so uneducated that he would not feel ashamed to have written so badly ... I would exclude that poet of yours from the company of literate men and leave him to the woolworkers ...[12]

After similar tirades against Petrarch and Boccaccio Niccoli exclaims that he rates 'a single letter by Cicero and a single poem by Virgil far higher than all the scribblings of these men taken together'.[13]

It is hard to understand, let alone forgive, this sensational blasphemy unless one reads it in the context of the dialogue. For Bruni is careful both in the setting and in the argument to prepare the reader for this denunciation of Florence's proudest tradition. In the opening section Coluccio Salutati, the chancellor, a sage as well as a scholar, is found politely reproaching the young men, Bruni, Roberto Rossi and Niccolò Niccoli because they neglected discussion or disputations of philosophical matters. Niccolò agrees that such exercises would be beneficial but it is not his fault but the fault of the times in which they live that they are not worth pursuing.

> I cannot see how one can pursue the mastery of disputations in such wretched times and with such a shortage of books. For what worthy skill, what knowledge can be found in these times that is not either dislocated or totally degraded? ... How do you think we can learn philosophy these days when large parts of the books have perished and those that survive are so corrupt that they are as good as lost? True enough, there are plenty of teachers of philosophy who promise to teach it. How splendid these philosophers of our age must be if they teach what they do not know themselves.[14]

They defer to Aristotle's authority, but those harsh, hard and dissonant words they quote as Aristotle cannot be by the same man of whom Cicero writes that

he wrote with incredible sweetness. And as with philosophy so it is with all the Liberal Arts. It is not that there are no talents nowadays, or no wish to learn, but without knowledge, without teachers, without books it cannot be done. 'Where are Varro's writings, where Livy's histories, where Sallust's or Pliny's? A whole day would not suffice to enumerate all the lost works.'[15] It is here that Salutati interposes and asks his opponent not to exaggerate. They have works by Cicero and Seneca, for instance, and he reminds him of the three great Florentines, thus provoking the final outburst.

In the second dialogue this attack is withdrawn. Niccoli maintains that he had only said these outrageous things to provoke Salutati into a eulogy of the Florentine 'triumvirate'. Since it was not forthcoming it is he who shows that he can argue the other side and give due praise to the Great Three.

The contrast between these two speeches is so startling that Hans Baron has concluded that they cannot date from the same period and must be indicative of a change of heart, at least on the part of Bruni.[16] But quite apart from the fact that the marshalling of effective arguments on both sides is part of the rhetorical tradition, Niccoli's conversion is perhaps not as complete as it looks on the surface. Bruni slipped in a malicious joke that turns out to be a very backhanded retraction of the original remark about Virgil and Cicero: 'As to those who assert that they rate one poem of Virgil and one letter by Cicero more highly than all the works of Petrarch', Niccoli is now made to say, 'I frequently turn this round, and say that I prefer one speech by Petrarch to all Virgil's letters and that I rate Petrarch's poems much more highly than all Cicero's poems.'[17] Cicero's poems, of course, were notoriously wretched, and we do not possess Virgil's letters. The retraction, therefore, is quite in character.

There is no doubt that it was this sensational irreverence that attracted most attention among Niccoli's contemporaries; and in revolutions of this kind to have gained attention is half the battle. The baiting of authority, the cry 'burn the museums' belong to that ritual of 'father-killing' that we associate with new movements. But the first dialogue shows us also that this attack was launched from a secure base. The humanists had probed the enemies' defences and found out their weakest spot. They were right in their complaint about the lack of good texts, right in their suspicion of the Aristotelian doctrine as it was taught in the universities, right in their demand that in such a situation first things must come first and that the greatest need was to find out what the ancients had in fact written and taught. Without these preliminaries there can be no valid disputations within a framework that relies on authorities. It is a temper that is not unfamiliar to those of us who have witnessed similar if less spectacular reactions in present-day scholarship against the grand

generalizations of philosophical historians. The proper edition of texts and charters acquires an almost moral significance for those rebels who submit to a self-denying ordinance in order to atone for the vapid rhetoric of their elders.

It is against this background that both the hostility aroused by Niccoli's group and its ultimate European triumph become more intelligible. Documents of this hostility there are plenty. No fewer than five formal 'invectives' against Niccoli and his circle are known,[18] among them vicious attacks by the greatest of fellow humanists such as Guarino and Bruni himself. The burden of their complaint is always the same: irreverence towards the great Florentine poets, excessive arrogance backed by no creative achievement, a foolish pedantry concerned with finicky externals of manuscripts and of spelling instead of an interest in their meaning.

Thus Cino Rinuccini pretends in his invective written around 1400 that his 'sacred wrath' drove him from Florence to seek refuge and peace from the empty and stupid discussions of a gang of prattlers.

> To appear very erudite in the eyes of the vulgar they shout in the piazza how many diphthongs the ancients had and why today only two are in use ... and how many feet the ancients used in their verses and why today only the anapaest is used ... and with such extravagances they spend all their time ... but the meaning, the distinction, the significance of words ... they make no effort to learn. They say of logic that it is a sophistic science and not much use ...

And so through the whole gamut of the Liberal Arts, each of which the arrogant set is accused of dismissing and which the writer feels called upon to defend against these 'vagabonds'.[19] Rinuccini does not mention the offending party. Guarino's invective dated 1413 is much more personal; though he does not name his victim he must have been easy to identify. The letter exists in two versions.[20] Both of them contain the gravamen of the charge that Niccoli forgets that 'it is not the eagle but the spider who catches flies'.[21] One of them expands on this point at some length with heavy sarcasm describing Niccoli as a student of 'geometry'.

> Neglecting the other aspects of books as quite superfluous he expends his interest and acumen on the *points* (or dots) in the manuscript. As to the *lines*, how accurately, how copiously, how elegantly he discusses them ... You would think you hear Diodorus or Ptolemy when he discusses with such precision that they should be drawn rather with an iron stylus than with a leaden one ... As to the paper, that is the *surface*, his expertise is not to be dismissed and he displays his

eloquence in praising or disapproving of it. What a vacuous way to spend so many years if the final fruit is a discussion of the shape of letters, the colour of paper and the varieties of ink ...[22]

Guarino had recently seen a little work by Niccoli, an Orthography compiled for the education of small boys.

It shows that it is the author who is a small boy and is not ashamed, against all rules, to spell syllables which are contracted by nature with diphthongs ... This white-haired man does not blush to adduce the testimony of bronze and silver coins, of marbles and of Greek manuscripts in cases where the word offers no problems ... Let this Solon tell us, if he can, which living author of his age he does not find fault with.[23]

Leonardo Bruni picked up these and other motifs when it was his turn to quarrel with Niccoli around 1424.[24] He offers a vivid caricature of Niccoli strutting through the streets looking left and right expecting to be hailed as a philosopher and a poet, as if he said:

Look at me and know how profoundly wise I am. I am the pillar of letters, I am the shrine of knowledge, I am the standard of doctrine and wisdom. If those about him should fail to notice he will complain about the ignorance of the age ...[25]

It is Bruni now who confirms that Niccoli does not stop at abusing Dante, Petrarch and Boccaccio, that he despises St Thomas Aquinas and anyone else who lived during the last thousand years.[26] Yet what has he done himself? He cannot put two Latin words together, he is sixty now and all he knows is about books and the book trade, he knows neither mathematics nor rhetoric, nor law. Allegedly he is interested in grammar, a subject fit for boys. He ponders about diphthongs ...[27]

Making allowance for the obvious distortions of these caricatures, they still supplement the picture of Niccoli in an important respect. If Bruni's Dialogue has shown us the rebel who wants to break with the immediate past in order to restore the higher standards of antiquity, the caricatures emphasize the weapon he was using in this fight. The old men should go back to school, they cannot even properly spell or write.

It was easy to ridicule this concern as tiresome pedantry, but the very resentment it caused betrays anxiety. For clearly Niccoli was often right. The spelling of Latin had been corrupted in the Middle Ages. In itself this was no

new discovery. Salutati was also interested in orthography.[28] But for him this was certainly not the most important issue. He could freely cultivate the heritage of Petrarch and pursue the study of the classics without being totally diverted to such concentration on minutiae. He could never contemplate a breach with tradition. As Ullman has brought out so well in his book on Salutati's humanism, medievalizing and modern elements do not clash in the mental universe of the Florentine chancellor.[29] To the young rebels this must have looked like compromising with the devil. Their programme 'first things first' now started with spelling and writing.

At first sight such a programme does not look like a promising start for a fashion and movement that was to embrace the whole of the Western world. It is understandable therefore that in Hans Baron's book this pedantic classicism is mainly used as a foil to bring out the 'civic humanism' of Bruni.[30] The pedants stand condemned as men lacking in patriotism and glorying in their isolation. Not all of the few facts we know about Niccoli fit this image. Niccoli quite frequently held public office and some of the posts he occupied were not without importance.[31] But even if the picture of Niccoli's detachment were entirely correct this need not prove that he might not have influenced the course of events. It is rash to assume that a concern with spelling and similar issues cannot have more far-reaching consequences than the best-intentioned participation in local politics. We have seen in our own days that spelling reforms can become an issue of no less explosive a kind than the design of flags. It only depends in what contexts such questions are raised.

There are indications that the concern with these famous diphthongs was aroused in this circle by an outsider. Manuel Chrysoloras, the admired sage from Constantinople whom Salutati had called to Florence to teach the young scholars Greek, was interested in this question of orthography[32] which probably impinged on the correct transliteration of Greek names. It must have been startling to be told by a Greek that Latin had been corrupted in the Western world and to find confirmation of this in inscriptions on coins and tombstones. The spelling *etas* was clearly wrong, it should be *aetas,* and so with many similar forms. No wonder that these matters could become a symbol of the new emphasis on accuracy, a banner to be raised in the fight against the corruption of language.

Even now, as it happens, the question of diphthongs can make hackles rise. We need only watch the reaction of a proud English scholar who has to accept American spelling of such words as color or labor, though in this case etymology favours the transatlantic usage. But the dropping of that old-fashioned 'u' becomes identified in the mind of the conservative with 'false quantities' or even with that proverbial dropping of aitches which marks the

uneducated Cockney on the stage and in real life. No wonder tempers could be frayed over matters of spelling. Salutati still clung to the medieval usage of *michi* and *nichil* for *mihi* and *nihil*, and wanted to enforce this barbaric tradition against the 'stiffnecked' opposition of Poggio Bracciolini, who called the spelling of *nichil* a 'crime and a blasphemy'.[33] He may have been joking but he surely felt strongly about the need to revert to the purity of ancient orthography.

It would be interesting to study in a wider context the importance which language has played in the formation of social groups. Bernard Shaw's Professor Higgins knew that language and accent are the passport to society. But language is more, it can create a new allegiance. The purist who claims special insight into language and castigates current abuses will always attract attention and arouse both hostility and passionate allegiance among users of language. Karl Kraus in Austria was a case in point, a satirist to whom little else was sacrosanct beside the rules of correct German, which he saw threatened and corrupted by journalistic jargon. Healthy as was his campaign in many respects, the feeling of superiority he gave to those who had learned to spot certain common mistakes was a noteworthy by-product of his pamphleteering. It appears that it even spread to England through his admirer Ludwig Wittgenstein who, in his turn, wanted to reform the language of the tribe and succeeded mainly in raising the self-confidence of those who had learned to spot linguistic muddles in others.

We need not overwork this possible parallel to realize that the movement which Niccolò Niccoli represents may have owed some of its dynamism to what Potter calls 'one-upmanship'. The humanists were reformers of style and language and in this field they could show their demonstrable superiority over the old men who still betrayed their ignorance by spelling *nichil* instead of *nihil* or *autor* instead of *auctor*. It may well be true that this passion sometimes crowded out all other interests. Niccoli, at any rate, was not a rebellious spirit in metaphysical matters. There is no reason to doubt Vespasiano's words that he was *cristianissimo*[34] and that 'those who harboured doubts concerning the truth of the Christian faith incurred his strongest hatred'.[35]

In a sense that concentration on form rather than on content that so much aroused the wrath of Niccoli's enemies in his own time and in ours facilitates this conservatism in religious and philosophical matters. Neither for him nor, a century later, for Erasmus was there any contradiction between this regard for philological accuracy and a respect for the Gospel.

Far from being a weakness therefore, this emphasis on form was an added asset for the success of the humanist movement. It established the superiority of those who adhered to it, but it did not cut at the root of their beliefs. From

this point of view it is not surprising that it was in this circle and at that moment of time that the direct transfer occurred from a literary concern and attitude to a change in a visual style. We have heard from Guarino how much Niccoli worried about 'points, lines, and surface' in books. Another satire[16] is even more explicit. It complains once more about a group of irreverent men who fail to respect the three great Florentine poets but have never created anything of themselves. It is true,

one of them may claim to know very much about books. But I should reply, yes, perhaps, whether they are well bound, and that might make a good beadle or stationer. For this turns out to be the height of genius of that professional fault-finder, to want to see a beautiful ancient script, which he will not consider beautiful or good, if it is not of the ancient shape and well spelt with diphthongs, and no book, however good it may be, pleases him, nor would he deign to read it if it is not written in ancient characters (*lettera antica*).[17]

Here we know that what struck contemporaries as a fad and an affectation in one man was to affect the whole of the Western world. For it was this *lettera antica* that replaced the Gothic script first in Italy, whence it spread in the wake of humanism wherever the Latin alphabet is now used, including the printers of this volume.

The story of this first tangible innovation which we owe to the Florentine circle of humanists is exceptionally well documented. An art historian may well envy the palaeographer the precision with which he can here follow a stylistic change. It has been treated with masterly clarity and acumen by L. Ullman in his book on the *Origins and Developments of Humanistic Script*.[18] Thanks to Ullman we can see this development in terms of particular people expressing preferences and making a choice rather than in terms of those anonymous collective forces and trends which are the bane of history. Not unexpectedly the story begins with Petrarch, who still wrote a Gothic script but who had strong opinions about the quality of lettering he preferred. What he wants, he writes to a friend, are not fine luxuriating letters which delight the eye from afar but fatigue it in reading. In 1395 Petrarch's heir and disciple Salutati tries to procure a book from France and writes: 'If you could get one in antique lettering I would prefer it, since no letters are more welcome to my eye.'[19]

There is little doubt that what Salutati meant by antique lettering was the type of lettering used before the arrival of Gothic script, the type we now call Carolingian minuscule, which is indeed much more lucid and easier to read. Very likely Salutati, whose eyesight was deteriorating, preferred it for that

351
Coluccio Salutati's script, from a manuscript of Seneca's works, before 1375. British Museum, London, Add. MS. 11987, fol. 12

352
Poggio Bracciolini's script, from Salutati's *De Verecundia*, 1402–3. Biblioteca Laurenziana, Florence, MS. Strozzi 96, fol. 22v

reason; but he must also have noticed that the earlier manuscripts offer on the whole a better text. His expression 'antique lettering' even suggests that he may have wrongly believed the oldest codices of this kind to go back to the classical age. Salutati normally wrote in a Gothic hand (Fig. 351) but Ullman has shown that there exists at least one manuscript by Salutati himself, a codex of letters by Pliny, which the aged humanist and chancellor copied out for himself, and in which he experimented with an imitation of this earlier form of lettering. He did not sustain the attempt. The first dated manuscript known to Ullman written in the new script is a codex written by Salutati's pupil and subsequent successor in the chancellery, Poggio Bracciolini, dating from 1402 to 1403 (Fig. 352).[40] It still shows traces of Gothic form but is written with the discipline and care of the professional scribe – for that is what Poggio apparently was in his youth.

It is interesting to follow Ullman here into an analysis of the spelling which reflects the very discussions in this circle which had attracted so much hostility and ridicule.[41] In the first part of the manuscript Poggio still writes *etas* but later *aetas*. On the whole Poggio is careful to employ the sacred diphthong, occasionally even too careful. As Ullman noticed, he had some difficulty in not introducing it where it does not belong. Thus he once wrongly writes *fixae* for the adverb *fixe* and twice *accoeptus* for *acceptus*.

Poggio himself was not to become an extremist in matters of diphthongs. But what is important here is not so much the individual spelling as the emphasis on a standardized orthography and a standardized script. We can trace the efforts by which Poggio spread the new form of lettering for we know from his letters that he had set himself the task of teaching it to the scribes who served the circle of the Florentine humanists.[42]

In a letter of June 1425 to Niccolò Niccoli he mentions a scribe who can write fast and 'in that script that savours of antiquity' (*litteris quae sapiunt antiquitatem*). By then he also had a French scribe at his disposal whom he had taught to write *litteris antiquis* (in antique lettering). In 1427 Poggio complains that for four months he had done nothing but to teach a blockhead of a scribe to write 'but the ass was too stupid'. Maybe he would learn in two years. By that time, of course, the manuscripts tell their own story; we can see the spread of the *littera antiqua* in manuscript after manuscript.

As far as we can tell, the amateur Niccolò Niccoli himself did not write in the same perfect hand – as little indeed as he wrote in a perfect Latin style. According to Ullman he had developed instead a more cursive utility version of the *littera antiqua* which must have served him well in his labours of copying ancient texts and which developed later into the type we know as italic.

And yet, if the picture painted by the satirists is any guide, the single-minded passion of this man must have had a share in that reform of letters that still affects us today. It was a reform in the true sense of the word: a turning back from a corrupt style and lettering to an earlier phase. Otto Pächt has shown how closely fifteenth-century manuscripts in Italy came to be modelled on twelfth-century exemplars both in their scripts and their initials.[43] He drew attention to the similarity between the Oxford Lactantius of 1458[44] (Fig. 353) and a Gregory manuscript of the twelfth century[45] (Fig. 354).

It is obvious therefore that there is a striking parallelism between this spread of the *littera antiqua,* which was really a twelfth-century form, and the momentous change in the style of architecture we connect with the name of Filippo Brunelleschi. Brunelleschi too rejected the Gothic mode of building current in Europe in his day in favour of a new style that became known as *all'antica* (the manner of the ancients). His reforms, like that of the humanist scribes, spread from Florence throughout the world and remained valid for at least five hundred years wherever the Renaissance style was adopted or modified. Throughout these centuries this style has been regarded as a revival of ancient Roman architecture, and that is what it effectively became at the time of Brunelleschi's successor, Alberti. But whatever Brunelleschi's own intentions may have been, modern research has revealed that, like the

353
Manuscript of Lactantius
Firmianus, Florentine,
1458. Bodleian Library,
Oxford, MS. Canonici
Pat. Lat. 138, fol. 2r

354
Manuscript of St
Gregory, *Dialogues*, North
Italian, first half of the
12th century. Bodleian
Library, Oxford, MS.
Can. Pat. Lat. 105, fol. 3v

humanists, he derived his alternative to the Gothic style less from a study of Roman ruins than from pre-Gothic exemplars in Florence which we now know to be in a form of Romanesque but which he probably invested with greater antiquity and more authority.[46]

The order and magnitude of Brunelleschi's achievement is of course on a different level from that slight adjustment in letter-forms carried out by Salutati and his disciples. And yet that comparison would perhaps have sounded less extravagant to the fifteenth century than it sounds today. Lorenzo Ghiberti, who, whatever his relations were with Brunelleschi, was in constant touch with him for many years, makes the explicit comparison in his *Commentarii*. Discussing proportion as a key to beauty he switches from the example of the human body to that of writing: 'Similarly a script would not be beautiful unless the letters are proportionate in shape, size, position and order and in all other visible aspects in which the various parts can harmonize.'[47] Now it is this discovery of an underlying harmony that is stressed by Brunelleschi's biographer as the true revelation that was granted to Brunelleschi in his contemplation of ancient statues and buildings where 'he

seemed to recognize quite clearly a certain order in their members and bones … whence he wanted to rediscover … musical proportions …'[48]

It is unnecessary here to revive the discussion that has centred round the problem of Brunelleschi's Roman journey.[49] The story which Vasari took over from that same biography, which maintains that Brunelleschi left Florence for Rome because he was not awarded the commission of the Baptistery doors, so obviously bears the stamp of a pragmatic reconstruction that it need not be taken seriously. Of course this would not exclude any number of trips by Brunelleschi to Rome during which he may have studied ancient methods of vaulting and ancient forms of capitals.

But seen in the light of the palaeographic parallel such studies of detail may well come after the main reform. Humanistic script also came to embody features, especially in majuscules, that were directly taken from Roman monuments, but the basic structure of the *bella lettera antica* was not Roman but Romanesque. Like the reform of script the reform of architecture was certainly due to the new and exclusive enthusiasm for antiquity, but its inspiration came mainly from monuments of the Florentine past that were venerated as Roman relics. In this respect there is evidence, not yet considered by art historians, that strongly suggests a link between these two reform movements, for once more the clues point to Niccolò Niccoli and to Coluccio Salutati.

Vespasiano actually tells us that Niccolò 'especially favoured Pippo di Ser Brunellesco, Donatello, Luca della Robbia and Lorenzo Ghiberti and was on intimate terms with them'.[50] But this testimonial is rather vague and late in date. More precious and more startling evidence is buried in Guarino's invective of 1413 against Niccolò Niccoli, a date that is a few years earlier than any of Brunelleschi's first efforts in the new style. This is what Guarino writes about Niccolò Niccoli:

Who could help bursting with laughter when this man, in order to appear also to expound the laws of architecture, bares his arm and probes ancient buildings, surveys the walls, diligently explains the ruins and half-collapsed vaults of destroyed cities, how many steps there were in the ruined theatre, how many columns either lie dispersed in the square or still stand erect, how many feet the basis is wide, how high the point of the obelisque rises. In truth mortals are smitten with blindness. He thinks he will please the people while they everywhere make fun of him …[51]

Here is a precious document therefore which shows Niccolò Niccoli as interested in the externals of ancient buildings as he was in ancient lettering

and spelling. We can even infer what spurred this interest in Florence at this particular moment. The clue is found in a famous pamphlet by Salutati which strangely enough has also escaped the attention of architectural historians.

Once more we are in the context of polemics. Salutati, the Florentine chancellor, was out to defend and exalt the dignity of Florence against the attacks of the Milanese Loschi.[52] The background of this polemic has been illuminated in Hans Baron's book on *The Crisis of Humanism*.[53] Baron has emphasized how the civic pride of Florence was aroused by the moment of mortal danger from the north when the Visconti of Milan made ready to snuff out the last of the independent city states. It was in this patriotic propaganda that the legendary links between Florence and the Roman Empire loomed large and Salutati was out to prove this claim to be well founded. He proved it by art-historical arguments:

> The fact that our city was founded by Romans can be inferred from the most compelling conjectures. There is a very old tradition obscured by the passage of years, that Florence was built by the Romans, there is in this city a Capitol and a Forum close by, … there is the former temple of Mars, whom the aristocracy believed to be the father of the Roman nation, a temple built neither in the Greek nor in the Etruscan manner, but plainly in the Roman one. Let me add another thing, though a matter of the past; there was another sign of our origin that existed up to the first third of the fourteenth century, … that is an equestrian statue of Mars on the Ponte Vecchio, which had been preserved by the populace in memory of the Romans … We also still have the traces of the arches of the aqueduct built according to the custom of our ancestors … and there still exist the round towers, the fortifications of the gates now joined with the Bishop's Palace, which anyone who had seen Rome would not only see but swear to be Roman, not only because of their material and brickwork, but because of their shape.[54]

There is yet more literary evidence for this interest in the architectural style of the monuments we now assign to the Florentine 'proto-Renaissance'. Giovanni da Prato's *Paradiso degli Alberti* which Baron dates around 1425, the very years of Brunelleschi's reform, contains another discussion of the Roman origin of Florence which is probably dependent on Salutati but gives more details. Its description of the Baptistery (Figs. 355, 356, 357) as an ancient temple of Mars scarcely has a parallel in pre-Renaissance literature:

> This temple can be seen to be of singular beauty and in the most ancient form of building according to the custom and method of the Romans. On close

inspection and reflection it will be judged by everyone not only in Italy but in all Christianity the most notable and singular work. Look at the columns in the interior which are all uniform carrying architraves of finest marble supporting with the greatest skill and ingenuity that great weight of the vault that can be seen from below and makes the pavement appear more spacious and more graceful. Look at the piers with the walls supporting the vault above, with the galleries excellently fashioned between one vault and the other. Look at the interior and the exterior carefully and you will find it as architecture useful, delightful, lasting, solved and perfect in every glorious and happy century.[55]

While these lines were being written Brunelleschi was probably already at work to revive this form of building. We do not know for certain to which building should go the honour of having been the first in which Brunelleschi ventured this deliberate break with current usage to become the *risuscitatore delle muraglie antiche alla romanescha* (the reviver of ancient building in the Roman manner) as he is called by Giovanni Rucellai.[56]

Brunelleschi's ascendancy in the Cathedral workshop coincides with the work on three important projects, the Ospedale degli Innocenti, the San Lorenzo Sacristy, and, if we can believe his early biographer, the Palazzo della

356
The Baptistery, Florence,
towards the high altar

357
The Baptistery, Florence,
opposite view

Parte Guelfa.[57] That there was some give and take between two of these projects at least is indicated by the fact that a certain Antonio de Domenico '*capomaestro della parte Guelfa*' (Master in chief of the Parte Guelfa) was detailed in March 1421 to do some work on the building of the Innocenti.[58] If it could ever be shown that the Parte Guelfa was the first project in which the new reformed style was used, a certain link could perhaps be established between the interest of the 'civic humanists' in the Roman monuments of Florence and the revival of the style. For though the *Parte Guelfa* appears to have lost much of its power in the course of the fourteenth century it may still have been true, to use Gene A. Brucker's formulation, that it remained a 'visible symbol of the Guelf tradition. Most Florentines had come to accept the Parte's contention that it was the city's most vital link with her past and also the guardian of her destiny.'[59] Among their ceremonial rights and duties was the precedence given

358
Filippo Brunelleschi, San
Lorenzo, Florence, begun
1418

359
SS. Apostoli, Florence,
11th century

to the captains of the *Parte* to lead the annual procession to the Baptistery at the Feast of San Giovanni, the patron saint of Florence.[60] Would it not have been fitting to build their palace in the admired style of that ancient shrine? A new statute of the *Parte Guelfa* was approved in March 1420. It had been prepared by a commission whose members 'in this preparation could rely on the work and aid of Leonardo Bruni'.[61] It would certainly be tempting to connect the new building with this attempt at reviving the institution. According to Manetti, Brunelleschi was only called in when the building had already been begun. In the absence of further evidence we cannot tell whether this may have happened as early as 1418 as some have conjectured[62] or whether the Innocenti project which was started in 1419 has the priority. One thing is likely – Brunelleschi's departure from the traditional Gothic methods was at first confined to certain commissions.[63] In all probability he continued to use the earlier idiom for some of the private houses which he apparently built in the 1420s.

This is evidently not the place to recapitulate the development of Brunelleschi's style, which has been so frequently discussed. Suffice it to repeat that it was a reform rather than a revolution. It is well known, for instance, that for the interiors of San Lorenzo (Fig. 358) and of S. Spirito he adapted the scheme of the Romanesque basilica, exemplified in Florence by the eleventh-century church of SS. Apostoli (Fig. 359), but that he changed not only its proportions but also such details as the arches resting directly on the columns. The device he used of interposing an 'entablature block' between the capital of the column and the arch was also prefigured in the arcaded orders of the exterior of the Baptistery (Fig. 355).

Even one of Brunelleschi's most perfect creations owes more to the

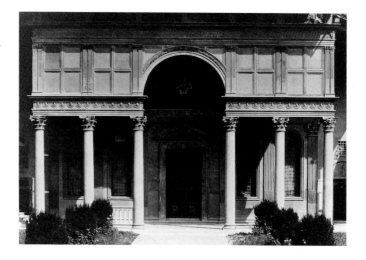

Baptistery than to genuinely Roman architecture. I am referring to the (unfinished) façade of the Cappella Pazzi (Fig. 360). This time it is the basic scheme of the interior of the earlier building, with the arch cutting into the zone above the columns (Fig. 356) that Brunelleschi adapted for his graceful design. Yet in adopting this arrangement he also purified the detail (perhaps on the authority of the Pantheon in Rome; cf. Fig. 361). He did away with the solecism of the truncated pilasters which, in the Baptistery, are showing over the arch.

Thus it is clear that Brunelleschi's reform parallels the humanist reforms also in that respect that it is more concerned with the weeding out of corrupt practices than with an entirely fresh beginning. What strikes us, in the vocabulary of Quattrocento architecture, is less its classical character than its link with the medieval past. The typical form of the palace window as we see it on Michelozzo's Medici palace is a case in point (Fig. 362). There is nothing here that matches Roman forms, but much that goes back directly to medieval practice as exemplified by the Gothic window of the Bargello (Fig. 363). All the Renaissance architect did was to remove the solecism of the pointed arch and so to make the general shape conform to the rules abstracted from Vitruvius and Roman buildings. The relation can be taken as typical. It is this type of continuity behind diversity which we so often find when we analyse the manifestations of the Renaissance. No wonder opinions differ so widely as to the degree of novelty we should attribute to the period. Would it not be correct to say that the novelty lies frequently in the avoidance of mistakes that would infringe the classical norm?[64] This avoidance in its turn springs from the new freedom to criticize the tradition and to reject anything that seems 'a crime and a sacrilege' in the eyes of ancient authority.

361
G. P. Pannini, *The Interior of the Pantheon in Rome*, *c*.1740 (detail). National Gallery of Art, Washington, Samuel H. Kress Collection

It is this after all that distinguishes the humanists from the more conformist scholastics. It is this which made Niccolò as their spokesman so unpopular and so startling. He arrogated to himself the right to feel superior over the greatest figures of the Florentine past because he knew certain things better – diphthongs for instance. Is it not possible that it was this same critical attitude that connects the humanist movement also with the second of Brunelleschi's momentous reforms, the introduction of scientific perspective into the vocabulary and the practice of painting?

The first great work of art, of course, in which Brunelleschi's style *all'antica* is combined with his achievement of mathematical perspective is the presentation of the Christian mystery of the Trinity in Masaccio's fresco in Santa Maria Novella, painted about 1425 (Fig. 373).

Much, perhaps too much, has been written about perspective and the claim has been made in various forms that this new style reflects the new philosophy, the new *Weltanschauung*, centred on man and on a new rational conception of space. But cannot Occam's Razor be applied to these entities? Can it not be argued that perspective is precisely what it claims to be, a

method of representing a building or any scene as it would be seen from a certain vantage point? If it does, Brunelleschi's perspective represents an objectively valid invention, no less valid than the invention of spectacles a century earlier. Nobody has as yet claimed that to look at the world through lenses to correct bad eyesight is due to a new *Weltanschauung*, though we may claim that it is due to inventiveness.

Maybe the invention of scientific perspective can be seen as a reform that originated from the same critical scrutiny of tradition as did the introduction of diphthongs. The Trecento tradition that had its origin in Giotto was as vulnerable from that point of view as was the poetry of Dante, Petrarch and Boccaccio. Boccaccio could claim of Giotto that he was able to deceive the sense of sight,[65] but looked upon with cool detachment and with the legendary fame of ancient painters in mind this claim could hardly be upheld. There are inconsistencies in the spatial construction of Trecento paintings which must have jarred increasingly on critical minds the more the narrative style demanded a convincing setting.[66] It fits well with this interpretation that in Bruni's first Dialogue of 1401 there is also a critical reference to painting put into the mouth of Niccolò Niccoli. The passage, which has also escaped the attention of art historians, occurs in the context of Niccoli's attack on Petrarch and the advance publicity he was accused of giving to his *Africa*.

What would you say of a painter who would claim to have such knowledge of his art that, when he started to paint a scene, people would believe that another Apelles or Zeuxis was born in their age, but when his paintings were revealed they would prove to be laughably painted with distorted outlines ? Would he not deserve universal mockery?[67]

364
The Florentines feeding the Sienese, c.1340. From the Biadaiuolo Manuscript. Biblioteca Laurenziana, Florence, Cod. Laurenziano Tempiano No. 3, fol. 58c

365
The City of Florence. Detail of a fresco, 1352. Museo del Bigallo, Florence

Whether or not Niccoli's darts are here directed against any particular artist, one thing is sure, at the time when they were published there was really nothing painters could do to rectify this strange impression of distorted outlines — indeed the closer they came to a naturalistic narrative, the more noticeable were such inconsistencies. Help had to come from outside, and looking at the matter *post factum* it is not at all surprising that it came from an architect.

The story of Brunelleschi's invention has been discussed and analysed by Panofsky, Krautheimer and John White.[68] According to Manetti the first perspective painting was a view of the Baptistery (Fig. 355) as seen through the door of the Cathedral. Looking at the painting, or rather its mirror reflection through a peephole, and looking at the real scene, the startled beholder could see that the two images were identical. It may be no accident that Brunelleschi took the Baptistery for his demonstration piece. For this famous landmark of Florence which Dante calls '*il mio bel San Giovanni*' (my fair St John's) had figured on many traditional views of the city in the Trecento. We can discern it well, both in the Biadaiuolo Codex on grain distribution (Fig. 364), and again on the fresco in the Bigallo of 1352 (Fig. 365). The examples show one of the difficulties in rendering this beautiful building without distorted lines; the representation must be consistently constructed if the patterns of the incrustation are not to get you into trouble. Even on that later cassone (Fig. 366), which may well have been influenced by Brunelleschi's panel, this inconsistency is disturbing, once attention has been drawn to it.

How was it that it fell to an architect to find the remedy for this awkward

366
The Baptistery. Detail of a
Florentine cassone
painting, *c.*1430. Museo
Nazionale del Bargello,
Florence

distortion of lines? Maybe, because an architect is used to asking a different question from the painter. The painter is apt to ask 'What do things really look like?' while the architect is more often confronted with the more precise question of what can be seen from a given point. It is the answer to this simple question which must have given Brunelleschi the means to solve the painter's puzzle. For obviously, if Brunelleschi was asked, for example, during the work on the cupola of the Cathedral whether the lantern would be visible from the door of the Baptistery he would have replied that this could easily be found out by drawing a straight line from the one point to the other. If the line hits no obstacle the points must be visible. Even today, whenever the problem is raised whether a new building is likely to obscure or spoil a famous view the architect will be called upon to show exactly how much of his projected building will be visible from a given point and how its silhouette will relate to the city's skyline. Needless to say this is a question that allows of an exact answer. None of the arguments that have been customarily adduced to stress the conventional character of perspective materially affect its accuracy – neither the fact that we see with two eyes nor the fact that the retina is curved or that there is a conflict between the projection onto a plane and onto a sphere. The same objective laws secure of course an uncontrovertible answer to the question as to what part of a room can be seen from a given spot through a window. It all follows from the fact that visual lines are straight and that Euclidean geometry works, at least here on earth.[69]

It also did in 1420. What Brunelleschi had to demonstrate to his painter friends was precisely a view through an opening that corresponds to a window or frame. He chose the door of the Florentine Cathedral. What such a door offers is of course a frame of reference at a given distance against which the view out there can be plotted. If it has a gate in form of a grille, or if a net is placed in front, so much the better. With the help of this simple demonstration it can be shown that a perspective picture can be projected onto a plane. The geometrical problems of projection may not yet be solved by this simple answer, but at least they can thus be correctly posed.

Why is it, then, that this simple solution did not occur to anyone ? Why is it even asserted today by the most eminent students of the problem that there is a flaw in this argument? It is because it may be claimed in fact that we always *see* the world *liniamentis distortis* (with distorted lines). We must not confuse this simple question of *what* we see from a given point with the similar-sounding question of how things appear to us from that point. Strictly speaking that second question allows of no objective answer. It will depend on many circumstances, a building will look small when 'dwarfed' by a neighbour, a room may look larger with one wallpaper than with another. Most of all, our knowledge and expectation will invariably transform the appearance of familiar objects or identical shapes receding in depth through what are technically known as the constancies, the stabilizing mechanism of perception that counteracts the objective fluctuations of the stimuli impinging on our retinas.

The paradox is only that this transformation does not justify the criticism that has been made of the validity of Brunelleschi's invention. For where perspective is applied convincingly it enables and even compels us to read a projection on a flat panel as a report of a three-dimensional configuration.[70] It can be shown and has been shown that in this reading the constancies come into their own and we again transform the appearance of the objects represented much as we would transform it in reality. This transformation must not be confused with the total illusion we call *trompe l'œil*. It even applies to schematic images of three-dimensional views. A few moments spent on architectural photographs such as Fig. 358 with a pair of dividers will demonstrate the degree to which we underrate the objective diminution of the distant door or columns as compared to features in the foreground.

These discussions may seem to lead far off the problem of this study. But we are unlikely to get a clear picture of any movement in history before we try to assess the advantages it offered its adherents. These advantages, we have seen, may be utilitarian, psychological, or both. They can spring from the feeling of superiority that follows even from a slight improvement that makes earlier

methods look first old-fashioned and soon ridiculous. Even the early humanist reform of Latin orthography had this effect of superior knowledge backed up by genuine philological and archaeological training. The reform of lettering had the added advantage of greater clarity and beauty. Both were in fact a symptom, but not a symptom of a new philosophy so much as of an increasingly critical attitude towards tradition, a wish to eradicate mistakes that had crept in, of getting back to better texts and an unclouded view of the wisdom of the ancients. Brunelleschi's reforms went further, but in the same direction. We may call the success of his architectural innovations a mere fashion though for him the eradication of such solecisms as the Gothic arch unsanctioned by Vitruvius was certainly a genuine improvement, a return to the correct manner of building. In his reform of painting methods he could feel the assurance that he had really discovered, or rediscovered, the tool that had enabled the famous ancient masters Apelles or Zeuxis to deceive the sense of sight. Here was tangible progress and this progress, in its turn, reacted back on the self-confidence of his generation and those who followed.[71] From the preoccupation of a small *brigata* of arrogant young men the Renaissance had become a European movement, irresistible in its appeal. But perhaps it is no mere paradox to assert that this movement had its origin not so much in the discovery of man as in the rediscovery of diphthongs.

Editor's Postscript

This essay offers an excellent example of what Gombrich means by 'the logic of the situation': a desire for reform caught on amongst a small circle of Florentine artists, intellectuals and patrons and developed as a piecemeal affair. The artists could have had no idea of their ultimate destination, which we only construct on a retrospective basis. Earlier essays which explore the same theme are 'The Renaissance Conception of Artistic Progress', 'The Style All'Antica: Imitation and Assimilation' and 'Apollonio di Giovanni: A Florentine Cassone Workshop seen through the Eyes of a Humanist poet', all in Norm and Form.

For overall scene-setting see J. B. Trapp (ed.), Background to the English Renaissance *(London, 1974), which includes Gombrich's 'The Renaissance - Period or Movement?'*

A useful introduction to humanist concerns with language and style is Michael Baxandall's Giotto and the Orators *(Oxford, 1971). Alberti's* De Pictura *is essential reading for the period, see Grayson's translation* On Painting: Leon Battista Alberti, *introduction and notes by Martin Kemp (Harmondsworth, 1991).*

Part IX On the Meanings of Works of Art

The Use of Art for the Study of Symbols

First published in the
American Psychologist, 20
(1965), pp. 34–50;
reprinted in James Hogg
(ed.), *Psychology and the
Visual Arts*
(Harmondsworth, 1969),
pp. 149–170

A psychologist could address a meeting of art historians on the use of symbols for the study of art. An art historian can reciprocate by telling psychologists of the use of art for the study of symbols. If the title I have chosen has an odd and slightly topsy-turvy appearance, it is to express this conviction.

For, thanks partly to the interest which Freud's writings have stimulated in all aspects of symbolism, art historians during the last few decades have also increasingly returned to this field which had previously been neglected, if not despised, by the formalist schools of criticism. A whole branch of studies has sprung up, under the name of iconology, which is devoted to the unriddling of symbols of art.[1] The Warburg Institute to which I belong can claim to have made its contribution to this development, which also found its response and continuation in the United States. And from iconology the interest in levels of meaning has spread to the study of literature. In short, emblems and allegories, only recently dismissed as abstruse aberrations, are all the rage, and the hunt for symbols threatens to become another academic industry. Some of you may have seen that amusing satire on this vogue, Frederick C. Crews's volume, *The Pooh Perplex* (1963), which subjects A. A. Milne's nursery classic to the whole spectrum of interpretations, including 'O *Felix Culpa!* The Sacramental Meaning of Winnie the Pooh'.

I, too, know the fascination of this game, but it will not concern me here. For if we want to make use of art to learn more about the functioning of symbols, we must clearly proceed from the known rather than from the

unknown. In fact, I believe that the very pleasures of the symbol hunt have tended to obscure the fact that the vast majority of monuments in our churches and museums do not present this type of riddle. We all recognize the *Statue of Liberty* (Fig. 367) without benefit of iconological study, just as we know that if she held a balance instead of a torch, we would call her Justice.

The symbol here would be the mark of identification, not different in principle from a label or a tag. This is indeed the sense of the term we often use when we speak of mathematical symbols or of the symbols used on roadsigns. But if iconology were only concerned with the identification of labels, its psychological interest would be slight. But is it? Not if we follow a different usage that insists that a symbol is more than a sign, whatever 'more' may mean in this context.[2] This clash over terminology that has much bedevilled discussions is partly due to a divergence of philosophical traditions in Western thought.[3] The extension of the term 'symbol' to cover any kind of sign can be traced in the Anglo-Saxon tradition from Hobbes to Pierce, and has led to such coinages as symbolic logic. Against this expansionist tendency, the German Romantics and their French successors[4] stressed the religious connotations of the term and wanted it restricted to those special kinds of signs which stand for something untranslatable and ineffable. It is not my intention to adjudicate between these usages. But I think it might be worthwhile to examine the restrictionists' case in the light of psychology. One of the advantages of the study of art is precisely that it should provide material for such an examination. For it is in the study of art and its history that even the rationalist and agnostic historian has to grapple with the symbol that is called 'more than a sign' because it is felt to be profoundly fitting.

In its most simple way, psychologically, this applies even to the balance of Justice or the torch of Liberty. For these clearly are not just fortuitous identification marks which could be exchanged at will. Their choice is rooted in the same psychological tendency to translate or transpose ideas into images which rules the metaphors of language. It was the idea of *Liberty Enlightening the World* which the Alsation sculptor Frédéric-Auguste Bartholdi wished to illustrate as a present of the French people to the Americans on the occasion of the first centenary of the Declaration of Independence.[5] It was the metaphor of light that suggested the fusion of this image with the beacon or lighthouse – classical antiquity providing a real or fictitious precedent of such a gigantic statue in the Colossus of Rhodes representing the sun god, one of the Seven Wonders of the World that lived on in the imagination of the West (Fig. 368).

You will not find Bartholdi's name in most histories of nineteenth-century art, and I do not want to make any exaggerated claims for his merits. But in a

way the very fact that his name is all but forgotten confirms that the statue has become a real communal symbol, an image that enlists loyalties and mobilizes emotions by itself. It is the symbol arriving passengers crowd to see at New York harbour, not a specimen of nineteenth-century art, or an expression of Bartholdi's personal feelings for his mother, who reputedly posed as his model for the statue. And it is as a symbol that the goddess with the torch held aloft has found her way on to postage stamps and countless similar images. For the spreading of light is a metaphor easily understood as is the balancing of claims that belongs to the Virtue of Justice, or the venomous serpent that belongs traditionally to the Vice of Envy.

The invention of such appropriate emblems or attributes was once a favourite pastime of courtiers and scholars whose job it was to advise the artists on the rendering of these ideas and conceits, and I think we could find no more rapid entry into this strange field than if we imagined ourselves in their company. It need not be virtues or vices we seek to symbolize. It can be anything from an idea to a person. I do indeed remember a parlour game from my childhood of which I was very fond, though I do not think I was particularly good at it. It was a guessing game based on comparisons or metaphors of the wildest kind. We would agree, for instance, that the person to be guessed would be a film star, but you can also play it with victims nearer home, including, for argument's sake, the members of one of your professional committees. The task would be to guess his identity through a series of appropriate emblems or comparisons. The guesser would ask the group in the know such questions as: *If he were a flower, what would he be? Or what would be his emblem as an animal, his symbol among colours, his style among painters? What would he be if he were a dish?* You can imagine what opportunity these questions give to those who are in the know to regress, aggress, or perhaps caress. But the interesting

thing is really that provided the field of choice is not too large the task of the guesser is by no means hopeless. Clearly if he started to ask what kind of flower would be the appropriate attribute and were told that it might be a thistle, a whole range of people who are either jovial or shrinking would be ruled out from the start. Should he then be told that among animals his symbol might be a bear, his prickliness would take on a more specific character – very different from the dire possibility of somebody assigning a hyena to that unknown character. If then that bear-and-thistle person is compared among musical forms to a polka rather than a nocturne, there would be another cue to go on.

Clearly the regressive irrationality of these equivalents is no obstacle to their ultimate efficacy as cues. You might indeed compare each of the answers to the indices of letters and numbers on the sides of a very irregular map which combine to plot a position. The psychological category of bear-like creatures sweeps along a wide zone of the metaphorical field, and so does the category of thistly characters, but the two categories are sufficiently distinct to determine an area that can be further restricted by other plottings.

I must leave it to your ingenuity to work out rules and standards of such a game that could be used in a more serious discussion of symbol and metaphor. But some results of such an experiment we can perhaps anticipate. Its interest would not only lie in the frequency of correct scores or guesses, but in the discussions or post-mortems when the guesser has been told the right answer. Sometimes, I remember, we used to say, 'Of course, how silly of me,' but sometimes also there would be violent remonstrations that X could never be a bear, he would surely be rather a world. The degree and intensity of assent between players might give you some kind of measure of what we call a common culture. For the conditions of assent are not only similar evaluations of persons; they must include equivalent gamuts of comparisons. Take the illustrations I have chosen. I doubt if they would meet with unqualified assent even here in the American West. I chose the thistle among flowers because it comes to my mind as the prickliest plant – for there are no cacti in Austria where I grew up. Nor is it likely that my bear is your bear – mine, if I examine my mind, is the creature of Aesop's fable; you might easily ask, 'What species of bear?' And as to the polka – the very choice of that cue dates and places me hopelessly and shows that if I were a geometrical shape, I would be a very square square indeed.

One incidental advantage of analysing these post-mortems would be, I think, that we could easily dispose of one of the issues that always come up when symbolism is discussed – the problem of translatability. Those whom I have called restrictionists always insist that signs are translatable, while the

meaning of symbols cannot be put into words. I think this much canvassed distinction rests on a misunderstanding of what is translatable. Even words rarely are. All symbols function within a complex network of matrices and potential choices which can perhaps be explained up to a point, but not translated into exact equivalences unless a happy accident provides one.

You may feel that this discussion of metaphors and matrices has taken us dangerously far away from the use of art for the study of symbols. But in a sense the history of all the arts provides among other things a series of such test performances to which we respond either with incredulity or assent. What else did Elizabethan poets play than the game, *If my mistress were a goddess, which of them would she be?* or, *If my rival were an animal, what would I call him?* Painters could do likewise. The French painter Nattier would paint a Rococo beauty in the guise of Hebe, the Olympian waitress who dispenses eternal youth to the Gods (Fig. 369), or William Hogarth in eighteenth-century England would portray his critic, Charles Churchill, as a bear clumsily hugging the club of Hercules (Fig. 370).

This particular use of metaphor in graphic satire and caricature I have attempted to explore in another paper which grew out of my collaboration with my late friend, Ernst Kris.[6] Today my subject compels me to move nearer to the centre of the origins of artistic symbolism, the field of religious art – and most of the art with which we art historians deal is religious in content. I remember overhearing a sophomore at a college who complained about some lectures – they may have been mine – 'It's terrible. The professor shows one Madonna after another.' But it is one of the permanent gains of iconology that we now see why you cannot, for instance, discuss that miraculous achievement of fifteenth-century Flemish realism, *The Adoration of the Lamb* by the brothers van Eyck (Fig. 371), without trying to enter into its meaning.[7] What else, then, is the lamb of God on the altar than a traditional metaphor originally chosen by a culture which could watch every day the difference between the behaviour of a lamb or a kid being taken to the altar for slaughter? Van Eyck's Madonna is, indeed, another such centre of symbolic references, for in the cult of the Virgin the link between word and image can best be studied. Her praise is sung in countless hymns and litanies which largely draw their imagery from the Hebrew love songs enshrined in the Bible that were transposed from the profane to the sacred.

Behind Van Eyck's Virgin enthroned we can read quotations from these scriptural praises: 'She is fairer than the sun, brighter than all the stars, like the radiance of eternal light, God's mirror without blemish'.[8] Clearly the white lilies and red roses of her crown are likewise the traditional metaphors for the Virgin's purity and love.[9] There are humbler types of devotional images in

369
Jean-Marc Nattier, *The Duchess of Orleans as Hebe*, 1774. Nationalmuseum, Stockholm

370
William Hogarth, *The Bruiser* (Charles Churchill), 1763. Engraving

which all these metaphors and comparisons are literally illustrated and neatly labelled for our contemplation. Fig. 372, from a French Book of Hours of 1505, shows the Virgin in the centre whom God the Father addresses in the words of the Song of Songs. All around her are the symbols of her praise: *Electa ut sol* (choice as the sun); *pulchra ut luna* (fair as the moon); *porta coeli* (the gate of heaven); *plantatio rosae* (the rose garden); *exaltata cedrus* (the exalted cedar); *virga Jesse floruit* (the rod of Jesse flowered); *puteus aquarum viventium* (the well of living waters); *hortus conclusus* (a garden inclosed) – fully to quote only those on the left side. On the right we still find the star of the sea, the lily among thorns, the fair olive, the tower of David, the mirror without blemish, the fountain of gardens, the city of God.[10]

I have chosen this example to remind you that art was once the servant of symbolism and not symbolism the servant of art. The images of the past in our churches and museums were commissioned and fashioned to proclaim the holiness of the supernatural or the greatness of the ruler. It is not easy, perhaps, for the modern psychologist to make this adjustment, for he has learned to look at art in the contemporary context where it serves such different social ends, for instance, as a release of the artist from social pressures or as a status symbol for the collector. In these contexts the overt and interpretable meaning of any painting or sculpture has almost ceased to matter, because what we are asked to assent to is not the metaphor but the claim that 'here is art'. Hence the historian is likely to talk at cross-purposes with the aesthetician or psychologist if he concentrates on the social meaning of symbols. Yet it was this meaning which once mattered, if images were to form the focus of worship and the reminders of power. And it was the

transcending primacy of meaning that led to the importance also of form.

It is one of the stock accusations against the study of symbols in art that it leads to a concentration on content and a disregard of the one thing that matters in art, the beauty and harmony of forms. I would not deny that such traps exist for the unwary, but if many were caught this was due, perhaps, to insufficient analysis rather than to insensitivity. It is those who introduced the distinction between form and content who prepared the trap for themselves and for others. For why should we assume that forms cannot symbolize? Take the two images of the Virgin – clearly the print (Fig. 372) is a rather humble product, an accumulation of symbols without great artistic pretensions, while Van Eyck's Virgin (Fig. 371) is a masterpiece. But is it not a masterpiece precisely also because it commands our assent far beyond the individual symbols of lilies, roses, or rays? 'She is lovelier than the sun', says the text, and she is. Who ever said that beauty itself could not be a fitting symbol?

We here come across another distinction that has worried the restrictionists. Characteristic of ordinary sign systems is what Karl Bühler called the principle of abstractive relevance;[11] by this he meant the irrelevance of certain features within sign systems. There are notoriously infinitely many ways of writing the letter 'a', or even of drawing a rose. They will signify the same as long as certain invariant relationships are observed. The same is true of traffic signs where it is the colour that counts and not the shape or height, of flags where the pattern matters but not the size or the material.

Yet even in our utilitarian civilization we pay some regard to our choice of form where ceremonial and solemn occasions preserve more archaic traditions. The flag should be presented and saluted in a worthy manner; we adjust our voice and our vocabulary to a suitable hush or drone when we think that the occasion demands it, and even pay attention to the form of lettering when the meaning of the text seems to preclude a casual scrawl. This exercise of choice from a range of possible tones or forms is usually treated under the heading of expression: we express awe in hushed tones, and our sense of occasion in writing diplomas on imitation parchment. But of course the choice of suitable lettering or material also falls under the category of symbolism, at least if we take this term in the expansionist sense. I remember an advertisement of a duplicating machine for business circulars which recommended its products on the very valid ground that each copy would look like a top copy, a personal letter. Every recipient should thus feel flattered at this sign or symbol or respect – though by now the trick is so general that it annoys more than it pleases.

It is clear, once more, why such a sign that is reinforced by its shape and material cannot be translated into a mere word, even less so, than can other words. You can type out a copy of a diploma, but you cannot even translate the true meaning of imitation parchment into discursive speech – for the exact relevance of its choice depends on a whole cluster of associations or potential contexts.

What is marginal and even occasionally comical as a survival in our civilization presents for the historian the true soil from which grew what we call art. In closed societies which are still ruled by awe it is a matter of course that the symbols of faith and power must not be profaned by unworthy presentation. We all remember how the holiness of the text leads to the elaboration of the script and that proliferating richness of initials we admire in medieval art. For the holy only the most precious may serve, and only the greatest care and love can fashion the vessel for such an awesome content. It is not, I believe, an illicit expansion of meaning if we call beauty here a symbol of divinity and power – nor need we worry too much in this context what is meant by beauty; we can take the medieval definition *quod visum placet* (what delights the eyes) and assume that glowing colours, sparkling jewels and intricate symmetries meet that definition. For one of the uses of art for the study of symbols is precisely the possibility of testing the assertion that such an idea of beauty is fairly widespread and occurs independently in various cultures. It is true that in the symbols of religion and power this visual aspect is much reinforced by the knowledge that the material is precious and the workmanship rare and expensive. There is an element of sacrifice here, and

also of sheer display of wealth in what is called conspicuous waste. Gold shows this confluence of meanings which makes it the natural choice for the rendering of the divine, for its radiance is not only pleasing and precious, but also the nearest approximation to light, that widespread metaphor for the good and the holy.[12] It is true, also, that certain cultures recognize a degree of holiness that must not even be written in letters of gold. It is here that the symbol sometimes rejects the services of art, but for our present context this is a marginal problem. For wherever art dos enter the service of symbolism, the division between content, form, and material becomes artificial.

If God is thus represented on Van Eyck's altarpiece in regal and priestly splendour as a dignified man with the papal crown, it is clearly impossible to separate the content of the symbol from the manner of its presentation. To van Eyck and his sponsors the doctrine was clear that God is not a man with a beard, but that among all sensible things of which man can have experience here on earth, a beautiful and dignified fatherly ruler of infinite splendour is the most fitting metaphor our mind can grasp.[13] The Church warns the faithful not to take any of these symbols literally but only as sensible analogues to higher meanings. The aesthetician and the psychologist might do worse than study the implications of this doctrine from their own points of view. For they seem to me superior to the traditional approach which scrutinizes symbols for the degree of likeness they exhibit with the so-called referent or *denotatum*. This likeness, or 'iconicity', is supposed to allow us to regard the symbol as a representative or a presentation of what it signifies.[14] Theology, if I understand its doctrines aright, asks us to consider only that a dignified man is perhaps the least unlike experience of the divine we mortals are able to select among a gamut of possible choices. But is this not true of all symbolization? We call van Eyck's paintings 'iconic signs' of gold, pearls and radiance, but even the painter's magic skill in representation only succeeds because he selects from his limited medium of ground pigments those mixtures that most closely approximate the appearance of light and of sparkle.

I must be careful here, for I am moving dangerously close to the subject of my book on *Art and Illusion*, which I do not want to harp upon. But I think that the problem under discussion is in a way the obverse, the mirror image of the question I tried to tackle in that book. There I aimed at drawing attention to the act that all so-called representations or iconic signs are in need of interpretation, and that we are too easily misled into taking this problem for granted. We say this is a seascape, or this the image of a man, without often pausing to ask how we know and what this implies. Where ordinary symbolism is concerned, as I said, we may sometimes have neglected the

opposite procedure. We have concentrated on problems of interpretation and have still to explore the potential value to us of works of art of which we know the meaning. How far, for instance, is Van Eyck's formal treatment of the figure of God the Father here typical of symbols of highest power? For of course it is not only the splendour that distinguishes this figure from others, but also its stillness, its frontality, all the formal characteristics which we experience as hieratic – a word that really derives from *hieros*, holy. Even a medium which cannot represent splendour in the way van Eyck's technique allowed him to do can symbolize the holy through this hieratic symmetry and immobility – whether you think of the fresco of the *Trinity* by Masaccio (Fig. 373), another of the great pioneers of realism, or of a humble French woodcut of the next generation (Fig. 374). Indeed, the meaning of this rigid immobility is so obvious in its context that it seems redundant to spell it out.

I have been sometimes taken to task by critics and aestheticians for operating too freely with the concept of understanding a work of art.[15] I was even accused of equating the word 'understanding' with that translation into conceptual terms that leads away from the artistic quality of the work. But this is far from my intention. On the contrary, I would think that it is only through art that some of us can still recapture the meaning of certain symbols and understand their import as well as their translatable significance. As a historian, I also know that this confidence is sometimes misplaced. Even forms and colours depend on contexts and traditions in their meaning, and what strikes us as hieratic in one context may have lacked distinctive significance in another style where all figures are rigid. It is or this reason that our attempts to stand in front of a slide and explain or evoke the confluence of meanings are bound to look artificial. But this technical difficulty does not diminish my conviction that we can become so familiar with a given idiom of form that we understand and appreciate the artist's choice. Even the agnostic historian can thus learn what the symbols of religion once meant to the community. Most people who have been to Chartres share this conviction. It is not an irrational one.

Let me try to substantiate this bold claim by an illustration from the realm of music. Countless composers through the ages have written liturgical music, notably Masses in which the recital of the creed forms a central part. Once more the meaning of the words, the interpretation of the symbolism presents no problem to the historian. But it is precisely because this meaning and context is so rigidly determined that a study of these compositions conveys to us something of the meaning the text has for the faithful. I recommend to those of you who like music a systematic comparison of how such great masters as Bach, Haydn, Mozart and Beethoven develop and orchestrate the

373
Masaccio, *The Holy Trinity,
the Virgin, St John and Donors,*
*c.*1427. Sta Maria Novella,
Florence

374
God the Father, 1487. From a
Missal printed in Lyons

identical words of the creed. How they select from the range of available
sounds, harmonies and rhythms strains of hieratic majesty to reinforce and
elucidate the words *Credo in unum Deum*; how frequently contrapuntal and
intellectual complexities appear in the composition of the dogmatic assertion
about the Second Person of the Trinity being 'begotten, not made, and
consubstantial with the Father'; and how the character of the music changes
to tenderness and sweetness with the words 'who for us men and for our
salvation came down from heaven' introducing the central mystery: 'and was
incarnate by the Holy Ghost of the Virgin Mary.' These words often call forth
the most unexpected and mysterious resources of the master's style. The
sorrow of the passion, the silence of the entombment, the jubilation of the
resurrection are all expected to be reflected in the music, and so they are in a
very precise sense.

Reflecting can here mean any number of devices – from the tradition of
using an ascending scale to depict Christ's ascension to the mysterious sounds
in the archaic Dorian mode that Beethoven uses in the *Missa Solemnis* to
proclaim the miracle of the Incarnation. Here as often our terminology shifts
between the music depicting or expressing the meaning of the words, but I
have always felt it might be better to reserve the term 'expression' for the

spontaneous symptoms that indicate an emotion. It is a commonplace of esthetics that the confusion of these two levels has wrought havoc in critical discussion. The composer's mood and even his innermost beliefs are private and for ever inaccessible to us. What we understand is not him, but his work, his choice, that is, of musical metaphors that reflect the majesty of the *Sanctus* or the sweetness of the *Benedictus* to all who have learned to assess the significance of his choices. And whatever the private beliefs of either the composer or the listener, the music can still convey the untranslatable meaning of the text.

Would the sound alone carry the meaning? Surely this is a wrong question. Not every ascending scale means the ascension of Christ; it only can mean it in the appropriate context. The classic formulation for the art of poetry here comes from Pope's *Essay on Criticism* that sums up the wisdom of an old critical tradition:[16] *The sound must seem an echo to the sense*; an echo, not a carrier.

Let me quote you the whole stanza that both teaches and demonstrates this doctrine:

'Tis not enough no harshness gives offence,
The sound must seem an echo to the sense:
Soft is the strain when Zephyr gently blows,
And the smooth stream in smoother numbers flows;
But when loud surges lash the sounding shore,
The hoarse, rough verse should like the torrent roar.
When Ajax strives some rock's vast weight to throw
The line, too, labours, and the words move slow ...

The speed of the verse is slowed down by deliberate phonetic obstacles, and so it reflects or underscores the meaning of the words where the hero hurls the heavy rock; the liquid consonants depicting and denoting the smooth stream stand in obvious contrast to the tongue twisters describing the storm.

The sound alone, of course, does not do this unaided. Read the verse to anyone who does not know English and all he will hear is an even stream of gibberish. I know, for I was once the unwilling subject of such an experiment when a Hungarian friend of mine recited to me reams of his favourite native poetry because he thought their pure sound alone would delight me. Had I understood the discursive symbols, I might also have grasped the way the sound echoed the sense. It just does not work the other way round.

I believe the study of known symbols in artistic contexts, be they in painting, music or poetry, might indeed elucidate to the psychologist what forms, colours, rhythms, or sounds are felt to go with what meanings. They

might direct his attention to the old doctrine of *decorum* which is precisely concerned with the search of such fitting or appropriate matches.

It is still my conviction that such an investigation would tend to confirm Osgood's idea of what he calls the semantic differential. That it would be possible in principle to plot gamuts of colour, or sound, or of shapes along the co-ordinates of Osgood's semantic space with its dimensions of active and passive, good and bad, potent and weak, though we may find in the process that the convenience of three dimensions is rather too dearly bought and that his co-ordinates do not necessarily represent the optimal way of plotting all feeling tones. There may be other ways in which the study of artistic symbols might draw attention to features neglected in Osgood's classic study on *The Measurement of Meaning*.[17] One of them is precisely the relation between sound and sense in our reaction to words. In his original study, at any rate, Osgood asked his subjects to plot ideas on his 7-point scales to find, as you remember, whether snow is more wise than foolish or sin more opaque than transparent. I am sure I am not the first to wonder whether the actual sound of the word does not influence this rating. What you call a truck is called a lorry in England. I would propose the hypothesis that a truck would be rated as heavier, darker, more active, but less friendly than a lorry, which to me conveys something slightly lighter, brighter, and a bit less efficient than the dark, sharp, monosyllabic truck.

Whatever the fate of my particular hypothesis, the consensus of artists and critics is strong that artistic media are all potentially suitable to reflect or echo the sense, however vaguely and in whatever indeterminate a form. For indeterminacy, as we see by now, is no obstacle. One form or sound might prove an appropriate echo to several meanings and command assent among the participants of the game.

For surely Osgood's findings can be fitted quite effortlessly into that guessing game I described and that we might now call 'multiple matrix matching'. You remember, after all, that it was not only matrices from the world of things that could be used as cues or pointers – animals, flowers or dishes – but also colours, shapes, sounds or tastes. None of these, of course, can be said to have an intrinsic meaning, but they can interact through their very multiplicity and generate meaning within suitably narrow contexts.

In referring to an interaction of independent matrices, I am alluding to the terminology recently advocated by Arthur Koestler in his wide-ranging book on *The Act of Creation* (1964). I am not sure I can agree with Koestler in his generalizations which subsume every artistic or scientific discovery under this type of fusion. I am more interested in my present context in the effect of such fusions on the beholder, the receiver of this multiple kind of message. For

remember, in the work of art the matrices are not neatly separated for stepwise decoding as they were in our guessing game. They are telescoped and condensed into one. The effect of this simultaneity can be dramatic. The sudden deflection of attention from one level of meaning to another creates a shock which is certainly worth investigating in psychological terms. The most suggestive treatment of this question I have come across is an article by Ulric Neisser.[18] Basing himself on his work with computers, the author proposes to replace some of the older distinctions between mental activities by the two types of information processing he calls sequential and multiple processing. Ordinarily, he writes, there is a main sequence in progress in human thought, dealing with some particular material in step-by-step fashion. The main sequence corresponds to the ordinary course of consciousness, consciousness being intrinsically single. But this main sequential operation of what might be called logical thought is normally accompanied by a complex orchestration of multiple operations which are, in the nature of things, infinitely richer though less precise than the well-focused sequential process. Neisser discusses the difficulty of multiple response or multiple conscious activity, and proposes fields of research. Maybe he would find the study of art of some use. For consider Pope's advice that the sound should prove an echo to the sense in its most precise application – the simple punning device of onomatopoeic sound painting. Take the way Ovid, in the *Metamorphoses*, tells the story of the wicked peasants who refused a refuge to the pregnant Latona, the mother of Apollo and Diana, and who were turned into frogs as a punishment. 'But even under water', Ovid ends his tale, they still try to curse' (*Quamvis sint sub aqua, sub aqua maledicere tentant*). We have been following the main sequence and focusing our conscious attention on the meaning of the words which step by step unfold the story. Suddenly one of the words not only signifies along the main sequence, it also paints the repeated sound of the croaking; we are hit, as it were, from an unexpected angle; the word becomes transparent, and we hear the frogs croaking. If you want a high-sounding term for this humble sound you might call it 'extrasystemic redundancy' – redundancy being normally confined to the channel of communication to which we are asked to attend, we suddenly get this whiff of immediate confirmation from an unexpected direction. Multiplicity is mobilized and forced into consciousness with all that feeling of richness and elusiveness that goes with the abandonment of the main sequence. We are a little closer, I hope, to a psychological account of the experience of the ineffable that the restrictionists claim to be the hallmark of symbol: the feeling that it is more than a sign, because it vouchsafes us a glimpse into vistas of meaning beyond the reach of convention and logic.

I have once before in this context quoted the passage from the first page of

Dickens's novel, *Great Expectations*,[19] but I still know of no better description of this dream-like and regressive attitude to signs than this masterly evocation:

> As I never saw my father or my mother, and never saw any likeness of either of them (for their days were long before the days of photographs), my first fancies regarding what they were like, were unreasonably derived from their tombstones. The shape of the letters on my father's gave me an odd idea that he was a square, stout, dark man, with curly black hair . . .

It is almost a pity, is it not, to dissect this convincing account of a child's imaginings, but all we need say, perhaps, is that the child experienced the conventional signs as profound. Remember Bühler's principle of abstractive relevance. Ordinary letters just do not signify beyond their meaning as letters, at least they are not ordinarily used to portray what they name. Hence, in dealing with letters, the grown-up person of our culture hardly attends to their shape or font. We may shut a book and not know what font it was printed in, though we may have scanned thousands of characters. Jerome Bruner has called this principle of economy in ordinary perceptual situations the mechanism of 'gating'.[20] Where we cannot derive more information or do not need it, we shut the gates and go on to other business. I would guess that gating is a typical operation of what Neisser calls the 'main sequence', the sequential process of logical thought. Dickens's child hero would not and could not gate; he could not accept what one of Bühler's students, Julius Klanfer in an unpublished Vienna dissertation, aptly called the sign limit. The sign or symbol must yield the information he so desperately needs, something of the appearance and looks of his father whom he never saw. For of course it is not any configuration of letters to which the child responds in this regressive way, cut the most important symbol in his little universe, his father's name.

I suppose it could be argued that what we call the aesthetic response in front of works of art involves a certain refusal to gate. The image is open, as it were, and we are free to look for further and further echoes of the sense in an indeterminate level of sound or form. But of course this refusal is only a relative one. We all can distinguish between sanity and insanity in criticism – or at least we hope we can. There are the constraints of tradition, or medium, of genre, and of culture that apply reins to the historian's and the critic's fancy. He knows, or thinks he knows, that the Grand Pyramid does not embody in its measurements a compendium of the world's subsequent history, that Shakespeare's plays are not to be read as cyphers referring to the authorship of Francis Bacon, and that Jerome Bosch's paintings are not cryptograms of a

nudist sect, of which the existence in his time an city has never been documented.[21] No doubt his insistence on these and similar sign limits makes him something of a spoilsport. For where should we be allowed to dream if not in front of works of art? We may grant these critics that the intensity of the experience is not necessarily proportionate to the clarity of understanding. In fact, we know that the archaic, the remote, the unintelligible even, exerts a fascination all of its own because we are not tied to any sequential discipline. Historically, it may well be true that it was the images and symbols of which the true meaning was forgotten that most aroused the imagination. That marvellous tag from Tacitus, *Omne ignotum pro magnifico* (the unknown is always impressive), applies certainly to the study of symbols.

The most handy example here is the impression made by the symbols and images of ancient Egypt, once their true significance had been lost in the mists of the past. The Greeks and Romans, no less than their heirs in the Renaissance, were convinced that the weird images known as hieroglyphs, that is as sacred signs, contained some deep revelation that the Egyptian priests had recorded in esoteric fashion.[22]

What is interesting to the psychologist in this particular episode is the attempt to rationalize the faith in the profundity of these signs. Marsilio Ficino, the influential Neoplatonic philosopher of the Renaissance, writes that it was for a profound reason that the Egyptian priests chose images rather than individual letters when writing of divine mysteries, for God has knowledge of things not through a multiplicity of cognitive steps, but as an integral and immutable idea. It is in this context that Ficino introduces what might be called the paradigm of all mystical symbols, the serpent biting its own tail (Fig. 375). For this image which stands for time can tell us in a flash what discursive argument could only enumerate, such as the proposition that time is swift, that time in its turning somehow joins the beginning to the end, that it teaches wisdom, and brings and removes things.

I am not sure that I understand all these propositions and many more which the mystic wants to find in the enigmatic image that has been handed down to him as a key to revelation.[23] But at least it is easy to see the connection between this attitude and Neisser's multiple processes. In contemplating this particular image, or course, sequential thought is baffled to distraction when it tries to think its implication to the end. Start with the head and follow the feed of the serpent which devours its own body, and you will soon come to the impasse of what happens when it reaches its own neck.

It is this kind of paradox that is to spur the mystic on to transcend the limits of logic and ascend to a realm where the law of contradiction no longer applies. In this respect, the mystical symbol differs from the artistic symbol.

Its principle might perhaps be described as that of deliberate dissonance against that consonance of meanings I tried to elucidate in the artist's treatment of the sign. The mystic's sign is often monstrous, abstruse, dissonant and perhaps even repellent because it wants to proclaim that the true ineffable mystery lies beyond it, not in it. It is not a sensuous analogue, but a challenge to leave the world of the senses. Its inadequacy as an image is a guarantee of its divinity.

It is this conception of the symbol that was taken over by the Romantic philosophy of art. Characteristically, its adoption was due to a student of ancient myth and religion, Friedrich Creuzer, whose approach stems in direct line from the Neoplatonic interpretation of hieroglyphs.[24] To Creuzer, writing around 1800, the mysterious and remote images of most ancient civilizations were such adumbrations of the mystery – groping, perhaps, in their esoteric monstrosity, but charged with profound meaning which challenged our understanding. It was Creuzer who first contrasted this early and mystical approach to the divine with the artistic triumph of Greece which Winckelmann, the prophet of eighteenth-century classicism, had taught him to see as a true act of artistic incarnation – the creation of visible shapes for the gods. For Creuzer and his contemporaries a statue such as the Apollo Belvedere (Fig. 376) is more than a symbol of the sun god; it is a manifestation or realization of the god in human shape, a true find and fitting symbol that commands assent among all right-minded people.

Creuzer's distinction gained currency through its embodiment in Hegel's aesthetics. In Hegel's view of history as a dialectical progress upwards, the Egyptian sphinx represents the enigmatic and inadequate symbol of the mystics, the Greek god the true consonance of form and meaning, while the Christian faith leads again to a divorce between the two. I am not known as a particular friend of Hegel's constructions, but I happen to think that there is something interesting in this distinction. Not that the images of the ancient Orient really correspond to Hegel's Romantic conception of the inadequate symbol, but it is true, I believe, that the classical conception of art is incompatible with the mystical symbol, its aim being the consonance of meanings. The tradition that started in Greece looked for the open sign where, perhaps, it can indeed be found, in the expressiveness of the human physiognomy. Not that our fellow beings are to us like open books, but we do look at the human countenance and gesture without gating, and feel that the sensuous and the meaningful can here for once be fused into an indissoluble unit.[25] Thus the classical conception of art replaced the serpent by the god. In the painting and sculpture of this tradition, symbolization thus merges with characterization. When a Renaissance handbook for artists recommends a

symbol for time it translates the concept into a personification of 'Old Father Time' (Fig. 377); the symbol of the serpent only survives as his identification mark.[26]

Perhaps Hegel was not even so far from the truth when he sensed the impermanence of this solution. For if it is ever true that familiarity breeds contempt, it is in this field of art. The perfectly characterized human symbol may lack precisely that strangeness that proclaims its transcendent meaning. Thus attempts were not lacking during the Renaissance and after to import the mystical conception of the dissonant symbol into art; but however interesting these complexities are for the iconologist, artistically they remained rather barren.

375
Attributed to Albrecht Dürer, *The Hieroglyph of Eternity*, c.1512

And yet, as you know, art has increasingly shied away from the consonant and satisfying to exploit the challenge of the enigmatic, the contradictory and unresolved for its own psychological ends. What it thus loses in clarity it hopes to gain in richness, in that plenitude of meaning that embodies all the ambiguities and ambivalences that orchestrate our experience.

It is thus, perhaps, no accident that the idea or conception of the symbol that conquered twentieth-century psychology and criticism derived through Romanticism from the mystical tradition of dissonance. There is indeed a line that links Freud's use of the term in the *Interpretation of Dreams* with the Romantic tradition of Schubert and Volkelt, and with the approach of German culture historians to the symbols of myth and anthropology.

Remember that Freud's dream symbols are also enigmatic, monstrous and opaque; they are in fact the masks that our unconscious wishes must don in order to pass the censor; their meaning is only accessible to the initiated. What they share with the mystic tradition is not only their character as revelations of an otherwise unknowable realm. Like their predecessors, they also embody the irrational, antilogical character of that realm where contradictions are fused and meanings are merged. The plenitude of meaning of each symbol is practically infinite in its over-determination which excludes the idea of a sign limit. It is free association, not meditation, which will reveal to the dreamer these infinite layers of significance behind the apparent absurdity of the manifest content.

There is no difficulty, however, in subsuming Freud's concepts of symbolism under the ancient idea of metaphor. If you accept my formulation that the symbol represents the choice from a given set of matrices of what is least unlike the referent to be represented, that variety of objects which can stand for sexual organs or acts need cause us no surprise. The set or matrix in Freud is of course frequently the memory traces of recent conscious impressions which stand in the foreground of the manifest dream content and

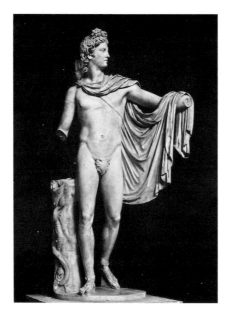

376
The Apollo Belvedere,
*c.*350 BC. Museo Pio
Clementino, Vatican

377
Father Time. From V.
Cartari, *Vere e nove imagini
degli dei antichi* (Padua, 1615)

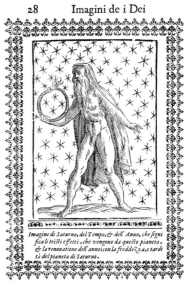

both represent and mask its deeper meaning – deeper here standing for another matrix closer to biological functions and drives.

There is no doubt that Freud's discoveries have enabled us to look deeper both into the consonance and the dissonance of multiple meanings that interlink in the structure of artistic symbols. They have allowed us to push the sign limit even further back, to ask fresh questions about the motives that made man select certain metaphors rather than others and to divine the reasons that make for the unconscious appeal of certain forms; they have added a fourth dimension to the semantic space whose depth has not, perhaps, been plumbed by Osgood's workers.

But as far as I can see, Freud nowhere encouraged or sanctioned the view that it is this dimension that presents the true or essential meaning of art. On the contrary, his whole conception of art and of culture postulated the fusion of this matrix with overt and communal meanings. He, less than anybody, welcomed a development that made the dream symbol into the standard of art. For he was convinced of its unintelligibility to all who had no access to the dreamer's associations.

It was only in the system of Carl Gustav Jung that the Freudian conception of the symbol regressed, as it were, to its origins in Neoplatonic mysticism. This is achieved, if I understand these dark matters, by fusing the transcendent realm of religious traditions with the ineffable content of the collective unconscious that talks to us in riddles – but riddles for which the key is somehow provided.[27]

The more one studies these mystical interpretations, the more one is struck by the unwillingness of man to accept the human condition which is grounded in the use of signs. The longing for immediacy, the faith in some direct communion with other minds, if not with spiritual beings, manifests itself in that leap across the sign limit that promises escape from the fetters of reason.

As a rationalist, I do not believe in this escape road, but I do not think that any psychological study of art can be worth its salt that cannot somehow account for this experience of revelation through profundity. I do not pretend that I have done that tonight, or that I shall be able to do it tomorrow; but I hope I have convinced you that if we are to make progress in this direction, we must not neglect the historical dimension; we must remember that art, as we know it, did not begin its career as self-expression, but as a search for metaphors commanding assent among those who wanted the symbols of their faith to make visible the invisible, who looked for the message of the mystery. Nobody who remembers the enigmatic hieroglyphs of our contemporary art can overlook the continued force of this longing. But to probe the use of that art for the study of symbols, you do not need to call in a historian.

Editor's Postscript

This essay has not appeared before in the Phaidon Gombrich collection, yet it is particularly useful because it brings together a number of different lines of analysis. It incorporates ideas from 'Icones Symbolicae', in Symbolic Images, *and 'Psychoanalysis and the History of Art', 'On Physiognomic Perception', 'Expression and Communication' and 'The Cartoonist's Armoury', all in* Meditations on a Hobby Horse. *The reader will also find links between this essay and 'Raphael's Stanza della Segnatura and the Nature of its Symbolism' and 'Nature and Art as Needs of the Mind', also reprinted in this volume (pp. 485–514, 565–84).*

See also 'Personification' in R. R. Bolgar (ed.), Classical Influences on European Culture *AD 500–1500 (Cambridge, 1971).*

In addition to the works cited in Gombrich's notes, Dan Sperber's Rethinking Symbolism *(Cambridge, 1988), will repay reading; Raymond Firth,* Symbols: Public and Private *(London, 1975), offers a useful resource for further exploration.*

Aims and Limits of Iconology

Introduction to *Symbolic Images* (1972); 3rd edition, 1985), pp. 1–22

There is admittedly some danger that iconology will behave, not like ethnology as opposed to ethnography, but like astrology as opposed to astrography.

Erwin Panofsky, *Meaning in the Visual Arts*, (New York, 1955), p. 32

The Elusiveness of Meaning

In the centre of Piccadilly Circus, the centre of London, stands the statue of Eros (Fig. 378), meeting-point and landmark of the amusement quarters of the metropolis. The popular rejoicings in 1947 which greeted the return of the god of Love as the master of revels from a place of safety to which the monument had been removed at the outset of the war showed how much this symbol had come to mean to Londoners.[1] Yet it is known that the figure of the winged youth aiming his invisible arrows from the top of a fountain was not intended to mean the God of earthly love. The fountain was erected from 1886 to 1893 as a memorial to a great philanthropist, the seventh Earl of Shaftesbury, whose championship of social legislation had made him, in the words of Gladstone's inscription on the monument, 'An example to his order, a blessing to this people, and a name to be by them ever gratefully remembered'. The statement issued by the Memorial Committee says that Albert Gilbert's fountain 'is purely symbolical, and is illustrative of Christian Charity'. According to the artist's own word, recorded ten years later in a conversation, he desired indeed to symbolize the work of Lord Shaftesbury: 'The blindfolded Love sending forth indiscriminately, yet with purpose, his missile of kindness, always with the swiftness the bird has from its wings, never seeking to breathe or reflect critically, but ever soaring onwards, regardless of its own perils and dangers.'

Eight years later another statement of the artist shows him veering a little closer to the popular interpretation of the figure. 'The Earl had the

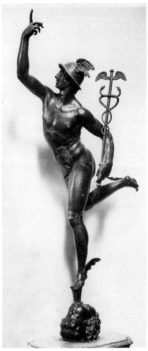

378
Albert Gilbert, *Eros*, 1893.
Piccadilly Circus, London

379
Giambologna, *Mercury*,
1580. Museo Nazionale
del Bargello, Florence

betterment of the masses at heart', he wrote in 1911 – 'and I know that he thought deeply about the feminine population and their employment. Thus, with this knowledge added to my experience of continental habits, I designed the fountain so that some sort of imitation of foreign joyousness might find place in cheerless London.' Perhaps Eros is Eros after all?

But another puzzle remains. A persistent rumour has attributed to the artist the intention of alluding to the name of Shaftesbury by showing the archer with his bow pointing downwards as if the shaft had been buried in the ground. At least one witness claimed in 1947 to have heard this explanation from the artist's own lips before the unveiling of the monument. Alas, Gilbert himself in his statement of 1903 counted this 'silly pun' by 'some ingenious Solon' among the many indignities he had to endure on the revelation of the fountain, which he had not been allowed to complete according to his design. His idea had been a drinking fountain, and he admitted in the same context that the chains by which the beakers were fastened were developed by him on the basis of Shaftesbury's initials, an idea he evidently thought much superior to the one he was eager to refute.

Close as the story is to our own time – Gilbert died in 1934 – the conscientious writer of the *Survey of London*, to whose research the above account is indebted, admits to a certain amount of uncertainty. How much

meaning did the artist have in mind? We know that he was an opponent of the 'coat and trouser school' of public monuments and keen to persuade the Committee to accept a different image as a monument. He had gained his reputation as a sculptor of such mythological themes as 'Icarus', and he was obviously captivated by the artistic possibilities of embodying in the monument another such figure which demanded a lightness of touch; his Eros, poised on tiptoe, is a variant of the famous sculptural problem so brilliantly exemplified in Giambologna's *Mercury* (Fig. 379). Should we not say that this was the meaning of the work that mattered to the artist, regardless of the symbolic reference or punning allusions that have become the concern of the iconologist?

But whatever motives Gilbert may have had in choosing his theme, he also had to persuade his Committee by accommodating his desire to a given commission and situation. The quarrel whether it was the Committee or the artist who was concerned with the 'true' meaning of the sculpture would get us nowhere. What we might find at the end of such a dispute would only be that 'meaning' is a slippery term, especially when applied to images rather than to statements. Indeed the iconologist may cast back a wistful glance at the inscription by Gladstone quoted above. Nobody doubts what it means. True, some passers-by may look for an interpretation of the statement that Shaftesbury was 'an example to his order', but nobody would doubt that the statement has a meaning which can be established.

Images apparently occupy a curious position somewhere between the statements of language, which are intended to convey a meaning, and the things of nature, to which we only can give a meaning. At the unveiling of the Piccadilly fountain one of the speakers called it 'a remarkably suitable memorial to Lord Shaftesbury, for it is always giving water to rich and poor alike ...' It was an easy, indeed a somewhat trite comparison to make; nobody would infer from it that fountains mean philanthropy – quite apart from the fact that giving to the rich would not fall under this concept.

But what about the meaning of works of art? It looks quite plausible to speak of various 'levels of meaning' and to say, for instance, that Gilbert's figure has a *representational* meaning – a winged youth – that this representation can be referred to a particular youth, i.e. the god Eros, which turns it into the *illustration* of a myth, and that Eros is here used as a *symbol* of Charity.[2] But on closer inspection this approximation to meaning breaks down on all levels. As soon as we start to ask awkward questions the apparent triviality of representational meaning disappears and we feel tempted to question the need invariably to refer the artist's form to some imagined significance. Some of these forms, of course, can be named and classified as a foot, a wing, or a bow,

380
Detail from the base of
Eros (Fig. 378)

but others elude this network of classification. The ornamental monsters round the base (Fig. 380) no doubt are meant partly to represent marine creatures, but where in such a composition does the meaning end and the decorative pattern begin? More is altogether involved in the interpretation of representational conventions than literally 'meets the eye'. The artist depends far more than the writer on what I called, in *Art and Illusion,* 'the beholder's share'. It is characteristic of representation that the interpretation can never be carried beyond a certain level of generality. Sculpture not only abstracts from colour and texture, it also cannot signify any scale beyond itself. Eros in Gilbert's imagination may have been a boy or a giant, we cannot tell.

If these limitations of the image may seem of little concern to the interpreter eager to arrive at the meaning of it all, the next level of illustration presents more serious problems. Clearly there are some aspects of the figure which are meant to facilitate identification – the winged youth as an archer calls up one and only one figure in the mind of the educated Westerner: it is Cupid. This applies to pictures exactly as it applies to literary text. The crucial difference between the two lies of course in the fact that no verbal description can ever be as particularized as a picture must be. Hence any text will give plenty of scope to the artist's imagination. The same text can be illustrated in countless ways. Thus it is never possible from a given work of art alone to reconstruct the text it may illustrate. The only thing we can know for certain is that not all its features can be laid down in the text. Which are and which are not, can only be established once the text has been identified by other means.

Enough has been said about the third task of interpretation, the establishment of symbolic references in our particular instance, to show the elusiveness of the concept of meaning. Eros meant one thing to the London

revellers, another to the Memorial Committee. The pun of shafts-bury seems to fit the circumstances so well that it might be argued that this cannot be an accident. But why not? It is the essence of wit to exploit such accidents and to discover meanings where none were intended.

But does it matter? Is it really with the intention that the iconologist is primarily concerned? It has become somewhat fashionable to deny this, all the more since the discovery of the unconscious and of its role in art seems to have undermined the straightforward notion of intention. But I would contend that neither the Courts of Law nor the Courts of Criticism could continue to function if we really let go of the notion of an intended meaning.

Luckily this case has already been argued very ably in a book concerned with literary criticism, E. D. Hirsch's *Validity in Interpretation.*[1] The main purpose of that astringent book is precisely to reinstate and justify the old common-sense view that a work means what its author intended it to mean, and that it is this intention which the interpreter must try his best to establish. To allow for this restriction of the term *meaning* Hirsch proposes to introduce two other terms the interpreter may want to use in certain contexts, the terms *significance* and *implication*. We have seen for instance that the significance of the figure of Eros has changed beyond recognition since the period in which it was set up. But it is because of such situations that Hirsch rejects the facile view that a work simply means what it means to us. The meaning was the intended one of symbolizing Lord Shaftesbury's Charity. Of course the choice of the figure of Eros may also be said to have had *implications* which account both for its meaning and its subsequent change of significance. But while the interpretation of meaning can result in a simple statement like the one issued by the Memorial Committee, the question of implication is always open. Thus we have seen that Gilbert opposed the 'coat and trouser school' and wished through his choice to bring a note of foreign gaiety into the stodgy atmosphere of Victorian England. To spell out and interpret this kind of intention one would have to write a book, and that book would only scratch the surface, whether it deals with the heritage of puritanism, or with the idea of 'foreign joyousness' prevalent in the 1890s. But this endlessness in the interpretation of implications is by no means confined to works of art. It applies to any utterance embedded in history. Gladstone, it will be remembered, referred to Lord Shaftesbury in the inscription on the memorial as 'an example to his order'. Not every modern reader may immediately catch the meaning of that term, since we are no longer used to think of the peerage as an order. But here as always it is clear that the meaning we seek is the one Gladstone intended to convey. He wanted to exalt Lord Shaftesbury as a person whom his fellow peers could and should emulate.

The implications of the inscription, on the other hand, are perhaps more open to speculation. Was there a hint of political polemics in calling the Earl 'an example to his order'? Did Gladstone wish to imply that other members of the order interested themselves too little in social legislation? To investigate and spell out these implications would again lead us to an infinite regress.

No doubt we would find fascinating evidence on the way about Gladstone and about the state of England, but the task would by far transcend the interpretation of the meaning of Gladstone's statement. Dealing, as he does, with literature rather than art, Hirsch comes to the conclusion that the intended meaning of a work can only be established once we have decided what category or genre of literature the work in question was intended to belong to. Unless we try to establish first whether a given literary work was intended as a serious tragedy or as a parody, our interpretation is likely to go very wrong indeed. This insistence on the importance of such a first step may at first look puzzling, but Hirsch shows convincingly how hard it is for the interpreter to retrace his steps once he has taken such a false turning. People have been known to laugh at tragedies if they took them to be parodies.[4]

Though traditions and functions of the visual arts differ considerably from those of literature the relevance of categories or genres for the business of interpretation is the same in both fields. Once we have established that Eros belongs to the tradition or institution of memorial fountains we are no longer likely to go very wrong in its interpretation. If we took it to be an advertisement for theatre-land we could never find our way back to the intended meaning.

2 Iconography and Iconology

It may be argued that any conclusions derived from an example of late Victorian art are scarcely applicable to the very different situation of Renaissance art which, after all, is the principal subject of these studies. But the historian will always do well to proceed from the known to the unknown, and he will be less surprised to discover the elusiveness of meaning that confronts the interpreter of Renaissance art, once he has discovered the corresponding problem at his very doorstep.

Moreover, the methodological principles established by Hirsch, particularly the principle of the primacy of genres — if it may so be called — applies to the art of the Renaissance with even greater stringency than it does to the nineteenth century. Without the existence of such genres in the traditions of Western art the task of the iconologist would indeed be desperate. If any image of the Renaissance could illustrate any text whatsoever, if a beautiful woman holding a child could not be presumed to represent the Virgin and the

Christ Child, but might illustrate any novel or story in which a child is born, or indeed any textbook about child-rearing, pictures could never be interpreted. It is because there are genres such as altar paintings, and repertoires such as legends, mythologies, or allegorical compositions, that the identification of subject-matters is at all possible. And here, as in literature, an initial mistake in the category to which the work belongs, or worse still, ignorance of possible categories will lead the most ingenious interpreter astray. I remember a gifted student whose enthusiasm for iconology so carried him away that he interpreted St Catherine with her wheel as an image of Fortuna. Since the Saint had appeared on the wing of an altar representing the Epiphany he was led from there to a speculation of the role of Fate in the story of salvation – a train of thought which could easily have led him to the postulation of a heterodox sect if his initial mistake had not been pointed out to him.

The identification of texts illustrated in a given religious or secular picture is usually considered part of iconography. Like all kinds of historical detective work the solution of iconographic puzzles needs luck as well as a certain amount of background knowledge. But given this luck the results of iconography can sometimes meet exacting standards of proof. If a complex illustration can be matched by a text which accounts for all its principal features the iconographer can be said to have made his case. If there is a whole sequence of such illustrations which fits a similar sequence in a text the possibility of the fit being due to accident is very remote indeed. I believe that there are three such examples in this volume which meet this standard. One identifies the astrological text or texts illustrated in the Sala dei Venti in the Palazzo del Tè, the second explains the version of the story of Venus and Mars in the same Palace; and the third fits Poussin's *Orion* to a text which not only tells but also explains the story, an explanation Poussin embodied in his illustration.[5]

Other essays are concerned with more speculative interpretations, but then they deal with iconological rather than iconographic problems. Not that the distinction between these disciplines is very obvious, or that it would be important to make it so. But by and large we mean by iconology, since the pioneer studies of Panofsky, the reconstruction of a programme rather than the identification of a particular text.

The procedure need only be explained to show both its interest and its hazards. There are a number of images or cycles in the art of the Italian Renaissance which cannot be explained as the straightforward illustration of a given existing text. We know moreover that patrons occasionally either invented subjects to be represented or, more often, enlisted the aid of some

learned man to supply the artist with what we call a 'programme'. Whether or not this habit was as frequent, particularly in the fifteenth century, as modern studies appear to suggest it is hard to say; but examples of this kind of 'libretto' have certainly come down to us in great numbers from the second half of the sixteenth century onward. If these programmes in their turn had consisted of original inventions or fantasies the task of reconstructing such a lost text from a picture would again be pretty hopeless. But this is not so. The genre of programmes was based on certain conventions, conventions closely rooted in the respect of the Renaissance for the canonic texts of religion and of antiquity. It is from a knowledge of these texts and a knowledge of the picture that the iconologist proceeds to build a bridge from both sides to close the gap between the image and the subject-matter. Interpretation becomes reconstruction of a lost piece of evidence. This evidence, moreover, should not only help the iconologist to identify the story which may be illustrated. He wants to get at the meaning of that story in that particular context: to reconstruct – in terms of our example – what Eros on the fountain is intended to signify. He will have little chance of doing so, if he has little feeling for the kind of programme a Victorian memorial committee was likely to impose on an artist. For taking the work as such, there is no limit to the significance that might be read into it. We have called the fish-like creatures around the fountain ornamental, but why should they not allude to the fish-symbol of Christ or, conversely, be intended as monsters over which Eros-Charity is seen to triumph?

One of the essays in this volume deals with the problems arising from this methodological uncertainty. It raises the question whether Raphael's *Stanza della Segnatura* has not been frequently over-interpreted (see below, pp. 485–514). While its specific suggestions are unlikely to meet with universal assent, the problem of the limits of interpretation could not well be omitted from a volume concerned with symbolism in Renaissance art. For all iconological research depends on our prior conviction of what we may look for, in other words, on our feeling for what is or is not possible within a given period or milieu.

3 *The Theory of Decorum*

Once more we come back to the 'primacy of genres' postulated before. This is obviously not a place to attempt a survey of all the categories and usages of art that can be documented from the Renaissance. Not that such a survey could never succeed. Émile Mâle[6] has exemplified the principles along which it might be attempted for religious art and Pigler[7] and Raymond van Marle[8] have at least made a beginning for secular subjects. But these serve the

381
Giovanni Angelo
Montorsoli, *The Fountain of Orion*, Messina, 1548

iconographer rather than the iconologist, listing possible subject-matter.

Luckily Renaissance authors have not been totally silent on the principles by which these subjects were to be used in given contexts. They obviously relied on that dominant consideration of the whole classical tradition, the notion of *decorum*. The application of this term was larger in the past than it is now. It signified what was 'fitting'. There is fitting behaviour in given circumstances, a fitting style of speech for given occasions and of course also fitting subjects for given contexts.

Lomazzo in the Sixth Book of his *Trattato*[9] has a list of suggestions for various types of places, starting, strangely enough, with such places as cemeteries where a number of episodes from the Bible relating to death are mentioned, such as the Death of the Virgin, the Death of Lazarus, the Descent from the Cross, the burial of Sarah, Jacob dying and prophesying, the burial of Joseph and 'such lugubrious stories of which we have many examples in the Scriptures' (Chap. xxii). For council rooms, on the other hand, which are used by 'secular princes and Lords', he recommends such subjects as Cicero speaking about Catilina before the Senate, the Council of the Greeks before sailing for Troy, the conflicts of captains and wise men such as Lycurgus, Plato and Demosthenes among the Greeks, and Brutus, Cato, Pompey and the Caesars among the Romans, or the contest for the arms of Achilles between Ajax and Ulysses. There follows an even longer list of Biblical and ancient subjects for court buildings, of feats of military prowess for palaces, while fountains and gardens demand 'stories of the Loves of the Gods where water, trees and other gay and delightful things' come in, such as Diana and Actaeon, Pegasus calling forth the Castalian springs, the Graces washing themselves by a spring, Narcissus by the well, etc.

382
Detail from Montorsoli's
Fountain of Orion (Fig. 381)

These and similar stories were clearly filed in the minds of Renaissance people in such a way that they could easily name, say, Biblical stories involving fire, or Ovidian stories involving water. Nor did this principle of decorum remain a dead letter. Montorsoli's Orion Fountain in Messina (Fig. 381) is as good an example as any to show this principle at work, with its decorative marble reliefs described by Vasari,[10] showing twenty mythological episodes involving water, such as Europa crossing the sea, Icarus falling into the sea, Arethusa changed into a fountain, Jason crossing the sea, etc., not to mention the various nymphs, river gods and marine monsters completing the decoration in accordance with the rules of decorum (Fig. 382).

What these examples suggest, then, is a simple principle of selection which is easy to discern. We may call it the principle of intersection – having in mind the use of letters and numbers arranged on the sides of a chequerboard or map which are used conjointly to plot a particular square or area. The Renaissance artist or artistic adviser had in his mind a number of such maps, listing, say, Ovidian stories on one side and typical tasks on the other. Just as the letter B on such a map does not indicate one field but a zone which is only narrowed down by consulting the number, so the story of Icarus, for instance, does not have one meaning but a whole range of meaning, which in its turn is then determined by the context. Lomazzo used the theme because of its association with water, while the humanist who advised on the decoration of the Amsterdam Town Hall selected it for the Bankruptcy Court (Fig. 383) as a warning against high-flying ambition, while Arion's rescue by a dolphin symbolizes, not water, but insurance against shipwreck (Fig. 384).

Not that the intersection of two such requirements would necessarily satisfy the demand of the Renaissance patron for the most fitting image. The overmantel by Benedetto da Rovezzano (Fig. 385) provides an instance of an even richer interaction: for a fireplace something involving fire was dearly *de rigueur* – the most conventional subject being the smithy of Vulcan (Fig. 386). But here we have the story of Croesus and Cyrus with the pyre meeting one

383, 384
The Fall of Icarus and *Arion on a Dolphin*. Town Hall, Amsterdam. Engravings from Jacob van Campen, *Afbeelding van 't stadt huis van Amsterdam* (1661)

385
Benedetto da Rovezzano, mantelpiece, early 16th century. Museo Nazionale del Bargello, Florence

386
Bernardino Luini, *The Forge of Vulcan*, c.1524. Brera, Milan

requirement of a fitting subject, the story of Solon's warning to 'remember the end' the equally important specification for a story with a moral lesson.

There were other requirements to be considered, not least among them the predilections and aptitudes of the artists concerned. It is often implied that the Renaissance programme paid no heed to the artist's creative bent, but this is not necessarily true. The repertory from which to choose was so rich and varied that the final choice could easily be adapted both to the demands of decorum and the preferences of the artist. Again it is not always easy to decide where, in these intersections, priority was to be sought. Describing to Aretino his frescoes from the life of Caesar, Vasari starts with the predilection which his patron has for this hero, which will make him fill the whole palace with stories from the life of Caesar. He had begun with that of Caesar's flight from Ptolemy when he swam across the water pursued by soldiers. 'As you see, I have

387
Taddeo Zuccaro, *Christ with Hermit Saints*; left, *The Essenes*; below, *Seneca, Charles V and Aristotle*, 1565. Caprarola, Palazzo Farnese, Rome

388
Taddeo Zuccaro, *Pagan Anchorites*; below, *Cato and Suleiman*, 1565. Caprarola, Palazzo Farnese, Rome

made a melée of fighting nudes, first to demonstrate the mastery of art, and then to conform to the story.'[11]

Here, perhaps, Vasari was his own master and could please himself, but we know that artists would not meekly submit to any invention thrust upon them. In this as in many other respects the programmes which Annibale Caro drew up for Taddeo Zuccaro's decorations in the Palazzo Caprarola deserve to be studied as paradigms. The one for the bedroom with mythological figures relating to night and to sleep is easily available in Vasari's Life of Taddeo Zuccaro.[12] The other, for the studio of the prince, may be even more worth pondering in its implications for the iconologist.[13] Unfortunately these learned humanists had plenty of time and were fond of displaying their erudition. Their writings, therefore, tend to tax the patience of twentieth-century readers, but we may look at some passages to sample the mode of procedure.

> The themes to be painted in the Study of the illustrious Monsignore Farnese must needs be adapted to the disposition of the painter, or he must adapt his disposition to your theme. Since it is clear that he did not want to adapt to you we are compelled to adapt to him to avoid muddle and confusion. Both the subjects relate to themes appropriate to solitude. He divides the vault into two main sections, fields for scenes, and ornament to go around.

Caro goes on to suggest for the central field 'the principal and most praised kind of solitude, that of our religion, which differs from that of the Gentiles, for ours left their solitude to teach the people, while the Gentiles withdrew from the people into solitude.' Hence Christ will occupy the middle and then St Paul, St John the Baptist, St Jerome and others if there is room for them (Fig. 387). Among the pagans withdrawing into solitude he suggests some of the Platonists who gouged out their own eyes so that sight should not distract

389
Taddeo Zuccaro, *The
Gymnosophists*; below, *Cicero*,
1565. Caprarola, Palazzo
Farnese, Rome

390
Taddeo Zuccaro, *The
Hyperboreans*, 1565.
Caprarola, Palazzo
Farnese, Rome

391
Taddeo Zuccaro, *The
Druids*, 1565. Caprarola,
Palazzo Farnese, Rome

them from philosophy, Timon, who hurled stones at the people, and others who handed their writings to the people while avoiding contact with them (Fig. 388). Two fields should show the Law conceived in solitude: Numa in the vale of Egeria and Minos emerging from a cave. Four groups of hermits should fill the corners: Indian gymnosophists worshipping the sun (Fig. 389), Hyperboreans with sacks of provisions (Fig. 390), Druids 'in the oak forests which they venerated … let them be dressed as the painter wishes, provided they all wear the same' (Fig. 391), and Essenes, 'a Jewish sect solely dedicated to the contemplation of divine and moral matters … who could be shown with a repository of the garments they have in common' (Fig. 387).

The ten oblong fields of the decoration Caro proposes to fill with the reclining figures of philosophers and Saints, each with an appropriate motto, while the seven little upright fields accommodate historic figures who withdrew into solitude, including Pope Celestine, Charles V (Fig. 387) and Diogenes.

There remain twelve tiny fields and since they would not accommodate human figures I would put some animals both as grotesques and as symbols of the theme of solitude. [The corners will take Pegasus (Fig. 389), a griffon, an elephant turning towards the moon (Fig. 389), and an eagle seizing Ganymede]; these should signify the elevation of the mind in contemplation; in the two little squares facing each other … I put the lonely eagle, gazing at the sun, which in this form signifies speculation, and the creature in itself is solitary, only bringing up one of its three offspring, casting two out. In the other I place the phoenix, also turned to the sun, which will signify the exaltedness and refinement of the concepts and also solitude, for it is unique.

Of the remaining six small round fields one is to hold the serpent that shows

astuteness, eagerness and prudence of contemplation and was therefore given to Minerva (Fig. 387), the next a solitary sparrow, the third another bird of Minerva such as the owl, the fourth an erithacus, another bird reputed to seek solitude and not to tolerate companions. 'I have not yet found out what it looks like but I leave it to the painter to do as he thinks fit. The fifth a pelican (Fig. 387), to which David likens himself in his solitude when he fled from Saul, let it be a white bird, lean because it draws its own blood to feed its young … Finally a hare, for it is written that this animal is so solitary that it never rests except when alone …'

> There remain the ornaments which I leave to the imagination of the painter, but it would be well to remind him to adapt himself, if he can, in various ways and select as grotesques instruments of solitary and studious people such as globes, astrolabes, armillary spheres, quadrants, sextants, … laurels, myrtles and … similar novelties.[14]

This point apart, the painter followed Caro, who probably added the further inscriptions and examples necessitating some changes in lay-out.

Two related questions will spring to mind when we read such a programme and compare it with the finished painting. The first, whether we could have found the meaning of the pictures without the aid of this text, in other words, whether we would have been successful in reconstructing the programme from the pictures alone. If the answer is in the negative, as I think it would have to be, it becomes all the more urgent to ask why such an enterprise would have failed in this particular instance, and what obstacles there are in general which impede this work of retranslation from picture to programme.

Some of the difficulties are fortuitous but characteristic. Caro does not claim to know how to dress Druids, and leaves the matter to the painter's fancy. One obviously would have to be a thought-reader to recognize these priests as Druids. Similarly with the bird 'erithacus', about which Caro has read in Pliny, who describes its propensity for solitude. We do not know to this day what bird, if any, was meant, and so, again, Caro gives the painter licence to draw on his own imagination. We could not know, and we could not find out.

There are other instances where Caro's programme demands such fanciful scenes that the painter had difficulty in reproducing them legibly: would we be able to guess that one of the Platonic philosophers is represented as gouging out his eyes, or that the tablet emerging from the wood is intended to save its owner any contact with the people? Would even the most erudite iconologist remember these stories and their connection with the Platonic school?

Vasari, at any rate, could not. Though he was exceptionally well informed about Caprarola and was a friend of Annibale Caro, though he knew the main theme of the cycle to be Solitude and correctly reported many of the inscriptions in the room, and identified Suleiman (Fig. 388), he misinterpreted some of the action in this panel (Fig. 388), which he describes as 'many figures who live in the woods to escape conversation, whom others try to disturb by throwing stones at them, while some gouge out their own eyes so as not to see'.[15]

But even where the difficulties of identifying the stories and symbols are less formidable than Caro and Zuccaro made them in this instance, we might still be perplexed by the meaning to be assigned to the individual symbols if Caro's text were not extant to enlighten us.

For though they are all assembled here for their association with solitude, nearly every one of them has other associations as well. The elephant worshipping the moon (Fig. 389) is used by Caro himself in the neighbouring bedroom for its association with night;[16] Pegasus, as we have seen, can decorate a fountain for its link with the Castalian spring; needless to say it can also be associated with Poetry or with Virtue. The phoenix, as a rule, stands for Immortality and the pelican for Charity. To read these symbols as signifying Solitude would look very far-fetched if we did not have Caro's words for it.

4 The Dictionary Fallacy

The programme confirms what has been suggested here from the outset, that taken in isolation and cut loose from the context in which they are embedded none of these images could have been interpreted correctly. Not that this observation is surprising. After all, it is even true of the words of an inscription that they only acquire meaning within the structure of a sentence. We have said that it is clear what Gladstone meant when he called Lord Shaftesbury 'An example to his order', but the word 'order' derives this definite meaning only from its context. In isolation it might mean a command, a regularity or a decoration for merit. It is true that those who learn a language are under the illusion that 'the meaning' of any word can be found in a dictionary. They rarely notice that even here there applies what I have called the principle of intersection. They are offered a large variety of possible meanings and select from them the one that seems demanded by the meaning of the surrounding text. If Lord Shaftesbury had been a monk the term 'his order' would have had to be interpreted differently.

What the study of images in known contexts suggests is only that this multiplicity of meaning is even more relevant to the study of symbols than it is to the business of everyday language. It is this crucial fact that is sometimes

obscured through the way iconologists have tended to present their interpretations. Quite naturally the documentation provided in their texts and footnotes gives chapter and verse for the meaning a given symbol can have – the meaning that supports their interpretation. Here, as with language, the impression has grown up among the unwary that symbols are a kind of code with a one-to-one relationship between sign and significance. The impression is reinforced by the knowledge that there exist a number of medieval and Renaissance texts which are devoted to the interpretation of symbols and are sometimes quoted dictionary-fashion.

The most frequently consulted of these dictionaries is Cesare Ripa's *Iconologia* of 1593, which lists personifications of concepts in alphabetical order and suggests how they are to be marked by symbolic attributes.[7] Those who use Ripa as a dictionary rather than read his introduction and his explanations – and there are more entertaining books in world literature – easily form the impression that Ripa presents them with a kind of pictographic code for the recognition of images. But if they spent a little more time with the book they would see that this was not the author's intention. It turns out, in fact, that the same 'principle of intersection' that has been postulated of programmes such as Caro's applies to Ripa's technique of symbolization. Luck will have it that he also lists the concept of Solitude and that his description reads like a précis of Caro's much more ample characterization: the allegory is to be represented as 'A woman dressed in white, with a single sparrow perched on the top of her head and holding under her right arm a hare and in her left hand a book'. Both the hare and the sparrow figure among Caro's symbols, and though we would not usually call the sparrow a solitary creature Ripa quotes the 102nd Psalm which says '*Factus sum sicut passer solitarius in tecto*'. If anyone, however, now wanted to interpret any hare or any sparrow in a Renaissance painting as signifying Solitude he would be much mistaken.

Ripa establishes quite explicitly that the symbols he uses as attributes are illustrated metaphors. Metaphors are not reversible. The hare and the sparrow may be used in some contexts for their association with solitude, but they have other qualities as well, and the hare, for instance, can also be associated with cowardice. Ripa was also quite clear in his mind that the method only worked if it was aided by language. 'Unless we know the names it is impossible to penetrate to the knowledge of the significance, except in the case of trivial images which usage has made generally recognizable to everybody.' If we ask, then, why Ripa went to the trouble of devising such unrecognizable personifications, the answer must be sought in a general theory of symbolism that goes beyond the immediate task of deciphering.

5 Philosophies of Symbolism

It is to this problem that the major essay in this volume is devoted. In 'Icones Symbolicae'[18] two such traditions are distinguished, but neither of them treats the symbol as a conventional code. What I have called the Aristotelian tradition to which both Caro and Ripa belong is in fact based on the theory of the metaphor and aims, with its aid, to arrive at what might be called a method of visual definition. We learn about solitude by studying its associations. The other tradition, which I have called the Neoplatonic or mystical interpretation of symbolism, is even more radically opposed to the idea of a conventional sign-language. For in this tradition the meaning of a sign is not something derived from agreement, it is hidden there for those who know how to seek. In this conception, which ultimately derives from religion rather than from human communication, the symbol is seen as the mysterious language of the divine. The augur interpreting a portent, the mystagogue explaining the divinely ordained ritual, the priest expounding the image in the temple, the Jewish or Christian teacher pondering the meaning of the word of God had this, at least, in common, that they thought of the symbol as of a mystery that could only partly be fathomed.

This conception of the language of the divine is elaborated in the tradition of Biblical exegetics. Its most rational exposition is to be found in a famous passage from St Thomas.[19]

> Any truth can be manifested in two ways: by things or by words. Words signify things and one thing can signify another. The Creator of things, however, can not only signify anything by words, but can also make one thing signify another. That is why the Scriptures contain a twofold truth. One lies in the things meant by the words used – that is the literal sense. The other in the way things become figures of other things, and in this consists the spiritual sense.

The allusion here is to the things which are mentioned in the narrative of the Bible and which are seen as signs or portents of things to come. If the Scriptures tell us that Aaron's rod 'brought forth buds, and bloomed blossoms, and yielded almonds' (Numbers, xvii.8) this could be interpreted as foreshadowing the Cross, the almond itself providing a symbol, its shell being bitter like the Passion but its kernel sweet like the victory of the Redemption.

But St Thomas warns us not to take this technique as a method of translating unambiguous signs into discursive speech. There is no authoritative dictionary of the significance of things, as distinct from words, and in his view there cannot be such a dictionary:

It is not due to deficient authority that no compelling argument can be derived from the spiritual sense, this lies rather in the nature of similitude in which the spiritual sense is founded. For one thing may have similitude to many; for which reason it is impossible to proceed from any thing mentioned in the Scriptures to an unambiguous meaning. For instance the lion may mean the Lord because of one similitude and the Devil because of another.

St Thomas, as will be perceived, again links this lack of a definite meaning of 'things' with the doctrine of metaphor. But where metaphors are conceived to be of divine origin this very ambiguity becomes a challenge to the reader of the Sacred Word. He feels that the human intellect can never exhaust the meaning or meanings inherent in the language of the divine. Each such symbol exhibits what may be called a plenitude of meanings which meditation and study can never reveal more than partially. We may do well to remember the role which such meditation and study once played in the life of the learned. The monk in his cell had only a few texts to read and re-read, to ponder and to interpret, and the finding of meanings was one of the most satisfying ways of employing these hours of study. Nor was this merely a matter for idle minds seeking employment for their ingenuity. Once it was accepted that revelation had spoken to man in riddles; these riddles embodied in the Scriptures, and also in Pagan myths, demanded to be unravelled again and again, to provide the answers for the problems of nature and of history. The technique of finding meanings would help the priest composing his sermons day in day out on given texts which had to be applied to the changing events of the community, it would sanction the reading of pagan poets, which would otherwise have to be banished from the monastic libraries, it would give added significance to the fittings of the church and to the performance of sacred rites.

Nobody who has looked into medieval and Renaissance texts concerned with symbolism can fail to be both impressed and depressed by the learning and ingenuity expended on this task of applying the techniques of exegetics to a vast range of texts, images or events. The temptation is indeed great for the iconologist to emulate this technique and to apply it in his turn to the works of art of the past.

6 Levels of Meaning?
But before we yield to this temptation we should at least pause and ask ourselves to what extent it may be appropriate to the task of interpreting the pictures or images of the past. Granted that any of these images could be seen to carry all kinds of implications—to allude to Hirsch's use of the terms—were

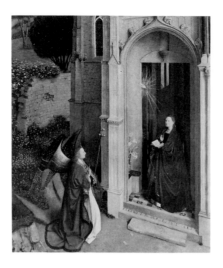

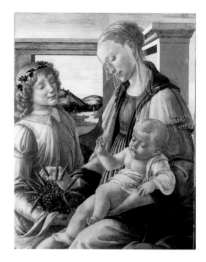

they intended to carry more than one meaning? Were they intended, as is
sometimes postulated, to exhibit the distinct four senses which exegetics
attributed to the Holy Writ and which none other than Dante wished applied
to the reading of his poem?

I know of no medieval or Renaissance text which applies this doctrine to
works of pictorial art. Though such an argument *ex silentio* can never carry
complete conviction, it does suggest that the question needs further
examination. Such an examination might well take its starting point from St
Thomas's distinction, quoted above, of the way words and things may be said
to signify. Recent iconological literature has paid much and justified attention
to the symbolic potentialities of things represented in religious paintings,
particularly those of the late Middle Ages.

Panofsky, in particular, has stressed the importance of what he calls
'disguised symbolism' in early Netherlandish art.[20] 'Things' represented in
certain religious paintings support or elaborate the meaning. The light falling
through the church window in the Friedsam *Annunciation* (Fig. 392) is a
metaphor for the Immaculate Conception, and the two styles of the building
for the Old and the New Testaments. Even though one might wish for more
evidence that these symbols and metaphors were commissioned to be *painted*,
there is no doubt that religious pictures do embody things as symbols. It is
certainly not for nothing that Botticelli made the Christ Child bless grapes
and corn, the symbols of the Eucharist (Fig. 393), and that the trees in the
background of the Berlin Madonna (Fig. 394) were intended as symbols was
attested by the scrolls with quotations from the Scriptures.[21]

I was exalted like a cedar in Libanus and as a cypress tree on the mountains of

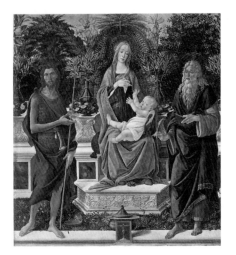

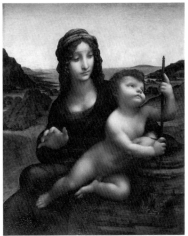

394
Sandro Botticelli, *Madonna
with St John the Baptist and St
John the Evangelist*, c.1485.
Staatliche Museen, Berlin

395
Leonardo da Vinci (copy
after), *Madonna with the
Yarn-Winder*, c.1499–1501.
Collection of the Duke of
Buccleuch

Hermon. I was exalted like a palm tree on the seashore, and as rose plants in Jericho, and as a fair olive tree in the plain; and I was exalted as a plane tree. (Ecclesiasticus, xxiv.3, 12–14)

The possibility of making 'things' signify was not lost on such masters as Leonardo, who represented the Christ Child playing with a yarn-winder (Fig. 395) recalling the shape of the cross.[22] But to what extent are these and similar examples applications of the principle of several meanings? The event is illustrated and the things figuring in the event echo and expand the meaning. But this symbolism can only function in support of what I have proposed to call the dominant meaning, the intended meaning or principal purpose of the picture. If the picture did not represent the Annunciation, the windows could not signify by themselves, and if the ears of corn and the grapes were not the object of blessing in a painting of the Madonna, they would not be transformed into the symbol of the Eucharist. Here as always the symbol functions as a metaphor which only acquires its specific meaning in a given context. The picture has not several meanings but one.

In my view this is not contradicted by the best-documented application of exegetics to a painting in the Renaissance, Fra Pietro da Novellara's famous description of Leonardo's *St Anne* (Fig. 151): .

It represents the Christ Child, about a year old, as if about to slip out of his mother's arms, grasping a lamb and seeming to hug it. The mother, as if about to rise from the lap of St Anne, grasps the Child to take him from the lamb, that sacrificial animal which signifies the Passion. St Anne, rising a little from her seat, seems to want to keep her daughter from taking the child away from the lamb:

this would perhaps stand for the Church that does not want to have the Passion of Christ prevented.[23]

The learned *frate*, Vice General of the Carmelite Order, was probably puzzled by the amount of movement Leonardo had introduced into a subject which was traditionally represented in the form of a hieratic group. Maybe the artist had the answer ready for those who asked for an explanation. But to interpret the interaction of the figures in terms of the coming drama of salvation does not, by itself, introduce a different level of meaning. The traditional group, such as we see it on a fourteenth-century Sienese altar (Fig. 396), had never been conceived as a realistic representation. No one was expected to believe that the Virgin ever settled in the lap of her mother with the Christ Child in her arms. The Child is the Virgin's symbolic attribute and the Virgin in her turn the attribute of St Anne. It is the same type of symbolic nexus which is discussed my essay on Tobias and the Angel.[24] Its symbolism is not hidden, but overt. Admittedly Novellara's tentative identification of St Anne with the Church introduces an extraneous element which may have been alien to Leonardo's intention.

In this respect Novellara's interpretation differs significantly from that given in a sonnet on the same picture by Girolamo Casio which concludes:

> St Anne, as the one who knew
> That Jesus assumed the human shape
> To atone for the Sin of Adam and Eve
> Tells her daughter with pious zeal:
> Beware if you wish to draw Him back
> For the heavens have ordained that sacrifice.[25]

In this interpretation, it will be noticed, there is no hint at two meanings. It is only implied that St Anne had prophetic gifts and interpreted the portent of 'things' at the time. In this version, then, the painting could still be seen as a genuine illustration rather than as an allegory.

7 *The Psychoanalytic Approach*

It so happens that the example chosen has also been paradigmatic for the psychoanalytic interpretation of a work of art. In his famous essay on Leonardo Freud saw in this composition a memory of the artist's youth, for the illegitimate child had been adopted into the family, he had had 'two mothers', one of whom may have had reason to hide her bitterness behind a forced smile. It can be shown that Freud was much influenced in his reading

of the childhood story of Leonardo by D. S. Merezhkovsky's historical novel[26] and that he was scarcely aware of the iconographic tradition on which Leonardo drew.[27] But too much emphasis on these sources of error would miss the more important methodological point of what is involved in interpreting an image. For even if Freud's reading of the situation rested on firmer evidence, even if Leonardo had been found on the couch to associate his childhood situation with this particular painting, it should still be obvious that the painting does not mean to refer to his mother and stepmother, but signifies St Anne and the Virgin. It is important to clarify this issue, because the discoveries of psychoanalysis have certainly contributed to the habit of finding so many 'levels of meaning' in any given work. But this approach tends to confuse cause and purpose. Any human action, including the painting of a picture, will be the resultant of many, indeed an infinite number of contributory causes. Psychoanalysis likes to speak in this context of 'over-determination' and the concept has its value as a reminder of the many motivations that may overlap in the motivation of anything we say, do, or dream. But strictly speaking any event that occurs is 'over-determined' if we care to look for all the chains of causation, all the laws of nature which come into operation. If Leonardo's childhood experience should really have been one of the determining causes for his accepting a commission to paint St Anne and the Virgin so, we may assume, were other pressures which might conceivably be traced to their source. Maybe the problem attracted him for its difficulty, maybe he was just in need of money.[28] What would matter in any of these cases is only that the innumerable chains of causation which ultimately brought the work into being must on no account be confused with its meaning. The iconologist is concerned with the latter, as far as it can be determined. The historian should remain aware of the complexity and elusiveness of the first.

Perhaps we best escape from the perplexities posed by the problem of intentionality by insisting more firmly than Hirsch has done that the intended meaning is not a psychological category at all. If it were, a sentence written by a computer could have no meaning. We are rather concerned with categories of social acceptance, as is the case with all symbols and sign systems. It is these which matter to the iconologist, whatever penumbra of vagueness they may of necessity exhibit.

Benvenuto Cellini's description of his own *Saliera* (Fig. 397) may provide an illustration of this point. It is a clear and conventional application of the principle of decorum. Being destined for salt and pepper, products of the sea and of land, he decorated it fittingly with the figures of Neptune and of the personification of Earth. But in describing his famous masterpiece he wanted

397
Benvenuto Cellini, *Saliera*,
1543. Kunsthistorisches
Museum, Vienna

to stress that this was not all: 'I arranged for the legs of the male and female to
be gracefully and skilfully intertwined, one being extended and the other
drawn up, which signified the mountains and the plains of the earth.[29] It would
be futile to ask whether this little conceit was intended from the outset, nor
would it be kind to inquire whether Neptune's knees signify the waves of the
sea. Clearly the artist is entitled further to embroider on his ideas and to
rationalize what he has done in terms of such explanations. What matters
here is surely that the work does not resist this particular projection of
meaning. The interpretation produces no contradiction, no jarring split. In
looking at a work of art we will always project some additional significance
that is not actually given. Indeed we must do so if the work is to come to life
for us. The penumbra of vagueness, the 'openness' of the symbol is an
important constituent of any real work of art, and will be discussed in the
essay on Raphael's *Stanza della Segnatura* (see below, pp. 485–514). But the
historian should also retain his humility in the face of evidence. He should
realize the impossibility of ever drawing an exact line between the elements
which signify and those which do not. Art is always open to afterthoughts,
and if they happen to fit we can never tell how far they were part of the
original intention. We remember the conflicting evidence about the pun of
'shafts-bury' which had either been saddled on Gilbert's Eros or had been part
of his original intention.

8 Codes and Allusions

It so happens that even the example of such a pun can be paralleled from the
Renaissance. Vasari tells us that Vincenzio da San Gimignano carried out a

façade painting after a design by Raphael, showing the Cyclops forging the thunderbolt of Jove, and Vulcan at work on the arrows of Cupid.[30] These, we read, were intended as allusions to the name of the owner of the house in the Borgo in Rome which these paintings adorned, one *Battiferro*, meaning hitting iron. If the story is true the subject was chosen as what is called in heraldry a 'canting device'. The story of such allusions should be quite salutary reading for the iconologist, for we must admit again that we could never have guessed.

Thus Vasari also describes the festive apparatus designed by Aristotile da San Gallo in 1539 for the wedding of Duke Cosimo de' Medici and Eleonora of Toledo.[31] The paintings, which drew on a vast repertory of history, heraldry and symbolism, illustrated episodes in the rise of the Medici family and the career of the Duke himself. But between the story of Cosimo's elevation to the Dukedom and his capture of Monte Murlo there was represented a story from Livy's twentieth book, of the three rash envoys from the Campania, driven from the Roman Senate for their insolent demands, an allusion, as Vasari explains, to the three Cardinals who vainly thought to remove Duke Cosimo from the Government. This is indeed an 'allegorical' reading of history since 'allegory' means literally 'saying something else'. Once more nobody could possibly guess the meaning if the painting were preserved outside its context. But even in such an extreme case it would be misleading to speak of various levels of meaning. The story refers to an event, just as Eros refers to Shaftesbury's Charity. In the context it has one intended meaning, though it is a meaning which it was thought wiser not to make too explicit, since it might have been better not to pillory the Cardinals.

It is characteristic, though, that this recourse to a code was taken in the context of a festive decoration, which would be taken down immediately. Secret codes and allusions of this kind have much less place in works of art intended to remain permanent fixtures. Codes, moreover, cannot be cracked by ingenuity alone. On the contrary. It is the danger of the cipher clerk that he sees codes everywhere.

Sometime in the dark days of the Second World War, a scientist in England received a telegram from the great Danish physicist Niels Bohr, asking for 'news of Maud'.[32] Since Bohr had been one of the first to write about the possibilities of using nuclear fission for the construction of a super-bomb, the scientist was convinced that the telegram was in code. Bohr evidently wanted to have news of M-A-U-D, 'Military application of uranium disintegration'. The interpretation seemed so apt that the word was in fact later adopted as a code word for the work on the atomic bomb. But it was wrong. Bohr really wanted news of an old nanny who lived in southern England and whose name was Maud. Of course it is always possible to go further; to postulate that

Niels Bohr meant both his nanny and the atom bomb. It is never easy to disprove such an interpretation, but as far as iconology is concerned it should be ruled out unless a documented example is produced.[33]

To my knowledge neither Vasari nor any other text of the fifteenth or sixteenth century ever says that any painting or sculpture is intended to have two divergent meanings or to represent two distinct events through the same set of figures. The absence of such evidence seems to me to weigh all the more heavily as Vasari was obviously very fond of such intricacies both in his own art and in the inventions of his scholar-friends. It is indeed hard to imagine what purpose such a double image should serve within the context of a given cycle or decoration. The exercise of wit, so relished by the Renaissance, lay precisely in the assignment of a meaning to an image which could be seen to function in an unexpected light.

9 The Genres

We come back to the question of decorum and the institutional function of images in our period. For the exposition of ambiguity, the demonstration of plenitude had indeed a place in Renaissance culture, but it belonged to that peculiar branch of symbolism, the *impresa*. The combination of an image with a motto chosen by a member of the Nobility was not often witty but more frequently the cause of wit in others. I have discussed the philosophical background of this tradition in the essay on '*Icones Symbolicae*'.[34] But the free-floating symbol or metaphor to which various meanings could be assigned with such ease and relish differs both in structure and purpose from the work of art commissioned from a master. At the most they were applied to the cover of paintings or were expanded in the fresco cycles which centred on such an image.

But if the iconologist must pay attention to the technique of the *impresa* and its applications, he should not forget to attend to the other end of the spectrum of Renaissance art, the free play of form and the grotesque which could equally be fitted into the theory of decorum. In contrast to the stateroom, a corridor, and especially a garden loggia, did not have to stand on dignity. Here the amusing grotesque was allowed to run riot and artists were not only permitted but even enjoined by Renaissance authors such as Vasari to let themselves go and display their caprice and inventiveness in these 'paintings without rule'.[35] The enigmatic configuration, the monsters and hybrids of the grotesque, are professedly the product of an irresponsible imagination on holiday. Take any of these images in isolation and place it in a conspicuous place in a solemn building and everyone would be entitled to look for a deep symbolic significance. The grotesque would become a

398
G. M. Butteri and G.
Bizzelli, grotesques from
the ceiling of the first
Uffizi corridor, Florence,
1581

hieroglyph, asking to be unriddled (Fig. 398). It is true that even in the Renaissance some writers made play with this affinity between the grotesque and the sacred symbols of ancient mysteries, but they did so only in order to defend a kind of art for which the theory of decorum had so little respect.36 Unlike the serious *letterati*, the laity enjoyed the play of forms and the dream-like inconsequence of meanings it engendered. I know of no more striking document to illustrate the freedom from logical constraints which was permitted in a Renaissance garden than the description given by Giovanni Rucellai of the shaped shrubs in his Villa di Quaracchi, where one could see 'ships, galleys, temples, columns and pillars ... men and women, heraldic beasts with the standard of the city, monkeys, dragons, centaurs, camels, diamonds, little spirits with bows and arrows, cups, horses, donkeys, cattle, dogs, stags and birds, bears and wild boars, dolphins, jousting knights, archers, harpies, philosophers, the Pope, cardinals, Cicero and more such things'.37

No wonder that the owner tells us that there is no stranger who can pass without looking for a quarter of an hour at this display. Still, it is clear that if this list of images occurred in any other context than that of a garden it would

challenge the ingenuity of any icolonogist to find a meaning in this juxtaposition of the Pope and cardinals with Cicero and philosophers, giants, camels and harpies.

Once more we see a confirmation of the methodological rule emphasized by Hirsch: interpretation proceeds by steps, and the first step on which everything else depends is the decision to which genre a given work is to be assigned. The history of interpretations is littered with failures due to one initial mistake. Once you take watermarks in sixteenth-century books to be the code of a secret sect the reading of watermarks in the light of this hypothesis will appear to you possible or even easy;[18] it is not necessary to refer to examples nearer home, nor need we scoff at such failures. After all, if we did not know from independent evidence that Taddeo Zuccari's fresco cycle for which Caro's programme has been quoted was designed for the customary *studiolo* into which the Prince could withdraw from the bustle of the court and that it is therefore devoted to the theme of solitude, we would almost certainly interpret the room as a place of worship of a syncretistic sect.

Iconology must start with a study of institutions rather than with a study of symbols. Admittedly it is more thrilling to read or write detective stories than to read cookery books, but it is the cookery book that tells us how meals are conventionally composed and, *mutatis mutandis*, whether the sweet can ever be expected to be served before the soup. We cannot exclude a capricious feast which reversed all the orders and accounts for the riddle we were trying to solve. But if we postulate such a rare event, we and our readers should know what we are doing.

One methodological rule, at any rate, should stand out in this game of unriddling the mysteries of the past. However daring we may be in our conjectures – and who would want to restrain the bold? – no such conjectures should ever be used as a stepping stone for yet another, still bolder hypothesis. We should always ask the iconologist to return to base from every one of his individual flights, and to tell us whether programmes of the kind he has enjoyed reconstructing can be documented from primary sources or only from the works of his fellow iconologists. Otherwise we are in danger of building up a mythical mode of symbolism, much as the Renaissance built up a fictitious science of hieroglyphics that was based on a fundamental misconception of the nature of the Egyptian script.

There is at least one essay in this volume to which this warning applies. The interpretation of Botticelli's Mythologies[19] in the light of Neoplatonic philosophy remains so conjectural that it should certainly not be quoted in evidence for any further Neoplatonic interpretation that could not stand on its own feet. I have given the reason in a brief new introduction for my

including this paper despite its risky hypothesis. I hope it gains some fresh support from some of the general considerations put forward in the essay on 'Icones Symbolicae'. But the conclusions of that paper luckily do not depend in their turn on the acceptance of my interpretation of this particular set of pictures. Even if Maud really just meant Maud, some telegrams in wartime meant more than they said.

Editor's Postscript

This is an extremely important essay in the development of ideas about iconological analysis. The academic study of the meaning of pictures started in the nineteenth century with scholars such as Émile Mâle; see, for example, Religious Art in France: The Thirteenth Century *(Princeton, 1984), also available as* The Gothic Image *(London, 1961). W. S. Heckscher, 'The Genesis of Iconology' in* Stil und Ueberlieferung in der Kunst des Abelandes, *Akten des XXI Internationalen Kongresses für Kunstgeschichte in Bonn, 1964 (Berlin, 1967), pp. 239-62, offers interesting background reading.*

The paradigm for this kind of approach to art history was offered by Erwin Panofsky in his introduction to Studies in Iconology *(New York, 1967). It has subsequently become institutionalized in* The Encyclopedia of World Art *and* The Dictionary of the History of Ideas *by Jan Bialostocki. The so-called 'Warburg method' was not Warburg's at all, but Panofsky's. Edgar Wind's idiosyncratic* Pagan Mysteries in the Renaissance *(Harmondsworth, 1967) has had few followers. The greatest flaw in both works is their lack of a strict historical sense of the realities of image production and of the circulation of 'texts'. An early complaint was made by Creighton Gilbert, 'On Subject and Not-Subject in Italian Renaissance Pictures',* Art Bulletin, *34 (1952), pp. 202-16.*

Besides the other essays collected in Symbolic Images, *the reader should consult 'The Limits of Interpretation' in* A Lifelong Interest; *'Tobias and the Angel', 'The Renaissance Theory of Art and the Rise of Landscape' in* Norm and Form; *'Jerome Bosch's "Garden of Earthly Delights"' in* The Heritage of Apelles. *'The Eccesiastical Significance of Raphael's "Transfiguration"' and 'Giotto's Portrait of Dante' in* New Light on Old Masters *address the topic of genre (for which, see also the following chapter).*

Raphael's Stanza della Segnatura and the Nature of its Symbolism

This essay is based on a lecture given at the Warburg Institute in 1956 and reworked for the Initial Address to the Anglo-American Conference of Historians on 9 July 1970; published in *Symbolic Images* (1972; 3rd edition, 1985), pp. 85–101.

On his arrival in Rome ... Raphael 'began in the *Camera della Segnatura* a painting of how theologians harmonize Philosophy and Astrology with Theology, where all the sages of the world are shown discussing in various ways.'[1] These opening words of Vasari's account of Raphael's fresco cycle in the first *Stanza* of the Vatican naturally set the key for the interpretation of these frescoes for centuries to come.[2] Not only did Vasari establish the conviction that the subject of this cycle was meant to be of profound philosophical import, he also enforced this interpretation by isolating the individual frescoes from their intellectual and decorative context, and treating them as illustrations of particular philosophical and theological activities. We now know the source of this error: Vasari worked from engravings after the frescos, either to refresh his memory or simply because access to these Papal apartments was not easy at that time.[3] It has long been acknowledged that this makeshift led Vasari into astonishing errors. He placed the Evangelists among the Greek philosophers simply because some of these groups had been adapted by Agostino Veneziano in engravings of these Saints.[4] Nevertheless the method and the tendency persisted. In 1695 the learned antiquarian Giovanni Pietro Bellori published his *Descrizione delle imagini dipinti da Raffaello d' Urbino nel Vaticano* as a showpiece of philosophical criticism. Bellori had an axe to grind. The partisan of academic classicism and the friend of Maratta, who had just restored or ruined the frescos, he was out to stress the importance of *invenzione* in art and to exalt the frescos as the most sublime inventions of modern painting. There are those, he exclaims, who decry such powers of invention in a painter and prefer him to be uncultured and ignorant, merely

399
Tabulation of
'identifications' in *Raphael's
School of Athens* (Fig. 406).
From A. Springer, *Raffaels
Schule von Athen* (1883)

400
Niccolò da Bologna, *The
Virtues and the Arts*, from
Giovanni Andrea's *Novella
super libros Decretalium*, 1355.
Biblioteca Ambrosiana,
Milan, MS. B.42 inf., fol. 1

luxuriating in fine pigments. How different was Raphael, whose erudition
Bellori now proceeds to document in his description and identification of all
the figures in the cycle.[5] His example was followed by Passavant in his pioneer
biography of Raphael,[6] and though scholars failed to agree on any one
interpretation the conviction persisted that there was a key to these frescoes
which must be in accord with the philosophical and humanistic ideas of the
sixteenth century. Indeed, in the nineteenth century this interpretation of a
work which was seen as the culmination of Renaissance art reacted back on
the arts of the time. Ambitious intellectual programmes like that of
Overbeck's *Triumph of the Reformation* or the statuary of the Albert Memorial
might be described as attempts to emulate the *Stanza della Segnatura*.

Writing in 1883 the great art historian Anton Springer hoped to reduce this
game *ad absurdum* by tabulating all the identifications that had been made of
the figures in the *School of Athens* (Fig. 399).[7] But the most radical reaction was

401
Raphael, *Stanza della
Segnatura*, 1509–11. Vatican
Palace. From E. Müntz,
Raphael (Paris, 1881)

402
Raphael, *Stanza della
Segnatura*. From
Letarouilly, *The Vatican and
St Peter's* (1882)

represented by Franz Wickhoff, whose work was in so many respects influenced by the aesthetics of Impressionism. In his article of 1893[8] he brushed aside all previous interpretations of the *Stanza* like so many cobwebs and proposed to start from scratch, that is from the inscriptions and the sources of the period. Unfortunately his article is vitiated by the theory that the *Stanza* must have been the Papal Library – an unlikely hypothesis since we know from Albertini's contemporary description that the library of Julius II was decorated with pictures of planets and constellations.[9]

Be that as it may, Wickhoff's paper was hailed as a 'liberation' by Wölfflin, who proclaimed in his *Classic Art*[10] that no historical knowledge was needed to appreciate the *Stanza* and proceeded to analyse the four walls in terms of formal harmonies. Characteristically, however, Wölfflin, too, betrays his dependence on reproductions of the individual walls, in fact he discusses at some length the merits of these engravings, which, as he tells us, every traveller to Rome took home as a souvenir. The change of approach came or should have come when Wickhoff's pupil Julius von Schlosser published an article of tremendous sweep and learning in 1896,[11] in which he at last placed the purified *Stanza* into a historical setting that should have made any further isolation of these compositions impossible. The paper on 'Giusto's Frescos in Padua and the Forerunners of the Stanza della Segnatura' has the weight and length of a book tracing the medieval tradition of associating the personifications of individual Arts or Virtues with certain typical representatives or authors, Geometry being associated with Euclid or Justice with Trajan. The uncovering of this tradition, which reaches back to the porches of the French cathedrals and is epitomized in an Italian fourteenth-century illustration to a

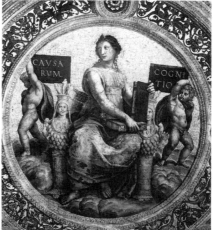

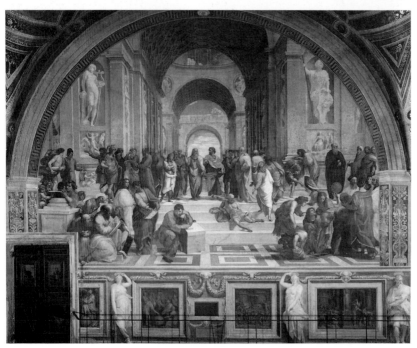

legal text[11a] (Fig. 400), disposed once and for all of the notion that the presence in the Papal apartment of famous Greeks and Romans was symptomatic of Renaissance 'paganism'. But it did more, it showed why the isolation of the individual walls completely falsifies not only the intellectual, but also the artistic interpretation of Raphael's decoration.

For the cycle of the *Stanza della Segnatura* is so organized that its composition must be read from the ceiling downwards, but the room is so small that no

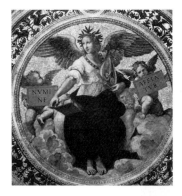
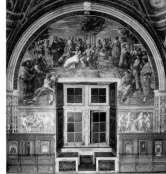
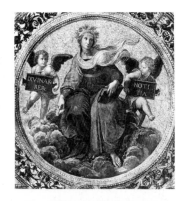
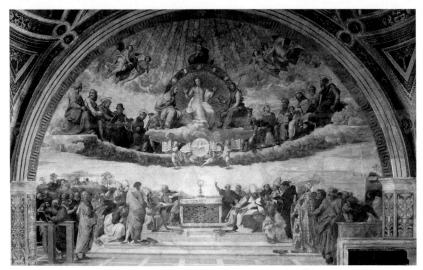

406, 407
Raphael, *Stanza della Segnatura*. Divine Inspiration: *Poetry* and *Parnassus*. Vatican Palace

408, 409
Raphael, *Stanza della Segnatura*. Knowledge of Things Divine: *Theology* and *Disputà*. Vatican Palace

photograph can take in part of the vaulted ceiling and walls at the same time. We have to rely on rather unprepossessing nineteenth-century engravings (Figs. 401, 402) to convey even this principal feature of the cycle. Basically it shows four allegorical figures enthroned on the ceiling, and underneath, on earth as it were, assemblies of people (Figs. 403–11). For instance, there is the personification of Poetry and below her the fresco we call the *Parnassus* with Apollo, the Muses and a group of poets, the foremost one carrying an inscribed scroll that marks her as Sappho (Figs. 406–7).

Such schemes of personifications enthroned with representative figures assembled below them were very much common form at the time when Raphael set to work. We do not know exactly when the *Stanza* was first planned – it was completed in 1511 – but we know that late in 1507 Julius II expressed the wish to move out of his predecessor's apartment in the Vatican because he could no longer stand the ubiquitous sight of the Borgia bull on

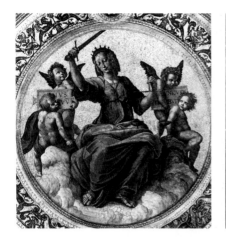

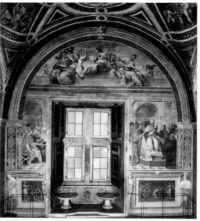

410, 411
Raphael, *Stanza della Segnatura*. To Each his Due: *Justice* and *Prudence* flanked by *Fortitude* and *Temperance*, and *The Institution of Civil and Canon Law*. Vatican Palace

its walls and ceilings.[12] He obviously had nothing against the general ideas expressed on its walls by Pinturicchio, for basically the new *Stanza* repeated the scheme of the Room of the Seven Liberal Arts painted some ten years earlier in the Borgia apartments (Fig. 412). The similarity of these enthroned figures such as Dialectic (Fig. 413) with its group of orators underneath with Raphael's scheme would always have been obvious if the ceilings and the walls of the *Stanza* could have been reproduced together.

We know from Schlosser that the series of the Liberal Arts was not the only group of personifications traditionally coupled with famous exemplars. Indeed, Fig. 401 shows them side by side with the other popular series, the Seven Virtues, each with their typical opponent, whom they trample underfoot.

It so happens that the tradition of personified virtues grouped with exemplars from history had also been applied in a famous fresco cycle which must have been known to Raphael and to Julius II. Perugino's *Cambio* in Perugia (Fig. 414) had been planned at the very time when Raphael was closest to Perugino, at the turn of the century, and completed about 1507, not more than a year before both Perugino and Raphael left for Rome to take up work in the apartments of the Vatican the Pope wished to have decorated.[13]

The *Cambio*, the Public Exchange, was decorated with the enthroned figures of the four cardinal virtues Prudence, Justice, Fortitude and Temperance, aloft in the sky and three representatives of each arranged below (Figs. 415, 416); thus under Justice we see three exemplars of the virtue from antiquity, Camillus, the Emperor Trajan and Pittacus. It has been suggested that the remaining three scenes were intended to symbolize the three theological virtues, Faith, Hope and Charity, the assembly of Prophets and Sibyls signifying Hope, the Nativity Charity, and the Transfiguration Faith.

412
Pinturicchio, *Sala delle Arti Liberali*, 1492–4. Borgia Apartments, Vatican Palace

Be that as it may, the kinship of this scheme with that of the *Stanza della Segnatura* cannot be emphasized too strongly. There is that same mixture of Christian themes and pagan examples which puzzled the nineteenth century but should not have caused any surprise to anyone who knew the habits of medieval moralists or indeed of St Augustine. The parallelism goes much further. The cardinal virtue of Prudence in the *Cambio* (Fig. 415) is accompanied by verses composed by the humanist Maturanzio, who makes her say: '*Scrutari verum doceo, causasque latentes*' (I teach to search for truth and hidden causes). The second of her disciples on earth is a very Italianate Socrates. One of the four personifications on the ceiling of the *Stanza della Segnatura* is accompanied by the inscription *causarum cognitio* (the understanding of causes), and underneath her we find the assembly of philosophers which a French seventeenth-century guidebook first called by the somewhat misleading name *The School of Athens*. Among its personages we see Socrates engaged in argument, his classical Silenus mask serving instead of the *titulus*. Even an echo of the virtue of Prudence is still to be found on its wall in the figure of Minerva (Fig. 405).

It is this kinship with accepted schemes of decoration which serves to remind us the *Stanza* will not stand fragmentation without complete disruption of its symbolic and artistic significance. For if we fail to read these compositions from the ceiling downwards we miss the type or class of work with which we are confronted and having thus lost the point of entry we get confused by details. For in this class of composition the enthroned personifications are not mere allegorical labels for the representations underneath. On the contrary, the walls must be seen as expositions or amplifications of the ideas expressed by the personifications on the ceiling

413
Pinturicchio, *Dialectica, Sala
delle Arti Liberali* Borgia
Apartments, Vatican
Palace

414
Perugino, frescos in the
Sala d'udienza, Collegio del
Cambio, Perugia, planned
1497–1500, completed
1507

(Fig. 403). We may do well to remember that except for a few nominalist outsiders the ecclesiastics of the Papal Court had learnt and accepted the view that *universalia sunt ante rem*, that the things of this earth are only embodiments, however incomplete, of general ideas or principles. This thought, which is so alien to our view of the world, must have come naturally to generations who conceived of the whole universe as of a hierarchy of principles emanating and descending from on high. *Causarum cognitio* is more real as an idea than are the individual philosophers, who merely exemplify instances of this eternal notion. We may even go further and say that this assembly of men is governed by Philosophy just as the so-called children of planets are governed by the star which determines the laws of their being, their character and their profession; here, too, there was an example of such a juxtaposition close at hand in Pinturicchio's Borgia apartment where, for instance, the children of Sol are shown as bishops and clergymen in whom the influence of the celestial principle of sunniness is manifest (Fig. 417). Maybe it was this example which led Pinturicchio to abandon in his room of the Seven Liberal Arts the traditional method of showing identified representatives of the various disciplines and rather to illustrate an anonymous assembly of people engaged in the appropriate activities. This, in its turn, determined Raphael's theme.

What becomes manifest from all high in the *Stanza della Segnatura*, is shown in the inscriptions – it is knowledge and virtue as expressions of the Divine.

These inscriptions accompanying the personifications must indeed form the starting point of any interpretation. They are, to recapitulate, *causarum cognitio* with the group of philosophers we call the *School of Athens*, *numine afflatur* constituting the claim of Poetry to divine origin, exemplified in the Parnassus, *Divinarum rerum notitia* (knowledge of things divine) pointing towards the group of sacred personages which has become known as the *Disputà*, and *Ius*

415
Perugino, *Prudence (with Fabius Maximus, Socrates and Numa Pompilius), Justice (with F. Camillus, Pittacus and Trajan*. Sala d'udienza Collegio del Cambio, Perugia

416
Perugino, *Fortitude (with L. Sicinius, Leonidas and Horatius Cocles), Temperance (with L. Scipio, Pericles and Cincinnatus*). Sala d'udienza Collegio del Cambio, Perugia

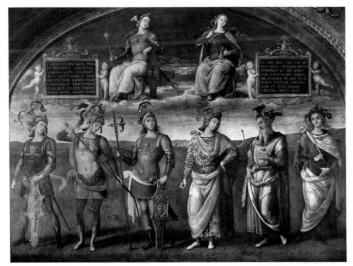

suumcuique tribuit (each his due), which is the motto of Justice, under whom we see two scenes exemplifying the promulgation of justice, the establishment of civil law through the Pandects under Justinian and of canon law through the Decretals under Gregory IX.

The name *Stanza della Segnatura* refers to the Papal court which held its sessions in this room, and though it cannot be proved that this had been its purpose from the beginning, the scheme of decoration makes this very likely. One can but admire the ingenuity by which the two precedents of decorative schemes were adapted without being actually repeated. It so happens that Justice is both one of the four cardinal virtues and the presiding

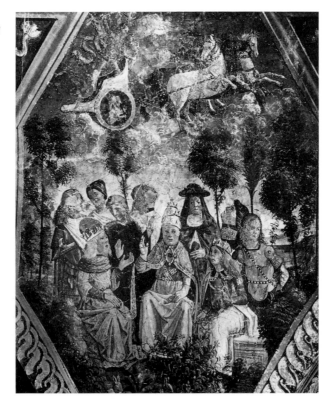

417
Pinturicchio, *Planet Sol and his Children, Sala delle Sibille,* 1492–4. Borgia Apartments, Vatican Palace

personification of legal studies. In the *Stanza* she is coupled with the three remaining virtues but also fitted into the scheme of disciplines or faculties which derives from the tradition of the liberal arts. Instead of the seven we now have four, Law, Theology, Poetry and Philosophy.

And just as the scheme of decoration merely varied a current usage so the choice of these disciplines reflected conventional ideas about the various paths through which knowledge comes to mankind. In looking for the historical context in which these ideas took shape we need not go far afield. It was in the universities that knowledge was organized and transmitted and thus it is in texts concerned with university teaching that we find a great many echoes of the intellectual themes of Raphael's fresco cycle.

It was the custom for university teachers to give formal inaugural lectures not only once in their career, as is done today, but at the opening of any course.[14] In these they had to advertise their subject by praising its dignity and its pre-eminence. In reading these formal orations we feel transported into the atmosphere that pervades the *Stanza*. They show that the subject of this scheme of images fits no less perfectly into the intellectual tradition of the age than it harmonized with its artistic conventions.

Thus one of the disciples of the great humanist Guarini, Giovanni Toscanella, introduced his course in rhetoric at the University of Bologna in c.1425 with a speech in which many of the commonplaces and tags of the *Stanza* are anticipated.[15]

> To begin with the poets, what should we say about their divine minds, what about their ancient lineage? My learned audience need not be told that it is not easy to encompass the praise of poets in a brief oration since poets are also frequently historians and often deserve rightly to be called renowned orators and philosophers, lawgivers and interpreters of the law as well as physicians and mathematicians … Truly it was the poets who first proclaimed of themselves that a God existed and who affirmed that God saw everything and ruled over everything. This, as we know, was felt by Orpheus, whom the ancients also considered a theologian, this by Homer and this by Hesiod among the Greeks but among us Virgil and Ovid proclaimed it quite openly in many passages. It was also the poets who most copiously and eloquently praised virtue in their poems through various fictions. In truth Basilius, an excellent and most erudite man, claims to have heard from a learned man, considered to be most gifted for the investigation of the mind of the poets, that the whole of Homer's poetry amounted to a praise of virtue. Why otherwise does Father Ennius call the poets sacred but because they are touched by a divine spirit and afflatus? (*quod divino videlicet spiritu afflatuque tanguntur*).

The speaker now proceeds to a praise of the ancient historians, Herodotus, Thucydides, Livy, etc.

> Let us now pass to philosophy, a gift rather of the immortal Gods than of men. Since it must truly be divided in three parts, the cause and nature of things, the subtlety of speech, true judgement and the reason for desiring or shunning things, it is everywhere so rich in fruit that if we desired to express our opinion and our judgement fully we would have to say that it is the greatest of the gifts which the immortal Gods bestowed on mortal man. For what is there more beautiful than to know the nature and the cause of everything (*cuiusque rei naturam causasque*)? What more admirable than to be able to judge between truth and falsehood, the correct and the absurd? What finally could be more desirable than to be able to understand the reasons for what is honest or vile, useful or useless. Those among the ancients who excelled in these matters were first considered and called wise men but since this appellation appeared to be too proud and arrogant they began later to be called philosophers instead and it is said that Pythagoras of Samos was the first to have adopted this name. Do you not see that

whatever we call them, whether wise men or philosophers which means lovers of wisdom, they are singled out for an illustrious appellation? For philosophy as Cicero says is nothing but a study of wisdom but wisdom as it was defined by the ancient philosophers is the science of the divine and the human and of the causes which are comprised by these things (*rerum divinarum et humanarum causarumque, quibus hae res continentur, scientia*). It was this which Plato who had heard Socrates, this which Aristotle, the disciple of Plato, this which Xenophon, the Socratic, and many others pursued with great zeal and industry. But the one that teaches the reasons for desiring or avoiding things bears the largest and most wonderful fruits. Its father was Socrates.

The speaker now proceeds to the praise of oratory and concludes:

> Come, therefore, most excellent and most learned man, let us make use of that divine and heavenly reason and intellect, take hold of these subjects of humane learning, these liberal arts with all possible zeal, work and industry; be alert in daytime and wakeful at night so that your mind, that divine gift, should not sink into earthly mire, but always gazing at the higher and the Divine, should think nothing and desire nothing but the way to fulfil the heavenly and divine tasks. If you do this you will also live in fame after your death.

Startling as some of the parallels between Toscanella's speech and the themes of the *Stanza* may look at first sight, it is obvious that this old *pièce d'occasion* cannot have been one of the sources of Raphael's scheme. Only the praise of poetry and of philosophy even recalls the *Stanza*, while a room illustrating Toscanella's eulogy would have to have its remaining walls dedicated to History and historians and Rhetoric and orators.

But the interest in Toscanella's very conventional eulogy lies less in the choice of disciplines than in the reasons for which he lauds them. It clearly is a commonplace for him that the dignity of all knowledge is derived from its link with the Divine. All intellectual disciplines somehow partake of the revelation of higher truth. Some indirectly and obscurely, some directly and radiantly. God had spoken implicitly through the mouth of inspired poets and philosophers and openly through the Scriptures and the traditions of the Church, though even these messages have to be expounded if they are to be understood. We see again that the juxtaposition in the *Stanza* of poets and philosophers on an equal footing with theologians has nothing to do with Renaissance secularism. If anything, the tradition on which Toscanella draws was not out to profane the sacred but to sanctify the profane. The respect paid to ancient poetry and philosophy could only enhance the importance of

divinarum rerum notitia, the knowledge of things divine represented in the so-called *Disputà* (Figs. 408–409).

The name is derived from Vasari's description, who speaks of Saints disputing about the host on the altar.[16] It has often been pointed out that this interpretation (which may have come naturally to Vasari in the post-Reformation period) tends to obscure the meaning of the composition. Here, as always, it must certainly be read from the ceiling downwards, from God to man. Once we see it in this all-embracing context, we perceive 'the knowledge of things divine' coming down to earth in the Incarnation. In this unusual configuration of the Trinity the dove of the Holy Ghost is seen descending below the figure of Christ and flanked by the four Gospels hovering over the altar, around which the Fathers of the Church expound the message to mankind in their inspired writings (Figs. 406–7).

In terms of these broad outlines there is indeed no difficulty in interpreting any of the frescos. The so-called *Parnassus* is a perfect visualization of *numine afflatur,* the divine inspiration of poetry with Apollo glancing ecstatically upwards as does blind Homer, and with the Muses and the poets directly handing on their supernatural knowledge to the people gathering in the *Stanza.*

Within the context of the *Stanza* the general import of the so-called *School of Athens* again presents no difficulty. *Causarum cognitio* is shown enthroned holding two volumes marked *Moralis* and *Naturalis,* the main divisions of philosophy. Of these natural philosophy is embodied below by Plato, who holds the *Timaeus,* the dialogue concerned with the creation and the nature of the Universe. His famous upwards pointing gesture may refer to the knowledge of causes rather than to any doctrinal contrast with his disciple Aristotle, who holds the *Ethics,* the moral philosophy he imparts to us.[17] We may expect the other philosophers also to exemplify the search for causes in natural and moral philosophy and this, no doubt, is the theme of the groups assembled under Minerva, the goddess of Wisdom, and Apollo, the teacher of Ethics (Figs. 404–5).

Was it also intended to exemplify in these men the theme of the Seven Liberal Arts from Pinturicchio's earlier scheme? Springer's suggestion is appealing,[18] and it is certainly possible to recognize Geometry in the group assembling around a demonstration and Music in the corresponding display of a tablet with the system of harmonies; Astronomy presents no difficulty, for there is the King with the globe traditional for Ptolemy (the astronomer having been confused with the ruler). But even Arithmetic, the fourth of the *Quadrivium,* is less easily identified, and when it comes to the *Trivium* of Grammar, Rhetoric and Dialectic, the choice becomes yet more arbitrary. Moreover, one may legitimately doubt whether *Trivium* could be subsumed

under the idea of *causarum cognitio*. Are the arguing people grouped around Socrates not rather concerned with that Moral Philosophy of which he was reputed to be the founder, while those which recall the *Quadrivium* represent Natural Philosophy or Science?

In any case there is no reason to think that the manifold activities of the philosophers must have been intended to tabulate a discrete number of 'arts'. On the contrary, the same university tradition which gave rise to Toscanella's speech habitually insisted on the essential unity of all human disciplines. Cicero had called Philosophy the procreator and mother of all the praiseworthy arts[19] and had expressed his faith in the unity of all humane learning in a memorable passage: 'All arts that relate to culture have a common link and are bound together by some affinity' (*Omnes artes quae ad humanitatem pertinent habent quoddam commune vinclum et quasi cognatione quadam inter se continentur*).[20]

Not unexpectedly there exists an inaugural lecture on this theme,[21] even among the few of the genre collected and printed by Karl Müllner in his invaluable anthology. Gregorius Tiphernius, who taught in Rome under Nicolaus V, patiently leads us in his speech through the list of the arts, each time pausing to prove that they could not be torn or separated from the others. The Grammarian as a student of language will have to study all the other disciplines using language. Dialectic occurs in the arguments used in the *Quadrivium*, and Rhetoric, which demands the mastery of words and things, must merge into all the others. Poetry is linked to Arithmetic since prosody requires counting, not to forget that poets frequently deal with such mysteries as Astronomy or Philosophy. It really fuses with Music which, in its turn, adjoins Geometry. The doctrine of the Pythagoreans linked Music to Philosophy but Music is also concerned with Moral Philosophy through its power over the affects. That Astronomy itself stands in need of other arts goes without saying, indeed the ancients were right, as the speaker reminds us, when they depicted the arts as maidens linked in a dance. Nor should students of Law be ignorant of the arts since Law itself originates from the inner recesses of Philosophy. Of Medicine, of Philosophy, and of Theology, the Queen of them all, Tiphernius assures us that he could also speak at length but on this occasion he forbore.

Once more we see how familiar the arrangement of the *Stanza* would have looked to men brought up in this tradition of learning; it happens to accord well with Raphael's cycle that the speaker thought fit in his peroration to link Philosophy with the study of Law before he bowed to Theology.

In the *Stanza*, of course, the fourth wall celebrates Justice both as one of the Cardinal Virtues and as a Discipline which is passed on to mankind in the

Pandects enshrining civil law and the Decretals codifying canon law. Nor is it hard to document the way in which legal studies could be fitted into the scheme of divine gifts to mankind. Cicero had called the Law the invention not of man but of the Gods. Embroidering on this theme a humanist such as Poggio Bracciolini[22] was able to compose an eulogy of legal studies in which he asserts the pre-eminence of his subject over all the rest.

Rightly had the ancient Romans placed concern for Law before all other concerns.

> For poetry began much after the inscribing of the Twelve Tables. Philosophy, too, and the other disciplines known as the Liberal Arts were the last to be received by the Romans into their state. These wise men, therefore, believed that no norms of civil life, no liberty, no fruit of their labours should exist in their city that was not upheld by the best laws.[23]

After enumerating famous Roman jurists Poggio finds no difficulty in making a transition to Plato and Aristotle, both of whom were concerned with Law. Without Law, we hear again, there could be neither Philosophy, Dialectic, Astrology nor any other art. Once more we are told about Pythagoras being the first to call himself a philosopher and about Socrates, who initiated moral philosophy and brought philosophy down from heaven to earth. Astrology was said to come from the Chaldeans if Zoroaster was not its inventor. And so we are back to the list of inventors of the arts, paying passing tribute to Orpheus, Linus and Musaeus, inventors of Poetry, till we arrive at Moses the lawgiver before the speaker pulls out all the stops in a final *laudatio*:

> O what an enormous and outstanding protection was here granted by God Almighty to the human race! For what better, what more useful, what more sacred gift could be bestowed on us than that heavenly bounty by which our minds are guided towards the good life, by which virtue is fortified, a quiet life achieved and by which we ascend to the very heaven?

Thus the trained churchmen and lawyers who assembled in the *Stanza* would find themselves surrounded by familiar imagery as they listened to counsel's speeches in which, no doubt, similar Ciceronian tags would make their frequent appearance. They were ensconced in the well-ordered universe of Disciplines through which divine principles were translated into the speech and actions of mortal men. If they were in a serious mood, they might even have hoped or felt that the divine spark was indeed passing from the venerable figures on the walls to the assembly, which could thus become the embodiment and mouthpiece of the heavenly knowledge radiating from above.

Were they content thus to be reassured and comforted as one must assume
they were when attending a solemn service or, indeed, a ritualistic university
function, or did they scrutinize the images on the walls for fresh insights? To
put it in more general terms, should we look to such a symbolic cycle for a
restatement of conventional beliefs or for some more specific and recondite
message?

To ask this question need not imply that the kind of texts so far adduced
must offer the key to all details of the *Stanza*. They certainly do not. We know
for instance that the personifications on the ceiling (Fig. 403) are flanked by
episodes which Passavant interpreted as linking the various faculties – the Fall
as between Theology and Justice, the Judgement of Solomon between Justice
and Philosophy, Astronomy or the contemplation of the Universe (Fig. 418)
between Philosophy and Poetry, and the Flaying of Marsyas between Poetry
and Theology, assuming that Dante's prayer to Apollo can thus be
interpreted. There are also the grisailles with further *exempla* under Justice and
the scenes under the *Parnassus*, some of which are not very clear and have been
variously interpreted. Finally, of course, there is the question of portraits of
imaginary and real persons on the walls. Some of the figures are clearly marked

419
Raphael, group from *The School of Athens* (Fig. 405)

420
Pinturicchio, *Geometry, Sala delle Arti Liberali*. Borgia Apartments, Vatican Palace

by inscriptions (such as Sappho), others like Socrates, Homer or Dante could be expected to be recognized. Nor need we doubt that Raphael incorporated in these groups portraits of contemporaries, for we know that he did so not only with Julius II, who is portrayed as Gregory IX, but that he also painted young Federigo Gonzaga, who was kept as a hostage at the Papal Court – though we can no longer identify him.[24]

But surely in this question of portraiture we come up against that notorious crux of interpretation, the question of the 'meaning of meaning'.[25] It is one thing for an artist to use a particular individual, an apprentice or a personage at the court as a model, another to do so with the intention of him being recognized for all times. The 'in-group' might have had their pleasure in seeing familiar faces looking at them from these walls, but is this part of the fresco's 'meaning'? We might go further and ask whether the intended meaning could have included even a long list of ancient poets or philosophers whose identification has proved so difficult?

It is worth here pointing to a startling contrast between the critic's reaction to Pinturicchio's frescoes and those of Raphael, for whom they certainly served as a model. Surely the groups assembled beneath these earlier personifications of Arts are similar enough in character and function, but no one has felt moved to give each of these figures a local habitation and a name in intellectual history. They remain an anonymous crowd, though there is no reason why Pinturicchio, too, might not have incorporated portraits of friends or contemporaries in these groups.

Take the striking figure of the old man in Raphael's *School of Athens* who bends down to draw a geometrical demonstration for a group of admiring disciples (Fig. 419) – he is usually called Euclid, and Vasari, who identifies him with Bramante, has rarely been contradicted. But what portrait intended to commemorate a friend has ever been taken from such a disadvantageous position from which only the bald pate is visible? Is it not much more likely that the geometer means no more and no less than the similar figure in Pinturicchio's cycle who has a similar crown of white hair (Fig. 420)?

Such questions are more easily asked than answered for it is obvious that the absence of a particular meaning can never be proved – *negativa non sunt probanda* as the lawyers say.

It is unlikely that a further study of Renaissance texts would here fulfil the hopes which are so often pinned on this kind of source. In a sense there are too many texts to choose from. The problem is not really to find more literary sources in which Plato and Aristotle, Homer and Orpheus, Theology and Justice are mentioned and related. It would be harder to point to a book from the period where these notions and commonplaces do not occur. The real question of method raised by the interpretations of the *Stanza* lies on a different plane; in iconography no less than in life, wisdom lies in knowing where to stop.

It is in the nature of things that no conceivable method can ever provide a cut and dried answer to this question. No sign or symbol can refer to itself and tell us how much it is intended to signify. All signs have a characteristic which Karl Buehler called 'abstractive relevance'.[26] The letters of the alphabet signify through certain distinctive features but in normal contexts their meaning is not affected by their size, colour or font. The same is true of the images which interest the iconographer, be they coats of arms, hieroglyphs, emblems or personifications traditionally marked by certain 'attributes'. In every one of these cases there are any number of features which are strictly speaking without a translatable meaning, and only a few which we are intended to read and translate. But while we can easily identify those in the case of codified signs, the limit of significance, what Buehler called the 'sign limit', is much more open in the case of symbolic images. Take the personification of *causarum cognitio* on the ceiling of the *Stanza* (Fig. 405). Care has been taken for us to know the meaning of the books she holds, for they are inscribed. Nor need we doubt that the decoration of the throne was intended to signify an aspect of Philosophy – the many-breasted Diana stands traditionally for Nature. Now Vasari also tells us in some detail that the colours of her garment, from the neck downward, are those of fire, air, earth and water, and are therefore symbolic. He may be right , but what of the

421
Raphael, *Poetry*, *c*.1510.
Drawing. Royal Library,
Windsor Castle

garments of the other personifications? He does not tell us, but even if he did, we could always ask further questions. Are the configurations of the folds significant? Are the positions of the fingers?

But though it is obvious that the limits of signification are invisible when looked upon from outside, as it were, when we are confronted with any particular image, the situation changes dramatically when we look at the problem from the other side, when we consider a text which is to be translated into an image. The reason is simple. Language operates with universals, and the particular will always slip through its net, however fine we may make its meshes. It is because language is discrete and painting continuous that the painted allegory cannot but have an infinity of characteristics which are from this point of view quite devoid of meaning.

Of course what is allegorically meaningless is not, thereby, without significance of some other kind. If it were, the image would be a pictogram and not a work of art.

Take another of Raphael's personifications, *Poetry* (Fig. 406), or better still, his ravishing drawing for that figure (Fig. 421). From one point of view it is a pictorial sign with the obvious and enumerable attributes of the wings, the lyre and the book. But this vision not only signifies *numine afflatur,* it also displays or expresses it. The sign limits are blurred. The upturned gaze may still be a conventional sign for inspiration, carried by the tradition of art from ancient times, but the tense beauty of the figure is Raphael's own, and not even he could quite transfer and repeat it, for it may well be that the finished image is a little less convincing as an embodiment of the divine afflatus, though it has an added laurel wreath.

Elsewhere in this volume the history of the distinction has been traced between the symbol and the allegory.[27] The allegory was felt to be translatable into conceptual language once its conventions were known, the symbol to exhibit that plenitude of meaning that approaches the ineffable.

But the same study has also suggested that historically speaking the distinction is falsely drawn. Personifications were not simply viewed as pictographs denoting a concept by image rather than by label. They were rather true representations or embodiments of those superior entities which were conceived as the denizens of the intelligible world. It is here, again, that the intellectual tradition embodied in the *Stanza* met the artist half-way. Indeed the orator who selected these universals as objects of praise could appeal to the visual imagination to clothe them with flesh and blood.

Here, too, we can draw on the conventions of 'epideictic oratory' collected in Müllner's handy anthology. In 1458 Giovanni Argyropoulos, the Byzantine humanist naturalized in Medicean Florence, wound up a lecture on Aristotle's *Physics* in words which call to mind Raphael's radiant vision of Astronomy (Fig. 418).

Immortal Gods, how great is the nobility of that Science, how great its perfection, how great its force and power, how great also its beauty. Concentrate your mind on this, concentrate it, I implore you, and do what I tell you. Imagine – for your minds are free and so are your thoughts, so that you can easily form an image in your mind by the use of reason, as if it were real – imagine, therefore, and place before the eyes of your mind Science herself in the guise and appearance of a maiden; gather in it all the ideas comprised in Science, does she then not truly look to you like the Helen of Zeuxis or rather like Helen herself, like Pallas, like Juno, like Diana, like Venus? Without doubt she will by far excel

422
Perugino, ceiling of the
Stanza dell'Incendio, 1508.
Vatican Palace

the beauty of all these and her comeliness, which can be perceived by the mind,
cannot in any way be described in words. O what loves would she then arouse,
what ardours, what desires, indeed, if I may say so, what lusts, to approach, to
embrace, to cherish her, if she were seen by the mind as she really is and could be
seen in that sphere . . .[28]

Needless to say, there is no more reason to assume that Raphael or his advisers
knew this particular text than that they knew any of the other specimens of
the genre quoted above. All they had to convey to the young artist was the
conviction that beauty is an attribute of the Divine. Not that an artist of
Raphael's stamp would have to be told of this belief. The tradition of
Christian art and indeed of Christian poetry would not be imaginable
without this anchorage.

If Raphael conceived his task in this light he may not have needed much
further verbal instruction on how to translate the idea of the divinity of
knowledge into a cycle of images. Perhaps he required no more detailed
guidance than the composer of a solemn text ever needed to set it to music.[29]

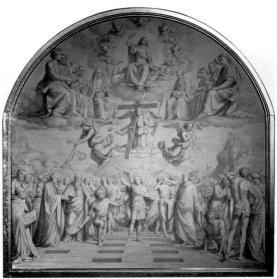

We cannot claim to know exactly what the text was on which Raphael thus set to work, but there is one type of evidence which virtually rules out the assumption that it can have been either very long or very detailed.

It is the record of his working procedure preserved in the many drawings for the *Stanza* which O. Fischel has sifted and discussed in such a masterly fashion in his monumental work on *Raphaels Zeichnungen*.[10] Though little can be added to his analysis, it is still relevant to review this evidence, which will never cease to startle and challenge any student of the creative process.[11] For briefly we shall see that it was not only the scheme as a whole which resulted from a fusion and modification of recent cycles known to Raphael, but that this whole perfect symphony of forms owes its degree of coherence and articulation to the artist's systematic use and modification of existing compositions which he embodied and transfigured in his masterpiece.

The record is most complete for the assembly under *divinarum rerum notitia*, the so-called *Disputà* (Fig. 409). Its central conception comes surprisingly close to another composition of Perugino, whose *Cambio* so obviously influenced the whole scheme. It is to be found on the ceiling of the very room adjoining the *Stanza della Segnatura*, today Raphael's *Stanza dell'Incendio* (Fig. 422). It is not known when Perugino painted this ceiling, but it seems it was in 1508, just before work on our *Stanza* began. As in the *Disputà* we see the descent of the Holy Ghost in the form of a dove spreading its wings beneath the figure of blessing Christ. So similar is the basic conception of the two works, that one cannot help wondering whether they are not also historically connected.

May not the twenty-five-year-old Raphael originally have been called to

423
Raphael, *The Trinity*, 1507–8. S. Severo, Perugia

424
Fra Bartolommeo, *The Last Judgement*, 1499. Museo di S. Marco, Florence

Rome to assist his aged master, who had just completed the *Cambio* in Perugia, and may not Julius II (perhaps prompted by Bramante) subsequently have decided to place the young genius in charge of the neighbouring room, where Sodoma had been at work? These may be idle speculations, but we know that, when Raphael first planned the wall, he made use of another formula he had recently employed in a joint work with Perugino, the *Trinity* of San Severo (Fig. 423), where a row of Saints are arranged in a semicircle around Christ enthroned on clouds. Basically Raphael appears to have planned to compose the upper half of the fresco along the lines of a Last Judgement with Christ in the centre, flanked by intercessors and Judges. The composition by Fra Bartolommeo (Fig. 424), an artist to whom Raphael owed so much, has often been quoted as his inspiration.

But looking at the beautiful sketch at Windsor which appears to embody Raphael's first complete plan (Fig. 425), we observe an even stranger dependence. The group on earth, linked to the heavenly apparition by a lovely figure pointing upwards in the way of the traditional representation of Hope, turns out to be closely modelled on Leonardo's unfinished *Adoration of the Magi* (Fig. 426). The figure of the dignified old man who stands wrapped in his cloak and sunk in meditation serves the same compositional purpose in Raphael as he does in Leonardo – to anchor the group while other members bend and surge forward.

But somehow Leonardo's beautiful compositional motif did not suffice to provide a basis for the long wall Raphael had to cover, and so he gave up his original idea of combining themes from Fra Bartolommeo and Leonardo. But he was far too circumspect an artist to part for that reason with the group he

obviously admired, and when he removed it from his plan of the *Disputà* he shifted it to the opposite wall, turning some of its elements into a group of the writing sage with others peering at his writing. The Cartoon of the *School of Athens* (Fig. 427) proves this dependence beyond any reasonable doubt and shows that Raphael had no compunction even in copying an individual type (Fig. 428), if it suited his purpose.

Having thus found a use for the Leonardo he was left without a model for the terrestrial group of theologians. But he did not have far to go for another exemplar, no further than across the corridor to the Sistine Chapel. It does not appear to have been noticed that the basic grouping of the *Disputà* on the lower left-hand side (Fig. 429) is modelled on Botticelli's fresco of the *Temptation of Christ* (Fig. 430), which, in its turn, may owe something to Leonardo's contemporary *Adoration*. The dependence is even closer in the first sketches for the composition, notably the drawing in Frankfurt, which may be a copy (Fig. 431). Like Botticelli's group it shows a surge of movement towards a centre, arrested in the middle, and a counter-movement of men debating among themselves.

Raphael retained this group of separatists even in the final version, and the question has been much discussed whether they are meant to be heretics. We may never know, but what we do know is that even this possibility could have

427
Raphael, detail from the cartoon for *The School of Athens, c.*1509. Biblioteca Ambrosiana, Milan

428
Leonardo da Vinci, detail from *The Adoration of the Magi* (Fig. 426)

429
Raphael, detail from the
Disputà (Fig. 410)

430
Sandro Botticelli, *The
Temptation of Christ*, 1481–2.
Sistine Chapel, Vatican

been suggested to Raphael not by a learned theologian but by the tradition of his art. He cannot but have seen Filippino's recent masterpiece of *St Thomas Confounding the Heretics* in S. Maria sopra Minerva (Fig. 432). Here, too, he used what he could assimilate, such as the *putti* with the *tituli*, the books which litter the steps of the centre and the upraised arm of one of the Cardinal Virtues.

But contrary to first appearances Raphael was not simply a magpie, making a pastiche from recent frescos. He was a great artist who knew how to fuse these elements of the tradition into a novel work of superior organization and complexity. It is here that the drawings provide the most telling and moving evidence.

In the Botticelli no less than in Raphael's Frankfurt drawing there is a gap between the movement towards the centre and the counter-movement towards the periphery. In Raphael's finished fresco the gap is triumphantly closed by a turning figure which links the two groups. Once more we can admire

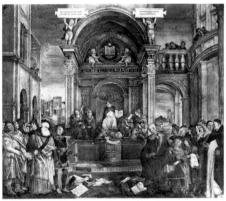

431
Raphael, study for the
Disputà, 1508–9. Drawing.
Städelsches Kunstinstitut,
Frankfurt

432
Filippino Lippi, *St Thomas
Confounding the Heretics*,
1488–93. S. Maria sopra
Minerva, Rome

Raphael's economy of means, for he took that figure from the first Windsor drawing where it links the lower with the higher order. But the drawings also reveal the care Raphael took to adjust it to the changing function; there are studies (Lille) in which he works on the exact degree of turning, but the most astonishing of these is another document which shows the use Raphael could make of tradition – his drawing in the Uffizi, where the image of a classical Venus is used to clarify this all-important posture of grace and apparent simplicity (Fig. 433).

If one gap was now closed, there remained another hiatus in the composition where the forward movement came up against the sitting figures of the centre. Once more Raphael needed a figure to take up the movement and carry it forward, a turning figure. There is a rapid pen drawing in the British Museum with fragments of a sonnet, a sketch for two arguing figures among the 'heretics', a foot, and a graphic record of Raphael's thoughts permitting us to watch him turning the figure around in space (Fig. 434). From there we can follow the invention taking shape; first it seems to belong to a group like those on the *School of Athens* watching or reading, but then on a drawing in Oxford (Fig. 435) which also contains ideas for the *Parnassus* the solution is almost achieved, and all that remains is to clothe the figure in that majestic drapery which, on a further charcoal drawing (Fig. 436), gives it that weight or *gravitas* that is demanded by its artistic function. This does not exclude, of course, that the figure was also given a name in some larger system of thought, but all the evidence points to the conclusion that if it happened it must have happened as an afterthought.

There are fewer drawings to document the growth of the assembly exemplifying *causarum cognitio*, the Search for the Knowledge of Causes, but there is equally little evidence that Raphael here wanted to give, or was instructed to give, a rigid system of Philosophy. Indeed there is again one

433
Raphael, *Vénus*, 1508–9.
Drawing. Uffizi, Florence

434
Raphael, study for the
Disputà, 1508–9. Drawing.
British Museum, London

small but decisive piece of evidence against the existence of a very detailed programme. The strange group on the extreme right (Fig. 419) is known to have been taken over from one of Donatello's reliefs in the Santo (Fig. 437), copied in a sketchbook from Raphael's circle (Fig. 438).

Wölfflin, who discussed this borrowing in his *Classic Art*, was sufficiently startled to suggest that it might have been incorporated in the composition by way of a joke.[32] At any rate, he said, it should not be taken as an indication of any poverty of invention on Raphael's part and should not be taken 'too tragically'. He was addressing readers steeped in the cult of originality. But we have seen that this approach can never do justice either to Raphael's methods of creation or indeed to the composition of the *Stanze*. The group was for Raphael an instance comparable to a musical modulation – the way to give a composition with a strong central accent a counterbalancing movement towards the edge. But in transplanting the group into the lofty hall he also transformed Donatello's anxious old spectator into a mysterious sage and the woman rushing out into a man with an enigmatic errand. If no written programme is likely to have included the group he found in Donatello, it follows by no means that we should only look at it as a mere formal flourish.

Wölfflin himself, who has so often been invoked as a champion of 'formal analysis', was the last to have advocated such an impoverishment. The very last sentence of *Classic Art* tries to forestall such a misreading. 'In no way do we want to have pleaded for a formalistic appreciation of art. It certainly needs the light to make the diamond sparkle.'[33] Wölfflin saw very clearly that the dichotomy between form and content, beauty and meaning is inapplicable to works of the High Renaissance. Raphael and his friends would certainly not have understood such a separation. They were brought up in that atmosphere to which allusion has been made so often in this paper, the tradition of

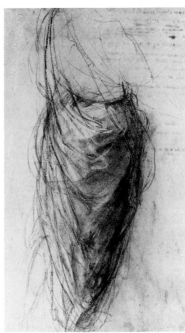

435
Raphael, study for the
Disputà, 1508–9. Drawing.
Ashmolean Museum,
Oxford

436
Raphael, study for the
Disputà (verso of Fig. 435),
1508–9. Drawing.
Ashmolean Museum,
Oxford

rhetoric. It is true that we tend to think of rhetoric as a hypertrophy of form
over content, but that is not how the Renaissance regarded it. They naturally
accepted the theory of decorum, the doctrine demanding that a noble content
should be matched by noble forms. The choice of such noble words, images
and cadences to do justice to the greatness of a theme was indeed the core of
that branch of rhetoric called 'epideictic'. There can be few even among
twentieth-century scholars who can read these compositions with the same
attention and appreciation with which they were probably listened to at the
time, for we have come to believe that a speech should convey information or
a cogent argument. What the Renaissance meant by wit, by the epigrammatic
play with metaphors and images, may appeal to us more readily because the
use of paradox and of esoteric allusions sets the mind a puzzle. There was also
a kind of visual image that corresponded to this second approach, the
emblem, the hieroglyph or the device. These were packed with meaning,
without being therefore very profound. In any case there is no reason to think
that a cycle such as the *Stanza* was intended to contain this kind of *acutezza
recondita*.[34]

In asking an artist to celebrate Justice and the Knowledge of Things Divine,
the Search for Causes and the Divine Afflatus in a room of the Papal
apartments, one would not have thought in terms of emblems and epigrams
so much as in terms of *amplificatio*, the restatement of the meaning in ornate

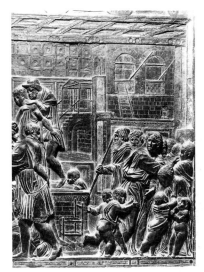 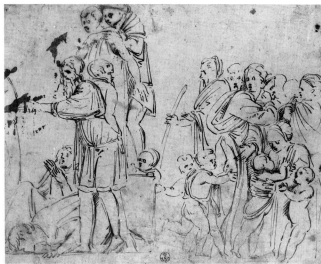

437
Donatello, *The Miracle of the
Miser's Heart* (detail),
1446–50. Chiesa del Santo,
Padua

438
School of Raphael, copy
after Donatello (Fig. 437).
Accademia, Venice

examples and beautiful periods, which orchestrate the idea of knowledge as a gift from all high.

For an artist of Raphael's genius that meant that the visual realization of this idea had to be infused with his own kind of harmony and beauty, his own melodious groups and formal cadences. They all contributed to the celebration of the exalted theme. Seen in this light every group, every gesture and every expression of the *Stanza* is indeed charged with significance, and is the appropriate form for a solemn content.[35]

But art, like music, certainly does more than simply restate the intellectual message. In clothing it with forms it also modifies and articulates the thought. Once we grasp the general message we are led to find fresh metaphors and symbols in the rich configurations which surround us. We learn to see and to understand something of the numinous quality which Raphael and his contemporaries saw in Knowledge, and there must have been many who gained a more intense picture of what was meant by Theology, Poetry or Philosophy through these frescos.

No wonder that so many admirers of Raphael's art also felt prompted to rationalize this response by trying to translate the meaning they felt to be present in the cycle into a profound philosophical statement. They were aroused to this confident search precisely by the beauty and complexity of the composition. Pinturicchio's cycle left them cold; they could pass it by and just take in the routine list of the Liberal Arts. It was Raphael's greatness as an artist who knew how to bring the whole tradition of pictorial composition to bear on this task that ultimately caused this feeling of an inexhaustible

plenitude. This plenitude is no illusion, even if it should turn out that the instructions the artist received contained no more than the current commonplaces of the school.

Editor's Postscript

It is a mistake to believe that a naturalistic image must offer a depiction of an imagined event. The crucial issue is one of genre. *Depending on one's overall understanding of an image, one will be inclined to read it one way rather than another. Imagine the 'School of Athens' to be a group of cliquey philosophers and one will soon start to wonder who is talking to whom about what. This line of thought invariably leads to the hypothesis of a learned adviser who is familiar with the intimate details of all the different philosophical systems.*

By following Schlosser's lead and arguing that Raphael was following the medieval tradition and offering representatives of the different arts, as might be found in medieval sculptural decorations, Gombrich is able to argue that no programme is needed, just a conventional knowledge of stock types. This line of thought is confirmed by an examination of Raphael's working drawings.

A fundamental issue concerns the likely reading habits, and the accessibility of texts, to painters who have illustrated those texts. One needs to take a balanced view of the situation:

> *I have written an article on the* Stanza della Segnatura *by Raphael where I said that I do not believe that Raphael had very much advice from learned scholars to construct the symbolism of these paintings. I tried to show that most of it one could explain by the tradition of earlier pictures in the Vatican. The same is true of the Sistine ceiling. These artists knew of course what their colleagues had done, and the tradition in which they had worked, and they incorporated certain modifications of their own. But they did not need a learned man by their side to tell them that God created the world or that Apollo was the leader of the Muses. My article on the* Stanza della Segnatura *is therefore a criticism of those who believed that they did. So is, for example, my article on Hieronymous Bosch. I found in reading the* Historia Scholastica, *a kind of narrative based on the Bible, you could explain much of* The Garden of Earthly Delights. *(A Lifelong Interest, p. 141.)*

Connected essays are 'Raphael's Madonna della Sedia', *'The Renaissance Theory of Art and the Rise of Landscape', 'Reynolds's Theory and Practice of Imitation' in* Norm and Form; *'Tobias and the Angel' and 'Icones Symbolicae', along with the other essays in* Symbolic Images *and* New Light on Old Masters. *The Bosch article referred to is 'As it was in the Days of Noe', in* The Heritage of Apelles. *See also the previous chapter.*

There are some interesting remarks on the dangers of over-interpretation in 'Michelangelo's Last Paintings' in Reflections on the History of Art.

The Subject of Poussin's Orion

First published in *The Burlington Magazine*, 84 (1944); reprinted in *Symbolic Images* (1972; 3rd edition, 1985), pp. 119–22

This was the vision, or the allegory:
We heard the leaves shudder with no wind upon them
By the ford of the river, by the deep worn stones,
And a tread of thunder in the shadowed wood;
Then the hunter Orion came out through the trees,
A tree-top giant, with a man upon his shoulder,
Half in the clouds . . .

Sacheverell Sitwell, 'Landscape with the Giant Orion.'[1]

Bellori tells us that of two landscapes Poussin painted for M. Passart one represented 'the story of Orion, the blind giant, whose size can be gauged from a little man who stands on his shoulders and guides him, while another one gazes at him'.[2] It is to Professor Tancred Borenius that we owe the identification and publication of this masterpiece, which is now in the Metropolitan Museum in New York (Fig. 439).[3] The strange tale of how the gigantic huntsman Orion, who had been blinded for an attempt to violate the princess Merope at Chios, was healed by the rays of the rising sun, would appear to be a tempting subject for illustration. And yet Poussin seems to have been the first – if not the only – artist to paint it.

Perhaps the story did indeed appeal to him – as Sacheverell Sitwell suggested – 'because of its poetical character, and because of the opportunity it afforded him to make a study of a giant figure, half on earth and half in the clouds, at the moment of sunrise', but the idea of making it the subject of a painting was nevertheless not his own. It was apparently first conceived not by a painter but by a man of letters, by that fertile journalist of late antiquity: Lucian.

In his rhetorical description of a Noble Hall, Lucian enumerates the frescoes which adorn its walls:

On this there follows another prehistoric picture. Orion, who is blind, is carrying Cedalion, and the latter, riding on his back, is showing him the way to the sunlight. The rising sun is healing the blindness of Orion, and Hephaestus views the incident from Lemnos.[4]

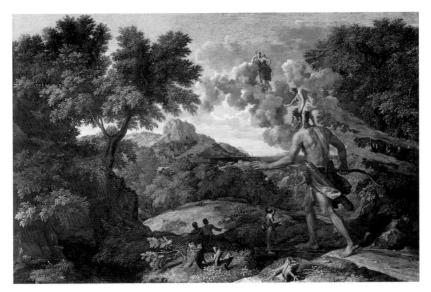

439
Nicolas Poussin, *Orion*,
c.1650–58. Metropolitan
Museum of Art, New
York

There can be little doubt that this passage is the immediate source of Poussin's painting. Like Botticelli's *Calumny of Apelles* or Titian's *Bacchanal* it thus owes its origin to that curious literary fashion of classical antiquity, the *ekphrasis*, which freed the imagination of later centuries by the detailed description of real or imaginary works of classical art.

But, although the passage from Lucian may serve to explain Poussin's choice of the subject-matter, it does not appear to have been the only literary source on which he relied when he began to reconstruct the classical fresco described by the Greek author. For in one point, at least, Poussin's picture does not exactly tally with Lucian's description: Hephaestus is not represented as 'watching the incident from Lemnos' – he is seen advising the guide he gave Orion and pointing the way towards the east where the sun is about to rise. The role of the spectator has been filled by another divinity, Diana, who is seen quietly looking down from a cloud. The same cloud on which she leans also forms a veil in front of Orion's eye and thus suggests some kind of connection between the presence of the goddess and the predicament of the giant. Félibien must have felt this connection when he described the picture as '*un grand paysage où est Orion, aveuglé par Diane*'[5] – quite oblivious of the fact that no classical version of the myth conforms to this description. It was not Diana who blinded Orion, however often the story of the hunting goddess may have been interwoven with that of the hunting giant. It was said that he loved her in his youth, attempted to violate her, was slain by her for his crime (or else for his boasts that he would kill all the animals in the world), and was finally changed by her into that mighty constellation on the night sky in which

his name lives on. No classical version of the tale, however, connects Diana with the episode of Orion's blindness. Indeed it is her intriguing appearance as 'a silent stone statue in the open sky' that inspired Sacheverell Sitwell in his highly imaginative poetical interpretations of the painting which centre round the poet's impression that 'she will fade out of the sky as soon as Orion recovers his sight'. However, the presence of the goddess becomes perhaps less mysterious if we turn from classical authors to the reference books Poussin may have consulted, when trying to deepen his acquaintance with the myth to which Lucian alluded.

A few lines in a satirical verse by Marston provide a neat enumeration of some of the most popular reference books in vogue with the poets and artists:

> Reach me some poets' index, that will show
> *Imagines Deorum,* Book of Epithets,
> Natalis Comes, thou I know recites,
> And makest anatomy of poesy.[6]

The modern reader who turns to works like *Natalis Comitis Mythologiae* will find it difficult to associate this bewildering farrago of pedantic erudition and uncritical compilation with the serene Olympian world of Poussin.[7] The most apocryphical and outlandish versions of classical and pseudo-classical tales are here displayed and commented upon as the ultimate esoteric wisdom. The very subtitle of Comes's book: '*Explicationis fabularum libri decem; in quibus omnia prope Naturalis et Moralis Philosophiae dogmata in veterum fabulis contenta fuisse perspicue demonstratur*' ('Ten books of explanations of fables, clearly demonstrating that all the doctrines of Natural and Moral Philosophy were contained in the fables of the ancients'), shows it to be part of that broad stream of tradition which kept alive the belief that, to the initiated, the old fables reveal themselves as symbolical or allegorical representations of the 'arcana' of Natural History or Moral Philosophy.[8]

The principal method of this strange art of hermeneutics is a fanciful etymology which so stretches the sound and meaning of words and names that they are made to yield their pretended secrets. Weird and abstruse as these 'interpretations' read today, it can hardly be denied that they satisfy at least one of the principal requirements of any successful interpretation: the most disparate elements of a myth are, through this method, reduced to one common denominator and even the most contradictory episodes can be made to appear as different symbols and manifestations of one 'hidden truth'. In his interpretation of the Orion myth, Natalis Comes chose to consider its various episodes in the light of a slightly repulsive apocryphal story which tells of the

giant's joint procreation by Neptune, Jupiter and Apollo, a story which, to Comes, clearly signifies that Orion stands for a product of water (Neptune), air (Jupiter) and sun (Apollo). Armed with this clue and a fanciful 'scientific' interpretation of meteorological phenomena he proceeds boldly to interpret the whole legend as a veiled symbol of the interaction of these elements in the origin and natural course of the storm cloud:

> ...through the combined power of these three Gods arises the stuff of wind, rain and thunder that is called Orion. Since the subtler part of the water which is rarefied rests on the surface it is said that Orion had learned from his father how to walk on the water. When this rarefied matter spreads and diffuses into the air this is described as Orion having come to Chios which place derives its name from 'diffusion' (for *chéein* means to diffuse). And that he further attempted to violate Aerope[9] [*sic*] and was expelled from that region and deprived of his lights – this is because this matter must pass right through the air and ascend to the highest spheres and when the matter is diffused throughout that sphere it somehow feels the power of fire languishing. For anything that is moved with a motion not of its own loses its power which diminishes as it proceeds.
> Orion is kindly received by Vulcanus, approaches the sun, finds his former health restored and thence returns to Chios – this naturally signifies nothing else but the cyclical and mutual generation and destruction of the elements.
> They say that he was killed by Diana's arrows for having dared to touch her – because as soon as the vapours have ascended to the highest stratum of the air so that they appear to us as touching the moon or the sun, the power of the moon gathers them up and converts them into rains and storms, thus overthrowing them with her arrows and sending them downwards; for the power of the moon works like the ferment that brings about these processes. Finally they say that Orion was killed and transformed into a celestial constellation – because under this sign storms, gales and thunders are frequent ...[10]

In this strange 'interpretation' Diana – the Moon and her power – does indeed form an integral part of the same process that is also symbolized in the episode of Chios: the drama of the circulation of water in nature.

But reading Natalis Comes's text in front of Poussin's picture, it appears to explain more than the mere presence of Diana on the scene. The long-stretched storm cloud through which the giant is striding, that conspicuously rises from under the trees, expands through the valley, gathers up in the air and touches Diana's feet, this cloud is no other than Orion himself in his 'real' esoteric meaning. We cannot but admire the ingenuity with which Poussin has contrived to represent the exoteric and the esoteric aspect of the myth in one

picture. To the uninitiated the storm cloud appears as a happy pictorial solution, a rational trick which helps to illustrate Orion's blindness as a transitory phase which will be over when he has passed the mist and approached the rising sun. To the circle of scholars who were accustomed to see 'the teachings of Natural and Moral Philosophy hidden in the fables of antiquity', the cloud rising in the grandiose scenery represented the whole myth again on a higher plane: the eternal drama of the 'mutual generation and destruction of the elements'.

Trained, as we are, in a predominantly visual approach to the arts, we may at first find little to commend in such an intellectual and even sophisticated trick of illustration that embodies a learned commentary into a representation of a classic myth. Indeed, had this trick remained purely on an anecdotal plane the connection with Natalis Comes's erudite compilation might just as well have remained forgotten. It constitutes the true achievement of Poussin's genius that he succeeded in turning a literary curiosity into a living vision, that his picture *expresses* in pictorial terms what it *signifies* in terms of allegory. Without the aid of any rational 'key' to its emblematic language the picture has always imparted its inner meaning to sensitive observers. It was of this 'Landscape of Poussin' that Hazlitt wrote, with strange intuition, in his *Table Talks*: 'At his touch, words start up into images, thoughts become things';[11] and Professor Borenius, the rediscoverer of the painting: 'the use made of the terms of land, sea and sky suggests the drama of nature for which the mythological terms are but symbols.'[12]

Reading the passage from Natalis Comes there can be no doubt that this quite literally describes Poussin's approach to mythological landscape painting. An artist like Poussin can only have made use, in his reconstruction of Lucian's 'ekphrasis', of the humanist's allegorical reading of the myth because he accepted this approach as a whole. He too conceived the ancient tale of violence and magic as a veiled and esoteric 'hieroglyph' of nature's changing course. Thus the landscape became more to him than the scene in which a strange and picturesque story was enacted. Its deeper significance lifted it beyond the sphere of realistic scenery or Arcadian dreams – it became fraught with the meaning of the myth; a vision *and* an allegory of Nature herself.

Editor's Postscript
Poussin's Orion *is a case of visual poetry: a painting illustrating a text from an esoteric mythological handbook. It illustrates Gombrich's way of working from text to image rather from image to text, which is the method adopted by many aspirant iconographers. In this case, he remarked in* A Lifelong Interest:

At ... times it is just a matter of chance: one reads a book, and suddenly one thinks of a picture. For instance, my article on the Orion *by Poussin. I don't think I was looking for the answer. I was reading Natalis Comes about mythologies; I read this story and I suddenly thought: 'Remember Poussin' (p. 142).*

Further remarks on source-hunting may be found in chapter 6: 'The Limits of Interpretation' in A Lifelong Interest, *pp. 147-59 and 'The Evidence of images: II. The Priority of Context over Expression', in C.S. Singleton (ed.),* Interpretation, Theory and practice *(Baltimore, 1969), pp. 68-104, which contains an important discussion of Jerome Bosch's 'Epiphany'.*

Important related and uncollected essays are: 'A Note on Giorgione's "Three Philosophers"', The Burlington Magazine, *128 (1986), p. 488 and 'Archaeologists or Pharisees? Reflections on a Painting by Maarten van Heemskerk',* Journal of the Warburg and Courtauld Institutes, *54 (1991), pp. 253-6.*

See also 'Michelangelo's Cartoon in the British Museum', in New Light on Old Masters.

Dutch Genre Painting

Originally published under the title 'Scenes in a Golden Age' in the *New York Review of Books* (13 June 1985), as a review of the catalogue of the exhibition *Masters of Seventeenth-Century Dutch Genre Painting* (edited by Peter C. Sutton); reprinted in *Reflections on the History of Art* (1987), pp. 109–14

In what is called the 'art world' of today exhibition catalogues have acquired an almost ritualistic function. Too heavy to carry around, too detailed to be read in their entirety, they serve to reassure the public of the care and thought that have gone into the arrangement of the show. The catalogue of the circulating exhibition *Masters of Seventeenth-Century Dutch Genre Painting*, which went from the Philadelphia Museum of Art to the Berlin Gemäldegalerie and finally to the Royal Academy of Arts in London, has many of the drawbacks of the genre. Its 400 pages, its 127 full-page colour plates, its countless black-and-white illustrations and extensive bibliography inevitably present a contrast with the paintings to which it is devoted, since many of them are lighthearted and unpretentious.

In this particular case, however, it would be wrong to dismiss the enterprise as inflated, for not only the individual entries but more exceptionally the introductory essays carry their justification in themselves. The organizer of the show, Peter C. Sutton of the Philadelphia Museum of Art, is responsible for the two preliminary texts, a detailed account of the masters represented and a chapter, 'Life and Culture in the Golden Age'. These essays must be warmly recommended to all lovers of Dutch art for their informative content, their aesthetic sensitivity, and their sanity. Strangely enough this last and most precious quality can no longer be taken for granted in art-historical writings on the topic concerned. For somehow we seem to have lost our innocence in dealing with these pictures. It used to be accepted as a matter of course that the genre paintings produced in such quantities by major and minor masters in various prosperous cities of Holland were intended to please and amuse. It

is only of late that they have appeared to present a puzzle. They remain agreeable enough, but what do they *mean?*

This preoccupation with meaning is due, of course, to the success and prestige of the branch of art-historical studies known as iconology, which concerns itself with the interpretation of allegorical and symbolical images. But the founders of this discipline never wished to imply that any statue that could not be given a title such as 'Liberty Enlightening the World' was therefore meaningless. Only in the discussion of language can we distinguish between statements that have a meaning and strings of words that are devoid of meaning. Images are not the equivalent of statements, and to ask in every case what a painting 'means' is no more fruitful than to ask the same of a building, a symphony, or a three-course meal. A painting of a moonlit landscape does not 'mean' a moonlit landscape, it represents one.

In her book *The Art of Describing*,[1] Svetlana Alpers had reason to reassert this common-sense view, devoting a special appendix to the 'emblematic interpretation' of Dutch art. She there takes issue with the attempt to apply the methods and aims of iconology wholesale to the study of the period in question by reference to a genre of art that once enjoyed great popularity, the tradition of emblem books. Emblems are illustrations of objects or scenes which are given a symbolic meaning in their captions and texts. Thus a pretty volume of *Zinnebeelden* (emblems) by one Claas Bruin contains indeed a minute picture of a moonlit landscape, the moon being reflected in a pool below. The accompanying motto, in Latin and Dutch, explains the meaning: *Non fulgore suo* (not with its own light). The lengthy poem on the opposite page adjures us never to forget that just as the moon owes its light to the sun, so we owe everything to God.

Nobody would conclude from this application that all paintings of night pieces in Dutch art are intended to preach this particular sermon, but it remains true that the absence of this or any other meaning can never be proved, for as the lawyers say, *negativa non sunt probanda* (you cannot prove a negative). You cannot establish beyond doubt that the painter of such a landscape or its owner never meditated on this particular truth, which he may have heard in a sermon. Here as elsewhere I have found it useful to remember the distinction proposed by E.D. Hirsch, Jun., between meaning and significance (see above, p. 461). The significance that such a painting may have for any owner or viewer is likely to vary, whether or not it was intended by the painter to have a specific 'meaning' at all.

As I have indicated, Sutton takes a balanced view of these controversies. His sections entitled 'Mute Poetry' and 'Allegories and Accessories' point to convincing examples which demonstrate that occasionally there is indeed

more in Dutch painting than meets the eye. We must be all the more grateful to him for not falling entirely under the spell of the search for meaning for its own sake. His words about a painting by Ter Borch owned by the Detroit Institute of Arts (Fig. 440) deserve to be quoted in full:

> Ter Borch was the master of refinement, not only in terms of his socially elevated subjects and peerless technique – renderings of satin and tulle to defeat an army of imitators and copyists – but also in terms of psychology. One can inventory the associations and potential symbolism of objects on a dressing table or discuss the implications of details of costume and furnishings, but the abstracted gaze of the woman fingering her ring speaks volumes.

How refreshing it is to read such a sensitive response to the essentials of a minor masterpiece, precisely because it contains both objective and subjective elements. That the volumes which her gaze appears to speak are closed books to us is suggested by the catalogue entry concerning the same painting, which

rightly stresses the ambiguity of the lady's gesture. 'Is she merely daydreaming as she takes off her jewellery or does she toy with larger issues of romance or marriage?' But, one might interpose, is it certain that she is fingering or taking off her ring? Is it not more likely that she puts it on after having rinsed her hands and now waits somewhat impatiently for the maid to get her ready at last? Maybe the artist did not want us to know, but what he certainly wished us to observe was his mastery in the rendering of satin, tulle, and other materials that Sutton so rightly admires.

Perhaps one could go even further than he does when he says of Frans van Mieris that his work 'established a standard of technical refinement never surpassed in paint. Only with the advent of photography were genre images of greater detail realized.' Were they really? It is far from sure that photography can match the suggestive power of Dutch paintings in conjuring up the effects of gleam and glitter. The realism of this school is a 'super-realism', mobilizing our response to a greater extent than the unassisted photographic image might be able to do. Admittedly, there are no experiments known to me that would enable one to make such a comparison; it is to be feared that the very preoccupation with meaning among art historians would make them dismiss such an investigation as philistine or worse. And yet the author is surely right in frequently drawing our attention to the virtuosity of these masters in the rendering of light.

As one walked through the exhibition it indeed became clear that these painters competed with each other and tried to outdo their rivals in these magnificent conjuring tricks. It can never be sufficiently stressed that fidelity to natural appearances is never a simple matter of 'transcribing' reality. Reality must be re-created, even reinvented, in the medium of paint, if its image on the panel or the canvas is to be recognized as true to life.

It is this power, first to convince and then to enchant by the magic of the brush, that makes the masterpieces of the period so unforgettable. Minor specialists had come to excel in the creation of particular effects, but only painters of the stature of Jan Steen, Gerard ter Borch, Pieter de Hooch, and, of course, Johannes Vermeer were able to combine them all without stridency or ostentation and thus to transfigure an ordinary sight into a thing of beauty. It is true that in doing so they were frequently celebrating ordinary scenes from daily life, but the author is surely right in stressing the selectiveness of their naturalism. A candid camera recording the behaviour of people in town and country would certainly have produced very different images. But once it is accepted that artists selected their subjects with an eye to their pictorial possibilities this difference cannot surprise. With the exception of Jan Steen's more boisterous compositions they were sparing in the representation of

rapid or violent movement. Their figures are often posed in an attitude that can be held without strain, they are engaged in household chores, reading or quietly conversing. To be sure there are exceptions, but we need only glance back at the art of the preceding century to understand how the scenes and settings of Dutch seventeenth-century genre paintings were cunningly chosen to offer a quiet feast to the eye.

Of course it is precisely this interpretation of Dutch art which has been challenged by those who stress its emblematic leanings. It has been argued, particularly in Holland, that the view presented by nineteenth-century art lovers from Hegel to Fromentin was coloured by the art of their own time and was therefore anachronistic. The Dutch masters of the seventeenth century, it is now said, were neither realists nor impressionists; they were the heirs of a tradition extending far into the Middle Ages which used the visual image to illustrate, to edify, and to preach. Scenes of carousing, so the argument goes, were first created as illustrations to the parable of the Prodigal Son, and never quite lost their moralizing purpose; the subjects of Jan Steen's revelries can be shown to be connected with the cycles of proverbs painted by Bruegel, who drew on an older tradition, and even pictures of smokers or drinkers still reflect the old didactic allegories of the 'Five Senses' created in the Middle Ages.

But interesting as these arguments are, they fail to convince because they present an oversimplified view not only of the art of the seventeenth century but also of that of earlier periods. We must never forget how fragmentary is our knowledge of the secular art of the Middle Ages; few of the murals in castles have survived, and even the costly hangings that adorned the halls of the mighty were discarded when they were overtaken by new fashions. Even so, enough remains to correct the idea of an art entirely devoted to didactic purposes. Sutton rightly points to 'the survival through the end of the sixteenth century of vestiges of the love garden tradition – a central theme in the profane iconography of the Middle Ages'. There are other elements of continuity here: elegant lovers conversing, comic yokels disporting themselves as woodcutters or Morris dancers – pictures of hunts and of pastimes had all established themselves in the artistic repertory of the later Middle Ages, in tapestries, murals, and prints. Far from regarding the idea of 'pure genre' as a creation of the nineteenth century, we should acknowledge its relative ubiquity, in the ancient world no less than for instance on the margins of medieval manuscripts.

It is this powerful tradition as much as that of didactic illustration on which the masters of the seventeenth century were able to draw when they looked for opportunities of displaying their ever-expanding powers of observation and

representation. To suggest that the display of such powers was frequently their dominant aim, of course, need not imply that they were as anxious as were the Impressionists of the nineteenth century to purge their creations of anything that smacked of the 'anecdotal'. Manifestly they were not. They had also inherited the age-old tradition in literature and on the stage of observing what is called 'the comedy of manners', and, just as the writers did, they kept to certain environments and social strata for the exercise of their skill.

Sutton offers a helpful survey of the social strata of seventeenth-century Holland, with its patricians, merchants, soldiers, and outcasts; he reminds us of the restrictions placed on revelries and luxury by the city fathers, but also of the limited efficacy of these efforts. A social historian who wanted to rely exclusively on the testimony of art would certainly gain a very distorted picture of the times, but it is still surprising to learn that many of the elegant women seen drinking or making music must be prostitutes rather than respectable ladies. In inventories such scenes are often described quite openly as brothel pictures, *bordeeltjes.*

Why were these subjects so popular, and what prompted the well-to-do citizens to display them in their houses? In other words, what did such paintings signify to their average viewer? Did he look at them as a warning against vice or vicariously enjoy these illicit pleasures? But should we not pause once more to consider whether we are asking quite the right question? There is an epigram among the *Xenien* jointly composed by Schiller and Goethe which art historians too anxious to establish symbolic or social meanings might do well to ponder:

If you desire to please the worldlings and also the saintly
Paint them a picture of lust – but with the Devil nearby.

Admittedly this is an advice which Hieronymus Bosch followed more closely than did the painters of the seventeenth century. Their pictures of 'lust' are muted by a strong sense of decorum, and far from ever including the Devil they were content with an occasional discreet reminder of the bad end to which such goings-on can lead . It is unlikely that they were out to convert or to improve the moral tone of society. Thus a close reading of the catalogue does not compel us to revise the traditional view that most of these pictures were meant to please and entertain. How else could the painters expect to make a living?

Some two hundred years before their time a Florentine merchant sent to Flanders to purchase tapestries for the private residence of the Medici wrote to his masters that the only set he found available represented the story of

Samson, with many dead bodies making it quite unsuited for the purpose. After all, he remarked, in such a room one wants '*cose allegre*', cheerful things. It is unfashionable to appeal to 'human nature' in such matters, but it seems likely that the Dutch citizens of the seventeenth century would have agreed.

Editor's Postscript

The interpretation of the meaning of Dutch paintings is a fascinating area to explore. The current debate started with Erwin Panofsky, Early Netherlandish Painting: its Origins and Character *(Harvard, 1953), especially chapter V: 'Reality and Symbol in Early Flemish Painting: "Spiritualia sub metaphoris corporalium"'. In that chapter he argued that 'this imagined reality [of the highly naturalistic Netherlandish paintings] was controlled to the smallest detail by a preconceived symbolical programme' (p. 137).*

Eugène Fromentin, Les Maîtres d'autrefois,[1] *had suggested that there was nothing to be seen in Dutch painting apart from reality itself: '...even in their really anecdotic or picturesque painting we cannot see the least sign of anecdote. There is no well-determined subject, no action requiring a thoughtful, expressive, or particularly significant composition; no invention, not a scene that breaks the monotony of this country or town life, which is so dull, commonplace, devoid of learning, of passion, one might say of sentiment' (p. 112). Gombrich, in an aside on Dutch still-life paintings in 'Tradition and Expression in Western Still Life',[2] had suggested that: 'The vanitas [the watch or timepiece] motif ... will render the banquet innocuous ... But useful as such emblematic alibis may be, they are not really needed. For every painted still life has the vanitas motif "built in" as it were, for those who want to look for it. The pleasures it stimulates are not real, they are mere illusion' (p. 104).*

Interpretations of seventeenth-century Dutch painting now vary between conceiving of them as richly symbolic, decipherable through the use of emblem books, through to being virtuoso displays of the art of visual description. Low-life allusions have been found in the most apparently innocuous domestic scenes and the question of what kind of humour is involved in depiction of pub brawls has become a specialist field in itself. The role of the theatre in analysing narrative imagery has frequently been raised as well.

For a useful corrective to Panofsky see now Henk van Os, The Art of Devotion in the Late Middle Ages in Europe 1300-1500 *(London, 1994), which is beautifully illustrated.*

Readers interested in the debates should start with Fromentin. An excellent source of material is then the journal Simiolus, *from the Foundation for Dutch Art Historical Publications. See particularly Jan Baptist Bedaux, 'The Reality of Symbols: The Question of Disguised Symbolism in Jan van Eyck's* Arnolfini Portrait', Simiolus, *16 (1986), pp. 5–28.*

A companion to this essay is 'Mapping and Painting in the Netherlands in the seventeenth century', a review of Svetlana Alpers's book The Art of Describing, *reprinted in* Reflections.

1. *Translated and published as* The Masters of Past Time: Dutch and Flemish Painting from Van Eyck to Rembrandt *(London, 1948, reprinted 1981).*
2. *Reprinted in* Meditations on a Hobby Horse.

Part X High Art and Popular Culture

Imagery and Art in the Romantic Period

This article represents some marginal notes to the *Catalogue of Political and Personal Satires preserved in the Department of Prints and Drawings in the British Museum*, VIII, *1801–10*, by Mary Dorothy George (London, 1947), published in the *Burlington Magazine*, 41 (June 1949); reprinted in *Meditations on a Hobby Horse* (1963; 4th edition, 1985), pp. 120–6

Most print rooms of Europe have in their care vast accumulations of prints brought together for the sake of their subject-matter rather than for any artistic merit. These collections of historical and topographical illustrations, of fashion plates, theatrical subjects and portraits are now rarely consulted except by antiquarians or writers of popular books in search of suitable illustrations. The British Museum's collection of political and personal satire has, on the whole, shared this fate. These prints are rarely considered as art. They are more frequently looked upon as part of the imagery of the past that is the domain of the historian of manners rather than of the historian of stylistic trends. This estimate is hardly surprising, for side by side with the best works of Gillray, Rowlandson, or Cruikshank, these folders contain a good many prints whose aesthetic value is scarcely higher than that of the humorous seaside postcards and comic strips of our own day. Nevertheless, the neglect of this imagery by the art historian cannot reasonably be defended. As a class of images, caricatures are neither more nor less embedded in a definite historical context than are state portraits or altar paintings. And if art history were to restrict its attention to inspired masterpieces we would have to exclude many a work that usually figures in histories of style.

As a matter of fact, the art historian's reluctance to deal with this type of material has been due much less to theoretical or aesthetic scruples than to practical difficulties. The knowledge and research needed to unravel the symbolism of these ephemeral productions and to resuscitate the humour of their topical allusions have often appeared to be out of all proportion to the

intrinsic value of the works themselves. We have all the more reason to be grateful to the distinguished social historian who has undertaken this prodigious labour, thereby opening up to the non-specialist the greatest collection in existence of English caricatures. With each new volume of Mrs M. D. George's *Catalogue*, it becomes increasingly evident that only now will it be possible to study the great period of English graphic journalism and to see its most creative phase in a wider perspective.

A few examples, picked almost at random from the last volume that has so far appeared, the volume covering the years 1801–10, must suffice to show the value to the art historian of the information placed at his disposal. The connection between these caricatures and the art and taste of the times can be well exemplified in a print such as James Gillray's spirited *A Phantasmagoria; Scene – Conjuring-up an Armed Skeleton* of 1803 (Fig. 441).[1] It is an impressive warning against the Peace of Amiens and its Francophile sponsors who are caricatured as the witches in *Macbeth*. The skeleton emerging out of the cauldron (in which the claws and tail of the British lion are seen to simmer) is the gruesome phantom of Britannia, conjured up by Addington (ladling guineas into the pot and raising the olive branch entwined with serpents), Hawkesbury (feeding the fire with papers inscribed *Dominion of the Sea, Egypt, Malta, Cape* … etc.) and Fox (holding up the broom). The crouching figure in the foreground, we learn, is Wilberforce in monkish robes, chanting a *Hymn of Peace*. The lavish display of French insignia on the politicians and the Gallic cock in the foreground perching on the decapitated head of the British lion drive home the point of Gillray's attack.

The link between this Shakespearean fantasy and the preoccupations of contemporary academic art needs no elaboration. It is clear that Gillray – who had satirized Boydel and his Shakespeare Gallery – knew and exploited the vogue for these Romantic subjects.[2] But the catalogue helps us to recognize another link with the taste and mentality of the time.

'Phantasmagoria' – Mrs George tells us – 'was the name invented in 1802 by Philipsthal for an exhibition of optical illusions produced by a projecting lantern. It was a new French invention … Philipsthal exhibited on a transparent screen at the Lyceum representations "in a dark scene" of apparitions and spectres which appeared to advance or recede … by means of lenses and concave reflectors.'

Philipsthal's magic lantern lights up, in a flash, the background of Gillray's print and the taste for which it catered. It is the exact parallel to Loutherbourg's *Eidophusikon*, which appealed to the lovers of Romantic scenery, by presenting on the stage such sensational effects as 'thunder and lightning,

the changes of cloud forms, the tumbling of waves and a shipwreck …'³ Romanticism pervaded political imagery no less than it transformed topographical imagery. In the sphere of literature it changed from an affair of lonely poets to a widespread fashion affecting the reading matter of the circulating libraries and producing the mystery novel, best remembered through Peacock's parodies. In the visual sphere it found its reflection not only in the art of those masters we now call the Romantic painters but also in the cheaper thrills of Philipsthal's and Loutherbourg's stage effects and in the fantastic inventions of Gillray and his followers.

Mrs George draws attention to a number of satirical prints called *Phantasmagoria*.⁴ Many more deserve the same label. In fact the prints of the period exceed in extravagance and daring nearly everything that the official art of this time produced. In passing in review these grotesque inventions we are reminded of Haydon's description of Fuseli's studio with its 'Galvanized devils – malicious witches brewing their incantations – Satan bringing Chaos, and springing upwards like a pyramid of fire – Lady Macbeth … humour, pathos, terror, blood and murder, met one at every look !'⁵ (Fig. 442).

How are we to explain this ready response of graphic satire to the Romantic trend? Should we merely attribute it to the crudeness of popular taste which relished spectral visions and horrors? No doubt it was partly the conservatism of the Academy which – despite Fuseli's prestige – prevented the Romantic movement from finding full outlet in 'serious' art. Unlike the acknowledged artist, the graphic journalist could give the public what it liked without fear of infringing any real or imagined code of good taste. But perhaps there is yet another reason for the prevalence of the 'phantasmagoric' spirit in the great period of English caricature; a reason more intimately bound up with the

specific problems of pictorial satire: a glance at the history of these problems suggests that these specific methods of visual propaganda could only be absorbed by the language of art, when Romanticism had brought about a shift in the function of the image.

To express the complex meaning of his message the satirical artist must often resort to the methods of the rebus and of primitive ideographic script.[6] He must crowd on to his page a number of incongruous images which stand for the ideas or forces he wants to symbolize. In periods such as the Middle Ages, when artistic conventions were entirely based on the symbolic use of images, no special problems arose from this need. The configuration of images was understood and read as purely symbolic. With the victory of a realistic conception of art, however, a dilemma makes itself felt. To a public accustomed to see images as representations of a visual reality, the mere juxtaposition of disconnected symbols produces a disquieting paradox in need of resolution. Thus, while the medieval idiom and medieval motifs lived on in satirical broadsheets with astonishing tenacity,[7] we also witness continuous efforts to rationalize and justify this antiquated language and to reconcile it with realistic conventions. This problem was tackled in various ways. The simplest was also the most frequent: to give up all pretensions at artistic coherence and to rely on an elaborate text in verse or prose explaining the meaning of the political emblems or 'hieroglyphicks'. Here the very disjointedness of their imagery is used to attract attention and to force the public to resolve the paradox by reading the 'key'. Close to this form – which has returned in a different guise in our posters and advertisements – is the exploitation, for humorous effects, of the contrast between symbolic sense and visual absurdity. The literal illustration of figures of speech, a legitimate means of didactic imagery in the Middle Ages, shades off into comic art at the time of Bruegel. His proverb illustrations rely on the shock effect of a topsy-turvy world in which real people try to run with their heads through the wall or to kill two birds with one stone.[8] Hogarth chose the opposite way. Following Dutch seventeenth-century precedents, he was fond of hiding his symbolic meaning behind a plausible pseudo-realistic façade. His cuckold does not show symbolic horns: he happens to stand 'accidentally' in front of a bull whose horns seem to be protruding from his head. The symbolic image is given a rational justification,[9] and this is part of its wit.

In between these possibilities there lie a number of other methods of combining the emblematic use of imagery with a satisfying visual aspect. To the seventeenth century the apparatus of classical mythology and allegory provided the favourite instrument for the translation of complex statements into accepted pictorial forms. Here, where the borderline between symbol and

illustration is blurred, where Mars represents war and Envy may be chased from the Temple of Peace, realism and symbolism are less likely to clash. In Rubens's political paintings, and – on a lower plane – in some of Romeyn de Hooghe's complicated allegorical prints, the world of human beings and conceptual symbols appears to be reconciled.[10] But there is yet another form of rationalization of visual symbolism and this is of the greatest interest in our present context. It is in the transference to the field of visual art of the stock method of justification used by medieval poets. To justify the incongruities of symbolic narratives these poets were fond of representing their allegorical stories as real dreams or visions. A realistic introduction describes how the poet fell asleep and leads us to a different level of reality. This simple device allowed the narrator to introduce fantastic beings into a realistic setting without being accused of 'lying'. The application of this formula to visual imagery has a long and varied history. There are a number of sixteenth- and seventeenth-century prints whose fantastic agglomerations of incongruous images are explained as the literal transcriptions of portents, visions, and prophetic dreams.[11]

It was in this mode of justification that the political print may have met the Romantic movement half-way, as it were. There are certainly many social and political reasons which account for the mounting tide of graphic satire towards the end of the eighteenth century. There are also obvious stylistic elements, like Hogarth's heritage and the influence of Italian *caricatura* which had its share in the increasing popularity of the pictorial lampoon. But besides these reasons, the congenial climate of the Romantic era might well have been an important contributory factor in the transformation of the hieroglyphic print into the triumphant idiom of Gillray and Rowlandson. For now the weirdest combinations of symbols, the most grotesque conglomerations of images, were no longer merely tolerated as the pardonable licence of a low medium of illustration. They could be attuned to the taste of the time if they were presented as phantoms, nightmares, and apparitions.[12] It seems that the Romantic movement gave new sanction to the inevitable visual inconsistencies of political imagery much in the way in which Surrealism to-day has given licence to the gayest absurdities of our humorists on the screen, on the air, and in the comic weeklies.[13] The device of the *phantasmagoria* is one instance of such a rationalization. It not only enabled Gillray to find a unified theme for his collection of symbols, it allowed him to endow the warning image of Britannia as a skeleton with truly visionary intensity.

There was no need for the caricaturists to discard the older methods of allegory, humorous illustration and allusive realism. But the new spirit of the Romantic era made it possible for them to stray beyond the narrow limits of

JOHN BULL and his FAMILY taking leave of the INCOME TAX

A NAKED TRUTH or NIPPING FROST

traditional emblems and allegories into the open field of free imagination. The artist was now entitled to create his own images of spiritual forces and psychological states. Figures like Woodward's *Income Tax*[14] (Fig. 443) or Williams's *Jack Frost*[15] (Fig. 444) are not only the direct ancestors of those kindly or malevolent imps which now haunt our daily lives – Mr Therm, the Squanderbug, or the Traffic Jimp – they are the legitimate offspring of Fuseli's phantoms and the poor relations of Blake's noble visions. But while Blake held fast to the belief that his figures represented a higher reality,[16] the ghosts and spectres of the caricatures are presented with the same 'suspension of disbelief' which must have given its edge to Philipsthal's show. Without disbelief this Romantic thrill is impossible. The grotesque ghost is a child of Enlightenment.

In his stimulating 'picture book' on Hogarth and English caricature,[17] Mr F. D. Klingender has not only drawn attention to the influence of Fuseli's *Nightmare* on the caricaturist's stock images, he has also suggested a parallel between these fantastic scenes in English political prints and the art of their greatest contemporary, Goya. If our analysis is correct it allows us to specify the nature of this parallel. Like Gillray, but on a still higher plane, Goya sought social justification for his fantastic visions by pouring them into the pre-existing mould of satirical art. Under different social conditions he was also forced – unlike Gillray – to exploit the twilight region of the grotesque for camouflaging his political comments in the guise of mere *Caprichos* and dreams of a fevered brain. But the motto of his capriccios, 'The Sleep of Reason produces Monsters', sums up his own personal approach to the problem of the age. To him the suspension of disbelief, or the recurrence of belief, may not have been a free fancy to be relished for its thrills but the oppressive nightmare of the sleep of Reason.[18]

These examples illustrate one way in which the study of imagery may benefit the understanding of art. It can focus attention on latent tendencies

443
G. M. Woodward, *John Bull taking leave of Income Tax*, 1802. Etching

444
C. Williams, *A Naked Truth or Nipping Frost*, 1803. Etching

which were never allowed to unfold fully in the sphere of high art and sought expression in more pliable media; a period's imagery may, through its very crudity, throw light on the more subtle problems of its great artists. It so happens that Mrs George's present volume also contains an example of yet a different type of interaction between imagery and art, of the direct influence, that is, which works of indifferent quality may yet exercise on the creations of genius. Once more the material of the volume leads back to the giant of the period, to Goya.

Among the anti-Napoleonic prints of the year 1803, Mrs George lists various plates illustrating atrocities perpetrated by Buonaparte.[19] They bear the signature of R. K. Porter, a poor artist but an interesting figure. A pupil of Benjamin West, Porter seems to have been very active in various patriotic schemes.[20] In 1805 he displayed his powers in a huge panorama of the battle of Agincourt on more than 2,800 square feet of canvas.[21] This Romantic showpiece of a patriotic theme was displayed at the Lyceum, the same place where Philipsthal had conjured up his Phantasmagorias. Porter then went to Russia and published illustrated travel books on Russia and Persia. He also accompanied Sir John Moore on his unsuccessful expedition to Salamanca, which ended in the evacuation at Corunna. He finally married a Russian princess.[22]

What is interesting in the propaganda prints conceived in his facile melodramatic idiom (Figs. 445, 446, 447) is their date and their motif. They anticipate by some nine years Goya's terrifying scenes of Napoleonic massacres in and after the Spanish wars (Figs. 448, 449, 450). It is tempting to speculate whether the two could have met. There is a tradition that Goya went to Saragossa in the autumn of 1808 to paint scenes of the war which had broken out – during the very same months, that is, when Porter was attached to Sir John Moore for the identical purpose. But the tradition is unsubstantiated.[23] It is possible that Porter may have distributed his prints in Salamanca and that this is the way in which they reached Goya, but it is not necessary to make this assumption. We know that British propaganda prints were circulated (and copied) in Spain[24] and we need not strain our historical imagination to explain the connection between these violent designs and Goya's great compositions. It is not only the tenor and the character of the episodes with their mixture of horror and defiance which are similar, but also many individual features: the protruding eyes and violent distortions of the victim's face, the effective contrast between pointing guns and helplessly kneeling figures, the abbreviated forms through which the masses of similar victims are conveyed while attention remains focused on the principal scene – all these recur in many variations in the paintings and etchings of Goya's war scenes.

A detailed comparison between Porter's crude atrocity prints and Goya's heartrending protests against human cruelty only serves, of course, to enhance the magnitude of Goya's achievement. But it does more. It helps us to adjust our assessment of the historical role of these works. Recent descriptions of Goya's anti-Napoleonic compositions have stressed the documentary realism of this phase of his development. They have represented these creations as a revolutionary break with tradition, and as the true beginning of the nineteenth-century approach to art which sees in the painter the eye-witness who fashions his work out of his personal experience.[25] The existence of Porter's prints does not altogether disprove this interpretation but it shows up its dangers. The very idea of 'documentary realism' requires qualification. These are not scenes at which a Spaniard and a patriot could easily have been present and survived. But even if Goya should have been an eye-witness to one or the other of the terrible episodes he portrayed (and this cannot be proved), he might never have recorded his experience in visual shape had not the existing type of atrocity imagery, as exemplified in Porter's prints, provided the crystallizing point for his creative imagination. We realize today more and more how long and tortuous is the road from 'perception' to 'expression'. The original genius who paints 'what he sees' and creates new forms out of nothing is a Romantic myth. Even the greatest artist — and he more than others — needs an idiom to work in. Only tradition, such as he finds it, can provide him with the raw material of imagery which he needs to represent an event or a 'fragment of nature'.[26] He can refashion this imagery, adapt it to its task, assimilate it to his needs and change it beyond recognition, but he can no more represent what is in front of his eyes without a pre-existing stock of acquired images than he can paint it without the pre-existing set of colours which he must have on his palette.

445
R. K. Porter, *Buonaparte at Jaffa Ordering 580 of his Soldiers to be Poisoned*, 1803. Etching

446
R. K. Porter, *Buonaparte Massacring 3800 Men at Jaffa*, 1803. Etching

447
R. K. Porter, *Buonaparte Massacring 1500 Persons at Toulon*, 1803. Etching

448
Francisco Goya, *The Second of May 1808–The Revolt against the French*, 1814. Prado, Madrid

449
Francisco Goya, *The Third of May 1808–The Execution of the Insurgents*, 1814. Prado, Madrid

450
Francisco Goya, *One Can't Bear to Look at it*. Etching from *The Disasters of War* (1810–20)

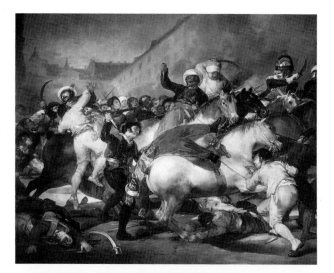

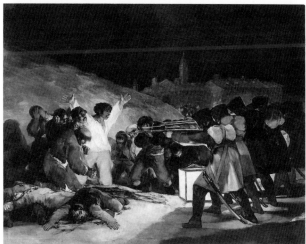

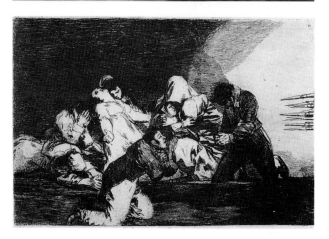

Seen in this light, the importance of imagery for the study of art becomes increasingly apparent. In tracing the motifs, methods, and symbols of these modest productions we not only study the pale reflections of creative art, but the nature of the language without which artistic creation would be impossible.

Editor's Postscript

Gombrich has always been fascinated by what could best be described as popular imagery, the kind of material one finds on advertising hoardings or, years ago, in broadsheets. It would only be confusing to describe this as minor artistic imagery; it is the visual 'prose' of the present and past. While the prose has its own history, and one may trace, for example, developments in popular satire in England in the eighteenth and nineteenth centuries, there are moments when its concerns intersect with the development of the great art of the past. There are even more interesting moments when developments in the dynamics of visual satire meet head on with larger stylistic shifts, in this case the emergence of the Romantic movement. In this case 'like Gillray, but on a still higher plane, Goya sought social justification for his fantastic visions by pouring them into the pre-existing mould of satirical art.'

In The Story of Art, *Gombrich deplored the separation between "applied" or "commercial" art, which surrounds us in daily life, and the "pure" art of exhibitions and galleries, which many of us find hard to understand' (p.596).*

Both cultural and art historians would do well to ponder on this essay as a model for thinking about developments in twentieth-century art. So far the debates have tended to hinge on Pop art and its relations to advertising and comics, but one of the most significant developments of the later twentieth century is the blurring of fine distinctions between High and Low art, and of the distinctions between the various areas of artistic practice themselves. Both painting and sculpture are no longer separated as they used to be, and performance art has disrupted traditional boundaries. Someone has yet to write an analysis of contemporary art using the conceptual framework offered here. Two interesting books that have recently addressed the issues are Kirk Varnedoe, A Fine Disregard: What Makes Modern Art Modern *(London, 1990) and Kirk Varnedoe and Adam Gopnick,* High & Low: Modern Art and Popular Culture *(New York, 1990).*

See also 'The Dream of Reason: Symbolism of the French Revolution', British Journal for Eighteenth-Century Studies, 2 *(1979), pp. 187-205.*

The Wit of Saul Steinberg

First published in the *Art Journal* (winter 1983); reprinted in *Topics of our Time* (1991), pp. 188–94

The ingenious dedication which Saul Steinberg kindly wrote and drew for me when he sent me his volume *The New World* (Fig. 451) prompts me to take it as a starting point for this brief discussion of the artist's wit. Look at the drawing more carefully and you will see that it does not 'work out'. What appears at first sight as a sequence of stacked oblongs, superimposed or stuck into one another, turns out to be so cunningly devised that it would be impossible to construct such a configuration in real space. It so happens that I owe this generous gift to the words which I devoted to the artist in my book *Art and Illusion*: 'There is perhaps no artist alive who knows more about the philosophy of representation.' The tribute, incorporated in an article by Harold Rosenberg, was quoted to my delight on the dust cover of Steinberg's next book; hence his present, which illustrates and confirms my words with that economy of means which is one of the hallmarks of Steinberg's art.

It has often been said that the real or dominant subject-matter of twentieth-century art is art itself. If that is the case, Steinberg's contribution to the subject must never be underrated. Without going over the ground again which I covered in my book, I may point out that the drawing which I chose here as my starting point offers a more illuminating comment on the essence of Cubism than many lengthy books.

Harold Rosenberg quoted Steinberg's remark: 'What I draw is drawing, [and] drawing derives from drawing. My line wants to remind constantly that it is made of ink.'[1] The reminder is made explicit on another page of *The New World* (Fig. 452), which shows the artist's pleasure in catching us in the traps of his visual contradictions. It would be otiose to point them out in detail. Indeed, one of the problems in writing about Steinberg's wit is precisely the fact that his drawings make their point so much better than words ever could.

451
Saul Steinberg, dedication
in the author's copy of *The
New World* (New York,
1965)

452
Saul Steinberg, drawing
from *The New World* (New
York, 1965)

However, what may be said about the artist's remark is that even though he
reminds us constantly, he never fully convinces us. Try as we may, what we see
is not just ink. The little man who cancels himself (Fig. 453) remains pathetic
and intriguing. The drawing proves, if proof were needed, that our reaction to
pictorial representation is quite independent of the degree of realism. It is a
function of our understanding and it takes an enormous effort to inhibit our
understanding and see only ink.

Our reactions to certain linguistic statements offer an instructive parallel. I
am thinking of the paradoxes of self-reference beloved of logicians, such as the
standard example of the Cretan who asserts that 'all Cretans are liars'. We feel
entrapped by the clash of incompatible meanings, for if he is right he must be
wrong.

What must be one of the earliest of Steinberg's humorous drawings to be
included in one of his volumes neatly illustrates the play between 'ink' and
meaning in a joke that still relies on a caption (Fig. 454). What starts as a
graph turns into a real force smashing through the floor. There is as yet no real
paradox here, no more than in the metaphors of language, which we do not
take literally, as when we say that prices 'rocket' or 'slump'. But in many of
Steinberg's later drawings we cannot assign a meaning to his lines without
running up against a contradiction, and contradictions are one of the many
humorous devices Steinberg uses to produce the shock of laughter, as when we
look at the mysterious table which is also the rim of a bathtub (Fig. 455) –
another visual joke worth many lengthy disquisitions about the reading of
images.

. . ."And how is business?"

This process of reading is examined in many of the drawings in which the artist explores the very limits of graphic signs. He shows us how the simplest geometrical configurations will suddenly resemble a human head and exhibit a definite individuality and expression, as is the case with the odious pair who appear as guests at a party (Fig. 456).

Needless to say, these explorations of what I have called 'the philosophy of representation' have also taken Steinberg much further afield. In some of his wittiest drawings we see him commenting on a time-honoured problem of criticism, that of the proper relation between form and content. The general

456
Saul Steinberg, drawing from *The New World* (New York, 1965)

457
Saul Steinberg, drawing from *The Passport* (New York, 1954)

heading under which this question has been discussed since classical antiquity is that of 'decorum', the fitting of the right word or style to the right subject-matter, memorably summed up (as far as poetry is concerned) in Alexander Pope's *Essay on Criticism*:

'Tis not enough no harshness gives offence,
The sound must seem an echo to the sense:
Soft is the strain when Zephyr gently blows,
And the smooth stream in smoother numbers flows:
But when loud surges lash the sounding shore,
The hoarse, rough verse should like the torrent roar.
When Ajax strives some rock's vast weight to throw
The line, too, labours, and the words move slow.

As I have indicated in the last chapter of *Art and Illusion*, attempts have not been wanting in the past to apply this doctrine to the visual arts, but we had to wait for a Steinberg to apply it with utmost simplicity. In many of his drawings it is again the line or the graphic medium which seems 'an echo to the sense'. His 'Family' (Fig. 457) shows us the father firmly modelled, the mother with undulating lines, the grandmother all but fading away between hesitant pen strokes, and, of course, the child drawn in the style of children's scribbles.

From here it is but one step to the representation of what are called our synaesthetic reactions, the depiction of one sense modality by another.[2] The sounds of 'Giuseppe Verdi' floating through the window (Fig. 458) do not leave us in doubt that it is early Verdi. As this example shows, there is no distinction in Steinberg's manipulation of 'ink' between representation and writing. He can incorporate all the means of visual communication in his images. To quote his words once more: 'I appeal to the complicity of my

458
Saul Steinberg, drawing
from *The New World* (New
York, 1965)

reader who will transform the line into meaning by using our common
background of culture, history, poetry. Contemporaneity in this sense is a
complicity.'[3]

The conventional device of a 'balloon' surrounding words or thoughts is
used to delightful purpose in the image of the rocking-chair dreaming of
being a rocking-horse (Fig. 460). The question mark, as so often in real life,
takes off and pursues us, the conventional lines indicating its bounces (Fig.
459). But Steinberg has also used script and words more insistently, indeed
more philosophically, in such compositions as Figure 462, where he contrasts
the firm foundation of the words I AM with the ramshackle instability of I
HAVE and the radiant triumph of I DO.

Everybody will have his own favourites among Steinberg's ingenious
visualizations, such as his mapping of time where we are shown the frontier of
March and April, which is just being crossed by his favourite cat, or his
parodistic manipulations of patriotic symbolism in his grand tableaux of
political rhetoric.[4] Nor should we forget that he is not merely a master of line
but can use all the means of *trompe-l'oeil* in his spoof picture postcards or his
meticulous working drawings.[5]

At the end of Plato's *Symposium*, when the rest of the company had either

459
Saul Steinberg, drawing
from *The New World* (New
York, 1965)

460
Saul Steinberg, drawing
from *The New World* (New
York, 1965)

461
Saul Steinberg, drawing
from *The Inspector* (New
York, 1973)

fallen asleep or gone home, we hear that Socrates was still arguing with
Agathon and Aristophanes. Socrates was driving them to the admission that
the same man could have the knowledge required for writing comedy and
tragedy, at which Aristophanes and then Agathon began to nod, while
Socrates walked off, apparently happy in the knowledge that he had won the
argument. But has he? The idea persists that the comedian or caricaturist is a
mere entertainer, hardly worthy of the attention of the superior persons who
study and analyse the creations of serious 'artists'.

Unless I am much mistaken, Steinberg's work is not referred to in the
standard books on twentieth-century art, nor does he seem to figure in the
survey courses explaining and tabulating the various 'isms' said to make up the
modern movement. Whether he resents this comparative lack of attention
accorded him in the curriculum of art historians I do not know. But it seems
to me that one of his drawings (Fig. 462) offers the best comment on this
situation: a solemn procession of stereotyped greybeards is marching past a

462
Saul Steinberg, drawing
from *The Inspector* (New
York, 1973)

dull official building aptly inscribed as 'The National Academy of the Avant-Garde'. Maybe they will all be forgotten when Steinberg is still remembered with pleasure and gratitude.

Editor's Postscript

Saul Steinberg's imagery has been a constant source of interest for Gombrich; in Art and Illusion *he declared 'There is perhaps no artist alive who knows more about the philosophy of representation.' Steinberg's repertoire has many facets. In 'Image and Word in Twentieth-Century art' Gombrich refers to 'an artist of our time who has found new ways of turning the word itself into an image of its meaning. I am speaking of course of Saul Steinberg'* (Topics of our Time, *p. 187). In* Art and Illusion, *amongst other things, his work is used to demonstrate how the meaning of a drawn line may change from context to context with some very interesting conclusions: 'After the many weighty tomes that have been written on how space is represented in art, Steinberg's trick drawings serve as a welcome reminder that it is never space which is represented but familiar things in situations. This formulation, though, requires an amendment which is also provided by Steinberg. Among the familiar things we can read into pictures, none may be more important than other pictures'* (p. 202).

It is arguable that Steinberg that is one of the few real experimental artists of the twentieth century. It would not be inappropriate to read this chapter in the context of the chapter 'Experimental Art' of The Story of Art. *See also Gombrich's other remarks on Steinberg in* Art and Illusion, *'Conditions of Illusion'.*

A related essay is 'A Master of Poster Design: Abram Games' in Topics of our Time.

Part XI Gombrich from within Tradition

Franz Schubert and the Vienna of his Time

This essay is based on a lecture delivered in Florence before the Musicus Concentus on the occasion of the sesquicentennial of the death of Franz Schubert, 1978; published in the *Yale Literary Magazine*, 149, no. 4 (February 1982), pp. 15–36

The story goes that after Beethoven's funeral in Vienna on 29 March 1827, three young composers who had followed the enormous cortege sat down in an inn to drink a glass of wine in his memory, after which one of the group raised his glass again 'to the one among us who will follow Beethoven first'. The one was to be Franz Schubert, who was to die less than twenty months later, before having completed his thirty-second year. Of the other two, both successful composers in later life, Franz Lachner, then twenty-three, died in 1890, and Benedikt Randhartinger, then twenty-five, in 1893. Thus while we were celebrating the 150th anniversary of Schubert's death, there must have been a good many people around whose lives overlapped with those of his companions.

For the historian these are not idle reflections. They bring it home to us that what we call the age of Schubert remained a living memory right to the threshold of this century. I myself remember someone telling me in my native Vienna that he knew Schubert's intimate friend Franz Schober, who died in 1882.

Paradoxically, it might be argued that we would know less of Schubert's earthly existence if he had not died so young. As a young batchelor who much enjoyed the company of friends he was immensely popular among his contemporaries, the majority, unlike him, members of the professional classes. Naturally they could not forget him, all the less as his genius was increasingly recognized in the musical world, and so many of them recalled incidents of his life and aspects of his personality in their reminiscences. They

463
Moritz von Schwind, *A Schubert Evening at Josef von Spaun's*, 1868. Historisches Museum der Stadt Wien, Vienna

464
Moritz von Schwind, *A Schubert Evening*, c.1868. Wiener Schubertbund, Vienna

might not have done so if he had still been alive. Whoever writes about Schubert has to draw on these memories, and this essay will be no exception.[1] But there is one type of memoir which is unique to Schubert and which is of special interest to a historian of art. It is the famous evocation of a *Schubertiade*, a musical party in honour of Schubert, given in the house of his friend Freiherr von Spaun, probably on 15 December 1827 (Fig. 463). It is the work of the Viennese painter Moritz von Schwind (1804–71), who was one of Schubert's most intimate friends during the last seven years of the composer's life, but it was not painted till 1868, some forty years after the event it depicts.[2] In a way this fact adds to its interest, for it may be the only instance of an artist painting his memoirs, rather than writing them. This was indeed part of Schwind's purpose though his full intention was never carried out. The drawing was meant as a *modello* for a mural which the artist lacked the time and opportunity to complete. An oil sketch (Fig. 464) gives us at least some idea of the way colour would have enriched the splendid scene Schwind remembered – not that he wished to produce a purely documentary record. The large company grouped around Schubert and the singer Vogl, most of whom are based on identifiable portraits, indicates that the artist rather thought of a glorification of the composer. Historians have pointed out that some members of the group, such as the playwright Franz Grillparzer or the painter Leopold Kupelwieser, are unlikely to have been present, even if they could all have squeezed into the music room, which one may doubt.

From the point of view of the historian of art, therefore, the painting may be said to draw on two distinct traditions: the first is the assembly of famous men, as exemplified in the mind of posterity by Raphael's *School of Athens* (Fig. 405) where a group of ancient thinkers crowds around the figures of Plato and Aristotle. The other tradition is that of realistic genre painting, particularly the depiction of social gatherings, such as Augustin de St Aubin's lovely print of a concert in a palace, dating from 1773.

465
Leopold Kupelwieser,
*Excursion of the Schubertians
from Atzenbrugg to Aumühl*,
1820. Historisches
Museum der Stadt Wien,
Vienna

466
Leopold Kupelwieser,
*Parlour Games among the
Schubertians at Atzenbrugg*,
1821. Historisches
Museum der Stadt Wien,
Vienna

Looking at Schwind's own life and *œuvre* we can even get a little closer to the genesis of this painted memoir. Portrayals of social gatherings were quite the fashion in Schubert's circle, and some of these lighthearted scenes have often been reproduced in books on Schubert: one represents an outing into the Wienerwald by Leopold Kupelwieser entitled *Excursion of the Schubertians* (Fig. 465), another a *Parlour Game at Atzenbrugg* (Fig. 466). The estate was used as a holiday home, where we see Schubert at the piano while friends perform a dumbshow punningly signifying the word '*Rheinfall*'. Schwind himself had also drawn genre scenes like *Picnic on the Leopoldsberg* in 1825 (which does not include Schubert), and even had his share in a rather poor effort representing another scene at Atzenbrugg, a ball game, with Schubert sitting on the ground with a long pipe. It had been drawn by Schubert's friend Schober, and Schwind pencilled in the landscape setting. We cannot tell whether at the time the artist also planned to make a more serious record of the group; in any case, we know of Schwind's habit of persistently cultivating themes he had first conceived in his youth.

In 1835, seven years after the composer's death, we find Schwind writing from Rome that he would love to decorate a room with murals devoted to Schubert. He never let go of that dream, yet it never came to pass. But in 1848 he conceived a monumental painting, much closer to the *School of Athens* tradition, a symbolic set of panels entitled *Symphony*, now in the Munich Neue Pinakothek (Fig. 467). It celebrates the love and marriage of a singer whose life was interwoven with music, and though the music is understood to be Beethoven's Choral Fantasy, with the choir in the background, the kinship of the lower panel with the later celebration of Schubert is quite apparent. Here Schubert is in the audience, next to the singer Vogl and his friend Schober. The conductor is Franz Lachner (whom we have already encountered), a prominent musician who remained Schwind's intimate friend when both moved to Munich.

467
Moritz von Schwind, *The Symphony* (detail), 1852. Neue Pinakothek, Munich

It was the wish to pay a gracious tribute to Lachner on his retirement in 1862 which revived these plans and ideas in Schwind's mind. He drew a kind of biographical cycle for Lachner on a scroll intended to go around the room, the so-called *Lachnerrolle*, in which the genre element is happily mixed with the symbolic (Fig. 468). Certainly Lachner had marvellous opportunities when he studied music in Vienna in the 1820s; Schwind shows him playing piano duets with Beethoven, serenading with Schubert, and later sitting in an inn, probably in Grinzing, with Schubert and Vogl, the peaks of Kalenberg and Leopoldsberg in the background.

It must have given Schwind pleasure to recall the days of his youth and to conjure up in his mind the likenesses of his friends. We find him trying out in his sketchbooks the portraits, from memory, of Schubert and Vogl (Fig. 469), and groping his way from there towards the final composition which certainly looked authentic to him.

Not that the artist had to rely entirely on his recollection for the features of Franz Schubert, which had repeatedly been recorded in his lifetime, the most popular of these portraits being a watercolour by Rieder (Fig. 470), dating from 1825 when the composer was twenty-eight. Quite apart from its documentary value, the portrait must enlist the interest of the art historian for the manner of its circulation. It was published twice in Schubert's lifetime (both as an engraving and as a lithograph), which indicates that the artist expected to find a ready market for such a representative portrait of the young composer. Schubert's music was at that time becoming well-known even outside the confines of Austria; he received letters from publishers in Germany asking for compositions, and though articles in the press at times criticized his music as too difficult, there were others which hailed the rising genius. It is quite likely that if he had lived but a few years longer he would

have become an international celebrity. Whether he would have enjoyed such a role is another matter.

In any case we must beware of exaggerations in speaking of Schubert's earthly existence. Not that we can ever say too much about his genius, which surprises us again and again by its inventiveness and power. Nor could one exaggerate the miracle and mystery of his creativity, the sheer volume of compositions he left us, more than 600 *Lieder*, not to speak of his part-songs, masses, operas, symphonies, chamber music and piano compositions, which make one wonder how he could ever have found time to relax in congenial company, as he certainly did. But we must not over-dramatize the circumstances of his heartbreakingly short life. He was poor, but not destitute. Even when occasionally his money ran out, his friends saw to it that he did not starve. From the start, he enjoyed the acclaim of a circle of friends most of whom belonged to the intellectual élite of Vienna. His popularity among the rising generation of well-established middle-class families was immense. He was their idol and, in a way, their pet. We have seen how the parties which centred around his music became famous as *Schubertiaden* and inseparable from his memory.

Nobody can doubt the contribution Schubert made to the cultural life of Vienna. What may be more elusive, but of equal relevance to the historian, is the influence which the culture of Vienna may have made on Schubert's life, and it is to this question that this essay is largely devoted.

At the beginning of the nineteenth century Vienna was one of the largest and most prosperous centres of Europe. It had about 320,000 inhabitants, of whom some 55,000 lived within the inner city, and 265,000, including Schubert's parents, in the suburbs.[3] This division between the two parts of the city was very marked, for Vienna still retained the fortifications which allowed it to survive two seiges by the Turks in 1529 and 1683. Within the girdle of these walls there were narrow streets crowded around the Cathedral of St

470
Wilhelm August Rieder,
Portrait of Franz Schubert,
1825. Historisches
Museum der Stadt Wien,
Vienna

Stephen and elegant thoroughfares, like the Graben, which impressed visitors by their splendour and bustle. Here also stood the many palaces of the nobility, most of whom owned large estates in Bohemia or Hungary but needed a sumptuous residence for the periods when they attended at court, such as the Palais Lobkowitz, of the family which befriended Beethoven. Beethoven was a frequent guest in these palaces, but not so Schubert.

Around the girdle of fortifications was the so-called Glacis, the free zone which had become a favourite place for walks, and outside lay the suburbs. There the nobility had their summer palaces such as the Belvedere, and other settlements ranged from solid middle-class buildings to the villages of winegrowers on the last slopes of the Alps – though there the habit of dispensing the new wine, the *Heurigen*, was not yet established in Schubert's time.

It was a comfortable city with a proverbially pleasure-loving population, likened by Goethe and Schiller to Homer's *Phaeaci*; yet the nostalgia for 'old Vienna' must not blind us to the underlying tensions in that turbulent period of history, the aftermath of the Napoleonic wars in which Austria and Vienna were so deeply involved, and which also affected Beethoven's life and outlook. It was at the Vienna Congress of 1815 that the European powers attempted to set back the clock, pretending that nothing had happened to the feudal system. The *spiritus rector* of this age of reaction was Prince Metternich, the chancellor of the Hapsburg Emperor Francis I. Averse to pomp and extravagance, the Emperor saw himself as a paternalistic ruler, but the paternalism which made him popular in Vienna did not prevent him from sending his recalcitrant Italian subjects to the dreaded fortress of the

Spielberg. As far as Vienna is concerned, there is a strange paradox about that period of absolute government which must concern every student of Schubert's life. The period has acquired the name of *Biedermeier*, derived from a satirical figure – Meier being a typical middle-class name, and *bieder* meaning respectable, law-abiding, and also perhaps somewhat naïve – a kind of Mr Pickwick, or the hero of the *Diary of a Nobody*. That atmosphere of prosperity, which we also sense in Schwind's evocation, is certainly not the product of nostalgia alone. In Vienna the period is also known as the *Backhendelzeit*, the age of fried chicken, a treat which was by then within reach of modest citizens. It is obvious from the letters of Schubert and his friends that the standard of living was indeed quite high. Even the poorer members of the circle, even Schubert himself, do not seem to have found it hard to afford an evening at an inn, or to throw a party.

But that sense of well-being must not blind us to the other aspect of the period, its lack of intellectual freedom. Mr Biedermeier may have enjoyed his fried chicken, but if he had a son who went to university, as the painter Schwind had done, he would have a different story to tell. Two of Schwind's most beloved teachers, one the Professor of Religion, the other of Philosophy, were removed from their chairs because of their free-thinking tendencies, one of them having even dared to teach the philosophy of Kant. Perhaps the little man was not much touched by such censorship, nor, we may guess, was the aristocracy much affected, but for the intellectual middle classes the atmosphere must have been suffocating. It suffices to read the life of Austria's greatest playwright, Franz Grillparzer, to sense this bitterness and exasperation.

Other ages had witnessed tyrannical governments, but peculiar to the age of Metternich was the disappointment, and the disillusion, that pervaded its life. This disappointment sprang from the failure of the French Revolution to live up to the hopes this cataclysmic event had aroused all over Europe. The first revulsion came with the news of the terror, the second with the rise of Napoleon who brought war rather than peace, the third with the discovery that his defeat resulted merely in the re-establishment of a discredited political system. What must have been particularly galling to the Austrian intelligentsia was the fact that they had been in the vanguard of the Age of Reason. Emperor Joseph II, who ruled from 1780 to 1790, had championed the ideals of the Enlightenment even before they had triumphed in France. In 1783 he had ruthlessly abolished more than 600 monasteries and convents, and his efforts to secularize society and establish an anti-clerical German speaking professional civil service created the tradition of *Josephinismus* in the Austrian administration which even Metternich could not quite break.

It would be tempting to say that where other creative outlets were blocked, the Austrians found one in music which, after all, was not subject to censorship. It was a thought which also occurred to Schubert's contemporaries such as Grillparzer, who, in a poem to the pianist Moscheles, praised music as the only one of the arts which was free and immune from the molestation of tyrants. But before committing ourselves to this plausible explanation we do well to remember that worse tyrannies than those suffered by the Austrians have not, alas, resulted in a similar blossoming of musical culture. To allow an escape into the free realm of music, that realm must already be in existence, and it is here that the presence of a local tradition must strike the cultural historian as decisive.

In 1772, more that fifty years before the musical evening in the house of Joseph von Spaun which Schwind would later immortalize, Charles Burney visited Vienna in search of material for his history of music, and the one hundred and fifty pages he devoted to the Austrian capital in his *Musical Journey* offer a vivid picture of the intense musical life at the time when the chamber music of Haydn or Vanhall was played in the homes he visited.[4] 'Vienna', wrote Burney, 'is so rich in composers and incloses within its walls such a number of musicians of superior merit, that it is but just to allow it to be, among German cities, the Imperial seat of music, as well as of power'. That, of course, was written before Mozart had come on to the scene.

Nor was Burney unaware of the share which the musical culture of the Austrian country folk had in this general efflorescence. As he travelled from Bavaria on the Danube he remarked that all the way to Vienna 'the common people in the public houses and the labourers at their work divert themselves with singing in two or sometimes more parts ... It is not easy to account for this facility of singing in different parts in the people of one country more than in those of another: whether it arises in Roman Catholic countries, from the frequency of hearing music sung in parts in their churches I cannot say.'

Perhaps Burney was too cautious in expressing his conclusion. For what is remarkable in the musical history of Austria is precisely the love and tenacity with which the common people defended the practice of liturgical music in their lands. Attempts were not lacking in the wake of the Enlightenment to curtail this practice as a useless expense, but if the tradition had not asserted itself we would not have the masses of Haydn, of Mozart, of Beethoven and Schubert.

Where these attempts to economize met with more ready response was in court circles. Burney was struck during his visit by the contrast between the lavish operas staged in Vienna during the early eighteenth century and the absence of such splendour in his time. But knowing of the state of the public

purse he feels compelled to approve of this restraint, 'for though I love music very well, yet I love humanity better'.

It was this Imperial parsimony which was to make it so hard for Mozart, and also for Schubert, to gain positions at court which would have relieved them of financial cares. At a time when performance rights and royalties were as yet unknown, bursts of popular acclaim were no substitute for such a regular source of income. Schubert said in a moment of dejection: 'I should be maintained by the public purse.' Of course he was right, but there was no institutional framework to match the general enthusiasm for music among the population. Of this enthusiasm we have any number of testimonies from Schubert's own time.

A guidebook to Vienna of 1827, after reviewing theatres, circuses, and dance halls, says: 'Vienna is the Athens of music. There is surely no city in Europe housing such a large number of virtuosos on all instruments and so many solid connoisseurs of music. The majority of them are amateurs, and hence one must have entry to private families to attend concerts which happen in the winter every week, indeed almost every day. But major musical productions are also performed publicly, and no virtuoso goes on tour without presenting himself here.' In 1819 Goethe's friend Zelter wrote from Vienna that he found the Viennese public profoundly versed musically. 'It is true that they put up with everything, but only the best remains.'[6] Another observer, Charles Sealsfield, describes in 1828 (the last year of Schubert's life) how on Sunday morning the Viennese go to church, while the whole afternoon and evening are devoted to music.

> Wherever you go in the streets, you always hear music. In every middle-class home the piano is the first thing you see. The visitor has hardly sat down and been refreshed by watered wine and confections than Fräulein Karoline or whatever her name may be is asked by her parents to play something for the visitor. Music is the pride of the Viennese and more or less the most important element in their education. The children start usually to learn music in their fourth or fifth year and by the time they are six they are already fairly competent. A new opera by Rossini in the Kärntnertor Theatre causes at least as much if not more sensation among these nice people as does the opening of Parliament in London.[7]

These quotations, which could easily be multiplied, may help to reinforce the theoretical point to which allusion has been made; they illustrate the meaning and relevance of a strong living tradition for the rise of any art. It is precisely because of the word 'tradition' has somewhat fallen out of favour that this fact

needs to be emphasized. Those who decry tradition wholly misunderstand its social and psychological function. Briefly, without such a tradition there can be no discrimination, no standards. In Titian's Venice they knew about painting, in Cremona about violin making, in Spain about bullfighting and other things besides. Whether we study the history of crafts or pastimes, of art or of science, we find that there is in the renowned centres a constant give-and-take between producer and consumer, what engineers might call a 'feedback loop', which leads to a steady escalation of demands and achievements. Real creativity may always be rare, but what makes all the difference is how the creative mind is nourished by the environment.

The whole life of Schubert, sad as it is from so many points of view, illustrates the practical effect of such discrimination by a large number of people, not necessarily professionals, but simply lovers of art who have standards.

Without such discrimination, to start at the beginning, Schubert's stern father would not have been struck by the exceptional talent and fine voice of little Franz and would not have entered him in competition for the vacancy existing in the boys' choir of the so-called 'Konvikt', which supplied the choristers for the services in the Imperial chapel. The Konvikt was a boarding school, run by a religious order, where boys received instruction in Latin and other advanced subjects, but particularly in music. It was the famous Italian composer Salieri – recently so much maligned – who supervised the selection of candidates and thus became Schubert's first teacher and mentor. The boy was expected to join the school orchestra and what we hear of its routine again underlines the formative role of tradition. Apparently there were performances almost every evening and so the young players gradually became familiar with the whole symphonic repertoire, including the works of Haydn and Mozart. But even more important for Schubert's future life were the classmates he encountered; music became the social bond which united him with his friends. It was in the Konvikt that he met Joseph von Spaun, who remained his lifelong friend and benefactor and certainly deserved the memorial Schwind was to provide for him in the painting of his Schubertiade.

Spaun was to tell in his memoirs that he was playing the first fiddle in the school orchestra when his discriminating ear noticed an exceptionally good player behind him, who turned out to be young Schubert. Spaun left the school early and Schubert never enjoyed it, but the network of friendships he had formed held throughout his life and grew from this nucleus to encompass much of Vienna's intellectual middle class. Spaun had embarked on the study of law, and it was he who, at his home in Linz, showed some of Schubert's songs to a fellow student called Franz von Schober. The discriminating young

man immediately took fire and decided to seek out the nineteen-year-old composer. He found him eking out a meagre existence as a teaching apprentice to his father and at once invited him to share his room. A bit of a dandy and jack-of-all-trades, well-to-do and intellectually ambitious, the gregarious Schober became the centre of the circle of friends which began forming around Schubert.

It was Spaun and Schober who jointly contrived the most important contact in Schubert's career. They realized that what the composer needed was an interpreter of sufficient public standing to make his Lieder universally known. They thought of the singer and actor Johann Michael Vogl who, after a brilliant career in which he had sung Pizzarro in Beethoven's revised *Fidelio*, was about to retire from the stage and devote himself to recitals. It was not an easy matter to persuade the elderly star to receive the young composer: 'Go away', he told the friends in effect, 'I always hear of such geniuses, but I have invariably been disappointed.' He was not disappointed with Schubert. In fact, he told the twenty-year-old that the only thing he lacked was a dash of charlatanry; he was not pushing himself enough. It is much to the credit of Vogl that he did the pushing, not only performing Schubert's new *Lieder* in many of his recitals, but also persuading friends that Schubert could not be judged by ordinary standards. When they were annoyed at Schubert for not turning up at a *Schubertiade* they had arranged with much anticipation, Vogl said, 'Before his genius we all have to bow down, and if he does not come we must crawl after him on our knees.' They must have been a strangely matched pair, the two, as we see them on a caricature attributed to Schober, Vogl titanic and rather theatrical, Schubert small and corpulent and rather shrinking in his appearance.

But what is again characteristic of the milieu in which Schubert lived is not so much the response of a professional such as Vogl, but the way discriminating amateurs immediately noticed the presence of a musical genius. We can participate in such a moment through the recollections of one of the daughters of a Viennese merchant named Fröhlich. A friend brought them songs written by a young man who was 'said to be good'. Her sister, who was, by the way, Grillparzer's great love, sat down at the piano and tried to play the accompaniment, when a civil servant who was an amateur singer suddenly pricked up his ears and said: 'What are you playing here? That is something quite extraordinary,' after which they performed Schubert songs for several evenings on end. Of course they invited Schubert and asked him why he had not published these songs; when he replied that no publisher was ready to print them, the friends banded together and had them printed at their own expense.

Vogl and Spaun also saw to it that Schubert never lacked the necessities. The memoirs and letters of the period tell of many joint excursions, of jolly evenings and junketings, when Schubert played and much wine was consumed till late in the evening.

But these accounts must give a very one-sided picture of Schubert's existence. A mere glance at the list of his compositions, that incredible list, must convince us that nearly all his days – from rather early in the morning – must have been spent simply writing music with very few interruptions. And if he relaxed after this sustained concentration, he still did not want to lower his standards. Reading his letters we find that he strongly disapproved whenever the tone of their circle was threatened by an influx of uncongenial members. In 1823 he complained in a letter to Schober, who was absent, that their reading circle had become undistinguished. 'What can we do with a group of quite ordinary students or officials ... they talk perpetually about riding and fencing, horses and dogs. If they go on like that I won't stand it for much longer.' He did stay away, and reported that the circle had broken up thanks to the vulgar crowd of 'sausage eaters and beer drinkers'. Luckily, Schober returned, and a new group of friends injected a fresh intellectual standard; the painter Moritz von Schwind (whom we have already encountered) and his classmate Eduard von Bauernfeld, a poet and writer, were worthy companions for the evening. It is said that whenever a new member was introduced into the circle, Schubert's first question would be 'Kann er was'? – roughly, 'What is he good at?' For Schubert was anything but a Philistine. One of Spaun's friends had offered Schubert hospitality in Linz and was totally astounded and captivated by his conversation:

> We sat together till close to midnight, and never have I seen or heard him like that – serious, profound, as if inspired. – As he talked of art, of poetry, of his youth, of his friends and other outstanding men, of the relation between the ideal and life ... I was increasingly astounded by this man who is said to create his art unreflectingly, without wholly realizing and understanding it himself and so on. And what simplicity! I cannot speak enough of the range and coherence of his convictions – I gained glimpses into a philosophy of life which he had not only absorbed from others ...

Even if we lacked these and other precious glimpses of the real Schubert, there is not only his music which tells us about it, but also that vast testimony of his corpus of *Lieder*. His choice of more than 600 poems which he decided to set to music presupposes a man who was deeply interested in poetry and always on the lookout for fresh publications. No doubt friends drew his attention to

this or that, or offered him their own verses to be set to music, but the range of his texts still amounts to an astounding cross-section of German lyrical poetry from Mathias Claudius to Goethe, Schiller, Uhland, Rückert and Heine.

There is a vulgar misunderstanding of such compositions which thoughtlessly and irrationally confuses the composer with the writer of the lyrics, which in their turn are taken to describe real events. Thanks to this kind of mental short circuit, Schubert has been represented in popular legends as the suffering hero of the *Müllerlieder* or the *Winterreise*. There is even a mill in the surroundings of Vienna which claims to have housed the original miller's daughter to whom Schubert addressed *Die schöne Müllerin*. Of course Wilhelm Müller, who wrote the cycle in Germany, never saw that mill. What these texts can tell us lies on a different plane.

Dietrich Fischer-Dieskau, one of the greatest interpreters of Schubert's lieder, has pointed out in a fine book devoted to their texts (*Auf den Spuren der Schubert Lieder*) how frequently the words Schubert selected centre on death, death not as a destroyer but as a release – as in the poem by Claudius, 'Death and the Maiden'. The world in many of his songs is a vale of tears. At the age of nineteen he set to music the poem by Schmidt von Lübeck, 'Der Wanderer': the wanderer roams through the wild mountains always in search of a happiness he never finds – 'Where art thou, beloved land?' – only to hear the ghostly voice of the echo replying 'Happiness is where thou art not.'

Some of this melancholy must certainly be attributed to the fashion of the time, when *Weltschmerz* was the vogue in the poems of Byron and in the deep pessimism of Leopardi, both contemporaries of Schubert. Elsewhere, too, this melancholic outlook sprang from disappointment with the false dawn of the French Revolution, but there is more specific evidence for linking the mood of Schubert and his friends with the suffocating atmosphere of the Metternich system and Sedlnitzky's police state.

Such evidence is provided by the life and tragic fate of another of Schubert's closest friends, Johann Mayrhofer, with whom he sometimes shared lodgings. Mayrhofer's gloomy and halting poems would hardly be remembered if Schubert had not set nearly fifty of them to music. He was indeed a tragic figure. Having studied law together with Spaun and Schober, he found employment as a civil servant in the censorship office. He was reputed to have been a meticulous and strict censor, but in a poem he addressed to Schubert he actually dared to insert the lines: 'Silently and honestly, as brothers, let us built a better and freer world.' Thus there is no reason to doubt the episode, recounted by Bauernfeld in a poem, of the friends having drunk together and of Schubert's music having loosened Mayrhofer's tongue so that he poured

forth his scorn of Austria's rulers and his longing for change. When Mayrhofer heard of the failure of the revolution of 1830 he attempted suicide, and when the fear of the cholera epidemic gripped Vienna he finally killed himself by jumping out of a window.

Perhaps the difference between Mayrhofer and Schubert was that Schubert always had the consolation of music within him. That consolation is celebrated in the words of one of his most popular *Lieder*, 'An die Musik', written by Schober in 1817 when the poet and composer were both twenty.

Thou fairest art, how often, in a gray hour
When life's entanglements held me oppressed,
You caused within my heart warm love to flower
And carried me towards a world more blessed.

Oft when a sigh rose from your harp sublime,
A sacred harmony to sweet and true
Unlocked the heavens of a better time.
Thou fairest art, for this I am thanking you …

That he constantly harboured this feeling is shown by a moving entry in his diary of 13 June 1816 where he writes of the impression a performance of Mozart's music had made upon him:

These beautiful and lasting impressions remain in our soul and the passage of time or altered circumstances cannot efface them … they show us in the darkness of this life a bright radiant fair prospect for which we hope with confidence. O Mozart, how many, how infinitely many such beneficent impressions of a brighter, better life you have engraved in our souls.

Eight years later he gave vent to the same sentiments in a letter to his brother: 'I try as far as possible to embellish the miserable reality with the help of my imagination for which I thank God … happiness is only within us.' After which he writes of two new compositions for piano duet. Music was always his solace.

Schubert left us in no doubt about the general reason for his depression. In one of the few poems we have from his hand (which he sent to Schober in the same year), he expressed his sentiments in somewhat halting lines. They may here be rendered in a prose translation so as to convey as accurately as possible the reasons he gives for his estrangement from a materialistic age:

O youth of our time, thou art spent,
The strength of countless people has been squandered.
Not one among them stands out from the crowd
And they all pass by without significance.

Too great is the pain that consumes me
And is the last that remains to me of that strength,
For I, too, am inactive, worn down by this age
Which prevents anyone from achieving great things.

The people drag themselves along in sick old age,
The deeds of its youth are called dreams,
And the golden rhymes are stupidly mocked,
Disregarding their forceful content.

Thou alone, O sacred art, are still granted the boon
To describe in images the age of strength and of action,
And so at least to mitigate that great pain
Which will never be reconciled to fate.

We must not fall into the trap of attributing Schubert's unhappiness solely to the political situation in which he found himself.[8] There were any number of reasons for a young man of Schubert's sensitivity to find reality 'miserable'. But if 'Biedermeier' is translated as 'Mr Law-Abiding', Schubert was certainly not Biedermeier. His name turns up in the police files for March 1820, when he was nearly arrested by Sedlnitzky's police together with his friend and former classmate Johann Senn.

It appears that a group of friends suspected – and obviously rightly suspected – a man who joined their circle at an inn of being a police spy and threw him out, whereupon the police raided Senn's rooms to examine and confiscate his books and papers, suspecting him of belonging to a forbidden student association. According to the report, Senn then shouted that he did not care a hang about the police and anyhow the government was too stupid to penetrate his secrets. Allegedly the 'school assistant Schubert' and three other named young men had also used insulting language against the police. Poor Senn was sent to prison and subsequently banished to his native Tyrol where he pined for Vienna, but the others were allowed to go free.

One wonders if there was not something in Senn's incautious remark that the government was too stupid to penetrate the secret of him and his friends. Not that they were likely to have been conspiring against the State, but was

their association entirely innocent? All clubs and associations were suspect in Metternich's Austria, but those most feared by the authorities were associations of students. They had all been banned in the so-called Carlsbad Resolutions of 1819 after a nationalistic student had assassinated the poet Kotzebue, and students were considered the most dangerous carriers of anti-authoritarian ideas. Now, there were many such students and ex-students in Schubert's immediate circle who might have wanted to meet regularly. Might it not have been convenient for them to have in Schubert a popular musician who had never been to a university and would not strike the police as a potential subversive?

These questions are prompted by the captions to the two watercolours by Kupelwieser previously mentioned (Figs. 465, 466), in which the company of young men assembled at Atzenbrugg are described as 'Die Schubertiane', 'The Schubertians'. One dates from the summer of 1820, immediately after the incident with the police, the other a year later; both pre-date the term 'Schubertiaden' which does not turn up in contemporary letters before October 1821. While this latter usage needs no explanation in terms of an ulterior motive – after all, these gatherings assembled for no other purpose than to hear Schubert's music – the appellation 'Schubertians', if it was indeed adopted by the group, may well have been chosen for its conspicuous innocence.

Be that as it may, there is no doubt of Schubert's sympathies. The Austrian monarchy was fully identified with the interests of the Church, and Schubert made no secret of his attitude towards it. Perhaps his years in the *Konvikt* had turned him against priests; at any rate, he referred to them in his letters to his brother Ignaz by the disrespectful term '*die Bonzen*', the bonzes, a word derived from the accounts of Buddhist priests and generally used by the anti-clericals. It is also well-known that in the six masses which Schubert wrote, he invariably omitted the words '*Et in unam sanctam ecclesiam catholicam et apostolicam*' ['and in one Holy Catholic and Apostolic Church'] from the Creed. Even if there had been a precedent for this omission, it is most unlikely that Schubert adopted it accidentally. On the contrary, it seems that if he had scruples about setting these words to music he could not have felt them in relation to the remaining words of the Creed. In other words, he was a devout Christian but not a champion of the Church. His father may well have worried about this outlook of his son, for Schubert obviously took pains in reassuring him in a letter of 1825 from Styria where he writes about the *Lied* '*Ave Maria*', still one of his most popular creations: 'I am rather surprised by my own piety, which I have expressed in a hymn to the Holy Virgin and which, so it seems, moves every heart to devotion. I think this is due to my never forcing myself to feel

devotion, except when it overwhelms me unawares.'

It was nature, not the text of hymns, which inspired in Schubert such feelings; his letters from travels through the beautiful scenery of the Austrian Alps can stand beside such famous *Lieder* as 'Die Allmacht'.

One consolation Schubert was denied; the consolation of fulfilled love. Early in his life he fell in love with a girl who sang in his first mass, but her parents would not hear of her marrying the penniless musician, and she married another. In his mid-twenties Schubert contracted syphilis, and though the symptoms seem to have receded, the illness left him unable or unwilling to contemplate another relationship. There exists a mysterious prose composition of his entitled 'My Dream', which tells of the greatest pain and the greatest love warring in his soul. He speaks of a vision of his mother's funeral and of his not wanting to love his father's garden. 'For many many years', it ends, 'I sang songs, and when I wanted to sing of love, it turned into pain, and when again I wanted only to sing of pain, it turned into love within me. Thus love and pain tore me apart.'

In the song cycle *Die Winterreise*, more than anywhere else, Schubert found a group of texts in which love and pain are fused into a single deepening tragedy. We hear that at the time of writing it Schubert was profoundly despondent; he is said to have confessed that those songs had taken more out of him than any he had written. His friends were taken aback by their gloom, but Schubert thought they would still come to like the cycle.

The only consolation we are offered is the resignation of the organ grinder. But we must not yield to the temptation, to which I have pointed before, of confusing the composer with the hero of Müller's poems. There is no reason to think that Schubert was resigned when he fell victim to typhoid fever (contracted through the bad water supply in Vienna's suburbs) and died after a short illness.

Some of his greatest works date from the last few months of his life (notably the C Major Quintet), and he must have had plans of advancing even further. Nothing is more moving than the fact that this great composer decided to enroll on a course on counterpoint with Simon Sechter, who became Anton Bruckner's teacher. To us the inscription which Franz Grillparzer composed for Schubert's tombstone sounds chilling: 'Here the art of music buries a rich possession but even richer hopes.' Yet his friends had selected this from various versions offered by the poet, for this was what they felt. They knew that Schubert had still new worlds to discover.

Those discoveries of which his *oeuvre* is so rich were not intended as conscious innovations, however, let alone as revolutionary gestures. As the heir to a great tradition he had acquired the idiom of classical music, of his teacher

Salieri, of Mozart, Haydn, Rossini, and of course of Beethoven, of whom he stood in awe, but also the idioms of folk music cultivated for so long in the yodels of Alpine villages and the dances of his native Vienna. There was no strict dividing line for Schubert between these ranges of music, and, even more than his Viennese predecessors, he liked to write and perform music for entertainment.

We can never cease to marvel at the variety and number of his creations, but what he wrote is surely only a fragment of what he heard in his mind. All he could do was to select and note down as fast as he could some of the miracles that had unfolded within him. Sometimes the task of setting a poem to music was the catalyst that caused this constant stream of divine music to crystallize, sometimes, we may guess, he would be arrested by a sequence of tones and modulations in this internal musical monologue which mysteriously answered the mood he described, hovering between love and pain, pain and love, that union of bliss and melancholy which exists nowhere but in his music.

Some of the elements in his life which must have contributed to his sadness and to his longing for a better world have here been adumbrated – the sufferings of his country, his poverty, his illness. But though these and other heartbreaking aspects of his biography are worth knowing for their own sakes, they neither explain his genius nor make his music more intelligible. For his music transcends the situation in which he noted it down. Pain and love are part of the human condition and the need for solace will remain with us. How fortunate we are, that we have Schubert.

Editor's Postscript

Gombrich has had a deep interest and involvement in music from childhood. It seemed appropriate, for that reason, to include this essay on Schubert, but also for the fact that it is about Viennese culture.

Other English publications relating to Vienna include his essays on Kokoschka, the most accessible of which is 'Kokoschka in his Time' in Topics of our Time *and 'A Grillparzer Anecdote',* German Life and Letters, *16 (1963), pp. 209-11.*

On music see also 'Epilogue: Some Musical Analogies' in The Sense of Order.

For further material see my postscript on p. 36 above. There is a specialist journal Austrian Studies *edited by Edward Timms and Ritchie Robertson, published by Edinburgh University Press, which is worth following. It appears once a year and is devoted to particular themes.*

Nature and Art as Needs of the Mind: the Philanthropic Ideals of Lord Leverhulme

The Fourth Leverhulme Memorial Lecture given at Liverpool University in February 1981; published by Liverpool University Press (1981); reprinted in *Tributes* (1984), pp. 70–91

1 *Victorian Values*

I should like to thank the Trustees for the honour they have done me in inviting me to give the Fourth Leverhulme Memorial Lecture. I am most conscious of the fact that it was an act of faith on their part to ask a cloistered historian of art to deal with 'a subject related to the more urgent problems of the day affecting the welfare of society at home and abroad'. I certainly would not have had the courage to accept, if my assignment had been to *solve* any of the more urgent problems of the day. But it is said that diagnosis is half the cure, and I hope you will at least consider my diagnosis a contribution to a problem which profoundly concerned Lord Leverhulme for its effect on the welfare of society. Thus I have ventured to take my cue for the topic and title of this lecture from certain of his statements which I found in the catalogue of the memorable Royal Academy Exhibition, in the spring of last year, dedicated to the Founder (Fig. 472) of the Lady Lever Art Gallery and Port Sunlight on Merseyside (Fig. 473).[1] These foundations, I discovered, were more than random benefactions, they sprang from a philanthropic conviction which I tried to sum up in my title, the conviction, to put it in Biblical terms, that man does not live by bread alone. 'A child', he wrote for instance, 'that knows nothing of God's earth, of green fields, of sparkling brooks, of breezy hill and springy heather, and whose mind is stored with none of the beauties of nature … cannot be benefited by education', and, more concretely, he commends 'semi-detached houses with gardens back and front, in which they will be able to know more about the science of life than they can in a back slum'. And as with Nature, so with Art. 'Art and the beautiful civilize and

471
Samuel Luke Fildes, *W. H. Lever, later first Viscount Leverhulme*, 1897. Lady Lever Art Gallery, Port Sunlight
William Hesketh Lever, first Viscount Leverhulme, industrialist, philanthropist and art collector, was born in Bolton, Lancashire, on 19 September 1851. He entered his father's grocery business at the age of sixteen and at twenty-one became a partner. In 1884 he patented 'Sunlight Soap', which he began to manufacture in 1885. In 1888–9 he started a new factory and a model village at Port Sunlight on the Mersey, near Bebington, Cheshire, on which he lavished much care. From 1906 to 1910 he was Liberal MP for the Wirral. Having purchased several art collections, he opened Hulme Hall Art Gallery at Port Sunlight. His wife, Lady Lever, died in 1913; the Lady Lever Memorial Art Gallery was opened in 1922. Meanwhile, in 1917, he had entered the House of Lords as Baron Leverhulme of Bolton-le-Moors and since 1922 as Viscount Leverhulme of the Western Isles. He died on 7 May 1925

elevate', he wrote, 'because they enlighten and ennoble', and this faith, of course, was behind his foundation of the Lady Lever Art Gallery.

The moral earnestness and the unquestioning optimism of these utterances may strike you as typically Victorian, and you will have no difficulty in sensing behind Lord Leverhulme's faith in the benefits of nature and of art the teachings of the great Victorian prophets, notably of course the admonitory voice of John Ruskin, who so frequently exhorted the merchants of England. But today Ruskin's voice only sounds like distant thunder, he may be read for his style, but his message is muted. Two connected notions, or perhaps slogans, have contributed to this dismissal of the ideals which inspired him and also Lord Leverhulme. I mean the charges of élitism and of paternalism. The two are connected, because élitism is alleged to pride itself in the possession of a superior culture, and paternalism adds to this charge the arrogant belief that members of the élite also know better than common mortals do what is good for them. Having promised in this brief hour to

472
Lomax-Simpson, *Port Sunlight: 'The Diamond'*. From T. Raffles Davison, *Port Sunlight* (1916)

discuss what I have called the needs of the mind, I must confront these charges, to which I shall have to return in the end. How can anyone claim to know the needs of the mind and allege that the vast majority of men and women here on earth who have little contact with the beauties of nature and none with art are short of mental sustenance? How can we be sure that we, who have enjoyed some of these benefits, have thereby improved our minds beyond the level of those who have not? I make no such general claim but I am not neutral in this matter. After all, if I had announced the title 'Gossip and Scandal as needs of the mind', or, perhaps, 'Hunting and Fishing as needs of the mind', even a convinced relativist might have raised his eyebrows. Such needs, it is true, might be defended on the general ground that what the mind requires most is an interest, an occupation. Not all such interests or occupations are equally desirable from the social point of view and we all would like to canalize these needs into areas which keep people out of mischief. Lucky are the people who have an interest which makes them creative, and twice lucky those who find that their own creations also mean something to others. I said lucky, not happy, for the satisfaction of the needs of the mind does not guarantee happiness. In any case it is not with the exceptional creators in art and in science that I shall be concerned, but with the minds of men in general.

2 *The Function of Metaphor*

Let me thus start with the somewhat dogmatic assertion that among the needs of the mind the possession of language comes first and foremost. Language is more than an instrument of communication, more than a set of labels to be attached to the people and objects which exist in our environment. Language must be creative to perform its vital functions. The external and the inner worlds of man are not composed of a number of entities waiting to be named and described. The multitude of potential experiences is infinite, while language, by its very nature, can never consist of more than a finite number of words. It would soon come to the end of its resources if the mind were not

473
Sunlight Soap
advertisement from the
Lancashire Grocer (1887)

474
Joseph Wright of Derby,
*Sir Brooke Boothby in a
Landscape, with a volume of
Rousseau*, 1780–1. Tate
Gallery, London

able to create categories, to parcel out this elusive world of ours into convenient packages to which more or less permanent labels can be attached at will. Traditional terminology calls the more permanent ones 'universals', the more movable ones 'metaphors'. Since nature and art are among the richest sources of metaphor, they answer the needs of the mind, *quod erit demonstrandum.*

There is an example close at hand to give a little more substance to these generalities. I mean the trademark 'Sunlight Soap' (Fig. 473). Metaphor is Greek for 'transfer' and according to the traditional interpretation the qualities of the 'universal' 'sunlight' are here transferred to another 'universal', namely 'soap'.[2] I would prefer to say that the new brand of soap was put into a parcel together with other things bright and beautiful such as sunlight, and labelled accordingly. Nobody would have called it 'Night-gloom'.

Any number of similar metaphors testify to this capacity of the mind consciously or unconsciously to articulate and order the world of experience by linking it with a natural phenomenon of universal significance – from the description 'a sunny temperament' to the old song-hit 'You are my sunshine'. So intimately do these impressions of the external world and our emotional response tend to fuse in the mind that we say with the same conviction that the sun is 'smiling'; a metaphor which does not tell astronomers much and has therefore been classed among the so-called 'pathetic fallacies', but which tells the psychologist that the sun and smiles can affect us in a similar way. Without forming such compounds linking our sensory experience with our emotional life we could not communicate our feelings to others – and to ourselves. In short, it is my belief that it is only through this process of creative articulation that the mind becomes wholly mind.

I call it creative, because it seems to me that it is only through naming that these feelings can fully emerge into existence. Animals, no doubt, have many responses which resemble our own; if we hesitate to attribute to them a mind,

it is, I submit, because they lack the capacity to code their experience. They can recognize, but they cannot recall, and thus they presumably live only in the present. Without arresting the flux of life and transferring it into the realm of symbols the mind could never achieve self-awareness. It is on these conclusions, as the lawyers say, that I wish to rest my case for the importance of nature and art to the needs of the mind.

3 Hazlitt on the 'Language of Nature'

I propose to call, as my first witness, a great English writer from the period when that love of nature which Lord Leverhulme shared had just become articulate. I am speaking of William Hazlitt and his essay of 1814, entitled 'On the Love of the Country'.³ It fittingly starts with a quotation from Rousseau, that great prophet of nature who rejoiced when he had moved to Annecy, seeing 'a little spot of green' from his window (Fig. 474). It concludes with the thought that 'for him ... who has well acquainted himself with Nature's work ... she ... always ... speaks the same well-known language, striking on the heart'. It is a conclusion which suits my case, but the way in which Hazlitt has reached it reminds me of the changes which have meanwhile come over psychology and philosophy. Briefly Hazlitt accounts for this experience in terms of Aristotle's logic and John Locke's picture of the mind. From the first he takes the distinction between the individual and the universal. Human beings, he rightly claims, are individuals, and our attachments here are to particular persons. I am not sure that Casanova or Don Giovanni would necessarily have agreed, but from the moral point of view he was of course right. I am less sure that he is right when he claims that in nature our attachment is always to universals, to classes of features such as fields and lawns rather than to particulars. Surely we can love a particular landscape or even a particular tree, but Hazlitt needs this distinction to explain our love of nature in general, for which he accounts, in the tradition of John Locke, by the association of ideas. 'Thus', he writes, 'if I have once enjoyed the cool shade of a tree, and been lulled into a deep repose by the sound of a brook running at its feet, I am sure that wherever I can find a tree and a brook, I can enjoy the same pleasure again.' And also, remembering his Aristotle, he asserts that '... in our love of Nature, there is all the force of individual attachment, combined with the most airy abstraction'. The trouble here is only that the notion of abstraction is so hard to square with that of association. How did his experience under one particular tree take him to that abstract or universal concept which allegedly guides him from then on? But of course no one has to solve that notorious teaser of philosophy, the problem of universals, to find a place for his repose.

Animals, too, can be seen taking shelter under a tree without having been taught philosophy. Hazlitt's requirements were surely somewhat more discriminating. He presumably did not look for shade only, but also for a gently sloping ground, maybe a mossy stone from which he could look out into the landscape, and – an important requirement he forgot to mention – a place without ants or too many other creepy-crawly things. We may assume that here as usual the mind did not go from the particular to the general, but from the general to the particular. But once he had discovered that there are trees which he can love, the experience could again take on a wider emotional meaning. He could have mentioned the imperishable image from the Song of Solomon (ii. 3): 'As the apple tree among the trees of the wood, so is my beloved among the sons. I sat down under his shadow with great delight, and his fruit was sweet to my taste.'

What Hazlitt does say is that 'When I imagine these objects, I can easily form a mystic personification of the friendly power that inhabits them, Dryad or Naiad, offering its cool fountain or its tempting shade. Hence, the origin of the Grecian mythology.'

Here speaks once more the son of the Age of Reason whose picture of the alleged origins of mythology and religion is somewhat oversimplified. But we can now safely leave him under his tree unmolested by further quibblings, simply acknowledging that long before nature and art detached themselves as identifiable entities, mythology and religion must have answered the needs of the mind for symbols and metaphors. Not the patchwork mind, if I may so call it, of the associationists which, as you have seen, is composed of single impressions, but a structured mind–using the term without reference to the controversies surrounding a particular school of thought.

4 *Culture and the Natural Order*

If the mind is not a patchwork of individual sensations, neither is nature a chaos of random events. It offers us the experience of a multitude of interacting but ordered regularities which the Greeks called the cosmos, using a term which means both beauty, as in cosmetics, and the universe, as in cosmic radiation. The mythology and rituals of countless religions testify to the embeddedness of culture in the natural order. Without such an order man could not form expectations, could not plan, could not develop science and, maybe, not art either. For the alternations of day and night, birth and death, the round of the seasons in temperate climates, and the rhythms of the tides, are not like the actions of a clockwork; there is constant variety in regularity, which must have impressed itself on the mind since the dawn of consciousness. Like a patient language teacher, nature familiarized the mind

of man with recurrent processes in ever-changing modifications, establishing a communicable pattern of events which determined survival but always needed fresh attention.

You need not listen to anything more solemn than talk about the weather to know what I mean: 'It's cold, but we must not complain, the winter has not been too bad.' I know that talk about the weather has other functions in English culture than communication, but even this minimal form of social contact illustrates the way nature seeps into our consciousness, however much we try to expel her with pitchforks or air conditioning.

It was during a recent visit to Japan, however, made under very favourable circumstances, that the responsiveness of the mind to the language of nature was brought home to me. No doubt, there is a connection here between the original nature religion of the country and that transition from cult to culture which I observed. The cycle of the seasons is very marked in Japan, and so is their significance in the minds of the Japanese. It is one thing to read of their love of cherry blossoms (Fig. 475), another still to see the festive crowds enjoying this magnificent token of the arrival of spring. The round of the year sets the key for many genres of art. The painter will select the characteristic flowers of each of the seasons to compose a sequence for folding screens or other forms of painting and, unless we are told, we are likely to miss the overtones of mood and response which these images are traditionally meant to evoke. In that popular and highly formalized tradition of the seventeen-syllable 'Haiku', the poetic rules demand an indication of the season which provides the setting of the scene or reflection.[4] It may, we read, be a definite reference such as summer heat or autumn wind, or more likely an allusion to features like snowflakes or plum-blossoms. The degree of refinement and the aesthetic sense of this tradition are equally evident in the art of gardening, where nature and art come together. Let me comment here on an episode in the astounding novel of the eleventh century, *The Tale of Genji*, by Lady Murasaki, which is only accessible to me in translation – and I still use the one by Arthur Waley.[5]

On page 430 of that translation the story of the loves and vicissitudes of the 'shining prince', as he is called, has reached a point when Genji begins to take stock of his amorous life and decides to expand his palace to offer accommodation to four ladies who particularly hold his affection. To provide for each of them what she loved most,

> He effected great improvement in the appearance of the grounds by a judicious handling of knoll and lake, for though such features were already there in abundance, he found it necessary here to cut away a slope, there to dam a stream,

475
Torii Kiyonaga, *Cherry-blossom at Asakayama near Edo*, c.1787. Colour print

that each occupant of the various quarters might look out of her windows upon such a prospect as pleased her best.

To the south-east he raised the level of the ground, and on this bank planted a profusion of early flowering trees. At the foot of this slope the lake curved with especial beauty, and in the foreground, just beneath the windows, he planted borders of cinquefoil, of red-plum, cherry, wistaria, kerria, rock-azalea, and other such plants as are at their best in spring-time; for he knew that Murasaki was in especial a lover of the spring; while here and there, in places where they would not obstruct his main plan, autumn beds were cleverly interwoven with the rest. Akikonomu's garden was full of such trees as in autumn-time turn to the deepest hue. The stream above the waterfall was cleared out and deepened to a considerable distance; and that the noise of the cascade might carry further, he set great boulders in mid-stream, against which the current crashed and broke. It so happened that, the season being far advanced, it was this part of the garden

that was now seen at its best; here indeed was such beauty as far eclipsed the autumn splendour even of the forests near Oi, so famous for their autumn tints.

I must not linger over the north-eastern garden designed to offer refuge from the summer heat through a cool spring and tall forest trees 'whose thick leaves roofed airy tunnels of shade'. Let me tell, however, that Lady Akashi's rooms in the north looked out on a close-set wall of pine trees,

> planted there on purpose that she might have the pleasure of seeing them when their boughs were laden with snow; and for her delight in the earlier days of the winter there was a great bed of chrysanthemums, which he pictured her enjoying on some morning when all the garden was white with frost. Then there was the mother oak (for was not she a mother?) and, brought hither from wild and inaccessible places, a hundred other bushes and trees, so seldom seen that no one knew what names to call them by.

No doubt the passage, for all its refinement, looks somewhat alien to our Western conventions and traditions; but I singled it out because it illustrates precisely the fusion between the objective orders of nature and the response of sensitive minds. If it were not so chilling I would say that it also illustrates the way the mind can turn the cosmic order into a filing system of its most personal feelings. Murasaki, the young girl Genji had brought up almost like a father, stood in his mind for spring; Lady Akashi, the aloof princess whose favours he had won in exile against all odds and who had borne him a child, stood on the opposite side of his emotional life.

But do we really not know this kind of reaction in our Western tradition?

> No spring, nor summer beauty has such grace
> As I have seen in one autumnal face.

says John Donne in an elegy called 'Autumnal', and Shakespeare:

> Shall I compare thee to a summer's day?
> Thou art more lovely and more temperate.

Shakespeare the master of rhetoric was, of course, using here a well-known figure of speech combining metaphor with comparison. For my purpose I might say pedantically that the categories offered by the filing system of Nature will not accommodate such excellence without extension and modification.

Admittedly metaphors can become so conventionalized that they cease to be creative. Those busy filing clerks, the poets and rhymesters of the Western world, have been so used to filing May, birds and love together that we would be startled to see them separated. Not surprisingly, the independent existence of these categories in the poetic genres of idyll or pastoral have irked honest minds who wanted to break through the veil of make-believe towards the social and psychological reality. I am thinking of the words of George Crabbe in his poem 'The Village', written a few years before Hazlitt's essay on the Love of the Country:

> I grant indeed that fields and flocks have charms
> For him that grazes or for him that farms;
> But when amid such pleasing scenes I trace
> The poor laborious natives of the place;
> And see the mid-day sun, with fervid ray,
> On their bare heads and dewy temples play;
> While some, with feebler heads and fainter hearts,
> Deplore their fortune, yet sustain their parts;
> Then shall I dare these real ills to hide
> In tinsel trappings of poetic pride?

But the very years which witnessed Crabbe's protest also saw a more thoroughgoing revolt against the dead wood of poetic metaphor. It was the aim of William Wordsworth's reform to free nature from the network of rhetorical tropes and to confront her face to face, as it were.[6]

> Ye Presences of Nature, in the sky
> And on the earth! Ye Visions of the hills!
> And Souls of lonely places! can I think
> A vulgar hope was yours when Ye employ'd
> Such ministry, when Ye through many a year
> Haunting me thus among my boyish sports,
> On caves and trees, upon the woods and hills,
> Impress'd upon all forms the characters
> Of danger or desire, and thus did make
> The surface of the universal earth
> With triumph, and delight, and hope, and fear,
> Work like a sea? *The Prelude*, Book I (490–501)

It is easy to say and to see that the communion with Nature which

476
Benjamin Robert
Haydon, *William
Wordsworth*, 1842. National
Portrait Gallery, London

Wordsworth (Fig. 476) celebrated in *The Prelude* was really a form of self-communication, a projection of subjective feelings onto the screen of Romantic scenery. But such a description would be one-sided. No doubt the poet lent Nature his feelings, but he also owed to Nature the capacity to give them a local habitation and a name.

In any case that new striving for freshness and intensity which ushered in the worship of Nature to which I referred in the beginning of this lecture must have been felt to meet a need of the mind which was left untended by the slow decline of religion, which had for so long filled and nourished the inner life. It was in this constellation also, I believe, that the arts began to rival nature as a source of emotional sustenance.

5 Secularized Religion

That conviction of Lord Leverhulme's, that 'Art and the beautiful civilize and elevate because they enlighten and ennoble', would have puzzled a Renaissance patron or a Baroque cardinal, however much they liked to surround themselves with works of art. Its beginning may be traced to Lord Shaftesbury in eighteenth-century England, but it did not take full root

among the English connoisseurs and collectors of the time so much as in German-speaking countries. It was there that Johann Joachim Winckelmann in his writings on ancient art set the key for a response to classical statuary which bordered on religious rapture, an almost pagan worship of beauty. Thus many generations of art lovers learned through him to find in the sublime serenity of the Greek Olympians and in the untroubled sensuality of satyrs and nymphs metaphors for their own psychological aspirations.

But the true embodiment of the new attitude to nature and to art in German-speaking countries was Johann Wolfgang Goethe, a genius whose vivid response to nature was expressed in his beautiful lyrical poetry no less than in his scientific investigations into geology, anatomy, botany and optics, and whose love of the arts encompassed the antique, northern Gothic, and, of course, the art of Italy, which he had studied and absorbed during a memorable journey.

I know that to many English people Goethe is little more than the name of the author of *Faust*, a play which is neither a play nor a philosophical poem and which anyhow loses its spell in translation. Thus the magic of Goethe's overpowering personality may be even harder to convey to another tradition than that of his contemporary Dr Johnson, whose authoritarianism he shared to some extent.

Unlike Dr Johnson, however, Goethe explicitly rejected Christianity. Declaring himself a pagan, he endeavoured all the more to rescue from the ruins of the orthodox faith the spirit of veneration and awe which was consonant with a certain pantheistic attitude towards all manifestations of sublime nature and great art. He once summed up his creed in the simple epigram of his *Zahme Xenien:*

> *Wer Wissenschaft und Kunst besitzt,*
> *Hat auch Religion;*
> *Wer jene beiden nicht besitzt,*
> *Der habe Religion.*

> He who has knowledge of Nature and Art
> Will never lack religion,
> Whoever lacks a knowledge of these
> He must not lack religion.

I would not deny that the opinion here expressed incurs the charge of élitism. After all, it implies that the enlightened do not need formal religion, for they have a valid alternative. It is only those without the blessing of this

nourishment of the mind who must not go without some other kind of organized faith.

Élitist or not, Goethe certainly practised his own faith and advocated its devotions. As he makes one of his characters in *Wilhelm Meisters Lehrjahre* (Book V, Chapter I) say: 'One should not let a day pass without listening at least to one little song, reading a good poem, seeing a fine painting and – if that were possible – saying at least a few sensible words.' That sceptical insertion 'if that were possible' saves the injunction from sententiousness. Goethe and those who took him as their model certainly did not always talk sense, but they looked upon a daily communion with nature and art as the equivalent of daily prayers. And those who followed him certainly included a large proportion of the middle classes in German-speaking countries of the nineteenth and early twentieth centuries. I suppose their eagerness to embrace Goethe's faith of culture, or *Bildung*, was due in no small part to the demise of organized religion. We know today through hindsight that this earnest faith in culture, to which so many of the practitioners owed their self-respect and their mental world, was insufficient to prevent the collapse of civilized values and the perpetration, or at least condoning, of unspeakable crimes against humanity. Alas, there are few religions against which similar charges could not be levelled. And with your permission I should still like to reflect on its assets rather than its unforgivable failures, for – not to beat about the bush – together with many other Central Europeans of my generation I was brought up in this religion. I am not using the term loosely. It was the rule in my Viennese childhood for my father to take us children on almost every Sunday either to a museum or to the countryside, the famous Vienna woods, and I remember distinctly that he thought more highly of this routine than of the religious observance to which we were urged at school. He never was a friend of high-sounding words, but he gently intimated that this was and should be for us the equivalent of divine worship.

Not all people of our acquaintance responded with equal readiness to all aspects of *Bildung* or culture. For most Viennese it was of course music which meant most; performances of classical masterpieces again bordered in spirit and devotion on religious rituals. I was certainly brought up to regard great music as a revelation of higher values and I do not regret it. For others the beauty of nature offered the most elevating moments; and many reformers set themselves the task of weaning the working classes away from their pubs and skittles and making them responsive to the majesty of Alpine peaks and the joys of climbing and, somewhat later, also skiing. The *Naturfreunde*, the Socialist Society of Friends of Nature, exerted an enormous pull and must have transformed the life-style of many.

But the enjoyment of mountain scenery would not exclude contact with art, visits to old churches, monasteries and ancient cities, and for those more affluent a descent into Italy for a few weeks' sight-seeing in Venice or Florence. School, of which we only had four or five periods in the morning, was felt to be a bothersome interruption in this process of initiation. The teachers of the Gymnasium did their best to teach us Greek and Latin grammar, quadratic equations and the Spanish wars of succession, but the curriculum included neither the history of art and music, nor many other fields of knowledge which belonged to the tradition of *Bildung*.

I make no great claims for the universality of that tradition. Compared to the knowable, its map of knowledge was arbitrary and schematic in the extreme. As is true of all cultures, certain landmarks were supposed to be indispensable for orientation while whole stretches of land remained *terra incognita*, of relevance only to specialists. Shakespeare and Dickens were marked in bold letters in the section on literature, Jane Austen not even in small print. But what I am trying to convey is that at least there was a map.

6 *The Landscape of Art*

Like the world of nature the universe of culture was felt to be not a chaos but a cosmos; it did not consist of random pieces of information, but of a coherent manifestation of the human mind. Music, literature and art, each had its own landscape, with forbidding peaks, charming valleys, and, to return to Hazlitt's example, shady trees by a brook inviting repose.

As a historian rather than simply a lover of art I have developed reservations against this emotional equation of the works of nature and the works of man. The works of man, after all, were made to be understood, we want to find out what they mean or meant to their makers and to their age – it is a laborious task and there is no short cut to this intellectual goal. The works of nature impose no such demands and no such heart-searchings. We cannot understand a tree as we might understand Michelangelo's *Moses*. In the first case we must be subjective, in the second we should try to transcend our personal reaction. And yet, I hope, I have never overdrawn this undeniable contrast. We must not repress our humanity when standing before the *Moses*. We can be impressed by the majestic grandeur of Egyptian sculpture, the poise of Greek statues, the mysterious glow of Byzantine icons, the serenity of Renaissance Madonnas, or the playfulness of Rococo decorations, without falling into the trap which I have described as the 'physiognomic fallacy', the trap of confusing the style with the age or, worse, with the men and women who made up the age.[7] Historical explanation and subjective response can be and must be kept apart. There is a letter by Lord Leverhulme on his views

about interior decoration which perfectly illustrates such a personal classification of the changing styles of art.[8] Whether or not you share his reactions, it reflects the kind of differentiation I have in mind:

> I feel [he wrote to Thomas H. Mawson in 1910] that in the course of centuries we have gradually gained experience in the type of architecture suitable for each room. For instance, I prefer Georgian dining-rooms as the rooms in which to give large dinners; for small dining-rooms I prefer Tudor. For drawing-rooms I prefer what is called the Adams style; for entrance halls the Georgian. For a large room such as a music-room, I prefer the period which I should call the Inigo Jones type of Renaissance.

I trust you will not take me to be advocating this prescription, though one must be careful here. Since the recent crisis in modern architecture there is a danger of any programme finding adherents. What impresses me is simply the degree to which some seventy years ago styles were still felt to be charged with emotional meaning, and this may, after all, be preferable to an entirely aseptic scholarly approach. Art demands involvement, or else it will turn into artefacts. You may like genre painting or hate it, you may be partial to Van Gogh or find that Poussin speaks more immediately to you. In any case you can always discover new idioms, new masters, new works which offer you new nuances of seeing, of feeling, of human sympathy. The portraits of Rembrandt, the landscapes of Claude, the dreamy whimsicalities of Paul Klee, there is always more for the responsive mind, not only to know, but to absorb and assimilate.

I have called this lecture 'Nature and Art as needs of the mind', not as 'the' needs of the mind. It would be folly to claim that no other set of experiences can perform a similar function. For the vast majority of the people of this globe it must be their religious faith which shapes their inner life. Not wanting to obtrude here, however, I may still ask how the needs I have singled out are faring today.

That nature is now threatened by the inroads of man has become painfully obvious to many, but this very awareness has its positive side. Only recently *The Times* carried a headline: 'Nature in the countryside thrills walkers young and old'.[9] The Royal Society for the Protection of Birds has eighty nature reserves and its membership stood at 34,000 in 1980; there may be more than a million bird watchers in Britain, many of whom surely learn to respond also to the other sights of nature. Nor do I think we need worry about that other means of maintaining contact with nature; I mean the art of gardening, which has always had a special place in the traditions of this country. Granted that

the aspirations and the means of Prince Genji have always been outside its reach, it is precisely the strength of that art that it can be appreciated and practised on any scale from the tending of houseplants to the laying out of grounds like The Hill at Hampstead, one of Lord Leverhulme's creations, which sometimes offers me that pleasure of repose which Hazlitt found under his tree.

7 *The Dangers of Barbarism*

Turning from nature to the arts, it would be futile and impertinent to pass them all in review, let alone to rank them according to the benefits they can bestow on the mind. What is not futile to ask, I believe, is whether it is possible to justify a ranking order within the arts in the light of my interpretation? Is highbrow art really more valuable than its lowbrow counterpart? Does classical music offer more to the mind than pop, Shakespeare more than thrillers, and Cézanne more than comics? Is it not simply a matter of taste and prejudice?

I have often said that I do not think that the value of any work of art to the mind can be demonstrated, and my deliberations today may go some way in explaining this impossibility. If art, like nature, offers us a range of metaphors, their meaning and import can only come to life in the context of the whole. Once we acknowledge this cohesion in the various languages of art, however, we are entitled to speak of poor and rich vocabularies and resources, possibilities for differentiation and discrimination which cannot remain without effect on the mind. There may be a natural transition from an interest in gossip columns to an enjoyment of trashy novels, but one hopes that the ladder continues to increasing subtlety and richness in the articulation of human problems. Psychoanalysis speaks of sublimation when describing the distance from immediate gratification and the compensatory rewards of increasing mastery.

Believing, as I do, in these rewards, I must ask in conclusion why there are so few takers on the market place? I do not think the answer is as simple as it once was when George Crabbe rightly reminded the poets of his time of the poor laborious natives of the place who have to toil in the sweat of their brow simply to satisfy their bodily needs. Even where these physical needs are happily satisfied, the needs of the mind may still be in danger of atrophy. For frequently, I suggest, their satisfaction is blocked by another overriding need, the social need for companionship, for the approval of one's peers, what are known as the pressures of conformism and the antagonism of rivalling groups. If proof were needed of the strength of these psychological forces it would be found, of course, in the overwhelming attraction of spectator sports, not as

sources of interest, but as means of creating and fostering group identities to the point of mutual warfare. But the same need for the security of the group also operates in the field of language and taste. If the idiom of your group is inarticulate, you had better be careful not to be too refined if you do not want to be ridiculed and expelled. If pop and comics are the pabulum of your peers, a preference for Mozart and the Elgin marbles would stamp you as an outsider and a hypocrite to boot, for how can anyone pretend that this stuff really means anything to him? Unfortunately it is a fact of social psychology that such mutual antagonisms are self-reinforcing and tend to escalate. They lead to the mutually exclusive images of the effeminate aesthetes on the one side, whose attitudinizing merely reveals a lack of common humanity, and on the other side the hearty philistines who claim to know what's what and have no use for all this flim-flam. Once the self-respect of groups is involved, they become impervious to persuasion. There is nothing new in this situation; the barbarians have always been at the gate. What is new and disturbing is that today the inarticulate have found highly articulate spokesmen who denounce civilized values as privileges in disguise. The charge of élitism I mentioned at the outset is part of that syndrome. I am afraid it has prevented faint hearts from taking that first step towards the museum or concert hall which is the one which counts.

Thus the complexity of the situation has certainly increased since the days of Lord Leverhulme. While radio and television have enabled countless people to make contact with new ranges of experiences at the pressure of a button, they have also threatened to perpetuate the distinctions of taste through their division into channels of differing sophistication, the public acknowledgement that the arts are a minority interest. Even so, the channels do not run in watertight compartments, and there is no doubt that they have spread a knowledge of the wonders of nature and the masterpieces of literature, music and the arts beyond the privileged few.

But against this very positive achievement we must not deny the dangers they have enhanced. I mean most of all the danger of over-stimulation and under-organization, the two sides of the same coin. The need for novelty, for fresh impressions and fresh sensations may counteract the benefits I have just mentioned. Moreover, there are the understandable pressures of living creators and their friends to gain a hearing, which nobody should deny them. It is only when these social pressures try to mobilize a kind of parochialism masquerading as progressivism that one feels like hoisting a warning signal. I have in mind the call 'What about us? What about our own age, our own art?' which can sometimes be heard when the achievements of the past are presented. Is it not inevitable that the poets, composers, and painters who

stood the test of ages may often outshine the unsifted efforts of the hour? It takes time for an artistic creation to fuse with the landscape of art, to turn into a landmark on our mental map. When it comes to safeguarding this landscape against over-hasty developers I am a conservationist.

But in my field, at any rate, over-stimulation also takes another form. I mean the craze for exhibitions, which too often monopolize the time of the genuine art lover. I sometimes quote the remark I heard attributed to a crusty old don: 'Whenever a new book comes out I read an old one.' There is some wisdom in this advice, at least as far as the arts are concerned. The way these exhibitions are often publicized and promoted to bring in the crowds, leads me to another distorting element, one moreover which is much more in evidence in my own field than elsewhere. I mean the emphasis on material value, on possession and all the false sensationalism it generates.

I am frequently tempted to envy the students of literature or music because they are but rarely concerned with these irrelevancies. Autograph collectors may compete for the manuscript of a Beethoven sonata or of a poem by Wordsworth, but who else minds where it is and what it costs? The sonata, the poem, belongs to all of us. I know I shall be told that painting and sculpture are different, because they elude reproduction and publication. I agree that we have to travel to see the Acropolis as we have to to see the Grand Canyon. Some of these treasures like some of the sights of nature may be inaccessible to ordinary mortals. But how much is accessible which nobody ever looks at? Would it not be better to draw the attention of all to the immense riches right under our noses? Granted that their meaning may not be immediately obvious to the casual visitor; need he remain a casual visitor? Could he or she not be made to seek out the real pleasures offered by our permanent collections, if only their displays were more permanent?

8 *The Failure of our Schools*
I think that the decline of concern for the needs of the mind is indeed a 'problem of the day affecting the welfare of society'. If we no longer believe in our own civilization the forces of vulgarity and barbarism will surely triumph. I do not see that those who are in charge of education are always aware of their responsibility in this matter. It is a responsibility which has increased immeasurably even within my lifetime. It may have been culpable for our schools to neglect these needs of the mind, but at least they had the excuse that in many cases the deficiency was likely to be made good by the home. In the changed conditions of our age and outlook this excuse is no longer valid, and yet our schools still wash their hands of the problem. It is still possible, indeed likely, for a child to pass through school without ever hearing a piece by

Mozart or seeing a work by Rembrandt in the classroom. As you remember, I am not a believer in the teaching of art appreciation. But I believe that much more could be done in 'exposing' the children, as the jargon has it, to great art without appearing to ram it down their throats. I know that individual teachers do so, and often have encouraging success, but such activities are still extracurricular. Alas, there is even a school of thought among educators which strictly condemns such efforts. When I once lectured to a teachers' training class I was firmly told in the discussion that no teacher must ever show what he personally likes since he must not influence the child. I was even told elsewhere that visits to art museums by schoolchildren were frowned upon by teachers, who alleged that the late Sir Herbert Read put freshness and originality above every other concern. But why allow oneself to be influenced by Herbert Read and not by Rembrandt? Why teach the child the words of our language but not the images of our tradition? None of us has discovered Rembrandt unaided; how can any growing mind find a point of entry into the cosmos of art without being given the opportunity? We must not be discouraged if a good many, for social and psychological reasons, remain indifferent. Here one *must* be élitist and say that it is the few who are responsive who matter, and are likely to benefit from such contact for the rest of their lives. We hear a lot about our heritage these days, but is not this spiritual heritage even more vital than its material counterpart?

I know that art history has become a school subject, one of the options now available for 'O' or 'A' level if the right teachers can be found, but I hope I am not speaking against the interests of my colleagues and students if I doubt that this is the answer. Both at school and at the university the cosmos of art is broken up into examinable chunks which you are expected to study in depth. You can take Autumn as your speciality, including fruit marketing and harvest festivals, but then you need not know of the birds that sing in the spring. To survey the round of the year counts as superficial, for there is a widespread prejudice against general surveys. Believing, as I do, that the progress of the mind is more often from the general to the particular, from the approximate to the precise, I think that even a crude map is better than no map. Indeed, having written such a rough survey myself, I have also experienced the surprise to find that the need for it must have been very widely felt. I am humbled by the thought of the multitude of readers who have chosen my *Story of Art*[10] as a guide; humbled, because if I had had the slightest inkling of their numbers I would have weighed every word so carefully that I could never have written the book. What gave me the courage or, if you like, the cheek to write it off the top of my head was, of course, that background in a vanished tradition to which I have alluded. I believe that for all its faults this tradition still has

something to offer to growing minds if only the schools could be made to see it.

I am fortified in this belief by an encounter I had in America some years ago with an unusual man, a ranger in the National Park of the Grand Canyon of Colorado, Mr C. R. Webb. I had the good fortune of meeting him when I was looking for somebody who could drive myself and my wife to Oraibi, a distant settlement of Hopi Indians which Aby Warburg" had visited before the turn of the century. In the end we palefaces were not permitted to enter this ancient village, but I have no reason to regret the excursion because I found in Mr Webb a man whose response to nature and to art struck a familiar chord. I learned that he had been a school teacher, I believe in Kansas City, and had tried with much ingenuity and pedagogic skill to interest his pupils in art and music. The result, alas, was not unexpected: the pupils loved it, but the parents came running to complain that he was wasting their children's time with subjects they did not need for the examinations. In the end he quit and withdrew into the majestic nature of the National Park, of which he has written a guidebook illustrated with his own photographs. He has also sent me typescripts explaining the structure of courses he advocates for the initiation of beginners into the fields of art and music which, next to nature, mean most to him. Living with his wife in a caravan filled with art books and records of classical music, he was, I found, as different from the popular stereotype of an aesthete as anyone could be. I asked him how he had come to develop these enthusiasms? Well, he said, in the war he had been stationed in Alaska and for a time he shared his quarters with a fiddler, a refugee from Vienna who liked to play classical music. It was this encounter which opened up the world of Beethoven to him, and the rest followed. The scattered seed of a submerged tradition had been blown across half the world by the storms of the age and had taken root in a receptive mind. It is this kind of miracle which vindicates the faith in civilization.

Editor's Postscript

Related essays by Gombrich include 'The Tradition of General Knowledge', 'Canons and Values in the Visual Arts: A Correspondence with Quentin Bell' and 'The Museum: Past, Present and Future' in Ideals and Idols; *'The Embattled Humanities: The Universities in Crisis' and 'The Conservation of our Cities: Ruskin's Message for Today' in* Topics of our Time; *'Focus on the Arts and Humanities' and 'The Ambivalence of the Classical Tradition' in* Tributes *and the pieces on tradition in this volume (pp. 169ff.).*

Goethe: the Mediator of Classical Values

Speech delivered on the occasion of the award of the Goethe Prize of the City of Frankfurt, September 1994

Herr Oberbürgermeister, Ladies and Gentlemen

To be awarded the Goethe Prize of the city of Frankfurt[1] is not only an overwhelming honour for me, it also means much to me that it should happen here. For my paternal grandmother, Johanna Flürscheim, was born in Frankfurt and spoke an unmistakable Frankfurt dialect to the very end of her life. I hope you will understand, and even forgive me, Herr Oberbürgermeister, if I add that the memory of my Frankfurt relations and everything that befell them is inexpressibly painful to me.

Thus I can be all the more grateful to fate that one cannot be deprived of citizenship in the *Respublica Litterarum*. If I really have acquired the right to be accepted in this commonwealth, I owe it, next to my parental home, most of all to my incessant reading in Goethe's writings, which already meant much to me even as a boy in the Gymnasium. Hence I feel that I must here express my gratitude to Goethe, to the best of my powers, for it was from Goethe's life and work that the consoling message reached us of a universal citizenship that transcends the confines of nationhood. Goethe had the right to feel at home everywhere. In the England of Shakespeare and Byron no less than in the France of Diderot and in the Italy of Benvenuto Cellini and Tasso; indeed in the Persia of Hafiz, and the India of Kalidasa, from whose Sanskrit play *Sakuntala* Goethe took the idea of a *Prelude on the Stage* for his *Faust*. Just as his spiritual homeland embraced the globe, so his mind embraced the whole of Western history, ideas and images derived from antiquity down to his own lifetime.

At the beginning of Goethe's *Maxims and Reflections*, in *Wilhelm Meisters Wanderjahre*, we read the well-known aphorism: 'Every intelligent thought has

been thought already, all we must do is try to think it again.' Possibly you will object that, after all, Goethe himself had many intelligent thoughts that had never been thought before, and yet his attempt to think the intellectual heritage of mankind afresh marks his life's work. Thus anyone who explores Goethe's writings will also become familiar with the tradition of Western thought that he had 'truly acquired, in order to possess it'. Thanks to the incomparable richness of his language he gives us access to this inheritance from which we might otherwise be debarred.

It would seem to me that this applies as much to his efforts in the natural sciences as to his ideas about art. As far as I am able to judge, the former always take us back to the philosophy of the ancients, most of all to Aristotle, whose distrust of mathematics Goethe notoriously shared, and to whom he is also indebted for his theory of colour, particularly for those aspects which we can no longer accept. The same may be said for his attitude towards the visual arts and to art as such.[2] It can hardly be denied that, today, the reader of his writings on this subject finds himself confronted with a world as foreign to him as does the reader of his theory of colour. He soon realizes that Goethe's life-work took shape on the other side of that great watershed that divides the sources nourishing Goethe's own from those to which we owe our modern conceptions of science and of art.

Who still speaks today of 'the dignity of Art'? Who still thinks that painting aims at beauty? Who is still ready at any time to regard classical art as the ultimate authority, the only true standard of progress and decline?

We know that Goethe himself lived long enough to experience and to deplore the downfall of these ideals, though he surely had no inkling of the degree to which subsequent settlements would lose contact with his inherited provinces. I would not claim that he was deprived of further influence. I trust not to blaspheme when I say that the old pagan even became, posthumously, the founder of a religion. I am thinking of the German religion of *Bildung*,[3] which, mostly among the middle classes, fulfilled for many generations the function of a religion. The followers of this religion modelled themselves on Goethe, in that the masters and achievements of the past became their guiding ideals in all situations of life.

I hope that it is not only due to my old age that, despite a number of qualifications, I regret the passing of this religion, because the general loss of memory that so frequently follows its death leads to an impoverishment that cannot be easily remedied. True, even people who live, and want to live, simply and only in the present, can be valuable members of society, but they still seem to me frequently to lack a dimension that I dare to call the dimension of depth.

Whether this diagnosis always applies or not is a moot point. For the historian such a loss of memory is naturally regrettable, for the art historian it is no less than disastrous: after all, his subject-matter should be the works of art of previous centuries, which are stored in our museums. And who could tell us about them, if not those favoured human beings who still shared the views and standards of those periods of art?

Admittedly, I must confess that while I was at the Gymnasium many aspects of Goethe's writings on art seemed remote. It was easy to be enthusiastic about his early essays, his rousing tribute to the builder of Strasbourg Minster, and the eloquent words he found at that time for Rembrandt's art;[4] but what he had written about art after the *Italian Journey* seemed to me much more distant. We had come to take it for granted that in painting, the so-called 'content' – what we described as the 'literary', or even the 'anecdotal' – was wholly irrelevant, and could only be of interest to Philistines. For what we were looking out for was always the formal structure: the drawing of diagonals and the analysis of pyramids. It was even less admissible to examine a painting for its 'truth to nature', which we had learnt to dismiss as 'purely photographic'. What mattered to us was, most of all, the expression; the expression of the artist's personality, and the expression of the age that the work of art was said to embody. Such a purely historical, so-called 'value-free', interpretation of the changing styles of art which we know from modern art-historical writings was certainly wholly alien to Goethe and his circle, the *Weimarer Kunst-Freunde*.

In the ultimate analysis we owe the modern attitude to Romanticism which, as I indicated, was nourished from those sources that lie on this side of the watershed that separates us from Goethe's period. In his time the history of art was most of all concerned with the perfect models it offered to budding artists. Goethe himself, as we know, had wooed the Muse of Painting for a long time, even if somewhat in vain, and had absorbed in Rome an artistic creed which he wished to pass on to the artists of Germany, who, however, had meanwhile set themselves very different aims. No wonder therefore, that to us, his utterances about art frequently sound dogmatic and one-sided, even where he made an effort to do justice, in his own way, to the views of the younger generations, conclusions which did not earn him much gratitude.[5]

Even so, I have learnt to see that his writings offer us the best approach to nearly forgotten values which were once the common currency of post-Renaissance Europe.

Can anyone seriously doubt that the Old Masters attached importance to subject-matter, regardless of whether we think of Giotto or of Raphael, of Rembrandt or of Delacroix? And is there any visitor to a gallery who cannot

have noticed what importance the struggle for the rendering of appearances, the impression of space, the effects of light and shade, of reflection and colour played in the history of Western art? Who saw as clearly as Goethe did, that the artist could never win this contest by simply transcribing the motifs of nature, but only by re-creating them on the canvas, and by incessantly examining their effects?[6]

For Goethe, contact with the new-created world of art was a necessity of life which later he satisfied by collecting: 'Please send me the engravings which you wanted to select for me,' he wrote to his friend Heinrich Meyer;[7] 'I am need of such friendly spirits which rise up to us from the depths of the art of the past.' I am even convinced that Goethe was also right when he did not want to explain the action of these 'friendly spirits', because, as he wrote:

> A genuine work of art, no less than a work of nature, will always remain infinite to our reason: it can be contemplated and felt, it affects us, but it cannot be fully comprehended, even less than it is possible to express its essence and its merits in words.[8]

To me, such a refusal seems infinitely more fruitful than many futile attempts to veil our helplessness in these questions with mysterious mumbo-jumbo. Goethe even came close to explaining the inexplicable character of works of art when he wrote: 'In speaking of a first-class work of art, it is almost necessary to speak of the whole of art.'[9] I think that this necessity is due to the fact that any artist, whether he is a musician or poet, architect or painter, must always make a selection from the means of his medium. In which case it not only matters which of them he decides to use, but also, which he rejects. Through both these choices he plays on our expectations, which have been formed through our commerce with the whole of art, and are, therefore, also determined by our personal likes and dislikes.

Here, too, 'the elements cannot be separated out from the compound.' The words Goethe used about the influence of his ancestors on his own mental and physical constitution apply no less to his formation and to his thinking. In Goethe's case these connections are particularly open to inspection because he always knew how to account for himself:

> Du hast getollt zu deiner Zeit mit wilden
> Dämonisch genialen jungen Schaaren,
> Dann sachte schlossest du von Jahr zu Jahren
> Dich näher an die Weisen, göttlich-milden.[10]

(After indulging early in the wild
Demonic-genius cult of boisterous youth
You later slowly searched for higher truth
By turning to the wise divinely-mild.)

The turn of Goethe's taste from Gothic to Neoclassicism, which I mentioned before, could hardly have been described more succinctly; but I should like to add that 'taste' seems to me an inadequate expression to describe our relation to art, which, after all, is bound up by a thousand threads with our very nature. Consider, for example, all the reverberations of the words *wild* and *mild* which Goethe had chosen here: we speak of *wild* beasts, but also of a *wild* dance, and a *mild* climate, but also of a *mild* punishment. In these last instances, where mildness merges with goodness, and wildness with violence, we find ourselves suddenly in the domain of human values which cannot, and must not, be merely a matter of taste. The more profoundly these values have taken root in our nature the more easily they may also influence our opinions. In this way, for instance, ideals which Goethe later adopted in his life led him to fight, in his geological studies, against the Vulcanists and for the Neptunists.

A modern geologist would be right if he said that Goethe should rather have examined the arguments objectively, but what I am driving at here is that in matters of art (in contrast with the natural sciences), there may be debates, but there can be no objective arguments; not really because they concern matters of taste, but precisely because our response to art has become inseparable from our culture and our accumulated experience.

Goethe, of course, was fully aware of these connections when he wrote in a more light-hearted vein:

Nicht Jeder kann Alles ertragen:
Der weicht Diesem, der Jenem aus:
Warum soll ich nicht sagen:
Die indischen Götzen, die sind mir ein Graus.
Nichts schreklicher kann dem Menschen geschehn,
Als das Absurde verkörpt zu sehn.[11]

(Not everything is to everyone's taste:
One sight or another, avoid we all must:
Why may I not say: If the facts should be faced,
That the idols of India arouse my disgust.
For nothing more dreadful can happen to me
Than the absurd embodied to see.)

It must be an open question whether Goethe was really thinking of Indian art, or rather of the works of his contemporaries. To me in any case, these utterances are precious, not because I happen to share all Goethe's prejudices, but because they strengthen my conviction that, in the domain of art, there can be no moral obligation to tolerate everything. I remember that Goethe also wrote in *Faust*:

> *Was euch nicht angehört,*
> *Müsset ihr meiden,*
> *Was euch das Innre stört,*
> *Dürft ihr nicht leiden.*[12]

> (What does not suit your mind
> You need not bear,
> What you disturbing find,
> Of that beware.)

Is it arrogance which makes me say that this has been my attitude throughout my life? An attitude that certainly puzzled, and occasionally also annoyed my contemporaries? That even so, you awarded me the Goethe Prize touches me profoundly.

The Goethe Prize of the city of Frankfurt-am-Main was founded in 1927, and is now awarded every three years. Among previous recipients are Albert Schweizer, Sigmund Freud, Thomas Mann, Max Planck and Raymond Aaron. The ceremony takes place in the historic Paulskirche of Frankfurt on Goethe's birthday, 28 August. The award is conferred by the Oberbürgermeister.

Editor's Postscript

An essay related to this in content is 'Reason and Feeling in the Study of Art' reprinted in Ideals and Idols. *On Goethe see also 'Understanding Goethe',* Art History, *5 (1982), pp. 237-42; 'Goethe and the History of Art. The Contribution of Heinrich Meyer',* Publications of the English Goethe Society, *n.s. 60 (1991), pp. 1–19. See also the index to* Reflections on the History of Art, *'Goethe', and p. 614 below, note 5.*

The collected works of Goethe are currently being translated into English and published by Princeton University Press. See, for example, Johann Wolfgang von Goethe, Essays on Art and Literature, *ed. John Gearey, trans. Ellen and Ernest von Nardorff (Princeton, 1986).*

Notes

Introduction

1 'Botticelli's Mythologies' and 'Icones Symbolicae', reprinted in *Symbolic Images*.
2 'An Autobiographical Sketch', reprinted in this volume, p. 34.
3 See above, p. 588.
4 *The Story of Art*, 16th edn. (1995), p. 405.
5 *The Story of Art*, p. 595.
6 *American Journal of Psychology*, 73 (1960), p. 654. Readers with a specialist interest in perception should consult Richard Woodfield (ed.), *Gombrich on Art and Psychology* (Manchester 1996).
7 Review of Gombrich's *New Light on Old Masters*, *Apollo* (January 1987), p. 75.
8 See Clark's autobiographical volume *Another Part of the Wood* (London, 1974), pp. 108, 114.
9 Review of Charles Morris, *Signs, Language and Behavior* (New York, 1946), reprinted in *Reflections on the History of Art*, p. 246.
10 See 'The Ambivalence of the Classical Tradition: The Cultural Psychology of Aby Warburg' in *Tributes*, pp. 123–4.

Part I

An Autobiographical Sketch
1. See *Adolf Busch*, a centenary volume edited by Irene Serkin-Busch, with a preface by E. H. Gombrich (Walpole, New Hampshire, 1991).
2. *Klassiker der Kunst in Gesamtausgaben* is a series of monographs illustrating the complete *œuvre* of individual masters, published in the early years of this century (Deutsche Verlags-Anstalt, Stuttgart and Leipzig). *Knackfuss Künstler Monographien* cover a wider range, with fuller text and more selective illustrations (Verlag Velhagen, Klasing, Bielefeld and Leipzig).
3. M. Dvořák, *Kunstgeschichte als Geistesgeschichte, Studien zur abendländischen Kunstentwicklung* (Munich, 1924).
4. H. Schrader, *Phidias* (Frankfurt am Main, 1924).
5. W. Waetzoldt, *Deutsche Kunsthistoriker*, 2 vols, Leipzig, 1921–4.
6. J. Strzygowski, *Early Church Art in Northern Europe, with Special Reference to Timber Construction and Decoration* (London, 1928).
7. J. Schlosser, *Die Kunstliteratur: ein Handbuch zur Quellenkunde der neueren Kunstgeschichte* (Vienna, 1924). The comprehensive bibliography in the Italian edition, *La Letteratura Artistica* (1935), was brought up to date in 1956 by Otto Kurz. There is now also a French edition.
8. E. H. Gombrich, 'Eine verkannte karolingische Pyxis im Wiener Kunsthistorischen Museum', *Jahrbuch der kunsthistorischen Sammlungen in Wien*, N. F. 7 (1933), pp. 1–14.
9. A. Riegl, *Stilfragen* (Berlin, 1893). See also *The Sense of Order*, pp. 180–90.

10. K. von Amira, *Die Dresdener Bilderhandschrift des Sachsenspiegels* (Leipzig, 1902).

11. 'Ritualized Gesture and Expression in Art', *The Image and the Eye*, pp. 63–77.

12. The chapter dealing with the Palazzo del Tè and other extracts were published under the title 'Zum Werke Giulio Romanos' in the *Jahrbuch der kunsthistorischen Sammlungen in Wien*, Neue Folge 8 (1934), and 9 (1935). See also essays on Giulio Romano in *New Light on Old Masters*, pp. 147–70, and above, pp. 401–10.

13. E. Kris, *Die Gemmen und Kameen im Kunsthistorischen Museum; Beschreibender Katalog* (Vienna, 1927). See also the essay on Kris in *Tributes*, pp. 221–33.

14. E. H. Gombrich and E. Kris, *Caricature* (Harmondsworth, 1940), and E. H. Gombrich and E. Kris, 'The Principles of Caricature' *British Journal of Medical Psychology*, 17 (1938), included in E. Kris, *Psychoanalytic Explorations in Art* (New York, 1952).

15. See *Aby Warburg: an Intellectual Biography*.

16. See E. H. Gombrich, 'The Warburg Institute, A Personal Memoir', *The Art Newspaper*, 2 November 1990, p. 9.

17. Olive Renier and Vladimir Rubinstein, *Assigned to Listen*, with a preface by E. H. Gombrich, BBC Publications (London, 1986).

18. 'Botticelli's Mythologies' in *Symbolic Images*.

18a. *Eine kurze Weltgeschichte für junge Leser* (Vienna, 1936; revised edition, Cologne, 1985).

19. *The Story of Art*.

20. A. W. Mellon Lectures in the Fine Arts, given 1956.

21. *Art and Illusion: A Study in the Psychology of Pictorial Representation*.

22. *The Sense of Order*.

23. See 'The Primitive and its Value in Art', reprinted above, pp. 295–330.

Part II

The Visual Image: its Place in Communication

1. *The Sense of Order*, chapter 9.

2. See 'Light and Highlights' in *The Heritage of Apelles*.

3. Frances Yates, *The Art of Memory* (London, 1966).

4. Walter and Marion Dietholm, *Signet, Signal, Symbol* (Zurich, 1970); see in particular pp. 23–31.

5. W. M. Ivins, Jr., *Prints and Visual Communication* (Cambridge, MA and London, 1953).

6. *Art and Illusion*, chapter 2.

7. Gottfried Spiegler, *Physikalische Grundlagen der Röntgendiagnostik* (Stuttgart, 1957).

8. 'The Form of Movement in Water and Air' in *The Heritage of Apelles*.

9. For an appreciation of the contribution of the Neuraths see Lancelot Hogben, *From Cave Painting to Comic Strip* (New York, 1949).

10. *Symbolic Images*.

11. 'The Cartoonist's Armoury' in *Meditations on a Hobby Horse*.

12. Sigmund Freud, *Der Witz und seine Beziehung zum Unbewussten* (Vienna, 1905) (*Jokes and their Relation to the Unconscious*, Vol. 8 of The Standard Edition (London, 1953–74), translated by James Strachey), and Ernst Kris, *Psychoanalytic Explorations in Art* (New York, 1952), especially chapter 6.

13. *Symbolic Images*.

14. 'Expression and Communication' in *Meditations on a Hobby Horse*.

15. Reinhard Krauss, 'Über den graphischen Ausdruck', in *Beihefte zur Zeitschrift für angewandte Psychologie*, 48 (Leipzig, 1930).

Part III

Psychology and the Riddle of Style

1. 'Da das Kunstschaffen, was es sonst immer sei, jedenfalls ein seelisch-geistiger Vorgang ist, muss die Wissenschaft von der Kunst Psychologie sein. Sie mag auch etwas anderes sein, Psychologie ist sie unter allen Umständen.' Friedländer, *Von Kunst und Kennerschaft* (Oxford and Zurich, 1946), p. 128. (Cf. tr. Tancred Borenius, *On Art and Connoisseurship* (London, 1942, 1943), p. 145. The translation in the text is by E. H. Gombrich.)

2. Heinrich Wölfflin, *Kunstgeschichtliche Grundbegriffe* (Munich, 1915), tr. M. D. Hottinger, *Principles of Art History* (New York and London, 1932), foreword to the 7th German edn.

3. See my predecessors in the Mellon Lectures, especially Étienne Gilson, *Painting and Reality* (New York [Bollingen Series XXXV: 4] and London, 1957), Ch. VIII.

4. Ludwig Wittgenstein, *Philosophical Investigations*, tr. G. E. M. Anscombe (Oxford, 1953), p. 194 (II.II).

5. There is a simple diagram in the *Encyclopaedia Britannica*, 14th edn. (1929), XV, 590; and an illustration of the size illusion in

G. A. Storey, *The Theory and Practice of Perspective* (Oxford, 1910), p. 262.

6. Kenneth Clark, 'Six Great Pictures, 3: "Las Meninas" by Velázquez', *The Sunday Times* (2 June 1957), p. 9.

7. E. H. Gombrich, 'The Tyranny of Abstract Art', *Atlantic Monthly*, April 1958. The title was the editor's; Gombrich's own title was 'The Vogue of Abstract Art'.

8. Plato, *Sophist* 266C, tr. H. N. Fowler (Loeb Classical Library, London, 1921), pp. 450–1. Iconology: Erwin Panofsky, *Studies in Iconology* (New York, 1939).

9. The allusion is to Rembrandt's pupil Samuel van Hoogstraeten, who gave his book *Inleyding tot de Hooge Schoole der Schilderkonst* (Rotterdam, 1678) the subtitle *De zichtbare Werelt* (The Visible World). According to Houbraken he planned a sequel, *De onzichtbaere Werelt* (The Invisible World), that would have dealt with religious and secular imagery.

10. Frédéric Schmid, *The Practice of Painting* (London, 1948), on eighteenth-century works. For further bibliography see *Art and Illusion*, ch. V.

Truth and the Stereotype

1. 'Dieser Schematismus unseres Verstandes, in Ansehung der Erscheinungen … ist eine verborgene Kunst in den Tiefen der menschlichen Seele, deren wahre Handgriffe wir der Natur schwerlich jemals abraten … werden.' Kant, *Kritik der reinen Vernunft* (Riga, 1787), pp. 180–1. Ludwig Richter (Adrian Ludwig), *Lebenserinnerungen eines deutschen Malers*, ed. Heinrich Richter, introd. Ferdinand Avenarius (Leipzig, 1909), pp. 176–7. The passage is also referred to in the beginning of Heinrich Wölfflin's *Principles of Art History*.

2. Emile Zola, *Mes Haines* (Paris, 1866); see *Collection des œuvres complètes Emile Zola* (Paris, n.d.), 23, p. 176.

3. See John Rewald's comparisons of Cézanne's paintings, with photographs of his subjects, in *Art News*, 43 (1944), Nos. 1, 11, 12, and a similar treatment of Van Gogh's motifs in the *Art News Annual*, 19 (1949). Also Erle Loran, *Cézanne's Compositions* (2nd edn., Berkeley, CA, 1946) and Josiah de Gruyter, *Vincent van Gogh* (The Hague, 1953). For a deliberate challenge to the camera, see Pietro Annigoni and Alex Sterling, *Spanish Sketchbook* (London, 1957).

4. One of the first to protest against the naïve assumption that the mind looks at this image was Thomas Reid, *An Inquiry into the Human Mind, on the Principles of Common Sense* (Edinburgh, 1764).

5. George Inness, Jr., *Art and Letters of George Inness* (New York, 1917), as quoted in *Great Paintings from the National Gallery of Art*, ed. Huntington Cairns and John Walker (New York, 1953), p. 174.

6. A strict definition of statement and, therefore, of truth, is only possible in what is called a 'formalized' language, as has been first shown in a famous paper by Alfred Tarski, 'The Concept of Truth in Formalized Languages', now available tr. by J. H. Woodger in A. Tarski, *Logic, Semantics, Meta-Mathematics* (Oxford, 1956).

7. Arthur Ponsonby, *Falsehood in War-time* (New York and London, 1928), pp. 135–9.

8. The reference is to Ernst Haeckel; see Richard B. Goldschmidt, *Portraits from Memory* (Seattle, 1956), p. 36.

9. See review by E. H. Gombrich of Charles W. Morris, *Signs, Language and Behavior* (New York, 1946), reprinted in *Reflections on the History of Art*.

10. George S. Layard, *Catalogue Raisonné of Engraved British Portraits from Altered Plates* (London, 1927).

11. V. von Loga, 'Die Städteansichten in Hartman Schedel's Weltchronik', *Jahrbuch der preussischen Kunstsammlungen*, 9 (1888). This was one of the favourite examples of Julius von Schlosser; see his 'Portraiture', *Mitteilungen des österreichischen Instituts für Geschichtsforschung*, Ergänzungsband 11 (Festschrift zu Ehren Oswald Redlichs; 1929), pp. 882–94.

12. See the work of Julius von Schlosser discussed in note 11, and also 'Zur Kenntnis der künstlerischen Überlieferung im späten Mittelalter', *Jahrbuch der kunsthistorischen sammlungen in Wien*, 23 (1903), p. 279, and *Die Kunst des Mittelalters*, ed. A. E. Brinckmann (Berlin, 1923).

13. R. S. Woodworth and Harold Schlosberg, *Experimental Psychology* (New York, 1954; London, 1955), p. 715. A somewhat fuller account is contained in the earlier edition of Woodworth, *Experimental Psychology* (New York, 1938; London, 1939), pp. 73 ff., based on an article by F. Kuhlmann, *Psychological Review*, 13 (1906), pp. 316–48. The importance of this

formula was stressed by D. O. Hebb, *The Organization of Behavior* (New York and London, 1949), pp. 46 and 111.

14. O. L. Zangwill, 'An Investigation of the Relationship between the Processes of Reproducing and Recognizing Simple Figures, with Special Reference to Koffka's Trace Theory', *British Journal of Psychology*, 27 (1937), pp. 250–75.

15. L. C. Carmichael, H. P. Hogan, and A. A. Walter, 'An Experimental Study of the Effect of Language on Visually Perceived Form', *Journal of Experimental Psychology*, 15 (1932), pp. 73–86. For a critical discussion of their findings, see W. C. H. Prentice, 'Visual Recognition of Verbally Labelled Figures', *The American Journal of Psychology*, 67 (June 1954), pp. 315–20.

16. F. C. Bartlett, *Remembering: A Study in Experimental and Social Psychology* (Cambridge, 1932), p. 180; see also J. J. Gibson, *The Perception of the Visual World* (Boston, MA, 1950), pp. 209–10.

17. Bartlett (see note 16), p. 19.

18. Julius von Schlosser, 'Zur Genesis der mittelalterlichen Kunstanschauung' (1901), in *Präludien* (Berlin, 1927), p. 198; André Malraux, *The Voices of Silence* (New York, 1953), pp. 132–44; see also R. Bianchi Bandinelli, *Organicità e astrazione* (Milan, 1956), pp. 17–40, the source of our illustration.

19. Walter Wreszinski, *Atlas zur altägyptischen Kulturgeschichte* (Leipzig, 1923), 2, p. 226, with a translation of the inscription.

20. Hans R. Hahnloser, *Villard de Honnecourt* (Vienna, 1935); see also Schlosser, in *Präludien*, p. 199, and his *Die Kunst des Mittelalters*, p. 83.

21. A. B. van Deinse, 'Over de potvissen in Nederland gestrand tussen de jaren 1531–1788', *Zoologische Mededeelingen . . . s' Rijks Museum van Natuurlijke Historie te Leiden*, 4 (1918). The drawing for our print by Goltzius, now in the Teylers Stichting, Haarlem, is listed in the catalogue of the exhibition *H. Goltzius als Tekenar*, Museum Boymans Rotterdam (May/July 1958), as No. 90 (with full bibliography).

22. F. J. Cole, 'The History of Albrecht Dürer's Rhinoceros in Zoological Literature', *Science, Medicine, and History* (Essays Written in Honour of Charles Singer), ed. E. Ashworth Underwood (New York and London, 1953), 1, pp. 337–56.

23. James Bruce, *Travels to Discover the Sources of the Nile in the Years 1768, 1769, 1770, 1771, 1772 and 1773* (Edinburgh, 1790), 5, pp. 86–7.

24. A. E. Popham, 'Elephantographia', *Life and Letters*, 5 (1930), and in *The Listener* (24 April 1947).

25. Franciscus Junius, *The Painting of the Ancients* (London, 1638), p. 234.

26. W. Reitsch, 'Das Dürer-Auge', *Marburger Jahrbuch für Kunstwissenschaft*, 4 (1928), pp. 165–200.

27. K. D. Keele, *Leonardo da Vinci on the Movement of the Heart and Blood* (London, 1952).

28. William M. Ivins, Jr., *Prints and Visual Communication* (Cambridge, MA and London, 1953); Claus Nissen, *Die naturwissenschaftliche Illustration* (Bad Münster am Stein, 1950), with rich bibliography.

29. The allusion is to Chiang Yee's beautiful book *The Chinese Eye* (London, 1935).

30. F. W. Nietzsche, *Scherz, List und Rache* no. 55, in *Die fröhliche Wissenschaft, Nietzsche' Werke*, 5 (Leipzig, 1895), p. 28. The German reads: *'Treu die Natur und ganz!'–Wie fängt er's an: Wann wäre je Natur im Bilde abgethan? Unendlich ist das kleinste Stück der Welt!– Er malt zuletzt davon, was ihm gefällt. Und was gefällt ihm? Was er malen kann!*

31. See the beautiful chapter on 'Individualität und Typus' in Max J. Friedländer, *Von Kunst und Kennerschaft*, pp. 74–6 (tr. Tancred Borenius, pp. 85–6).

32. André Malraux, *The Voices of Silence*, pp. 315ff.

33. For some remarks on the history of this distinction, see the lecture by E. H. Gombrich on 'Lessing' in the series on Master Minds, in *Proceedings of the British Academy*, 43 (1957), reprinted in *Tributes*, p. 35.

34. Gustaf Britsch, *Theorie der bildenden Kunst*, ed. Egon Kornmann (Munich, 1926, 1930); Rudolf Arnheim, *Art and Visual Perception* (Berkeley, CA, 1954), esp. pp. 128–30. See also Helga Eng, *The Psychology of Children's Drawings* (London, 1937), with rich bibliography.

35. K. R. Popper, 'The Philosophy of Science: a Personal Report', in *British Philosophy in the Mid-Century*, ed. Cecil A. Mace (London, 1957), esp. pp. 171–5.

36. Colin Cherry, *On Human Communication* (Cambridge, MA and London, 1957), p. 85.

37. See W. Sluckin, *Minds and Machines* (Harmondsworth, 1954), pp. 32ff.; Donald

M. McKay, 'Towards an Information-Flow Model of Human Behaviour'. *British Journal of Psychology*, 47:1 (1956), pp. 30–43. Recent applications of related ideas to the theory of perception are surveyed in D. T. Campbell, 'Perception as Substitute Trial and Error', *Psychological Review*, 63 (September 1956), pp. 330–42, and J. S. Bruner, 'On Perceptual Readiness', *Psychological Review*, 64:2 (1957), p. 64; to expression, in Rene A. Spitz, *No and Yes* (New York, 1957), pp. 15ff.

38. O. G. Selfridge, 'Pattern Recognition and Learning', *Information Theory* (Papers read at a symposium on information theory held at the Royal Institution, London, September 12–16, 1955), ed. Colin Cherry (New York and London, 1956), p. 349.

39. *The Sunday Pictorial* (London), 14 May 1950, p. 9; the name of the artist referred to is Al Valanis. A more recent instance was reported and illustrated in *The New York Times*, 5 August 1958, p. 28.

40. Stephen Ullmann, *The Principles of Semantics* (Glasgow, 1951), with rich bibliography. See now also C. Rabin, 'The Linguistics of Translation', *Aspects of Translation*, Studies in Communication 2 (The Communication Research Centre, University College, London, 1958).

41. B. L. Whorf, *Language, Thought and Reality*, ed. John B. Carroll (Cambridge, MA, 1956). For a critical discussion of Whorf's views, see C. Levi-Strauss, R. Jakobson, C. F. Voegelin, and T. A. Seboek, 'Results of the Conference of Anthropologists and Linguists' (in Bloomington, Indiana), *International Journal of American Linguistics*, 19 (April 1953).

Action and Expression in Western Art
1. See *Art and Illusion*; 'The Leaven of Criticism in Renaissance Art' in *The Heritage of Apelles*; and 'Visual Discovery through Art' in *The Image and the Eye*.
2. See E. H. Gombrich, 'Moment and Movement in Art' in *The Image and the Eye*, pp. 40–62.
3. K. Bühler, *Ausdruckstheorie* (Jena, 1933).
4. J. J. Engel, *Ideen zu einer Mimik* (Berlin, 1785–6). Letter XIV, translation by E. H. Gombrich.
5. Ibid. Letter XXVI.
6. Ibid. Letter XX.
7. Ibid. p. 131.

8. In 'Moment and Movement in Art', pp. 40–2.
9. Heinrich Schäfer, *Principles of Egyptian Art*, transl. John Baines (Oxford, 1974), with a Foreword by E. H. Gombrich.
10. For a bibliography of symbolic gestures see Desmond Morris, Peter Collett, Peter Marsh, and Marie O'Shaughnessy, *Gestures, their Origins and Distribution* (London, 1979).
11. See 'Ritualized Gesture and Expression in Art' in *The Image and the Eye*, pp. 63–77.
12. H. A. Groenewegen-Frankfort, *Arrest and Movement* (London, 1951).
13. John Carter, 'The Beginning of Narrative Art in the Greek Geometric Period', in *Annual of the British School of Archaeology at Athens*, 67 (1972), pp. 25–58, has taken the hypothesis I put forward in *Art and Illusion* as a starting-point for his analysis.
14. See 'Moment and Movement in Art'.
15. W. Deonna, *L'Expression des sentiments dans l'art grec* (Paris, 1914); G. Neumann, *Gesten und Gebärden in der griechischen Kunst* (Berlin, 1965).
16. E. Buschor, *Griechische Vasenmalerei* (Munich, 1921); P. E. Arias, *A History of Greek Vase Painting* (New York and London, 1961); and John Boardman, *Athenian Red Figure Vases* (London, 1975).
17. Xenophon, *Memorabilia*, III.x.1–5, ed. E. C. Marchant (1923).
18. Jennifer Montagu, 'Charles Le Brun's *Conférence sur l'expression*', unpublished PhD thesis, University of London, 1960.
19. H. A. Murray (Boston, MA, 1943).
20. J. Montagu, op. cit. (note 18).
21. This example is taken from a series of experiments made at Karl Bühler's seminar in Vienna in the early 1930s in which I took part as a subject. I was introduced to these studies by Ernst Kris, who also organized a series of experiments on the reading of facial expression in art. I have applied these insights in 'Botticelli's Mythologies' (in *Symbolic Images*), where the divergent interpretations of the expression of Venus in the *Primavera* are quoted, and in 'The Evidence of Images: The Priority of Context over Expression' (in *Interpretation*, ed. C. S. Singleton, Baltimore, MD, 1969), which centres on the various interpretations of a figure in one of Hieronymus Bosch's compositions.
22. R. Brilliant, *Gesture and Rank in Roman Art*, *Mem. Conn. Acad. Arts Sci.*, 14 (1963).

23. See the review by E. H. Gombrich of J. Bodonyi, 'Entstehung und Bedeutung des Goldgrundes', in *Kritische Berichte zur kunstgeschichtlichen Literatur*, 5 (1935), pp. 66–75.

24. See *The Story of Art* and *Means and Ends: Reflections on the History of Fresco Painting* (London, 1976), and also 'The Visual Image: Its Place in Communication', pp. 41–64 above.

25. See 'Moment and Movement in Art'.

26. Michael Baxandall, *Painting and Experience in Fifteenth-Century Italy* (Oxford, 1972) discusses a sermon dealing with the sequence of emotions expressed in the episode of the Annunciation.

27. L. B. Alberti, *De Pictura* (*c.* 1435), ed. Cecil Grayson (London, 1972), section 44.

28. Filarete, *Treatise on Architecture* (*c.* 1460), ed. J. R. Spencer (New Haven and London, 1965).

29. Leonardo da Vinci, *Treatise on Painting, Codex Urbinas Latinus 1270*, ed. A. P. McMahon, II, Facsimile (Princeton, 1956), p. 58.

30. *Cod. Urb.* fol.33.

31. Ibid. (*Cod. Urb.* fol. 33).

32. J. W. Goethe, 'Joseph Bossi über Leonardo da Vincis Abendmahl', in *Über Kunst und Alterthum*, 1 (1817), p. 3.

33. See my 'Ritualized Gesture and Expression in Art' in *The Image and the Eye*, pp. 69–70.

34. E. Mâle, *L'Art religieux après le Concile de Trente* (Paris, 1932).

35. André Félibien, *Entretiens sur les ouvrages des peintures*, 2 (Paris, 1968), pp. 407–27.

36. S. Ringbom, *Icon to Narrative* (Åbo, 1965).

37. K. Clark, 'Motives', in *Acts of the Twentieth International Congress of the History of Art at New York*, 4 (1961) (Princeton, 1963).

38. But see C. Nordenfalk, 'Tizians Darstellung des Schauens', in *Nationalmusei Arsbok* (1947–8).

39. See E. H. Gombrich, *Ideas of Progress and their Impact on Art* (New York, 1971). Privately circulated.

40. R. Lister, *Victorian Narrative Painting* (New York, 1966).

41. See 'Expression and Communication' in *Meditations on a Hobby Horse* and also 'Ritualized Gesture and Expression in Art', in *The Image and the Eye*.

42. See E. H. Gombrich, 'Four Theories of Artistic Expression' in *Architectural Association Quarterly*, 12:4 (1980).

Illusion and Art

1. Plato, *Republic* X, 602–3; see E. H. Gombrich, 'Illusion and Art', in R. L. Gregory and E. H. Gombrich, *Illusion in Nature and Art* (London, 1973), pp. 193–4.

2. E. H. Gombrich, 'Action and Expression in Western Art', pp. 113–38 above.

3. R. R. Ward, *The Living Clocks* (London, 1972).

4. H. E. Hinton, 'Natural Deception', in R. L. Gregory and E. H. Gombrich, *Illusion in Nature and Art*.

5. E. H. Gombrich, 'Visual Discovery through Art', *Arts Magazine* (November 1967), reprinted in J. Hogg (ed.), *Psychology and the Visual Arts* (Harmondsworth, 1969).

6. See E. H. Gombrich, *The Heritage of Apelles*, pp. 3–19.

7. E. H. Gombrich, *Art and Illusion*, p. 304.

8. E. H. Gombrich, 'The Mask and the Face: the Perception of Physiognomic Likeness in Life and in Art' in *The Image and Eye*.

9. O. Koenig, *Kultur und Verhaltensforschung* (Munich, 1970).

10. E. H. Gombrich, 'Visual Discovery through Art', and N. Tinbergen, *Social Behaviour in Animals* (London, 1953), p. 95.

11. E. H. Gombrich, *The Story of Art*, p. 46.

12. R. Gombrich, 'The Consecration of a Buddhist Image', *Journal of Asian Studies*, 26, 1 (1966), pp. 22–36.

13. R. Gombrich, *Precept and Practice: Traditional Buddhism in the Rural Highlands of Ceylon* (Oxford, 1971).

14. E. H. Gombrich, 'The "What" and the "How": Perspective Representation and the Phenomenal World', in R. Rudner and I. Scheffler (eds.), *Logic and Art: Essays in Honor of N. Goodman* (New York, 1972).

15. E. H. Gombrich, 'Visual Discovery through Art', and 'The Leaven of Criticism in Renaissance Art', in *The Heritage of Apelles*.

16. S. E. Kaden, S. Wapner and H. Werner, 'Studies in Physiognomic Perception II: the Effect of Directional Dynamics of Pictured Objects and of Words on the Position of the Apparent Horizon', *Journal of Psychology*, 39 (1955), pp. 61–70; and E. H. Gombrich, 'Moment and Movement in Art', in *The Image and the Eye*.

17. R. H. Thouless, 'Perceptual Constancy or Perceptual Compromise', *Australian Journal of Psychology*, 24:2 (1972), pp. 133–40.

18. E. H. Gombrich, *Art and Illusion*, p. 4; and E. H. Gombrich, 'The Sky is the Limit: the Vault of Heaven and Pictorial Vision' in *The Image and the Eye*.

19. E. H. Gombrich, op. cit. (notes 5, 14, 18); and R. L. Gregory, *Eye and Brain: The Psychology of Seeing* (London and New York, 1966).

20. K. R. Adams, 'Perspective and the Viewpoint', *Leonardo*, 5 (1967), pp. 214f.

21. E. H. Gombrich, 'The "What" and the "How"' (note 14).

22. J. J. Gibson, 'The Information Available in Pictures', *Leonardo* 4 (1966), pp. 27–35 and 195–9.

23. E. Kris and O. Kurz, *Die Legende vom Künstler, Ein geschichtlicher Versuch* (Vienna, 1934).

24. R. L. Gregory, *The Intelligent Eye* (London and New York, 1970).

25. E. H. Gombrich, 'The Evidence of Images I: The Variability of Vision', in C. S. Singleton (ed.), *Interpretation: Theory and Practice* (Baltimore, 1969); Tinbergen, *Social Behaviour in Animals*, pp. 48, 61f.

26. J. Hochberg, 'The Representation of Things and People' in *Art, Perception and Reality* (Baltimore, 1972); and E. H. Gombrich, 'Perception and Visual Deadlock' in *Meditations on a Hobby Horse*.

27. U. Neisser, *Cognitive Psychology* (New York, 1967).

28. E. H. Gombrich, *Art and Illusion*.

29. Jan B. Deregowski, 'Illusion and Culture', in R. L. Gregory and E. H. Gombrich (eds.), *Illusion in Nature and Art* (London, 1973), pp. 161–93.

The Use of Colour and its Effect

1. R. Kudielka, 'The Paintings of the Years 1982–1992', in *Bridget Riley, Paintings 1982–1992*, exh. cat. (Nuremberg and London, 1992), p. 32.

2. 'Bridget Riley in conversation with Robert Kudielka', in *Bridget Riley, Paintings and Drawings, 1961–1973*, exh. cat. (London, 1973), p. 13.

3. C. Blanc, 'Eugène Delacroix', *Gazette des Beaux-Arts* (October 1864), p. 6.

4. J. Ruskin, *The Elements of Drawing* (London, 1857), letter 3, section 153 and footnote to section 240.

5. S. Zeki, 'The Visual Image in Mind and Brain', *Scientific American* (Sept. 1992), pp. 43–50.

6. E. A. Piron, *Eugène Delacroix. Sa Vie et ses oeuvres* (Paris, 1865), pp. 416–18.

Part IV

The Necessity of Tradition

1. For a portrait of Schlosser see also the essay on Otto Kurz in *Tributes*, pp. 235–49.

2. Benedetto Croce, *The Breviary of Aesthetics*, originally published in 1915. The quotation, no. 4, vol. 2, p. 47.

3. 'Ars Poetica' in I. A. Richards, *New and Selected Poems* (Manchester, 1978).

4. See also 'Focus on the Arts and Humanities', in *Tributes*, pp. 22–3.

5. See E. H. Gombrich, 'Illusion and Art' in R. L. Gregory and E. H. Gombrich, *Illusion in Nature and Art* (London, 1973) and pp. 136–60 above.

6. See also 'Visual Discovery Through Art' in *The Image and the Eye*, especially p. 25.

7. This is also discussed in the essay 'Reason and Feeling in the Study of Art' in *Ideals and Idols*.

8. For more on this subject see 'Ritualized Gesture and Expression in Art' in *The Image and the Eye*.

9. Xenophon, *Memorabilia*, III.x.8.

10. See E. H. Gombrich, 'Freud's Aesthetics' in *Reflections on the History of Art*.

11. *Encounter*, 53 (1979), pp. 10–14.

12. Lorenz Eitner, 'Art History and the Sense of Quality', *Art International* (May 1975).

Verbal Wit as a Paradigm of Art

1. M. H. Abrams, *The Mirror and the Lamp* (Oxford, 1953). See also E. H. Gombrich, 'Four Theories of Artistic Expression' in *Architectural Association Quarterly*, 12, 4 (1980).

2. Letter, 1 November 1914.

3. Sigmund Freud, *Gesammelte Werke*, ed. Anna Freud, 14 (Frankfurt am Main, 1940–68), p. 91.

4. E. H. Gombrich, 'Freud's Aesthetics' in *Reflections on the History of Art*.

5. Letter, 8 July 1915.

6. Letter, 26 December 1922.

7. See the essay on Kris in *Tributes*, pp. 221–33.

8. 'Ist das nicht der rote Fadian, der sich durch die Geschichte der Napoleoniden zieht?'

9. *Gesammelte Werke*, 6, p. 204.

10. *Gesammelte Werke*, 6, p. 146.

11. Letter, 16 April 1909.

12. *Gesammelte Werke*, 10, p. 172.

13. Letter to Lou Andreas-Salomé, 10 July 1931.

14. Letter, 20 July 1929

15. Letter, 24 September 1907.

16. 'Warum kann der lebendige Geist dem Geist nicht erscheinen? *Spricht die Seele, so spricht, ach! schon die Seele nicht mehr.*'

17. Interestingly enough the Russian novelist knew how to have it both ways. He knew that the type was prefigured in art, and so he continued his description of Leonardo's mother quoted above as follows: 'Once, in Florence, in the museum of San Marco, in the gardens of the Medici, he saw a statue which had been found in Arezzo, an olden city of Etruria, a litter copper Cybele, the immemorially ancient goddess of the Earth, with the same strange smile as that of the young village girl of Vinci – his mother.' D. S. Merezhkovsky, *The Romance of Leonardo da Vinci* (1903). In this way Walter Pater's famous description of the *Mona Lisa* as 'older than the rocks' could be effortlessly fitted into the story of Leonardo's life.

18. Ernest Jones, *The Life and Work of Sigmund Freud* (1953–7), vol. 3, p. 441.

19 . Letter, 7 November 1914.

20. *Gesammelte Werke*, 14 (1940–68), p. 437–8.

Leonardo's Method for Working out Compositions

1. Bernard Berenson, *The Drawings of the Florentine Painters*, 3 vols (Chicago, 1938).

2. 'O tu componitore delle istorie non membrifficare con terminati lineamenti le membrifficationi d' esse istorie che t' entervera come a molti e vari pittori intervenire suole li quali vogliano che ogni minimo segno di carbone sia valido e questi tali ponno bene acquistare richezze ma non laude della sua arte, perche molte sono le volte, che lo animale figurato non a li moti delle membra apropriate al moto mentale e havendo lui fatta bella e grata membrifficatione ben finita li parra cosa ingiuriosa a trasmutare esse membra piu alte o basse o piu indietro che inanzi e questi tali non sonno merittevoli d' alcuna laude nella sua sientia.' (Leonardo Da Vinci, *Treatise on Painting, Codex Urbinas Latinus 1270*, ed. A. P. McMahon, II, Facsimile (Princeton, 1956), fols. 61v–62r).

3. Giorgio Vasari, *Le vite de' piu eccellenti pittori, scultori ed architettori*, ed. G. Milanesi, 1 (Florence, 1878), p. 383.

4. The line is not quite unaided as it is based on a preliminary tracing from which it deviates slightly, but even the earlier one shows no *pentimenti*.

5. Cennino Cennini, *Il libro dell' arte*, edited by D. V. Thompson Jr. (New Haven, 1932). Apparently only the apprentice should rub out his fumbling beginnings (op. cit., p. 17).

6. R. Oertel, 'Wandmalerei und Zeichnung in Italien, die Anfänge der Entwurfszeichnung und ihre monumentalen Vorstufen', *Mitteilungen des kunsthistorischen Instituts in Florenz*, 5 (1940), pp. 217–314.

7. B. Degenhart, *Italienische Zeichnungen des frühen 15. Jarhhunderts* (Basle, 1949).

8. Even such a slight adjustment as that on Filippo Lippi's drawing of the Crucifixion in the British Museum (A. E. Popham and Philip Pouncey, *Italian Drawings in the Department of Prints and Drawings in the British Museum, The Fourteenth and Fifteenth Centuries* (London, 1950), no. 149) appears to be rather exceptional.

9. Cf. A. E. Popham and Philip Pouncey, op. cit., nos. 87 or 261. On the drawing here illustrated, see B. Degenhart in *Münchner Jahrbuch der bildenden Kunst*, 1 (1951), pp. 114–15.

10. 'Hor, non ai tu mai considerato li poeti componitori de lor versi alli quali non da noia il fare bella lettera ne si cura di canzellare alcuni d' essi versi riffaccendoli migliori adonque pittore componi grossamente le membra delle tue figure e' attendi prima alli movimenti apropriati alli accidenti mentali de li animali componitori della storia, che alla bellezza e bonta delle loro membra . . .' (Leonardo da Vinci: ed. cit., fol. 62r).

11. 'Il bozzar delle storie sia pronto, e'l membrificare no' sia troppo finito, sta contento solamente a' siti d' esse membra, i quali poi a' bel' aggio piacendoti potrai finire' (Leonardo da Vinci, ed. cit., fol. 34r).

12. For the background of this development, cf. E. Gombrich and E. Kris, 'The Principles of Caricature' in E. Kris, *Psychoanalytic Explorations in Art* (New York, 1951).

13. 'per che tu hai a' intendere che se tal componimento inculto ti reussira apropriato alla sua inventione tanto maggiormente satisfara essendo poi ornato della perfettione apropriata a' tutte le sue parte. Io ho gia veduto nelli nuvoli e' muri machie, che m' anno deste a belle inventioni di varie cose le quali machie anchora che integralmente fussino in se private di perfectione di

qualonque membro non manchavano di perfectione nelli loro movimenti o altre actioni' (Leonardo da Vinci: ed. cit., fol. 62r).

14. 'una nova inventione di speculatione … a destare le ingegnio a varie inventioni' (Leonardo da Vinci: ed, cit., fol. 35v).

15. E. Kris, op. cit., p. 53.

16. I have discussed some implications of this invention in 'Meditations on a Hobby Horse', reprinted in the volume of that title, pp. 1–11, and also in *The Story of Art*, p. 303.

17. Marilyn Aronberg, 'A New Facet of Leonardo's Working Procedure', *The Art Bulletin*, 33 (1951), p. 235. We may well owe the preservation of many of Leonardo's rough sketches to this habit, inconceivable to earlier workship practice where only the usable pattern was preserved.

18. Luca Beltrami, *Documenti e memorie riguardanti la vita e le opere di Leonardo da Vinci* (Milan, 1919), no. 107.

19. K. Clark, *A Catalogue of the Drawings of Leonardo da Vinci … at Windsor Castle*, no. 12591.

20. 'S' el pittore vol vedere belleze che lo innamovino egli n' e signore di generarle …' (Leonardo da Vinci, ed. cit., fol. 35r).

21. K. Clark, *Leonardo da Vinci* (Cambridge, 1939), esp. p. 66. I have dealt with one aspect of this problem, Leonardo's caricatures, in 'Leonardo's Grotesque Heads: Prolegomena to their Study', *The Heritage of Apelles*, pp. 57–75.

22. 'perche nelle cose confuse l' ingegnio si desta a' nove inventioni, ma fa prima di sapere ben fare tutte le membra di quelle cose che voi figurare come le membra delli animali come le membra de paesi cié sassi piante e' simili' (Leonardo da Vinci, ed. cit, fol. 35v).

23. 'Quello maestro il quale si dessi d'intendere di potere riservare in se tutte le forme, e' li effetti della Natura certo mi parrebbe che quello fussi ornato di molta ingnorantia conciosia cosa che detti effetti son' infiniti, la memoria nostra non e di tanta capacitàe' che basti' (Leonardo da Vinci, ed. cit, fol. 38v).

24. 'attenderai prima col dissegno a' dare con dimostrativa forma al ochio la intentione, e la inventione fatta in prima nella tua imaginativa di poi va lerando e' ponendo tanto che tu ti sadisfacia di poi fa aconciare homini vestiti, o nudi, nel modo che in sul' opera hai ordinato e' fa che per misura e' grandezza sotto posta alla prospettiva che non passi niente del'

opera che bene non sia considerata della ragione e' dalli effetti naturali …' (Leonardo da Vinci, ed. cit., fol. 38v).

25. Leonardo da Vinci, ed. cit., fol. 43v.

26. I have discussed this problem in *Art and Illusion*, chapter III.

27. Leonardo da Vinci, ed. cit., fol. 36v.

Part V

The Force of Habit

1. Edward Burnett Tylor, *Primitive Culture* (1871), chapter 1.

2. Many examples in O. Koenig, *Urmotiv Auge: neuentdecke Grundzüge menschlichen Verhaltens* (Munich, 1975).

3. *Art and Illusion*, chapter III.

4. James Mellaart, 'Çatal Hüyük, a Neolithic city in Anatolia', *Proceedings of the British Academy*, 51 (1965), pp. 201–14 (with illustrations).

5. The relevance of this example for the study of types was stressed by Oscar Montelius, whose illustrations are reproduced in D. Wilson, *The Anglo-Saxons* (London, 1960), p. 14.

6. R. B. Onians, *The Origins of European Thought* (Cambridge, 1954).

7. *Symbolic Images*, pp. 165–8.

8. *Art and Illusion*, chapter X (quoting William James).

9. London, 1963; the quotation on p. 231 comes from p. 3.

10. See below, p. 601, note 10.

11. See 'From the Revival of Letters to the Reform of Art', in *The Heritage of Apelles*.

12. There is a telling example in Peter Meyer, *Das Ornament in der Kunstgeschichte* (Zürich, 1944), pp. 25–6.

13. Giorgio Vasari, *Le Vite de' piu eccellenti pittori, scultori ed architettori*, ed. G. Milanesi (Florence, 1878–85), vol. 7, p. 193.

14. J. von Schlosser, *La Letteratura Artistica* (Florence, 1956), pp. 412 and 421 (see also above, p. 591, 'An Autobiographical Sketch', note 7).

15. 'Knowledge, Belief and Freedom', in Paul A. Weiss (ed.), *Hierarchically Organized Systems in Theory and Practice* (New York, 1971), pp. 231–62.

16. *Aby Warburg: An Intellectual Biography* (London, 1970).

17. W. H. Goodyear: for his life (1846–1923) and work see A. Johnson and D. Malone

(eds.), *Dictionary of American Biography*.

18. Kunstwollen: the debate about the meaning of this term was joined by E. Panofsky, 'Der Begriff des Kunstwollens' (1920), reprinted in his *Aufsätze zu Grundfragen der Kunstwissenschaft* (Berlin, 1967).

19. Flinders Petrie, *Decorative Patterns of the Ancient World* (London, 1930), pls. XXIX–XXXII.

20. Diodorus Siculus, I.98. The account continues: 'So soon as the artisans agree as to the size of the statue, they separate and proceed to turn out the various sizes assigned to them in such a way that they correspond, and they do it so accurately that the peculiarity of that system excites amazement.' Diodorus of Sicily, with English translation by C. H. Oldfather (Loeb Classical Library, London, 1933), p. 339.

21. David R. Olson, *Cognitive Development, the Child's Acquisition of Diagonality* (New York and London, 1970).

22. Discussions after Riegl include: Hans Möbius, *Die Ornamente der griechischen Grabstelen* (Berlin, 1929); Carl Nordenfalk, 'Bemerkungen zur Entstehung des Akanthusornaments', *Acta archaeologica*, 5 (1935); and Roar Hauglid, *Akanthus* (Oslo, 1950). Only the first chapters of this two-volume work deal with the development of the motif outside Norway.

23. Carus Sterne, *Natur und Kunst* (Berlin, 1891), p. 165.

24. See the note by E. H. Gombrich on 'Bonaventura Berlinghieri's Palmettes', *Journal of the Warburg and Courtauld Institutes*, 39 (1976), pp. 234–6, with bibliography.

25. Joan Evans, *Pattern, a Study in Ornament in Western Europe 1180–1900* (Oxford, 1931), Figs. 79–101; Lottlisa Behling, *Die Pflanzenwelt der mittelalterlichen Kathedralen* (Cologne, 1964); Denise Jalabert, *La Flore sculptée des monuments du moyen âge en France* (Paris, 1965).

26. N. Pevsner, *The Leaves of Southwell* (London and New York, 1945).

27. H. Bauer, *Rocaille: zur Herkunft und zum Wesen eines Ornament-Motif* (Berlin, 1962) alludes to the continuities between acanthus, palmette and shell and to the relevant bibliography, but concentrates on their differentiation.

28. This interpenetration was the subject of one of the Slade lectures delivered by Otto Kurz at Oxford in 1970/71 under the title 'Islamic Art between East and West'. It is hoped that they will be published. Cloud bands: These and other motifs are conveniently assembled in Walter A. Hawley, *Oriental Rugs, Antique and Modern* (New York, 1913 and 1970), plate O, p. 291, but the author's discussion in Chapter 6 is perfunctory. For the origins of the cloud band in dragon designs see William Willetts, *Foundations of Chinese Art* (London, 1965), pp. 146–7.

29. So called after the imitation of Kashmir shawls in Paisley. The chapter of Hawley mentioned in the preceding note lists descriptions of the motif as Cone, Palm, Mango, Almond, Riverloop and Pear. Fabio Formento, *Oriental Rugs and Carpets* (London, 1972), p. 69, also mentions the fig, but favours the cypress tree. In Ian Bennett (ed.), *The Country Life Book of Rugs and Carpets* (London, 1978) we also read on p. 340 of 'somewhat fanciful' interpretations such as 'the Flame of Zoroastra, the imprint of a fist on wet plaster or the loop in the river Jumna'. Otto Koenig, *Urmotiv Auge* (see above, note 2) has no difficulty in seeing in the 'botah' the shape of the human eye. The Indian version, correctly called *būtā* (flower), is discussed in John Irwin, *The Kashmir Shawl* (London, 1973).

30. Ferdinand de Saussure (1857–1913): His *Cours de linguistique générale* was published posthumously in 1931.

The Psychology of Styles

1. 'Wie mir immer eine Furcht ankommt, wenn ich eine ganze Nation oder Zeitfolge durch einige Worte charakterisieren höre—denn welch eine ungeheure Menge von Verschiedenheiten fasset das Wort Nation, oder die mittleren Jahrhunderte, oder die alte und neue Zeit in sich!' Johann Gottfried Herder, *Ideen zur Geschichte und Kritik der Poesie und der bildenden Künste, in Briefen*, 1794–6, no. 38, *Sämtliche Werke* (Stuttgart, 1829), *Zur schönen Literatur und Kunst*, vol. 16, p. 74.

2. The article by Barbara Harlow, 'Re-alignment, Alois Riegl's View of Late Roman Art', *Glyph 3*, was not available to me at the time of writing.

3. *Die Wiener Genesis* (Vienna, 1895), published in English as *Roman Art* by E. Strong (London, 1900).

4. 'Ornament as Art', *The Sense of Order*, pp. 33–62.

5. Adolf von Hildebrand, *Das Problem der Form in der bildenden Kunst* (Strasbourg, 1893), published in English as *The Problem of Form in Painting and Sculpture* (New York, 1907).

6. See also the article by E. H. Gombrich on 'style' in the *International Encyclopedia of the Social Sciences* (1968), and the chapter 'Kunstwissenschaft' in M. Hürlimann (ed.), *Das Atlantisbuch der Kunst* (Zürich, 1952).

7. The article is reprinted in H. Damisch (ed.), *Viollet-le-Duc, l'architecture raisonnée* (Paris, 1964). (The passage quoted is on p. 169.) The best point of entry to the vast *œuvre* of the architect is now the catalogue of the exhibition organized by the Caisse Nationale des Monuments Historiques (Paris, 1965).

8. See E. H. Gombrich, 'In Search of Cultural History' in *Ideals and Idols* and pp. 381–99 above, and 'Hegel und die Kunstgeschichte', *Neue Rundschau*, 88, no. 2 (1977), pp. 202–19.

9. See 'On Physiognomic Perception', in *Meditations on a Hobby Horse*.

10. In a footnote Wölfflin refers to his sources, writings by the influential philosopher R. H. Lotze (1817–81), Robert Vischer, *Das optische Formgefühl* (1872), and others. A few years later the psychologist Theodor Lipps attempted to base the theory of empathy on experimental foundations. In English-speaking countries it mainly gained currency through Bernard Berenson. Peter Gunn, *Vernon Lee (Violet Paget), 1856–1935* (London, 1964), pp. 150–60, discusses Berenson's claims to priority *vis-à-vis* Kit Anstruther-Thomson, who seems to have inspired Vernon Lee, but concedes that the idea was 'in the air' at the time. In 'The Mask and the Face', in *Art, Perception and Reality* (Baltimore, 1972, reprinted in *The Image and the Eye*), I have argued against dismissing the theory altogether, without, however, convincing my fellow author Julian Hochberg.

11. Wölfflin, *Renaissance and Baroque*, translated by Kathrin Simon (London, 1964), p. 78.

12. 'Kunstgeschichtliche Grundbegriffe, eine Revision' in *Gedanken zur Kunstgeschichte* (Basle, 1940). Given the frequency with which Wölfflin's *Principles* are assigned as basic reading in art history courses it is depressing that his own second thoughts have never even been translated into English.

13. Wölfflin, *Die Kunst der Renaissance in Italien und das Deutsche Formgefühl* (Munich, 1931), p. 6.

(The translation in the text is by E. H. Gombrich.)

14. P. Frank, *The Gothic Literary Sources and Interpretations through Eight Centuries* (Princeton, 1960).

15. Rachel Meoli Toulmin, 'L'Ornamento nella Pittura di Giotto', in *Giotto e il suo tempo*, a Congress of 1967 (Rome, 1971), pp. 177–89.

16. See *The Heritage of Apelles*, p. 11.

17. For a sympathetic account of his ideas see Jean Bony's introduction to H. Focillon, *The Art of the West in the Middle Ages* (London, 1963), with bibliography.

18. H. Focillon, *The Life of Forms in Art*, trans. C. B. Hogan and G. Kubler (New York, 1948); original French edition 1934, p. 18.

19. My quotations are from his *Art of the West*, 1, pp. 131, 148, and 2, pp. 148, 152.

20. Prosper Mérimée, *Essai sur l'architecture religieuse du moyen âge, particulièrement en France*, reprinted in P. Josserand (ed.), *Prosper Mérimée: études sur les artes du moyen âge* (Paris, 1967). The translation in the text is by E. H. Gombrich. For the origin of these ideas one might go back to the opening statement of Winckelmann's *History af Ancient Art* (1764): 'The arts depending on design began like all inventions with the necessary: then one looked for beauty and finally there followed the superfluous. These are the three principal phases.'

21. *The Works of John Ruskin*, ed. Cook and Wedderburn (London and New York, 1903–12), vol. 8, pp. 119–21.

22. 'Shapes and Things', *The Sense of Order*, pp. 149–51.

23. Ibid., pp. 154–5.

24. Ernst Kitzinger, *Byzantine Art in the Making, Main Lines of Stylistic Development in Mediterranean Art, 3rd–7th Century* (London, 1977), has used precisely the example of decorative sculpture to advocate a return to Riegl's interpretation of stylistic change in the period: 'We must certainly accept a change such as this as wholly "inner directed", a pure manifestation of the sculptor's own aesthetic preference and intent. There is no content here, no point to be made, no message to be conveyed. No patron can have demanded, let alone generated this innovation … It was a kind of chain reaction among artists with each successive step being predicated on the preceding one. And whatever the motivation

was in a specific instance, there is no doubt that the process as a whole has meaning' (p. 79). The author goes on to compare this meaning with the rise of Cubism in our century. One hesitates to take issue with so eminent an authority to whom all students of the period owe so very much, but much depends for my own argument on whether or not his evidence is in fact cogent. The tidy evolutionary series of capitals he presents is based on the important book by Rudolf Kautzsch, *Kapitellstudien* (Berlin, 1936), but it appears that Kautzsch himself frequently used his evolutionary hypothesis to date monuments which cannot be otherwise precisely dated; his argument is therefore somewhat circular. No doubt the frequency of certain features increased statistically in the course of time, but such developments, which can be paralleled from many fields, do not justify a teleological 'Lamarckian' interpretation. My own reading of such 'global' trends should become clearer towards the end of this chapter.

25. For the Baroque see Karl Ginhart, 'Die gesetzmässige Entwicklung des österreichischen Barockornamentes', *Kunstgeschichtliche Studien* ed. Hans Tintelnot (Breslau, 1943), which was not available to me. From a different point of view Dwight E. Robinson, 'Style Changes: Cyclical, Inexorable and Foreseeable', *Harvard Business Review* (Nov./Dec. 1975), argues for the autonomy of cycles in such fashions as beards.
26. Alexander Speltz, *Styles of Ornament* (New York, 1959), p. 238.
27. John Fitcher, *The Construction of Gothic Cathedrals: a Study of Medieval Vault Erection* (New York, 1961).
28. K. R. Popper, *The Poverty of Historicism* (London, 1957), and E. H. Gombrich, 'The Logic of Vanity Fair' in *Ideals and Idols*.
29. George Kubler, *The Shape of Time: Remarks on the History of Things* (New Haven, and London, 1962), p. 68.
30. 'The Logic of Vanity Fair', *Ideals and Idols*.
31. Focillon, op. cit. (note 17), p. 150.
32. Thomas Rickman, *An Attempt to Discriminate the Styles of Architecture in England* (London, 4th edn., 1835), p. 5.
33. Apart from the collections by Berliner and by Jessen, see P. Jessen, *Der Ornamentstich* (Berlin, 1920); *Katalog der Ornamentstichsammlung*

der staatlichen Kunstbibliothek, Berlin (Berlin and Leipzig, 1939) and Peter Ward-Jackson, 'Some Main Streams and Tributaries in European Ornament from 1500–1750', *Bulletin of the Victoria and Albert Museum*, 3 (1969), nos. 2–4 (also available as a separate publication).
34. H. M. Colvin, *The Sheldonian Theatre and the Divinity School* (Oxford, 1964).
35. Bruno Grimschitz, *Johann Lucas von Hildebrandt* (Vienna, 1932), p. 15.
36. Adolf Göller, *Zur Ästhetik der Architektur* (1887).
37. *The Sense of Order*, pp. 43–6.
38. Ibid., pp. 120–6.
39. 'It seems to me that some things have to be changed, that the themes are too serious and that an element of youthfulness has to be mixed into the project. You will bring me the designs when you wish to … there must be childhood spread all round.'
40. *The Sense of Order*, pp. 118–20.
41. See E. H. Gombrich, 'In Search of Cultural History' in *Ideals and Idols* and pp. 381–99 above, and 'The Renaissance – Period or Movement?' in J. B. Trapp (ed.), *Background to the English Renaissance* (London, 1974).
42. *The Sense of Order*, pp. 20–31.
43. See lecture by E. H. Gombrich, 'The Unrepentant Humanist', *Cornell Review*, 1 (Spring 1977), pp. 55–67, where the styles of buildings on Cornell campus are discussed in this light.

Part VI

The Primitive and its Value in Art
1. George Levitine, *The Dawn of Bohemianism* (London, 1978).
2. Arthur O. Lovejoy and George Boas, *Primitivism and Related Ideas in Antiquity* (Baltimore, 1935).
3. 'Longinus' *On the Sublime*, IX.10.
4. Quintilian *Institutio oratoria*, X.i.88.
5. Cicero *De oratore* III.78–100.
6. op. cit., XII.x.3.
7. Arthur O. Lovejoy, 'The Supposed Primitivism in Rousseau's *Discourse on Inequality*', *Essays in the History of Ideas* (Baltimore, 1948), pp. 14–37.
8. Anthony Earl of Shaftesbury, 'Advice to the Author' in *Characteristics*, vol. 1 (London, 1749), p. 229.
9. *Vom deutscher Baukunst* – there is an English translation in John Gage (ed.), *Goethe on Art*

(London, 1980), pp. 105–12.

10. There is a large selection from this seminal book in Elizabeth Gilmore Holt's *From the Classicists to the Impressionists* (New Haven and London, 1986), pp. 57–71.

11. Book I, part 3, ch. 1.

12. 'Nachricht von den Gemalden in Paris', Friedrich Schlegel, *Kritische Gesamtsausgabe* (Paderborn, 1959), p. 13.

13. Fritz Herbert Lehr, *Die Blütezeit Romantischer Bildkunst: Franz Pforr, der Meister des Lukasbundes* (Marburg, 1924), pp. 35f.

14. 'A descriptive catalogue' in William Blake, *Poetry and Prose*, ed. G. Keynes (London, 1948), p. 593.

15. E. H. Gombrich, 'A Primitive Simplicity', in *Kunst um 1800 und die Folgen, Werner Hofmann zu ehren*, ed. C. Beutler, P. K. Schuster and Martin Warnke (Munich, 1988), pp. 95–7.

16. Cited in Cornelius Gurlitt, *Die deutsche Kunst im 19. Jahrhundert* (Berlin, 1899), p. 214.

17. *The Works of John Ruskin*, ed. Cook and Wedderburn (London and New York, 1903–12), vol. 20, p. 254.

18. I have told that story in greater detail in 'The Values of the Byzantine Tradition, a Documentary History of Goethe's Response to the Boisserée Collection', in G. P. Weisberg and L. Dixon (ed.), *The Documentary Image* (Syracuse, NY, 1987), pp. 291–308.

19. See *The Sense of Order*.

20. Cited in Alf Boe, *From Gothic Revival to Functional Form* (Oslo, 1957), a book to which this chapter is much indebted.

21. G. Semper, *Kleine Schriften* (Berlin, 1884), p. 97.

22. J. B. Waring, *Masterpieces of Industrial Art and Sculpture at the International Exhibition, 1862*, 3 vols. (London, 1863), I.60 and II.283.

23. William Morris, 'The Arts of the People' in *On Art and Socialism* (London, 1947), p. 79.

24. John Ruskin, *Lectures on Art, The Works of John Ruskin*, vol. 7, p. 230.

25. Walter Crane, *The Claims of Decorative Art* (London, 1892).

26. op. cit., p. 131.

27. Henry Moore, in *The Listener* (1941).

28. Herbert Read, *The Meaning of Art* (London, 1949), p. 37.

29. Vasari, *Le Vite...*, ed. Milanesi (Florence, 1881), vol. 7, p. 278.

30. *Roy Lichtenstein*, Tate Gallery exhibition catalogue, 6 Jan.–4 Feb. 1968, no. 67.

Magic, Myth and Metaphor

1. 'The Dream of Reason: Symbolism of the French Revolution', *The British Journal for Eighteenth Century Studies*, 2, no. 3 (autumn 1979), pp. 187-205. An Italian translation entitled 'Nostra Signora della Libertà' was published in *FMR*, 34 (June-July 1985), pp. 90-112, the original English version under the title 'Signs of the Times' in *FMR*, English edition, 39 (August 1989), pp. 1-24.

2. *French Caricature and the French Revolution, 1789-1799*, exhibition catalogue by Cynthia Burlingham and James Cuno, Grunwald Center for the Graphic Arts, Wight Art Gallery, University of California, Los Angeles (University of Chicago Press, 1988).

3. Hartman Grisar, S.J., ed., *Luther Studien, Luthers Kampfbilder*, I-III (Freiburg, 1923).

4. Miroslav Hrock and Anna Skybova, *Die Inquisition im Zeitalter der Gegenreformation* (Leipzig, 1985), illustrate relevant engravings but on pp. 121-37 express doubts concerning their documentary value.

5. K.C. Cameron, 'Henri III, a Maligned or Malignant King? Aspects of the Satirical Iconography of Henri de Valois', University of Exeter, 1978.

6. See Dorothy M. George, *English Political Caricature to 1792* (Oxford, 1959), pp. 15f.

7. London, 1964.

8. I have discussed Freud's theory of verbal wit in 'Verbal Wit as a Paradigm of Art', pp. 189–210 above. *Tributes* also contains an account of my collaboration with Ernst Kris, pp. 221-33.

9. Our ideas were summarized in a joint article, 'The Principles of Caricature', *British Journal of Medical Psychology*, 17 (1938), pp. 319-42, and in the King Penguin book *Caricature* (Harmondsworth, 1940).

10. In incorporating our joint article from the *British Journal of Medical Psychology* in his *Psychoanalytic Explorations in Art* (New York, 1952), Kris added the note on p. 200: 'On reconsidering this passage written some fifteen years ago, we now (1951) find our ideas incomplete. A good deal of further investigation concerned with the relation of word and image in ontogenetic development and in historical contexts may prove rewarding. We hope to return to this question jointly.' Unhappily this hope never

materialized.

11. See my address to the Internationalen Germanisten-Kongress of Goettingen, 1985, '"Sind eben alles Menschen gewesen": Zum Kulturrelativismus in den Geisteswissenschaften', *Acts of the Congress*, I (Tübingen, 1986), pp. 17-28; English translation in *Critical Enquiry*, 13, no. 4 (summer 1987), pp. 686-99.

12. 19 July 1989.

13. 27 July 1989.

14. Ithaca and London, 1985. See also David Freedberg, *The Power of the Image* (Chicago and London, 1989), chapter 10, with many bibliographical references.

15. Reprinted in my collection of essays of that title.

16. Second edition (Berlin, 1913).

17. *Mittel und Motive der Karikatur in fünf Jahrhunderten*, ed. Gerhard Langemeyer, Gerd Unverfehrt, Herwig Guratzsch and Christoph Stölzl (Munich, 1984).

18. Reprinted in *Meditations on a Hobby Horse*.

19. A. Warburg, 'Heidnisch-Antike Weissagung in Wort und Bild zu Luthers Zeiten', *Gesammelte Schriften*, 2 (Leipzig, 1932).

20. For a discussion of the picture's relation to the Biblical text, see the catalogue quoted in note 2.

21. The publisher, A. Allard, was neither the first nor the last to adapt earlier compositions for satirical purposes: a print after Titian's *Diana and Callisto* was changed by Pieter van der Heyden in *c.* 1585 into *Queen Elizabeth I Discovering the Lewdness of the Papacy*; cf. David Kunzle, *The Early Comic Strip* (Berkeley and Los Angeles, 1973), p. 122, and *Mittel und Motive der Karikatur* (above, note 17), pp. 266-74.

22. Petrus Ansolini da Ebulo, *De Rebus Siculis Carmen*, a cura di Ettore Rota (Rerum Italicarum Scriptores, ordine da L.A. Muratori, XXXI) (Città di Castello, 1904).

23. Mirjam Bohatcova, *Irrgarten des Schicksals, Einblattdrucke vom Anfange des dreissig-jährigen Krieges* (Prague, 1966).

24. The historian might do well, however, to remember the response by Ridolfo Varano to his *pittura infamante* as told by Edgerton (see note 14), pp. 85-7: the Condottiere refused to feel disgraced, replied in kind, and finally made it up with his detractors.

25. Draper Hill, *Mr Gillray the Caricaturist* (London, 1965), pp. 58-63.

26. The conversation with Frank Whitford was broadcast on BBC Radio 3 on 1 April 1989. I am greatly obliged to the artist for allowing me to quote his words.

Part VII

Approaches to the History of Art

1. K. R. Popper, *The Poverty of Historicism* (London, 1959), p. 28.

2. Vasari, *Le Vite*, ed. Milanesi, vol. 9, p. 93.

3. See E. H. Gombrich, 'Art History and the Social Sciences' in *Ideals and Idols*, pp. 131–66.

4. B. Berenson, *The Venetian Painters of the Renaissance* (New York, 1899).

5. Alois Riegl, *Die Spätrömische Kunstindustrie* (Vienna, 1901); *Gesammelte Aufsätze* (Vienna, 1929). For the following see also my contribution to the XXV International Congress for the History of Art held in Vienna, published in English as 'Art History and Psychology in Vienna Fifty Years Ago', *Art Journal* (summer 1984), pp. 162–4.

6. *Art and Illusion*.

7. Cicero, *De oratore* III.98: 'For it is hard to say why exactly it is that the things which most strongly gratify our senses and excite them most vigorously at their first appearance are the ones from which we are most speedily estranged by a feeling of disgust and satiety. How much more brilliant, as a rule, in beauty and variety of colouring are the contents of new pictures than those of old ones! and nevertheless the new ones, though they captivated us at first sight, later on fail to give us pleasure – although it is also true that in the case of old pictures the actual roughness and old-fashioned style are an attraction. In singing, how much more delightful and charming are trills and flourishes than notes firmly held! and yet the former meet with protest not only from persons of severe taste but, if used too often, even from the general public. This may be observed in the case of the rest of the senses – that perfumes compounded with an extremely sweet and penetrating scent do not give us pleasure for so long as those that are moderately fragrant, and a thing that seems to have the scent of earth is more esteemed than one that suggests saffron; and that in touch itself there are degrees of softness and smoothness. Taste is the most voluptuous of all the senses and more sensitive to sweetness than the rest, yet

how quickly even it dislikes and rejects anything extremely sweet! who can go on taking a sweet drink or food for a long time? whereas in both classes things that pleasurably affect the sense in a moderate degree most easily escape causing satiety. Thus in all things the greatest pleasures are only narrowly separated from disgust.' Translated by H. Rackham, Loeb Classical Library (Cambridge, MA, 1961).

8. 'The Logic of Vanity Fair: Alternatives to Historicism in the Study of Fashions, Style and Taste' in *Ideals and Idols*, pp. 60–92.

9. K. R. Popper, *The Open Society and its Enemies*, (London, 1966), vol. 2.

10. Pliny, *Historia Naturalis*, XXXV.56–8.

11. See *The Heritage of Apelles*.

12. 'Leonardo on the Science of Painting' in *New Light on Old Masters*.

13. I Kings 5; 2 Chronicles 2, 13.

14. Vasari, *Le Vite*, ed. Milanesi, vol. 2, p. 413.

15. Vasari, *Le Vite*, ed. Milanesi, vol. 3, pp. 567–8. I have discussed both passages in 'The Leaven of Criticism in Renaissance Art' in *The Heritage of Apelles*.

16. Dürer's letter to Pirkheimer of 7 February 1506 in K. Lange and E. Fuhse, *Dürers schriftlicher Nachlass* (Halle, 1893), p. 22.

17. In *Ideals and Idols*, pp. 131–66.

18. Ibid., pp. 149–52.

19. J. H. Huizinga, *Dutch Civilization in the Seventeenth Century and Other Essays* (London, 1968), pp. 97ff., and my 'Reynolds Lecture', *Styles of Art and Styles of Life* (London, 1991).

20. *Ideals and Idols*, p. 163.

21. 'Over een Definitie van het begrip Geschiedenis' (1929) in J. Huizinga, *Verzamelde Werken*, vol. 7 (Haarlem, 1950), pp. 95–103. I know of no English translation of this important essay. For a German version see J. Huizinga, *Wege der Kulturgeschichte* (Munich, 1930), pp. 78–88.

The Social History of Art

1. cf. K. R. Popper, 'What is Dialectic?', *Mind*, n.s. 49 (1940), reprinted in *Conjectures and Refutations* (New York and London, 1962).

2. cf. review by E. H. Gombrich of Charles W. Morris, *Signs, Language and Behavior* in *Reflections on the History of Art*.

3. Raffaello Borghini, *Il Riposo* (Florence, 1584), pp. 71f.

4. The inscription is quoted by H.

Kauffmann, *Donatello* (Berlin, 1935), p. 172. The MS source (not known to Kauffmann) is a letter of condolence on Cosimo's death to Piero il Gottoso by 'F. Francischus cognomento paduanus' copied in B. Fontio's *Zibaldone*, Cod. Ricc. 907, fol. 142v. Fontio notes on the margin of the distich, '*In columna sub Iudith in aula medicea*'.

In Search of Cultural History

1. H. Wölfflin, *Renaissance und Barock* (Munich, 1888), p. 58.

2. See *Art and Illusion*; and now *The Sense of Order*, Chap. VIII (reprinted above, pp. 257–93).

3. See above, pp. 369–80; and E. H. Gombrich, 'Style', in *International Encyclopedia of the Social Sciences* (New York, 1968).

4. See Karl J. Weintraub, *Visions of our Culture* (Chicago and London, 1966).

5. Wilhelm Dilthey, *Der Aufbau der geschichtlichen Welt in der Geisteswissenschaft (Plan und Fortsetzung)*. *Gesammelte Schriften*, vol. 7 (Leipzig and Berlin, 1927), p. 269.

6. See, for example, Hans-Joachim Schoeps, *Was ist und was will die Geistesgeschichte? Über die Theorie und Praxis der Zeitgeistforschung* (Göttingen, 1959); and Edgar Wind, 'Kritik der Geistes geschichte, Das Symbol als Genenstand kulturwissenschaftlicher Forschung', *Kulturwissenschaftliche Bibliographie zum Nachleben der Antike*, Einleitung, ed. Bibliothek Warburg I (Leipzig and Berlin, 1934).

7. Alois Riegl, *Die Spätrömische Kunstindustrie* (1901) (Vienna, 1927).

8. Ibid., p. 404.

9. Max Dvořák, *Kunstgeschichte als Geistesgeschichte* (Munich, 1924).

10. E. Panofsky, *Aufsätze zu Grundfragen der Kunstwissenschaft* (Berlin, 1964). See also pp. 257–93 above.

11. E. Panofsky, *Gothic Architecture and Scholasticism* (Latrobe, 1951).

12. E. Panofsky, *Renaissance and Renascences in Western Art* (Stockholm, 1960), p. 3.

13. R. L. Colie, 'Johan Huizinga and the Task of Cultural History', *American Historical Review*, 69 (1964), pp. 607–30; Karl J. Weintraub, *Visions of our Culture* (Chicago and London, 1966). See also E. H. Gombrich, 'The High Seriousness of Play: Reflections on *Homo ludens* by J. Huizinga (1872–1945)' in *Tributes*.

14. Jacob Burckhardt, *Briefe*, ed. Max

Burckhardt (Basle, 1949ff.), vol. 3, p. 70.

15. J. Huizinga, *The Waning of the Middle Ages* (1919; London, 1924). Huizinga later regretted the choice of title for this reason, as I mentioned in 'Reflections on *Homo ludens*' (see note 13).

16. J. Huizinga, 'Renaissance and Realism' (1926), in *Men and Ideas* (New York, 1959).

17. J. Huizinga, 'The Task of Cultural History' (1929), in *Men and Ideas* (New York, 1959).

18. Morse Peckham, *Man's Rush for Chaos* (New York, 1966); Edgar Wind, op. cit. in note 6.

19. See *Art and Illusion*; and 'From the Revival of Letters to the Reform of the Arts', pp. 411–35 above.

20. E. H. Gombrich, 'The Logic of Vanity Fair, Alternatives to Historicism in the Study of Fashions, Style and Taste' in *Ideals and Idols*.

21. See E. H. Gombrich, 'Art and Scholarship' in *Meditations on a Hobby Horse*; and *Art and Illusion*.

22. See Morse Peckham, op. cit. in note 18.

23. A. O. Lovejoy, 'The Parallel between Deism and Classicism', *Essays in the History of Ideas* (Baltimore, 1948).

24. W. T. Jones, *The Romantic Syndrome* (The Hague, 1961).

25. See 'From the Revival of Letters to the Reform of the Arts', pp. 411–35 above.

26. Eugene Marais, *The Soul of the White Ant* (1934) (London, 1937).

27. Colin G. Butler, *The World of the Honey-bee* (London, 1954).

28. See now E. H. Gombrich, 'The Renaissance – Period or Movement?' in *Background to the English Renaissance: Introductory Lectures*, ed. J. B. Trapp (London, 1974), pp. 9–30.

29. Francis Haskell, *Patrons and Painters* (London, 1963).

30. Edgar Wind, op. cit. in note 6.

31. K. R. Popper, 'Truth, Rationality and the Growth of Scientific Knowledge' (1960), in *Conjectures and Refutations* (London, 1963).

32. Jacob Burckhardt, *Briefe*, ed. Max Burckhardt (Basle, 1949ff.), vol. i, pp. 206f., quoted in *Ideals and Idols*, p. 35.

33. N. Timasheff, *Sociological Theory* (New York, 1967).

34. K. R. Popper, *The Poverty of Historicism* (1944) (London, 1957); Evon Z. Vogt, 'Culture Change', *International Encyclopedia of the Social Sciences* (New York, 1968).

35. See E. H. Gombrich, 'The Tradition of General Knowledge' in *Ideals and Idols*.

36. W. K. Jordan, *Philanthropy in England, 1480–1660* (London, 1959).

Part VIII

Architecture and Rhetoric in Giulio Romano's Palazzo del Tè

1. *Studi su Giulio Romano* ... (Accademia Polironiana, San Benedetto Po, 1975), and see '"That Rare Italian Master": Giulio Romano, Court Architect, Painter and Impresario' in *New Light on Old Masters*.

2. The best access to the large bibliography of this topic is still provided by the record of the section on Mannerism in the *Acts of the Twentieth International Congress of the History of Art* (Princeton, 1963), with contributions by Craig Hugh Smyth and John Shearman. E. H. Gombrich's introduction to that section is reprinted in *Norm and Form*, pp. 99–106.

3. *Giulio Romano als Architekt* (PhD thesis, University of Vienna, 1933). The chapter dealing with the Palazzo del Tè and other extracts were published as 'Zum Werke Giulio Romanos', *Jahrbuch der Kunsthistorischen Sammlungen in Wien*, N. F. 8 (1934) and 9 (1935), and in an Italian translation in *Quaderni di Palazzo del Tè* (July–December 1984).

4. See 'Focus on the Arts and Humanities' in *Tributes*, p. 14. See now also pp. 27–8 above.

5. See review by E. H. Gombrich of Egon Verheyen, *The Palazzo del Te in Mantua* (Baltimore, 1977), in *Burlington Magazine* (January 1980), pp. 70–1.

6. See, in particular, E. Verheyen, 'Jacopo Strada's Mantuan Drawings of 1567/68', *Art Bulletin*, 49 (1967–9), and K. Forster and R. Tuttle, 'The Palazzo del Te', *Journal of the Society of Architectural Historians*, 30 (1971), pp. 267–93. For the subsequent literature see the catalogue of the exhibition, *Splendours of the Gonzaga*, ed. David Chambers and Jane Martineau, Victoria & Albert Museum (London, 1981).

7. Sebastiano Serlio, *Regole generali di architettura* (Venice, 1537), Libro IV, p. 133v.

8. Munich, Staatsbibliothek, cod. icon, N. 190, based on Book VI of the treatise by Polybius devoted to Roman encampments.

9. J. Shearman has drawn attention to the importance of the theory of rhetoric. See his

'Giulio Romano: tradizione, licenze, artifici', *Bollettino del Centro internazionale di studi di architettura Andrea Palladio*, 9 (1967), pp. 354–68.

10. *Denys d'Halicarnasse, La Composition Stylistique*, ed. G. Aujac, 6 (Paris, 1981), p. 22.

11. Demetrius, *On Style*, ed. W. Rhys Roberts (Hildesheim, 1969), pp. 299–300.

12. Cicero, *Orator*, XXIII.77, 78.

13. Baldassare Castiglione, *Il libro del Cortegiano*, 1, chapters 126–8 (Venice, 1527).

14. Sebastiano Serlio, *Regole*, loc. cit. (see note 7). The description of Fig. 155 reads as follows: 'This gate has elements of the Doric, the Corinthian, the Rustic and also (to tell the truth) of the bestial: the columns are Doric, their capitals are a mixture of the Doric and the Corinthian, the pilasters around the gate are Corinthian in their decorative detail and so is the architrave, the frieze and the cornice. The whole gate is surrounded by the Rustic as will be seen. As to the bestial order, it cannot be denied that since there are a few stones made by nature which have the shape of beasts, they are bestial work.'

15. Giorgio Vasari, *Le Vite de' piu eccellenti pittori, scultori ed architettori*, ed. G. Milanesi, 7 (Florence, 1881), p. 193.

16. Torquato Tasso, *Aminta*, Act I, Scene 1.

17. As cited above in note 6.

18. E. Verheyen as cited above in note 5.

19. Leonardo Bruni, *Epistolarum*, ed. Mehus (Florence, 1741), Lib. VII, epistola 4.

20. Plato, *Sophist*, L. 266c.

From the Revival of Letters to the Reform of the Arts
This paper is based on a lecture originally given at the New York Institute of Fine Art in December 1962.

1. *Vorlesungen über die Philosophie der Geschichte*, ed. E. Gans (Berlin, 1840), pp. 493–6. I have referred to this problem in my inaugural lecture on 'Art and Scholarship' (1957), reprinted in *Meditations on a Hobby Horse*, pp. 106–19, and more fully in 'In Search of Cultural History', pp. 381–99 above.

2. Rudolf Wittkower, *Architectural Principles in the Age of Humanism*, 2nd edn. (London, 1952).

3. Augusto Campana, 'The Origin of the Word "Humanist"', *Journal of the Warburg and Courtauld Institutes*, 9 (1946), pp. 60–73; P. O. Kristeller, *Studies in Renaissance Thought and Letters* (Rome, 1956), esp. p. 574.

4. Charles Singer, E. J. Holmyard *et al.*, *A History of Technology*, 2 (Oxford, 1956); 3 (Oxford, 1957).

5. *The Works of John Ruskin*, ed. Cook and Wedderburn (London, 1903–12), vol. 2, p. 69 (*Stones of Venice*, III, ch. 1).

6. Hans Baron, *The Crisis of the Early Italian Renaissance* (Princeton, 1955), and bibliography on p. 444.

7. Giuseppe Zippel, *Niccolò Niccoli* (Florence, 1890). For a sympathetic appraisal of Niccoli's position, see E. Müntz, *Les Précurseurs de la Renaissance* (Paris, 1882), and George Holmes, *The Florentine Enlightenment* (London, 1969), which draws on the same material as this chapter.

8. Vespasiano da Bisticci, *Vite di uomini illustri*, ed. P. d'Ancona and E. Aeschlimann (Milan, 1951), pp. 442–3.

9. Vespasiano, ed. cit. (note 8), pp. 440.

10. For Bruni's dialogues see below. Niccoli is also introduced in the dialogues by Poggio Bracciolini, *An seni uxor sit ducenda, De nobilitate* and *De infelicitate principum*, in Lorenzo Valla, *De voluptate* and in Giovanni Aretino Medico, *De nobilitate legum aut Medicinae* (first published by E. Garin, Florence, 1947).

11. Leonardo Bruni, *Dialogi ad Petrum Histrum*. The most accessible edition (and Italian translation) is in E. Garin, *Prosatori Latini del Quattrocento* (Milan, 1952), pp. 44–99.

12. Bruni, ed. cit. (note 11), pp. 68–70.

13. Bruni, ed. cit. (note 11), p. 74.

14. Bruni, ed. cit. (note 11), pp. 52–6.

15. Bruni, ed. cit. (note 11), p. 60.

16. H. Baron, op. cit. (note 6), pp. 200–17.

17. Bruni, ed. cit. (note 11), p. 94.

18. For four of them, see below; for the fifth, by Lorenzo di Marco de' Benvenuti, see Hans Baron, op. cit. (note 6), pp. 409–16. In addition there are Francesco Filelfo's many attacks.

19. *Invettiva contro a cierti caluniatori di Dante, etc.*, in Giovanni da Prato, *Il Paradiso degli Alberti*, ed. A. Wesselofsky, vol. 1, pt. 2 (Bologna, 1867), pp. 303–16.

20. Guarino Veronese, *Epistolario*, ed. R. Sabbadini, 1 (Venice, 1915), pp. 33–46.

21. Guarino, ed. cit. (note 20), p. 36.

22. Guarino, ed. cit. (note 20), p. 37.

23. Guarino, ed. cit. (note 20), p. 38.

24. *Leonardo Bruni Oratio in Nebulonem Maledicum* in G. Zippel, *Niccolò Niccoli* (Florence, 1890),

pp. 75–91.

25. Bruni, ed. cit. (note 24), p. 77.

26. Bruni, ed. cit. (note 24), p. 78.

27. Bruni, ed. cit. (note 24), pp. 84–5.

28. B. L. Ullman, *The Humanism of Coluccio Salutati* (Padua, 1963), pp. 108–12.

29. Ullman, op. cit. (note 28), pt. III.

30. Ullman, op. cit. (note 28), esp. pp. 289–90; 2nd ed. (Princeton, 1966), pp. 322–3.

31. Lauro Martines, *The Social World of the Florentine Humanists, 1390–1460* (London, 1963), pp. 161–3.

32. B. L. Ullman, *The Origin and Development of Humanistic Script* (Rome, 1960), pp. 70–1, where more passages on diphthongs are quoted.

33. Ullman, op. cit. (note 32), pp. 25 and 53.

34. Vespasiano, ed. cit. (note 8), p. 435.

35. Vespasiano, ed. cit. (note 8), p. 438.

36. This anonymous attack was published by Wesselofsky together with *Il Paradiso degli Alberti*, ed. cit. (note 19), vol. 1, pt. 2, pp. 321–30, but does not form part of it.

37. Ed. cit. (note 19), p. 327.

38. As quoted above (note 32).

39. Ullman, op cit. (note 32), pp. 13–14.

40. Ullman, op. cit. (note 32), p. 18 and fig. 8.

41. Ullman, op. cit. (note 32), pp. 24–5.

42. Ullman, op. cit. (note 32), pp. 86–7.

43. *Italian Illuminated Manuscripts from 1400–1550*, catalogue of an exhibition held in the Bodleian Library (Oxford, 1948).

44. MS. Can. Pat. Lat. 138.

45. MS. Can. Pat. Lat. 105.

46. Hans Tietze, 'Romanische Kunst und Renaissance', *Vorträge der Bibliothek Warburg 1926–27* (Berlin, 1930). The point is also discussed *inter alia* by E. Panofsky, *Renaissance and Renascences in Western Art* (Stockholm, 1960), p. 40, and recently by Eugenio Luporini, *Brunelleschi* (Milan, 1964), esp. notes 31 and 33.

47. 'Similmente las scrittura non sarebbe bella se non quando le lettere sue proportionali in figura et in quantità et in sito et in ordine et in tutti i modi de' uisibili colle quali si congregano con esse tutti le parti diuerse …', *Lorenzo Ghibertis Denkwürdigkeiten* (I Commentarii), ed. J. v. Schlosser (Berlin, 1912), MS. fol. 25v. I am indebted for this reference to Mrs. K. Baxandall.

48. Antonio Manetti (attrib.), *Vita di Ser Brunellesco*, ed. E. Toesca (Florence, 1927), 'E nel guardare le sculture, come quello che aveva buono occhio ancora mentale, et avveduto in tutte le cose, vide el modo del murare degli antichi et le loro simetrie, et parvegli conoscere un certo ordine di membri e d'ossa molto evidentemente … Fece pensiero di ritrovare el modo de' murari eccellenti e di grand'artificio degli antichi, e le loro proporzioni musicali …'

49. See above, especially E. Luporini, note 46 above.

50. Vespasiano, ed. cit. (note 8), p. 441.

51. Guarino, ed. cit. (note 20), pp. 39–40. 'Quis sibi quominus risu dirumpatur abstineat, cum ille ut etiam de architectura rationes explicate credatur, lacertos exerens, antiqua probat aedificia, moenia recenset, iacentium ruinas urbium et "semirutos" fornices, diligenter edisserit quot disiecta gradibus theatra, quot per areas columnae aut stratae iaceant aut stantes exurgant, quot pedibus basis pateat quot (obeliscorum) vertex emineat. Quantis mortalium pectora tenebris obducuntur!'

52. For an (abbreviated) edition and translation into Italian see E. Garin, *Prosatori Latini del Quattrocento* (Milan, 1952), pp. 8–36.

53. H. Baron, op. cit. (note 6), esp. pp. 81–5; for the question of date B. Ullman, op. cit. (note 28), p. 33, and Baron, 2nd ed., pp. 484–7.

54. 'Quod autem haec urbs romanos habuerit auctores, urgentissimis colligitur coniecturis, stante siquidem fama, quae fit obscurior annis, urbem florentinam opus fuisse romanum: sunt in hac civitate Capitolium, et iuxta Capitolium Forum; est Parlasium sive Circus, est et locus qui Thermae dicitur, est et regio Parionis, est et locus quem Capaciam vocant, est et templum olim Martis insigne quem gentilitas romani generis volebat auctorem; et templum non graeco non tusco more factum, sed plane romano.

'Unum adiungam, licet nunc non extet, aliud originis nostrae signum, quod usque ad tertiam partem quarti decimi saeculi post incarnationem mediatoris Dei et hominum Jesu Christi apud Pontem qui Vetus dicitur, erat equestris statua Martis, quam in memoriam Romani generis iste populus reservabat, quam una cum pontibus tribus rapuit vis aquarum, annis iam completis pridie Nonas Novembrias septuaginta; quam quidem vivunt adhuc plurimi qui viderunt. Restant adhuc arcus aquaeductusque vestigia,

more parentum nostrorum, qui talis fabricae machinamentis dulces aquas ad usum omnium deducebant. Quae cum omnia romanae sint res, romana nomina romanique moris imitatio, quis audeat dicere, tam celebris famae stante praesidio, rerum talium auctores alios fuisse quam Romanos? Extant adhuc rotundae turres et portarum monimenta, quae nunc Episcopatui connexa sunt, quae qui Romam viderit non videbit solum, sed iurabit esse romana, non solum qualia sunt Romae moenia, latericia coctilique materia, sed et forma' (Garin, ed. cit. (note 52), pp. 18–20).

55. 'Vedesi questo tempio di singulare belleza e in forma di fabrica antichissima al costume e al modo romano; il quale tritamente raguardato e pensato, si giudicherà per ciascuno non che in Italia ma in tutta cristianità essere opera più notabilissima e singulare. Raguardisi le colonne che dentro vi sono tutte uniforme, colli architravi di finissimi marmi sostenenti con grandissima arte e ingegno tanta graveza quanto è la volta, che di sotto aparisce rendendo il pavimento più ampio e legiadro. Raguardisi i pilastri colle pareti sostenenti la volta di sopra, colli anditi egregiamente fabricati infra l'una volta e l'altra. Raguardisi il dentro e di fuori tritamente, e giudicherassi architettura utile, dilettevole e perpetua e soluta e perfetta in ogni glorioso e felicissimo secolo' (Giovanni da Prato, ed. cit. (note 19), vol. 3, pp. 232–3).

56. *Giovanni Rucellai ed il suo Zibaldone*, ed. A. Perosa (London, 1960), p. 61.

57. For a calendar of dates and documents see Cornelius von Fabriczy, *Filippo Brunelleschi* (Stuttgart, 1892), pp. 609–17, and the same author's 'Il palazzo nuovo della Parte guelfa', *Bullettino dell'Associazione per la difesa di Firenze antica*, 4 (June 1904), pp. 39–49.

58. Fabriczy, *Brunelleschi* (note 57), p. 559.

59. Gene A. Bruckner, *Florentine Politics and Society, 1343–1378* (Princeton, 1962), pp. 99–100.

60. Fabriczy, *Brunelleschi* (note 57), p. 292.

61. H. Baron, op. cit (note 6), p. 612, n. 18.

62. A. Chastel, *L'Art Italien* (Paris, 1956), vol. 1, p. 191. It appears, however, that this date, which is sometimes found in the literature, is based only on the negative evidence mentioned by Fabriczy in the article quoted in note 57: in the *Protocolli notarili delle provvisioni dei Capitani e Consuli della Parte* of 1418–26 there

is a reference under 17 September 1422 to the construction of the palace and to the *Operai* previously appointed to supervise this venture. Since this appointment is not recorded in the volume concerned Fabriczy concluded that it must have been referred to in an earlier (and lost) volume. So far, therefore, we have no means of knowing when the new palace was begun nor can we tell when Brunelleschi was called in.

63. G. Marchini, 'Il Palazzo Datini a Prato', *Bolletino d'Arte*, 46 (July–September 1961), pp. 216–18.

64. See E. H. Gombrich, 'Norm and Form' in *Norm and Form*, pp. 81–98.

65. Giovanni Boccaccio, *Decamerone*, Giornata VI, Novella 5.

66. E. H. Gombrich, 'Visual Discovery through Art', *Arts Magazine*, 40, no. 1 (November 1965); now in James Hogg (ed.), *Psychology and the Visual Arts* (Harmondsworth, 1969).

67. 'Quid igitur, si pictor quispiam, cum magnam se habere eius artis scientiam profiteretur, theatrum aliquod pingendum conduceret, deinde magna expectatione hominum facta, qui alterum Apellen aut Zeuxin temporibus suis natum esse crederent, picturae eius aperirentur, liniamentis distortis atque ridicule admodum pictae, nonne is dignus esset quem omnes deriderent?' Bruni, ed. cit. (note 11), p. 72.

68. For a full bibliography see Luporini, *Brunelleschi*, (note 46 above), n. 63.

69. E. H. Gombrich, 'The "What" and the "How": Perspective Representation and the phenomenal World' in R. Rudner and I. Scheffler, *Logic and Art, Essays in Honor of Nelson Goodman* (New York, 1972), pp. 129–49.

70. *Art and Illusion*, chapters, VIII and IX.

71. E. H. Gombrich, 'The Renaissance Concept of Artistic Progress and its Consequences' in *Norm and Form*.

Part IX
The Use of Art for the Study of Symbols
1. E. Panofsky, *Studies in Iconology* (Oxford, 1939).

2. E. Castelli (ed.), *Umanesimo e Simbolismo* (Padua, 1958) and L. C. Knights and B. Cottle (eds.), *Metaphor and Symbol* (London, 1960).

3. K. Bühler, *Sprachtheorie* (Jena, 1934), pp. 185–6.

4. L. Dieckmann, 'Friedrich Schlegel and

Romantic concepts of the symbol', *Germanic Review* (1959) and H. R. Rookmaaker, *Synthesist Art Theories* (Amsterdam, 1959).

5. H. Pauli and E. B. Ashton, *I Lift my Lamp: the Way of a Symbol* (New York, 1948).

6. 'The Cartoonists' Armoury' in *Meditations on a Hobby Horse*.

7. E. Panofsky, *Early Netherlandish Painting* (Cambridge, MA, 1953).

8. L. Baldass, *Van Eyck* (London, 1952), p. 272.

9. E. Panofsky, op. cit. (note 7), pp. 446, 448.

10. E. Mâle, *L'Art religieux de la fin du moyen âge en France* (Paris, 1908), p. 223.

11. K. Bühler, op. cit. (note 3), pp. 42–8.

12. *Meditations on a Hobby Horse*, pp. 15–16.

13. Anthropomorphism, *Catholic Encyclopedia* (1913), pp. 558–9.

14. S. K. Langer, *Philosophy in a New Key* (Cambridge, MA, 1942) and E. Schaper, 'The Art Symbol', *British Journal of Aesthetics*, 4 (1964), pp. 228–39.

15. J. Stolnitz, 'review of E. H. Gombrich, *Meditations on a Hobby Horse*, *British Journal of Aesthetics*, 4 (1964), pp. 271–4.

16. *Art and Illusion*, ch. XI.

17. C. E. Osgood, G. J. Suci, and P. H. Tannenbaum, *The Measurement of Meaning* (Illinois, 1957).

18. U. Neisser, 'The Multiplicity of Thought', *British Journal of Psychology*, 54 (1963), pp. 1–14.

19. E. H. Gombrich, 'Icones Symbolicae' in *Symbolic Images*.

20. J. S. Bruner, 'On Perceptual Readiness', *Psychological Review*, 64, pp. 123–52.

21. D. Bax, 'Het Tuin der Onkuisheiddrieluik van Jeroen Bosch gevolgd door kritiek op Fraenger', *Verhandelingen der koninklijke Nederlandse Akademie van wetenschappen, Letterkunde* (Amsterdam, 1956), part 63, 2, pp. 1–208.

22. 'Icones Symbolicae'.

23. G. Boas (ed. and trans.), *The Hieroglyphics of Horapollo* (New York, 1950).

24. L. Dieckmann, op. cit. (note 4).

25. 'On Physiognomic Perception' in *Meditations on a Hobby Horse*.

26. E. Panofsky, op. cit. (note 1), ch. 3

27. J. Jacobi, *Complex, Archetype, Symbol in the Psychology of C. J. Jung* (London, 1959).

Aims and Limits of Iconology

1. For this and the following, see F. H. W. Sheppard (ed.), *Survey of London*, 31 (London, 1963), *The Parish of St James Westminster*, pt. 2, pp. 101–10.

2. E. Panofsky, *Studies in Iconology* (New York, 1939) and Göran Hermerén, *Representation and Meaning in the Visual Arts* (Lund, 1969).

3. E. D. Hirsch, *Validity in Interpretation* (New Haven and London, 1967).

4. I have discussed this problem from a slightly different angle in 'Expression and Communication', *Meditations on a Hobby Horse*, especially pp. 66 and 67.

5. *Symbolic Images*, pp. 101–18, 108, 118–22.

6. Émile Mâle, *L'Art religieux du 12e siècle en France* (2nd edition, Paris, 1924; new edition 1940); *L'Art religieux du 13e siècle en France* (6th edition, Paris, 1925); *L'Art religieux de la fin du moyen-âge en France* (Paris, 1908); *L'Art religieux après le Concile de Trente* (2nd edition, Paris, 1951).

7. Andor Pigler, *Barockthemen. Eine Auswahl von Verzeichnissen zur Ikonographie des 17. und 18. Jahrhunderts*, 2 vols. (Budapest, 1956).

8. Raimond van Marle, *Iconographie de l'art profane au moyen-âge et à la Renaissance et la décoration des demeures*, 2 vols. (The Hague, 1931, 1932).

9. Giampaolo Lomazzo, *Trattato dell' arte della pittura* (Milan, 1584), book VI, chapter 23 (I quote from the Rome, 1844, edition).

10. Giorgio Vasari, *Le Vite de' più eccellenti pittori scultori ed architettori*, ed. G. Milanesi (Florence, 1878–85), vol. 6, p. 647.

11. G. G. Bottari, *Raccolta di lettere sulla pittura, scultura ed architettura scritte de' piu celebri personaggi dei secoli XV, XVI e XVII, pubblicata da M. Gio. Bottari, e continuata fino ai nostri giorni da Stefano Ticozzi* (Milan, 1822–5), vol. 3, pp. 31f. For these frescoes, formerly in the Medici Palace, see also Vasari's life of Cristofano Gherardi, Vasari, op. cit. (note 10), vol. 6, pp. 215–16.

12. Vasari, op. cit. (note 10), vol. 7, pp. 115–29.

13. Bottari-Ticozzi, *Raccolta di lettere*, vol. 3, pp. 249–56 (Letter of 15 May 1565). The whole letter is given in *Symbolic Images*, pp. 23–5. For Taddeo Zuccaro, see J. A. Gere, *Taddeo Zuccaro* (London, 1969).

14. Ibid.

15. Vasari, op. cit. (note 10), 7, p. 129.

16. Vasari, op. cit. (note 10), 7, p. 128.

17. For Ripa see also *Symbolic Images*, pp. 139–144.

18. *Symbolic Images*, pp. 123–95.

19. St Thomas Aquinas, *Quaestiones quodlibetales*, VII.14, ed. P. Mandonnet, (Paris, 1926), p. 275:

'... non est propter defectum auctoritatis quod ex sensu spirituali non potest trahi efficax augumentum; sed ex ipsa natura similitudinis, in qua fundatur spiritualis sensus. Una enim res pluribus similis esse potest; unde non potest ab illa, quando in Scriptura sacra proponitur, procedi ad aliquam illarum determinate; sed est fallacia consequentis: verbi gratia, leo propter aliquam similitudinem significat Christum et diabolum.'

20. E. Panofsky, *Early Netherlandish Painting. Its Origin and Character*, 2 vols. (Cambridge, MA, 1953).

21. See H. Horne, *Alessandro Filipepi commonly called Sandro Botticelli, Painter of Florence* (London, 1908), pp. 136–40, where the sources and their interpretation are discussed in greater detail.

22. Luca Beltrami, *Documenti e memorie riguardanti la vita e le opere di Leonardo da Vinci* (Milan, 1919), Document 108.

23. Beltrami, op. cit., Document 107.

24. *Symbolic Images*, pp. 26–30.

25. See A. Gruyer, 'Léonardo de Vinci au Musée du Louvre', *Gazette des Beaux-Arts*, 36, second period (1887); for the author and the poem see F. Cavicchi, 'Girolamo da Casio, *Giornale storico della letteratura italiana*, 66 (1915), pp. 391–2:

Ecce agnus Dei, disse Giovanni,
 Che entrò e uscì nel ventre di Maria
 Sol per drizar con La sua santa via
 E nostri piedi a gli celesti scanni.
De immaculato Agnel vuol tuore e panni
 Per far al mondo di se beccaria
 La Madre lo ritien, che non voria
 Veder del Figlio e di se stessa e danni.
Santa Anna, come quella che sapeva
 Giesù vestir de l'human nostro velo
 Per cancellar il fal di Adam e di Eva
Dice a sua figlia con pietoso zelo:
 Di retirarlo il pensier tuo ne lieva,
 Che gli è ordinato il suo immolar del Cielo.

26. See review by E. H. Gombrich in the *New York Review of Books*, 4, no. 2 (1965).

27. Meyer Schapiro, 'Leonardo and Freud: an Art Historical Study', *Journal of the History of Ideas*, 17, no. 2 (1956).

28. For the history of this composition, see 'The Renaissance Conception of Artistic Progress' in *Norm and Form*, and 'Leonardo's Method for Working out Compositions',

pp. 211–21 above.

29. Benvenuto Cellini, *Trattato del Oreficeria*, ed. L. De-Mauri (Milan, 1927), pp. 111–12.

30. Vasari, op. cit. (note 10), vol. 4, p. 490

31. Vasari, op. cit. (note 10), vol. 6, p. 444.

32. Bertrand Goldschmidt, *The Atomic Adventure* (London and New York, 1964), p. 16.

33. An example may here be quoted as an apparent exception to this rule: the remark in the letter by Sebastiano del Piombo of 7 July 1533 where he tells Michelangelo that the Ganymede would look nice in the Cupola: 'you could give him a halo so that he would appear as St John of the Apocalypse carried to Heaven'. Erwin Panofsky (*Studies in Iconology* (New York, 1962), p. 213) rightly characterizes the remark as a joke, but then possibly projects too much into it.

34. See *Symbolic Images*, pp. 123–95.

35. Vasari, op. cit. (note 10), vol. 1, p. 193.

36. Nicole Dacos, *La Découverte de la Domus Auréa et la formation des grotesques à la Renaissance* (London, 1969) (Studies of the Warburg Institute, 31), especially pp. 165ff.

37. A. Perosa, *Giovanni Rucellai ed il suo Zibaldone* (London, 1960) (Studies of the Warburg Institute, 24), p. 22.

38. See Harold Bayley, *The Lost Language of Symbolism*, 2 vols. (London, 1912).

39. *Symbolic Images*, pp. 31–81.

Raphael's Stanza della Segnatura

1. Giorgio Vasari, *Le Vite de' più eccellenti pittori, scultori ed architettori*, ed. G. Milanesi (Florence, 1878–85), vol. 4, pp. 329–30, '... dove giunto ... cominiciò nella camera della Segnatura, una storia, quando i teologi accordano la filosofia e l'astrologia con la teologia; dove sono ritratti tutti i savi del mondo che disputano in varij modi.'

2. For a dicussion of the *Stanza della Segnatura*, see especially J. Klaczko, *Jules II* (Paris, 1898), chapter 12, and L. Pastor, *Storia dei Papi*, vol. 3 (Rome, 1959), book III, chapter 10; most recently L. Dussler, *Raphael, a Critical Catalogue* (London, 1970), and John Pope-Hennessy, *Raphael* (London and New York, 1970).

3. Oskar Fischel, *Raphaels Zeichnungen*, text volume (Berlin, 1913).

4. Harry B. Gutman, 'Medieval Content of Raphael's "School of Athens"', *Journal of the History of Ideas*, 2, no. 4 (1941), pp. 420–9, has found few followers with his proposal to

accept Vasari's interpretation.

5. Giovanni Pietro Bellori, *Descrizione delle imagini dipinti da Raffaelle d'Urbino nel Palazzo Vaticano, e nella Farnesina alla Lungara* (Rome, 1751), Preface, pp. lx–lxi.

6. Johann D. Passavant, *Rafael von Urbino und sein Vater Giovanni Santi*, 3 vols. (Leipzig, 1839–58).

7. Anton Springer, 'Raffael's Schule von Athen', *Die graphischen Künste*, 5 (1883), p. 87.

8. Franz Wickhoff, 'Die Bibliothek Julius II', *Jahrbuch der Königlichen preussischen Kunstsammlungen* (1893), no. 1.

9. See Pope-Hennessy, op. cit. (note 2), ch. IV, note 20.

10. Heinrich Wölfflin, *Die klassische Kunst* (Munich, 1899).

11. Julius von Schlosser, 'Giustos Fresken in Padua und die Vorläufer der Stanza della Segnatura', *Jahrbuch der kunsthistorischen Sammlungen des allerhöchsten Kaiserhauses*, 17 (1896), pp. 13–100.

11a. Cf. L. Dorez, *La conzone delle Virtù e delle Scienze* (Bergamo, 1904), chapter IX.

12. Vincenzo Golzio, *Raffaello nei documenti, nelle testimonianze dei contemporanei e nella letteratura del suo secolo* (Vatican City, 1936), p. 14.

13. Fiorenzo Canuti, *Il Perugino*, 1 (Siena, 1931), pp. 138–9.

14. Karl Müllner, *Reden und Briefe italienischer Humanisten* (Vienna, 1899).

15. *Iohannis Tuscanellae oratio pro legendi initio*, Müllner, op. cit. (note 14), pp. 191–7.

16. Vasari, op. cit. (note 1), vol. 4, pp. 335–6.

17. The books the two philosophers hold, the *Timeo* and the *Etica*, did not exist as such in Raphael's time. There were no separate Italian translations of these two treatises.

18. A. Springer, loc. cit. (note 7).

19. Cicero, *De Oratore*, I.9.

20. Cicero, *Pro Archia Poeta*, I.2.

21. *Gregorii Tiphernii de studiis litterarum oratio*, Müllner, op. cit. (note 14), pp. 182–91.

22. Poggio Bracciolini, *Oratio in laudem legum*, in Eugenio Garin, ed., *La Disputa delle arti nel quattrocento* (Florence, 1947), pp. 11–15.

23. Bracciolini, ed. cit. (note 22), pp. 11–12.

24. Golzio, op. cit. (note 12), p. 24.

25. See 'Aim and Limits of Iconology', pp. 457–84 above.

26. Karl Buehler, *Die Darstellungsfunktion der Sprache* (Jena, 1934).

27. See *Symbolic Images*, pp. 183f.

28. *Iohannis Argyropuli, Die* III. *Novembris* 1458, *hora fere* XIV, *In libris tribus primis Physicorum*, Müllner, op. cit. (note 14), p. 43.

29. See 'The Use of Art for the Study of Symbols', pp. 437–56 above.

30. Oskar Fishel, *Raphaels Zeichnungen*, vol. 5 (Berlin, 1924), vol. 6 (Berlin, 1925).

31. John White, 'Raphael and Breugel. Two Aspects of the Relationship between Form and Content', *The Burlington Magazine*, 103, no. 699 (1961); and Pope-Hennessy, op. cit. (note 2), pp. 58ff.

32. Wölfflin, op. cit. (note 10).

33. Wölfflin, op. cit. (note 10).

34. Mario Praz, *Studies in Seventeenth-Century Imagery*, 2 vols., Studies of the Warburg Institute, 3 (London, 1939).

35. See above, note 29.

The Subject of Poussin's Orion

1. Sacheverell Sitwell, *Canons of Giant Art. Twenty Torsos in Heroic Landscapes* (London, 1933). The volume contains two poems and notes on Poussin's *Orion*.

2. 'Per lo Signore Michele Passart, Maestro della Camera de' Conti di Sua Maestà Christianissima, dipinse due paesi; nell'uno la fauola d'Orione cieco gigante, la cui grandezza si comprende da un homaccino, che lo guida in piè sopra le sue spalle, et un'altro l'ammira', G. P. Bellori, *Le Vite de' pittori, scultori, et architetti moderni* (Rome, 1672) (reprint of 1968, Quaderni dell'Istituto di storia dell'arte della Università di Genova, 4), p. 546.

3. T. Borenius, 'A Great Poussin in the Metropolitan Museum', *The Burlington Magazine*, 59 (1931), pp. 207–8.

4. Lucian, *The Hall*, ed. A. M. Harman, Loeb Classical Library (London, 1913), p. 203.

5. A. Félibien, *Entretiens sur les vies et sur les ouvrages des plus excellens Peintres ...* (Trévoux, 1725), vol. 4, Entretien VIII.

6. Quoted by Douglas Bush, *Mythology and the Renaissance Tradition in English Poetry* (Minneapolis, 1932), p. 31.

7. Charles Mitchell, 'Poussin's *Flight into Egypt*', *Journal of the Warburg Institute*, 1 (1937–8), p. 342, and note 4, first drew attention to Poussin's use of Natalis Comes.

8. J. Seznec, *The Survival of the Pagan Gods*, trans. B. F. Sessions, Bollingen Series, 38 (New York, 1953).

9. Comes uses the form Aerope instead of Merope to interpret the meaning of the name as 'Air' in this context.

10. Natalis Comes, *Mythologiae, sive Explicationis fabularum libri decem* ... (Padua, 1616), book VIII, chapter XIII, p. 459.

11. W. Hazlitt, *Table Talks*, vol. 2 (London, 1822).

12. Op. cit. (note 3), p. 208.

Dutch Genre Painting
1. Svetlana Alpers, *The Art of Describing: Dutch Art in the Seventeenth Century* (Chicago, 1983).

Part X

Imagery and Art in the Romantic Period
1. B.M. No. 9962.

2. Cf. T. S. R. Boase, 'Illustrations of Shakespeare's Plays in the Seventeenth and Eighteenth Centuries', *Journal of the Warburg and Courtauld Institutes*, 10 (1947); for Fuseli's version of the subject see Fig. 420.

3. John Piper, *British Romantic Artists* (London, 1942), p. 13.

4. B.M. Nos. 9971, 10,059, 10,366.

5. Piper, op cit. (note 3), p. 26.

6. A recent book on the subject is J. V. Kuyk, *Oude politieke Spotprenten* (The Hague, 1940).

7. I have collected some examples in footnotes to F. Saxl, 'A Spiritual Encyclopedia of the Later Middle Ages', *Journal of the Warburg and Courtauld Institutes*, 5 (1942), pp. 100 and 128.

8. Cf. K. Fraenger, *Der Bauernbreugel und das deutsche Sprichwort* (Leipzig, 1923); the whole genre of proverb illustrations is exhaustively treated in L. Lebeer, 'De Blauwe Huyck', *Gentsche Bijdragen tot de Kunstgeschiedenis*, 6 (1939–40). For the psychological aspect of this type of 'literal' illustration, cf. E. Kris, 'Zur Psychologie der Karikatur', *Imago* (1934), republished in *Psychoanalytic Explorations in Art* (New York, 1952). I am greatly indebted to Dr Kris and his approach to a field of research in which we collaborated for many years.

9. The example is from Hogarth's *Evening* (*The Four Times of the Day*).

10. For the Neoplatonic elements in this approach to the visual image, cf. 'Icones Symbolicae', in *Symbolic Images*. The problem of justification is an aspect of this question which I have not treated there.

11. Cf. for instance, B.M. 167, 198, 315, 1047.

12. It is characteristic that Mrs George had to introduce the catchword 'ghosts and apparitions' into her index of selected subjects in Vol. VII (1793–1800) (18 entries) and VIII (1801–10) (23 entries).

13. The fact that one of the most brilliant exponents of humorous absurdity, James Thurber, likes to make fun of Dali and the psychoanalysts does not refute, but confirms, the common background. In the same way Gillray's caricature of Monk Lewis and his 'tales of wonder' (B.M. No. 9932) only emphasizes the atmosphere that is common to both.

14. B.M. No. 9861.

15. B.M. No. 10, 190.

16. Cf. R. Todd, op cit., pp. 29 ff. The similarity of Blake's views with the Neoplatonic tenets on visual symbols as analysed in my article quoted above (note 10), is striking.

17. F. D. Klingender, *Hogarth and English Caricature* (London and New York, 1944), pp. 16–20.

18. Cf. José López-Rey, 'Goya and the World Around him', *Gazette des Beaux-Arts*, 28 (1945), 2, p. 129, where the motif of the Sleep of Reason is traced back to Addison and further instances of Goya's relation to the champions of Enlightenment are discussed.

19. B.M. Nos. 9992, 10,062, 10,063, 10,095; cf. also Mrs George's introductions, vol. VIII, pp. xxi and xxxix.

20. The Victoria and Albert Museum possesses diplomas of the Patriotic Society for the years 1803 and 1805 with cartouches drawn by Porter.

21. W. T. Whitley, *Art in England, 1800–20* (Cambridge, 1928), p. 93.

22. Porter's sketchbook of the campaign in Portugal and Spain in the British Museum in an interesting document. The fullest biography of Porter is still the one in the *Dictionary of National Biography*.

23. Enrique Lafuente Ferrari, *Goya, El Dos de Mayo y los Fusilamientos* (Barcelona, 1946), pp. 19f.

24. Cf. *B.M. Catalogue*, loc. cit. s.v. Spain and Nos. 11,058–11,061. For Goya's interest in English imagery cf. also J. López-Rey, op. cit. (note 18).

25. E. Lafuente Ferrari, op. cit. (note 23), pp.

1ff. and F. D. Klingender, *Goya in the Democratic Tradition* (London, 1948), pp. 150f.
26. For important parallels in the fields of science cf. K. R. Popper, 'Towards a Rational Theory of Tradition', *The Rationalist Annual* (1949), reprinted in *Conjectures and Refutations* (London, 1963).

The Wit of Saul Steinberg
1. Harold Rosenberg, *Saul Steinberg* (New York and London, 1978), p. 19.
2. See E. H. Gombrich, 'Image and Word in Twentieth-Century Art' in *Topics of our Time*, especially p. 173.
3. Rosenberg, op. cit., p. 22.
4. Rosenberg, op. cit., pp. 70, 172–3.
5. Rosenberg, op. cit., pp. 214–28.

Part XI
Franz Schubert and the Vienna of his Time
1. All are easily accessible in Otto Erich Deutsch, *Schubert: A Documentary Biography*, translated by Eric Blom (London, 1946). No individual references are therefore given.
2. K. Kobald, *Schubert und Schwind* (Zurich, 1921).
3. W. Hebenstreit, *Der Fremde in Wien* (Vienna, 1832), p. 39.
4. *The Present State of Music in Germany, the Netherlands and the United Provinces or the Journal of a Tour through those Countries* (London, 1773), vol. 2.
5. 'Fidelis' (pseud.), *Vier Wochen in Wien* (Vienna, 1827). Reprinted 1930, pp. 107–8.
6. W. Bauer, *Briefe aus Wien* (Leipzig), p. 49.
7. J. and W. Hofmann, *Wien* (Munich, 1956), pp. 142–3.
8. This is the tendency of H. Goldschmidt, *Franz Schubert* (Leipzig, 1980).

Nature and Art as Needs of the Mind
1. Catalogue of the Lord Leverhulme Exhibition, Royal Academy of Arts, London, 12 April–25 May 1980.
2. See *Symbolic Images*, pp. 165–7 and note. See also *Critical Inquiry*, special issue on metaphor, 5, no. 1 (1978), with supplementary articles in 6, no. 1.
3. William Hazlitt, *Selected Essays*, edited by Geoffrey Keynes (London, 1948), pp. 3–8.
4. Harold G. Henderson, *An Introduction to Haiku* (New York, 1958).
5. Lady Murasaki, *The Tale of Genji*, a novel in

six parts translated from the Japanese by Arthur Waley (London, 1935).
6. William Wordsworth, *The Prelude, or Growth of a Poet's Mind*, text of 1805 edited by Ernest de Sélincourt (Oxford, 1933).
7. See 'Art and Scholarship' in *Meditations on a Hobby Horse*.
8. See note 1 above.
9. *The Times*, 21 February 1981.
10. *The Story of Art*.
11. See essay by E. H. Gombrich on Warburg in *Tributes*, pp. 117–37.

Goethe: the Mediator of Classical Values
1. The Goethe-Preis of the City of Frankfurt-am-Main was founded in 1927 and is now awarded every three years. The list of recipients includes Albert Schweitzer, Sigmund Freud, Max Planck, Hermann Hesse, Thomas Mann, Walter Gropius and Raymond Aron. The prize is conferred by the Oberbürgermeister in the historic Paulskirche on Goethe's birthday, 28 August.
2. The reader in search of translations will find a useful selection in John Cage, *Goethe on Art* (London, 1980), which I reviewed in *Art History*, 5, 2 (June 1982), pp. 237–42.
3. For this notion see also 'Old Masters and other Household Gods', pp. 37–9 above, and 'Nature and Art as Needs of the Mind', pp. 565–84 above.
4. English in John Gage, op. cit., pp. 103–112 and 17–20.
5. See 'The Values of the Byzantine Tradition, a Documentary History of Goethe's Response to the Boisserée Collection', in G. P. Weisberg and L. Dixon (ed.), *The Documented Image* (Syracuse, NY, 1987), pp. 291–308.
6. 'Der Sammler und die Seinigen', English in John Gage, op. cit., p. 57.
7. In August 1809. See *Goethes Briefwechsel mit Heinrich Meyer*, ed. Max Hecker (Weimar, 1922), 2.238.
8. 'Über Laokoon', 1798, see John Gage, op. cit., p. 78.
9. Ibid.
10. *West-östlicher Diwan, Buch des Unmuts*.
11. *Zahme Xenien*, 2.
12. *Faust 2*, Chorus of Angels in *Grablegung*, Akt 5, 11745–8.

Index

Photographic Acknowledgements

© Heather Angel: 110
Archivi Alinari: 86, 90, 398, 414, 415, 432
Art Institute of Chicago, Helen Birch Bartlett
 Memorial Collection (26.417): 28
Bayerischen Staatsgemäldesammlungen,
 Munich: 467
Bildarchiv Foto Marburg: 117, 284, 382
Bildarchiv Preussischer Kulturbesitz, Berlin:
 469
Trustees of the British Museum: 168
© Bill Chaiktin, courtesy of the Architectural
 Association: 269
Courtauld Institute Galleries, Gambier Parry
 Bequest, 1966: 111
Detroit Institute of Arts, Founders Society
 Purchase, Eleanor Clay Ford Fund, General
 Membership Fund, Endowment Income Fund
 and Special Activities Fund: 440
By permission of Gerald Duckworth & Co.Ltd;
 107, 108, 109, 116, 127, 129-132
Mary Evans Picture Library: 150
FMR/Roberto Ponzani, Milan: 4
Courtesy of the Fogg Art Museum, Harvard
 University Art Museums, Bequest of Meta
 and Paul J. Sachs. Photo © President and
 Fellows, Harvard College, Harvard University
 Art Museums: 122
Werner Forman Archive: 218
Gabinetto Fotografico Soprintendenza B.A.S.,
 Florence: 385
© Nicholas Garland: 341
Peter Gauditz: 295, 296, 297, 301-8, 310, 311, 313-5,
317, 326, 329, 332, 333, 338, 340
© Anne Gold: 294
Index: 348 (Giovetti), 387, 388, 389, 390, 391

(Arch.Fot.I.C.C.D)
Metropolitan Museum of Art, New York: 282
 (The Harris Brisbane Dick Fund, 1933), 439
 (Fletcher Fund, 1924 (24.45.1))
Direktion der Museen der Stadt Wien: 157, 465,
 466, 468, 470
NASA: 16
Trustees of the National Gallery, London: 119,
 120, 121
National Gallery of Art, Washington DC: 54
 (Gift of Mrs Huttleston Rogers, 1945), 361
 (Samuel H. Kress Collection)
Trustees of the National Library of Scotland,
 Edinburgh: 2 (facsimile edition), 290, 291, 368,
 377 (facsimile edition)
Canon Parsons, courtesy of the Architectural
 Association: 345
Philadelphia Museum of Art, George W.Elkins
 Collection: 52
Range/Bettmann: 367
© photo R.M.N.: 164, 202
© Rijksmuseum-Stichting, Amsterdam: 320
RCHME © Crown Copyright: 278
E.S.Ross, Curator of Entomology, California
 Academy of Science: 137
The Royal Collection © Her Majesty The
 Queen: 104, 105, 106, 166, 171-173, 421, 425
Courtesy of the Royal Ontario Museum,
 Toronto: 233, 234
© Solo Syndication Ltd, London: 309
© Saul Steinberg, New York: 451-462
© The Board of Trustees of the Victoria and
 Albert Museum: 115, 128, 239
Yale University Art Gallery, Bequest of Stephen
 Carlton Clark, B.A., 1963: 29